THE LIFE AND ART OF
ALBRECHT DÜRER

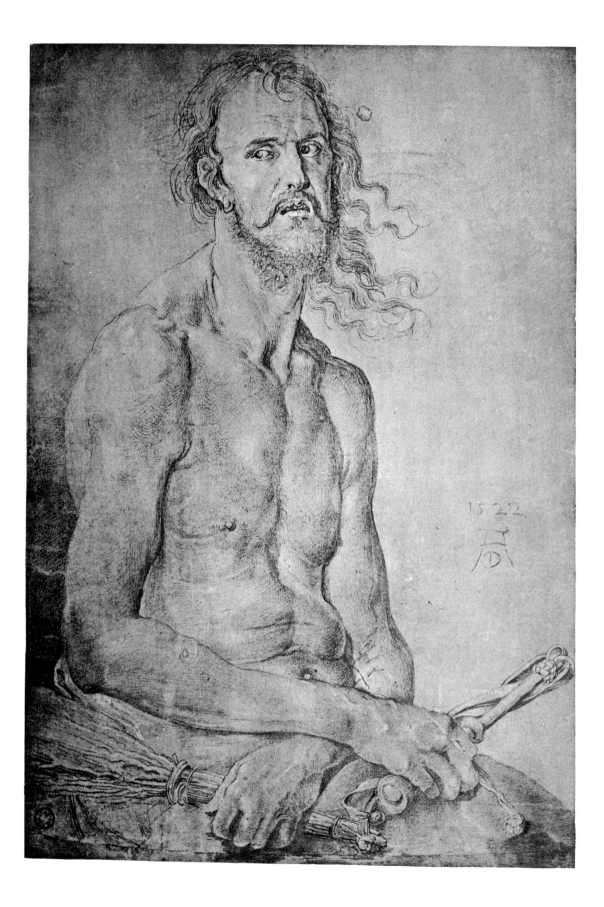

The Life and Art of

ALBRECHT DÜRER

BY ERWIN PANOFSKY

PRINCETON UNIVERSITY PRESS · 1955

PRINCETON, NEW JERSEY

REPRODUCTIONS BY THE MERIDEN GRAVURE COMPANY

DESIGNED BY P. J. CONKWRIGHT

SECOND EDITION, REVISED, 1945

THIRD EDITION, 1948

FOURTH EDITION, 1955

Second Printing, 1965

Third Printing, 1967

PRINTED IN THE UNITED STATES OF AMERICA

THE FIRST EDITION OF THIS BOOK WAS AIDED BY A GRANT

FROM THE AMERICAN COUNCIL OF LEARNED SOCIETIES

FROM A FUND PROVIDED BY

THE CARNEGIE CORPORATION OF NEW YORK

To Walter W. S. Cook,

Abraham Flexner,

Charles Rufus Morey

Preface

FOR reasons best known to itself, the Princeton University Press has proposed to make my book on Albrecht Dürer, last issued in 1948, available in what may be called a portable edition: a single volume containing the Text (including the Bibliography and the previous Prefaces) as well as the Illustrations, but not the Handlist of Works. I have accepted this proposal the more readily as the remarkable improvement of the offset process, largely due to the ingenuity and patience of Mr. E. H. Hugo of the Meriden Gravure Company, now makes possible the successful duplication of the original illustrations.

The very nature of this process precluded major alterations;* but this restriction, it is hoped, will increase rather than impair the usefulness of the present volume. Since neither the pagination of the text nor the numeration of the pictures has been changed, references to the earlier editions are equivalent to references to the new one and vice versa. And that the text still bristles with Handlist numbers (Arabic numerals in parentheses), even though the Handlist itself has disappeared, may be helpful to those who wish for more specific information than the present volume provides.

This new edition, then, differs from its more ambitious predecessors in size and appearance rather than in purpose: it is still the same book, addressed to the student as well as the "general reader." And with the interests of the former in mind, the Princeton University Press has agreed to the addition of an Appendix (p. 299) containing some corrections and amplifications; so that, if the original editions may serve as a completive adjunct to the present volume, the present volume may serve as a corrective postscript to the original editions.

<div align="right">E. P.</div>

Princeton, N.J.
November 1, 1954

* Such changes as were made will be found in the following places: p. 24, line 4 from the foot of the page; p. 44, line 14 s.; p. 75, beginning of first paragraph; p. 89, line 5 s. of the section beginning with "The year 1503"; p. 90, line 2; p. 91, opening of the section beginning with "Dürer did not do much painting"; p. 146, last lines of the second paragraph; same page, last sentence of the third paragraph; p. 147, last line of the second paragraph; same page, line 14 ss. from the foot of the page; p. 157, line 6; p. 170, line 10 ss. from the foot of the page; p. 192, line 15 s.; p. 215, line 1.

PREFACE TO THE FIRST EDITION

THE text of the present publication was mainly developed from the Norman Wait
Harris Lectures delivered at Northwestern University in 1938. It is therefore ad-
dressed to a "mixed audience" rather than to scholars. Time-honored truths and
errors are intermixed with new ones; what might be held indispensable in a comprehensive
monograph is at times suppressed, and emphasis is placed on what may seem trivial to the
specialist.

However, in order to make the book somewhat useful to the more serious student two
additions have been made. Appended to the text is a *Selected Bibliography* (pp. 287-296),
and in Volume II is found a *Handlist of the Works of Dürer, including Ascribed Works and
Important Copies*, followed by a Concordance of the Engravings, Woodcuts, Drawings and
Book Illuminations. This Handlist—consistently referred to in the text—is not a "critical
catalogue" but a mere inventory which, it is hoped, will help the English-speaking reader to
find his way through the vast and bewildering mass of material which, rightly or wrongly, is
associated with the name of Albrecht Dürer. It will refer him to catalogues and corpuses
where illustrations and more specialized information may be found, and indicates, as far as
possible, the connections which exist between two or more works, particularly between draw-
ings on the one hand and prints and paintings on the other. As a rule, bibliographical refer-
ences are given only if not yet included in the catalogues and corpuses referred to, and
explanatory remarks have been restricted to a minimum. The writer has mostly contented
himself with expressing his personal opinion as to date and authenticity. Only where he
hoped to make some contribution to the argument, or where he felt that the case needed
restating, has he embarked upon a brief discussion. The Handlist thus serves a threefold
purpose: first, to help the reader to locate illustrations not found in this book; second, to
make him aware of the genesis and affiliations of the works discussed in the text; third, to
call his attention to works not mentioned in the text at all.

The writer has to apologize, first, for having repeated in his last chapter several para-
graphs already published, in more or less identical form, in a recent but not easily accessible
study entitled *The Codex Huygens and Leonardo da Vinci's Art Theory* (Studies of the
Warburg Institute, XIII), London, 1940; second, for not having discussed Dürer's Treatise
on the Theory of Fortification the subject of which is plainly beyond his compass; third, for
having incorporated in the section on the engraving *Melencolia I* (pp. 156-171) the more
important results of the as yet unpublished second edition of his and his friend Dr. Saxl's
previous book on the subject (*Bibliography*, no. 166). Its publication having been prevented
by the War, he could not help anticipating it to some extent, but he wants to make it perfectly
clear that half of the credit, if any, goes to Dr. Saxl and his associates. He furthermore wishes
to thank all those who, in one way or another, have assisted him in the preparation of these

present volumes, particularly Mr. F. Lugt and Miss Agnes Mongan for information as to the present location of drawings; Messrs. H. H. Arnasson, Q. Beckley O.P., H. Bober, E. F. Detterer, H. A. Mayor, M. Meiss, R. Offner, H. P. Rossiter, G. Schönberger, D. A. Stauffer, H. Swarzenski and Miss K. Serrell for various suggestions, general helpfulness, and assistance in procuring photographs; Messrs. George H. Forsyth, Jr. and Richard Stillwell for the design of Text Illustrations 1 and 2; and, first of all, Miss Margot Cutter for her understanding help in revising the English and for preparing the Indices of Vol. II. The writer's especial gratitude is due to the American Council of Learned Societies and the Carnegie Corporation whose financial help made this publication possible, and to Mr. Lessing J. Rosenwald and Miss Elizabeth Mongan who not only allowed most of the reproductions of prints and illustrated books to be made from the admirable originals in the Alverthorpe Gallery but also placed at the writer's disposal the skill of their excellent photographer, Mr. W. Auerbach.

PREFACE TO THE SECOND EDITION

THE second edition of this book appears so soon that the writer had no time to change his mind on any major point. He has therefore limited himself to minor corrections and adjustments on the one hand and to a few *Addenda* on the other.

The corrections and adjustments have not been especially indicated, but the writer wishes to mention those—apart from simple typographical errors—which were suggested by others:

Vol. I, p. 25, l. 16 from bottom: the fact that the material of the drawing L. 658 (653) cannot be sepia was pointed out in W. Stechow's Review of this book in *Art Bulletin*, XXVI, 1944, pp. 197-199 (hereafter referred to as "Stechow").

Vol. I, p. 64: the error in the original *text ill.* 1 (handle of the burin upside down) was kindly brought to the writer's attention by a letter from Mr. Kalman Kubinyi.

Vol. I, p. 66, second paragraph: the identity of the "praying-cricket" in the engraving B. 44 (151) was doubted by Dr. R. Bernheimer, and his doubts were subsequently confirmed by the Museum of Natural History in New York.

Vol. I, p. 109, last lines: the fact that the *"Feast of the Rose Garlands"* (38) is no longer in the Monastery of Strahow was pointed out by Stechow.

Vol. II, p. 8, no. 13: the possible connection between the inscription on the *Bearing of The Cross* in Richmond and Dürer's theoretical views was pointed out by Stechow.

Vol. II, p. 93, no. 907: the writer's opinion of this drawing became still more favorable upon inspection of a large-scale photograph kindly shown to him by Mrs. E. Tietze-Conrat.

Vol. II, p. 109, nos. 1062 and 1063: F. Winkler's statement to the effect that the drawing T. 381 (1062) was done with the pen—unaccountably overlooked by the writer—was brought to his notice by Stechow.

Vol. II, p. 119, no. 1198: the fact that the attribution of the drawing L. 92 (1198) to Jacques de Gheyn had been rejected by J. Q. van Regteren Altena was pointed out by Stechow.

The *Addenda* consist, first, of two fortunately not very important Handlist items originally overlooked by the writer; second, of some supplementary remarks elicited by such contributions as have been published after the first edition of this book had gone to press. For

typographical reasons these *Addenda* are printed in an Appendix at the end of the Handlist (vol. II, p. 164) to which reference has been made in the proper places.

The writer wishes to express his gratitude to Messrs. Bernheimer, Kubinyi and Stechow, as well as to Mrs. Tietze-Conrat; and to repeat his thanks to all those who have assisted him in the preparation of the first edition.

PREFACE TO THE THIRD EDITION

THE third edition follows the same principles as does the second.

Remarks referring to the few Handlist items not yet included in the previous editions, or elicited by such books and articles as were published or became accessible to the writer after the second edition had gone to press, are printed in another Appendix (vol. II, p. 167).* It should be noted, however, that the writer, in spite of the generous assistance of his good friends H. Bober, E. Breitenbach and F. Saxl, was still unable to keep up with the literature since 1939/40; in several cases he had to quote apparently noteworthy publications from indirect sources without having been able to see them in the flesh.

Other additions and corrections have been incorporated without special indication; but only six of these amount to material changes, and only four to modest material contributions.

By way of rectification, the writer is now inclined to accept the inscribed date—1527—rather than the conjectural one—1521—for the *Head of a Bearded Child* in the Louvre (vol. II, p. 18, no. 84), to be more optimistic as to the quality of the *Fugger Portrait* in Munich (vol. II, p. 14, no. 55), and to admit the basic authenticity of the *Portrait of Endres Dürer* in Budapest (vol. I, p. 91 and vol. II, p. 19, no. 89) while dating it in 1504 instead of about 1515; he was able, thanks to detailed information kindly supplied by Drs. M. Pfister-Burkhalter and W. Rotzler in Basel, to dispel the confusion surrounding the number of woodcuts preserved, and impressions from cut woodblocks lost, within the series of the *Terence Illustrations* in Basel (vol. II, p. 52 s., no. 436, *a*); he has corrected the erroneous substitution of Pseudo-Anacreon for Pseudo-Theocritus in his remarks on the drawing *Cupid the Honey Thief* (vol. I, p. 172 and vol. II, p. 93, no. 908); and he now suggests Aulus Gellius rather than Aelian as the source of the drawing *Androclus and the Lion* (vol. II, p. 92, no. 899).

By way of amplification, the writer proposes to interpret the somewhat puzzling inscription on the replicas of the *Bearing of the Cross* (vol. II, p. 8, no. 13) in connection with the still more puzzling inscription on the *Self-Portrait* in Munich (vol. II, p. 14, no. 50); he

* The correction of the caption of *fig.* 3 (vol. II, p. ix) was suggested by Dr. O. Benesch who kindly called the writer's attention to his article in the *Wiener Jahrbuch für Kunstgeschichte*, VII, 1930, where the author of the picture is identified as the "Younger Master of the Schotten Altarpiece" (p. 189 s., *fig.* 55 a). Though this master was an Austrian by birth he received his training in Nuremberg and helped to introduce the Franconian style into his homeland (Benesch, *l.c.*, p. 177 ss.); a work of his can thus still serve to illustrate the characteristics of the "Wolgemut manner" as described in vol. I, p. 17.

conjectures that the intriguingly unattached woodcut *Cain Slaying Abel* (vol. II, p. 31, no. 221) was intended for a broad-sheet the text of which would have consisted, as in three analogous cases (vol. II, pp. 35 and 42, nos. 275, 352, 353), of a poem by Dürer himself; and he adduces some documentary evidence in connection with the drawing *Androclus and the Lion* (vol. II, p. 92, no. 899) and with the much-debated *Stag-Beetle* (vol. II, p. 131, no. 1359).

Losses and changes caused by the war are still unknown, except for the destruction of the manuscript formerly in the Landesbibliothek in Dresden which contained the following drawings: Handlist nos. 571, 661, 701, 839 (*fig.* 312), 947, 952, 1082, 1122, 1126, 1131, 1182, 1183, 1262, 1307, 1316, 1326, 1404, 1444, 1445, 1446, 1459, 1460, 1461, 1462, 1463, 1464, 1510, 1530, 1550, 1568, 1569, 1602, 1603, 1612, 1616, 1617, 1618, 1619, 1620, 1621, 1623, 1631, 1632, 1635, 1636, 1640, 1641, 1643, 1647, 1649, 1650, 1654, 1655 (*fig.* 322), 1656, 1656a, 1663, 1664, 1686, 1689, 1701, 1702, 1705, 1707, 1708.

As for the illustrations, attempts have been made to replace some of the least satisfactory photographs by better ones but have been successful—through the good offices of Messrs. E. Breitenbach, E. Hanfstaengl, C. H. Smyth, H. Swarzenski, and John Walker III, to all of whom the writer wishes to express his gratitude—in only a limited number of cases. He is, however, pleased to announce that his, the Princeton University Press's and the Meriden Company's united efforts have finally succeeded in substituting, in *fig.* 68, the right picture of *Katharina Fürlegerin* for the wrong one.

Contents

In the List of Illustrations the following abbreviations are used:

B., followed by a numeral, and *B. app.*, followed by a numeral (*B.* 10 or *B. app.* 10), refers to the numbers in Adam Bartsch, *Le Peintre Graveur*, Vienna, vol. VII, 1808, p. 30 ss. and p. 173 ss. respectively.

L., followed by a numeral (*L.* 10), refers to the numbers on the plates in Friedrich Lippmann, *Zeichnungen von Albrecht Dürer in Nachbildungen*, Berlin, 1883-1929 (vols. VI and VII; F. Winkler, ed.).

M., followed by a numeral (*M.* 10), refers to the numbers in Joseph Meder, *Dürer-Katalog, Ein Handbuch über Albrecht Dürers Stiche, Radierungen, Holzschnitte, deren Zustände, Ausgaben und Wasserzeichen*, Vienna, 1932.

Pass., followed by a numeral (*Pass.* 110), refers to the numbers in J. D. Passavant, *Le Peintre-Graveur*, Leipzig, vol. III, 1862, p. 156 ss. and p. 177 ss.

W., followed by a numeral (*W.* 10), refers to the numbers on the plates in Friedrich Winkler, *Die Zeichnungen Albrecht Dürers*, Berlin, 1933 ss.

The numbers in parentheses refer to the Handlist as printed in *Albrecht Dürer*, Princeton, 1943, 1945, 1948, Vol. II.

List of Illustrations*

* Because of the war some of the paintings and drawings here illustrated had to be reproduced from fairly unsatisfactory photographs. The prints, however, could be reproduced, with very few exceptions, from the originals in the Alverthorpe Gallery at Jenkintown (Pennsylvania), the Metropolitan Museum in New York, the Pierpont Morgan Library in New York, and the Museum of Fine Arts in Boston. To these institutions and their staffs the writer wishes to express his sincere gratitude.

In order to correct the misleading impression produced by the changing scale of reduction the actual measurements of Dürer's prints and drawings have been indicated in the customary fashion (height preceding width).

THE LIFE AND ART OF
ALBRECHT DÜRER

Introduction

THE evolution of high and post-medieval art in Western Europe might be compared to a great fugue in which the leading theme was taken up, with variations, by the different countries. The Gothic style was created in France; the Renaissance and Baroque originated in Italy and were perfected in cooperation with the Netherlands; Rococo and nineteenth century Impressionism are French; and eighteenth century Classicism and Romanticism are basically English.

In this great fugue the voice of Germany is missing. She has never brought forth one of the universally accepted styles the names of which serve as headings for the chapters of the History of Art. German psychology is marked by a curious dichotomy clearly reflected in Luther's doctrine of "Christian Liberty," as well as in Kant's distinction between an "intelligible character" which is free even in a state of material slavery and an "empirical character" which is predetermined even in a state of material freedom. The Germans, so easily regimented in political and military life, were prone to extreme subjectivity and individualism in religion, in metaphysical thought and, above all, in art. "I have to take into consideration," Dürer says, "the German mentality. Whosoever wants to build something insists on employing a new pattern the like of which has never been seen before."

Owing to this individualism German art was never able to achieve that standardization, or harmonious synthesis of conflicting elements, which is the prerequisite of universally recognized styles. But thanks to this very same quality Germany exerted an international influence by producing specific iconographical types and isolated works of art which were accepted and imitated, not as specimens of a collective style but as personal "inventions."

For instance; many of the "Andachtsbilder" ("devotional images") later to spread throughout Europe are German creations. Devised for private worship, they consist of single figures strongly appealing to the sentiments of the beholder, or of groups knit by an interplay of mutual emotions; detached as they are from any scenic or historical context, these images are suitable for lasting subjective contemplation. They show the isolated Christ with the Cross on His shoulders instead of the Bearing of the Cross; St. John leaning on the Bosom of the Lord instead of the Last Supper; the Virgin in Childbed instead of the Nativity; the Virgin on the Crescent instead of an illustration of Apocalypse XII; and, above all, the *Pietà* instead of the Lamentation of Christ: a lonely Madonna tragically transformed after the pattern of the grieving mothers in the Slaughter of the Innocent.

Again in Germany, in the fifteenth century, book printing, engraving and woodcuts for the first time enabled the individual to disseminate his ideas all over the world. It was by means of the graphic arts that Germany finally attained the rank of a Great Power in the domain of art, and this chiefly through the activity of one man who, though famous as a painter, became an international figure only in his capacity of engraver and woodcut designer:

3

Albrecht Dürer. His prints set a new standard of graphic perfection for more than a century, and served as models for countless other prints, as well as for paintings, sculptures, enamels, tapestries, plaques and faiences, and this not only in Germany, but also in Italy, in France, in the Low Countries, in Russia, in Spain and indirectly even in Persia.

Albrecht Dürer was born in Nuremberg on May 21, 1471, the third child of a hard-working and not particularly prosperous goldsmith, also called Albrecht. His father had been born in a small place in Hungary the name of which ("Ajtas") seems to be connected with the Hungarian word ("Ajtó") for "door," in German "Tür" or "Dür." He had come to Nuremberg in 1455 and twelve years later had married the daughter of his master Hieronymus Holper, a girl named Barbara, who was to bear him eighteen children within twenty-four years.

According to custom, young Dürer, too, was intended for the goldsmith's trade, and after a few years' schooling he became his father's apprentice. This early apprenticeship is more important than is generally assumed, for it was from his father that the young Dürer learned two things which were to prove essential in his future development.

In the first place he acquired a thorough familiarity with the tools and materials of the goldsmith's craft, especially with the graver or burin. To engrave a design on a copper plate is not different in principle from engraving an ornament or a monogram on a silver spoon or on a gold box, except that the design on the copper plate is intended to be multiplied by printing. As a matter of fact the greatest engravers of the fifteenth century were originally not painters or book illuminators but goldsmiths who applied their old technique—almost as old as art itself—to the new purpose of producing impressions on paper instead of designs on metal. Engraving in this sense was not practiced in Nuremberg before Dürer, and we can easily understand how much it meant to him to have been taught the use of the burin in his very boyhood.

In the second place, Albrecht Dürer the Elder had had his own training in the Nether-lands, "with the great masters," as Dürer himself expressed it in his little book of family records. Thus he served as an intermediary between his son and the very fathers of modern European painting. Young Dürer was brought up in the worship and, to some measure, in the tradition of Jan van Eyck and Rogier van der Weyden and must have longed to familiarize himself with this tradition at its very source.

In a medieval or a Renaissance goldsmith's workshop draftsmanship played a much more important role than in a modern one where the production is limited to jewelry and plate. Yet it remained naturally subordinated to the more mechanical work, and Dürer, gradually becoming conscious of his innate gift, asked and finally received permission to enter the workshop of a painter. On November 30, 1486, having attained a respectable proficiency in his father's trade, he was apprenticed to the foremost painter of Nuremberg, Michael Wolge-mut, with whom he was to stay more than three years. Wolgemut's workshop, like that of other painters in those days, was a rather large commercial enterprise, with many assistants who treated the apprentices somewhat roughly. Dürer looked back upon these years with

mixed feelings, but he never ceased to respect Wolgemut himself, whom he portrayed with affection and sympathy as late as 1516, three years before the old master's death (70). While apprenticed to him, Dürer received instruction in all the branches of his art. He learned to handle the pen and the brush, to copy and draw from life, to do landscapes in gouache and water color, and to paint with oils. Moreover, woodcuts for illustrated books were produced in Wolgemut's workshop during Dürer's apprenticeship, and the most important of these books were printed on the presses of his godfather, Anton Koberger, the greatest publisher in Germany. Thus he had occasion to become familiar with a graphic medium that was to play an outstanding part in his future career, and this not only in the house of his master but also in the workshops of those designers and cutters who were directly employed by Koberger and other publishers without belonging to the Wolgemut shop.

In addition to what Dürer could learn from Nuremberg artists, he was naturally subject to whatever outside influences might reach him through drawings and particularly through prints. Chief among these were the engravings of Martin Schongauer, the great master of Colmar in Alsace, and the dry points of the Housebook Master, who practiced his spirited and entirely original art chiefly in the Middle Rhenish region. It is perhaps the lure of this strange genius that accounts for the bewildering course of Dürer's "bachelor's journey."

As was customary with young artists, Dürer was sent away as soon as he had finished his apprenticeship, that is after Easter (April 11) 1490. It seems that he was supposed to go to Colmar to work under Schongauer. We learn from an account based on Dürer's own records that he actually appeared there, but that he was too late. Schongauer had died on February 2, 1491, and it was not until the beginning of the following year that Dürer reached Colmar "peragrata Germania," after having traveled through the whole of Germany. Thus more than a year and a half of traveling remains unaccounted for and has given rise to much speculation and controversy. The most reasonable assumption is that it was the fascination of the Housebook Master which prevented Dürer from finding Schongauer alive. Instead of going southwest he seems to have gone northwest and to have reached the Rhine, not in the neighborhood of Strassburg and Colmar but in the neighborhood of Frankfort and Mayence. Whether he saw the Housebook Master in person we shall probably never know. If so, he did not stay with him very long, for there is some reason to believe, both on stylistic and documentary grounds, that he proceeded northward for a visit to Holland whence the Housebook Master had probably come. Then he turned round and went straight up the Rhine, arriving in Colmar early in 1492.

Here he was hospitably received by Schongauer's surviving brothers, the goldsmiths Caspar and Paul and the painter Ludwig, and benefited, as far as he could, from the tradition which the great master had left behind him. However, there was little for Dürer to do in the declining workshop at Colmar. The three brothers recommended him, therefore, to their fourth brother, Georg, who lived as a wealthy and highly respected goldsmith in the city of Basel, and he received the young painter with that "benevolence and humanity" which was apparently characteristic of the whole Schongauer family.

Basel, where Dürer arrived late in the spring or early in the summer of 1492, was one of the foremost European centers of bookmaking and Dürer, the house guest of the distinguished Georg Schongauer and the godson of Anton Koberger, had every opportunity to establish contacts with the great publishers. As early as August 8, 1492, Nicolaus Kessler published an edition of the Letters of St. Jerome, the title page of which bears a portrait of the Saint by Dürer; so great was the success of this woodcut that three other publishers, Amerbach, Furter and Bergmann von Olpe, asked him to work for them. Young though he was, he introduced a new style into the book illustration of Basel, and his relationship with Amerbach developed into a lasting friendship.

In the fall of 1493 Dürer left Basel and went to Strassburg. His sojourn in this city is documented, first, by the entries in an old inventory where we find mention of two portraits, now lost, of "an old man and his wife, the former having been his master at Strassburg in 1494"; second, by two woodcuts in Grüninger's (or Prüss's?) *Opus speciale Missarum*, published at Strassburg on November 13, 1493. It was apparently from Strassburg that Dürer was "ordered home" to Nuremberg where he arrived after Whitsuntide (May 18) 1494. Here he married a nice, modest girl named Agnes Frey, thus falling in with the plans of his parents and hers. The final arrangements, providing for a dowry of two hundred florins, were made after Dürer's return, but it is probable that the "negotiations" (to use his own term) had been under way for some time. His Self-Portrait of 1493, now in the Louvre (48), seems to have reference to a prospective marriage; the inscription reads: "Myn sach dy gat als es oben schtat" ("My affairs will go as ordained on high"), and the Eryngium in his hand is a symbol of "luck in love," more specifically, of a successful match. The wedding took place on July 7, 1494. But the promise of the Eryngium was not to be fulfilled.

The character of Dürer's wife has long been a subject of agitated debate. In her youth she was fairly good-looking and harmless, but in her later years she turned into a somewhat forbidding lady. According to some she was a peaceful and good wife who suffered from the neglect of her famous husband; according to others she was a real termagant who did everything in her power to make his life miserable and practically brought about his death by forcing him to work incessantly to increase their income. Both parties agree that the childless marriage was not happy, and of this indeed there are many indications. Aside from certain references in one of Dürer's letters, which, even as jokes, reveal a definite lack of marital tenderness, his Diary of the Journey into the Netherlands in 1520-21 casts a somewhat unflattering light on his attitude toward his wife. It was the only journey which the couple undertook together, but it is doubtful whether he dined with her more than a score of times during a sojourn of almost a year. Every time he had dinner with one of his many friends he recorded the fact in his notebook by making a little stroke after the name of the person in question. But whenever he started a list of "dinners with his wife" (which he did at periodical intervals) the rows of strokes never seemed to get beyond the first; and when they had their meals in the inn where they were staying, Dürer dined "by himself" or with his host, while his wife and the maid ate "in the upper kitchen."

This fact, however trivial it may seem, is symptomatic of what was really wrong with Dürer's married life. Agnes Frey thought that the man she had married was a painter in the late medieval sense, an honest craftsman who produced pictures as a tailor made coats and suits; but to her misfortune her husband discovered that art was both a divine gift and an intellectual achievement requiring humanistic learning, a knowledge of mathematics and the general attainments of a "liberal culture." Dürer simply outgrew the intellectual level and social sphere of his wife, and neither of them can be blamed for feeling uncomfortable. He loved the company of scholars and scientists, associated with bishops, patricians, noblemen and princes on terms of almost perfect equality, and generally preferred to domesticity the atmosphere of what might be called clubs ("Stuben"), studios and libraries. She could not understand why he left her alone in the house and went off to discuss mythology or mathematics with his learned friends, and why he spent hours on end composing treatises on the theory of human proportions or on descriptive geometry instead of doing what she would call practical work. He lived in a world apart from hers which filled her with misgivings, resentment and jealousy.

Her most intense dislike she reserved for Willibald Pirckheimer, Dürer's best friend, who in later years was to write (though not to dispatch) that famous letter in which he practically accused her of having killed her husband by her greed and pious nastiness. Pirckheimer was one year older than Dürer, and his lifelong friendship with the painter was in itself an anomaly, or at least a novelty. Dürer was born and brought up in the humble and restricted circumstances of a lower middle class family. Pirckheimer, on the other hand, was the scion of one of the oldest and richest patrician families of Nuremberg. He had been reared in all the arts and sports of chivalry and had studied law and the humanities at the fashionable universities of Padua and Pavia, thereby becoming a political and military leader of his community and a great scholar as well. One of the most learned men in an extremely learned period, he was a huge man of enormous vitality and violent temper, witty, superior, and far from virtuous. His wife having died after seven and a half years of marriage, he stanchly refused to renounce the advantages of his bereavement. Surrounded by numerous sisters and daughters (his only son was an illegitimate child), he lived as a widower up to his death in 1530, his later years being somewhat beclouded by failing health, family troubles and the political and religious turmoil of the Reformation.

The relationship between this full-blooded humanist and Dürer was one of complete confidence and intimacy, bred out of affection, fostered by a close community of interests and spiced with good masculine chaff. Pirckheimer initiated his friend into the Greek and Roman classics and kept him informed of the developments in contemporary philosophy and archeology; he patiently assisted him in his literary labors and would suggest amusing or cryptic subjects for prints. Dürer in turn provided illustrations for Pirckheimer's writings, hunted around for him in shops and artists' studios, and illuminated the books in his library, not to mention such favors as portraits, bookplates and emblematic designs. Both criticized each other's weaknesses as frankly and good-naturedly as they themselves were teased by their

mutual intimates. Small wonder that Agnes looked upon these friendships with an aversion fully reciprocated by Pirckheimer.

One instance which reveals the lack of affection between Dürer and his wife is the fact that he left her almost immediately after their honeymoon. In the autumn of 1494 he set out for a trip to Venice and possibly to some other places such as Padua, Mantua and Cremona. That he actually made such a trip is proved, not only by drawings of landscapes, costumes, animals and works of art which presuppose Dürer's presence in the Tyrol and North Italy and demonstrably antedate his later journey through these parts, but also by his own testimony: in a letter from Venice, written on February 7, 1506, he mentions certain works of art which did not please him any more though he had liked them very much "eleven years ago." But even if external evidence were lacking, the very evolution of Dürer's style would bear witness to the fact that he had been in Italy, though certainly not in Rome, long before he "revisited it"—to borrow a phrase from a contemporary writer—in 1505.

It has been said that Dürer fled from a plague which had broken out in Nuremberg in the summer of 1494. But while this epidemic may account for his leaving town (though not for his leaving his wife), it does not justify his going so far. To Dürer, the lure of Italy was twofold: he would see Pirckheimer who was then a student at Pavia, and he would breathe the air of a southern world where classical Antiquity had been reborn. After Dürer had blazed the trail it became almost a matter of course for Northern artists and art-lovers to go to Italy. However, in the fifteenth century the Mecca and Medina of German painters were still Bruges and Ghent. Aside from some borderline cases such as Michael Pacher who worked in the southern part of the Tyrol and was half German and half Italian by direct tradition, the art of the Italian Quattrocento had not exerted any appreciable influence in the North. In France there were of course Foucquet and his followers; but in the Netherlands only some ornamental details, such as classicizing garlands, medallions and *putti*, were timidly taken over toward the very end of the century, and in the Germany which Dürer left the only reflection of the Italian Renaissance was to be found in a few copies in pen or woodcut of Italian drawings and prints. Yet these scattered messages, together with what Dürer could learn in the humanistic circles normally inaccessible to young German painters, sufficed to show him a "new kingdom" beyond the Alps, and he set out to conquer it. Dürer's first trip to Italy, brief though it was, may be called the beginning of the Renaissance in the Northern Countries. He became at once possessed with a passionate wish that was to become one of the persistent purposes of his life; he felt that somehow the German artists should participate in the "regrowth" ("Wiedererwachsung") of all the arts brought about by the Italians "in the last one hundred and fifty years after they had been in hiding for a millennium."

After his return from Italy in the spring of 1495 Dürer settled down to about ten years of an incredible productivity which even an illness in 1503 did not interrupt. Besides numerous paintings he produced, between 1495 and 1500 alone, more than sixty engravings and woodcuts which, printed on his own presses, brought him at once international fame. In 1502 he

lost his father to whom he had been much attached, and two years later he took his mother into his house, where she lived up to her death in 1514.

In the summer or fall of 1505 Dürer set out for a second trip to Italy, the direct cause, it seems, being again an outbreak of the plague. He broke his journey in Augsburg, and his friendly relations with the prominent members of Augsburg society may have been instrumental in securing for him, upon his arrival in Venice, the most honorable commission for which a German painter could hope: the execution of an altarpiece for the altar of Our Lady in the national church of the German colony, S. Bartolommeo.

Dürer stayed abroad about a year and a half, busily working at this and other paintings, and gleaning information in the field of art theory wherever he could. By the middle of October 1506 he announced his intention to come home as soon as he would have returned from Bologna where he expected to receive instruction in the "secret art of perspective," but his actual departure was delayed until January 1507. Since his first letter from Venice—that is, the first one preserved—is dated January 6, 1506 some scholars believe that he might have used the last months of 1505 for a trip to Florence, but this conjecture is not yet supported by sufficient evidence; a stay in Padua, on the other hand, is attested by his portrait in a fresco, ascribed to Giulio Campagnola, in the "Scuola del Carmine."

Much honored by his German friends and by the Venetian nobility, and much envied by his Italian fellow-artists (except for old Giovanni Bellini with whom he lived on terms of mutual friendship and esteem), Dürer finally reappeared in Nuremberg in February 1507, more than ever convinced of his mission and full of envious admiration for the social position and encyclopedic culture attained by the Italian artists during the fifteenth century. "How shall I long for the sun in the cold," he had written to Pirckheimer; "here I am a gentleman, at home I am a parasite."

Not long after his return he bought a stately house, settled down to study languages and mathematics, made the first draft of a great treatise on the theory of art, the gradual elaboration of which was to occupy him up to his death, and in a touching attempt at real universality, he even tried to write verse. Thus he developed more and more into an "erudite" artist, capable of collaborating with scholars and scientists and fully participating in the intellectual movements of his period. It was not only because of his competence as a painter and draftsman but also because of his humanistic qualities that he was employed by the Emperor Maximilian I, the relationship beginning 1512 and developing in a way equally honorable both to the artist and to the Emperor.

Apart from short occasional trips (in 1517, for instance, he went to Bamberg; in the following year he visited Augsburg where he portrayed Jacob Fugger the Rich, the Emperor Maximilian and several notables attending the Diet; and it is possible, though by no means certain, that he was in Frankfort in 1508) nothing interrupted Dürer's quiet and laborious life until the untimely death of the Emperor on January 12, 1519. On September 6, 1515, he had favored Dürer with a pension of a hundred florins a year which, though it came in rather irregularly, was not to be despised. To obtain its continuation Dürer determined at once

to see the Emperor's successor, Charles V, even if he would have to go to Spain or to England to meet him. These panic-stricken projects did not materialize, and instead Dürer accompanied his friend Pirckheimer on a brief excursion to Switzerland whence they returned at the beginning of July. The next year, however, Charles V went to the Netherlands and Aix-la-Chapelle where Dürer could approach him much more easily. It was for this reason, or at least with this excuse, that he set out for his last major voyage. He left Nuremberg on July 12, 1520, accompanied by his wife and by a maid, and stayed a whole year, returning in July 1521.

He came home, intellectually refreshed by innumerable new experiences, successful in his business with the new Emperor, and overwhelmed with honors, but physically a broken man. Insatiably interested in every curious thing produced by man or nature, he had ventured into the mosquito swamps of Zeeland to look at a whale which had been washed ashore. The whale had disappeared before Dürer could see it, but he contracted a malarial fever which slowly and irresistibly undermined his health. He spent the rest of his life in Nuremberg (a trip to Livonia, allegedly undertaken after his journey to the Netherlands, is wholly improbable), and remained indefatigably at work up to the very end. He died on April 6, 1528, leaving behind him more than six dozen paintings, more than a hundred engravings, about two hundred and fifty woodcuts, more than a thousand drawings, and three printed books on geometry, fortification and the theory of human proportions, the last of which appeared about six months after his death. His tomb can still be seen in the "Johannes-Friedhof" in Nuremberg. Embossed on a simple plaque of bronze is one of the most moving epitaphs ever composed, a last tribute of Pirckheimer's unfaltering friendship: "Quicquid Alberti Dureri mortale fuit, sub hoc conditur tumulo"—"Whatever was mortal of Albrecht Dürer is covered by this tomb."

As with most great men the image of Dürer has changed according to the periods and minds in which it has been reflected.

As to his personal character there could be little diversity of opinion. He lived and lives in everybody's memory as a man at once great, good and human. Of rather delicate health, handsome and more than a little vain of his good looks, he was the most loyal of citizens, the most faithful of Christians, the most conscientious of craftsmen and the best of friends. His simple habits and meticulous accuracy in money matters did not interfere with his natural generosity, with his love for good company and with his innocent passion for collecting. For, in queer little animals, in rare plants and stones, in tortoise-shells and quaintly shaped nuts, in fans and spears manufactured by American natives he admired Him Who had created "wondrous things" and had endowed the people in far-off lands with "subtle *ingenia*."

Sure of his genius, yet he remained simple and affable and was ready to befriend his fellow artist wherever he could. He loved recognition and was made happy by every token of kindness and esteem because he was humble and honest; for only pride will spurn the admiration of others and only hypocrisy will pretend to do so. His sense of humor and genuine modesty

prevented him from being either resentful or overbearing. When his friends made their standing joke about his well-kept beard, or when a sarcastic man of letters ridiculed his awkward attempts at poetry, he would reply in jocular vein and remain on the best of terms with his critics. When Pirckheimer was boastful of his exploits in scholarship or diplomacy Dürer would answer, amicably including himself in his reproof: "How good we feel, both of us, I with my picture and you *cum voster* wisdom. When we are praised we turn up our noses and believe it all. But there might stand a nasty mocker behind us and scoff at us."

As to the character of Dürer's art there was and is less unanimity of opinion. His greatness was instantaneously recognized and never questioned, but the distinctive qualities of this greatness were variously defined. His Italian contemporaries objected to his handling of color, to his anachronisms in settings and costume and to his lack of true "classical" spirit, but they admired him as a supreme technician in the field of woodcut and engraving and praised his teeming inventiveness; with the awakening of a strong regional patriotism in northern Italy he became, for Lomazzo, the "grand Druid" of art; and in Bologna he was credited with more important contributions to the Renaissance than Raphael and Michelangelo. To Joachim Sandrart, the Vasari of the Northern Baroque (who devised a tenth Muse named Teutillis, exclusively engaged in superintending the art of the Germans), Dürer was mainly an "industrious" man, but also undeniably a great inventor and faithful observer of the "true rules of art." To the young Goethe he meant vigor and unyielding, "woodcarved" manliness while the Goethe of the "Venetian Epigrams" objected to the "brain-confusing" phantasmagorias of the Apocalypse; and the Goethe of the "Weimarer Kunstfreunde" admired the humor and all-embracing universality of the Prayer-Book of Maximilian I. Wilhelm Heinse—opposing and opposed by Goethe in more than one respect—reiterated the opinion of the Italian Renaissance in more violent terms: "Dürer could never wholly outgrow the goldsmith's apprentice from Nuremberg; in his works there is a diligence approaching anxiety which never permitted him to attain to broad vision and sublimity . . . ; Proserpine abducted by Pluto on a billy-goat, Diana clubbing a Nymph in the arms of a Satyr—all this reveals his misguided imagination though he is otherwise a competent master of power and strength." The German Romanticists, finally, liked to think of Dürer as a meek and pious soul wholly devoted to the interpretation of Christian subjects and "contented with a quiet and dependent life, never forgetting that an artist is nothing but a workman of God."

One of these Romanticists, however, Carl Gustav Carus, sensed an altogether different quality in Dürer's disposition. Basing his interpretation on the engraving *Melencolia I*, he discovered a Faustian element in Dürer's nature, a restless craving for a perfection never to be attained, and an acute awareness of problems never to be resolved. Carus's statements are not free from exaggerations and positive errors (he went so far as to identify the "Melencolia" with Dr. Faustus in person); yet they do justice to what is perhaps the most significant aspect of Dürer's personality.

The very fact that the most productive artist of a country previously averse to theorizing in the field of art should have felt the urge to undertake scientific treatises on perspective,

human proportions, etc., reveals a tension between conflicting psychological impulses. Dürer was the most patient observer of realistic details and was enamored of the most "objective" of all techniques, line engraving in copper; yet he was a visionary, "full of inward figures," to quote his own characteristic words. Convinced that the power of artistic creation was a "mystery," not to be taught, not to be learned, not to be accounted for except by the grace of God and "influences from above," he yet craved rational principles. He felt that without "Kunst"—that is, knowledge—art was a haphazard mixture of thoughtless imitation, irrational fancy and blindly accepted practice ("Brauch"). He frankly admitted that the German artists of his period, however excellent in technique and natural talent, lacked the indispensable complement of what he called the "right foundations" ("rechter Grund"), and he spent half his life trying to cure this deficiency. Yet he untiringly repeated that theoretical rules were incapable of doing justice to the "infinite complexity of God's creation," and that their value was sorely limited, not only by the inequality of individual gifts and tastes but also by the finiteness of human reason as such: "For, the lie is inherent in our very cognition."

The famous studies from life where every hair in the fur of a little hare and every grass and herb in a piece of turf are studied and rendered with a devotion closely akin to religious worship are by the same man who, precisely in the same years, subjected the human body to a system of lines and circles no less rigid than a construction in Euclid. While Dürer's imagination seethed with the phantasmagorias of the Apocalypse he strove to rival the Italians in female nudes as gracefully sensuous and well-proportioned as he could possibly make them. While he pondered over the projection of regular and semi-regular solids and contrived an apparatus to achieve correct perspective images by mechanical methods he executed etchings in which space seems to dissolve into a welter of unearthly shapes.

To ascribe this interior tension solely to the impact of the Italian Renaissance on the mind of a German artist trained in the Late Gothic tradition would be too simple. Even if it were true that a humble reverence for particulars, combined with the mystical conception of "inspiration from above," were exclusively "Northern" (in reality the "inspired genius" was a discovery of the Florentine Neo-Platonists), and that, conversely, the search for universals and the tendency toward rationalization were exclusively Italian: even then it would be more correct to say that Dürer's yearning for Italy was caused by an innate conflict in his mind than that the conflict in his mind was caused by the influence of Italy. The contact with artists like Barbari and Bellini, Pollaiuolo and Mantegna, Lorenzo di Credi and Raphael, and with thinkers like Alberti and Leonardo da Vinci is not responsible for the dual nature of Dürer's genius; it merely made it conscious and articulate.

Perhaps there is no more characteristic manifestation of Dürer's mentality than a water color drawing in which he tried to record a nightmarish dream which had left him "trembling all over" when he woke. This drawing (1410) shows huge streams of water pouring from the sky, and it is explained by the following text: "In the year 1525, after Whitsuntide, in the night between Wednesday and Thursday, I saw this vision in my sleep, how many big waters fell from the firmament. And the first hit the earth about four miles from myself with great

violence and with enormous noise, and drowned the whole land. So frightened was I thereby that I woke before the other waters fell. And these were huge. Some of them fell far away, some closer, and they came from such a height that they seemed to fall with equal speed. . . ." Even in the grip of a nightmare Dürer could not help observing the exact number of miles which seemed to separate him from the imaginary event, and to draw logical conclusions from the apparent speed of the falling waters to the distance whence they came.

THE ACTIVITIES OF ARTISTS are generally divided into three periods, early, middle and late. This scheme, however rudimentary, is not only based on an analogy to physical life, where we distinguish between youth, maturity and old age, but has some justification in history. However great an artist may be, he will normally begin by absorbing the tradition prevailing at the time of his youth, and by taking a definite attitude toward it. During his second phase, formerly often called his "best period," he will develop a style entirely his own and, if he is strong enough, create a tradition himself. In the last phase, finally, he may either continue with the style of his maturity in a more or less mechanical way and thereby cease to be productive, or else—and this applies to the greatest only—he will outgrow the tradition established by himself. In both cases this "late period" will mean a certain isolation, and it depends on the artist's stature whether this isolation is a "splendid" or a pathetic one. Minor personalities will end as the mannerists of their own "classic" style and will be left behind by younger artists—great masters will do the opposite; while followers and imitators will continue to work, with suitable concessions to a changing taste, along the lines laid down by the great master in his middle period, the great master himself will venture into entirely new regions inaccessible to any of his contemporaries. He, too, will therefore cease to have an immediate following and often forfeit his former popularity, not because he is "outmoded" but because he has overstepped the limits of contemporary understanding. The latest works of Rembrandt, Titian, Michelangelo and Beethoven are cases in point.

When applying this tripartite scheme to the evolution of Dürer we are not wholly satisfied. In his case, too, we may distinguish between the customary three phases. We may classify the works produced up to Dürer's second pilgrimage to Italy in 1505 as "early," the works produced between 1505 and his departure for the Netherlands in 1520 as "middle period," and the works produced between 1520 and 1528 as "late." Such a division is, however, not entirely adequate to the specific character of Dürer's œuvre. The influence exerted in his "middle period" does not predominate so distinctly over that of his "early" and "late" productions as is the rule with other great masters; the imitators, especially in foreign countries, even preferred his early woodcuts and engravings to his "classic" ones. Dürer's last works, on the other hand, though clearly distinguished from the preceding ones by a new rigor and austerity, are not so incommensurable and inaccessible as is the "ultima maniera" of Titian, Rembrandt or Michelangelo. It is also characteristic of Dürer that he did not hesitate to execute paintings or engravings on the basis of drawings made many years before. When Rubens or Titian "repeated" earlier compositions in their late years the style

thereof was changed as thoroughly as the style of Diabelli in Beethoven's variations. Dürer used a drawing of 1498 for an engraving of 1513, or a landscape study of about 1495 for an engraving of 1519 without any appreciable change.

Thus Dürer's evolution seems to differ from that of other great artists by a peculiar invariability or constancy. Nevertheless, his development passed through numerous changes too rapid to coincide with the three major periods, yet too distinct to be neglected. Dürer's evolution, though it seems to be steadier than that of other great masters, is governed by a principle of oscillation which leads to a cycle of what may be called *short periods*; and the alternation of these *short periods* overlaps the sequence of the customary three phases. The constant struggle between reason and intuition, generalizing formalism and particularizing realism, humanistic self-reliance and medieval humility was bound to produce a certain rhythm comparable to the succession of tension, action and regression in all natural life, or to the effect of two interfering waves of light or sound in physics. A mutual reinforcement of conflicting impulses produced a "maximum," and each "maximum" was preceded and followed by phases of tension or release.

It is according to the sequence of these short periods, which, except for the first and the last, have a tendency to comprise about five years each, that Dürer's works will be presented in the following chapters.

I · Apprenticeship and Early Years of Travel,
1484-1495

THE first phase of Dürer's development—by definition a preliminary one—begins with his apprenticeship under his father. The works which bear witness to his activity in this brief period are only three in number, but they could not be more varied in subject matter and medium.

One of these precious documents is a chalk drawing of a young Lady Falconer (1270), not very different from what was typical in the South German schools of the 'eighties, yet distinguished by a fine, eager susceptivity for lively movement and juvenile gracefulness.

The second is a pen drawing dated 1485 (649). Already signed with Dürer's initials, it aims at monumentality where the drawing of the young huntress is cheerfully informal. The composition, consisting of a Madonna symmetrically flanked by musical angels, may reflect an altarpiece or possibly a mural of Dürer's native region. But the poses of the angels are again somewhat easier and more fluently rendered than was customary in Nuremberg; in fact they seem to announce the youthful artist's predisposition for the suppler style of Rhenish masters such as Martin Schongauer.

The third work, a drawing in silver point, is probably the earliest but certainly the most important of the group. It is the well-known Self-Portrait of 1484, "made out of a mirror," as Dürer's later inscription states (996, *fig.* 1). The features of the man are distinctly recognizable in those of the boy: the slightly Mongolian eyes and well-defined cheekbones (perhaps inherited from Hungarian forefathers), the high-bridged, rather protruding nose and the small, sensitive, bud-like mouth. The drawing is remarkable in many other ways. It is unusual that a boy of thirteen should have made his own portrait at all, particularly in a period when the self-portrait was not yet an accepted genre of painting. It is surprising that this boy should have been able to solve the technical problem of such an undertaking as well as he did. And it is even more extraordinary that he should have chosen to use silver point, a most exacting medium which permits neither corrections nor emphasis by mere pressure, and thus demands an unusual degree of assurance, precision and sensibility.

The technique of silver point originated, it seems, in the workshops of book illuminators rather than in those of painters, and was brought to perfection in Flanders where it was especially employed for careful copies and for studies from life. It was apparently not in favor with the Nuremberg painters of the fifteenth century who used pen and ink even for portrait drawing. But Dürer's father, we remember, had spent his early years "with the great masters" of the Netherlands. Is it to his instruction that we owe the astonishing performance of his young son?

Proof of this assumption is furnished by another portrait drawing, also in silver point and very similar to Dürer's precocious masterpiece in general arrangement (1016, *fig.* 2). There can be no doubt that this drawing represents Dürer's father. His identity can be firmly established, not only by the silver statuette which he proudly carries as an attribute of his profession, but also by his unmistakable resemblance to the two portraits painted by his son, especially the one of 1490 in the Uffizi (52, *fig.* 31). The authorship of the drawing, however, is still controversial. It has been attributed to Albrecht Dürer the Younger, but this assumption must be discarded for reasons both stylistic and, if one may say so, iconographical. The portrait of the father is sober and reticent where that of the son is eloquently spirited, and it suffers from a profusion of detail not entirely subordinated to a unified pattern. But it excels in a technical delicacy and in an almost metallic precision compared to which the work of the boy looks experimental and rough.

Even if this contrast in style and interpretation were less fundamental, the portrait of Albrecht Dürer the Elder could not be ascribed to his ingenious son. An artist portraying himself in three-quarter profile and in half length is confronted by two problems: first, how to render his right hand (which, of course, appears as his left in the portrait); second, how to render his own eyes. His right hand eludes observation because it is engaged in handling the pencil or pen, and his eyes cannot look at the mirror and at the drawing at the same time. It is precisely in these two respects that the two drawings here under discussion reveal embarrassment. In both cases the left hand (that is, in reality, the right) is carefully kept out of sight by the other forearm, and the eyes have a curious, slightly squinting stare which indicates that the irises and pupils were not portrayed from life but were filled in later.

Thus the portrait drawing of Albrecht Dürer the Elder resembles that of Albrecht Dürer the Younger, not because they are both by the same artist, but because they are both self-portraits and were made in competition, so to speak. In portraying himself "out of a mirror" the son chose the same medium and the same pose that his father had used; and he used the same trick to hide the "working hand" and drew in the irises and pupils after the rest was finished. No doubt his work surpassed that of his father in freshness and intensity, but he could not yet compete with him in technical perfection. A silver point drawing of an Armored Knight (St. George?), strikingly similar to the portrait of Albrecht Dürer the Elder in style and technique (1233), must therefore also be ascribed to the father and not to the son.

MICHAEL WOLGEMUT, whose workshop young Dürer entered in 1486, shares the misfortune of many other artists who happened to be the early masters of a genius: their works tend to be contemplated only to enhance the greatness of their pupils instead of being measured by their own standards. "Secondo la natura di quei tempi," as Vasari would say, Wolgemut was a highly respectable and even important figure in German fifteenth century art. In 1473 he had married the widow, and inherited the workshop, of Hans Pleydenwurff, presumably his former employer. Wolgemut developed the shop into an enterprise of wide repute receiv-

ing commissions not only from Nuremberg but also from fairly distant communities. So much work was turned out that it is hard to single out the master's personal contribution from that of his collaborators. So far as we can see, he was decidedly progressive. The style of Hans Pleydenwurff, like that of his anonymous contemporary, the "Landauer Master," was rooted in the tradition of Rogier van der Weyden and Dirk Bouts and aimed at quiet dignity, at spaciousness and realism in the treatment of landscapes and interiors, and at coloristic refinement. Wolgemut tried to keep abreast of the tendencies which came to the fore in the last quarter of the century; engravings by Martin Schongauer and others, as well as Italian prints and drawings, were demonstrably copied and employed in his workshop. In deference to the spirit of what has been called the "Late Gothic Baroque" he endeavored to enrich and to enliven the traditional schemes of composition—at times to such an extent that figures and backgrounds merge into a single, somewhat confused but highly ornamental pattern. Wolgemut and his followers were interested in dramatic force rather than in "beauty," and sharpened the characterization of human nature to a degree little short of caricature. They complicated and intensified the movements of their figures with no regard for dignity or even clarity, and liked to develop the draperies into tangly masses of angular ridges and hollows contrasting with violently curvilinear contours (*fig.* 3).

This cramped and agitated style was not, however, the only one which could impress itself on Dürer's mind during his stay with Wolgemut. The qualities of the earlier tradition —those of Hans Pleydenwurff and the "Landauer Master"—survived in a more delicate and, so to speak, attenuated form, in such important works as the altarpiece of the "Augustinerkirche" (formerly mistakenly called the "Peringsdörffer altarpiece") which was completed in 1487, the second year of Dürer's apprenticeship. Its panels are uneven in quality (those signed with the problematic monogram R.F. are definitely not the most important ones), but some of them belong to the most sensitive and moving creations of German fifteenth century art, for instance the St. Luke painting the Virgin, or the Crucified Christ descending from the Cross to embrace St. Bernard (*fig.* 4). Such a subject would have presented no problem to high medieval art; but a master committed to the principles of Flemish realism must be admired for having endowed the dead body of a human being with the dignity of a hieratic image miraculously enlivened.

Whether this altarpiece was produced by a comparatively independent group of artists within the Wolgemut shop or in an altogether different workshop, and whether Wilhelm Pleydenwurff, Wolgemut's stepson and associate in various enterprises, had any part in it, are open questions. But that Dürer saw the Pseudo-Peringsdörffer altarpiece *in statu nascendi* is certain: one of its panels—St. *Vitus Healing a Man Possessed*—shows a boyish face strikingly similar to Dürer's self-portrait of 1484; the intensely absorbed St. Luke, too, looks, curiously enough, as Dürer was to look a few years later. Whoever painted this enigmatical altarpiece must have observed young Albrecht with affection and understanding.

Thus Dürer's training in painting was by no means one-sided. The Portrait of his father in the Uffizi, done at the end of his apprenticeship (52, *fig.* 31), combines Wolgemut's

incisiveness and energy of outline with a reticence in color and a quiet insight into human character more reminiscent of Pleydenwurff. Also derived from the "conservative" tradition are Dürer's amazing landscape studies in water color and gouache, such as the *Linden Trees*, the *"Johanneskirchhof"* and the *Wire-drawing Mill* (1367-1369, *figs.* 6, 7). They bring to mind the enticing details found in the backgrounds of pictures by Pleydenwurff (*fig.* 5), the "Landauer Master" and the Master of the Pseudo-Peringsdörffer altarpiece (see the mirror effect of the house near the water in the St. Bernard panel) ; such details must indeed have been preceded by studies from nature quite similar to Dürer's in style and technique.

However, Dürer's most fundamental experience during his years with Wolgemut was his initiation into a field quite new to him, and one in which Wolgemut achieved lasting distinction: the making of woodcuts.

A woodcut is a relief print. A block of wood, sawed along the grain, is covered with a white ground on which the composition can be drawn in ink. Then the block is "cut" in such a way that wood is removed on either side of what is intended to appear as a dark line in the impression. It is to the remaining crests or ridges that the ink is applied in order to be transferred to the paper. Woodcut lines have thus a minimum width beyond which the crests or ridges cannot be narrowed without breaking, and they are separated by intervals which cannot be diminished indefinitely.

The earliest woodcuts, dating from the first quarter of the fifteenth century, show, therefore, nothing but a skeleton of sturdy lines with ample blank spaces in between; when they were illuminated with water colors, a very common practice, the effect was comparable to that of stained-glass windows. It was but gradually and, as it were, reluctantly, that hatching began to rival hand coloring and ultimately replaced it, so that the printed pattern itself gave some illusion of the third dimension. Cheap and adaptable to many purposes, these earliest woodcuts—mostly simplified replicas of paintings, miniatures and even sculptures—were tacked to walls, pasted on furniture, boxes and book covers, or mounted on panels so as to serve as small, inexpensive icons or altarpieces.

At times the pictures were explained by text carved on the same block, and an extension of this principle led to the so-called "block-books" which made their first appearance about 1455 and were to linger on to the end of the century. But the really important step was taken when the impressions ceased to be made by hand and the use of presses set in; this permitted the development of linear patterns so dense and intricate that they would have been hopelessly blurred if printed by hand. This innovation occurred when woodcuts began to be used for the illustration of books printed with movable letters. The first instance on record is Boner's *Edelstein* of 1461; but by 1470/75 the making of woodcuts for printed books had become an organized practice, and the use of presses was soon extended to single prints.

In many cases the cuts continued to be mere transcriptions of the hand-painted miniatures found in the manuscripts about to be published, as is the case with the popular Augsburg Calendars, with Bämler's "Alexander" of 1473, with Quentell's Cologne Bible of about 1479, and with Colard Mansion's *Ovide Moralisé* of 1484, to mention only a few well-

known examples. In the 'eighties, however, the designing of woodcuts for illustrated books developed into an independent profession. Yet the style of the cuts remained a comparatively simple and purely graphic one, with most of the shading obtained by short, straight lines in parallel series; the publishers would often divide the editions into two classes: copies "de luxe" with hand-colored woodcuts and ordinary ones with woodcuts in black and white. The illustrators acted, so far as we know, as employees of the publishers, whereby the work tended to be divided between designers, cutters and, in larger enterprises, copyists ("Formzeichner") who had to adapt the compositions from sketches and studies and transfer them to the blocks.

It is to Wolgemut that credit is due for having emancipated the art of woodcut designing from the domination of publishers and for having vindicated for painters what had been a domain of professional "illustrators." Instead of being employed by a printer he associated himself with his stepson, Wilhelm Pleydenwurff, enlisted the financial support of two capitalists named Sebald Schreyer and Sebastian Kammermeister, and then proceeded to employ a printer; this printer, by the way, was none other than Anton Koberger, the god-father of Dürer. As a result of this arrangement there appeared two justly famous publications, the *Schatzbehalter* of 1491 and Hartmann Schedel's "Nuremberg Chronicle" of 1493, in which the accent of responsibility, the relative importance of the illustrations as compared to the text, and the character of the woodcuts as such were basically changed. Not only did the woodcuts in these two volumes surpass most previous efforts in number and size—the "Chronicle" contains no less than 645 (or, according to a more recent count, even 652) different cuts, some of them as large as about 10 by 15 inches—they also opened up a new vision of the representational and expressive possibilities of the medium. Some of the woodcuts, for instance the scenes from Genesis or the Dance of the Dead (*fig.* 9), attain genuine monumentality. Yet their style, in spite of considerable differences in quality, is always definitely "pictorial." The illusion of depth is intensified by bold foreshortenings, strong contrasts in size, suggestions of aerial perspective and a dramatic use of "repoussoirs" (*fig.* 8). Cast shadows and reflections in water or crystal are freely employed, and the modelling, with frequent cross-hatchings, is so rich that the addition of color spoils rather than improves the effect. Moreover—and this is the most striking encroachment on the domain of metal engraving and painting—phenomena like smoke and flames, and the texture of such materials as metal, glass and velvet are rendered by making the lines merge into frayed masses of black. Where the woodcuts were copied from such emphatically "graphic" models as the topographical illustrations in Breydenbach's "Pilgrimage to the Holy Land," or in Foresti's *Supplementum Chronicarum*, a fundamental change in style makes Wolgemut's intentions all the more evident.

Sticklers for stylistic purity may object to his illusionistic devices as though to a sin against the spirit of the woodcut and against the aesthetic requirements of book illustration. It cannot be denied that the contemporary woodcut designers in Italy (and, in most instances, in France) were more intensely conscious of the essentially graphic quality of the medium and of the problem of achieving an aesthetic harmony between the picture and the letterpress.

Not only such typographical masterpieces as the *Hypnerotomachia Polyphili*, Lorenzo de' Rossi's *De Claris Mulieribus*, or the Naples "Aesop" of 1485, but also the more modest Italian books show an economy and purity of style which makes the illustration "fit the page" as a gobelin fits the wall. Renouncing pictorial ambitions in favor of a decorative effect, these woodcuts form a varied yet transparent pattern of clean-cut lines and unbroken surfaces in black and white which harmonizes to perfection with the aesthetic character of the letterpress. In comparison, the woodcuts in Wolgemut's "Chronicle" seem to lack discipline and taste; but just for this reason they are richer in force and potentialities. The Italian books were illustrated by professional specialists—the "Nuremberg Chronicle" and the *Schatzbehalter* were an adventure of artists accustomed to express themselves in what is called a "major art." In embarking upon this adventure Wolgemut and Pleydenwurff immeasurably, though perhaps unduly, widened the scope and raised the ambitions of what had been a secondary medium, and thereby paved the way for Dürer and Holbein. True, these two masters had to discipline the excessively pictorial style of Wolgemut's woodcuts, and Holbein even tried to temper the German manner with the transparency of the French and Italian. But the act of pruning presupposes the tree, and the tree was growing in Wolgemut's garden while Dürer served his apprenticeship.

For, though the *Schatzbehalter* and "Nuremberg Chronicle" did not appear until 1491 and 1493 respectively, we know that the preparations, at least for the "Chronicle," were well under way long before the final contract was signed (December 29, 1491). In this document mention is made of woodblocks already cut; Wolgemut's masterly "Visierung" for the title page bears the date 1490, and preliminary negotiations between the two painters and the two capitalists started as early as 1487/88. Several woodcuts in the "Chronicle" appear indeed to be earlier than those in the *Schatzbehalter*. The "Chronicle" came out at a later date only because it contains a much greater number of illustrations.

It is even possible and, I think, not improbable that young Dürer was allowed to participate, in a small way, in the work on the "Chronicle." Its 645—or 652—woodcuts had naturally to be allotted to a great number of workers, whereas the illustrations of the *Schatzbehalter* are much more homogeneous in style and execution. Setting aside some incidental details such as plants and ornaments, Dürer's ingenious though inexperienced hand, which could not yet have learned to make a difference between an ordinary pen drawing and a woodcut design, might possibly be recognized in a few illustrations of small size and unorthodox treatment. Chief among these is the representation of the beautiful sorceress Circe and her lovers (435, *k*, 3; *fig.* 10), the only mythological scene in the "Chronicle." It is distinguished by a peculiar imaginative charm and by a style of drawing which obviously presented difficulties to the cutter; the heroine herself is reminiscent of the Lady Falconer already mentioned (1270).

As will be remembered, there was at work in Nuremberg at the time another group of woodcut designers not connected with the Wolgemut shop but directly employed by Koberger and other publishers. Though many of these were probably native artists who could not alto-

gether free themselves from local traditions the leader must have come from "abroad"; his style is not derived from Nuremberg sources and is so closely akin to that of the woodcuts in the "Ulm Terence" of 1486 (printed by Conrad Dinckmut) that a direct connection cannot be questioned.

This "Ulmian style," which first appeared in Koberger's "Lives of the Saints" of 1488 and suddenly vanished after two or three years, is very different from that of Wolgemut. Where the woodcuts in the *Schatzbehalter* and in the "Chronicle" are succulently pictorial in treatment, comprehensive in interpretation and often monumental in size and spirit, those in Koberger's "Lives of the Saints" (*fig.* 11), Ayrer's "Bruder Claus" (*fig.* 12) or Wagner's "Pfarrer vom Kalenberg" are strictly graphic in style, epigrammatically concise in their narrative and small in format. The modelling is frequently reduced to a minimum, and incidentals such as trees, hills and houses are indicated by shorthand abbreviations. As in the "Ulm Terence," details like windows, doors, shoes, etc. are turned into opaque black spots which produce a startling silhouette effect when placed within the comparatively large blank areas; the smallish figures move rapidly yet stiffly, not unlike marionettes (435, *a-c*).

Owing to his and his master's friendly relations with Koberger, Dürer of course had access to the workshops of these "alien" illustrators. That their style made a lasting impression on him would be unquestionable even if his *St. Jerome* of 1492 (414, *fig.* 32) were the one and only woodcut produced during his bachelor's journey. Whether he actually participated in their work is, however, a different question. That an apprentice, even a gifted one, should have taken a really important part in the work of book illustrators not connected with his own employer is *ipso facto* improbable. Only occasional and modest contributions would seem to be possible, and these might be expected to show a less "professional" touch and a more marked influence of Wolgemut's pictorial tendencies than is the case with the general run of woodcuts in the "Ulmian" style. The imaginative representation of Hell in Wagner's *Allerhailsamste Warnung* (435, *e*, 3) and the title page of Stüchs's *Gersonis Opera* (435, *h*) seem to be the most convincing attributions to Dürer.

While Dürer's active participation in the woodcut production of 1488-1490 remains a matter of surmise, some pen drawings of this period are of unquestionable authenticity: an impassioned *Crucifixion* (586), a *Group of Lansquenets* (1220), a vigorous *Battle of Horsemen* (1221), and a sprightly *Cavalcade* of fashionable young people setting out for a ride (1244, *fig.* 13); all are dated 1489 except for the *Crucifixion* which is no doubt the latest work in the group.

Some of these drawings, particularly the *Cavalcade*, which may be compared with such prints as the one illustrated in *fig.* 14, already reveal the influence of that perplexing genius who was to divert Dürer's bachelor's journey from its prescribed course: the Housebook Master, as he is now named from the "Hausbuch" of Wolfegg Castle, a miscellaneous manuscript containing information about numerous "subjects useful and curious," or the Master of the Amsterdam Cabinet, as he used to be called after the most complete collection of his prints.

The Housebook Master and Schongauer were the greatest "Peintres Graveurs" of their generation, but they were antipodes in every respect. Schongauer, having started his career in a goldsmith's workshop, was a supreme engraver who also made paintings. The Housebook Master, having emerged from the studios of Dutch illuminators, was a supreme painter and draftsman who also made prints. These prints were not formal engravings, but—for the first time in the history of art—dry points. They were produced, not by the patient calligraphical action of a burin on copper but by the rapid flicks and scratches of any sharp instrument on lead.

This contrast in technique is symptomatic of a contrast in imagination and feeling. Schongauer began with the rich and almost coloristic style of the *Virgin with the Parrot* or the *Man of Sorrows between the Virgin Mary and St. John*, and ended with the ascetic precision and simplicity of the later *Annunciation* or the *Wise Virgin in Half Length*. The Housebook Master developed from small, unpretentious impromptus with few figures and little or no scenery such as the *Family of Savages on a Stag*—reverting, as it were, to the very beginnings of the engraver's art—to such elaborately pictorial compositions as the *Circumcision of Christ* or the *Adoration of the Magi*.

Schongauer's engravings are final statements, impeccably finished, perfectly balanced, and pervaded by an atmosphere of impregnable dignity. The Housebook Master's dry points are spirited improvisations, now sketchy, now crammed with picturesque detail, adventurous in composition, and expressive even at the expense of grace and propriety. Where Schongauer's St. Joseph remains within the traditional pattern of a somewhat pathetic but decorous old man (*fig.* 17), the Housebook Master makes him lurk behind a grassy bench and throw apples from his hiding place (*fig.* 18). Where Schongauer interprets the Bearing of the Cross (*fig.* 15) as a scene of such sustained grandeur that the composition was used again, with suitable changes, by Guido Reni in his mural in San Gregorio Magno, the Housebook Master shows the fallen Christ flat on the ground and pitifully crushed by the weight of the cross (*fig.* 16). Where Schongauer's St. Michael conquers the Devil with the same effortless poise as the Virtues on the portal of Strassburg Cathedral conquer the Vices, the Housebook Master's homely St. Michael has a hard time with his antagonist who has got a firm hold of one of the Archangel's wings.

The Housebook Master is perhaps the earliest artist who can justly be called a humorist. When he depicted, on a page of the "Housebook," the varied activities of the men and women born under the planet Mercury, the celestial Virgin (one of the two "mansions" of this planet) looks at a mirror and arranges her hair; the wife of the sculptor, who, like all artisans, is a child of Mercury, offers a goblet to the journeyman while her husband looks on with marital and professional jealousy; and the painter, busily working at an altarpiece, is agreeably interrupted by the caresses of a lovely girl. Schongauer, too, attempted some engravings in a lighter vein, but no one is moved to laughter by his *Swine Family* or by his *Fighting Apprentices* (*fig.* 21). The Housebook Master's children are irresistibly funny (*fig.* 22); and his Dog scratching Himself fills the beholder with both amusement and sympathy because

the artist was able to reexperience the blissful trance of a creature who, however humble, is man's brother in God (*fig.* 20).

Contrary to the mere satirist, the humorist does not presume to be superior to the objects of his amusement. He sympathetically understands what he seems to ridicule, be it a hideous old woman, or a couple of ill-bred children, or a dumb beast; for he knows that *sub specie aeternitatis* there may be no great difference between what our finite judgment distinguishes as low and lofty, ugly and beautiful, stupid and wise. Satire, one might say, is bred out of bitterness and pride, humor out of love and humility; and there is truth in Jean Paul's untranslatable phrase: "sie verstand keinen Spass, folglich auch keinen Ernst."

The opposite is true of the Housebook Master. The man who could share the raptures of a dog scratching himself could also share the bashful happiness of young lovers and the pathos of a desolate beggar. The man who did not shrink from depicting Christ's humanity in an undignified manner also found an emotional approach to His divinity. The man who understood children also understood death. The theme of Death and Youth was very common in late medieval art, but it is only in a dry point by the Housebook Master that Death appears as a mystery, awesome yet kindly, threatening yet alluring, merciless yet full of pity (*fig.* 27).

Small wonder that this master attracted Dürer even from a distance and that his influence immeasurably deepened when Dürer had left his native environment. Many of the drawings produced in the first years after his departure are unthinkable without the Housebook Master; for instance the *Elevation of the Magdalen* at Veste Coburg (861), the *Holy Family* in Berlin (725, *fig.* 24), and another *Holy Family* in Erlangen (723, *fig.* 23).

The drawing of the Holy Family in Berlin, the more accomplished of the two, surprises however by an unusually "modern" treatment of space which is suggested by way of division rather than of addition. Depth is not interpreted as an agglomeration of single units arrayed behind each other, but as a continuous expanse parcelled out by undulating rivulets and rows of trees arranged so as to follow the course of imaginary vanishing lines.

This method had been developed by Dutch painters rather than by Flemish and German ones, and had been brought to perfection by Geertgen tot Sint Jans, one of whose pictures (the *St. John the Baptist* in the Museum of Berlin) is very close to Dürer's Holy Family with respect to the treatment of scenery. Now, according to Karel van Mander, it was precisely Geertgen tot Sint Jans whose works had been admired by Dürer when he saw them "in Haarlem"; and since this cannot have occurred during Dürer's journey in 1520-1521, every day of which is accounted for, we must either discard van Mander's story altogether or assume that Dürer had been in Holland in 1490/91. In general van Mander is not the most reliable of biographers, but the stylistic peculiarities of the Holy Family drawing lend some support to his statement. Nor is this drawing the only early work by Dürer which seems to reveal a first-hand knowledge of Dutch fifteenth century painting. A Boutsian element has often been sensed in the Dresden altarpiece of 1496/97 (4, *fig.* 64); the gesture of the St. John in the Strassburg Canon Page of 1493 (441) is distinctly North Netherlandish in character; the Apocalypse seems to be connected, in a mysterious way, with the tradition of early East

Flemish book illumination; and, most astounding of all, the peculiar distribution of the groups, and the diagonal organization of the landscape found in the woodcut *The Martyrdom of the Ten Thousand* (337, *fig.* 69, about 1498) almost repeat—in reverse—the compositional pattern of one of the most impressive pictures by Geertgen tot Sint Jans: the *Burning of the Relics of St. John the Baptist*, now in Vienna and formerly in Haarlem (*fig.* 70).

Be that as it may, before Dürer finally found his way to Colmar he had already been subject to experiences almost too varied and intense for one so young. The remarkable Self-Portrait on the back of the Holy Family drawing in Erlangen (997, *fig.* 25) reflects his high-strung and excited state of mind: gloomy yet ardent, passionate yet observing, perplexed by conflicting impressions and emotions yet hungry for more. But Dürer, even in his fervid youth, was conscious of the dangers of genius. "His only fault," to quote a man who knew him well, "was a unique and infinite diligence, often too harsh a judge of his own self." Instead of indulging in spirited improvisations after the fashion of the Housebook Master he felt the necessity of disciplining himself to faultless craftsmanship and patient study. Even in technical matters he did not permit himself to follow the Housebook Master's example; not until he had become the greatest master of orthodox line engraving did he experiment with the treacherously facile technique of dry point.

Thus he plunged into a study of Schongauer as though he had felt the need of an antidote. We know that he failed to find the great master alive and hurried on to Basel. But the drawings of 1492/93 bear witness to his absorbing interest in Schongauer's drawings and prints. Suffice it to mention the *Execution of a Youth* (1259), the magnificent *Wise Virgin* (645) and the charming "*Promenade*," where the young lover, in fashionable Basel costume, bears an unmistakable resemblance to Dürer himself (1245, *fig.* 28). Moreover the influence of the Master B.M., Schongauer's principal follower in the field of engraving, has recently been traced in several instances.

Other drawings of this period, such as the "*Pleasures of the World*" where frolicsome young people disport themselves on a pleasure-ground while Death, unseen, threatens their happiness (874, *fig.* 29), bear witness to Dürer's inventive imagination. Still others show him as an untiring observer of reality. He devoured it as insatiably as he did the creations of his predecessors. He drew his first female nude (1177, *fig.* 45), heads, hands, animals, draperies and inanimate objects, in short everything accessible to his keen eye and already infallible pen. Reclining on a couch or on two chairs, he would portray his own left leg in two positions (1219). He would punch and crumple a pillow into six different shapes and make a careful record of each variation (1442). The back of the sheet, however, he used for a seventh variation on the pillow theme, a study of his own left hand holding a flower, and a new Self-Portrait (998, *fig.* 26).

This drawing, now in the Robert Lehman Collection at New York, is dated 1493, only about two years after the earlier Self-Portrait in Erlangen. But the difference in attitude is enormous. Where the Dürer of the Erlangen drawing had gazed at the universe with the brooding passion of a bewildered youth, and where the Dürer of the "*Promenade*" had

strutted about as a carefree, long-legged beau, proud of his first successes in art and love, the Dürer of 1493 casts a quiet, scrutinizing glance at the beholder and has the self-assurance of a young master.

The studies of 1493 were freely used for the painted Self-Portrait with the Eryngium in the Louvre (48, *fig.* 30). This picture, completed in the same year and presumably sent home in connection with Dürer's prospective engagement, may be said to synthesize the drawing in Lemberg with that in Erlangen. Dürer looks, of course, older than in the drawing of 1491, but, curiously enough, appreciably younger than in that of 1493, and this not only physically but also psychologically. The precocious maturity and aloofness of expression characteristic of the later drawing appears to be tempered with sentiment, while the somber intensity of the earlier one appears to have calmed down to an almost lyrical mood.

Technically, the painting in the Louvre is distinguished by a freedom of touch and by a tender, iridescent quality of color not to be found in Dürer's other works. Probably painted in Strassburg, it seems to be imbued with some of the sensuous refinement always character-istic of Alsatian art.

However, two works likewise attributable to the Strassburg period reflect impressions of a different nature. One of these is a little miniature representing the *Salvator Mundi* in the guise of an Infant Jesus in half length; it bears the date 1493 and was probably sent out as a Christmas and New Year's greeting at the end of that year (628). The other is a drawing of the Madonna and Child, also in half length, which may be dated in the spring of 1494 (653, *fig.* 34). In both cases Dürer endeavored to give a quasi-sculptural effect; the figures emerge from behind a breast-molding and are surrounded by a stone-carved frame. In the Madonna drawing the illusion of a plastic work is further strengthened by the use of a new medium: it is a pure brush drawing in ink or bister, with bold washes suggesting the depth of a vigorous high-relief. Strassburg was the very place where Dürer, always appreciative of sculpture, could admire a greater profusion of eminent works than anywhere else. In par-ticular he could not fail to be impressed by the only Northern sculptor after Claus Sluter who can be called a peer of the great Italians: Nicolaus Gerhaert von Leyden, the founder of a tradition still flourishing in Dürer's times throughout Alsace. His Epitaph of a Canon in Strassburg Cathedral, dated 1464 (*fig.* 35), can serve as an example of what Dürer had in mind when making his brush drawing. It must have been a work like this that inspired him with the idea of a half-length Madonna in high-relief, emerging from a gothic niche and holding on the parapet a child whose healthy vitality defies the limitations of the picture plane.

THAT A JOURNEYMAN HAD TO WORK FOR HIS LIVING is obvious, and that Dürer's talent for woodcut designing was discovered as early as 1492 is a matter of record. Yet, since only one woodcut prior to his return to Nuremberg can be ascribed to him on documentary grounds, the attribution of others has given rise to a controversy comparable only to the notorious quarrel about the iota in the word *homoiousios*.

The unquestionable piece of evidence is a woodblock, fully signed with the inscription "Albrecht Dürer von Nörmergk," which was used for the title page, already mentioned, of Nicolaus Kessler's *Epistolare beati Hieronymi*, published in Basel on August 8, 1492 (414, *fig.* 32). It shows St. Jerome in his study, nursing the paw of an apprehensive, poodle-like lion. The composition appears to be derived from a woodcut in Koberger's "Lives of the Saints" (fol. CLXXIIII) which in turn harks back to early Flemish models dating from the first half of the century. But Dürer, retracing, as it were, the steps of the development, more nearly approaches those archaic archetypes than is the case with the woodcut of 1488. The objects displayed in still-life fashion are selected according to the examples set by Jan van Eyck, the Master of Flémalle and their immediate followers, and the compact, block-like appearance and long-nosed facial type of the Saint himself may have reminded the Basel public of Conrad Witz, the greatest painter of the city's past, who may be called the German Master of Flémalle. The unusual idea of juxtaposing St. Jerome's Latin translation of *Genesis* I, 1 with the corresponding passages of the Hebrew original and of Septuagint might have been suggested by the scholarly adviser who must have supplied the models for the Greek and Hebrew lettering. The graphic style, however, is Dürer's own. The succinctness of the "Ulmian" style, clearly discernible in the treatment of the city prospect, has been fused with Wolgemut's illusionism which can be observed in the free use of cross-hatchings, in bold chiaroscuro effects (the shadows in the alcove), and in the effort to characterize the tactile value of the velvet cushion. Most of this was evidently too much for the cutter, but he did not entirely destroy Dürer's most personal achievement: the dynamic quality of the lines remain, and they manage to impart the semblance of life even to such inanimate objects as bedspreads and curtains.

The first edition of Kessler's *Epistolare*, published in 1489 by the same publisher and identical with that of 1492 in every other respect, had not yet been equipped with an illustrated title page; Dürer's woodcut, on the other hand, was copied, not only for a third Basel edition of St. Jerome's Letters which appeared in 1497, but also for three later editions published in Lyons in 1507, 1508 and 1513. Moreover an experienced local master, who had to supply the title woodcut for the "Opera" of St. Ambrose published by Amerbach in the latter part of 1492, borrowed extensively from Dürer's *St. Jerome* (438, *fig.* 33).

This tends to show, first, that Dürer, in spite of his youth, must have made an extraordinary impression on Kessler who had apparently not thought of providing his new edition of the *Epistolare* with a title woodcut before the young man from Nuremberg made his appearance; second, that Dürer's *St. Jerome* proved to be a most exceptional success. It is hardly conceivable under these circumstances that Dürer designed no other woodcuts until he had established himself in his native town. This would be as unlikely as if a brilliant young pianist, after a sensational debut, were not heard of again for four or five years. To quote Gustav Pauli, the question is not so much: "*Are* there any woodcuts produced by Dürer

between the *St. Jerome* and, say, the Apocalypse?" as: "*Which* are the woodcuts produced by Dürer between the *St. Jerome* and the Apocalypse?"

These woodcuts must of course fulfill a number of conditions. First, they must originate from Basel or Strassburg, and they must fall in the years between 1492 and 1494; second, their style must be different from that of the rest of the contemporary production in these cities, emerging with Dürer's arrival and vanishing with his departure, exception being made for woodcuts showing his influence (such as, for instance, the illustrations of the *Revelationes* of Methodius, published by Michael Furter in 1500); third, they must fit into Dürer's development. Not only must they be compatible with the *St. Jerome* and other authenticated works of the same period, they also must contain stylistic elements and motifs which reappear in Dürer's later works and which can be accounted for by his earlier education. While announcing, to some extent, the woodcuts and engravings of 1496-1498, they must reflect that peculiar combination of influences which is characteristic of Dürer's previous career: the styles of the Housebook Master and Schongauer, superimposed upon a Nuremberg training in woodcut designing which implied a familiarity with both the pictorial breadth of the Wolgemut workshop and the epigrammatic crispness of the "Ulmian" group.

Setting aside a few isolated cases of dubious authenticity or minor artistic importance (such as the woodcuts in the Strassburg Missal mentioned in the Introduction), such contributions by Dürer are found in three publications prepared at Basel in 1492/93.

The first of these is a sumptuously illustrated edition of the Comedies of Terence planned by Johannes Amerbach, the publisher of that St. Ambrose edition whose title page so clearly revealed the influence of Dürer's *St. Jerome*. This "Basel Terence" was never to appear because it was unexpectedly anticipated by a rival publication which came out at Lyons in 1493. However, almost one hundred fifty illustrations had been prepared, and one hundred thirty-nine of these have come down to us: most of them in the form of pen drawings on white-grounded woodblocks not even touched by the cutter's knife; a few in the form of blocks already cut (after Dürer's departure); and some in the form of prints from blocks already cut but lost (436, *a*).

To determine Dürer's personal share in this vast enterprise is exceedingly difficult. The illustrative task required great numbers of nearly identical settings and figurines which had to be repeated, reversed, or turned from front to back and vice versa with only minor variations in poses and gestures; this was obviously done, as in Walt Disney's studio, by a number of subordinate draftsmen. The cutting of the finished blocks, probably carved long after Dürer's departure from Basel, is of an exceptionally poor quality which all but obscures the style of the original designs. The original designs themselves, finally, cannot be compared with ordinary pen drawings on account of the conditions of their execution. They had to be drawn on whitened wood instead of on paper; they had to be free from corrections in order to avoid misunderstandings on the part of the cutter; and the modelling had to consist of relatively schematic lines. Even where the ultimate design on wood was done by the "inventor" himself it presupposed an elaborate preparatory drawing from which it was copied in a more or less

mechanical way, its dry and impersonal effect being sharpened by the fact that the designer had constantly to bear in mind what the cutter could and could not do in his medium. Thus even "original" designs on uncut woodblocks can be evaluated only as self-copies—or, rather, "auto-tracings"—and are automatically put at a disadvantage when compared with free pen drawings by the same master; Bruegel's *Mopsus and Nisa* block in the Metropolitan Museum has been doubted because of its difference from his other drawings although much more could be expected from Antwerp cutters about 1560 than from Basel cutters in 1492. Thus the term "authenticity" cannot be applied to the Terence pictures without reservations. However, the style of the cycle can neither be derived from indigenous sources nor from any other definite tradition, least of all from the Ulm Terence of 1486. It presupposes that special blend of Schongauer and the Housebook Master with Wolgemut and the "Ulmian" style which is peculiar to the early works of Dürer. He must be considered as the leading spirit of a group of draftsmen whom he supplied with a certain number of basic patterns which were traced, copied, varied, and transferred to the blocks in different combinations. In addition, he seems to have carried out a limited number of designs on the blocks themselves, partly in order to establish standards for his collaborators and partly in order to replace exceptionally unsatisfactory pieces, as was his custom when he supervised, at a much later date, the execution of Maximilian's *Triumphal Arch* (figs. 36 and 37, the elegant young "Pamphilus" in fig. 37 significantly recurring in a page of the Apocalypse).

Apart from its (rather limited) artistic value the Terence cycle is of interest in that it sheds further light on Dürer's early contact with humanistic circles. It is well known that we still possess about a dozen Carolingian and early medieval Terence manuscripts whose illustrations were directly revived from a classical archetype, the latest specimen dating from the end of the twelfth century. It was only after an interruption of more than two hundred years that the illustration of the Comedies was resumed, and this on an entirely modern basis. Neither the "Térence des Ducs" of 1407/08, nor the "Terence of Martin Gouge," nor the Ulm Terence of 1486 show any trace of classical influence. The Basel cycle is the first modest attempt at reinstating the classical tradition, not only in the format of the pictures and in the relative scale of the figures, but also in several specific motifs. Dürer must have been given an opportunity to use a Carolingian manuscript and thereby to participate in a distinctly humanistic experiment. Also the Roman theater shown in the only full-page woodcut is almost archeologically correct as compared to that in the "Strassburg Terence" of 1496.

The second publication illustrated in part by Dürer is Marquart von Steyn's *Ritter vom Turn von den Exempeln der Gottsforcht und Erberkeit*, printed by Michael Furter in 1493 (436, *c*). The Chevalier de la Tour-Landry, who in 1370/71 had composed the French original "pour l'enseignement de ses filles," was a kindly, frank and very human father. He succeeded in improving the mind and morals of his daughters by interspersing the better-known examples of well-deserved misfortunes (e.g. the Fall of Man, Samson and Delilah, or the fate of Sodom and Gomorrha) with such amusing stories as the one of the garrulous woman who talked so much in Church that the Devil, while trying to take down her remarks

on a piece of parchment, had to stretch it repeatedly with his teeth; or the one of the vain lady who, when looking at the mirror once too often, beheld the hindquarters of the Evil One instead of her own pretty face.

Of the forty-five woodcuts in the "Ritter vom Turn" (which were already carefully copied two years after their appearance) about four-fifths can be ascribed to Dürer. To point out only one or two details: the draperies in the St. Jerome woodcut are as closely akin as possible to the bedspread and curtains in the *Death of the Hard-Hearted Lady* who is licked on her deathbed by two little black dogs because she spoiled her pets but was cruel to the poor; the admirable figure of her despairing husband, too, can hardly be credited to any artist but Dürer (*fig.* 39). The landscapes bear throughout the imprint of Dürer, and the two cities in the *Destruction of Sodom and Gomorrha* (*fig.* 38) are almost identical in style and structure to the castles in such woodcuts as the *Bath-House* (348, *fig.* 71), *Samson rending the Lion* (222) and the *Martyrdom of St. Catharine* (340, *fig.* 72), while, on the other hand, their similarity with the buildings in such Wolgemut prints as *"Portugalia"* (*fig.* 8) bears witness to their Nuremberg ancestry. Similarly the "brimstone and fire" in the same woodcut, while unthinkable without the illusionism of the *Last Judgment* in the "Nuremberg Chronicle," announce such interpretations of flames and explosions as are later to be found in the Apocalypse and, again, in the *Martyrdom of St. Catharine*.

In the "Ritter vom Turn" the woodcuts attributable to Dürer show a slight disparity in style which is accounted for by the individualities of the cutters. One of these is obviously the same skillful but somewhat mechanical craftsman who cut the *St. Jerome*. Other woodcuts are rather mediocre from a technical point of view. A few, however, are cut with so much understanding for the intentions of the designer and with so intense a feeling for plastic values that Dürer himself has been credited with the cutting—which is, at least, a plausible conjecture. The publication proceeding according to schedule, Dürer would have wished to set a standard for the cutting as well as for the design.

An analogous situation obtains with the third work in which early Dürer woodcuts can be found: the *Narrenschyff* by Sebastian Brant (436, *b*), printed at Basel in 1494 by the interesting gentleman-publisher Johann Bergmann von Olpe, who had also participated, in a somewhat mysterious way, in the publication of the "Ritter vom Turn." In the "Narrenschiff," too, we can observe the contrast between the smooth regularity of the "St. Jerome cutter" and the vitality of the other artisan who has been identified with Dürer himself. However, in the "Ritter vom Turn" the woodcuts not designed by Dürer amount to a fairly small fraction of the whole series, and even this fraction reveals his influence, so that the general impression is a fairly homogeneous one. In the "Narrenschiff," on the other hand, about two-thirds of the whole cycle (which comprises well over a hundred different pictures) have no appreciable connection with Dürer and are inferior in design as well as in cutting. It is only on some of these inferior woodcuts that the date 1494 is found. They were apparently produced after Dürer had departed from Basel, and can thus be considered indirect evidence for the assumption that he had been responsible for the others.

Like the "Ritter vom Turn," the "Narrenschiff" is a moralizing treatise, profoundly prosaic in spite of what purports to be poetic form. But where the Chevalier de la Tour observes the foolishness of the world with the mellow wisdom of a gracious old gentleman, Sebastian Brant assails it in the spirit of that famous character who said to his wife: "The whole world is crazy except me and thee, and even thee is a little queer." To Brant, the seven capital sins are not much worse than such harmless vices as book collecting and faith in astrology, or such likable weaknesses as procrastination or overconfidence in the mercy of God; even the man who helps his neighbor before helping himself is a "fool."

However, the very universality of Brant's self-righteous surliness makes his book a remarkably complete mirror of human life, and the picturesqueness of his metaphors was a blessing for the illustrator. He could develop Brant's chief example of ill-advised altruism (the "fool's" attempt to put out his neighbor's fire while his own house is ablaze) into an impressive conflagration (*fig.* 41); from a comparison between the trusting soul and the "mind of geese and sows" he could develop a lovely study in rustic genre (*fig.* 40).

These two woodcuts also serve to illustrate some points of contact between the more accomplished illustrations of the "Narrenschiff" and authenticated works by Dürer. The flames in the conflagration scene bring to mind the instances already mentioned in connection with the *Destruction of Sodom and Gomorrha* in the "Ritter vom Turn"; moreover the sheet of flame bursting forth from the rear end of the house on the left anticipates the bursts of hell-fire seen in the *Babylonian Whore* (293) and the *Angel with the Key of the Bottomless Pit* (295); and the stream of water poured from a bucket by the Helpful Fool breaks up into little lozenges as does the water "cast out from the mouth of the serpent" in the *Apocalyptic Woman* (291). The farmyard scene distinctly foreshadows the engraving *The Prodigal Son* (135, *fig.* 94; note the recurrence of the primitive trough fashioned from a tree-trunk cut in half), while the vicious curves of the geese's necks announce, *si parva licet componere magnis*, the seven-headed dragon in the *Beast with two Horns like a Lamb* (294). It is not possible here to accumulate further analogies. Suffice it to mention only one more instance which is of particular interest in that it combines the anticipation of a later work with the reminiscence of a slightly earlier one: the woodcut satirizing the Adherents of Astrology (*fig.* 42). The Fool is a forerunner of the peasant in an engraving of about 1497 (190, *fig.* 43), while the costume of his companion almost duplicates the garment of the young lady in the pen drawing *"The Promenade"* already mentioned as a significant work of 1492 (1245, *fig.* 28).

In spite of the humanistic atmosphere of Basel it was in Nuremberg that Dürer awoke to Renaissance art. In Nuremberg, as everywhere in Germany, the general response to the revival of Antiquity was literary and scholastic rather than visual and aesthetic. In Italy the discovery of a piece of classical sculpture called forth enthusiastic comments upon its expressive power, beauty and lifelikeness; in Germany it provoked discussions of a purely antiquarian nature. Inscriptions held more interest than images, and images were appreciated as

iconographical puzzles and sources of historical information, rather than as works of art.
Yet Pirckheimer owned an important collection of Greek and Roman coins (which he himself
used mainly for a treatise on the comparative buying power of classical and modern cur-
rencies), and Hartmann Schedel, author of the "Nuremberg Chronicle," though insensitive
to the value of form, collected and copied pictures no less assiduously than texts. He possessed
a whole book of "Antiquities" with drawings of classical monuments executed partly by
himself and partly by a pupil of Wolgemut's, and it was probably through him that the
local artists first became familiar with original specimens of the Quattrocento style. The
"Chronicle" contains several topographical illustrations copied from Italian models, and
even a portrait of Mohammed patterned after Pisanello's medal of the Byzantine Emperor
Johannes VII Palaeologus.

When Dürer returned from his bachelor's journey he found Wolgemut's workshop
engaged in the preparation of a series of woodcuts intended for a publication which never
appeared; it comprised, besides assorted allegorical subjects of medieval origin, copies of a
Venetian edition of Petrarch's "Triumphs" and of a set of engraved Italian playing cards,
known as "Tarocchi," which mirrored, in a playful way, the hierarchical order of the uni-
verse, including personifications of philosophical concepts, the Virtues, the Arts, the Muses,
the Planets, the Estates of Men, etc. Dürer too, became interested in this kaleidoscopic
encyclopedia and copied the Italian prints after his own fashion (976-995). A comparison
between his copies and those produced in the Wolgemut workshop is truly revealing. To give
only one instance: in the Wolgemut woodcut the Minerva serving as a personification of
Philosophy looks like a "supporter" in Late Gothic heraldry rather than like a classical
goddess. The figure is set against a rich Northern landscape not unlike those in the "Nurem-
berg Chronicle." The perpendicular spear, intended to form the sharpest possible contrast
with the elastic curve of the figure, is placed aslant whereas the curve itself is flattened into
a sagging vertical. The resiliency of the posture is destroyed by the omission of one foot and
by the awkward alteration of the other. The modelling of the legs is obscured by heavy
drapery, and the fluttering skirt—so typical of Quattrocento taste—was made to trail on
the ground (*fig.* 44). Dürer's copy, precisely contemporary with the Wolgemut cut, shows
the keenest understanding for Renaissance characteristics (*fig.* 46). He respected the statu-
esque isolation of the figure, and not only retained but actually strengthened its dynamic
quality. He verticalized the shield as well as the spear. He enlivened the contours, he inten-
sified the movement of the ribbons (which are entirely omitted in the Wolgemut woodcut),
and he dramatized the expression of the tossed-back head.

To "improve" upon the work of an anonymous Ferrarese engraver of about 1460 might
seem comparatively easy. But even when confronted with a genius Dürer was able to vitalize
what he imitated. In 1494 he copied several mythological engravings by Mantegna; two
drawings, one after the *Battle of Sea Gods*, the other after the *Bacchanal with Silenus*, have
come down to us (902, 903), and the existence of a third one (after the *Bacchanal by the Vat*)
can be inferred from reminiscences in Dürer's later work. In these copies the contours are

directly traced from the originals; only the modelling is entered in free hand. Yet, even while copying the outlines as mechanically as possible, Dürer involuntarily strengthened their graphic energy, and to achieve the modelling he replaced Mantegna's schematic parallels by a pattern of curves and violent, comma-shaped hooks which endow the forms with vibrant life (*figs.* 47 and 48).

A drawing likewise dated 1494 and equally Mantegnesque in character represents the Death of Orpheus according to the Ovidian version. It shows how the great singer was killed by the women of Thrace for having introduced into their land the vice of pederasty (928, *fig.* 49). Earlier illustrations of this incident in Northern art depict the punishment as well as the sin (which Dürer merely indicated by a straightforward inscription). But where a picture like the woodcut from Colard Mansion's *Ovide Moralisé* of 1484 (*fig.* 51) strikes us as almost comical for want of expressiveness and dramatic concentration, Dürer's drawing, executed only ten years later, has the force of a classic tragedy. The woodcut, illustrating as it does a complicated moral allegory superimposed on a story of passion and cruelty, shows Orpheus twice: embracing a "damoiseau," and stiffly lying on the ground, with the serpent already gnawing his head, and his lyre floating in the river Hebrus. The Thracian women, however, attired in the dress of Bruges *bourgeoises*, lamely continue to throw stones at his corpse. In Dürer's drawing the scene is interpreted according to the classical formula which had been revived by Mantegna in a fresco in the Camera degli Sposi at Mantua—the very place where Politian's *Favola d'Orfeo* had had its "world première" a few years before (*fig.* 52). The women are clad in billowing draperies which accentuate the vigorous beauty of their bodies, and they burst upon their victim with the fury of genuine maenads. Orpheus, alive and suffering, struggles in vain to protect himself, his kneeling form displaying that beautiful *contrapposto* which classical art had employed for the countless heroes and warriors dying in battle. His book of music, suspended on a tree after the fashion of rustic *ex votos* in Greek and Roman bucolics, recalls the song of one who will not sing again: "hic arguta sacra pendebit fistula pinu." The prototype of Dürer's drawing has come down to us only in a Ferrarese engraving of rather inferior quality (*fig.* 50), and it is possible—though not too probable—that Dürer had access to a more satisfactory model. But even an original drawing or engraving by Mantegna could not have shown so passionate an animation in outline and modelling, so deep a horror in the face of the sufferer, and so much individual character in the gnarled trunks and bristly foliage of the trees.

Whether these Mantegnesque drawings of 1494 were made before or after Dürer's departure for Italy is an open question. Their style seems more Italianate than that of the "Tarocchi" copies, and the expression "puseran" in the inscription of the Orpheus drawing is a garbled form of the Italian word "buggerone." On the other hand it is difficult to imagine that an impatient tourist would have spent so much of his time at a drafting board, making meticulous copies of prints which were available in other places. Be that as it may, the very uncertainty in this respect is highly significant. It shows to what extent Dürer had absorbed the spirit of Italian art before he ever set foot on Italian soil.

Much has been done to explode the old theory according to which the Renaissance came in with a bang, so to speak. It has been shown that the classical heritage survived throughout the Middle Ages in a thousand ways, and that the efflorescence of the Medicean age resulted from a gradual evolution and not from a sudden awakening. In one respect, however, the Italian Quattrocento did bring about a fundamental change in attitude and still deserves the name "rinascimento dell'antichità." In the Middle Ages classical Antiquity had been looked upon with a strange ambiguity of feeling. On the one hand, there was a sense of unbroken continuity which seemed to link the medieval Empire to Caesar and Augustus, medieval theology to Aristotle, medieval music to Pythagoras and medieval grammar to Donatus. On the other hand, an insurmountable gap was seen between the Christian present and the pagan past. Thus the monuments of classical philosophy, science, poetry and art continued to be known and to be used, but they were not yet thought of as manifestations of a coherent cultural system, irretrievably removed from the present, yet alive in itself and capable of being accepted and emulated in its entirety.

One of the most significant aspects of this situation is the fact that the high Middle Ages, though neither blind to the charm of classical art nor indifferent to the fascination of classical myths and history, had been unable or unwilling to retain the unity of classical subject matter and classical form. With very few and, historically speaking, irrelevant exceptions, we find classical motifs invested with non-classical meanings and classical themes presented in non-classical disguise. The statues of Roman goddesses could serve as models for Christian Madonnas, but Aeneas and Dido, Apollo and Daphne, Orpheus and the Maenads would be depicted as courtly knights and ladies or, as in the case of the *Ovide Moralisé* woodcuts, as bourgeois dandies and housewives. It was precisely in this respect that the progressive masters of the Italian Quattrocento broke away from medieval traditions. They reintegrated classical form with classical subject matter and thereby reinstated the emotional qualities of classical art. In it, mythological or legendary scenes were pervaded by what may be called an animalistic conception of human nature. Beauty was the poise and strength of a perfect animal, pain was a reaction against physical injury, and love was either an enjoyment of sensual pleasure or a suffering from unappeased sensual appetites. When medieval art transformed gods and heroes into princes and burghers, it changed not only their appearance but also their behavior and their feelings. Beauty and ugliness, lust and pain, cruelty and fear, love and jealousy came to conform to the contemporary codes of morals, taste and manners. Conversely, when the Renaissance discarded the modish dresses in favor of classical nudity or semi-nudity it unveiled not only the nature of the human body but also the nature of human emotions; it stripped man not only of his clothes but also of his protective cover of conventionality.

Two drawings following the Mantegna copies of 1494 bear witness to Dürer's preoccupation with this emotional aspect of Renaissance art.

One of these is a copy after Pollaiuolo showing the abduction of two women by two naked athletes (931, *fig.* 53, dated 1495). There is reason to believe that the two groups belong to a lost composition which showed the Rape of the Sabine Women and was part

of a continuous series of scenes from Roman legend and history. Certain it is that the strenuous pose of the abductors, or rather abductor (for, the second figure is practically the same as the first, drawn from the back and then reversed), derives from the classical type of Hercules carrying the Erymanthean Boar which also served as a model for several other figures by Pollaiuolo, for instance his *Hercules Killing the Hydra* in the Uffizi.

The history of the other drawing, the *Abduction of Europa* (909, *fig. 57*), is somewhat analogous to that of the *Death of Orpheus*. In both cases Dürer dealt with an Ovidian subject which, after a process of "moralization" in late medieval art, had come to be revitalized "all'antica," and in both cases he employed a North Italian composition inspired by classical monuments as well as by the poetry of Politian. For, as the Mantegnesque interpretations of the Death of Orpheus are predicated upon Politian's "Favola d'Orfeo," so the prototype of Dürer's *Abduction of Europa*, containing as it does several motifs and details not present in Ovid's "Metamorphoses," presupposes a familiarity with two delightful stanzas from Politian's "Giostra": "Here behold Jove transformed into a beautiful bull by the power of love. He dashes away with his sweet, terrified load, her lovely golden hair fluttering in the wind which blows back her gown. With one hand she grasps the horn of the bull while the other clings to his back; she draws up her feet as if she were afraid of the sea, and thus crouching down with pain and fear, she cries for help in vain. For her sweet companions remained on the flowery shore, each of them crying 'Europa, come back'; the whole seashore resounds with 'Europa come back'; and the bull swims on [or: looks round] and kisses her feet." Dürer's drawing, bringing to life this sensuous description, differs in feeling from medieval representations of the subject in precisely the same sense as his *Death of Orpheus* differs from the woodcut in Colard Mansion's *Ovide Moralisé*.

All this throws light on Dürer's peculiar position in relation to classical art. It is almost a miracle that an artist educated in the tradition of Wolgemut, the Housebook Master and Schongauer could capture the spirit of Antiquity. But even he could not gain direct access to its material remains. So far as we know he never copied a classical statue or relief, but approached the originals only through the intermediary of Italian prints and drawings. In these, the style of Greek and Roman sculpture was transformed to fit the standards of the fifteenth century, and this applies not only to the free interpretations of creative masters like Mantegna and Pollaiuolo, but even to reproductions of a deliberately archeological character such as the drawings in the *"Codex Escurialensis"*: the stony surface of the marble was changed so as to suggest flesh and skin; the forms appeared to be surrounded with a kind of atmosphere; and the unseeing eyes acquired a human glance (*fig.* 120). The role of such Italian intermediaries is well exemplified by a figure found on the right half of the same sheet of paper which had been used for the *Abduction of Europa*. One of the sketches scattered about this part of the page shows a standing youth characterized as an Apollo by his attributes, but evidently derived from the "Praxitelian" statue of Cupid Bending the Bow of Hercules. A replica of this statue can still be seen in Venice, and it has been thought that Dürer copied it directly. But the addition of such typical Quattrocento accessories as

the laurel wreath, the modish boots, the coquettish tunic and the fluttering ribbons is proof
of the fact that Dürer copied an Italian "reconstruction" and not the mutilated original.

Thus it appears that Dürer could read the classical texts only in contemporary trans-
lations. But as a great poet, while unable to understand Euripides's Greek, may understand
Euripides's meaning better than any philologist, so Dürer's interpretations, two steps removed
from the originals, could be more classical in spirit than were his direct Italian sources. In
the Orpheus drawing the maenads are more perfectly modelled beneath their draperies than
is the case in the Italian engraving, and the modern lute is carefully replaced by the orthodox
lyre. Even in the copy after Pollaiuolo the abductors reflect their classical archetype more
adequately than do the nudes in Pollaiuolo's own works. In these, Herculean vigor is
tempered with Quattrocento elegance of proportions, outline and movement (*fig.* 54), but
Dürer recaptured some of the hero's original sturdiness. He used, in fact, this very drawing
for an engraving and a painting both of which illustrate incidents from the myth of
Hercules (105 and 180, *fig.* 108).

The graceful "Praxitelian" Apollo shows that Dürer, though fascinated by classical
pathos and violence, was not impervious to classical beauty. We know by his own testimony
that it was a Venetian painter, Jacopo de' Barbari, who showed him two figures, male and
female, which were constructed by geometrical methods, and that this experience caused him
to embark upon his lifelong search for the secret of human movement and proportions.
The meeting may have taken place in 1494-1495 when Dürer was in Venice, or else in 1500
when Barbari went to Germany. But it was certainly in Barbari's town that Dürer became
conscious of Barbari's problem. On a sketch-leaf containing several Italian motifs (1469,
fig. 55) is seen a naked youth whose elastic *contrapposto* movement announces the balanced
pose of Dürer's later Apollos and Adams; and a study from life, dated 1495, shows a nude
woman, poised with the help of a long staff, from whom was to descend a long line of
Venuses, Fortunes, Lucretias and Eves, many of them less lovely than their ancestress
(1178, *fig.* 56). A comparison of this regal Venetian nude with the awkward German girl
of 1493 (1177, *fig.* 45) eloquently illustrates what two brief years could mean in Dürer's
early development.

However, there was more for Dürer to draw than what he himself called "nackete
Bilder." The sketch-leaf mentioned in the preceding paragraph and the right half of the
Europa drawing are actual sample cards of things which were of interest to him: a rider
on a horse armored so as to resemble a monstrous unicorn; a reclining infant; a Turk's
head, later to be used for the wicked Emperors in the *Martyrdom of St. John the Evangelist*
(281) and in the *Martyrdom of St. Catharine* (340, *fig.* 72); a lion's head in three different
views; an alchemist in oriental dress.

The fantastically caparisoned horse and the reclining infant seem to reveal the influence
of Leonardo da Vinci (a somewhat similar child occurs in an elaborate drawing after
Lorenzo di Credi, 626). The Turk and the alchemist, on the other hand, testify to Dürer's
interest in the orientals and semi-orientals who played a greater role in Venice than in any

other corner of the Western world. Dürer not only portrayed them from life but also from pictures and drawings by Gentile Bellini which abound in these picturesque characters. This painter must have received the young German with benevolent courtesy; for he permitted Dürer to copy a group of Turks employed by himself for a picture still in the making (1254) and gave him access to a profile portrait of Caterina Cornaro, Ex-Queen of Cyprus (1045).

The portrait of this rotund and resplendent lady—who was, perhaps, the object of a still enigmatical Allegory also datable about 1495 (938)—caught Dürer's fancy not only as a work of art but also from a sartorial point of view. Dürer was always intensely interested in costumes, so much so that his drawings in this special field would make a very handsome little volume. He drew the fashions worn by different classes and ages in Germany and Flanders (at times with a workmanlike analysis of their technical construction); he went out of his way to copy illustrations of the costumes in Ireland and Livonia; quite late in life he supplied his bootmaker with an elaborate "engineering drawing" for a pair of shoes (1300). Small wonder that the garments of the Venetian ladies delighted him no less than the ladies themselves.

He portrayed Circassian slave-girls (1256, *fig. 58*) and native courtesans; in one case he carefully depicted the back of a dress as well as the front (1278, later appropriately used for the Babylonian Whore in the Apocalypse, 293); he made a model, gorgeously attired, pose as St. Catharine (852); and in one truly remarkable drawing he illustrated the fundamental difference between the Southern and the Northern fashion by representing a Venetian *gentildonna* side by side with a Nuremberg *Hausfrau* (1280, *fig. 59*). Everything wide and loose in the Italian dress is narrow and tight in the German one, the bodice as well as the sleeves and shoes. The Venetian skirt is cut on what may be called architectural lines; the figure seems to rise from a solid horizontal base, and the simple parallel folds give an effect not unlike that of a fluted column. The German skirt is arranged so as to create a picturesque contrast between crumpled and flattened areas, and the figure seems to taper from the waist downward. The Italian costume accentuates the horizontals (note the belt and the very form of the necklace), uncovers the shoulder joints and emphasizes the elbows by little puffs. The German costume does precisely the opposite. The very idea of this juxtaposition might have been suggested by Heinrich Wölfflin. Dürer contrasted the two figures as a modern art historian would contrast a Renaissance *palazzo* with a Late Gothic town house; there is, in fact, another Dürer sketch, probably made on the occasion of his second trip to Venice (1682), where an analogous comparison is drawn between the groundplans of two central-plan buildings, one medieval and the other Leonardesque. In sum, the costumes are interpreted, not only as curiosities but also as documents of style.

Another of Dürer's lasting enthusiasms was his passion for animals. Contrary to the professional *animalier*, he had no preference for any definite species, but looked with equal interest and understanding upon all creatures great or small, majestic or clownish, beautiful

or loathsome. So far as we know, no other artist has ever thought of a subject such as Dürer's *Virgin with a Multitude of Animals* (658, *fig.* 135).

While traveling, Dürer was of course particularly attracted by unusual animals, and in Venice, the city of St. Mark, he naturally looked around for lions. But even in Venice, it seems, live lions were not readily available. The lion's heads on the Europa drawing were certainly not drawn from life but from a sculpture such as the *Leoncini* near St. Mark's; Dürer added impressive whiskers and treated the hair in naturalistic fashion, but gave himself away by the patently sculptural stylization of the ears and eyebrows. In another drawing, or rather miniature (1327), Dürer tried even harder to suggest a living animal. He placed the lion in what he supposed to be its natural habitat, the mouth of a cave framing its head like a dusky halo, and made its pose as lively and fierce as he could. But just this pose betrays the source of Dürer's inspiration: his lion is, in fact, the Lion of St. Mark, its paws still poised as though they were holding the Gospel book.

Not until he came to Ghent in 1521 did Dürer have occasion to see a lion in the flesh (1497/98, *fig.* 268). But what he could study in Venice were the weird creatures of the sea, doubly exciting to a man brought up in one of the most "landlubbery" spots of the continent. It was with obvious enthusiasm that he made large-scale water colors of a giant sea crab (1354) and of a magnificent lobster (1332, *fig.* 60); its fiendish eye and hungry claws—seemingly leading a vicious life of their own—must have made him feel as though a grotesque devil had stepped out of an engraving by Schongauer or a picture by Bosch.

One of the most far-reaching effects of Dürer's trip to the South, finally, was an essential change in his attitude toward landscape. His early studies, made during his apprenticeship with Wolgemut, fall, roughly speaking, into two classes: either they represent individual "motifs" such as a complex of buildings, a group of rocks, or a cluster of trees (1368, 1370-1372); or they portray some definite locality such as the Wire-drawing Mill (1367, *fig.* 6), or the Cemetery of St. John's (1369, *fig.* 7). In the latter case the artist's lack of training in perspective is apt to result in a kind of lopsidedness, the space tending to slope toward the lower left-hand corner of the picture, and the predominance of what may be called a topographical interest leads to a certain dryness and uniformity in treatment. The factual data are stated rather than interpreted according to a compositional idea. All the details, whether distant or close, are rendered with almost equal emphasis and precision, and the objective colors of buildings, trees and meadows are scarcely affected by the action of light and air.

In comparison with these early attempts the water color drawings which Dürer brought back from his passage through the Alps—most of them executed on his way home in 1495— are advanced not only in perspective but also, which is more important, in conception. Even when Dürer limited himself to representing a single "motif" such as the Castle of Trent (1376) the details are coordinated into a comprehensive and coherent pattern; sharply defined by an indented diagonal outline, the complex of buildings seems to contrast with, and yet to grow out of, the heavy masses of almost amorphous terrain—"non murato ma

nato," to quote Vasari's phrase—and the whole scene appears to be suffused with a luminous atmosphere.

Technically, this means a broader and more differentiated handling of the medium and a closer observation of coloristic phenomena. In principle, it means a new approach to the problem of landscápe as such. The whole begins to be more relevant than the parts, and every individual object, whether man-made or natural, is thought of as partaking of the universal life of nature. As the *Castle of Trent* is no longer a record but a "picture," so the representation of Trent as a whole (1375) is no longer a topographical inventory but a "view." In the magnificent drawing entitled "Wehlsch Pirg," that is: South-Tyrolian Mountains (1384, *fig.* 63), the very anonymity of which is highly significant, Dürer achieved a panoramic or even cosmic interpretation of scenery. The drawing has no "subject" except the breathing movement of the earth as such; it heralds, as far as possible within the limits of a much earlier style, the visions of Bruegel, Hercules Seghers and Rembrandt.

Upon his return Dürer looked at his native Franconia with new eyes. Color, hitherto merely recorded as an essentially unchangeable characteristic of certain objects, came to be interpreted as a phenomenon variable according to luminary and atmospheric conditions, and it looked for a brief time as if Dürer might develop into a *plein-airiste*. One of the landscape studies of this period shows a Pond in the Woods, its water modulating from leaden gray to vivid blue, with sunbeams of a violent orange breaking through purple clouds (1387); another a House on an Island ("Weiherhaus") mirroring its red roof and green willows in a lake opalescent with the reflection of a sky at eventide (1386). Even the careful studies of Quarries made in preparation for prints reveal not only Dürer's customary interest in form and texture but also a surprising sensitivity for the subtle nuances of brown and gray (1391-1396). The City of Nuremberg emerges from flat grasslands and winding dirt roads no less mysteriously than the Castle of Trent from its verdant hills (1385, *fig.* 62); and toward the end of the century, with the color scheme changing from varicolored transparency to severer and opaquer harmonies of olive-green and brown, we find such masterpieces of perspective energy and panoramic breadth as the views of the hamlet Kalchreut and its surroundings (1397 and 1398).

II · Five Years of Intense Productivity,

1495-1500

THE period from 1495 to about 1500 is the first and perhaps the most distinctive "maximum" phase in Dürer's career. Established as an independent master and reaping the harvest of his varied experiences, he produced about a dozen paintings, more than twenty-five engravings, seven large-sized single woodcuts, the greater part of the Large Passion, and the whole Apocalypse. Stylistically, these works represent a first synthesis between the Flemish and German traditions and the *maniera moderna* of the Italians and lay the foundations of a Northern Renaissance. Iconographically, they comprise, besides Biblical themes, theological and philosophical allegories, satirical subjects, "actualities," and genre scenes; and their expressive qualities range from balanced formality to trenchant realism and visionary fury.

Dürer's first commissions for paintings came from Frederick the Wise, Elector of Saxony. He had visited Nuremberg in April 1496, was at once impressed by Dürer's genius, and remained his admiring patron as long as he lived. In 1496 he ordered, simultaneously, his own portrait and two altarpieces for the "Schlosskirche" in Wittenberg, which had been in course of erection since about 1490. One of these, consisting of a central panel with a Madonna in half length, and two wings with Sts. Anthony and Sebastian (the wings, however, added about 1504), is now in Dresden and is known as the "Dresden Altarpiece." The other was a polyptych composed of seven small panels (now also in Dresden) representing the Sorrows of the Virgin and of a central panel (now in Munich) representing a *Mater Dolorosa*.

Both of these commissions were carried out without delay. The *Mater Dolorosa* polyptych (3), designed by Dürer, was executed by an assistant, with the master's personal participation limited to certain portions of the main panel. The Madonna in Dresden (4, *fig.* 64), however, is Dürer's work alone. It is carefully painted in size colors on canvas, a medium which was popular in the Netherlands and in North Italy rather than in Nuremberg, and the influence of these two schools can also be observed in style and iconography. While the type of the Virgin is vaguely Boutsian, and while she adores the Infant Jesus exactly as in Dutch and Flemish Nativities (note also the St. Joseph busily at work in an adjoining room), the metallic hardness of the modelling, the treatment of the still-life features in the foreground and the perspective—though not the architecture—of the cheerless interior are reminiscent of Squarcione and Mantegna. The expression of the Virgin is stern, almost haggard. The Infant, very small in comparison with His mother, is fast asleep; but His stiff posture and pale color suggest a little corpse rather than a living child, an impression strengthened by the motif of the asperge held over Him by an angel. This strange suggestion

of twilight between life and death was certainly deliberate on Dürer's part. In many theological texts relating to the Passion of Christ a tragic comparison was drawn between the sleep of childhood and the sleep of death, and the *corporale* (that is, the cloth spread over the altar for the Host to rest upon) is still interpreted both as a symbol of Christ's swaddling-cloth and of His shroud. This idea is expressed in Michelangelo's *Madonna of the Steps*, as well as in Raphael's *Virgin with the Veil* and its numerous derivations; and a madonna type which may have been the direct source of Dürer's composition had been developed in Venice and conclusively formulated by Giovanni Bellini. It shows the Virgin with her hands joined in prayer, and the Infant Jesus lying asleep across her lap, the whole arrangement deliberately reminiscent of a *Pietà*. The iconography of the Dresden altarpiece can thus be understood as a synthesis of a Bellinesque invention with the tradition of the Low Countries and Germany.

The Portrait of Frederick the Wise, now in Berlin (54, *fig.* 65), is, like the "Dresden Altarpiece," painted in size colors on canvas. The medium itself produces a more subdued coloristic effect than oils, but here the impression of austerity results not so much from the quality as from the choice of the colors. The Elector is clad in deep black with a few gold ornaments and a very small touch of green in the embroidery of the shirt, and this dark figure is set off against a light chamois background. In comparison with the Self-Portrait of 1493, the picture is simplified both in color and in composition. But just by virtue of this simplification it attains a higher degree of reality and of dramatic power. The figure, reduced to sheer volume, seems to hold sway over a province of three-dimensional space; it revolves around an axis instead of clinging to the frontal plane, from which it is separated by a heavy breast-molding; it is sufficiently removed from the background to cast a shadow upon it, and there is ample space on either side. The general effect is strongly Mantegnesque, a characteristic apparent not only in the style and in the treatment of such details as the hair, but in the psychological interpretation as well. The portrait has a somberly heroic quality, the imperious glance of the Elector commanding rather than courting the attention of the beholder.

The three portraits of the following year, 1497, have come down to us only in copies or replicas, but some of these are adequate enough to have been considered originals.

A Portrait of Dürer's father (best replica in London, 53, *fig.* 66), affording an interesting comparison with that of 1490, shows Dürer's newly acquired capacity for suggesting space without actually depicting it. The figure is turned slightly toward the spectator so that it seems to detach itself both from the frontal plane and from the background; but the resulting slight asymmetry is counterbalanced by the fact that the hands (joined in front of the belly) and the face are placed on the central axis of the panel. The head, with the fine, high forehead no longer hidden by the cap, emerges proudly from a simple pyramidal mass which is enlivened, however, by a studied contrast between the rising lines of the lapels and the descending curves of the wide sleeves. The general impression is therefore one of composure without stiffness. The comparatively rigid posture suggests, not archaic constraint but rather

potential energy disciplined by unassuming self-possession. It is not surprising that even Jacopo de' Barbari, who elsewhere exerted a certain amount of influence on Dürer, was sufficiently impressed by this portrait to use it as a model for his *St. Oswald* of 1500. However, since precisely those points which have been mentioned escaped him, his version strikes us as flatter and at the same time overcharged.

The two other portraits of 1497 represent a pretty girl of eighteen, probably one Katharina Fürlegerin. So great is the contrast between the two compositions that it has been questioned whether the same girl is represented in both pictures. The best replicas, however, not only agree in size and scale, but show the same coat-of-arms; and the distinctive features of the face are clearly identical. Both portraits present a young lady whose outstanding characteristics are a very small, intriguingly sensual and slightly ironical mouth with a rather full lower lip and a "Cupid's bow," a dimpled chin, a remarkably wide-bridged nose and, above all, an enormous mass of hair which filled her, it seems, with justifiable pride. The apparent differences are due to a sharp contrast in interpretation. In one picture (best replica in Frankfort, 72, *fig.* 67) the figure of the girl is foiled by a plain dark background; she is clad in an austerely simple dress, casts down her eyes and joins her hands in prayer; her beautiful hair, bound only with a fillet, flows down in a shining cascade. In the other (best replica in Lützschena, 71, *fig.* 68) she is shown seated by a window which opens upon a cheerful landscape; she is dressed "for the dance" (as we know from a costume study by Dürer's own hand, 1284); her hair is braided and arranged in complicated tresses; and she looks at the beholder with a whimsical smile. Attached to the molding of the window is a statuette of an elderly scholar whose oriental dress, combined with his place in the embrasure of a window, immediately suggests the well-known story of Virgil and the beautiful but virtuous daughter of the Roman Emperor. Moreover she significantly holds two flowers symbolic of love: the Eryngium, already known to us from Dürer's Self-Portrait of 1493, and an Abrotanum, the amorous implications of which are even more explicit.

In fact the two portraits reflect the personality of the young lady in two opposite aspects —the same ones which we shall encounter, with different connotations but with the same iconographical distinctions, in the engraving "*Hercules*" (180, *fig.* 108). One of them depicts her under the guise of Virtue, Piety, or "Castitas" (it is significant that two copies of this version show the hair covered with a long veil of almost imperceptible thinness, even if absent from the original, bears witness to the contemporary interpretation of the subject; in the copy in Budapest a prayer book is added for good measure). The other represents her as Pleasure, Love, or "Voluptas" (within the limits of honor and modesty). She was thus represented as possessing qualities a combination of which would constitute a maximum of desirability in any girl of marriageable age.

For the "Portrait of Katharina Fürlegerin as *Voluptas*," as we may call it, Dürer had adopted a Flemish scheme of composition: the sitter is placed in the corner of a room, one wall of which is pierced by a window overlooking an open landscape (compare Dirk Bouts's London portrait of 1462). In the Self-Portrait of 1498 in the Prado (49, *fig.* 109) this

Flemish scheme is reconciled with the requirements of Italian monumentality, as is also the case with the apparently contemporary *Madonna* in the Thyssen Collection at Lugano (25, painted on a panel the back of which had already been used for a *Flight of Loth and his Daughters from Sodom and Gomorrha*). Dürer's pose is more informal than in any of the earlier portraits; the hands are joined with a certain show of "good manners," and the right arm is bent in an elegant curve instead of forming an angle as in the portraits of Frederick the Wise and the "Fürlegerin." But this almost nonchalant figure keeps the beholder in his place. Its tall, slim haughtiness is enhanced by a heavy, strictly frontalized architecture, the window no longer cut in the foreshortened side wall but in the rear wall which runs parallel to the picture plane; and heavy moldings, forming a frame within the frame, lend dignity to the proudly erect head.

This elaborate *mise en scène* serves the same end as do the careful arrangement of the hair and beard, the modish and expensive-looking dress, and the gentlemanly gloves of soft gray leather. Unlike the "engagement portrait" in the Louvre, the Prado picture was painted without any ulterior purpose and is thus perhaps the first independent self-portrait ever produced. It was, in a sense, a challenge to the world at large, claiming for the artist the status of a "homo liberalis atque humanus," or, to use Dürer's own word, of a "gentilhuomo." In Italy, this claim had long been granted—in Germany, it had yet to be raised. But it could be raised only by an artist become "self-conscious"—in every possible sense of the word—through his providential encounter with the Italian *rinascimento*. There is undeniably an element of vanity and pride in Dürer's attitude, quite natural in an artist who had already won the confidence of great men and achieved international fame at the age of twenty-six. But this personal element is outweighed by the gravity of a more than personal problem— the problem of the "modern" artist as such; just as the somewhat showy colors and patterns of Dürer's dress are overshadowed by the hypnotic force of his unsmiling eyes.

In the portraits of 1499 the modified Flemish scheme employed for the Self-Portrait in the Prado was developed in apparently opposite directions. In the three Tucher Portraits in Weimar and Cassel (69, 74, 75) the landscape prospect is widened to about one-third of the total width of the panel, so that one side of the figure stands out against the open space. In the Munich Portrait of Oswolt Krell (59) it is narrowed down to a strip about one-fifth the width of the panel. Yet these four pictures have one thing in common: the landscape is no longer seen through a window cut into a massive wall, but appears behind a thin curtain of woven material; instead of "looking out" from a closed room, we are out in the open where a portion of the view is screened off, but still forms part of one homogeneous space.

In the Tucher Portraits the curtain is of embroidered brocade; in the Krell Portrait it is solid red. In this respect the Krell Portrait announces a portrait, also in Munich, which bears the date 1500 and was formerly held to represent the younger brother of the artist, Hanns Dürer (76). In it, Dürer reverted to the plain dark background of his earlier portraits, but employed it as he had the red curtain in the Krell picture: the face detaches itself almost

violently from the dark background, with the contour of the brow and cheek emphatically stressed and intensified.

The plain dark background is also employed in Dürer's most famous Self-Portrait, which is preserved in the same museum and was painted in the same year (50, *fig.* 110). In every other respect, however, these two pictures form the sharpest contrast imaginable. The Self-Portrait of 1500 is the only portrait by Dürer in which the figure is both rigidly frontalized and verticalized. The effect of this hieratic arrangement is paralleled only by half-length images of Christ, and this resemblance is strengthened by the position of the hand which occupies the same place as the blessing right of the *Salvator Mundi*. It is indeed unquestionable that Dürer deliberately styled himself into the likeness of the Saviour. He not only adopted the compositional scheme of His image, but idealized his own features so as to make them conform to those traditionally attributed to Christ: he softened the characteristic contours of his nose and cheekbones and enlarged the size and altered the shape of his small and somewhat slanting eyes.

How could so pious and humble an artist as Dürer resort to a procedure which many less religious men would have considered blasphemous? To understand his intentions we must remember two things. First, that at Dürer's time the doctrine of the "Imitatio Christi"— "noch Christo z'leben," to quote his own words—was interpreted more literally than nowadays and could be illustrated accordingly; an individual person could be depicted with the Cross on his shoulders (894). Second, that for Dürer the modern conception of art as a matter of genius had assumed a deeply religious significance which implied a mystical identification of the artist with God. To his way of thinking the creative power of a good painter derives from, and to some measure is part of, the creative power of God, much as an anointed king rules "Dei gratia" and as the Pope acts as the "Vicar of Christ." "God," to quote one of Dürer's earliest and most characteristic statements on art, "is honored when it appears that He has given such insight [*Vernunft*] to a creature in whom such art resides."

From this point of view the reproach of self-glorification is less justified in connection with Dürer's Self-Portrait in the guise of Christ than it is in connection with his Self-Portrait in the guise of a *gentilhuomo*. It is no longer a challenge, but a confession and a sermon. It states, not what the artist claims to be, but what he must humbly endeavor to become: a man entrusted with a gift which implies both the triumph and the tragedy of the "Eritis sicut Deus." He has to subordinate his private self to an ideal postulate; he has to strive for "insight" although he knows that "ultimate truth will not enter the mind of man"; and he has to go on in spite of the fact that "the best is not within our reach." The Munich Self-Portrait marks that crucial point in Dürer's career when the craving for "insight" began to be so all-absorbing that he turned from an intuitive to an intellectual approach to art, and tried to penetrate into the rational principles of nature. At this stage of his development his concept of the "Christ-like" artist seemed to be best prefigured in the impersonal clarity and calm of a hieratic image such as the *Salvator Mundi*.

WHEN ERASMUS OF ROTTERDAM devoted two pages of his charming dialogue *De recta Latini Graecique sermonis pronuntiatione* to what he calls a "monument to the memory of Albrecht Dürer" he borrowed most of his praise from Pliny's eulogy on Apelles. He made, however, one significant change. He extolled Dürer, and even rated him above the ancient master, for having accomplished by black lines on white paper what the great Apelles had been able to do only with the aid of color: "I admit that Apelles was the prince of his art, upon whom no reproach could be cast by other painters except that he did not know when to take his hand off the panel—a splendid kind of blame. But Apelles was assisted by colors, even though they were fewer and less ambitious—still by colors. But Dürer, though admirable also in other respects, what does he not express in monochromes, that is, in black lines? Light, shade, splendor, eminences, depressions; and, though derived from the position of one single thing, more than one aspect offers itself to the eye of the beholder. He observes accurately proportions and harmonies. Nay, he even depicts that which cannot be depicted: fire, rays of light, thunder, sheet lightning, lightning, or, as they say, the 'clouds on a wall' [which means, according to Erasmus' own definition, "something most similar to nothing or a dream"]; all the sensations and emotions; in fine, the whole mind of man as it reflects itself in the behavior of the body, and almost the voice itself. These things he places before the eye in the most pertinent lines—black ones, yet so that if you should spread on pigments you would injure the work. And is it not more wonderful to accomplish without the blandishment of colors what Apelles accomplished with their aid?"

In thus immortalizing Dürer as an engraver and woodcut designer rather than as a painter, Erasmus expressed an opinion shared by almost all of his contemporaries and endorsed by posterity. Dürer himself complained of the fact that the Italians appreciated and copied his prints while criticizing his use of color. But shortly after he practically bade farewell to painting himself: "From now on I shall concentrate on engraving. Had I done so all the time I should today be richer by a thousand guilders."

That Dürer explained his preference for the graphic media as a matter of economic expediency is not surprising. The production of prints, involving little outside help and practically no material expense, may well have been more profitable than the tedious and complicated process of painting where the cost of lapis lazuli alone would devour a considerable fraction of a reasonable fee. Yet there was another and more fundamental justification for Dürer's attitude. He felt surer of his public, and surer of himself, as a graphic artist than as a painter, and this for two good reasons. First, lines had more meaning for him than colors; he thought in terms of lines as Chopin thought in terms of the piano and not of strings or wind instruments, and as Keats thought in terms of verse and not of prose. Second, and perhaps no less important, the graphic media were the most appropriate means of expression for a mind dominated by the idea of "originality."

The postulate of originality—and, conversely, the condemnation of plagiarism—is a fairly modern phenomenon which presupposes the interpretation of art and other intellectual achievements as a matter of individual "genius." The Middle Ages conceived of the indi-

vidual not as an originator but as a link within the chain of tradition, and they acted and judged accordingly in every field of human endeavor. A scholastic philosopher did not pride himself on the originality of his thoughts but tried to eliminate apparent contradictions in the writings of his predecessors by redefining their premises. A medieval artist developed the types handed down by his forerunners without attempting to break the current of tradition by the short-circuit of either a new "invention" or a direct observation from nature. Our first question in connection with a Renaissance or Baroque drawing, is: "Is it an original drawing *for* a painting or print, or a mere copy *after* a painting or print?" A medieval drawing, if we can apply this term at all, is as a rule both a reflection of one work of art and a potential basis for another.

Dürer, in this respect ahead of even the Italians, was one of the first artists to insist that the chief requirement of a good master was to "pour out new things which had never before been in the mind of any other man." He looked down upon those who "imitated" his compositions in their work and made fun of the Venetian painters who, too unimaginative to invent "new stories," contented themselves with "painting the same old subjects over and again."

Now, in Dürer's time a major painting was undertaken only on commission. That a picture not falling into the class of standardized devotional images should be designed with no definite end in view was an idea which developed only when art had come to be interpreted as a means of "expressing the artist's personality." A German painter, therefore, of the late fifteenth or early sixteenth century was normally restricted in subject matter to the accepted religious themes on the one hand, and to portraits on the other. Patrons who would order a canvas like Dürer's *Hercules Killing the Stymphalian Birds* (105) were very rare, and this picture is indeed the only mythological subject ever treated by Dürer in painting. The magic of the multiplying arts, however, permitted the artist to take the initiative: instead of waiting for a commission he could turn out, in a great many impressions, works of his own original invention. As almost every one could afford to buy a print, these impressions found a market like the copies of a printed book; and though the graphic artist (not unlike the writer) had to conform, to some extent, to the taste of the "public," this taste in turn proved amenable to education by the graphic artist. Thus the graphic media became a vehicle of self-expression long before self-expression had been accepted as a principle of what is called the major arts.

Even in the sphere of religious representations the engraver and woodcut designer was freer than the painter; he could select subjects unsuitable for altarpieces, such as the Apocalypse, and could be unconventional in his interpretation of others. In the secular field his liberty was altogether unlimited. He could represent whatever interested him and, he hoped, a more or less general public. He could show objects picturesque or curious; he could plunge into folklore and into the news of the day; he could contrive unusual variations on historical or mythological themes and could think up brand-new inventions of a symbolic or allegorical character. Small wonder that Dürer was partial to the graphic media and that he played a more significant role in their development than he did in that of painting. It can be said

without exaggeration that the history of painting would remain unchanged had Dürer never touched a brush and a palette, but that the first five years of his independent work as an engraver and woodcut designer sufficed to revolutionize the graphic arts.

Except for two incidental works of semi-scientific character—one of them, *The Syphilitic* (403), adorning a broad-sheet published by Dr. Ulsenius in 1496, the other, entitled *"Caput Physicum"* (444), illustrating a psychological treatise by Ludovicus Pruthenius printed in 1498 by Koberger—the woodcuts produced by Dürer before 1500 are all "ganze Bogen" ("whole sheets"), printed from blocks about 15 by 11.5 inches in size. Like the ships of a great merchant these giant woodcuts carried their cargo and their flag—Dürer's famous 🄰 — all over the world. They had a threefold right to bear his initials. They were issued on his own responsibility; they were invented and designed by him; and most, if not all of them, were even cut by his own hand.

While working for the publishers of Basel and Strassburg, Dürer did not normally cut his woodcut designs himself. He was then a mere cogwheel in a machine which functioned according to the principle of division of labor, and his natural talent as well as his previous training qualified him for the job of "cartoonist" rather than for that of cutter. His pre-Italian style was new in that it was based on an unusual fusion of diverse traditions and elements, but none of these was in itself a novelty to German craftsmen; they found themselves confronted with a somewhat difficult yet by no means insurmountable task. It is clear, then, that Dürer, if indeed he did carve some of the Basel blocks himself, could limit this kind of work to comparatively rare occasions; he undertook it in order to familiarize himself with the technical process, and in order to demonstrate his intentions to the professional cutters, but not as a part of his regular duties.

Similarly, Dürer handled the cutting knife only rarely in his later years, particularly after his second journey to Italy, but now for directly opposite reasons. Busy, not only with paintings and engravings but also with theoretical work and with the enterprises of Maximilian I, Pirckheimer and other humanists, he had to resort to a division of labor again, but now with himself in command of the machine. Having shouldered such tasks as the *Triumphal Arch*, the *Triumphal Procession* and the illustration of his own treatises, he had once more to limit his personal contribution to working drawings or even to mere sketches to be carried out by assistants. But now, as far as the cutting was concerned, he could rely on a new generation of craftsmen. These might be members of his own workshop, or they might have set up an independent business devoted exclusively to the manufacture of woodblocks—this latter as in the case of Hieronymus Andreae, called "Formschneyder," who, from about 1515, did most of Dürer's "woodcutting" in the purely technical sense. But in any case, they had all grown up under the master's influence and had learned completely to adjust their technique to the requirements of a "Dürer style"—soon more or less adopted by all the other woodcut designers in Germany—the fundamentals of which had been developed in the half-decade from 1495 to 1500.

During these truly formative years Dürer must have done most of the cutting himself. Had he entrusted the blocks of the Apocalypse to cutters previously employed by Wolgemut or Koberger, he would have had to dismiss them as speedily as Michelangelo did those unfortunate Florentine Quattrocento painters who were supposed to assist him with his work at the Sistine Chapel. No one else could, at that time, translate his conceptions into an entirely adequate language. The two "incidental" woodcuts which have been mentioned (403 and 444) give us an idea of what happened to two Dürer designs of 1496 and 1498 respectively when handed over to a professional Nuremberg cutter; and a brilliant analysis by William M. Ivins, Jr., has revealed the basic technical difference which exists between two woodblocks of 1497/98 (222 and 340) and several of after 1510, the latter ones produced by professional cutters.

What, then, are the characteristics of the new woodcut style which appeared in the Apocalypse and in the other "whole sheets" of 1496-99?

The uppermost consideration in Dürer's mind was, naturally, to impart to his woodcuts the plastic force and emotional vitality which fascinated him in the "nackete Bilder" of the Italians, and yet to retain, and even to strengthen, the richness and variety which had distinguished the illustrations of the "Nuremberg Chronicle" and the *Schatzbehalter*. To accomplish this he had to redefine the very function of the medium.

In the woodcuts of Dürer's German predecessors, there had been two different kinds of lines which can be termed "descriptive" on the one hand, and "optical" on the other. The "descriptive" lines, or contours, had served mainly to define the forms without contributing to the characterization of light, shade and surface texture. The "optical" lines, or hatchings, had served mainly to suggest light, shade and surface texture without contributing to the definition of form. Where these separate functions had happened to coincide, as in the representation of hair, fur or foliage, the result had often been utter confusion; and neither the contours nor the hatchings had had much plastic or emotional significance, the former being too monotonous in thickness and movement to go beyond a mere delimitation of areas, the latter being either too schematized or too chaotic to express organic structure.

In Dürer's post-Italian woodcuts this functional disparity was eliminated. The hatchings were no longer permitted to appear as schematic series of stiff, indifferent strokes or to fuse into indistinct masses, nor were the contours confined to the function of mere boundaries. Both were subjected to the discipline of what may be called "dynamic calligraphy," and were thereby reduced to a common aesthetic denominator. Both Wolgemut and Dürer tried to appropriate in their woodcuts some of the qualities of copper-plate engravings; but while Wolgemut endeavored to achieve their illusionistic rendering of surface textures, Dürer emulated their purely graphic qualities. He taught woodcut lines, hatchings and contours alike, to behave like the prolonged, elastic *tailles* produced by Schongauer's burin. They were made variable in length and width, they learned to move in curves significant both from an ornamental and representational point of view, and, above all, they acquired the capacity for swelling and tapering so as to express organic tension and relaxation. Thus hatchings as well

as contours were transformed into flexible and expressive "modelling lines," with equal emphasis on the concepts of "line" and of "modelling."

As a result, the woodcut medium became an adequate vehicle for the dynamic tendencies of the Italian Renaissance where all things, whether alive or inanimate, were interpreted as organic entities molded and stirred by inherent forces. Dürer had to renounce, of course, the aspiration for pictorial effects. But the very principle which prevented his woodcuts from attaining illusionism endowed them, almost paradoxically, with new and powerful chiaroscuro values. For, since the functional difference which formerly existed between contours and hatchings had been eliminated, the contours, originally merely "descriptive," assumed a luminary significance in proportion as the hatchings, originally merely "optical," fulfilled a plastic function. In other words, the relationship between paper and printer's ink came to be sublimated into a relationship between light and shade: every black line, in addition to being "black" and to indicating form and volume, came to signify "darkness"; and the blank paper came, accordingly, to signify "light."

This transformation of black lines and white intervals into negative and positive symbols of the same entity, namely, light, opened up entirely new possibilities. Where a lighted form had to be singled out from a blank area, it was, of course, bounded by a black line; but where a shaded form, even if it happened to be part of the same piece of drapery, had to be separated from a dark environment, the black contour was replaced by a white one (a remarkable anticipation of what is known as "white-line engraving"); and where a lighted form had to stand out from a dark background, the contour was omitted altogether—absorbed or swallowed up by the surrounding darkness. Suffice it to adduce the cut-work coats and trappers in the *Four Horsemen of the Apocalypse* (284, *fig.* 78) and *Samson rending the Lion* (222), or the magnificent fruit tree in the *Knight on Horseback and Lansquenet* (351).

Thus the primitive contrast between black and white came to express a gliding scale of chiaroscuro values—gliding in so far as the relation of luminary intensity was bound to be affected by the factor of quantity. "More black" meant "deeper darkness"; not only the greater or lesser density, but also the tapering and swelling of the black lines gave the impression of more or less impenetrable shade, and this, by way of contrast, strengthened or softened the brilliancy of the adjacent whites. What applied to the relation between single elements also applied to the relation between larger complexes, so that the whole woodcut began to glitter and to glow with varying degrees of luminosity—not in spite but because of the fact that the profusion and confusion of the earlier style had been restricted to a purely linear mode of presentation.

Motifs such as the mane of Samson's lion (222), the plants in the *Holy Family with the Three Hares* (322) or the trees in the *Knight on Horseback and Lansquenet* (351) are like fireworks in black and white. Set out against long parallel strokes which indicate a darkening sky (a borrowing from line engraving inconceivable in any woodcut before Dürer), or contrasted with a system of concentric curves standing for a stretch of terrain,

blank paper seems to be magically transformed into luminous clouds, blazing flames, or wide landscapes suffused with sunshine.

The new style did not, of course, emerge like Athena from the head of Zeus. The modest book illustrations of 1492/93, in attempting to synthesize the Nuremberg and the "Ulmian" technique, had paved the way, to some extent, for what was to be accomplished in the large woodcuts of the following lustrum, and within the latter a definite development can be observed.

One of the earliest, if not the earliest, of the "whole sheets" produced after Dürer's return from Italy is the *Bath House* (348, *fig.* 71). It is the only woodcut of this period in which the light comes from the right (which shows the lack of established working habits), and its iconographical counterpart, a drawing of Bathing Women (1180, *fig.* 95), bears the date 1496. Here the characterization of surface texture is still somewhat reminiscent of Wolgemut's illusionism, as is particularly evident in the group of buildings near the left margin. An attempt is made to bring out the qualities of weather-beaten wood, latticed windows, mellowed masonry and thatched roofs. The fortified castle in the *Martyrdom of St. Catharine* (*fig.* 72), executed but two or three years later, is reduced to a complex of stereometrical forms described in terms of strictly graphic lines (*figs.* 82 and 83).

Analogous comparisons can be drawn *ad libitum* and can serve to establish a relative chronology, not only of the single woodcuts but also of the individual pages within the Apocalypse. The buildings in the woodcut *St. John before God and the Elders* (283, *fig.* 77), for instance, are obviously more like those in the *Bath House* than like those in the *Martyrdom of St. Catharine*; this print must thus belong to the earlier pages of the Apocalypse. Similarly, we note that the elaborate Venetian dress which appears in both the *Martyrdom of St. Catharine* and the *Babylonian Whore* (293) is rendered with impressionistic *sprezzatura* in the latter case and with systematic precision in the former. Again the inference is that the *Babylonian Whore* is about two years earlier than the *Martyrdom of St. Catharine*, and this assumption is confirmed by the treatment of the "fire from heaven," where pictorial illusionism has given way to a simple but surprisingly effective contrast between black and white.

The peculiarities of the woodcut medium influenced subject matter and content as well as "style." Unless they served some ulterior purpose (as did book illustrations, emblems, heraldry or such exceptional enterprises as the *Triumphal Arch* of Maximilian I), woodcuts were, on the whole, more "popular" in character than engravings, not only because they were less laborious to produce and therefore cheaper to acquire, but for internal reasons as well. Their technique called for the summary statement of essentials rather than for the particularizing elaboration of details. It suppressed individual variations of modelling and texture in favor of a simplified linear pattern, and sacrificed tonal differences to powerful contrasts of light and dark. Woodcuts were thus ill suited for a display of "art for art's sake" where connoisseurs might revel in pictorial refinements or in the consummate beauty of the nude. They did not invite minute examination and leisurely enjoyment. But the very succinctness

and directness of their style produced a strong and instantaneous psychological reaction, and the non-realistic quality of the medium was favorable to excursions into a domain essentially inaccessible to copper-plate engraving: the realm of the fantastic and the visionary.

Dürer never lost sight of these inherent potentialities and limitations; he even became increasingly aware of them. Of his "independent" woodcuts only three are devoted to secular subjects. None of these is later than 1497, and two of them, already briefly mentioned, represent simple and rather commonplace genre subjects already familiar to earlier fifteenth century art: the *Knight on Horseback and the Lansquenet* (351), and the *Bath House* (348, *fig.* 71). The former is a monumental restatement of motifs in which Dürer had been interested from the very beginning of his career (see the drawings 874 and 1244) and it would be difficult to find for it an interpretation other than factual. That the latter, too, has scarcely any cryptic allegorical meaning may be inferred from the fact that bathing scenes of this kind were very popular in late medieval and Renaissance genre art. Even the "onlooker," who has been identified with Plato's silly youth looking in on the Dionysian mysteries but never initiated into them, is a standard feature of these representations. It occurs also in that drawing of 1496—already mentioned in connection with the Bath House woodcut— where six women and two children appear more seriously engaged in the good work of cleanliness than the fun-loving men (*fig.* 95).

Only one woodcut, not very much later than the *Bath House*, deals with a definitely humanistic subject. It is entitled *"Ercules"* and represents the combat between Hercules and Cacus (347). The interpretation is, however, characteristically not based on original classical sources but on a medieval compendium known as the "Mythographus III," probably supplemented by suggestions from Dürer's learned friends. This accounts for the unusual features of the narrative. Since the "Mythographus III" relates the Cacus incident before all the other labors of Hercules, the hero is not yet clad in the lion's skin which he was to wear throughout his later life—the lion still happily loitering in the background—but in the skin of a deer or calf. The defeated Cacus, dressed in what Dürer then believed to be classical armor, is represented in the form of "Siamese Twins," owing to the boldly literal interpretation of the epithet *duplex* which may mean "deceitful" (as in our word "duplicity"), as well as "double" or "bipartite." The unhappy girl pursued by a Fury of grimly Mantegnesque appearance, finally, is Cacus's sister Caca. She had—we are not told how and why—"betrayed her brother to Hercules" and thereby brought about the former's death. Whether or not she foresaw the result of her action, she was thus guilty of fratricide and had to be punished by the avenging goddess especially appointed for the prosecution of this crime, the "Erinys fraterna."

All the other large-sized woodcuts produced before 1500, then, represent religious subjects; but only four of them were intended to appear as single prints: the *Samson*, the *Holy Family with the Three Hares*, the *Martyrdom of St. Catharine*, and the *Martyrdom of the Ten Thousand* (337), where Italian reminiscences had been incorporated into a framework derived, as we remember, from Geertgen tot Sint Jans (*figs.* 69 and 70). The rest

—twenty-two in number—belong to two coherent series or, to quote Dürer's own words, "large books"—the Apocalypse and the Large Passion. The Apocalypse is made up of fifteen woodcuts, the first of which represents the Martyrdom of St. John the Evangelist. It was first published in two parallel editions, one with German and the other with Latin text, both of which appeared in 1498; a reprint of the Latin edition, with a new frontispiece, appeared in 1511 (280-295).

The enterprise of the Apocalypse was novel in two respects. First, it was the earliest book designed and published by an artist as exclusively his own undertaking. The "Nuremberg Chronicle," too, had been printed at the initiative of Wolgemut and Pleydenwurff, but they had obtained the support of two capitalists, and these as well as the printer, Anton Koberger, had been credited with the publication in the colophon. Dürer, however, signed himself not only as the artist but also as the publisher, and even had the text been set and printed in Koberger's shop, which is not certain, this fact was not made known to the public.

Second, the Apocalypse was a new type of illustrated book as such. Setting aside the Carolingian manuscripts to which we shall shortly revert, the illustrated copies of the Revelation had been, roughly speaking, of three kinds. Either a number of self-contained and fairly large pictures, preferably full-page, had been distributed throughout the volume, as in the Bamberg Apocalypse, the Beatus manuscripts and several other instances; or, a series of comparatively small illustrations had been inserted into the script or letterpress, as in the big Dutch Bibles of the early fifteenth century and their remote descendants, the printed Bibles of the 'seventies and 'eighties; or else, each page had been divided into two or, occasionally, more tiers of pictures explained by brief captions and internal inscriptions, as in the majority of French, English, Flemish and German manuscripts of the thirteenth and fourteenth centuries. The gradual disintegration of this last type, with more and more text invading the area of the pictures, had ultimately resulted in the Block-Book Apocalypses of the middle of the fifteenth century.

Dürer, however, wanted to bring out a book containing the complete text and, at the same time, a continuous yet brief series of pictures neither interrupted by text, nor inserted in the text, nor, of course, interspersed with text. He therefore reserved the front of his huge pages for woodcuts free from inscriptions and printed the text on the back. This arrangement is reminiscent of the aforesaid Carolingian manuscripts, but in these the principle is not observed consistently and is applied in an altogether different spirit. The closely related Apocalypses in Valenciennes and Paris (Bibliothèque Nationale, Nouv. Acqu. 1132) show a consistent alternation of pictures on the recto and text on the verso, but the pictures are not always full-page illustrations and actually honeycombed with inscriptions. The closely related Apocalypses in Treves and Cambrai, on the other hand, have full-page illustrations free from script, but there is a sudden shift from leaves with pictures on the verso and text on the recto to leaves with pictures on the recto and text on the verso. And in all four cases the narrative, comprising from thirty-eight to seventy-four pictures, is as prolix as Dürer's is concise.

In only one instance do we find anything like a genuine anticipation of Dürer's general scheme. This is the remarkable East Flemish manuscript in the Bibliothèque Nationale (MS. Néerl. 3, *fig. 73*), where the content of the whole Revelation is crammed into a limited number of pictures (twenty-two as against Dürer's fourteen); where the illustrations occupy the whole page and are of similar format, though naturally not quite of the same size, as Dürer's woodcuts; where the text is invariably given on the back of the pages and never encroaches upon the pictures; and where, within the limits of the style of about 1400, a similar spirit of grandeur and pathos holds sway. Whether or not Dürer had occasion to see this or a similar manuscript (which is by no means impossible, especially if he actually did visit the Low Countries as a journeyman), it is, as a "book," the nearest approach to his Apocalypse.

There is, however, apart from everything else, one very significant difference in structure. In the Paris manuscript the text is not only abbreviated but so arranged that each chapter faces the corresponding illustration and forms a kind of text-and-picture unit with the latter (which, by the way, is also true of an unauthorized reprint of Dürer's Apocalypse published in 1502 by Hieronymus Greff). Dürer printed the text without interruption so that the back of his last woodcut is blank. He did not want the reader to compare an individual picture with an individual passage of writing, but rather to absorb the whole text and the whole sequence of pictures as two self-contained and continuous versions of the same narrative.

To achieve this end, Dürer applied two principles: concentration and dramatization. On the one hand, he condensed the entire content of the Revelation into fourteen woodcuts, each presenting a closed and unified composition; incidents enlarged upon in other cycles were abbreviated or entirely omitted, and repetitions were strictly avoided. The "mountains and islands moved out of their places" of Chapter VI, 14 and the "falling star" of Chapter IX, 1, for instance, were omitted because similar events were represented in the illustration of Chapter VIII, 8 and VIII, 10 respectively (288); the content of Chapters VII, 9, 10 and 13 and XIX, 1-4 was incorporated into the illustration of Chapter XIV, 1 and 3 in order to avoid the recurrence of great multitudes worshipping the Lamb (287). On the other hand, Dürer did everything in his power to transform mere situations or phenomena into dramatic action. When the text speaks of "a voice from the four horns of the golden altar which is before God," the horns (*cornua*; Luther's translation has "Ecken") appear as Cherubs' heads emitting blasts of air (289); when mention is made of the "hundred and fourty and four thousand" who were "sealed in their foreheads," Dürer does not merely show a group of people signed with a cross but illustrates the act of signing them, performed by an angel of his own free invention (286, *fig. 79*); when white robes "are given" to the "souls of them that were slain for the word of God" and clamor for more speed in the administration of justice, we see the impatient martyrs resurrected, brought before the altar by angels, reaching for the garments, and actually donning them (285); and when the seven-headed beast is seen by the visionary with one of its heads "as it were wounded to death," one of its necks

collapses like a dying snake (294). The Four Horsemen who, according to the text, "go out" singly and do not come into direct contact with mankind appear as a closed squadron charging upon a crowd of helpless victims (284); the "great mountain burning with fire" is "cast into the sea" by two gigantic hands emerging from clouds (288, *fig.* 80); and the stars that fall from heaven "even as a fig tree casteth her untimely figs" seem to behave like living creatures, each writhing like a starfish rather than a star, and provided with a quivering tail (285). Furthermore, the Evangelist, who is more or less ubiquitous in other illustrations of the Apocalypse, is included only where he plays an active part in the drama. He appears not as a mere "seer" but as one who directly participates in the action: where he goes to his knees before the Son of Man and listens to His voice (282, *fig.* 76), where he is spoken to by the Elders (283, *figs.* 77 and 287), where he devours the book (290), and where he is shown the Heavenly Jerusalem (295). The undramatic episode of the letters to the Seven Churches remained, of course, unillustrated.

In thus departing from the written text, Dürer could draw, to some extent, upon a representational tradition which, though with altogether different intentions, had paved the way for a livelier interpretation of the textual data. The Block-Book Apocalypse and its hand-painted predecessors had already depicted the actual clothing of the impatient martyrs, and the whole fifteenth century had shown a growing tendency to unite the Four Horsemen within a coherent picture space instead of representing them on four separate pages or, at least, in four separate sections. The Quentell Bible of about 1479 and its derivatives, the Koberger Bible of 1483 and the Grüninger Bible of 1485 (the former illustrated with reprints of Quentell's original blocks, the latter with rough but fairly inventive copies in reverse), even include a little group of human victims (*fig.* 75).

There are many other indications that Dürer carefully consulted the woodcuts of his modest predecessors. What may be called the "raw material" of his compositions was largely furnished by the illustrations of the Quentell-Koberger Bible on the one hand, and of the Grüninger Bible on the other. A brief tabulation may serve to facilitate a comparison which sheds an interesting light on Dürer's methods.

MARTYRDOM OF ST. JOHN THE EVANGELIST (281). The motifs of the henchmen were in part suggested by the Quentell-Koberger and, even more particularly, by the Grüninger Bible.

THE VISION OF THE SEVEN CANDLESTICKS (282, *fig.* 76). The general scheme of composition was directly taken over from the Quentell-Koberger Bible (*fig.* 74).

THE FOUR HORSEMEN (284, *fig.* 78). In addition to the fact that the four riders appear in a unified picture space and that their human victims are included, it should be mentioned that the Quentell-Koberger Bible shows a kneeling woman in the same place where an analogous figure, however much improved, occurs in the Dürer woodcut.

THE OPENING OF THE FIFTH AND SIXTH SEALS (285). While the idea of representing the actual act of clothing (and possibly the division of the composition into two

zones) was suggested by the Block-Book Apocalypse, the motif of the angel standing behind the altar and handing out the garments is derived from the Grüninger Bible.

THE FOUR ANGELS HOLDING THE WINDS (286, *fig.* 79). The swords carried by the Angels—not required by the text and absent from the earlier tradition—appear in both the Quentell-Koberger and the Grüninger Bibles. The Angel at the upper left is a variation in reverse on the Angel at the upper right in the Quentell-Koberger woodcut. The idea of uniting the Four Angels into a solid block placed in the left foreground, with all the other figures pushed back into the center plane, may have been suggested by Michael Pacher some of whose works Dürer may have seen while crossing the Alps; a similar distribution of masses can be observed, for instance, in the *Miracle of Loaves and Fishes* in the St. Wolfgang altarpiece.

THE SEVEN TRUMPETS (288, *fig.* 80). The eagle saying "We, We, We" and swooping down upon the earth—instead of quietly displaying his wings—occurs in almost identical fashion in the Grüninger Bible while he is absent from the Quentell-Koberger Bible; the motif of the foundering ships was likewise suggested by the Grüninger woodcut. The falling star, on the other hand, is included only in the Quentell-Koberger Bible. The burning mountain appears in both versions, but the idea of having it tossed into the sea by two huge hands is Dürer's.

ST. JOHN DEVOURING THE BOOK (290). The "Mighty Angel" is an improved version of the figure in the Quentell-Koberger Bible, except for the fact that Dürer's interpretation of the metaphor "and his feet as pillars of fire" is more literal: the earlier woodcut shows human feet protruding from under the bases of the "pillars" while Dürer eliminates the feet altogether.

THE APOCALYPTIC WOMAN (291). The general arrangement of the composition is derived from the Quentell-Koberger Bible. The motif of the Child carried heavenward by two angels was, however, revised after the pattern of funerary monuments and prayer books ("Commendatio animarum"), where the soul of the deceased, in the guise of an infant, is carried upward in a cloth.

ST. MICHAEL FIGHTING THE DRAGON (292, *fig.* 81). The posture of St. Michael was suggested by the Quentell-Koberger Bible.

THE BABYLONIAN WHORE (293). The general composition of the main group, the posture of the Whore, and the presence of an angel were suggested by the Quentell-Koberger Bible.

THE BEAST WITH TWO HORNS LIKE A LAMB (294). The posture and physiognomical appearance of the Beast were suggested by the Grüninger Bible, rather than by the Quentell-Koberger Bible.

THE ANGEL WITH THE KEY OF THE BOTTOMLESS PIT (295). The main group was, in a very general way, suggested by the Quentell-Koberger Bible.

In remodelling the schemes and motifs suggested by these old-fashioned woodcuts, Dürer drew upon the experiences of his bachelor's journey and of his visit to Italy. It has already been mentioned that Dürer's new woodcut technique owes much to Schongauer's engravings. With regard to the Apocalypse, these served not only to improve Dürer's grammar but to enrich his vocabulary. It need hardly be pointed out that the Seven Candlesticks in the initial vision are diversified and, in part, modernized variations on the magnificent candelabrum in Schongauer's *Death of the Virgin*. The figure of the Evangelist in the same woodcut, kneeling so as to show his nude soles to the beholder, also reveals the influence of this engraving, and so great was the fascination of this realistic detail that Dürer repeated it four times in later years: in the Heller altarpiece (8, 496, *fig.* 168); in the two woodcuts representing the Death and the Assumption of the Virgin (313 and 314, *fig.* 178); and in the *Last Judgment* in the Small Passion (272). The facial type of the Son of Man in the *Vision of the Seven Candlesticks* is no less Schongauerian than the aerial apparition in the *"War in Heaven"*; with its fantastic fringe of devils' tails and wings it evidently presupposes the *Temptation of St. Anthony*. The child seen in the lower left-hand corner of the *Opening of the Fifth and Sixth Seals*, finally, is almost identical with Schongauer's Infant Jesus as *"Salvator Mundi."*

The mother of this child, however, is of different ancestry. Her horror-stricken face, the mouth wide open with a cry of anguish, is unthinkable without such models as the mourning old woman in Mantegna's *Deposition of Christ* (*fig.* 198)—models which in turn reflect the frozen pathos of classical tragic masks. Another reflection of Mantegna's style can be discovered in the background of the same woodcut where the posture of the dying Orpheus (928, *fig.* 49) is repeated in the figure of an elderly man vainly trying to protect himself from the downpour of stars. Other reminiscences of the trip to Venice are found in the Italianate architecture and the Turk's head in the *Martyrdom of St. John* (281, for the Turk's head see the drawing 1469, *fig.* 55), in the fantastic helmet of the warrior in the group of people listening to the Beast with two Horns like a Lamb (294, the helmet recurring later in the engraving *"Hercules"*), and in the Venetian costume of the *Babylonian Whore* (293, see the drawing 1278).

All these details are, however, of minor importance as compared to the influence of the Italian Renaissance as a new method of approach. It was thanks to Mantegna, or rather to classical models transmitted through him and his followers, that Dürer was able to "realize" the visions of St. John without destroying their phantasmagoric quality.

A vision is a supernatural event, or rather a sequence of supernatural events, experienced by a person "being in the Spirit" or, as one would say today, in a trance. Its content is thus both miraculous and imaginary. It is miraculous in so far as the laws of ordinary physical life are temporarily suspended; it is imaginary in so far as this suspension is not supposed to take place in actuality as is the case, for instance, of the miracles accepted by the Church, but only within the consciousness of the visionary. To "realize" a vision in a work of art—that is, to make it convincing without the aid of conventional signs or inscriptions—the artist has to fulfill two seemingly contradictory requirements. On the one hand, he must be an accom-

plished master of "naturalism," for only where we behold a world evidently controlled by what is known as the laws of nature can we become aware of that temporary suspension of these laws which is the essence of a "miracle"; on the other hand, he must be capable of transplanting the miraculous event from the level of factuality to that of an imaginary experience.

In Dürer's Apocalypse the second of these conditions was partly fulfilled by his new woodcut style, the "dematerializing" quality of which has already been mentioned, and partly by compositional devices intended to stress the plane surface. In most of the woodcuts the design is dominated by a vertical axis (frequently crossed by a horizontal dividing line) on which are aligned a number of objects located in different spatial planes. Diagonals play an important part, and the forms are arranged so as to balance and connect on the flat sheet no less emphatically than in space; occasionally, for instance in the *Avenging Angels* and the *Apocalyptic Woman*, adoring angels are added only for reasons of symmetry.

To fulfill the requirement of "naturalism," however, Dürer's Northern training, which gave him a sufficient command of space, volume and color, had to be complemented by further study of the kinetics of the human body and the phraseology of human emotions. Without Mantegna, or rather without the classical tradition deliberately revived by him and those who shared his views, Dürer could not have made convincing the swift strength of the Avenging Angels, the statuesque beauty of the Angels holding the Winds, the agony of human beings in despair, and the cold fury of the Four Horsemen. Their phalanx is patterned after a classical type which had survived in Consular Diptychs and Carolingian miniatures, but had been in abeyance for many centuries thereafter; and the group formed by the rider with the "pair of balances" and the woman collapsing before the feet of his horse—a splendid substitute for the analogous figure in the Quentell-Koberger Bible—is reminiscent of one of the reliefs at the Arch of Constantine.

To illustrate this almost paradoxical contrast between a "naturalistic" rendering of visible things and a non-naturalistic mode of presentation, let us consider one specific case: the *Vision of the Seven Candlesticks* (282, *fig.* 76). In general arrangement it remains particularly faithful to the woodcuts in the Quentell-Koberger and Grüninger Bibles (*fig.* 74), but it is infinitely more advanced in the rendering of spatial depth and realistic detail. The enormous candlesticks—enormous because they must catch the visionary's eye before he sees the Son of Man—are all diversified; each of them is an individual masterpiece of goldsmith's work, and the flames of the candles flicker in a supernatural breeze; they are shown in perspective instead of in geometrical elevation, and they are arranged behind instead of above one another. They are placed on realistic cumuli, and these seem to carry, not only the candlesticks but also the figure of the visionary. In the earlier print he had been kneeling before an apparition which appears to him within a conventionalized mandorla—in Dürer's woodcut he is included in his own vision.

However, just these innovations fill the beholder with a sense of fantastic unreality. The same clouds which serve as a kind of platform for the candlesticks and the figure of St. John

develop into what resembles vertical columns of smoke, weightless and unrestrained by the rules of perspective. The three-dimensionality of space is stressed and denied at the same time (with the strict symmetry of the whole composition and the abstract transparency of the woodcut lines lending support to a non-naturalistic interpretation), and the very fact that the Evangelist—a mortal like ourselves—appears to be transported bodily into a supernatural realm invites us to share, and not merely to witness, his visionary experience.

Analogous observations can be made on every page of the Apocalypse. Wherever earthly scenery occurs it is developed into those panoramic landscapes which Dürer had learned to master on his journey through the Alps. Even the flood "cast out" by the Dragon in his pursuit of the Apocalyptic Woman spreads out into a veritable river. The goblet of the Babylonian Whore, the jewelry worn by sacred as well as secular personages, the crowns of the seven-headed monster, the tracery of the "altars before God" and such sturdy pieces of carpentry as the Gates of Heaven and the lid of the Bottomless Pit are depicted with the same work-manlike respect for technical details as the Seven Candlesticks. And in the representation of living things, whether angels, humans or animals, the principle of variety, which had gov-erned the capitals, window-traceries and baldaquins of Gothic cathedrals, came to be coupled with the Renaissance achievement of organic mobility.

The heads of the Dragon, particularly where he appears together with the Beast with two Horns like a Lamb, are varied in relative position, physiognomy, and movement so as to express the operation of the seven capital sins, the proudly erect lion's head in the center standing for "Superbia" (the root and mother of the other vices), the stupid face with little snail's horns for "Acedia," the head with the beak and narrow-set eyes for "Invidia," etc. The behavior of the Four Angels holding the Winds is diversified so as to create a rhythmical crescendo, while corresponding to the character of their antagonists. Gentle Zephyr can be quieted by a beautifully statuesque angel who raises his left hand with a gesture of mild persuasion and carries his sword like an attribute rather than a weapon; the neighbor of this angel, confronting "Auster," makes a more emphatic gesture with his right arm and lifts his sword with a firm and somewhat menacing grasp; the angel at the upper right addresses Eurus with his arms outstretched, his left emphatically raised and his sword almost ready for use; and "Boreas," the wildest of the winds, can be tamed only by actual battle. The very pace of the Four Horsemen is differentiated so as to create the illusion of increasing speed. The group of the three leading riders, though patterned after classical models, differs from these in that the horses do not move in unison. The Rider with the Balance tries to catch up with the Rider with the Sword, and he in turn with him who "has a bow." As they proceed the victims fall like wheat before the reaper, and Death, equipped with a pitchfork instead of with the customary scythe—a gatherer and not a killer—lags far behind on an emaciated jade whose hobbling gait is no less inescapable than the thunderous gallop of the three other horses.

And yet, the more authentic the earthly scenery, the more phantasmagoric such events as the "War in Heaven" or the apparition of the Twenty-Four Elders; the more lifelike and individualized the details of the Dragon, the more monstrous the whole; the more natural and

effective the gestures of the Angels holding the Winds, the more exorbitant the spectacle; and the more real the Four Horsemen and their mounts, the more inevitable the impression that the terrible squadron appears out of nothingness. In short, every increase in verisimilitude and animation strengthens rather than weakens the visionary effect.

It is for this reason that Dürer could frequently omit the figure of St. John where medieval illustrators had deemed it indispensable. Their non-naturalistic style, not even admitting of a clear distinction between a miracle and a natural event, could hardly distinguish a vision from a miracle without including the visionary. It is for the same reason that he dared to illustrate the bold imagery of the Apocalypse more literally than any of his predecessors. When the text says that the eyes of the Son of Man were "as a flame of fire," Dürer could show actual flames bursting from the face of the Lord because the "dematerializing" power of his lines reduced flames, flesh, and hair to the same degree of incorporeality. St. John could actually "eat up" the book (which is merely presented to him in most of the medieval and in all of the fifteenth century representations) because it almost seems to evaporate under his fiery breath. The virtue of the woodcut medium, as reinterpreted by Dürer, enabled him to act upon Aristotle's advice to the dramatist: "What is impossible yet probable should be preferred to what is probable but unconvincing."

It would be futile to attempt a chronology of the Apocalypse series according to which all the woodcuts would follow each other as neatly as the cars of a railroad train; the preparation of the whole work did not take more than about two years, and Dürer certainly worked at more than one composition at a time. Yet a definite development is recognizable. Not unlike Michelangelo's frescoes in the Sistine Chapel, Dürer's compositions gradually grew in "scale" and monumentality at the expense of richness and variety, and they show an increasing freedom, boldness, and economy in the exploitation of the medium. When Dürer composed the *Seven Trumpets* (288, *fig.* 80), *St. John before God and the Elders* (283, *fig.* 77) and the *Worship of the Lamb* (287), he was still apt to crowd too much into the given space so that the individual motifs appear comparatively small in relation to the format of the page. Essentials and accidentals tend to merge into a complicated network of forms whose message has to be decoded instead of being grasped at first glance. The modelling, not yet completely systematized, still shows the traces of the Wolgemut tradition and does not yet attain the transparency and thrifty precision of the later pages. Suffice it to refer to the fuzzy coat of the Lamb in the *Worship of the Lamb*, to the fluffy wings of the Eagle and the Angels in the *Seven Trumpets*, and to the treatment of hair, brocade and velvet throughout. Where the Evangelist occurs he appears very young, with silky curls, his soft-cheeked face invariably turned to full profile and wearing an expression of childlike bashfulness. The woodcut of the Seven Trumpets shows the most crowded composition of all and is the only one where letterpress encroaches upon the area of the picture; it evidently marks the very beginning of the whole enterprise.

This early group is easily distinguished from a late one comprising *St. John devouring the Book* (290), the *Martyrdom of St. John* (281) and the *Vision of the Seven Candlesticks*

(282, *fig.* 76). These three compositions represent the utmost in grandeur of scale, concentration on essentials and graphic economy. The type of the Evangelist, too, is thoroughly changed. Instead of a diffident boy we see a passionate ascetic, his hair dishevelled, his bony, fanatical face distorted with emotion or frozen in an ecstatic stupor (*figs.* 84 and 85). Apparently, like most prefaces and "introductories," the first two pages of the whole series were undertaken last.

Given the end and the beginning of the development, we can divide the rest of the woodcuts into two classes, one being the sequel of the early group, the other announcing the late one. The latter class, including the *Four Horsemen* (284, *fig.* 78), the *Opening of the fifth and sixth Seals* (285), and the *Four Angels holding the Winds* (286, *fig.* 79), is marked by the culmination of those Mantegnesque influences the importance of which has already been stressed. The other class, forming the transition between this "Mantegnesque" group and the three earliest woodcuts, comprises the rest of the series: the *Heavenly Jerusalem* (295, with the Evangelist still reminiscent of the earlier type), the *Babylonian Whore* (293), the *Beast with two Horns like a Lamb* (294), the *Apocalyptic Woman* (291, the development of the Seven-headed Monster in these three woodcuts epitomizing, so to speak, the tendency of the whole evolution), and *St. Michael fighting the Dragon* (292, *fig.* 81, leading over to the "Mantegnesque" group). The woodcut of the *Avenging Angels* (289), finally, holds an exceptional position in that the timid style of the scenes in heaven forms a sharp contrast with the impetuous force of the action on earth. Apparently Dürer had designed this composition at an earlier date and, dissatisfied with the lower zone, remodelled the combat scene into a magnificent synthesis of Gothic ornamentalism (with the two foremost Angels forming a regular swastika) and Mantegna's *maniera antica*.

Like Leonardo's *Last Supper*, Dürer's Apocalypse belongs among what may be called the inescapable works of art. Summarizing, yet surpassing an age-old tradition, these works command an authority which no later artist could or can ignore, except perhaps by way of a deliberate opposition which in itself is another form of dependence. Dürer's compositions were copied, not only in Germany but also in Italy, in France and in Russia, and not only in woodcuts and engravings but also in paintings, reliefs, tapestries and enamels. Their indirect influence, transmitted by a master like Holbein, as well as by such modest craftsmen as the illustrators of the Luther Bibles, reached even the monasteries of Mount Athos.

The impression made by the Large Passion, though no less profound, was less sensational; first, because it lacked the appeal of the novel and the fantastic; second, because it did not reach the public as an integrated whole. Four of the eleven woodcuts—the *Last Supper*, the *Betrayal of Christ*, the *Harrowing of Hell* and the *Resurrection*—were not executed until 1510; it was not until the following year that the Frontispiece was added, and that the whole series, explained in Latin verse by Benedictus Chelidonius (*recte* Benedict Schwalbe), was published in book form. The woodcuts completed before 1500, seven in number, were thus originally sold and circulated as single prints.

Three of these seven woodcuts—the *Agony in the Garden* (226), the *Flagellation* (228), and the *Deposition* (232)—appear to have been executed as early as about 1497. Stylistically they seem to be rather less developed than the "Mantegnesque" woodcuts of the Apocalypse, and their composition suffers from a youthful redundance which is particularly noticeable in the *Flagellation* and the *Deposition*. The *Crucifixion* (231) is slightly more advanced and may be dated 1497/98; and the three remaining woodcuts, the *"Ecce Homo"* (229), the *Bearing of the Cross* (230), and the *Lamentation* (233) may be said to take up the thread of evolution at exactly that point which had been reached when the Apocalypse was finished.

The *"Ecce Homo"* (*fig.* 88), for instance, resembles the *Martyrdom of St. John* (281) in that a crowd plays an important part in both, and that the pagan rulers are represented as Turks, an interesting survival of the medieval tendency so to confuse Islamic and classical paganism that a Roman tomb could be called "la sepouture d'un sarazin." But while the crowd in the *Martyrdom of St. John* is separated from the main incident by the mechanical device of a parapet, the *"Ecce Homo"* woodcut finds for the same problem a purely optical solution.

The palace of Pilate (flamboyant Gothic in style but characterized as a "heathen" build-ing by the statue of a goat-footed Satyr) is shown in sharp foreshortening so that an oblique lane is formed between the people and the group of Christ, Pilate, and a servant who appear on the palace porch. It has often been observed that this foreshortening is incorrect from a perspective point of view: the four steps of the porch converge in one vanishing point, and the horizontal joints of the palace wall in another. But just this "fault," though detrimental to the formal harmony of the composition, serves to emphasize its significance. Instead of "first determining space and then placing the figures therein," as an Italian theorist puts it, Dürer, not yet conversant with a consistent method of perspective construction, first devised the figures and subsequently added the features determining space. Thus it was natural for the architecture to reflect the antithetical character of the incident rather than the unity of space. The discrepancies between the two vanishing points—that of the steps located right in the center of the crowd, that of the palace wall at the level of the head of Christ and far out of the picture—are visually symbolic of the contrast between the Saviour and the hostile "multi-tude," just as, in the *Martyrdom of St. John*, the larger scale of the Roman Emperor is visually symbolic of his social position.

The composition of the *Bearing of the Cross* (230, *fig.* 89) is, in a general way, reminiscent of Schongauer's famous engraving (*fig.* 15). In both, the procession files in from the rear, reaching the center of the stage with the figure of Christ; Christ Himself is represented on His knees, supporting the weight of His body with His left arm. But while Schongauer's caravan proceeds relentlessly in spite of the delay, the van disappearing toward the right in the same way as the rear approaches from the left, Dürer abruptly checks its progress. The Roman captain, again dressed up as a Turk, turns round on his horse, and a huge Italianate lansquenet faces about toward the fallen Christ, his vertical halberd giving the effect of a full stop at the end of a sentence. This lansquenet, though important from a formal point of view,

is yet excluded from the main incident: the miracle of the Sudarium. There is a gap between him and Christ while Christ and St. Veronica form a close-knit group, framed by the stem and one arm of the cross. By this device the Christ and Veronica group is separated from the crowd which pours from the gate of the city; but this crowd is, in turn, divided by the other arm of the cross: the friends of Christ—Simon of Cyrene, St. John the Evangelist and the Holy Women—are set apart from the Roman soldiers, one of whom brutally stabs the neck of Christ with the handle of a battle axe.

In spite of this complicated scheme the figure of Christ easily dominates the scene. He maintains a central position both in a geometrical and in a dynamic sense, and His posture is, from the point of view of the period, conspicuous by its very modernity. In Schongauer's engraving Christ had been represented in profile, His body forming an undulating curve. Only His head had been turned to full face, and His right arm had not been visible. In Dürer's woodcut He does not glide gently to His knees but breaks down under His terrible load: a fluent Gothic pose is replaced by a violent *contrapposto*. While the legs are shown in profile, the chest is turned toward the beholder, and the head is turned sharply back. The right arm of Christ is raised and bent at an acute angle, the hand clasping the beam of the cross, and with His left He tries to support Himself. This attitude is almost identical with that of the dying Orpheus in the drawing of 1494 (928, *fig.* 49). Unconsciously reestablishing the Early Christian identification of Christ with Orpheus, Dürer kept to his principle of "employing the forms of heathen deities for representations of the Virgin Mary and Christ." But it is significant that the fallen Christ merely suffers while Orpheus dies. Where Dürer wanted to conjure up the image of actual death he invented other postures, distorted or weirdly rigid; the classical *contrapposto* was, to his way of thinking, too beautiful to horrify.

We can easily see why this reinterpretation of the Bearing of the Cross appealed to the greatest master of the Italian High Renaissance: Raphael. His *"Spasimo di Sicilia"* (now in the Prado) is clearly influenced by Dürer's woodcut, though every detail has been changed in accordance with the standards of Raphael's late style. Thus a classical motif, revived by Mantegna, was repatriated by Raphael after having been Christianized by Dürer; and it is perhaps to this Northern admixture that Raphael's *"Spasimo"* owes its prophetically "Baroque" character.

The woodcut of the *Lamentation* (233, *fig.* 90), finally, is important not only for itself but because of its connection with the two large paintings in Munich (16, *fig.* 91) and Nuremberg (17). The dead Christ lies on the lap of St. John. The Magdalen throws up her hands in a pathetic gesture of complaint handed down from Antiquity by Byzantine and Early Renaissance art; another woman, half kneeling, half bending, takes up the right hand of Christ; a third, crouching aside with her back turned upon the others, represses her grief by desperately clasping her knee; the Virgin however towers above them all, wringing her hands but otherwise motionless like a statue, upright and lonely.

In the Munich painting, ordered by the goldsmith Albrecht Glimm and traditionally dated 1500, Dürer deliberately abandoned the central idea of this composition. Convinced

that an altarpiece required richness, quiet monumentality and composure rather than suc-cinctness, dramatic movement and emotional pathos, he included the figures of Nicodemus and Joseph of Arimathea, avoided the isolation of the Virgin, which had created a harsh gap in the formal structure of the woodcut, and disciplined the whole composition to the shape of a pyramid culminating in the figure of St. John. Furthermore, two of the figures (the woman with the blue mantle obviously derived from the Virgin Mary in the woodcut) were made to hold big ointment jars, so that expressive gesticulation was replaced by more conventional attitudes; only an old woman in the background is allowed to give vent to her despair by a dramatic gesture. The figure of the Virgin, formerly rigid and lonely, is now the nucleus of the whole group, tenderly surrounded by her friends and wringing her hands with gentle resignation. The body of Christ is reversed and a woman in worldly dress, probably the Magdalen, takes up His arm with both of her hands.

Except for some portions probably executed by assistants, this picture must be ascribed to Dürer himself. The transformation of the earlier composition is so thorough and consistent that it can only be credited to the master. This is not true of the painting in Nuremberg and it must be attributed to an imitator who tried to combine the distinctive features of the woodcut with those of the panel in Munich. From the woodcut, he retained not only the posture of the dead Christ but also the general scheme of composition with an isolated woman crouching on the left and a rigidly erect one dominating the center (though shifted slightly off axis). From the painting he borrowed the figures of the Virgin Mary and Joseph of Arimathea. But the woman on the left, originally clasping her knee in silent despair, was made to throw up her arms (in compensation for which the figure originally distinguished by this dramatic gesture was omitted entirely), and the figure towering above the others is no longer a tragic mother, wringing her hands, but an indifferent mourner with an ointment jar. As a result the picture lacks both the architectonic unity of the painting and the dramatic power of the woodcut. The woman on the left seems merely to have lost all connection with the other figures instead of suggesting isolation. The arm of Christ, no longer supported by one of the women, seems to dangle in mid-air. And the dominating figure with the ointment jar has not only lost contact with the main group (because the woman throwing up her hands had been eliminated), but also reveals a disappointing contrast between compositional emphasis and dramatic insignificance.

IN VENTURING INTO THE FIELD OF ENGRAVING, Dürer took up a technique not only unfamiliar in his native Nuremberg but also diametrically opposed to the older and indigenous craft of the woodcutter. While a woodcut is a relief print an engraving is an intaglio print, the printer's ink being held by grooves or channels incised into a highly polished copper plate. When the edges of the grooves have been smoothed, the ink is rubbed in, the surface is wiped clean and the impression is made on moistened paper under very high pressure.

The engraver, like the woodcutter, works from a careful "working drawing" which pre-establishes practically every line intended to appear in the finished product. But there can be

no further division of labor. The acts of transferring the design to the plate and of producing the final result inevitably merge into one because the design laid down in the "working drawing" can be conveyed to the plate only by actually incising it. The process of incision itself is divided into two distinct stages. First, the engraver defines the contours; secondly, he fills in the details, working, however, not here and there as he pleases but undertaking and bringing to completion a limited area of not more than one or two square inches at a time, while the rest of the plate remains covered for protection. Thus he works much as a surgeon operates on a small portion of a body swathed in aseptic cloth. His work proceeds piecemeal, as it were, and proof prints show that an "unfinished" plate is sharply divided into different sections, some completely elaborated, others containing only empty contours. The lines themselves differ from those in a woodcut in that their widths and intervals can be narrowed down to the fraction of a millimeter without any loss in distinctness and transparency. An engraving tends therefore to be as analytical, particularized and concrete as a woodcut tends to be synoptic, abbreviatory and abstract.

In view of this difference in approach, it is clear that the development of engraving was bound to take a course exactly opposite to that of woodcut. The earliest woodcuts showed, we remember, no more than a robust linear "skeleton" without any modelling. It remained for the following generations to add flesh and epidermis, so to speak; we have seen how they achieved an increasing degree of realistic concreteness, and how this process culminated in the full-fledged illusionism of Wolgemut and his associates. Conversely, the earliest engravings—intended to suggest the actual quality of hand-painted illuminations instead of roughly reproducing their compositional schemes—exhibit an elaborate, silvery modelling obtained by an accumulation of tiny, parallel hatchings which closely resemble the brush strokes in contemporary miniatures *en grisaille*. It was for the following generations to discipline this amorphous tonality to a purely graphic mode of expression. The development of woodcut during the fifteenth century had tended from the abstract toward the concrete; the development of engraving tended from the concrete toward the abstract. Where the woodcutters had tried gradually to enrich linear rigidity by three-dimensional space and volume, the engravers tried to replace diffused softness by a system of sharply defined "tailles."

The need for some such transformation was felt all the more strongly as the aesthetic unity of the earliest engravings had been marred by a conflict between the character of the modelling and that of the outlines. The tool of the engraver, the burin, is a small, sharp-pointed chisel (the point being obtained by obliquely grinding a four-edged piece of steel) which is set into a handle shaped like a mushroom. With this handle resting in the palm of the right hand, the instrument is moved in a diagonal direction, producing straight parallel strokes which, if the plate lies straight in front of the artist, will tend to run from its lower right-hand corner toward its upper left. The modelling of the earliest engravings was accomplished by making these strokes so short, so thin and so numerous that they were submerged in a non-linear mass. Engraved contours, however, can never be non-linear. Since they do not consist of straight lines, but of more or less complicated curves, they cannot be obtained by

the action of the burin alone but presuppose the counteraction of the plate. The latter is placed on a small cushion filled with sand and can thus be rotated at the same time that the burin is pushed forward (see text ill. 1).

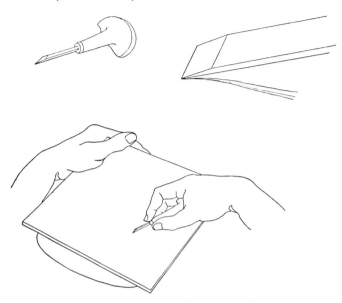

1. The Burin and Its Use

Contours produced by a burin, therefore, have four essential characteristics: first, they are inherently linear, or, to use an expression derived from the very process here under discussion, "incisive"; second, they are inherently continuous; third, they are inherently elastic in that they are not of uniform thickness throughout but swell and taper between two infinitesimally small points; fourth, and perhaps most important, they are inherently subject to a quasi-mathematical principle. In contrast to the free-moving lines drawn with a pen or a pencil, and not unlike the pattern produced by a figure-skater, they are determined by the interaction of two simple impulses, one straight, the other circular. It is to this inward geometry, if we may say so, that burin engraving owes a specific character and a specific beauty, which set it apart from any other medium. There are things which cannot be done with a burin however hard the artist may try—for instance, every kind of "impressionistic" effect (which may account for the fact that the technique was almost entirely discarded in the nineteenth century and was revived, to some extent, during the last two decades). There are other things which are enforced by the burin however little the artist may aim at them—for instance, that ornamental stylization of hair or fur, and that intensification of curvature which can be observed wherever an engraving can be compared with its preparatory drawing.

A tendency to accentuate the graphic quality of the modelling and thereby to bring it into harmony with the contours can already be seen in the later works of the first great engraver,

the Master of the Playing Cards. The hair-thin strokes began to gain in length, energy and distinctness so as to emerge as linear entities. Cross-hatchings were used in some instances, and at times the modelling lines even tended to curve so as to indicate the forms by graphic rather than pictorial means and to conform with the contours. The followers of the Master of the Playing Cards, particularly the Master E.S., proceeded along similar lines, and the development was brought to a glorious close by Martin Schongauer. In his engravings, which for the first time fully deserve the name of "line engravings," he gradually accomplished an almost perfect unification and systematization of the burin style. Except for the characterization of human flesh, which is rendered in a somewhat loose and arbitrary fashion even in his latest engravings, the forms are circumscribed as well as modelled by those prolonged, curvilinear "tailles" which, we remember, served as models for Dürer's new woodcut style. The lines, whatever they may express, form a pattern of crystalline transparency and precision. While apprehending the objects (frequently chosen so as to harmonize with the peculiar strictness of the medium—hence Schongauer's predilection for bare or metallic-looking trees such as palms or dragon-trees), we constantly reexperience the movement of the graver as it furrows the revolving plate; and when following the swinging contours with our eye we may have a sensation not unlike that of steering a motor car over a winding highroad.

Dürer as an engraver thus found himself confronted with a problem altogether different from that which faced him as a woodcut designer. In his woodcuts he had to discipline the non-graphic exuberance of Wolgemut and Pleydenwurff; as an engraver he felt the need for loosening the over-graphic rigidity of Schongauer. This accounts for the fact that his earliest efforts in this medium show an attempt to galvanize the technique of orthodox line engraving by the very unorthodox spirit of dry point. Dry point is by nature as flexible and capricious as line engraving is strict and methodical. Instead of being produced by the regulated movements of the burin and the plate, the pattern is arbitrarily scraped into the metal by any sharp instrument. It consists therefore, not of smooth, continuous "tailles" but of unsystematic flicks and scratches, long or short, hair-thin or sturdy, straight or ragged as the case may be. The metal is not entirely removed, as by the line engraver's burin, but most of it is merely moved to the side; and if these dislodged particles are allowed to remain they give, when printed, a certain roughness and fuzziness to the lines and produce those patches of cloudy or velvety black which are technically known as "bur."

Dürer's earliest engravings, then, while executed with the burin, were intended to fuse the style of Schongauer with that of the Housebook Master. The first of them, the *Great Courier* (188), was obviously made by way of experiment and does not yet carry Dürer's signature. A mere copy of a drawing owned by Dürer, but executed by one Wolfgang Pewrer, otherwise unknown (1235), it is of somewhat limited value as a document of Dürer's personal style. Yet it throws light on his tendencies in that it reveals a nervous impetuosity thoroughly different from Schongauer's patient exactness. The second engraving, still unsigned, is an *Allegory of Death* (199, *fig.* 93). Death is represented in the guise of a hideously emaciated, naked man with dishevelled hair, stringy beard, a lustful mouth and

cruel eyes, ravishing a young woman. Themes of this lurid kind were not uncommon in German fifteenth century art. But Dürer's passion and sincerity surpasses all the efforts of his predecessors—except one: the Housebook Master. The latter's influence is evident, not only from the spirit of the work (though the young Dürer lacked of course the older master's mellow humanity), but also from a treatment still stormier than in the *Great Courier*, and from such details as the bench, the plants and the empty scroll. Even the rather unusual format is paralleled by several prints of the Housebook Master.

The third of Dürer's early engravings, the *"Virgin with the Dragonfly"* (probably less correctly relabelled as the *Holy Family with the Praying-Cricket*), already has a certain air of authority (151, *fig.* 92). Almost twice the size of the *Allegory of Death*, it is proudly signed with Dürer's initials—though the "A" is still somewhat Gothic in shape and the "d" is not as yet capitalized—and it sums up a whole series of earlier drawings (650, 651, 723-725, *figs.* 23 and 24). All of these show the influence of the Housebook Master. But Dürer had been in Italy in the meantime; and this is evident, setting aside the dubious argument of the praying-cricket which is frequent in the south of Europe but rare in Germany, from a formal balance and almost hieratic solemnity utterly foreign to the drawings on which the composition is based. It includes the figure of God the Father, and this figure, the face of the Virgin Mary and the big, vertical folds descending from her knee constitute a central axis bisecting exactly the picture plane. The atmosphere of the scene is dignified rather than intimate, and the handling of the medium shows an effort at what may be called a well-groomed appearance. Compared with the *Allegory of Death*, the *"Virgin with the Dragonfly"* indicates a reaction against spirited nonchalance in favor of orderliness and systematization.

However, no sooner had Dürer achieved what seemed to be a perfect synthesis between the Housebook Master and Schongauer than he realized that no further progress could be made in this direction. He felt that the technique of burin engraving had to be developed according to its own inherent principles instead of being forced into a union with a style engendered by another medium. Unless violence was to be done to the spirit of the burin, the lines had to retain their schematic and almost predetermined character. But Dürer came to discover how the illusion of spatial depth, plastic modelling, textural concreteness and even luminosity could be strengthened, not only by breaking the rules, as it were, but also by applying them with greater subtlety. The curvature of the "tailles," though subject to what we have called a "secret geometry," could be so differentiated as to indicate the most complex combinations of concavities and convexities. Their widths and intervals could be so modified as to disclose those fleeting variations of light and shade which define the surface texture of things. Not until the beginning of the following century did Dürer learn to exploit fully these possibilities and to discover such added refinements as the use of "double cross-hatchings" (achieved by superimposing a system of diagonals on the system of "simple cross-hatchings"), or the breaking up of a "taille" into a sequence of infinitesimal strokes or points which, while following the course prescribed by the push of the burin and the turning of the plate, suggest

tiny specks of dust lit up with sunshine. But once the *"Virgin with the Dragonfly"* had been finished, Dürer never ceased to "render unto the burin the things which are the burin's."

Compared with the *"Virgin with the Dragonfly"* of about 1495, the *Virgin with the Monkey* of about 1498 (the monkey, symbol of lewdness, greed and gluttony, was commonly associated with the Synagogue and more especially with Eve and could thus serve, by way of contrast, to enhance the virtue of the Virgin Mary who represents the New Covenant and, as "Eva nova," redresses the sin of our ancestress) marks a great advance in the realization of space, volume and texture (149, *fig.* 102). The figures detach themselves more clearly from the background. Trees are given as sharply defined solids instead of as indistinct masses of light and dark. The group of the Virgin and Child, derived from Leonardesque sources transmitted through Lorenzo di Credi, has the plastic power of a sculpture in the round. The little "Weiherhaus," transcribed from a water color study which has come down to us (1386), is as convincingly rendered as the furry coat of the monkey, the velvet of the Virgin's sleeve, the seasoned wood of the bench, the fluffy clouds set out against the dark sky, and the shining surface of the water. But all of these "naturalistic" effects are obtained by much more legitimate methods than had been the case with the *"Virgin with the Dragonfly."* No arbitrary elements are allowed to encroach upon the horizontal parallels indicating the sky behind the clouds; the modelling of the log to which the planks of the bench are fastened is not effected by short strokes of different direction but by uniform "tailles" whose curvature corresponds to the cylindrical form of the log; their variations in length and width suffice to suggest the tactile quality of bark and moldy wood. It is truly revealing to draw a comparison in technique between the big tubular fold in the drapery of the *"Virgin with the Dragonfly"* and the analogous motif in the *Virgin with the Monkey* (*figs.* 127 and 128). In the earlier print, long straight diagonals intermingle with short horizontal hatchings, and the transition from the shaded portions to the lighted ones is awkwardly indicated by an amassment of irregular scratches. In the *Virgin with the Monkey* the convex and concave parts of the drapery are modelled by two systems of parallel curves perfectly "in gear" with one another, and the deep shadow gathered in the hollow on the right of the tubular fold is rendered by prolonged verticals which turn into concentric curves in order to mark the Virgin's knee.

In only one respect, in spite of a considerable progress beyond the *"Virgin with the Dragonfly,"* can a certain lack of system be observed. Dürer was still reluctant to apply a strictly graphic method to so tender and delicate a substance as human flesh. How he, in contrast to Schongauer, succeeded in overcoming this reluctance may be illustrated by the treatment of one characteristic detail, the female breast. There is a kind of *a priori* correspondence between its spherical shape and the circular form of burin lines; the object itself seems, in this case, to invite or almost to demand the simplest and most geometrical kind of graphic treatment. Yet Dürer was comparatively slow in realizing this preestablished harmony. In the earliest engravings in which female nudes occur—the *Small Fortune* (185), the *Penance of St. John Chrysostom* (170, *fig.* 100), and most particularly in the so-called *"Four Witches,"* dated 1497 (182, *fig.* 97), the modelling lines of the breast are, if anything, less systematic

than the others. A gradual progress toward systematization can be observed in the *"Dream of the Doctor"* (183, *fig.* 98, about 1497/98) and, to an appreciably higher degree, in the *"Sea Monster"* (178, *fig.* 107, about 1498). But not until 1498/99 did Dürer hit upon what now appears to be the natural solution. In the engraving *Hercules* (180, *fig.* 108) the modelling is rendered by two systems of absolutely concentric and equidistant curves intersecting one another like degrees of latitude and longitude on a terrestrial globe. Once established, this system remained essentially unaltered. When Dürer, in the *Fall of Man* of 1504 (108, *fig.* 117), wished to impart to the skin of Eve a silken softness which her predecessors had not possessed, it was sufficient for him to use a finer grade of "net," so to speak, to dissolve some of the lines into stipples, and to add a third series of curves which divide the spherical rhomboids into spherical triangles (see *figs.* 129-132).

Similar observations could, of course, be multiplied *ad infinitum*. The detail here under discussion is merely an indication of a general and consistent progress. For, however skeptical modern art historians have become of the concept of "progress," the technical treatment of line engravings produced by one artist does show continued development. Burin work is not a matter of unhampered self-expression but requires disciplined dexterity like fencing, tennis, or, to take up our previous simile, figure-skating. An artist gains proficiency not by alternate unexpected relapses and inspired anticipations but "learns" step by step, and each new feat once acquired is not easily forgotten. Thus, what would be presumptuous in the domain of any other medium—namely, to determine a precise chronological sequence on the basis of mere progress in "skill"—is quite feasible where Dürer's earlier engravings are concerned.

As has already been mentioned, the iconography of these earlier engravings is more diversified than that of the contemporary woodcuts. Of these, we recall, no more than three were of a secular character, and even the inclusion of the *Syphilitic* (403) and the *"Caput Physicum"* (444) brings this number to only five, less than one-sixth of the total production. With the engravings of the same period the situation is reversed. Only six or seven out of almost thirty are devoted to religious subjects, and most of these are selected and interpreted so as to fascinate the art lover no less than edify the devout.

The subject matter of the secular engravings is of the widest variety. First, we find a considerable number of what may be called genre scenes pure and simple, dictated only by the artist's interest in the life and habits of people characteristically different from his own social group and therefore appearing as either strange or quaint or "glamorous." These include another version of the *Courier* theme (187); Peasants (190, *fig.* 43); a Young Lady conversing with a Halberdier (189); Five Lansquenets—two of them very Italianate in posture—commanded by a beturbaned captain on horseback (195); a Family of Turks or possibly Gypsies (192); and an Oriental Ruler Enthroned (219). In a second group of engravings the characterization of a curious *milieu* is sharpened by an anecdotal or satirical element. This is true of the representation of an elderly man buying the favors of a young woman, a variation on the "Ill-assorted Couple" motif which, because of certain unusual features, has been interpreted by some as the Biblical story of Judah and Tamar (200); and of the illustra-

tion of a tale from the "Ritter vom Turn" where a magpie informs a husband that his wife has secretly eaten an eel which he had planned to enjoy himself (191). Third, there is one print inspired by a "news story" and therefore dated with more than usual precision: the *Monstrous Sow of Landser*, representing an eight-footed pig which had been born on March 1, 1496 (202). According to an age-old belief, such freaks or "terata" were caused to appear by God whenever He saw fit to warn the world of portentous events; even Luther, the arch-enemy of judicial astrology, believed in their prophetic significance. Thus the miraculous sow of Landser had been immediately publicized and interpreted in an illustrated broad-sheet by Sebastian Brant, the author of the "Narrenschiff," and it was from this broad-sheet that Dürer borrowed the view of the little hamlet which appears in the background of his engraving. But he refrained from any explanatory inscription and, characteristically, paid no attention to the crude and lifeless picture of the pig itself: instead of exploiting the supernatural implications of the incident, he tried to reconstruct the little monster with the sympathetic objectivity of a zoographer.

The fourth and most important class of secular engravings prior to 1500 deals with subjects of an allegorical or symbolical character, and it is in this field that Dürer could fully gratify his passion for "originality." The engraving known as *"The Promenade"* (201, *fig.* 99) is the only one in which he followed traditional iconography. It resumes the theme of Love and Death already treated in one of Dürer's most impressive early drawings (874, *fig.* 29). But the moralistic contrast between thoughtless *joie de vivre* and the specter of destruction has given way to a softly elegiac feeling prophetic of the later evocations of the "Tomb in Arcadia." A pair of happy lovers has stopped on a stroll through blossoming country; the young man points out to the girl the beauty of the scenery, but both his gesture and the splendor of the sunlit landscape are belied by the tragic gravity of his eyes which rest upon the face of his companion with an expression not unlike that of Death in the Housebook Master's unforgettable dry point *Death and the Youth* (*fig.* 27). For, in contrast with the unsuspecting frolickers in the earlier drawing, the young lover has sensed the awful presence that lurks behind the tree, invisible to the eye but overshadowing the soul of man when he rejoices in an hour of bliss.

With all its psychological subtlety this composition is, as such, neither novel nor "humanistic." The other allegorical or symbolical engravings of these years possess both of these attributes to such a degree that their interpretation presented—and, in part, presents—a rather difficult problem. Assisted by his learned friends, Dürer deliberately sought to invent such themes as "had never been in any one's mind before," and which, in addition, would afford an excuse for presenting to the Northern public nudes *all'antica*. For, while Dürer's trip to Venice had given him occasion to witness that reintegration of classical form and classical subject matter which we considered one of the most characteristic achievements of the Italian Renaissance, and while such drawings as the *Death of Orpheus* or the *Abduction of Europa* reveal a perfect understanding of this process, it took him a surprisingly long time to avow the new gospel in public. When it came to prints, accessible to all and published

"over his signature," he felt at first obliged to change the subject wherever he wished to employ a classical motif. We have seen how the Orpheus pose was used for the Fallen Christ and for the victim of an Apocalyptic catastrophe; and we shall see how his studies in human proportions, originally developed with an eye on classical or classicizing themes, were ultimately incorporated in the engraving of Adam and Eve. Not until about 1505 did he issue such prints as the *Family of Satyrs* or *Apollo and Diana* (*figs.* 123 and 124). Before that time classical nudity seemed to require a safe-conduct under which it could pass the barriers of medieval prejudices; it seemed acceptable only when made subservient to an idea of non-classical and preferably moralistic character.

In the earliest engraving of this kind, the *"Small Fortune"* of about 1496 (185), a Mantegnesque Muse, restudied after a Nuremberg model and thereby deprived of much of her original gracefulness, was transformed into the goddess Fortuna by placing her on a sphere where she maintains a precarious balance with the aid of a staff. But this "Fortuna" was equipped with a definitely non-classical attribute: she holds an Eryngium, a flower whose amorous connotations have been mentioned on two previous occasions (48 and 71). The meaning of the composition was thereby tinged with the suggestiveness of such fifteenth century works as the so-called *Love Spell* in the Städtisches Museum at Leipzig, or the popular prints and plaques which wistfully depict the dangers—and the charms—of carnal pleasures. In transferring the attribute of the Eryngium to the goddess Fortuna, Dürer found a humanistic way of saying that love is both omnipotent and fickle.

A moralistic program is more elaborately stated in the two following engravings: the so-called *"Four Witches,"* dated 1497, and the slightly later print still commonly quoted as *"The Dream of the Doctor."*

In style and composition the *"Four Witches"* (182, *fig.* 97) shows an even stranger combination of Northern and Italianate features than does the *"Small Fortune."* The upper halves of the two lateral figures were taken over from a drawing representing a bath house scene (1180, *fig.* 95) already mentioned in connection with the woodcut that forms what may be called its masculine counterpart. The postures were, however, changed so as to fit into the classical scheme of the Three Graces with which Dürer must have become familiar through an Italian source. As the *"Small Fortune"* was based on a Mantegnesque figure restudied from nature, so the *"Four Witches"* is derived from a classical group remodelled after the observations laid down in the Bath House drawing, with a fourth figure squeezed in with obvious difficulty.

Whether Jacopo de' Barbari's engraving *Victory and Fame* also exerted some influence on Dürer's composition, as the present writer assumes, or whether the reverse is true, remains debatable so long as the exact date of Barbari's print cannot be determined. It is, however, significant that another North Italian engraver, Nicoletto da Modena, had only to change the inscription and the accessories in order to transform Dürer's *"Four Witches"* into a Judgment of Paris, the iconography of which was always closely connected with that of the Three Graces.

A skull and bone lying on the ground and the Devil himself lurking in the background amidst a burst of smoke and fire make it very clear that something fiendish is going on, and the gestures of the older women, suggestive of objectionable practices, serve to corroborate this impression. The exact nature of the action remains obscure, however, and the meaning of the three letters "O.G.H." which are inscribed on the ornamented globe hung from the ceiling (hardly a natural fruit, and most certainly not a mandrake berry, as has been conjectured) is still enigmatical. Such readings as "O Gott hüte" ("May God forbid"), "Origo generis humani," "Obsidium generis humani," etc. are arbitrary and could be multiplied *ad infinitum* (for instance by "Orcus, Gehenna, Hades"), while two more recent conjectures, *viz.*, "Oef-fentliches Gast-Haus" and "Ordo Gratiarum Horarumque," can be shown to be plainly absurd. Perhaps old Moritz Thausing was not far wrong in hinting at the *Malleus Malefi-carum*, that terrible handbook of witch-hunting which had appeared in 1487 and long enjoyed a sinister popularity. In it an incident is related which may give an idea of the witch stories then current in Germany. A young gentlewoman expecting a child had hired a midwife who was soon suspected of being a witch. She was turned out of the house and took a horrible revenge. Accompanied by two other women she broke into the lady's chamber, and this unholy triad destroyed the child in the mother's womb by "touching her belly and pronouncing an evil imprecation." To this, the action in Dürer's engraving corresponds exactly, except for the fact that the young lady shows a singular lack of emotion. She seems to be an accomplice rather than a victim, and may in fact be a young witch wanting to get rid of a "Devil's child." But whatever the subject may be, certain it is that a prodigious display of female nudity, intended as "modern" in the sense of the Italian Renaissance, was turned into a warning against sin.

The same is true of the so-called *"Dream of the Doctor"* (183, *fig.* 98). An elderly man is asleep on a bench by an enormous, apparently well heated stove (with fruits drying on the tiles), his body comfortably resting on thick pillows. As in numerous other late medieval "moralities," this man who slumbers while he ought to work or pray (*fig.* 103) personifies the vice of "Acedia," or Sloth. So popular was this interpretation of what may be called the "sleep of the unjust" that a pillow alone sufficed to indicate the sin of laziness—"Idling is the pillow of the Devil," as the proverb says. The tradition of those allegories of Acedia is sum-marized in some lines in Sebastian Brant's "Narrenschiff" which might well serve as a caption for Dürer's engraving:

> *"Eyn träger mensch ist nyemans nutz*
> *Denn das er sie eyn wynterbutz*
> *Vnd das man jn losz schloffen gnug.*
> *Sytzen bym ofen ist syn fug . . .*
> *Der bösz vyndt nymbt der tragkeyt war*
> *Vnd sägt gar bald syn somen dar.*
> *Tragkejt ist vrsach aller sünd*
> *Macht murmelen Israhel die kynd.*

Dauid dett eebruch vnd dottschlag
Dar vmb das er träg müssig lag."

("A sluggard is no use except to be a hibernating dormouse and to be allowed a full measure of sleep. To sit by the stove is his delight. . . . But the Evil One takes advantage of laziness and soon sows his seeds therein. Laziness is the root of all sin. It caused the children of Israel to grumble. David committed adultery and murder because he lolled in idleness.")

This description, whose picturesqueness defies translation into a modern language, not only accounts for the stove and the whole atmosphere of wintry somnolence, but also for the Devil, who in Dürer's engraving prompts the sluggard by means of a pair of bellows; moreover it sheds light upon the remaining features of the composition. In stating that "laziness is the root of all sin," and in referring to David's adultery as a result of idleness, Sebastian Brant alludes to the belief that "sloth begets lewdness and makes the idler subject to the temptations of Luxury," to quote from the *Somme le Roi*, one of the most popular treatises on moral theology. To express this idea Dürer again resorted to humanistic symbols. The visions instigated by the Devil materialize in the shape of the classical Venus (possibly patterned after the sensuously languid beauties of Jacopo de' Barbari); she is unmistakably identified by the presence of a Cupid who tries to climb upon a pair of stilts, perhaps in order to suggest that lewdness in an elderly man is no less futile than it is sinful.

However, while modernizing the medieval concept of "The Idler subject to Temptation" Dürer medievalized, to some extent, the classical concept of Venus. She beckons to the sinner with her right hand, and on her left she wears a ring—a most unusual attribute (especially in a figure otherwise entirely nude), which does not occur in any other work of Dürer's except in portraits and, naturally, in representations of St. Catharine. This attribute, in combination with the smallish sphere on the ground, would call to the mind of every well-read beholder a legend which, in different versions, was told and retold from the twelfth century up to the times of Heinrich Heine and Prosper Mérimée. According to the German version, some fashionable Roman youngsters, not yet converted to Christianity, were playing ball, or rather *boccia*, when one of them threw the ball out of bounds. Rolling along, it led the youth to a dilapidated pagan temple, where he beheld a statue of Venus so inconceivably beautiful that he was at once bewitched. But none other than the Devil was hidden in the image; it beckoned to the youth and induced him to put his ring on its finger, thereby concluding a formal engagement. The sequel is more or less obvious: the young man begins to worry about his extraordinary commitment, tries to retrieve his ring in vain, falls severely ill, and is finally saved by a Christian priest who forces the Devil to restore the ring and to leave the statue. The youth adopts the Christian faith while the statue is consecrated by the Pope and placed on top of the Castel Sant'Angelo. Thus the correct title of the "*Dream of the Doctor*" should read: *The Temptation of the Idler.*

The next engraving here to be considered, and the first in which all the whites are set out against a uniform dark background, shows the abduction of a nude girl from her bathing place

(178, *fig.* 107). The abductor is a fabulous being, half man, half fish, embellished by a long white beard and little antlers, and carrying a tortoise shell and a jawbone for weapons. The companions of his victim seek the shore in terror; her mother wrings her hands; her father, dressed in oriental garb, runs toward the edge of the water with futile gestures of despair. The maiden herself, apparently much less perturbed than her entourage, reclines on the fish-tail of her abductor, displaying her beauty in a pose *all'antica* and limiting the expression of her grief to a low sob or moan.

No doubt a certain similarity in theme, in general arrangement and in such details as the frightened girls in the background exists between this engraving and the Europa drawing of about 1495 (909, *fig.* 57). It is thus doubly tempting to explain the print by an analogous classical myth. But neither the legend of the Argive princess Amymone nor the Ovidian tale of Achelous and Perimela agrees with the factual evidence; and Dürer himself, who elsewhere by no means avoided mythological nomenclature, calls the engraving simply *"Das Meer-wunder"* (*"The Sea Monster"*). The inference is that it does not represent a definite mythological incident but one of those anonymous atrocity stories which, though ultimately of classical origin, were currently reported as having taken place in recent times and in a familiar environment. Poggio Bracciolini, for instance, relates a tale wherein the horrifying story of a Triton, told in Pausanias's description of Tanagra, is transferred to the fifteenth century and to the coast of Dalmatia. A monster, half human, half piscine, with little horns and a flowing beard, was in the habit of abducting children and young girls enjoying themselves on the beach, until it was killed by five determined washerwomen. Its "wooden form" (it is not known exactly whether a carved image or the monster itself in a state of extreme desiccation) was on display in Ferrara—Poggio had seen it with his own eyes—and silenced every sceptic.

This tale fits in with Dürer's engraving to a remarkable degree, and there is every reason to believe that it, or a similar yarn, is responsible for the iconography of the *"Meerwunder."* Dürer may have divined the classical core beneath the veneer of modern pseudo-reality, and the subject may have conveyed to him and to his public the idea of "unregenerated sensuality," as did the Centaurs and Satyrs found in the decoration of medieval cloisters and church façades; but it seems fruitless to scan the classics in search of a specific appellation.

That Dürer did not hesitate to give his works definite mythological titles when he intended to represent definite mythological subjects is demonstrated by the engraving to which he refers as *"Der Hercules"* (180, *fig.* 108). Technically still more advanced than the *Sea Monster* and hardly executed before 1498/99, it terminates the series of secular prints here under discussion and sums up the results of Dürer's Italian experiences. The militant lady with the club, the terrified *putto* and the group of trees in the center are taken over from the *Death of Orpheus* (928, *fig.* 49); the arm of the Satyr and the naked girl on his lap from the copy of Mantegna's *Battle of Sea Gods* (903, *fig.* 47); and the hero himself from the *Abduction* after Pollaiuolo (931, *fig.* 53).

The title "Der Hercules" proved puzzling rather than helpful so long as one attempted to identify the subject of the engraving with one of the hero's recognized "labors." It repre-

sents, however, not an act of physical bravery but a moral dilemma. According to a parable first recorded by Xenophon, the youthful Hercules, not yet resolved about his future, encountered two attractive and eloquent though very different ladies. One of these, Pleasure, lasciviously dressed and carefully made up, tried to lure him into a life of luxury and self-indulgence; the other, Virtue, simple and honest, described the moral satisfaction to be gained by hardships and gallantry. Hercules, of course, decided for Virtue, and forth he went to kill his first lion.

Before Dürer, this allegory—conspicuously absent from medieval imagery but much in favor with the artists of the Renaissance—had been represented in very undramatic fashion. Hercules was shown between the two personifications who were characterized by their appearance and by the scenic background rather than by their actions; they addressed themselves exclusively to the hero, paying no attention to each other. In a German woodcut of 1497 they appear in a dream to Hercules, who, clad in armor, lies on the ground like Paris in the illustrations of medieval versions of the Trojan cycle. Pleasure displays her nude body amidst blooming roses but is threatened by Death and hellfire; and Virtue, here identified with Poverty, is an emaciated old woman with a water jug, clothed in rags and standing on a thorny rock, but illuminated by the heavenly stars. A Florentine painter of the same period, more humanistic in spirit, depicted Hercules in orthodox classical fashion; barefooted Virtue, in nun's garments, recommends a narrow, stony path full of anchorites and philosophers, while Pleasure, affecting gilded boots and an elaborate hairdress (as prescribed by Philostratus the Elder), points to a wide and easy road alive with fashionable youngsters of both sexes; the narrow, stony path, needless to say, leads to a lovely temple, the wide and easy road to Hell.

In employing one of the maenads in the *Death of Orpheus* for Virtue and the voluptuous female in Mantegna's *Battle of Sea Gods* for Pleasure, Dürer not only sharpened the characterization of both contestants (with Pleasure literally reclining in "the lap of luxury," *viz.*, of a Satyr), but also transformed their theoretical dispute into an actual fight. Turning away from the tradition of "Syncrises" or debating pictures, he employed Mantegna's pagan pathos for revitalizing those "Psychomachia" illustrations where Vices and Virtues had been shown in single combat or in pitched battle. He was, however, careful to retain the accessories characteristic of the more conventional representations of Hercules at the Crossroads. As in these, the landscape background of his engraving is treated as a *paysage moralisé* where the forbidding Castle of Virtue is contrasted with a pleasant little town surrounded by water, trees and a rich countryside; and the hairdress of the two women differs from that of their prototypes so as to conform to the accepted rule: the hair of Virtue is covered with a modest kerchief, and Pleasure wears those complicated plaits and tresses ("comas discriminatis variis nodis alligata," to quote the Philostratus translation of 1501) which were apparently regarded as a *ne plus ultra* of feminine appeal, and have already been mentioned in connection with the portrait of "Katharina Fürlegerin as *Voluptas*" (71, *fig.* 68).

While the identity of the two female personifications cannot be and has not been doubted, the role played by the hero has given rise to discussion. It has been said that Dürer, instead

of glorifying the real Hercules, intended to ridicule a spurious one. This Pseudo-Hercules, described by Lucian as "Hercules Gallicus," was allegedly worshipped by the Gauls as a god of irresistible eloquence and was thus closely akin to Mercury, the god of oratory and sophistry. Dürer himself depicted him, in a much later illustration of the Lucian text (936), under the guise of an authentic Hermes type. It has been argued that the hero of our engraving, though looking like a "genuine" Hercules, was nevertheless identical with this ambiguous divinity because of his fantastic headgear (the cock being at once a reference to Mercury, to whom he was sacred, and to the "Galli"), and because of such other unusual features as the laurel wreath ("the orator's decoration"), the open mouth (which would stigmatize him as a hero of words rather than of deeds), the pointed beard, etc. His attitude, furthermore, supposedly betrays his unwillingness to commit himself or even, still worse, his intention to avert the blows of Virtue while ostensibly attacking her foes. It has even been suggested that the frightened infant alludes to a vice imputed not only to the modern "Galli" but also to the classical Hercules (in this case, however, the genuine one).

This writer still believes that Dürer did not mean to cast aspersions on the character of his hero. The cock denoted courage, victory and vigilance (as in the device of Emperor Rudolf II with the motto *Cura vigila*) no less than blustering noisiness. A symbol of contests and battles, he is a usual feature of the Panathenaic Amphorae (in one instance even in connection with Herakles Kallinikos); he was perched on the helmet of the Athena of Elis (the vizor of a German sixteenth century helmet is even shaped into the likeness of a rooster's head); and he was considered the only creature capable of striking fear into the heart of the lion. A headgear crowned by a cock is thus by no means unsuitable for a young hero and future killer of lions, not to mention the fact that a similar helmet already occurs in the Apocalypse where it is merely intended to distinguish a warrior from a group of civilians (294). The laurel wreath forms an obvious contrast with the wreath of vine leaves worn by the Satyr; the open mouth betrays surprise and anger rather than talkativeness; and the noncommittal attitude follows logically from the rewritten scenario. The very concept of a "choice" implies a preliminary state of indecision. Where the two rival personifications had limited themselves to speeches and had concentrated their efforts on the hero, the latter had remained a passive listener; where they come to blows, he must maintain an attitude of "non-belligerency." Without as yet participating in the fight he is, to quote from a Hercules play written by a good friend of Dürer's (the same Benedict Schwalbe, or Chelidonius, who was to write the text to the Life of the Virgin and the two woodcut Passions) a "supporting witness" of Virtue. That there exists, finally, a "vicious relation" between the frightened child and Hercules is incompatible both with the infant's age and with the fact that he belongs, not to the hero but to the lascivious couple on the left. Looking back at them with panic-stricken eyes, he runs away from their plight as he did from that of Orpheus in the original drawing.

As for the beard, an altogether different explanation presents itself. It is quite true that the pointed beard is characteristic of the archaic "Hermes Sphenopogon" who was the indirect model of the Mercury in the "Tarocchi" and also of Dürer's later "Hercules Gallicus." But it

is equally true that Dürer, where he did wish to depict either of these two (981 and 936), represented them beardless. On the other hand, the beard of our Hercules shows a very definite similarity with that sported by Dürer himself when the engraving was made. A comparison with the Self-Portrait of 1498 in the Prado (49, *fig.* 109) reveals some further physiognomical analogies (e.g. the nose) and thus suggests the possibility that Dürer may have wished to cast himself in the role of a hero whose experience at the Crossroads was more often used for personal confessions and admonitions than any other mythological subject. Thus all the details which seem to support a satirical interpretation of the engraving are no less susceptible of a "serious" one. And it is the latter which is more in harmony with Dürer's psychology. He could be facetious and, on occasion, magnificently coarse; but he was never given to subtle irony and sly insinuations.

Of the religious engravings two have already been discussed: the *"Virgin with the Dragonfly"* and the *Virgin with the Monkey*. Apart from the symbolism of the animals they offer no iconographical problems. The remaining ones are no less remarkable in content than in technique and composition. Three of them give a novel twist to themes which, though not unique, were definitely unusual, and one presents an entirely original invention.

The earliest of these prints, probably executed shortly after the *Monstrous Sow* of 1496, is the *Prodigal Son amid the Swine* (135, *fig.* 94). Illustrations of this scene are extremely rare and, before Dürer, fairly stereotyped. The text, which says that the young man was sent "into the fields to feed swine," evoked the memory of Hellenistic pastorals, and in the few Byzantine specimens which have come down to us the scene looks like a combination of the reliefs adorning the side walls of Endymion sarcophagi with the "Feeding the Hogs" page in medieval calendars: the prodigal son leans on his staff in the canonical pose of an elegiac shepherd while an assistant knocks acorns from a tree. This scheme is still retained in the only representations readily available to Dürer, *viz.*, in the closely related woodcuts found in the appendices of the *Speculum Humanae Salvationis* editions by Bernhard Richel (Basel, 1476) and Peter Drach (Speyer, 1478), except that the classical shepherd's staff is replaced by a sturdy club, that the assistant is omitted, and that the swine feed from a trough instead of depending on acorns (*fig.* 105). That Dürer knew one or both of the *Speculum* woodcuts is evident. But he made two important iconographical changes. On the one hand, the scene is staged, not in the "fields" but in a farmyard, the masterly characterization of which creates an atmosphere of genuine, yet intensely poetic rusticity. On the other hand, this extraordinary emphasis on genre values—a dangerous thing in religious art—is balanced by an increase in pathos: the prodigal son no longer stands by the swine with mournful composure, but has gone to his knees in their very midst, wringing his hands in bitter remorse; and while he thus, quite literally, abases himself to the level of beasts, he raises his eyes and his thoughts to the heaven of God. It was precisely this combination of the rustic with the emotional that won the admiration of the world. The Italians copied and recopied the engraving (which even furnished the model of a Persian miniature) in all sorts of media and

Vasari wrote: "In another print Dürer represented the Prodigal Son who kneels after the fashion of a peasant, wringing his hands, and looks up to heaven, while some swine feed from a trough; and in it there are hovels after the fashion of German villages, most beautiful."

The two following engravings are also centered around the concept of penitence. One of them, *St. Jerome beating his Breast before the Crucifix* (168), offers an interesting analogy with the *Prodigal Son*. In both cases a kneeling figure, placed slightly off center, is set out against a strip of dark terrain in such a way that head and shoulder emerge as a kind of silhouette; and as the background of the *Prodigal Son* is an almost independent study in rustic genre, so the background of the *St. Jerome*, incorporating several careful studies from nature (1392 and 1393), is an almost independent study in romantic landscape. Yet in both cases the emotional significance of the figures is too strong to be dwarfed by the charm of the scenery. Northern art had generally preferred to show St. Jerome in his cell, working at his translation of the Bible or nursing the paw of his friendly lion. So far as we know, the type of St. Jerome in penitence is of Italian origin. In Germany it was taken up with some reservation and, as a rule, not used for a conspicuous display of nudity. It occurs neither in paintings nor in engravings, but only in a number of woodcuts mostly dating from the last third of the fifteenth century, and Dürer himself was not to resume it in any later representation of his favorite saint. In his engraving of about 1497, however, at the height of his enthusiasm for the "modern" and the dramatic, he adopted it directly from North Italian sources; and the grim vigor of his Neptunian saint must have struck his contemporaries as no less remarkable than the despair of his Prodigal Son.

The other engraving showing a saint in penitence is of a totally different character, so different in fact that the subject is not easily identified at first glance (170, *fig.* 100). The greater part of the composition is occupied by a rocky cave at the mouth of which is seated a naked young woman, nursing a child. Far in the background on the left is seen the diminutive figure of a bearded man, also entirely nude but nimbed, who walks on all fours like an animal. He is none other than St. John Chrysostom: while living in a cave as an anchorite, he had allegedly seduced an Emperor's daughter, who had taken refuge in his abode; and he did penance by crawling around for many years until he was discovered and forgiven. How and why this disreputable story had come to be attached to the blameless name of St. John Chrysostom is immaterial. Absent, of course, from the *Acta Sanctorum* and the original "Golden Legend," it had found its way into the German versions of the latter, and Dürer could have encountered it, illustrated by woodcuts, in Günther Zainer's "Lives of the Saints" of 1471, as well as in Koberger's "Lives of the Saints" of 1488. But neither of these two illustrations shows the unfortunate princess nursing her child in the wilderness. This motif, reminiscent of ancient fairy tales and yet, perhaps, suggested by a composition by Jacopo de' Barbari (*fig.* 106), was freely added by Dürer who, as Vasari would say, "volle mostrare che sapeva fare gl'ignudi." In suppressing almost entirely the dismal saint in favor of this touching group he transformed a spurious story of "sin and punishment" into an idyll of tender humanity and primeval innocence.

Let us conclude this chapter with an engraving which, in spite of its small size, belongs to Dürer's most impressive creations (186, *fig.* 101). A nimbed man with the attributes of Justice, a pair of scales and a sword, is seated on a lion patterned after those which Dürer had sketched in Venice (909, *fig.* 57, and 1327). The crossed legs also refer to the idea of Justice; this attitude, denoting a calm and superior state of mind, was actually prescribed to judges in ancient German law-books. But the face of the man is surrounded with a quivering halo, his eyes burst into flames like those of the Son of Man in the *Vision of the Seven Candlesticks*, and his features show a fierce, yet woeful expression, strangely akin to that of his fantastic mount. The halo and the flames bring to mind the verse: "His countenance was as the sun shineth in his strength"; and this was indeed the idea which Dürer wished to convey.

Astrology had established a special connection between each of the seven planets (which, before Copernicus, included the moon and the sun) and each of the twelve signs of the zodiac. To every planet had been allocated two zodiacal "mansions," one for the day and one for the night, except for the moon who needed a home only for the night, and for the sun of whom the opposite was true. His "mansion" was the Lion, the sign of July, when he is at the height of his power, and this association was depicted in many different ways. One, peculiar to the Islamic East, was to place the figure of Sol on the back of his Lion, and one of the few non-Islamic specimens of this type is found where it could easily have attracted Dürer's attention: in one of the capitals of the Palace of the Doges at Venice, the most oriental city of the Western World (*fig.* 104). This figure, then, is the visual model of Dürer's engraving: a Sol on his zodiacal sign, the Lion. But why was this astrological image represented with the attributes of Justice? The answer lies in a verse of Malachi: "But unto you that fear my name shall the Sun of righteousness arise." On the strength of this line the Fathers of the Church had transformed the supreme god of the Roman Empire, the "Sol Invictus" or Never-vanquished Sun, into a "Sol Iustitiae"—thereby displacing the natural force of a life-giving and death-dealing astral divinity by the moral power of Christ. This bold equation, well adapted to strike the fear of judgment into the hearts of the faithful, survived for more than a millennium; and in one of the most widely read theological handbooks of the later Middle Ages, the *Repertorium morale* by Petrus Berchorius, we find a passage which must be regarded as Dürer's direct source of inspiration, all the more so because this handbook had been printed by Koberger in 1489 and again in 1498, the very year in which the engraving was probably conceived. The passage reads: "The Sun of Righteousness shall appear ablaze [*inflammatus*] when He will judge mankind on the day of doom, and He shall be burning and grim. For, as the sun burns the herbs and flowers in summer-time when he is in the Lion [*in leone*], so Christ shall appear as a fierce and lion-like man [*homo ferus et leoninus*] in the heat of the Judgment, and shall wither the sinners. . . ."

Only the "imaginativa stravagante" of Dürer was capable of charging the form of an insignificant astrological image with the content of this apocalyptic vision. His engraving

served as a model to several later artists. But they either used it for representations of the planetary Sol, with every reference to the idea of Justice left out, or else for allegories of Justice without the grandeur of a cosmological perspective. Not one was able to recapture the concept of a Sun who is both Justice and Christ.

III · Five Years of Rational Synthesis,

1500-1505

THE year 1500—that of the Self-Portrait in Munich—marks, with some precision, a fundamental change in Dürer's style and *Weltanschauung*. He began to feel that his previous works, however much admired by all, were open to that very criticism which he himself was to level, in later years, at German art in general: that they were "powerful but unsound" ("gewaltiglich, aber unbesunnen"), revealing as they did a lack of that "right grounding" which seemed to be the only safeguard against "errors in design" ("Falschheit im Gemäl"). So he began to study the essential branches of Renaissance art theory: the theory of human proportions, which had been brought to his attention by Jacopo de' Barbari; the theory of the proportions of animals, especially the horse; and, last but not least, perspective. Within a few years, and in spite of Barbari's uncommunicativeness, he was an accomplished master in these three disciplines.

However, that sense of balance which automatically asserted itself at every critical point of Dürer's career warned him to compensate for this trend toward rationalization. While reducing the variety of shapes and movements to general formulae, and while subjecting the visual experience of space to the rules of projective geometry, he became all the more deeply engrossed in the minute details and individual differences of God's creation. Such drawings and water colors as the famous *Little Hare* (1322), the *Parrot* (1343, *fig.* 137), the *Greyhound* (1321), the *Elk* (1319), the admirable studies for the arms and hands of Adam (1207), the *Iris* (1430), the *Turk's Cap* (1439) and, above all, the *Great Piece of Turf* (1422, *fig.* 135a)—all of which can be dated between 1500 and 1503—record the most microscopic of observations, and Dürer's graphic technique developed accordingly. During these three years he trained himself to handle the burin with a delicacy and refinement never aspired to before, or indeed ever after. The major engravings of this period reveal twice or three times as many lines per square inch as the earlier ones (*figs.* 133 and 134); a subtle veil of "double cross-hatchings" and infinitesimal strokes or points all but conceals the linear character of the basic pattern; the epidermis of things seems almost more important than their structure. And yet just these engravings bear witness to the awakening of Dürer's theoretical interests.

The so-called "major" engravings are: the *St. Eustace* and the *Nemesis* (more generally known as the "*Large Fortune*"), probably executed about 1501 and 1501/02 respectively. Vasari admired them so much that he explained them as special efforts to excel Lucas van Leyden "in quantity as well as in quality," and Dürer himself thought highly of them even twenty years later. They are, in spite of their meticulous workmanship, the largest of all his engravings: the *Nemesis* (called "*Temperanza*" by Vasari) is approximated in size only by the *Hercules*; and the *St. Eustace*, which is almost as large as the Apocalypse and the other

"whole sheet" woodcuts, is approached by none. This huge engraving (164, *fig.* 114) illustrates the legend of a Roman soldier of noble birth who set out for a hunt and, like St. Hubert, encountered a stag bearing the Crucifix between his antlers and addressing his pursuer in the name of Christ; moved by this miracle, St. Eustace became a Christian and died for his faith. The kneeling Saint greets the stag with a gesture in which astonishment melts into adoration. But the attention of the beholder is held less by the experience of St. Eustace than by the landscape and the animals. Dürer has never approached more closely what may be called an Eyckian quality of scenery. An untold wealth of details, including even a flight of birds circling around the belfry of a fortified castle, and in part visible only through a magnifying glass, is organized into a monumental whole. The utmost solidity of substance and precision of form are mysteriously combined with the greatest softness and richness of tone; the eye feasts on such subtleties as the nuances of different types of foliage and the interior-like half-light of a secluded swannery darkened by trees. The animals, too, are studied from life with an eye to tone and texture. It is characteristic that the only extant study (1321) was done, not with the pen but with a hair-thin brush. At the same time, however, Dürer evidently wished to render account of their "true proportions." As in a scientific handbook, the miraculous stag, St. Eustace's horse and three of his five dogs are represented in pure profile; a fourth one is shown in full front view, and only the fifth exhibits a more casual pose. The very size of the horse, which occupies a whole half of the available space, bears witness to Dürer's awakening interest in the "Moss der Pferd" to which a special chapter was to have been devoted in his never-written comprehensive treatise on the theory of art.

What Dürer sought to achieve in the St. Eustace with respect to animals and to a more intimate type of scenery, he attempted in the *Nemesis* (184, *fig.* 115) with respect to the human body and to a panoramic view. The subject, identified by Dürer's own testimony, was suggested by a Latin poem of Politian which synthesizes the classical goddess of retribution with fickle Fortune: clad in a white mantle, she hovers in the void, tearing the air with strident wings, driven hither and thither by the gales, and always wielding the goblet and the bridle—symbols of favor and castigation—with a contemptuous smile. Now the poet can easily shift his image from a state of rest to a state of movement, from a "vacuo sublimis in aëre pendens" to an "atque huc atque illuc ventorum turbine fertur." The plastic artist, on the other hand, has to choose between them, and it is highly significant that Dürer decided in favor of a pose not only static but deliberately schematized. The huge figure (with Politian's "white mantle" transformed into an accessory which serves the double purpose of suggesting a breeze in spite of the motionless posture, and of providing the lighted parts of the figure with a dark foil) is represented in geometrical side elevation like a diagram in a treatise on anthropometry. It is, in fact, dimensioned according to the only canon of proportions which classical Antiquity has left to posterity: that is, the canon of Vitruvius. This had come to Dürer's attention in 1500, and while the actual appearance of his ponderous goddess is studied from life with a feeling for detail and texture still absent from the more metallic and less particularized nudes of his earlier prints, her principal measurements agree exactly with those

prescribed by the Roman writer. The foot, from the heel to the tip of the conspicuously extended big toe, is one-seventh of the total height (from the heel to the top of the head); the length of the head, from top to chin, is one-eighth; the length of the face, from the chin to the jewel in the diadem, is one-tenth; and the "cubit," from the finger-tips (if the fingers were extended) to the well-marked bone of the elbow, one-fourth.

No doubt a conflict can be felt between the didactic and at the same time excessively naturalistic treatment of this figure and the fantastic character of the theme. Dürer never repeated the experiment of dealing with a visionary subject in a line engraving. That he did it in this case is illustrative of a transitional period in which his new scientific interests were not yet harmonized with his artistic imagination.

A similar duality of purpose is evident in the interpretation of the landscape. The scenery is transcribed from a lost drawing—probably a water color—representing the site of Chiuso, or Klausen, in the Southern Tyrol. It has been mentioned that an influence of such Alpine bird's-eye views can already be noted in the Apocalypse. But in a woodcut like *St. Michael fighting the Dragon* the individual features of the scenery had been obliterated in favor of a general impression of illimited expanse, and the same is true of such later instances as the landscape in the Vienna *"Adoration of the Trinity"* (23, fig. 172). On the other hand, a direct and literal use of studies from nature was normally restricted to individual "motifs" such as the rock formations in the *St. Jerome* (168), the "Weiherhaus" in the *Virgin with the Monkey* (149, fig. 102), or, later on, the city prospects in the *"Feast of the Rose Garlands"* and in the engraving *St. Anthony* (165, fig. 247). The view in the Nemesis engraving, however, combines panoramic vastness with a stupendous amount of accurate, identifiable detail and, more important, with perfect measurability. Like Barbari's *Map of Venice*, and not unlike a modern airplane photograph, it is a superb piece of cartography rather than a landscape in the ordinary sense.

One small but symptomatic innovation has yet to be noted. Before 1500, Dürer printed his monogram directly on the paper, as nearly as possible in the center of the lower margin. In the *St. Eustace*, however, the initials are made to look like an inscription on a stone or piece of paper, and in the *Nemesis* they appear on a little tablet called "cartellino" by the Italians; moreover, while the inscription of the *St. Eustace* still occupies the customary place in the center, that of the *Nemesis* is placed in the lower right-hand corner of the composition. The majority of the prints produced after 1500 show variations of these two devices: initials and numerals, foreshortened according to circumstances, seem to be carved into rocks, trees, walls or pavements; the "cartellino" may be replaced by a little scroll; and it may seem to dangle from a tree like an *ex voto*, or from a building like an innkeeper's sign. Such an artifice served an obvious end. In affixing his monogram to one of the objects comprised within the picture space instead of to the paper, Dürer suggested to the beholder to interpret this paper, not as a material sheet on which letters can be printed as on the pages of a book, but as an imaginary projection plane through which is seen the picture space and its contents.

The incredible diligence which is characteristic of the *St. Eustace* and the *Nemesis* (Dürer himself would have spoken of the "allerhöchster Fleiss so ich kann") was naturally not bestowed upon such minor engravings as the *Virgin on the Crescent* (137), the two *St. Sebastians* (162 and 163), the weird *Witch*—riding backward on a goat to illustrate the idea of a topsy-turvy, or perverted, world—(174), the *Putti with a Shield and a Helmet* (173), the rather indifferent *Virgin with the Infant Jesus and St. Ann* (136), and the *Man of Sorrows with His Arms Outstretched* (127). They are of coarser fiber but for this very reason not unimportant for Dürer's further development. They had retained that firm, incisive, emphatically "graphic" quality which could be observed in such engravings as the *"Meerwunder"* or the *Hercules* and had been sacrificed in the two capital prints of 1500/01.

In simultaneously practicing these two manners, each of which had the faults of its virtues, Dürer was bound to realize that perfection could be achieved only by synthesizing their distinctive qualities. This is precisely what he undertook to do in the two engravings of 1503: in the *Virgin nursing the Child* (141) and, with still greater authority, in the *Coat-of-Arms of Death* (208). This masterly engraving—preceded by the similar though less ambitious *Coat-of-Arms with the Cock* (207)—shows a shield with an enormous skull, surmounted by a winged helmet, both supported by a savage and a girl in festive dress who are engaged in amorous conversation. Iconographically, this composition can be described as an heraldic version of the "Love and Death" theme treated in the drawing called *"The Pleasures of the World"* and in the engraving called *"The Promenade."* From a technical point of view, it may be said to preserve much of the miniature-like delicacy characteristic of the *Nemesis* and the *St. Eustace*, and yet to recapture the toughness and definiteness of line which distinguish Dürer's earlier engravings. There is no weakening in his sensibility for texture. The smooth but brittle ivory·of the skull, the contrast between the polished steel of the helmet and the duller metal of the shield, the soft flesh of the girl and the shaggy limbs of the savage, the difference between feathers and pinions, the luscious foliage of the mantling —all this is keenly observed and tangibly rendered. Yet the calligraphic swing of the contours is so consciously stressed, and the hatchings and little points that constitute the interior modelling are so rigidly systematized and so widely spaced, that every element, from long-drawn curves to seemingly casual dashes, fulfills an ornamental as well as a representational function.

Dürer himself seems to have been aware of an element of finality in the engravings of 1503. Except for the isolated case of the *"Four Witches"* they are the first of his prints to bear a date in addition to the signature. Henceforth all of his engravings save three were to be dated (while the dating of woodcuts was not usual with Dürer until 1509/10). In fact, whatever further developments can be observed in his burin style can be defined in terms of its relation to the style of 1503.

In graphic technique the two engravings of the following year brilliantly maintain the course established by the *Coat-of-Arms of Death*. In design and composition they are of

prime importance in that they embody the first final results of Dürer's studies in the two main fields of art theory.

In the *Nativity*, referred to by Dürer as *"Weihnachten"* (109, *fig.* 116), the figures, though placed in the foreground, occupy less than one-twentieth of the total area. The stage is almost more important than the actors and is a spectacle in itself. The dilapidated frame house which shelters the adoring Virgin and the Child, its crumbling plaster exposing the decay of the brickwork, rests on two posts of sturdy oak and on an ancient wall of Romanesque style. It leans against the remnants of a stone building so old that it encourages the growth of grass and little trees, while a bridge of rafters and disjointed planks connects this ruin with a pile of sharp-edged, massive, almost Roman-looking masonry. St. Joseph fills a pitcher from an elaborate draw-well, and a round-topped archway, its opening hinged to the central axis of the composition, provides the effect of a "vista" in a way reminiscent of Michael Pacher.

All of these features are not uncommon in the Nativities of the fifteenth century which had developed a special technique of hiding symbolical meanings under the veil of "realistic" paraphernalia. The Romanesque style and dilapidated state of the buildings, and the vegetation sprouting from ruins signify the birth of the New Dispensation amidst the decay of the Old; the draw-well and unbroken pitcher allude at once to the purity of the Virgin, the waters of Paradise, and the sacrament of Baptism. But in Dürer's *"Weihnachten"* the picturesque symbolism of the fifteenth century is controlled by the scientific rationalism of the Renaissance. Between 1498/99, when woodcuts like the *Martyrdom of St. John* or the *"Ecce Homo"* revealed a definitely medieval conception of space, and 1504 Dürer had mastered the technical rules of perspective construction and had grasped the modern principle of composition according to which the definition of space precedes the grouping of the figures. His *Nativity* is not only impeccable from the point of view of projective geometry (with all the vanishing lines correctly converging in one point, and equal magnitudes diminishing in constant gradation), but also achieves a perfect unity of space as an aesthetic experience. The values of light and dark, the relative weight of the masses, and even the accents of the narrative are subtly balanced so as to harmonize with the perspective construction.

The other engraving of 1504, the *Fall of Man* (108, *fig.* 117) has always been deservedly famous for the splendor of a technique which does equal justice to the warm glow of human skin, to the chilly slipperiness of a snake, to the metallic undulations of locks and tresses, to the smooth, shaggy, downy or bristly quality of animals' coats, and to the twilight of a primeval forest. The studies for the plants and animals range from careful portrayals in brush and water color (e.g. 1319) to what may be called snapshots done with the quickest of pens (e.g. 1346).

In addition, Dürer's contemporaries would have observed certain iconographic features which easily escape the modern beholder. They would have shared his delight in paralleling the tense relation between Adam and Eve to that between a mouse and a cat crouching to spring, and they would have appreciated the symbolism of what most of us would be apt to

dismiss as "picturesque accessories." They would have understood that the mountain ash, to which Adam still holds, signifies the Tree of Life and that the same contrast exists between it and the forbidden fig tree as between the wise and benevolent parrot and the diabolical serpent; and the selection of the animals in the foreground would have reminded them of a widespread scholastic doctrine which connects the Fall of Man with the theory of the "four humors" or "temperaments."

According to this doctrine, which had been formulated in the twelfth century, the original nature of man was not yet qualified and corrupted by the predominance of any one of those mysterious fluids to which we still allude when we use such expressions as "sanguine," "phlegmatic," "choleric," and "melancholic." Before Adam had bitten the apple, man's constitution was perfectly balanced ("had man remained in Paradise he would not have noxious fluids in his body," to quote St. Hildegarde of Bingen), and he was therefore both immortal and sinless. It was believed that only the destruction of this original equilibrium made the human organism subject to illness and death and the human soul susceptible to vices—despair and avarice being engendered by the black gall, pride and wrath by choler, gluttony and sloth by phlegm, and lechery by the blood. The animals, however, were mortal and vicious from the outset. They were by nature either melancholic or choleric or phlegmatic or sanguine—provided that the sanguine temperament, always considered as more desirable than the others, was not identified with perfect equilibrium. For in this case no sanguine animal could be admitted to exist, and it was assumed that man, originally sanguine pure and simple, had become more or less severely contaminated by the three other "humors" when biting the apple.

An educated observer of the sixteenth century, therefore, would have easily recognized the four species of animals in Dürer's engraving as representatives of the "four humors" and their moral connotations, the elk denoting melancholic gloom, the rabbit sanguine sensuality, the cat choleric cruelty, and the ox phlegmatic sluggishness.

Yet Dürer's main concern was certainly not to show his skill in burin work and his knowledge of "natural philosophy." As the engraving *"Weihnachten"* is intentionally a model of perspective, so the *Fall of Man* is intentionally a model of human beauty. Dürer wished to present to a Northern public two classic specimens of the nude human body, as perfect as possible both in proportions and in pose.

In the Nemesis engraving he had done no more than fuse the dimensions transmitted by Vitruvius with observations from life into a forthright and simple statement of facts. Apart from the measurements, the figure had not been "idealized" in any way. Its modelling is overcharged with details; its face retains the features of an individual model (perhaps Crescentia Pirckheimer rather than Agnes Dürer); its contours are, to say the least, unbeautiful; and its pose is so stiff that by comparison the lilting sway of any Gothic statue seems to have captured more of classical gracefulness. Fully aware of the problem, Dürer had at once begun to work out a geometrical construction which would serve the threefold purpose of establishing the proportions, preferably in accordance with Vitruvius; of determining as many contours as pos-

sible; and of providing the framework for a classical *contrapposto* attitude as typified by such famous statues as the Apollo Belvedere and the Medici Venus. Here the weight of the body (which is presented in full front view, with the head more or less turned to profile) rests on the "standing leg" while the foot of the "free leg," touching the ground only with the toes, steps outward; the pelvis is balanced against the thorax in such a way that the hip of the standing leg is slightly raised whereas the corresponding shoulder is slightly lowered. Dürer had long been fascinated by this attitude (see 1178 and 457, *figs.* 56 and 96), and had tried to capture it in such engravings as the *Small Fortune*, the *"Four Witches,"* and, above all, in the *"Dream of the Doctor."* From 1500, he endeavored to systematize both the pose and the proportions of such figures "mit dem zirckel und richtscheyt" ("with the compass and the ruler").

The constructed drawings preceding the Adam and Eve engraving indicate that Dürer originally planned to present the "perfect male" and the "perfect female" in two separate engravings, no less classical in iconography than in formal appearance. The men—derived from classical models which had come to Dürer's attention through Italian intermediaries— are characterized as warriors (1601), Sols, or Apollos (1596-1600, *fig.* 118) and are, with only one exception, proportioned according to the canon of Vitruvius; the women— revised versions of a Venus type already employed in the *"Dream of the Doctor"*—appear as allegorical figures with divers attributes, some of them perhaps suggesting a lunar divinity to parallel the solar ones (1627-1637). A critical point was reached in the most advanced of the Sol or Apollo drawings (1599, *fig.* 119). It showed originally only the figure of the Sun-god, standing right in the center of the sheet and holding a scepter and a solar disk. A little later, and probably under the influence of an engraving by Barbari in which Diana, goddess of the moon, is shown driven away by a triumphant Apollo, Dürer made several changes, the most important of which was the addition of a seated woman, seen from the back. She is pictured trying to shield her face from the sun—a gesture by which she, too, is uniquely determined as Luna or Diana. But, since she sits on the farther edge of a strip of land instead of disappearing behind the celestial globe (as is the case in Barbari's engraving), her action implies a dislocation of her neck, of which Dürer was quickly aware. He left the head unfinished and tried to solve the problem by twisting the whole figure around so that she faced the beholder; the contours of this new Diana can be discovered on the right of the fully modelled one. But Dürer soon felt that the composition, developed as it was from a figure designed to stand by itself, could not be saved. He decided not to use it for an engraving, as he had planned to do (witness the reversed inscription "Apolo" on the solar disk), and put it aside after having made a record of the main figure; he traced its contours on a new sheet, but improved its iconography by substituting Barbari's bow and arrow for the original scepter (1600).

Yet Dürer did not renounce the new idea of juxtaposing male and female nudity in one engraving. But he decided to develop the previous drawings into two entirely different compositions, one of them interpreting human beauty in terms of static form, the other in terms of dynamic movement.

The first of these compositions is the *Fall of Man*. It sums up the studies in regulated proportions and constructed equilibrium. The earlier Aesculapii, Sols, and Apollos, slightly remodelled after the pattern of the Apollo in Barbari's engraving, were synthesized into an Adam while the studies in female proportions were similarly summarized in the figure of Eve. Both figures, superbly modelled, were aligned on one standing plane and set out against the penumbral darkness of a thicket. In choosing this background, however, Dürer paid a belated tribute to Antonio Pollaiuolo in whose so-called *"Ten Nudes"* (*fig. 54*) a similar problem had been solved in analogous fashion. The Northern master acknowledged his debt by a direct "quotation" which, at the same time, amounts to a subtle challenge. Like Pollaiuolo, Dürer signed his engraving on an unusually large "cartellino" which hangs from a tree. It bears, for the first time in Dürer's career, an inscription in Latin, and this inscription is worded so as to oppose to the pride of the Florentine the pride of the citizen of Nuremberg: as Pollaiuolo had written "OPVS ANTONII POLLAIOLI FLORENTTINI" so Dürer wrote "ALBERTVS DVRER NORICVS FACIEBAT." His satisfaction with his work is understandable; he had indeed contrived to "better the instruction." While Pollaiuolo's engraving, with all its emphasis on anatomical structure, yet gives the effect of an entangled Gothic ornament, Dürer's *Fall of Man* has a quality which can be defined only as "statuesque."

The other composition derived from the same group of previous drawings reverts to the Apollo and Diana theme (175, *fig. 124*). But instead of presenting two paradigms of formalized beauty, it dramatizes the contrast between masculine vigor in action and feminine loveliness in repose. Diana—developed from the cursorily sketched figure in the drawing discussed above—sits quietly on the ground, petting her doe. Apollo, however, strains every nerve to bend his bow, his muscles tense with the effort of a violent torsion. Herculean rather than Apollonian, his mighty form fills the space of the composition to the very limit; and even beyond, for, while his left foot fits, by a hair's breadth, into the lower left-hand corner of the engraving, his head, his bow, and his arrow do not find room enough within its margins.

As has already been mentioned, the engraving *Apollo and Diana* is one of the two first prints in which classical subject matter appears reunited with classical form. The other, dated 1505, is the *Family of Satyrs* (176, *fig. 123*) which had developed from one of Dürer's most enticing drawings, a hasty sketch inspired by Philostratus's description of a family of Centaurs (904, *fig.* 121; cf. 905, *fig.* 122). To judge from the exact identity in style and measurements, this charming scene, staged in a forest still denser than that in the Adam and Eve engraving, was conceived as a companion piece of the Apollo and Diana composition. Taken together, the two prints appeal indeed to two of the most potent impulses in the psychology of the Renaissance: to the nostalgias for the Olympian and for the idyllic.

The same year, 1505, brought two representations of horses which bear, strange to say, precisely the same relation to the *St. Eustace* as the Apollo and Diana print and the *Fall of Man* to the *Nemesis*. In one of the two engravings, known as the *Large Horse*, the mount of St. Eustace was improved upon (just as the Apollo had been) with an eye to volume, muscular development, and a general impression of supernormal strength; in the other, called the

Small Horse, it was subject (as the figures of Adam and Eve had been) to a thorough idealization with respect to proportions, posture, and breeding.

The *Large Horse* (204, *fig.* 126) has received its name, not from the actual size of the print—which is not very much larger than its counterpart—but from the relative scale of the animal. Its powerful form, modelled with long sweeping "tailles," is viewed from the back in a violent foreshortening. This type of foreshortening is, as such, apt to strengthen the impression of volume, the object hurling itself in the beholder's face, so to speak. In this particular case it has the further effect of emphasizing the magnificent curves of the horse's croup, belly, and shoulder, and of enormously increasing its apparent size. For, if the form of the animal, foreshortened to about half its natural length, yet fills the space almost from margin to margin, how truly colossal must it be in actuality! The very fact that its real size can only be supposed gives free play to our imagination so as to make us overestimate what we see, and the fact that the spear-feet of the animal are placed higher than its fore-feet makes its appearance almost overpowering. Small wonder that Caravaggio, when he wanted to represent the Conversion of St. Paul in a space of similar proportions, freely employed Dürer's *Large Horse* in order to achieve a maximum of both naturalism and monumentality.

Opposite principles of composition obtain in the *Small Horse* (203, *fig.* 125). In the *Large Horse* the foreshortened animal had been contrasted with a relatively flat and strictly frontal architecture in comparison with which it appeared all the more colossal. In the *Small Horse* the animal is presented in pure side elevation (so as to reveal its exquisite proportions) and is set out against a heavy and sharply receding barrel vault in comparison with which it looks all the more slender and elegant. The Large Horse stands motionless and hangs its head with the patient apathy of a subdued giant; the Small Horse nervously raises its off foreleg and tosses its fine, long-nosed head with a whinny.

This contrast in formal appearance perhaps extends also to the iconography. The Large Horse and its realistically attired master—a grinning halberdier in heavy riding boots—can hardly be interpreted mythologically or allegorically, except for the fact that the classical column surmounted by a nude idol may allude to the presence of Northern armies in Italy. The Small Horse, on the other hand, controlled as it is by a "classical" warrior whose headgear and footwings identify him as either Perseus or Mercury, may well be meant to signify "Animal Sensuality restrained by the Higher Powers of the Intellect." In medieval and Renaissance symbolism the horse stands for violent, irrational passion, and quite specifically for "Lussuria"; and the flame bursting forth from a vase conspicuously placed above the group is no less common a symbol of "illuminating reason."

This interpretation is admittedly conjectural. One thing, however, is certain: the Small Horse is of Italian breed. It is patterned after a Leonardesque model which Dürer had recorded in two drawings, both dated 1503 (1671 and 1672, *fig.* 138). The Small Horse differs from these drawings in that it does not raise its near hind leg in answer to the movement of the off foreleg (it was not until 1513 that Dürer did justice to the rhythmical as well as to the plastic beauty of Leonardo's conception), and it is relatively shorter. The bodies of

Dürer's horses—measured from the breast to the root of the tail, and from the standing line to the upper edge of the croup—are always inscribed in a square and not in a rectangle. But all the other features of the Small Horse—its interior proportions, its modelling, and above all, its narrow, "pig-snouted" head with the short lower jaw and the large, lustrous eyes— are as unmistakably Leonardesque as the graceful movement of its foreleg and its whole thoroughbred personality. The helmet of its master, too, presupposes Dürer's familiarity with such Leonardo drawings as the so-called "Hannibal" in the British Museum.

In the engraving St. George on Horseback (161, so called in contradistinction to the con- temporary St. George on Foot, 160) Dürer sought to combine the monumentality of the Large Horse with the elegance of the Small. The charger of the Saint is shown in a fore- shortening marked enough to strengthen the impression of power and volume, yet not so violent as to obscure the objective proportions; it fills the picture space from margin to margin but is not contrasted with a background deliberately reduced in scale. That this engraving is slightly later than the two other "Horses" is proved by the "cartellino" which bears the date 1505 corrected to 1508. The only possible explanation of this anomaly (paralleled only by the double date of the engraving St. Philip, 153) lies in the assumption that the St. George was almost, but not entirely, finished in 1505 and could not be released until after Dürer's return from his sojourn in Venice.

THE YEAR 1503—that of the two drawings which served as a basis for the Small Horse— plays a peculiar role in Dürer's development.

In the first place it brought a technical innovation. Just when Dürer's burin style had reached that state of perfection to which he himself testified by adding dates to his signature, he discovered—perhaps under the influence of Grünewald with whom he seems to have come in contact as early as 1502-1503—a completely different graphic medium, and one most emphatically opposed to line engraving, namely, charcoal. Blunt and crumbly, easy to handle but incapable of refinement, it invited speed and required large formats. It permitted the sweep and firmness of linear contours to be reconciled with the "rilievo" and "sfumato" of a non-linear modelling and was best suited for large portraits or studies from life where indi- vidual heads had to be rendered in a kind of al fresco manner, reduced to essentials, but in the fullness of their personality. Charcoal was to remain Dürer's favorite medium for this specific purpose, but no less than eight large-sized portraits and studies of heads bear or bore the date 1503, apart from those which may be lost. The virtues of the medium are eloquently illus- trated by a portrait of Pirckheimer (1037, fig. 139). Vigorous black strokes determine the basic features and accentuate such details as the shadows in the ear, the pupils, the hair, and the band of the snood or fillet then worn under the headgear; the numerals of the date (which, characteristically, form an integral part of the compositional scheme) are similarly empha- sized. The modelling, on the other hand, varies from the opaqueness of the large shadow on the beret to the transparency of light gray touches sparingly distributed over the face. As for the face itself, Dürer has ennobled his friend without flattering him. The fleshiness of Pirck- heimer's countenance and the deformity of his nose are by no means minimized. Yet the full

profile view, but seldom paralleled in other portraits prior to 1521, endows him with some of the dignity of a Roman Emperor; the drawing, preceded by a silver point sketch whose Greek inscription is not for Victorian eyes (1036), may in fact have been made with a medal in mind. The heaviness of the lower part of the face is offset by the beret which lends relief to the volume and height of the brow. There is both will power and keen intelligence on the taurine forehead. And the full mouth bespeaks not only sensualism but also Erasmian irony.

In the second place, the year 1503 was marked by a series of strange and sinister events which left their imprint on Dürer's imagination. A comet appeared, and what Dürer calls "the greatest portent I have ever seen" filled Nuremberg with terror: a "blood rain" (now known to be caused by a harmless alga, *palmella prodigiosa*) fell on many people, staining their clothes with the sign of the cross. Dürer recorded one of these mysterious marks—not only a cross, but a whole Crucifixion with the Virgin Mary and St. John—which he had seen on the shirt of a terrified servant-girl (587). Soon enough these evil omens were followed by the outbreak of epidemic diseases—then all grouped under the name of "the plague"—which flared up here and there and reached dangerous proportions in various parts of Germany. In Nuremberg, it seems, the situation did not grow serious until the early summer of 1505, but many persons had already fallen sick in 1503, and among them Dürer himself. The *Coat-of-Arms of Death* (208), hard to reconcile with the spirit of a period which produced the *Little Hare* and the engraving *Adam and Eve*, must be interpreted against this background of horror and fear, and two of the large charcoal studies of 1503 bear an even more direct implication. One is the portrait of a man, his features distorted with pain and his mouth half open in a stifled groan (1120). If it does not actually represent a stricken person, it certainly reflects the atmosphere of "the disease." The other is a head of the Dead Christ, presented in a ghastly foreshortening and truly gruesome by the lack of irises and pupils (621, *fig.* 140). The reminiscence of other works of art (such as Marco Zoppo's *Head of St. John the Baptist* in Pesaro) seems to merge with Dürer's own agonized features into a frightful vision which may indeed have come to him in a feverish dream; for, in this case we know by Dürer's own testimony that the drawing was made "during his illness." An actual Self-Portrait, in three-quarter length and entirely nude (999), was probably executed shortly afterwards. The convalescent painter looks at his emaciated body and still haggard face with the same mixture of fatigue, apprehension, and dispassionate curiosity with which a farmer might take stock of his crops after a bad storm.

In the third place, the year 1503 is a milestone in the development of Dürer's relations with Leonardo da Vinci. Up until this time Leonardesque motifs had come to Dürer's attention through the intermediary of minor artists such as Lorenzo di Credi. In 1503, however, he must have gained access to Leonardo's inventions either in the original or at least in direct copies. To this the two drawings discussed in connection with the *Small Horse* bear witness. But Leonardo's influence was not restricted to hippology. In two portraits in silver point (1060 and 1105, *fig.* 136) Dürer attempted to render a fleeting smile, and one of the studies in charcoal, presently used for a Virgin Mary, shows, in addition, a mildness of posture and

expression and a *sfumato* treatment of lighting which strike us as Leonardesque (717). The Vienna Madonna in half length (26), also dated 1503, and the Portrait of Endres Dürer in Budapest (89), datable 1504, shine with the same sweet smile, and in the *Adoration of the Magi* in the Uffizi of 1504 (11, *fig.* 113), the head of the standing King, pictured in full profile in spite of the frontal pose of the figure, gently inclined, with no perceptible break between the long, straight nose and the forehead, and almost femininely soft in temperament and modelling, would readily fit into Leonardo's *Last Supper*.

DÜRER DID NOT DO MUCH PAINTING BETWEEN 1500 AND 1505. The two *Lamentations* (16, 17, *fig.* 91), *Hercules killing the Stymphalian Birds* of 1500, already mentioned in connection with the *Abduction* after Pollaiuolo (105), mark the end of the preceding phase rather than the beginning of the ensuing one; and, except for the Vienna Madonna, the Budapest portrait just mentioned, and the Munich Self-Portrait already discussed (50, *fig.* 110), only three works attributable to Dürer himself reached completion before he left again for Italy. These are the Paumgärtner altarpiece in Munich, the two panels representing the story of Job in Frankfort and Cologne, and the *Adoration of the Magi* in the Uffizi.

The Paumgärtner altarpiece (5, *fig.* 111), probably executed between 1502 and 1504, has not been preserved in its entirety. The fixed wings, which showed Sts. Barbara and Catharine, are lost (see, however, the drawings 851 and 854), and of the *Annunciation* in grisaille that was seen on the exterior of the movable shutters only the figure of the Virgin Mary remains. The loss of the Angel is not too serious, for the picture of the Virgin shows that the *Annunciation* was painted by a rather indifferent workshop assistant. The paintings of the interior, however, were executed by Dürer himself.

The central panel shows the Nativity, the wings (according to a trustworthy tradition), the brothers Lucas and Stephan Paumgärtner in the guise of St. George and St. Eustace respectively. This scheme is Netherlandish rather than German. Where the wings of German altarpieces showed Saints in full length, the center was, as a rule, occupied by a wood-carved relief and not by a painting; where the center was occupied by a painting, the wings showed, as a rule, scenic representations, often arranged in two stories, and not Saints in full length. The closest parallels to the scheme of the Paumgärtner altarpiece are found in such works as Dirk Bouts's triptych in Munich and, most particularly, in the Portinari altarpiece by Hugo van der Goes; the influence of this tradition can also be felt in the two shepherds, the one ascending the step being a variation on a motif recurrent both in Hugo van der Goes and Geertgen tot Sint Jans. There is, however, this difference: in the Netherlandish instances the Saints are placed in a realistic landscape which expands the scenery of the central panel into a continuous picture space; Dürer, while staging the Nativity in a picturesque court-yard, sets out the Saints against a neutral black background. This arrangement, unquestion-ably detrimental to the aesthetic unity of the work, is illustrative of the fact that the Paumgärtner altarpiece presents a neat solution of two entirely different artistic, or rather art-theoretical problems—in fact, the same problems which are dealt with in the engraving *"Weihnachten"* on the one hand, and in the engraving *The Fall of Man* on the other. Like the "Weihnachten" print the central panel shows the picturesque setting of fifteenth century

Nativities remodelled according to the rules of geometrical perspective. We have, again, the Romanesque wall, the ruined masonry overgrown with luxuriant vegetation and the round-topped arches placed at right angles to one another; and while the "disguised symbolism" of the well and pitcher has been abandoned, Dürer reverted to the tradition established by the Master of Flémalle in equipping St. Joseph with a lantern (time-honored symbol of the "splendor materialis" drowned out by the "splendor divinus" of the new-born Saviour, to quote from St. Bridget), and in symbolizing the birth of Christ, the "Sol Iustitiae," by the rising sun. Like the *Fall of Man*, however, the wings exhibit "classic" examples of proportion and equilibrium, the firm and somewhat heavy, though far from lifeless pose of the St. Eustace forming a striking contrast with the Italianate elegance of the St. George. Potential mobility is juxtaposed with actual mobility, and it is evident that the elastic posture of the St. George derives from the same Sol and Apollo drawings which were employed for the Adam in the *Fall of Man* (a by-product of this process is the engraving *The Standard Bearer*, 194). It was in order to display fully the plastic perfection of these two Saints that Dürer decided to sacrifice pictorial unity to a clean-cut distinction between an exemplary presentation of space and an exemplary presentation of human figures.

This dichotomy was abolished in the *Adoration of the Magi* in the Uffizi, dated 1504 (11, *fig.* 113). In it, perfect specimens of humanity are placed right in the middle of a perfect space where the now familiar motifs, with special emphasis on the carefully constructed arches, are used for the enhancement of the figures. The group of the Virgin and Child, displayed in full profile and organized into a pyramidal shape, is amplified, as it were, by the slanting roof of the stable and by a tall piece of masonry which, from a formal point of view, fulfills a function similar to that of the cloth of honor in the enthroned Madonnas by Jan van Eyck or Memlinc. Another piece of masonry lends distinction to the central figure whose Leonardesque character has already been mentioned; and the Moorish King, magnificently framed by two sharply foreshortened arches, is set out against the brightest part of the landscape. In posture, finally, his dusky figure is derived from the same ancestry as the St. George in the Paumgärtner altarpiece, that is to say, from the preparatory studies for the *Fall of Man*, and it bears a particular resemblance to the *Standard Bearer*.

The *Adoration of the Magi* was ordered by Dürer's faithful patron, the Elector Frederick the Wise, and was originally placed in the "Schlosskirche" at Wittenberg. So also were two panels in Frankfort and Cologne representing the Story of Job and known as the "Jabach altarpiece" (6, *fig.* 112). Since they roughly agree with the *Adoration of the Magi* in period and measurements, it has even been suggested that the three pictures may have formed a triptych with the *Adoration* in the center, the Story of Job appearing on the exterior of the wings, and Sts. Joseph, Joachim, Simeon, and Lazarus (now in Munich, but generally supposed to have been painted on the back of the Job panels) flanking the Adoration scene when the shutters were opened. Such a disposition is open to question and the present writer even believes it possible that the two "Jabach wings" may originally have formed one single panel.

But whatever the arrangement, Frederick the Wise certainly had a very personal motive in selecting, for illustration, the Story of Job.

Since the beginning of Christian writing the story of Job, the patient sufferer, had been interpreted as a prefiguration of the Passion of Christ. But later on the man whom God had afflicted with ineffable sorrow and "smitten with sore boils," and who had yet been "accepted" and cured in the end, was worshipped and invoked by those who suffered from what all ancient medicine called "melancholy" or from such diseases as leprosy, ulcers, or scabies. In Venice, always menaced by epidemics, "San Giobbe" attained the rank of a local saint, and Giovanni Bellini liked to pair him with St. Sebastian, protector from the plague from Early Christian times. It was in this capacity of a healer that Job was honored by Frederick the Wise. A typical valetudinarian, the Elector was more than normally afraid of those epidemics which had haunted Germany since 1503, and there is little doubt that his preoccupation with the plague and other contagious diseases accounts for the choice of the subject. To make assurance doubly sure, he gave, about the same time, two other commissions which would serve the same protective purpose. First, Dürer's Dresden *Madonna* of 1496/97 (4) was provided with wings which show St. Sebastian and, opposite to him, St. Anthony, the patron saint against erysipelas ("St. Anthony's fire") as well as against the new scourge of Europe, syphilis. Second, a large-sized triptych was ordered on the exterior of which appears another St. Sebastian, this time paired off with his most recent competitor in the healing profession, St. Roch (7).

Dürer, however, must have known, or divined, the older and deeper meaning of Job, for Job's unforgettable pose—the knees drawn up, the heavy-laden head supported by one hand, the other lethargically resting in the lap—was to recur, not only in the engraving *Melencolia I*, but also in the title page of the Small Passion (236). Here Christ, forever suffering for the sins of the world, is obviously portrayed as a "new Job"; and the "Man of Sorrows" in the title woodcut of the Large Passion, where the same idea is expressed by a figure more gracefully posed (224, *fig*. 182), is very reminiscent of the Job in Carpaccio's *Meditation of the Passion* in the Metropolitan Museum, which Dürer may have seen in Venice more than once.

From a purely narrative point of view, however, Dürer kept well within the framework of late-medieval iconography. While Job's sheep and servants are burnt by the "fire of God," and his camels are carried away by the Chaldeans, a flute player and a drummer—who bears an unmistakable resemblance to Dürer himself—try to comfort him by their tunes. But his traditionally uncooperative wife adds insult to injury by pouring a bucket of water over his neck.

Music was known as a cure for spiritual distress from times immemorial. David "took an harp" when "the evil spirit of God was upon Saul"; the psychiatrists had applied musical therapy to "melancholy" ever since Theophrastus and Asclepiades; and when Hugo van der Goes had an attack of depressive mania his kindly abbot called at once for music. Thus the later Middle Ages imagined that Job, the archetype of all melancholics, was comforted by

"minstrels"—which, by the way, accounts for the gaudy garments of Dürer's musicians. Having no money to reward them "aftyr his will," he gave them "the brode Scabbes of his sore body" which promptly turned into gold. But when the minstrels showed their treasure to Job's wife she became so angry that she resorted to violence. In a Flemish picture of about 1485 she is already seen threatening Job with a bucket of water, and Dürer was certainly acquainted with this version of the story. He omitted the rewarding scene—as represented, for instance, by Lucas van Leyden—and replaced the mere threat by definite action. But that he had the story of the rewarded "minstrels" in mind is proved not only by the forerunners but also by the free imitations of the "Jabach Altarpiece." In a Nuremberg miniature of 1535 Job's wife stands between the musicians and her praying husband, scolding the latter while pointing to the former; and in a provincial Saxonian altarpiece of about the same date the wife pours the water while Job rewards the players. Dürer's interpretation sharpens the contrast between the spitefulness of his wife and the friendly spirit of the strangers and at the same time monumentalizes the grandiose impassiveness of Job. The patient hero pays no more attention to the well-meant efforts of the "minstrels" than to the cruel action of his wife.

The triptych with Sts. Sebastian and Roch, which has been mentioned in connection with the Job altarpiece, is now in Ober St. Veit in Austria (7). On the interior the *Calvary* is represented between the *Bearing of the Cross* and the *"Noli me tangere."* But it was ordered too late—probably by the end of 1504 or the beginning of 1505—to be executed by Dürer himself. This thankless task fell to Hans Schäuffelein who acted as Dürer's lieutenant during the latter's sojourn in Italy. For the wings, which might have been assigned to assistants even if Dürer had stayed in Nuremberg, careful working drawings in pen and brush on bluish-grounded paper, washed with black and heightened with white, had been prepared before Dürer's departure (479-482). These "Visierungen" were carried out with comparatively slight variations, the most important change being the substitution of a *"Noli me tangere"* for an isolated figure of the Resurrected Christ. But with respect to the Calvary, which Dürer may have wished to reserve for himself, there were only a few sketches for the upper part of the composition (477 and 599), and Schäuffelein had to cope with the problem to the best of his very limited abilities.

The Ober St. Veit altarpiece was not the only painted work which remained unfinished when Dürer left in 1505. A rather overly sweet *Salvator Mundi* in the Metropolitan Museum, revealing the influence of Barbari and possibly Leonardo da Vinci (18), and two small panels in Bremen showing Sts. John the Baptist and Onuphrius (42), are still uncompleted. The stately *Madonna with the Iris* (now in the National Gallery at London), finally, was apparently begun shortly before Dürer's departure, was carried further and nearly finished by the more talented younger members of his workshop during his absence, and was completed, signed and sold in 1508 (28). The Iris (sword-lily, "Schwertlilie," formerly called *gladiolus* in Latin) stands for the "sword that shall pierce through" the Virgin's soul while the vine on the right is an even more direct allusion to the Passion. Together, these plants express the same idea as the angels bringing in the instruments of torture while Christ still plays at the

feet of His mother, or the Crucifix overshadowing the Adoration of the Magi in Rogier van
der Weyden's Columba altarpiece in Munich.

As HAS BEEN STATED in the preceding chapter, any answer to the notorious question of
whether or not Dürer usually cut his own woodblocks must be qualified. We have seen that
he did not normally do the actual cutting while working as a journeyman for the big pub-
lishers of Basel and Strassburg; that he did do it when creating the new woodcut style of the
Apocalypse and the other "whole sheets" of 1496-98; and that he ceased to do it after his
second journey to Italy when he could rely on a staff trained to carry out his personal inten-
tions and, finally, on the establishment of Hieronymus Andreae which could produce a
woodblock from any given design as a modern firm of engravers makes a "halftone cut" from
a photograph.

The period between 1500 and 1505, now, is a transitional one. As Dürer's workshop
expanded and as he devoted more time to theoretical studies, he naturally tried to rid himself
as far as possible of the purely mechanical work. He was gradually training his assistants to
do more and more of the cutting, but the quality of their work was still somewhat uneven.
Where he attached special importance to the result he would exert rigid control and perhaps
occasionally do some of the "knife work" himself by way of example. At other times he would
leave more scope to his collaborators and occasionally not even supply them with an elaborate
working drawing.

Thus the woodcuts produced in these five years fall, roughly speaking, into two classes.
On the one hand, we have the major achievement of this period: the *Life of the Virgin*, cut
under Dürer's closest supervision and, in some cases, with his personal participation (296-
315). On the other hand, we have a group of woodcuts executed under what modern states-
men would call the master's limited liability: a bookplate for Pirckheimer, elegant in design
but imperfectly cut (395); a few book illustrations and broad-sheets made to oblige the
famous humanist Conrad Celtes (350 [*fig*. 215], 388, 412, 417, 418, most of them based on
slight sketches only); and eleven representations of religious subjects so unambitious and, in
part, so deficient in technique that Dürer himself referred to them as "plain" or "homely"
woodcuts ("schlechtes Holzwerk"). It was not until about 1510 that both the magnificence
of Dürer's personal cutting style and the homespun simplicity of this "schlechtes Holzwerk"
were superseded by the standardized perfection of professional craftsmanship.

The woodcuts of the second class are "minor" ones, not only in that they are less delicate
in execution and less elaborate in composition, but also in that they are smaller in size. As
"Viertelsbögenle," to use Dürer's own descriptive expression, they are but half as large as the
woodcuts of the Life of the Virgin. But these in turn are only "halbe Bögen," that is to say,
they are but half as large as the Apocalypse and the other woodcuts prior to 1500. This
diminution in size is concomitant to a change in style analogous to that which could be
observed in such engravings as the *St. Eustace* and the *Nemesis*. After 1500, Dürer's wood-
cuts, too, developed toward the delicate and subtle, with denser modelling and an unheard-of

emphasis on detail. The Life of the Virgin—for obviously the refinements of this new style do not appear in the "schlechtes Holzwerk"—does not relapse into the pictorialism of the "Nuremberg Chronicle"; on the contrary, the lines are handled with a feeling for graphic purity surpassing even the standards of the earlier woodcuts (see *fig.* 86). But such details as the trees and shrubs in the *Flight into Egypt* (309), the still-life motifs in the *Birth of the Virgin* (300), or the dimly lighted interior in the *Betrothal* (302, *fig.* 143), reveal a passion for the luminary, the intimate, and the particular which fundamentally differs from the spirit of the Apocalypse and the Large Passion. Without doing violence to the potentialities of the medium, the subtlety of these woodcuts rivals, to some extent, that of the contemporary engravings; while the technique of the Italian woodcutters sufficed for a fairly creditable copy of the Apocalypse (published by Alexandro Paganini in Venice in 1515/16), the Life of the Virgin could be copied only by a master engraver such as Marcantonio Raimondi.

The series of the "plain woodcuts" consists of the *Calvary* (279), two versions of the Holy Family theme—the *Holy Family with Five Angels* (319) and the *Holy Family in a Vaulted Hall* (320)—and eight portrayals of Saints, presented either singly or in groups of two or three: *St. Christopher* (324), *St. Francis* (330), *St. George* (331), *The Magdalen* (341), *Sts. Anthony and Paul in the Desert* (327), *Sts. John the Baptist and Onuphrius* (332), *Sts. Stephen, Sixtus and Lawrence* (328), and *Sts. Nicholas, Ulrich and Erasmus* (338, probably cut about 1508 on the basis of a drawing of about 1504). The term "series" was used advisedly, for, though the eleven woodcuts were released as single prints, there is little doubt that they were originally intended for a *"Salus Animae"* (a devotional book not unlike the more popular *"Hortulus Animae"* which is in turn a variant of the regular Book of Hours). A small-sized *"Salus Animae"* de luxe, illustrated by members of Dürer's workshop, had been printed by the Nuremberg publisher Hölzel in 1503 (448), and it is very probable that Dürer himself planned a similar publication of larger size—the woodcuts, by the way, have exactly the same dimensions as Dürer's contemporary book illustrations—but somewhat more popular in character. Because of his departure to Italy and other circumstances unknown to us this plan was never to materialize.

The *Life of the Virgin* also remained unfinished because of Dürer's departure to Italy. Seventeen of the twenty woodcuts were completed before he left, but the *Death of the Virgin* and the *Assumption* were not added until 1510. In 1511 the whole series was provided with a brand-new Frontispiece, and was published in book form, each picture being explained, in elegant Latin distichs, by the same Benedictus Chelidonius who has already been mentioned in connection with the Large Passion and with the Hercules engraving.

The very choice of the theme is significant. As the grand style and imperious temper of the years before 1500 required and presupposed such subjects as the Apocalypse and the Passion of Christ, so the serene and delicate spirit of the following half-decade required and presupposed a narrative neither tragic nor phantasmagorical—a narrative which would justify the presence of peasants and burghers, shepherds and scholars, landscapes and animals and childlike little angels, and where all kinds of architecture, from homely interiors and

rustic farmyards to fantastic temples and palaces, afforded opportunity for a display of Dürer's newly acquired skill in perspective.

Like the delightful water color drawing known as *The Virgin with a Multitude of Animals*—with the wicked fox tied to a tree stump, a little griffon dog attacked by a stag beetle, and St. Joseph engaged in wistful conversation with the stork (658, *fig.* 135)—the Life of the Virgin is pervaded by an atmosphere of intimate warmth, tenderness and even humor. But the professional interest of the artist was focused on the problem of three-dimensional space. As in the engraving *"Weihnachten"* and as in the Paumgärtner altarpiece, but with more variety and with emphasis on interiors as well as exteriors, Dürer wished to demonstrate how groups and figures could be coordinated within a correctly constructed and consistently lighted space without impairing either the human values of the narrative or the rules of "scientific" design. It is worth noting that architectural motifs are "featured" in no less than thirteen of the seventeen woodcuts completed before Dürer's departure, and that in four of these the whole picture space is viewed through an enormous archway, which brings to mind Alberti's definition of a perspective image as "that which is seen through a window."

The so-called *Glorification of the Virgin* (315), which concludes the Life of the Virgin as published in 1511, is by almost universal agreement of slightly earlier date than the rest of the series. Not only is it signed by a simple monogram while all the other woodcuts show the initials painted on a "cartellino" or incised into a stone, but its architecture reveals a primitive delight in overcomplication and perspective *tours de force*, coupled with an extravagance in proportions which later on gave way to a less ostentatious but more effective treatment of the setting. Enormously elongated columns (their maximum diameter being only one-fifteenth of their total height), surmounted by Gothicizing capitals, support a would-be classical epistyle. Walls are pierced not only by archways but also by irregular openings, and the whole composition, with about a dozen figures crowded into a dense group which is itself almost submerged by picturesque detail, betrays a certain *horror vacui*.

This woodcut was very probably not intended for the place which it now occupies. Both from a formal and from an iconographical point of view, it would be more appropriate as an opening page than as a postscript to the glorious finale of the *Assumption*. But even assuming that the *"Glorification"* was originally intended to open the series and was not relegated to its present place until 1511, when the new title page was devised, even then its iconography would not entirely agree with its function.

The Virgin Mary—the Infant Jesus standing on her knee and reading from a Gospel book presented to Him by an Angel while another Angel plays the harp—is surrounded by a group composed of St. Joseph, St. John the Baptist, St. Anthony, St. Augustine, St. Jerome with his lion, St. Paul, and, most prominent of all, St. Catharine. This group of Saints and Angels, united in the worship of Christ, has gathered in a room characterized as the "Thalamus Virginis" ("the Nuptial Chamber of the Virgin"). It contains a bed and a conspicuous candlestick and through an opening in the wall, above which is a figure of Moses, can be seen a gloomy back room with what seems to be the tabernacle of the Old Law. A gayer note is

struck in the foreground where four winged *putti* disport themselves, one playing a flute, a second trying to catch a rabbit, the third and fourth, placed in the lower corners of the composition, supporting empty shields. These shields were obviously intended to be filled with the coats-of-arms of the respective owners, the coat of the husband to be entered, of course, in the dexter shield, and that of the wife in the sinister one; the latter is furthermore of smaller size, and—very humorously—is being struck by a *putto* with a pair of keys, time-honored symbol of feminine sovereignty in household matters (in German law this limited independence of the wife is still called "Schlüsselgewalt" or "Schlüsselrecht"). This motif, combined with the facts that the rabbit is the most common symbol of fertility, that the peonies in the vase beneath the Madonna were ranked in beauty with lilies and roses and were held to possess the power of dispelling evil spirits and curing disease, and that St. Catharine was the patroness of virgins and brides (hence the bouquet of lilies-of-the-valley, a symbol of virtuous purity often associated with the Virgin Mary herself), suggests that the "Glorification" woodcut was originally conceived, not as an integral part of the Life of the Virgin but as an independent devotional print, to be given to young couples on their wedding day.

Similar questions are raised by the woodcut known as *"The Sojourn of the Holy Family in Egypt"* (310, *fig.* 142). Though already signed on a "cartellino," it is stylistically closer to the *"Glorification of the Virgin"* than to the other woodcuts. The group of Angels worshipping the Virgin Mary (who spins while rocking the cradle with her left foot) is still somewhat overcrowded; the handling of space, with the vanishing point emphatically shifted to one side, is still what may be called *outré* without being altogether convincing; and the playful *putti* collecting the chips and splinters from St. Joseph's carpenter's work are almost interchangeable with those in the *"Glorification."*

The charming idyll of the aged artisan surrounded by little "Cupids" doing their best to keep the workshop clean was suggested by Philostratus's description of Daedalus. It is not by accident that the explanatory poem of Benedictus Chelidonius refers to precisely this mythological hero of craftsmanship to glorify St. Joseph's activity in Egypt: as a new Daedalus, he says, the husband of the Virgin practiced and taught wonderful arts and crafts where nothing like it had been known before. But we must remember that these verses were written about ten years after the woodcut was made; they were written by a man presumably familiar with Dürer's literary source; and they were written not so much to explain the actual meaning of the woodcut as to justify its present place within the Life of the Virgin, directly after the *Flight into Egypt* (309). In reality neither the Gospels nor the *Apocrypha* enlarge upon St. Joseph's Daedalian exploits in the land of the Pharaohs, and there is nothing in the woodcut to indicate that the scene is laid outside the normal and permanent habitat of the Holy Family. The setting consists of the now familiar combination of ruined Romanesque masonry with wooden sheds and rustic implements of every description, and one important detail makes it almost certain that the woodcut was not always intended for its present place. This is the apparition of God the Father and the Dove, a motif restricted to scenes which permit a Trinitarian interpretation. It occurs in the Annunciation and in the Nativity where the Trinity

is manifested by the conception and birth of the Christ Incarnate; in the Baptism, where Its manifestation is revealed to St. John; in representations of the dead or dying Christ (especially the Crucifixion), where Its manifestation comes to an end; and in the Resurrection or Ascension, where the original situation is reestablished. Aside from these "historical" scenes, God the Father and the Dove are found only in images of a universal and doctrinal rather than a particular and historical character. Rogier van der Weyden could use this motif in his Vienna *Madonna*, and Dürer could employ it for the *"Virgin with the Dragonfly"* (*fig.* 92) or for the *Holy Family with Five Angels* (319), but it could not possibly appear in a special and even secondary episode within the life of the Virgin. It must be concluded, therefore, that the woodcut now figuring as *"The Sojourn of the Holy Family in Egypt"* was originally a *Holy Family* pure and simple. Like the *"Glorification of the Virgin,"* and independently thereof, it seems to have been composed as a single woodcut before the plan of a coherent "Marienleben" series was formed. That these two woodcuts have exactly the same format, and that this format was subsequently retained for the rest of the series, is not surprising in view of Dürer's custom of standardizing the dimensions of his woodblocks. The giant woodcuts of 1496-98, too, are all identical in size, whether they were released as single prints or belong to the series of the Apocalypse and the Large Passion, and the *Mass of St. Gregory* of 1511 (343) agrees exactly with the measurements of the Life of the Virgin without having the slightest connection with it.

The fifteen other woodcuts constituting the Life of the Virgin as far as completed before Dürer's departure—beginning with the *Rejection of Joachim's Offering* and ending with the *Leave-Taking of Christ*—were executed, in rapid succession, between 1502/03 and 1505. Their chronology is a much discussed problem, but again it seems more advisable to divide the material into a few groups presumably succeeding one another than to attempt a "linear" chronology.

Only two woodcuts can be dated precisely: the *Adoration of the Magi* (307) presupposes a drawing of 1503 (717), and the *Meeting of Joachim and Ann at the Golden Gate* (299, *fig.* 141) carries the date 1504. Again the presence of a date—most exceptional for a woodcut of this time—may be interpreted as an expression of satisfaction, which was, indeed, fully justified by the remarkable progress made within a single year. The *Adoration of the Magi* still bears certain resemblances to the two earlier woodcuts which have just been discussed. The architecture, almost as complicated and honeycombed as in the *"Glorification of the Virgin,"* is rendered in the same violent and lopsided foreshortening as in the *"Sojourn of the Holy Family in Egypt."* Sharp contrasts of light and dark, combined with a still somewhat crowded composition, give a certain mottled effect. The rather small figures still tend to cling to the picture plane, and the interpretation of the exotic and resplendent scene of homage is as gently humorous as that of family life in a carpenter's courtyard: the ass, in contrast with the humans, casts a pious glance on the miraculous apparitions in the sky; the younger King, while offering a goblet with his right hand, good-naturedly encourages his black companion

with his left (with a kind of "double back-hand gesture" still reminiscent of the Terence illustrations) and wears a riding hood over his royal crown.

In contrast, the *Meeting of the Golden Gate* is distinguished by a balance and dignity surpassing even the composure of the *Adoration of the Magi* in the Uffizi. The mottled appearance has given way to a subtle differentiation of light and dark. All traces of *horror vacui* have disappeared; the composition is built up from large rather than from small elements; and such details as windows, doors, and arcades are integrated into a unified whole. The impression of three-dimensionality is no longer achieved by force, but by an effective rationalization: a clear distinction between foreground, middle distance, and background has been made, and the whole picture space is viewed through the "Golden Gate" itself. Decorated with a border of interlaced branches, in which are set small statues of Moses, three Prophets, David and Gideon, this Gate fulfills the double purpose of frame and "repoussoir." A new feeling for intervals is also evident in the arrangement of the groups and figures; they are treated as plastic units surrounded by space. And, most important of all, the movements of the hero and the heroine, with Joachim's gentle firmness lending support to the enraptured exhaustion of St. Ann, have a distinction entirely new in Northern art; Gothic fluency and classical equilibrium are fused into a new ideal of Christian nobility.

With the *Adoration of the Magi* and the *Meeting at the Golden Gate* as nuclei, two groups of woodcuts can be formed: a "primitive" and a "classic" one.

The "primitive" group comprises the *Nativity* (305), which is very close to the *Adoration of the Magi* in composition, technique and "eccentric" perspective; the *Presentation of the Virgin* (301), which may be a little later than these two; and the *Annunciation* (303), which may be a little earlier. This woodcut is the first in which the picture space is seen through an archway as in the *Meeting at the Golden Gate*. However, in the later composition we look into an open space in relation to which the archway has the function of a "diaphragm," emphatically overlapping not only the buildings in the middle distance but also the figures in the foreground. In the *Annunciation* the archway is simply substituted for the front wall of an interior the width of which does not exceed the diameter of the opening so that no overlappings can occur. The circular relief of Judith with the head of Holofernes can be explained by the *Speculum Humanae Salvationis* where Judith's deed is described as a prefiguration of the Virgin's victory over the Devil. The allusion is all the more obvious as the defeated, badger-faced Devil is shown in the lower left-hand corner, chained in a dungeon beneath a little flight of stairs.

The "classic" group includes the *Visitation* (304), the *Flight into Egypt* (309), *Joachim and the Angel* (298), and *Christ taking Leave from His Mother* (312), with the two former woodcuts apparently preceding, and the two latter ones apparently following the dated *Meeting at the Golden Gate*. The *Flight into Egypt* reveals the influence of Schongauer's famous engraving (whence Dürer borrowed the "Dragon tree," henceforth an almost compulsory item in renderings of the subject), but it is enriched by such unusual and charming details as the ox patiently following the Holy Family on their voyage; and here for the first

time is a "forest interior" achieved in woodcut instead of in engraving. In the woodcut
Joachim and the Angel the woodland mystery of the *Flight into Egypt* is synthesized with
the dignity and beauty achieved in the *Meeting at the Golden Gate*; and the *Leave-Taking
of Christ* is so classically perfect in poses and gestures that it was believed to presuppose
Dürer's second trip to Italy. This can be disproved by the fact that the composition is included
in the series of copies by Marcantonio Raimondi which was released in 1506, and there is no
positive indication of a later date. Architectural motifs no less Italianate than the ribbed
cupola, the flat pediment, and the windows surmounted by conchs already occur in the
Martyrdom of St. John and in the *Angel with the Key of the Bottomless Pit* (here, too, the
cupola denoting the idea of "Jerusalem"); and the beautiful posture of Christ has a prece-
dent in that of the "Leonardesque" King in the *Adoration of the Magi* in the Uffizi. Yet the
doubts as to the date are understandable, for Dürer—and German art in general—seldom
approached the Renaissance ideal of "dignitas hominis" more closely than in the image of a
Saviour at once perfectly human and remote. That His figure is framed by two impressive
verticals—the tree and the doorpost—not only lends majesty to His appearance but also
expresses His unapproachability. It is not by accident that Dürer changed the traditional
iconography of the scene—Christ taking His mother by the hand—in favor of a scheme
derived from that of the *"Noli me tangere."*

Between the "primitive" and the "classic" group may be placed two woodcuts distin-
guished by the fact that the main incident is pushed into the background while the fore-
ground is filled with groups and figures of a genre character: *Christ among the Doctors* (311)
and the *Birth of the Virgin* (300). They also pave the way for the "classic" group in that the
blacks and whites already tend toward greater homogeneity, and in that the frontal arch,
which occurs in both cases, already fulfills the function of a "diaphragm," as in the *Meeting
at the Golden Gate.*

The "classic" group is followed, on the other hand, by four woodcuts where the ideal of
formalized perfection was sacrificed to sovereign freedom and, ultimately, to a union of free-
dom with grandeur. Figures and groups are neither displayed in "lone splendour" nor scat-
tered about the picture space, but are distributed according to what may be called a sym-
phonic principle. In the *Rejection of Joachim's Offering* (297) the five principal characters
—the mournful St. Ann, the humiliated Joachim, the High Priest and his assistant, and
Joachim's more fortunate counterpart, a brutish father proud of his little boy—are set out
against an anonymous crowd like a quintet of woodwinds against an accompaniment of
strings. In the *Presentation of Christ* (308, *fig.* 144) a similar scheme is employed, but the
whole scene is enacted on the second plane of the stage, the left-hand corner of the foreground
being occupied by a gigantic column about which an equally gigantic onlooker clasps his arms.
In the *Circumcision* (306), which in more than one respect harks back to the little panel in
Dresden (3, *a*), the place of this column is filled by an enormous candle-bearer. "Faisant le
vide autour de lui," he holds the balance to the figure of the Virgin Mary which is placed in
the opposite corner. Comparable to a niche, the opening of which is flanked by pilasters, a

semicircular wall of humanity connects these two figures, and it is in the apex of this human niche that the throne of the priest is placed. But while the Infant Jesus, Whom the priest holds on his lap, is right in the center of the composition, the group of figures performing the ritual is not arranged symmetrically: they form a compact block, separated from the candle-bearer by a yawning gap and boldly thrown across space in a diagonal direction. On the other hand, in the *Betrothal of the Virgin* (302, *fig.* 143) strict symmetry prevails, and the figures are compressed into a relief space bounded by the picture plane on the one hand and by the front of the Temple on the other. Yet we have the impression of a dense crowd, not only because the figures stand three or four deep as in an altarpiece by Stoss or Riemenschneider but also because they seem to overflow the lateral boundaries of the composition: the outer-most figures extend, so to speak, in part beyond the margins, and the impression of continuity is further strengthened by the fact that the gorgeously bonneted lady behind the Virgin seems to approach the center from the right whereas the man next to St. Joseph looks to the left. That the lady with the bonnet is relegated to a second plane, while the man next to St. Joseph, though placed in the foreground, turns his back upon the beholder not only makes for variety and the illusion of depth but also ensures the predominance of the central group.

The scene of these four woodcuts, like that of some of the earlier ones, is laid in or before the Temple of Jerusalem which, according to a tradition established at the beginning of the fifteenth century, had to be rendered as a monument at once ancient, singular, and vaguely oriental. With an admirable feeling for aesthetic and historical values the fathers of Northern painting, the Master of Flémalle and, more consistently, the brothers van Eyck, had therefore chosen to represent the Temple of Jerusalem not as a contemporary building in flamboyant Gothic style but as an architecture of—generally speaking—"Romanesque" appearance. They felt, quite rightly, that the "Romanesque," gloomy and heavy, yet thoroughly fantastic with its profusion of historiated capitals, ornate pavements, and crawling decoration in flat relief, was not only "old" but also closer to Eastern art than the Gothic, and they would have justly disapproved of its misleading modern name. Dürer kept, in a general way, to this tradition; that is to say, he preferred round arches, circular windows, flat reliefs, and ribless vaults to more specifically Gothic features. But he also freely used flamboyant forms, and, more important, did not hesitate to intersperse this hybrid architecture with Italian Renais-sance elements, then still associated with the idea of an ancient and pre-Christian civilization. He also sought by structural complications and sophisticated lighting to enhance the impres-sion of strangeness and exotic oddity, and endowed the architecture with a symbolical signifi-cance relative to both the locale and the subject.

All this could already be observed in such woodcuts as the *"Glorification,"* the *Annun-ciation*, or the *Meeting at the Golden Gate*. As further instances we may adduce the *Presentation of the Virgin* (301), where the arch connecting the Temple with another building is adorned by "mythological" reliefs and is surmounted by a statue apparently intended to represent Apollo the Dragon-Killer; and the woodcut *Christ among the Doctors*

(311), where a flamboyant Gothic throne, placed in a more or less "Romanesque" interior, is overhung by two garlands of purest North Italian Renaissance style.

In the four latest woodcuts, however, the architectural setting is not only "strange" and fanciful but also full of awesome grandeur and age-old mystery. In the *Rejection of Joachim* a half-drawn curtain and an enormous arch, piercing an ancient brick wall with crumbling plaster, disclose as well as conceal the Holy of Holies, a dimly lighted room of majestic proportions and a kind of fallacious simplicity; for, while it is prismatic in shape and covered with a plain quadripartite vault, it has mysterious annexes and recesses too gloomy for the eye to penetrate, and the tables of the Law lurk menacingly behind a second arch in the background.

The *Betrothal of the Virgin* shows an interesting variation of the "diaphragm" scheme employed in the *Meeting at the Golden Gate*. In both cases the door of the Temple is depicted as a frontal archway exactly fitting into the margins of the woodcut. But in the *Betrothal* the action takes place before and not behind the arch: instead of separating the entire picture space from the beholder it separates two spheres, or worlds, within the picture itself. This function is reflected by the symbolism of the decoration. The "Golden Gate" had been adorned exclusively by the Prophets and Heroes of the Old Testament. The door in the *Betrothal*, however, has a twofold message. Its inner molding shows a combat between armed men on unicorns and women on lions, an obvious allusion to the conquest of sensuality by innocence; but it is surmounted by an owl—time-honored symbol of the night, a lightless state of mind, and, therefore, of the Synagogue. One symbol refers to the chastity of the marriage just being concluded in front of the Temple, the other to the benightedness of the Jewish religion, the rites of which are practiced within. The interior is fantastic as well as forbidding. Sturdy columns, forming a deambulatory like that of a choir, surround the Ark of the Covenant above which is hung a big conical canopy; but from the background emerges a towering Tora Shrine in severe Renaissance style. The whole room is illuminated only by what little light streams in through the door and by the gleam of a solitary candle; for, it is not by chance that the only visible window—accepted symbol of "illuminating grace"—is "blind."

The *Circumcision* is staged in a well-lit anteroom of simple stateliness which communicates with a gloomy, groin-vaulted chamber. The dividing wall, pierced by a round-topped door and a circular opening, is partly covered by curtains and partly overspun by stone-carved ornament which opposes to the sternness of the "Romanesque" the graceful luxuriance of a flamboyant Gothic best exemplified by decorative sculpture and engraving in Alsace. Ensconced in it are four figures which, like the reliefs in the *Betrothal of the Virgin*, commemorate the Jewish past while heralding the Christian future: Judith, the greatest heroine of Hebrew history and, at the same time, a prefiguration of the Virgin; Moses, the giver of the Old Law to be replaced yet respected by the New; and, in the center, the Lion of Judah and a nude Infant who is, of course, none other than the Messiah. But more important (at least for the modern art historian) than this elaborate symbolism of light-*versus*-dark, and "old"-*versus*-"new" is the experience of space as such. The perspective construction of the *Circum-*

cision has an unusually strong subjective appeal. The fact that the vanishing point is shifted to the side gives an impression of unstudied reality; and that it is not located on an "ideal" level but on the eye level of the big candle-bearer in the extreme foreground corresponds to our natural inclination to identify our own stature with that of the figure closest to the picture plane. Moreover the barrel-vaulted ceiling is so emphatically cut off by the margins that it seems to transcend, not only the frame but also the very front plane of the composition. As a result we feel ourselves included within the picture space and seem almost to take part in the events unfolding therein.

The same is true, perhaps to an even greater degree, of the *Presentation of Christ*. Here Dürer represents a huge classical structure of columns and architraves obviously taken over from an Italian prototype such as the *Meeting of Solomon and the Queen of Sheba* by Piero della Francesca. But while he appropriated the classical features—except for the fact that he decorated the capitals with vines—he destroyed their classical meaning. First, he abolished the coffers so that the whole construction stands free in a larger and wholly inconceivable room, the dark atmosphere of which seems to flow down through the hollow spaces. Second, he avoided showing a second column on the right so that the room appears to us, again, as arbitrarily presented and entered, and as limitless in its lateral extension. Third, he made the orthogonal architrave project beyond the picture plane, and we are so near to the big column to which it belongs that it seems to extend over our very heads. Thus the illusion of being included within the pictorial space is even more insistent than in the case of the *Circumcision*; were we to draw the perspective to natural scale it would be found that the distance between the beholder and the big column is less than the interval between one column and another, which means that he is actually in the room.

In 1505 a French priest by the name of Jean Pélerin (in Latin, Johannes Viator) published a treatise on perspective illustrated by numerous schematic woodcuts. In 1509 it came out in a second edition in which is inserted a skeletonized copy of Dürer's *Presentation* as a further example. But he was unable to understand the anachronistic beauty of a composition anticipating, in a way, the conceptions of such Dutch seventeenth century painters as Gerrit Houckgeest and Emanuel de Witte. In an attempt to amend it according to what he understood to be the rules of classical harmony, he closed the hollow spaces in the ceiling and not only added the "missing" column on the right but also removed the whole construction from the frontal plane.

THE SCENE OF THE LEAVE-TAKING OF CHRIST, which concludes the "Marienleben" as far as it was completed by the time of Dürer's departure, is very seldom found in earlier Lives of the Virgin. Where it occurs, however, it serves as a transition to the Passion, either preceding the Entry into Jerusalem, as in an early fifteenth century panel in Berlin, or inserted between the Entry into Jerusalem and the Last Supper, as in a somewhat related picture in Cologne. There is some reason to believe that Dürer, too, originally planned to continue the Life of the Virgin with a new cycle of the Passion of Christ. In the first place,

the Small Passion of 1509-1511 still reflects a program where the Passion proper was preceded by scenes of the Infancy; as in the panel in Berlin, the *Leave-Taking of Christ* is inserted before the *Entry into Jerusalem* (241/42). In the second place, a drawing of 1502, representing the Flagellation of Christ, seems to have a direct connection with the original project (573, *fig.* 145). Since all the figures appear to be left-handed, the drawing must have been made in preparation for a print; and since its size and style preclude the possibility of an engraving this print must have been a woodcut. Such a woodcut, on the other hand, cannot have been intended for the *"Salus Animae"* series, which is only half as large as the drawing and has no room for a Flagellation scene; nor is it probable that this subject would have been chosen for a single print. It appears, then, that the drawing of 1502 was made for one of the woodcuts originally intended to follow the Life of the Virgin, and this conjecture is corroborated by the fact that it agrees with this series not only in its dimensions but also in that it shows the characteristic motif of the "diaphragm arch."

That Dürer ultimately abandoned the plan for continuation may be accounted for by the fact that he had been commissioned with another Passion cycle which had to be prepared while the Life of the Virgin was still in the making. This is the much debated "Green Passion," so called because the eleven (originally twelve) drawings of which it consists (523-533) are executed on green-grounded paper. Comprising the sequence of events from the Betrayal to the Deposition—with the *Agony in the Garden* lost but transmitted through indirect sources (556)—the series is dated 1504, and its style agrees in fact with that of the "classic group" within the Life of the Virgin (*fig.* 146). The drawings were hardly carried out by Dürer himself, but he must have supervised their execution, and the invention is unquestionably his. Four original sketches in pen, slightly squatter in format, have come down to us (566, 569, 570, 575).

What was the purpose of this "Green Passion" which is much too elaborate to have been produced without a very definite reason? Like the studies for the Ober St. Veit altarpiece (479-482) the drawings are most carefully executed in pen and brush, enhanced by black washes and white heightenings. These and other similar examples (e.g. the drawings for the Fugger Tombs in Augsburg, 1537-1539) show that this technique, more final and affirmative in the characterization of lighting and modelling than others, was used for entire compositions almost exclusively where other artists, whether members of Dürer's own workshop or "outsiders," had to be supplied with models to be followed as closely as possible. Such drawings, then, served as what was known as "Visierungen," and this may also have been the purpose of the "Green Passion." The twelve drawings may have been intended to serve as models for paintings commissioned under the condition that Dürer would provide the design but would not be responsible for the manual execution. Series of this kind, each panel about one yard high, are commonly, though not quite correctly, known as "Kreuz-Stationen" ("Stations of the Cross"), and were very popular in the sixteenth century. Each nave pier of a church was adorned with one scene of the Passion; and since the "Schlosskirche" in Wittenberg, completed shortly after 1500 and still in want of interior decoration, happens to have precisely

six bays we may venture the hypothesis that the twelve panels prepared by the "Green Passion" were intended for this very church. We know that Dürer was the favorite painter of Frederick the Wise, and that the "Schlosskirche" in Wittenberg was full of other works commissioned from his workshop at exactly the same time.

The last of these was, we remember, the Ober St. Veit altarpiece (7). Its central panel shows the Calvary, and the same subject is represented in another "Visierung" on green-grounded paper, similar to the "Green Passion" in period and technique though hardly executed by the same hand or hands (598). This drawing, too, may have been made in preparation for an altarpiece for Wittenberg, soon to be superseded by the more sumptuous and timely project executed by Schäuffelein.

Howsoever that may be, these plans, like so many others, were interrupted by Dürer's sudden departure for Italy. But before he left he commemorated, in one of the greatest charcoal drawings ever made, the sinister force which drove him away. It shows Death as a king, or, to speak more exactly, as the King of Plague (876, *fig.* 147). Crowned with a royal crown, he rides on an emaciated horse, stooping and without room enough within the frame to straighten up. His mount has a cowbell strung around its neck—a weird reminder of the death knell, the "belle clynking biforn a cors" when "caried to his grave," and the signal "to bring out the dead"; and its gait is a ghastly caricature of what Dürer had admired in the representations of horses by Leonardo da Vinci: as in the drawings of 1503, the jade of Death lifts its near foreleg and simultaneously puts forward its off hind leg; but the rhythmic beauty of its movement is distorted into a crawl as slow and deadly as the advance of a lava stream.

IV · The Second Trip to Italy and the Culmination of Painting, 1505-1510/11

WHOEVER travels from Nuremberg to Venice passes through the rich and beautiful city of Augsburg. Dürer stopped there not only on his voyage in the summer or fall of 1505 but also on his return trip in February 1507. We learn from a letter of his host, a patrician gentleman named Conrad Fuchs von Ebenhofen, that the first of these sojourns lasted considerably longer than the second, and it has even been supposed that Dürer's original intention had been to stay in Augsburg for the whole duration of the plague. One of his letters from Venice, however, seems to indicate that a trip to Italy had been planned, and was already discussed in his family circle, before he left Nuremberg: "I should have liked to take him with me to Venice," he writes referring to his brother Hanns, "and this would have been a good thing for me as well as for him, also because of the language; but she [that is, their mother] was afraid the sky might crash down on him." Yet the lengthy "stopover" at Augsburg may have had some importance for the realization of what was to be the main achievement of Dürer's sojourn in Venice: the altarpiece known as the "*Feast of the Rose Garlands.*"

The use and maintenance of the national church of the Germans in Venice, S. Bartolommeo, was shared by two separate fraternities or clubs, who also operated the social and commercial center of the German colony, the Fondaco dei Tedeschi. One of these clubs comprised the merchants from Nuremberg, the other those from different parts of Germany; and within the latter the Augsburg element had achieved more and more prominence, reaching a climax with the meteoric rise of the house of Fugger. It is significant that no one disputed with this family the privilege of renting the most desirable chambers—nos. 1 and 2—in the Fondaco dei Tedeschi when it had been rebuilt after the fire of January 27, 1505. As we know by Dürer's own testimony, the *"Feast of the Rose Garlands"*—to be placed in the left chapel of S. Bartolommeo—was ordered by "the Germans," that is to say, not only by his townsmen but by the Nuremberg and Augsburg groups in conjunction. It is a fair assumption that the associations formed during his stay with the hospitable Conrad Fuchs went a long way to prepare the ground for this joint donation; but the attempts at identifying actual members of the Fugger clan in the panel itself cannot be called convincing.

We do not know exactly when Dürer reached his destination, but it was probably well before the end of 1505. The young beginner who had visited Venice eleven years before was now a world-renowned master whose inventions were copied and imitated everywhere. Also he was no longer poor. Pirckheimer had lent him some money, he had sold or bartered five of six panels apparently brought along for this purpose, and the commission of "the Germans" was not only honorable but also fairly lucrative, in spite of protestations to the contrary

which should not be taken more seriously when uttered by a painter than when voiced by a banker or industrialist. Thus he did not walk about the city as an unknown and insignificant tourist but plunged into its colorful and stimulating life as a distinguished guest. He became acquainted with "intelligent scholars, good lute-players, flutists, connoisseurs of painting and many noble minds" who honored and befriended him. He even ventured to take dancing lessons (which, however, he gave up after the second attempt) and dressed more fashionably than ever. He bought—and proudly reported the fact to Pirckheimer—a French mantle, a brown coat, an overcoat ("Husseck"), and a woolen cloth for which he paid eight ducats and which was unfortunately destroyed by fire on the following day. He could afford to lend money to impecunious friends, some of whom bolted or inconveniently died without having repaid him, and tried to satisfy, though not always successfully, Pirckheimer's rather exacting wishes concerning new Greek editions, oriental rugs, crane's feathers, jewelry, precious stones, and pictures which might be interesting from an antiquarian or iconographic point of view; in this latter respect he was, characteristically, much disappointed: "Concerning 'stories,' " he writes, "I do not see that the Italians produce anything particularly amusing in relation to your studies; it is always the same old stuff; you yourself know more than they paint."

The tone and flavor of Dürer's communications to Pirckheimer are very delightful. His letters express the relief of a man who had been torn between a disgruntled wife and a tired, over-pious mother ("lost among the women," as he writes of his brother Hanns); they reflect the warmth and splendor of an environment where the "poor painter" could blossom forth into a "gentleman"; and they bear witness to a friendship too deep and manly to require a show of affection. Only once, when Dürer had reason to believe that Pirckheimer was hurt by an unduly long silence, do we read such phrases as: "Thus I humbly beg of you to forgive me, for I have no other friend on earth but you." Normally, the content of the letters is confined to factual narration, gossip, indecent jokes and good-natured banter. But whether Dürer harps on Pirckheimer's pride in his achievements as an orator and statesman, or facetiously contrasts his huge physique and senatorial dignity with his philanderings, or teases him about his weakness for pretty German girls and handsome Italian lansquenets, we always feel how much he loved the other's very faults, and how little he begrudged him his successes. When Pirckheimer had outlined a refutation of certain claims raised by the Margrave of Branden-burg and Ansbach-Bayreuth—a refutation which involved a hundred different headings—Dürer addressed him as "Most learned sir, experienced in wisdom, expert in many languages, fast unmasker of any falsehood which may be uttered, and speedy discoverer of rightful truth." He also praised his friend's prodigious memory, but finally expressed the fear that the Margrave might not grant him audience long enough: "For 100 articles, each of 100 words, will take 9 days, 7 hours and 52 minutes, not counting the *suspiri*." And another mock-eulogistic passage, mostly written in a Maccharonian mixture of Venetian Italian and Latin, is so amusing and characteristic of the atmosphere in which the two men lived that it deserves to be quoted in full: "Grandisimo primo homo de mundo. Woster serfitor, ell schciavo Alberto Dürer disi salus suum mangnifico miser Willibaldo Pircamer. My fede el aldi wolentire cum

grando pisir woster sanita e grondo hanor. El my maraweio, como ell possibile star vno homo cusy wu contra thanto sapientissimo Tiraybuli [*sic*] milytes; non altro modo nysy vna gracia di Dio. Quando my leser woster litera de questi strania fysa de cacza my habe thanto pawra el para my vno grando kosa. Aber ich halt, dz dy Schottischen ewch awch gefurcht hand, wan Ir secht awch wild vnd sunderlich im heiltum, wen ir den schritt hypferle gand." "Greatest and first man of the world! Your servant and slave Albrecht Dürer greets his magnificent Mr. Willibald Pirckheimer. My word, I have heard gladly and with pleasure of your health and great honor, and I am marveling how it was possible for a man like you to hold your own against so many soldiers of the most cunning Thrasybulus, which indeed you could not have done, save by a peculiar grace of God. When I read your letter about this strange adventure I was very frightened, and it seems a big thing to me. But I believe that Schott's men were also afraid of you. For you, too, look wild, and particularly at the Feast of the Imperial Insignia when you are dancing the Hopping Step."

To understand this amusing piece of chaff one has to know, first, that Nuremberg was at war with a robber baron by the name of Kunz Schott vom Rothenberg; second, that Pirckheimer had to face this really dangerous enemy (who, on another occasion, cut off the right hand of a Nuremberg Senator, saying: "Now you will not write me letters any more") on a diplomatic mission; third, that the name "Kunz" is an abbreviation of the name "Konrad" or "Kuonrat," which means "a man who combines boldness with wisdom" and can therefore be equated with the classical name of Thrasybulus.

When it came to self-praise Dürer was fortunately able to reciprocate in kind, always— as we remember—ready to make fun of his own boastfulness as gracefully as of Pirckheimer's. He was sought after by one and all and had his full share of the two inevitable concomitants of success: honors and professional jealousies. His fellow-painters were apt to criticize his use of color and his lack of understanding for the classical style (". . . they imitate my work in churches and wherever they get hold of it; then they blame it and say it was not 'antikisch Art' "), and he was even warned not to share their meals lest they might try to poison him. But many other Italians, particularly the *gentiluomini*, liked and admired him so much that he had "to hide himself at times" in order to get some peace and privacy. Old Giovanni Bellini, the dean of the Venetian school, and in Dürer's own estimation "still the best in the art of painting," praised him in front of a distinguished gathering, visited his studio and expressed the wish to acquire one of his pictures; and if we can believe what Dürer wrote to the Senate of Nuremberg in 1524 he was even offered a well-paid permanent position as Painter to the *Signoria*. When the *"Feast of the Rose Garlands"* was completed it was admired by the whole Venetian aristocracy, including the Doge and the Patriarch, and finally even by Dürer's colleagues. "And as you are so pleased with yourself," he wrote to Pirckheimer, "so I herewith announce that there is no better image of the Virgin in the country."

The *"Feast of the Rose Garlands,"* now transferred from the Premonstrants' monastery at Strahow to the Museum in Prague, was indeed an effective means to "silence those who said

that I was good as an engraver but did not know how to handle the colors in painting" (38, *figs*. 148-150). Having been subject to several restorations—the first in 1663, the last in 1839-41—the panel is today no more than a ruin. Large sections, amounting to about half of the whole surface and unfortunately including the heads of nearly all the principal figures, had already been destroyed and completely repainted in the seventeenth and eighteenth centuries and were brought into their present shape by the restorer of 1839-41, one Johann Gruss. However, those portions which were then in good condition—carefully charted by the excellent G. F. Waagen—are still intact and are, in point of fact, in a better state of preservation than numerous museum pictures which, owing to the greater and more dangerous skill of our modern restorers, give the impression of a uniformly perfect condition. And these portions, such for instance as some of the portrait heads in the more distant planes, a considerable part of the landscape and the delicious *pluviale* of the Pope, are of a coloristic splendor never attained by Dürer before or after. In one propitious moment he succeeded in synthesizing the force and accuracy of his design with the rich glow of Venetian color.

Dürer, for the first time including a real self-portrait in a monumental altarpiece, signed the picture with the proud inscription: "Exegit quinquemestri spatio Albertus Dürer Germanus." This statement is, however, somewhat at variance with what we learn from his letters according to which he began the work on February 7, 1506, and finished it some time between August 18 and September 8 of that year. Since this amounts to at least six months and a half, we have to assume that Dürer discounted the time spent on preparatory studies and even on the underdrawing on the panel itself; evidently he added up the days devoted to actual brushwork.

The theme of the composition was suggested by the cult of the rosary which had grown to unusual proportions during the latter half of the fifteenth century. A rosary is known to all, first, as a peculiar form of prayer where decades of Hail Marys alternate with single Our Fathers (the total number amounting to 150 Hail Marys and 15 Our Fathers in the "complete" rosary, and to 50 Hail Marys and 5 Our Fathers in the "ordinary" one); second, as a string of beads that allows one to keep count of these invocations since each Hail Mary is represented by a smaller and each Our Father by a larger bead. The rite of the rosary was a Dominican form of devotion. Ascribing its invention to St. Dominic himself, the order encouraged it wherever possible and popularized an attractive symbolical interpretation of the still enigmatical name: the string of beads was said to represent an actual wreath of white and red roses, the white roses (corresponding to the smaller beads and to the Hail Marys) denoting the Joyful Mysteries of the Virgin, the red ones (corresponding to the larger beads and to the Our Fathers) the Sorrowful Mysteries of the Passion; and the hoop which holds the blossoms together (corresponding to the thread and to the Creed with which the recitation of the rosary begins and ends) was said to signify the Christian Faith. Thus the rosary seemed to express the idea of a Christian community united by orthodox beliefs, victorious in its fight against all forms of heresy, worshipping Christ and the Virgin Mary with equal devotion and—very Dominican—comprising the clerical and lay element alike. In 1474 this idea received concrete

expression in the Confraternity of the Rosary—founded by the same Jacob Sprenger who wrote the horrible *Malleus Maleficarum*—and it was in connection with this foundation that a special iconographic scheme, the "Rosenkranzbild," was evolved. Designed to illustrate the idea of a universal brotherhood of Christianity, it shows clergy and laymen, women and men, the noble and the poor offering—or receiving—garlands of white and red roses, the whole composition often surrounded by a larger garland of roses where ten medallions, shaped like cinquefoils, depict the five Joyful and the five Sorrowful Mysteries (*fig.* 157). The main scene is dominated by the Madonna enthroned and crowned by two flying angels. On her right is the clergy (including a nun), headed either by the Pope or by a mere Cardinal, but always with St. Dominic in the foreground. On her left are laymen of all ranks and both sexes, led by the German Emperor in knightly armor. The garlands are offered by or bestowed on either group, but the clergy are in direct relation to Christ Himself whereas the laymen, one step removed from the grace Divine, have access only to the Virgin Mary.

Whether or not a chapter of Sprenger's confraternity existed in Venice as early as 1506, there is no doubt that Dürer's altarpiece for S. Bartolommeo follows the pattern of these "Rosenkranzbilder." It should be called the *Brotherhood of the Rosary*, rather than the *"Feast of the Rose Garlands"*; for, an actual "feast" of the rosary was not instituted until 1573 when Gregory XIII wished to commemorate the victory of Lepanto. Dürer retained all the principal features of the earlier scheme, even the motif of the two crowning angels. But he transformed it no less thoroughly than he had, about ten years before, the Apocalypse series in the Quentell-Koberger and Grüninger Bibles.

The scene is no longer enacted before a neutral background but is staged in a luminous landscape based upon accurate studies from life; and the stereotyped representatives of the Christian community, clerics as well as laymen, are replaced by individualized portraits. Careful preparatory studies are preserved in large numbers (736-759, *figs.* 151-153), and Dürer spared no effort to achieve the semblance of reality even where the people to be portrayed were not available in person. For the portrait of the Pope (Julius II) he selected a model that more or less agreed with what he knew of the Pontiff's appearance (741). The face of the Emperor (Maximilian I) was executed on the basis of a Milanese drawing, probably made on the occasion of his marriage to Bianca Sforza (1031); but the sensitive hands were studied from life (745). The identity of the others—presumably all members of the Germany colony in Venice—cannot be established with certainty; we do not even know the name of Dürer's companion. Only the architect near the right margin, whose nervous, unworldly features and sovereign indifference to a well-groomed appearance form a strange contrast with the stately environment, can be identified as Master Hieronymus, the builder of the new Fondaco dei Tedeschi; the drawing from life which has come down to us (738, *fig.* 151) is a masterpiece of penetrating characterization.

While thus surpassing the earlier "Rosenkranzbilder" in naturalism and individualization, Dürer also endeavored to strengthen the impression of movement. The rose garlands—all received, not offered, by the worshippers—are actually placed upon their heads, and this action

is represented with as much liveliness and variety as possible. The Virgin Mary crowns the Emperor with ceremonial dignity while the Infant Jesus turns to the Pope with the impetuous enthusiasm of a child greeting his grandfather. Saint Dominic, removed from his customary place in the foreground, was granted the privilege of participating in the distribution of garlands and fittingly places a wreath on the head of a young Cardinal. Four chubby little Cherubs, of the Venetian kind with only a globular head, a pair of arms and a pair of wings, approach in flight with a further supply of garlands. Two Cherubs of the same informal type fulfill the office of crowning the Virgin, and two others hold up behind her a cloth of honor; it is not insignificant that Dürer dispensed with the massive throne of the conventional "Rosenkranzbilder" and resorted to a cheerful improvisation—particularly in favor in the fourteenth and early fifteenth centuries—which suggests movement, sun, and air.

But however "real" the figures, and however sprightly the behavior of the little angels, the composition as a whole is solemnly monumental and marks, in fact, the transition from a Quattrocento to a Cinquecento interpretation of the Renaissance style. As we have seen, the Emperor in the earlier "Rosary pictures" was clad in armor. Dürer, however, used this armored figure for a simple knight and pushed it back into the second plane, arraying the Emperor in a magnificent mantle of fur-trimmed velvet which in volume and outline corresponds to the brocaded *pluviale* of the Pope. This, combined with the fact that the figure of St. Dominic had been removed from its traditional place in front of the ecclesiastics, enabled Dürer to fill the entire foreground of the composition with two majestic, perfectly symmetrical figures. Together with the enthroned Madonna and with a Musical Angel placed at her feet, they form an almost perfect pyramid which both contrasts with and supports the mobile throngs of donors and Cherubs, much as a "cantus firmus" serves as a basis for a vivid, complicated fugue.

The balanced grandeur of this composition would not have been attainable to Dürer without the study and complete understanding of the style of Giovanni Bellini whom he so frankly admired, and to whom he paid tribute by including the beautiful Musical Angel, almost a hallmark of the old master's *Sacre Conversazioni*. And yet one may sense in the *"Feast of the Rose Garlands"* a spirit which had already been present in Northern art in certain earlier periods but had disappeared in the latter half of the fifteenth century. The paintings of Jan van Eyck, the Master of Flémalle, Conrad Witz, or Stephan Lochner, and, still earlier, the sculptures of those anonymous masters who had adorned the Cathedrals of Reims and Amiens, Bamberg and Naumburg, had already been conceived in a spirit of dignified and simple monumentality closer to the tendencies of the High Renaissance than was the style of Dürer's immediate predecessors, Michael Wolgemut, the Housebook Master, and Schongauer. Thus it is perhaps not by accident that a curious similarity exists between Dürer's *"Feast of the Rose Garlands"* and Stephan Lochner's *Adoration of the Magi* in the Cathedral of Cologne. If allowance is made for the difference entailed by an interval of more than sixty years, this famed altarpiece may be said to anticipate much of what strikes us as new in Dürer's composition: the symmetrical, yet by no means schematic arrangement of the

whole; the quiet dignity and comparative heaviness of the individual figures; the magnificent contrast between a solemn pyramidal group in the center and lively throngs of worshippers unfolding in the second plane; and even the detail of a cloth of honor spread out by two angels.

This does not mean that Dürer, while composing the *"Feast of the Rose Garlands,"* must have remembered this particular picture—though he may well have seen it on his bachelor's journey. But it is well to bear in mind that in many parts of Europe the efflorescence of a High Renaissance style was preceded, and in part accompanied, by a reversion to the great masters of the past who had more nearly approached the ideal of Cinquecento grandeur than had the late fifteenth century artists. Jan Gossart and Quentin Massys—not to mention a deliberate and almost professional archaist like Colin de Coter—reverted to Jan van Eyck and the Master of Flémalle during their formative years; young Michelangelo copied the works of Masaccio and even of Giotto because they seemed to be more congenial to his new concept of monumentality than those of Botticelli, Filippino Lippi, and Ghirlandaio. And it is therefore understandable that Dürer's first painting to deserve the title of a High Renaissance work reveals both the manifest influence of Giovanni Bellini and a recollection, perhaps unconscious, of Stephan Lochner.

While Dürer was still working at the *"Feast of the Rose Garlands"* he undertook two other religious paintings: the *Virgin with the Siskin* in the Deutsches Museum at Berlin, and *Christ among the Doctors*, now in the Thyssen Collection near Lugano.

The *Virgin with the Siskin* (27, fig. 154) has greatly suffered at the hands of restorers and appears now somewhat glaring and flashy. Originally it must have resembled the *"Feast of the Rose Garlands"* as much in color as in composition. The posture of the Infant Jesus and the gestures of the Virgin Mary had of course to be adjusted to the scheme of a Madonna in half length. But in every other respect the composition looks almost like a "detail" from the larger panel, including such motifs as the cloth of honor symmetrically flanked by open land-scape and the Venetian Cherubs crowning the Virgin (the crown, however, is replaced by a wreath of natural flowers). From an iconographical point of view the most remarkable feature is not the siskin perched on the left arm of the Infant Jesus but the presence of the little St. John who approaches the group from the right in order to present the Virgin with a lily-of-the-valley, while an angel carries his cross-staff for him. The inclusion of this figure in a representation of the Madonna was an utter novelty in Northern art which, if we except the group of Mother and Child alone, knew only the triad of the Holy Family and the com-plete circle of the Holy Kinship, but not the "Virgin with the Infant Jesus and the Little St. John." This theme was Central Italian rather than Venetian; but that compositions not unlike Dürer's *Virgin with the Siskin* existed in Venice and the "Terra Ferma" as well is demon-strated by such pictures as the *Madonna* in the Metropolitan Museum formerly ascribed to Antonello da Messina (now mostly to Michele da Verona) where the little St. John, sim-ilarly emerging from the lower corner of the composition and seen in lost profile, proffers a cross-staff to the Virgin and the Infant Jesus (*fig. 158*). Dürer, however, surpassed this and

similar "prototypes" by enlivening the entire composition and by endowing the little St. John with a Leonardesque or even Raphaelesque vitality which had been foreign to the earlier Venetian and Venetianizing schools. The result left a lasting impression on Titian, for a direct descendant of Dürer's little St. John, similarly placed, similarly posed and even similarly dressed, occurs in the *Virgin with the Cherries* in Vienna, not to mention the questionable *Virgin with St. Anthony* in the Uffizi. It is not impossible that young Titian was among those "many painters much superior to Jacopo de' Barbari" whom Dürer mentions in his letter of February 7, 1506.

The *Christ among the Doctors* (12, *fig.* 156) is probably the picture which Dürer describes, in another letter, as " a *quar* [that is *quadro*, a painting] the like of which I have never done before." If this identification is correct, the work must have been finished before September 23, 1506; and if we can trust the inscription on the panel itself, it would have been executed within five days ("Opus quinque dierum"); but again we have to assume that Dürer counted neither the underdrawing nor the careful preparatory studies (547-550, *fig.* 155).

That the artist himself considered this painting as something new and extraordinary is not surprising. In spite of its careful preparation it was executed in an almost impromptu fashion, a thin coat of color being applied in broad and fluid strokes utterly different from Dürer's normally meticulous brushwork. The composition is no less unusual than the technique, especially when compared to Dürer's previous interpretations of the subject. In these, that is to say, in one of the seven small panels in Dresden (3, *c*) and in a woodcut from the Life of the Virgin (311), the scene had been laid in an elaborate interior, and Christ had been seated in the rabbinical chair with a voluminous book before Him. In the panel of 1506 we have only figures in half-length set out against a neutral background. Books are handled only by three of the six old men whose faces, wicked, tense, self-righteous, sceptical, or tired, surround the innocent beauty of the youthful Christ with the threatening nearness of a nightmare. Christ Himself, standing in the center of the hostile group, no longer argues by the book; rather He extemporizes with a characteristic gesture frequently found in Italian representations of teaching or debating scholars: He enumerates the points of His argument, touching the thumb of His left hand with the index finger of His right. Only one of the Doctors—he alone whose face is a real caricature—takes an active part in the debate. Turned to full profile, he hisses his objections straight in the ear of Christ, and his gnarled fingers challengingly touch Christ's hands; so that the center of the composition is occupied by a group of four hands, intensely illustrative of a contrast between youth and old age, gentle firmness and contentious spite, and at the same time forming a kind of complicated ornament.

The emphasis on manual gesticulation, and even the specific gesture of arguing by counting fingers is unquestionably Italian, as is also the compositional form as a whole. The idea of presenting a dramatic incident by half-length figures so that the whole effect is concentrated on the expressive quality of hands and faces had been sanctioned by Mantegna (see his *Presentation of Christ* in Berlin) and had gained favor in all the North Italian schools, par-

ticularly in Venice and Milan. The only parallels in Northern art are found in two late pictures by Jerome Bosch, particularly in the *Christ before Pilate* in Princeton, N.J., and these may well have been inspired, however superficially, by Leonardo da Vinci whose influence was felt in the Netherlands as early as the first decade of the sixteenth century.

Dürer's *Christ among the Doctors*, too, reveals the influence of Leonardo. The very idea of a direct contrast between extreme beauty and extreme ugliness agrees with a prescription in Leonardo's "Trattato della Pittura," and the face of the wicked old scholar can hardly be imagined without some knowledge of Leonardo's so-called "caricatures." That these, and other drawings of a scientific kind, had come to Dürer's knowledge during his sojourn in Venice can also be inferred from the development of his theoretical studies. The only question is to what extent Dürer's composition as a whole depends on a prototype created by Leonardo.

We know that Isabella d'Este, in a letter of May 14, 1504, had asked Leonardo to paint for her a Christ "at the age of twelve at which he debated in the Temple." This request was literally carried out in a composition, transmitted through several copies, which shows the youthful Christ as an isolated figure, holding the orb in His left hand and blessing with His right. It is tempting to assume that, "later or earlier," this isolated figure "was made the center of a group of Doctors whose general disposition we know from Luini's free version in the National Gallery," and that the same "lost cartoon by Leonardo da Vinci" was "reproduced" in Dürer's panel of 1506. There is, however, no other evidence for the assumption that Leonardo ever composed a *Christ among the Doctors* save the Luini composition and its variants; and this composition does not seem very authentic. The "debating gesture" of Luini's Christ, with the index finger of His right touching the stiffly extended middle finger of His left, is strangely lifeless, as though the artist had been unable to overcome the formal rigidity of the original *Salvator Mundi* (it should be noted that the gesture of Dürer's Christ is much more like that of the Thomas Aquinas and the Duns Scotus by Joos van Ghent); and the disposition of the four Doctors shows a pedestrian symmetry, and an anxiety not to interfere with the main figure, which smacks of Luini rather than of Leonardo da Vinci. It is of course possible that Luini was incapable of doing justice to a "lost cartoon" by Leonardo; but it is equally possible that there was no such cartoon and that Luini added the four Doctors of his own accord, keeping as closely as possible to Leonardo's isolated image of the youthful Saviour and modelling the faces of the Doctors upon such Leonardo drawings (in part of much earlier date) as he thought suitable. In this case Dürer's panel would not be a "Gothic version" of a lost cartoon by Leonardo, but Luini's composition would be a Leonardesque readaptation of a panel by Dürer. If Titian did not scruple to accept Dürer's interpretation of an Italian theme, Luini had much less reason for reluctance in this respect. It should also be borne in mind that even Isabella d'Este's isolated *Christ* was no more than a fond hope as late as May 1506, and that Dürer's *Christ among the Doctors* never left Italy until it was sold in 1934.

It may quite justifiably, however, be described as "Gothic." Italianate though it is in some respects, in principle it is much farther from Renaissance ideals than either the *"Feast*

of the Rose Garlands" or the *Virgin with the Siskin*. As the twenty fingers of Christ and the wicked Doctor give the impression of entangled roots or tendrils rather than of articulated human hands, so the whole composition is not built up from clearly defined and fully developed plastic units but from fragmentary shapes, floating in space, crowding one another, and yet arranging themselves into a kind of ornamental pattern: a magic ring with the four hands in the center. Dürer's *Christ among the Doctors* shares more of its essential qualities with the *Christ before Pilate* by Bosch than with the smooth composition by Luini—except for the fact that with Dürer the goodness of Christ (and goodness in general) is a positive quality which can take visible shape in beauty, whereas in Bosch's nocturnal world, goodness is nothing but the absence of evil, expressible only by a vacant mask.

In addition to these three religious paintings several portraits were produced during Dürer's stay in Venice. The earliest of these, preserved in the Gemäldegalerie at Vienna, is dated 1505. It shows a young girl, dressed after the Milanese rather than the Venetian fashion, whose sweet-natured face is made even more attractive by the faintest suggestion of a squint (100, *fig.* 159). The panel is not quite finished, and since it must have been executed at the very beginning of Dürer's sojourn it cannot be expected to show a very far-reaching influence of the Venetian style. Yet there can be sensed a certain breadth and fluidity which had been absent from Dürer's earlier portraits. Details tend to be suppressed in favor of a comprehensive view. The vision of the whole begins to precede the realization of the parts; the sensuous quality of hair and skin is more acutely felt; and the light begins to caress the forms instead of merely clarifying them.

A portrait in Hampton Court, dated 1506 and representing the same young man who, somewhat incongruously, appears among the clergy in the *"Feast of the Rose Garlands"* (fourth figure from the right, perhaps identical with one Burcardus de Burcardis of Speyer), is almost reminiscent of Vincenzo Catena's portrayals of fair-complexioned, fluffy-haired youths (77), and the same is true of the Vienna portrait of another young man, probably also a member of the German colony, who apparently did not live up to Dürer's financial expectations; the artist took his revenge by painting a Giorgionesque personification of avarice on the back of the panel (80, dated 1507).

A climax of "Venetianizing" tendencies is reached in the Portrait of a Lady, sometimes erroneously identified as Agnes Dürer, in Berlin (101, *fig.* 160). Its very colors—dark green, soft brown, and dull old gold, set out against two shades of pale, grayish blue—are subdued in favor of tonal unity. Even if allowance is made for the effects of reckless cleaning and for the possibility that the light, atmospheric background is not the original one, the fact remains that no other portrait by Dürer shows so little emphasis on line and anatomical details, and so much on light and shade. The modelling is obtained by contrasting a large area of moderate light with an approximately equally large one of transparent shadow, and the very fact that this shadow extends over, and thereby unifies, two physically different units, *viz.*, the cheek and the throat, bears witness to the recognition of light as something independent of the structural data, diffused in space and no longer subservient to the task of modelling.

Except for a Portrait of a Young Man in Genoa which bears the date 1506 but is too damaged to be evaluated (78), there remains one of the most enigmatical paintings ever produced by Dürer, a portrait dated 1507 and preserved in the Deutsches Museum at Berlin (79). Painted on vellum instead of on wood, it has a less formal character than the five others, and the impression that it may have been a personal gift or souvenir rather than a portrait made to order is further strengthened by its unconventionality in composition and interpretation. The youthful sitter is not represented in three-quarter profile, as was the accepted rule (and is the case with all the other painted portraits by Dürer except for his Self-Portrait of 1500), but appears in full face. The head is, however, slightly inclined to the right, and the eyes, their serious look forming a piquant contrast with the faintly amused expression of the mouth, avoid the glance of the beholder. But the most intriguing feature of the portrait is its androgynous quality. It is variously listed as "Portrait of a Girl" and "Portrait of a Boy," and neither of these opinions is without foundation. The deep décolleté and the small, soft, smiling mouth give a definitely feminine impression, whereas the hair, the lack of ornament on the border of the doublet, the flatness of the chest, and the beret suggest a pretty and girlish boy dressed up as a "page." This writer favors the second alternative and is even inclined to believe that the very same boy, with his pointed chin, soft mouth and finely pencilled, slightly raised eyebrows, served as a model for the youthful Christ among the Doctors, where he appears with longer hair and, of course, in more idealized fashion (see particularly *fig. 155*); his facial type recurs, shortly after Dürer's return, in a drawing of 1508 (1062/63). That Dürer was not unsusceptible to the charm of handsome boys is more or less implied by a facetious letter of his and Pirckheimer's mutual friend, the merry Canon Lorenz Beheim of Bamberg; he writes, on March 19, 1507, and characteristically inserting some Italian phrases into his Latin text: "Concerning our Albrecht, I do not think that much begging is necessary if he is willing of his own accord [*scil.*, to favor Beheim with a drawing]. After all, I do not want anything big and elaborate, only a drawing which tastes a little of Antiquity as I described it to him in my last letter. The obstacle is his pointed beard [*barba bechina*] which doubtless has to be waved and curled every single day. But his boy, I know, loathes his beard [*Ma il gerzone suo abhorret, scio, la barba sua*]; thus he had better be careful to shave."

Dürer revisited Venice as an accomplished master, fully occupied with productive work. His sketch-books were no longer filled with drawings of strange costumes and characters, studies of animals and copies of Italian works of art, as they had been in 1494/95. Venetian life now held no surprise for him, and he knew the language of Renaissance art too well to bother about its vocabulary. Occasionally, he would still copy a Venetian painting (1061), and he took some interest in architecture (1681-1683); but what he really wished to carry home was theoretical knowledge rather than material for practical work. Having thus far approached the problems of perspective, human proportions, etc., from a purely empirical point of view, he now felt the need of penetrating into the underlying principles. He bought the 1505 edition of Euclid containing both the *Elementa* and the *Optica* (a partial transla-

tion of which is found among his autographs in the British Museum), and it has already been mentioned that he undertook a special trip to Bologna in order to be taught the "secret art" of perspective. He came into contact with the ideas of Leone Battista Alberti and Leonardo da Vinci and must have gained access to some of the latter's studies in human proportions, physiognomy and, possibly, anatomy. All this made him realize that the theory of art might be understood as a scientific pursuit *sui iuris*, instead of being subsidiary to practical work, and left him with a burning desire to spread this gospel in Germany. While his first journey to Italy immediately and fundamentally affected his artistic production, the chief result of the second was to make him conscious of his mission as a theorist.

This does not mean, of course, that the second journey to Italy was without influence on Dürer's evolution as an artist; only, this influence amounted not so much to a lasting reorientation as to a temporary strengthening of coloristic and luminaristic tendencies. These tendencies are also manifested in the technique of Dürer's Venetian drawings. Most of these are large-scale studies of single figures, heads, hands, and draperies made in preparation for the three religious compositions, the *"Feast of the Rose Garlands,"* the *Virgin with the Siskin* and *Christ among the Doctors*, and all but one or two of them are executed in a new and characteristic medium: dark brush, heightened with white, applied on that blue Venetian paper which does not owe its color to a grounding process but is dyed in the grain. In a purely optical way this technique is reminiscent of that employed in the "Green Passion" or in the preparatory studies for the Ober St. Veit altarpiece (479-482), where apparently similar effects had been obtained by the use of pen, dark washes, and white heightenings on paper covered with a colored ground. In both cases the drawing surface serves as a "middle tone" from which the shadows and highlights stand out. However, apart from the fact that brush strokes are less strictly linear than pen lines and that paper dyed in the grain gives a more spatial effect than paper covered with a colored ground, most of those earlier drawings had not been studies but "Visierungen." Comparatively small in scale, they had not been made from life but had summarized previous sketches and studies into complete and final compositions destined to be translated into paintings in a more or less mechanical way. They had been patterns, not records. That Dürer now used a similar and even more "pictorial" technique for large-scale studies from nature betrays his wish, not to preestablish the distribution of *valeurs* in the finished product but to interpret the first-hand experience of reality in terms of light and color. With all their uncompromising linearism these drawings have, in fact, a lustrous and chromatic quality which makes them appear as equivalents, rather than as anticipations, of paintings. The study for the Infant Jesus in the *Virgin with the Siskin* (627) is a particularly characteristic example.

In one of the few drawings in which he employed a different technique Dürer ventured still farther into the field of "pictorialism"—farther than at any other time in his career. The study for the *pluviale* of the Pope in the *"Feast of the Rose Garlands"* (759, *fig.* 152) is a pure water color in purple and dulled yellow, done for the sole purpose of catching the effect of gold-and-violet brocade. Dürer's costume studies of other periods, for instance the seem-

ingly comparable ones made in preparation of the Portrait of Charlemagne in Nuremberg (1009-1013, dated 1510), enter the colors into firm outlines and put them down as soberly and objectively as the cut of a garment or the pattern of an embroidery. The *pluviale* drawing, broad and practically without contours, renders account of a coloristic experience instead of tabulating pigments. Compared with the other costume studies it almost seems to anticipate the seventeenth century.

Studies from the nude called, naturally, for a different treatment. But a comparison between the Giorgionesque *Nude viewed from the Back* of 1506 (1188, *fig.* 163) and such earlier instances as the *"Four Witches,"* the *Nemesis* and even the *Fall of Man* shows increased luminosity even within the limits of a basically "plastic" style. Since the highlights are indicated by white heightenings, and the shadows by dark hatchings, the colored paper as such stands *ipso facto* for a light of medium intensity. It was thus possible to reduce the size of deeply shaded areas without weakening the plastic effect, and yet to make them exceedingly dark without destroying the impression that the whole form is bathed in light. This is precisely what was done in the drawing here under discussion. Some of the shadows are very opaque, but these opaque portions are reduced to small patches and narrow strips surrounded by much larger areas of direct or reflected light (note particularly the almost uninterrupted reflex running from the right shoulder to the right foot). A luminous medium diffused in space literally seems to have "flooded" the form much as the rising tide will flood a slightly uneven beach. Obviously this kind of treatment creates a stronger feeling of unity or continuity. Where the form of the "Four Witches," the Nemesis, or the Eve of 1504 seems to be built up from several numerable units separately modelled, the drawing of 1506 presents a unified undulating surface. And this new continuity of modelling is matched by a new continuity of outline: the contour is no longer composed of single convex or concave segments but forms a tight uninterrupted curve soaring like a slender vase or a jet of water.

Dürer himself was conscious of this change, as three "constructed" nudes devised in preparation for a new version of the Adam and Eve theme clearly indicate. The numerous drawings preceding the *Fall of Man* of 1504 had been so constructed that not only the dimensions and postures but also, wherever possible, the outlines were determined by geometrical methods; large sections of the contour were made up of a series of arcs drawn with the compass. In the later drawings, dated 1506 like the *Nude viewed from the Back*, the construction, employing straight lines but no longer circular arcs, determines only the proportions and the poses; the contour unfolds in a flowing line of unrestricted freedom (464-469, *figs.* 161 and 162).

THE PROJECT in connection with which these constructed drawings were made was carried out immediately after Dürer's return to Nuremberg. It took shape in two life-sized paintings, dated 1507, which for a time belonged to Queen Christina of Sweden and are now in the Prado (1, *figs.* 164/165) while copies are preserved in the Altertumsmuseum at Mayence and in the Pitti Gallery at Florence. Like the engraving of 1504 these panels are intended to present specimens of humanity as perfect as possible. But Dürer's ideas of beauty had changed

significantly during the intervening three years. Both figures are considerably more slender, their height amounting to about nine heads instead of to eight. The contours are smooth and fluent, and no great emphasis is placed on anatomical details. The Adam of 1507 no longer moves with a firm, aggressive step but exhibits an unsteady, swaying pose in keeping with the halting gesture of his right hand and with the almost affected way in which he holds a very thin branch between the thumb and index finger of his left; he wears his hair in long, fluttering locks instead of in short, wiry curls; and his mouth is opened with a yearning sigh —a motif probably borrowed from Andrea Rizzo's marble Adam on the Palace of the Doges. The figure of Eve differs even more markedly from Dürer's previous standards of beauty. Delicately built and softly modelled, she leans over to her partner with the cautious tread and tense expression of one listening at a door. The almost furtive glance of her eyes and the curious gesture of her right hand betray a certain nervousness, and her posture, with the left leg slightly bent and stepping over behind the other one, is of that pirouetting kind which is seen in numerous St. Martins and St. Georges of the later fifteenth century.

In short, the Adam and the Eve of 1507 look more "Gothic" than their predecessors of 1504 (*fig.* 117). This is not as paradoxical as it may seem. Dürer apparently felt that the Gothic taste agreed, in a sense, with what he had been striving for in Venice. Like his own drawings of 1506, Gothic figures are marked by a tendency toward continuous, elastic contours, arbitrarily elongated proportions and swaying, weedy movements, as opposed to a pronounced articulation in outline and anatomy, a standardized canon of "normal" measurements, and a stability of posture based on the equilibrium of separate units. Gothic taste prefers the soft and lyrical moods to the hard and dramatic (or epic) ones, and generally tends to "feminize" the beauty of the male while the opposite is true of classical and classicistic art. Small wonder, then, that Dürer's Venetian experiences led him back to a Gothicizing mode of expression. He had been trying to overcome an "additive" method of composition in favor of unity or continuity, and this endeavor had led him, who always remained a designer rather than a painter, from a unification in terms of lighting to unification in terms of form and contour. Thus we can see how his Venetian style could merge with Gothic reminiscences, and how both these factors could act as an antidote to the classicistic ideals to which he had paid homage in his engraving of 1504.

Compared to this engraving, where the Eve, with her heavy step and square chest, is as masculine as the Adam of 1507 is feminine, the Prado panels may be termed an anticipation of Mannerism; for Mannerism—first represented in Italy by such masters as Pontormo, Rosso, Beccafumi and Parmiggianino and in Germany by Lucas Cranach, Hans Baldung Grien and many other masters of the "second generation"—resulted from a recrudescence of Gothic tendencies within the framework of an already classical style. Its champions harked back to the past in order to escape from a normative perfection of which they were tired or which they failed to understand. The Italians frequently drew from Northern sources in this process, and the Northerners twisted Dürer's formulas so as to serve a, generally speaking, non-Dürerian purpose. In the case of the two Prado panels, however, Dürer himself con-

formed, though for altogether different reasons, to the Mannerist principle. The Eve in particular is closer to Cranach's helical nudes than any other figure ever devised by Dürer. But with him this proto-Mannerism remained an episode. His *Lucretia* in Munich, finished and signed as late as 1518 but composed and partly carried out as early as 1508 (106), already shows a marked reaction toward the statuesque solidity and calm of the preceding period.

That the new version of the Adam and Eve theme appeared in two paintings and not in another engraving was no accident. The stay in Venice had interrupted Dürer's activities as an engraver and woodcut designer with the single, and not unquestionable, exception of six *Patterns for Embroideries*, copied in woodcut after engravings mysteriously connected with Leonardo da Vinci (360); and he had formed a taste for brushwork which was to last for several years. In addition to the two Prado panels and to the unfinished *Lucretia* already mentioned, he produced no less than three major altarpieces, the last of which was finished and delivered in 1511.

The first of these is a shutterless retable representing the *Martyrdom of the Ten Thousand*, now in the Gemäldegalerie at Vienna (47, *fig.* 166). Commissioned, once more, by the Elector Frederick the Wise, it was begun almost immediately after Dürer's return and was completed in April or May 1508.

Why Frederick the Wise should have insisted on a subject which for all we know could not particularly appeal to his artistic tastes can be inferred from the iconography of the picture itself. Almost exactly ten years before Dürer had represented the Martyrdom of the Ten Thousand in a large woodcut (337, *fig.* 69), and many features of this earlier composition—reversed, which shows that Dürer worked not from the woodcut itself but from preparatory drawings—recur both in the picture of 1508 and in a large-sized sketch which must have been executed very shortly after Dürer's return in 1507 (868). We recognize, for instance, the group of oriental dignitaries in the foreground; the group of martyrs flogged while tied in a circle around a tree (a motif probably derived from a series of reliefs by Pietro da Rhò in Cremona); the procession of martyrs driven up a hill in order to be thrown into the thorns; and the group of those who are forced over the edge of a cliff, their postures illustrating, in almost cinematographic fashion, the successive phases of one fatal plunge from the moment of losing balance to the somersault in mid-air.

But there is one important iconographical change. In the woodcut great emphasis had been placed on the atrocious torture of the alleged leader of the Ten Thousand, Bishop Achatius, whose eyes are bored out with a carpenter's drill. In the new version this group is omitted, and instead we perceive, analogously placed, what looks like a reenactment of Calvary: in the drawing of 1507 we have a regular "Erection of the Cross," and in the painting two of the martyrs are crucified, quite like the Thieves, on rough-hewn crosses while a regular cross, still on the ground between them, awaits a Christ-like victim patiently standing in the second plane. It is quite understandable that Karel van Mander described the Vienna panel as "a *Crucifixion* with many other tortures, stonings, slayings and so on."

Thus what appealed to the religious feeling of the Elector—already a friend of Staupitz and a protector of Luther—was not so much the martyrdom of the Ten Thousand in itself as the analogy between this martyrdom and the Passion of Christ. Like Christ, they were greeted with a sneering "Avete, Reges Iudaeorum" and crucified after unspeakable tortures; like Christ, they invoked God from their crosses at the canonical hours, and finally expired amidst an earthquake. In visually stressing this analogy, Dürer transformed a purely narrative rendering of tortures and slaughter into a symbol of the "Imitatio Christi" or, to use the ancient term, the "Schola Crucis"—into an illustration of St. Augustine's glorious sentence: "Tota vita Christiani hominis, si secundum Evangelium vivat, crux est" ("The whole life of the Christian, if he live according to the Gospels, is the Cross").

As was his custom since the *"Feast of the Rose Garlands,"* Dürer included his own portrait in the picture, this time resplendent in the "French mantle" which he had purchased at Venice. In the preparatory drawing he is still alone, but in the painting he is accompanied by an elderly humanist most probably identical with Conrad Celtes who had died a few months before the work was finished, and whom Dürer as well as the Elector had good personal reasons to commemorate. But more important than this particular addition is the expansion of the composition as a whole. The distribution of the groups around the flogging-tree is still reminiscent of the woodcut. But the whole configuration which had made up the composition of the earlier work has been pushed into the background, so to speak. The woodcut looks like a "clipping" from the painting; or, to put it more appropriately, the composition of the painting resulted from an enlargement of the woodcut. The woodcut was still used, but it was used as a mere nucleus which was developed both laterally and in depth. Dürer had learned to think in terms of volume and perspective, rather than in terms of lines and two-dimensional patterns. The groups, with all their crowded appearance, are conceived as something displacing and surrounded by space; and the rule that quantities seem to diminish in the inverse ratio of their distance from the eye is so conspicuously observed that Pélerin-Viator—the same who embellished his Treatise on Perspective by a skeletonized copy of Dürer's *Presentation of Christ*—saw fit to include a similar copy of the *Martyrdom of the Ten Thousand* in order to exemplify that very rule:

> *"Les quantitez/et les distances*
> *Ont concordables différences."*

After the *Martyrdom* had been completed Dürer began to work on a more sumptuous enterprise, a folding triptych ordered, perhaps as early as 1503, by Jacob Heller, a merchant of Frankfort, for the Dominican Church of his town (8, *fig.* 168). The central panel—the only part which Dürer undertook to paint entirely with his own hand—represented the Assumption and Coronation of the Virgin, while the interior of the wings show the portraits of the donor and his wife (née Katharina von Melem) and, above these, the martyrdoms of their patron Saints, Sts. James and Catharine. On the exterior are painted *en grisaille* (in "stone color" as Dürer puts it) the Adoration of the Magi and, below, two pairs of Saints, namely, Sts.

Peter and Paul, and Sts. Thomas Aquinas and Christopher. The presence of Sts. Peter, Paul, and Christopher needs no explanation; that of St. Thomas Aquinas can be accounted for by the fact that he was the titular Saint of the altar which Dürer's triptych was to adorn.

The work was ill fated from the start. There was much bickering about the time of delivery and, more serious, the price. The discussion with the wealthy employer—who fortunately saved Dürer's nine letters so that they could be copied in the seventeenth century—became so heated that the artist offered to cancel the whole matter and to sell the altarpiece, more advantageously, to someone else. Ultimately the differences were straightened out. Instead of the 130 florins originally stipulated Dürer received 200, plus a gratuity of two florins for his brother and a present for his wife. The triptych was dispatched to Frankfort by the end of August 1509, but Dürer still felt insufficiently rewarded. Even after Heller had yielded to his demands he had received 80 florins less than for the *Martyrdom of the Ten Thousand*; he had spent more than 25 florins on ultramarine alone; and he felt that he had wasted his time with what he terms "painstaking drudgery" ("fleissig Kleiblen"). In fact about twenty careful studies for the center piece alone have been preserved, all of them executed in the "Venetian" technique except for the fact that Dürer had to use green-grounded paper instead of paper dyed in the grain (483-502, *fig.* 171). The last act of the tragedy took place almost exactly two hundred years after the master's death. In 1615 the Dominicans had sold the central panel—the only part painted by Dürer himself—to Maximilian I, Elector of Bavaria, and it was destroyed by fire in Munich in 1729. Compared with this loss the disappearance of one of the wings—the left half of the *Adoration of the Magi*—is of minor importance.

Fortunately, a local painter named Jobst Harrich had made a copy of the central panel shortly before the original was sold, so at least its composition has come down to us. This composition, familiar though it looks to modern eyes, presents a rather complicated iconographical problem in that it is neither an Assumption nor a Coronation of the Virgin but a novel combination of both. The Apostles are seen surrounding the empty tomb of the Virgin. Two or three are petrified with wonderment, one—probably Thomas—bends down to examine her cast-off shroud, and the others point upward or gaze at the sky where she is crowned by the Trinity.

In fact Dürer's conception resulted from a fusion of three different iconographical types. The first of these is the Assumption of the Virgin as interpreted by his local predecessors, for instance the Master of the Imhof altarpiece of 1456 (now in Breslau) and Michael Wolgemut (altarpiece in the "Jacobskirche" at Straubing). These presentations differ from earlier ones, and anticipate Dürer's Heller altarpiece, in two important points: the Apostles are not lined up in relief-like fashion but form a spatial group around the empty tomb, and the Virgin is not shown floating upwards in a mandorla but is praying on her knees while she receives a scepter from Christ and a crown from an angel (*fig.* 167); in a "Düreresque" redaction of this traditional scheme Christ even joins the angel in placing the crown on the Virgin's head (520). Yet this scene is not yet the ceremonial and final "Coronation" where the Virgin is formally inaugurated as the "Regina coeli," but a reunion of the "Sponsa" of the Song of

Songs with her mystical bridegroom. It is significant that, in the Imhof altarpiece, she is greeted by Christ with a direct quotation from the Song of Songs which suggests approach rather than presence: "Veni electa mea."

Dürer replaced this preliminary reception scene, which forms a transition between the Virgin's temporal existence on earth and her eternal existence in heaven, by the Coronation proper, employing a formula peculiar to the fifteenth century which is best represented by Dirk Bouts (Vienna, Kunstakademie) and Michael Pacher (Munich, Alte Pinakothek). The Virgin kneels before God the Father and Christ who jointly perform the ceremony while the Dove of the Holy Ghost hovers above the crown. The dignity of the Queen of Heaven is thus bestowed by the whole Trinity—a concept presupposed but not expressed in representations prior to about 1400—and Dürer went out of his way to emphasize the solemnity of the occasion; in contrast with an almost universally accepted rule, and even with his own general custom (see the Coronation woodcut of 1510 and the *Trinity* of 1511, *figs.* 178 and 185), he presented Christ with a papal tiara without, however, attiring him in full papal garb. Wrapped in the mantle of the Passion which exposes the wound in His breast, He yet officiates as the Eternal Priest: "Thou art a priest for ever" (*Ps.* cx, 4).

This Coronation type, then, is the second element which enters into the iconography of the Heller altarpiece. Its inclusion seems almost natural in view of the fact that the motif of the Virgin praying on her knees and invested with a scepter and a crown had already been adopted in the Nuremberg Assumptions of the fifteenth century. And yet Dürer would hardly have dared to combine the scene at the tomb with the formal Coronation—a miracle on earth with a ceremony in Heaven not meant to be observed by mortal eyes—had he not gone to Italy in 1505. For, a few years before, Raphael had taken this very step in his famous Vatican altarpiece (*fig.* 169), fusing, however, the wonderstruck Apostles—including St. Thomas with the Virgin's girdle—not with the modern Coronation by the Trinity, but with the more archaic Coronation by Christ alone, with the Virgin sharing His royal seat. This type, still prevalent in Italy, originated in the Gothic cathedrals of France; and Raphael's altarpiece, though substituting the scene at the tomb for the Death or Burial originally associated with the formal Coronation, is still reminiscent of a Gothic tympanum, not only in the iconography of the Coronation scene but also in general composition. Christ and the Virgin are enthroned together; the Apostles are aligned in "isocephalic" fashion; and the whole composition is sharply divided into two zones, a horizontal band of massive clouds dividing the scene on earth from the scene in Heaven.

There is little doubt that Dürer knew a work directly or indirectly reflecting this composition. But in blending it with the Northern tradition, he dynamized the former while monumentalizing the latter. Like Raphael, he made a clear distinction between the celestial and the terrestrial spheres. But unlike him—and in this respect a follower of his Nuremberg predecessors—he strove to connect the two worlds by a stream of synchronized movement. His Apostles are not arranged in a row but in a semicircle which opens toward the back, so that the celestial apparition seems to soar from their very midst. Their heads form a curve

instead of a horizontal line, and the shape of the group in Heaven corresponds to that of the terrestrial scenery as a cogwheel is geared with another: its contour is convex while the garland of heads is concave, it shows projections where the silhouette below shows indentations, and it is indented where the horizon is overlapped by heads or trees.

This formal correspondence is illustrative of an emotional interrelation. In Raphael's painting the melting glances and restrained gestures of the Apostles emphasize rather than bridge the gap between Heaven and earth, and the group of Christ and the Virgin retains the timeless isolation of a sacred image. The passionate piety of Dürer's Apostles seems to take Heaven by storm, and the very fact that the figure of the Virgin is still on a lower level than those of God the Father and Christ, and still needs the support of many little angels, serves to keep her in contact with the terrestrial world. At the very moment of her Coronation she is not yet absorbed by Eternity; she carries with her some of the impulse of her ascent and all the emotions of the Disciples.

While Raphael's composition resulted from a combination of two motifs—the Coronation of the Virgin and the group of Apostles originally belonging in the Assumption—Dürer's amounts to an integration of two concepts, a static ritual and a dynamic rise. The Coronation is thus presented not only as it occurs in Heaven but also, or even more, as it reflects itself in the consciousness of those remaining on earth. It is interpreted as a "vision" experienced by mortal men and therefore capable of being shared by the beholder.

The third of the three altarpieces executed between 1507 and 1511 is the "*Adoration of the Trinity*" in Vienna (23, *fig.* 172). It was destined for the chapel of the "Zwölfbrüderhaus," a home for twelve aged and indigent Nuremberg citizens which had been founded in 1501 by two devout and wealthy merchants, Matthaeus Landauer and Erasmus Schiltkrot. Not much is heard or seen of Schiltkrot after this, but Landauer devoted the rest of his life almost exclusively to his Foundation. He went to live there himself in 1510, and his fine old face survives, not only in the altarpiece itself but also in the stained-glass windows of the chapel and in one of Dürer's most inwardly expressive portrait drawings (1027, *fig.* 170). The chapel was ready for decoration in 1508, and Dürer was asked not only to paint the altarpiece but also to design its frame (now in the Germanisches Museum at Nuremberg) and to provide the sketches for the windows (now in the Schlossmuseum at Berlin). The composition of the altarpiece, including the frame, was essentially established in a drawing of 1508 (644, *fig.* 174), but its actual execution had to wait until the impatient Jacob Heller was satisfied. It was completed and put in place in 1511, and we learn from the inscription on the frame that this event marked the consummation of Landauer's enterprise: "Mathes Landauer hat entlich volbracht das gotteshaus der tzwelf bruder samt der stiftung und dieser thafell nach xpi gepurd MCCCCCXI Jor."

The chapel of the "Zwölfbrüderhaus" was dedicated to the Trinity and All Saints, and this determined the program of the altarpiece. The beholder is faced with a dazzling apparition in the sky. God the Father in Imperial garb, and above Him the Dove, holds before Him the crucified Christ while angels spread His mantle behind Him like a pair of gigantic wings;

other angels bring the instruments of the Passion. Vast multitudes, floating on clouds, adore this "Throne of Mercy," and the earth lies deep below: a shining landscape devoid of life except for the figure of the artist himself. He stands, alone and very small, in the lower right-hand corner of the picture, holding a tablet with his signature. The worshippers are divided into two zones, one on the same level as the Trinity, the other below it; and in both zones two groups can be distinguished, one on the left and one on the right.

The iconography of the higher zone can easily be explained by the idea of "All Saints." The two groups are led by the Virgin Mary and St. John the Baptist respectively, the former, as always, occupying the place on the right of God; and the retinue of the Virgin includes, besides a score of others, the well-known figures of Sts. Barbara, Agnes, Catharine, and Dorothy. The cortege of St. John consists exclusively of characters of the pre-Christian era, namely, Moses, David, a prophet clad in an ermine-lined coat (like Jan van Eyck's Zechariah in the Ghent altarpiece), the fifteen other prophets and a number of austerely attired women who must be prophetesses and sibyls. But those who believed in Christ before His appearance on earth are mentioned in all the texts connected with the Feast of All Saints and have their rightful place opposite those who "saw Him after He came":

> "Da questa parte, onde il fiore è maturo
> Di tutte le sue foglie, sono assisi
> Quei che credettero in Cristo venturo.
> Dall'altra parte, onde sono intercisi
> Di vuoti i semicircoli, si stanno
> Quei ch' a Cristo venuto ebber li visi."

There are, in fact, manuscripts and editions (such as Caxton's) of the *Golden Legend* where an analogous representation of Christians and precursors, united in the worship of the triune God, serves to illustrate the chapter on "All Saints," and in the Breviary of Ercole I of Ferrara it opens the section known as *Commune Sanctorum*.

The lower zone of Dürer's Heaven is, however, occupied by men and women who cannot possibly be considered as Saints. In spite of their celestial status they form a mere Christian community which, as in the *"Feast of the Rose Garlands,"* consists of ecclesiastics on the one hand and of laymen of all ranks—including even a peasant with his flail—on the other. Several members of this community bear the features of members of the Landauer and Haller families, and old Matthaeus Landauer himself appears near the left margin, his touching humility outshining the graciousness of a sponsoring Cardinal. But it should be noted that some of the most exalted dignities are represented twice; there are possibly two Emperors and certainly two Popes.

It has been observed that a similarity, too close to be accidental, exists between this altarpiece and an earlier composition which occurs in several printed Books of Hours of Paris provenance, the best and apparently first instance being the metal cut in Philippe Pigouchet's

Heures a l'Usaige de Rome of 1498 (*fig.* 173). Belonging to the section "De Sanctissima Trinitate" (which in turn opens the "Suffragia plurimorum Sanctorum et Sanctarum"!), this composition illustrates, like Dürer's, the Adoration of the Trinity, and it also agrees with the Landauer altarpiece in that the community of worshippers is divided into the same two zones or hierarchies, the now familiar assembly of "All Saints" (including the believers of the pre-Christian era), and the equally familiar groups of clergy and laity. But it differs from Dürer's painting in that the less exalted congregation—headed by one Pope and one Emperor only, as was the usual thing—is not yet admitted to the heavenly realm. Its members kneel on the ground in front of a Gothic chapel which, piercing the band of clouds that separates the terrestrial sphere from the celestial one, symbolizes the visible Church. Dürer, then, obliterated the sharp distinction between the Saints in Heaven and the men and women on earth; he fused them into one "kingdom not of this world."

To understand this difference between Dürer's altarpiece and what appears to be its prototype we must consider the theological concepts involved in the light of Augustinian doctrines. It was St. Augustine who had formulated the dogma of the Trinity in stating that wherever the Christian speaks of "God" he means "neither the Father nor the Son nor the Holy Ghost, but the one and only and true God, the Trinity Itself"; and it was he who had written the constitution and traced the past and future history of the Christian community which he calls the "City (or State) of God." The iconography of these concepts is therefore inextricably connected with St. Augustine's teachings, especially after a vigorous revival of Augustinianism had set in towards the end of the thirteenth century, and an illustrative tradition had developed, from about 1350, in the manuscripts of the *De Civitate Dei*. The influence of this tradition makes itself felt, not only in representations of the "All Saints" theme proper—which are, in part, literally copied from miniatures illustrating the last Book of St. Augustine's treatise—but also wherever late-medieval art tried to express the idea of a kingdom "whose every citizen is immortal." This is true of modest Spanish retables as well as of the Ghent altarpiece and of Stephan Lochner's and Rogier van der Weyden's interpretations of Paradise; and it applies also to the metal cuts in the Paris Books of Hours. These ancestors of Dürer's "Allerheiligenbild" are, at the same time, descendants of the miniatures in the *"Cité de Dieu"* manuscripts.

The City or State of God draws its origin, its form and its beatitude from the Holy Trinity. Founded by Abel, it is reigned over by Christ, while the "terrena civitas," the city or state of earth, was founded by Cain and is ruled by the Devil. Yet—and this is stated in the very first sentence of St. Augustine's treatise—the City of God exists partly in Heaven and partly on earth. Throughout human history or, to use the Saint's own words, "while it wanders through this course of time among the sinners," it includes both angels and living human beings, and has therefore a temporal as well as an eternal aspect. The City of God is thus not coextensive with the visible Church, but is at once larger and smaller. It is smaller in that the visible Church, being in part a terrestrial institution, is in a greater or lesser degree defiled by the spirit of the "terrena civitas" and contains a certain amount of evil with the

good. It is larger in that it extends both beyond the limits of the material universe and beyond the limits of the Christian era. It has earthly as well as heavenly citizens, the former comprising those Christian men and women who have received remission of sins through the Blood of Christ and justification of the Holy Spirit, the latter comprising the Angels who have always been true to God and, in addition, the Saints and those blessed few who "believed in Christ even before He came."

Throughout human history, then, the two Cities are intermingled ("invicem permixtae") so as to become, at times, almost indistinguishable. But this confusion will end with the Last Judgment. Then those who "are not inscribed in the Book of Life" will be committed to the Eternal Fire (of the nature and place of which St. Augustine admits ignorance); the rightful earthly citizens of the City of God, however, will "attain what the Holy Angels have never lost," that is to say unforsakable immortality and everlasting incapacity for sin. They will be permanently united with the Angels, Saints, and Prophets and will rest and rejoice before the face of the triune God. At the same time the form of the material universe will be destroyed by fire as it was once destroyed by the Flood, and its substance, purified from "the qualities which pertain to corruptible bodies," will be used for the creation of a "new heaven" and a "new earth" so that a perfected material world "may correspond to men perfected also in the flesh."

When trying to express these grand conceptions in visible form the illustrators of the *De Civitate Dei* could base themselves on a well-established tradition as far as the Last Judgment is concerned. It appears, in the usual form, at the beginning of the Twentieth Book. To illustrate the concept of the Two Cities and to visualize the ultimate glory of the City of God, the artists had to resort to invention or at least to adaptation. The final beatitude of the Elect is depicted in a composition which naturally belongs to the Last, or Twenty-Second, Book. The triune God, either in the guise of a single figure or of the explicit Trinity (which difference is unimportant from a theological point of view), is seen presiding over what has been not inappropriately termed "La Cour Céleste." It is composed of the Virgin Mary, for whom a special place of honor is frequently reserved on the right of God, "All Saints" including St. John the Baptist, the Apostles, Martyrs, Fathers, Confessors and ordinary Saints, and the personages of the Old Testament among whom Moses and David are particularly conspicuous.

The same "Court" also appears in the representation of the Two Cities which invariably opens the cycle of the "Cité de Dieu" illustrations. But here, where the artists had to depict the City of God as it exists before the Last Judgment, the assembly of Saints and Prophets is enclosed within the walls of a real city built on terrestrial ground. This city reaches into Heaven where, again, the triune God and the Virgin appear in their glory; but it rests on the earth, and its terrestrial aspect is often emphasized by the presence of ordinary human beings about to be admitted at the gates. The "terrena civitas" is depicted in front of—or, reading the picture as a plane surface, below—the City of God. It is a lively town, teeming with human activities both good and bad; it shares the earth with the City of God, but it is cut off

from Heaven; and while the "Civitas Dei" is governed by the Trinity the walls of the "terrena civitas" are surrounded by dancing devils.

It is now possible to determine the meaning of Dürer's Landauer altarpiece as opposed to that of the metal cuts in the printed French Horae which may be said to synthesize the tradition of the *"Cité de Dieu"* illustrations with the more recent iconography of the "Rosary pictures." Like Dürer's painting, these metal cuts divide the citizens of the City of God into two classes; but unlike it, they interpret this division as a dichotomy not yet resolved. The upper section, patterned after the fashion of the "Cour Céleste," depicts the heavenly citizens of the City of God. The lower zone, arranged according to the scheme of the "Rosary pictures," depicts the Christian community as it exists on earth. The members of this terrestrial community still need the visible Church—whose threshold can be crossed by human feet while its tower literally penetrates to Heaven—as a vehicle of Salvation. They have to wait for the day of Judgment when the City of God will be extricated from what St. Augustine calls "hic temporum cursus," and when its earthly citizens, united with the celestial ones, will be allowed "to rest and to see, to see and to love, to love and to praise."

This ultimate consummation is anticipated in Dürer's Landauer altarpiece. Those who are neither Saints nor Prophets have already been accepted among the beatified. They live in a lower zone of Heaven—for even Paradise cannot exist without a hierarchy—but they live in Heaven; and, as Dante paraphrases the words of St. Augustine:

> *"The principle of blessedness is this:*
> *To keep ourselves within the Will divine,*
> *So that, as we are ranked from grade to grade*
> *Through all the realm, we all are satisfied."*

The earthly citizens of the City of God, then, are proleptically transformed into heavenly ones, and it was probably for this reason that Dürer duplicated some of their most prominent representatives. The terrestrial community will not tolerate more than one Pope; the celestial one—in which the idea of the "Vicar of Christ" has lost its meaning—will include as many as are worthy.

In short, where the metal cuts represent the City of God as it exists in time, Dürer represents it as it will exist after time has come to an end; and this accounts for the fact that the frame shows the Last Judgment. It is not only a "serious admonition to the beholder," but forms an integral part of the iconography of the whole altarpiece. As in the illuminated manuscripts of the *"Cité de Dieu"* a picture of the Last Judgment had to precede the final glory of the "Cour Céleste," so Dürer's frame serves as a prelude to that which is fulfilled in the painting itself (*fig.* 175). Its aesthetic function—that of a "gateway" through which we enter the pictorial space—is thus in perfect harmony with its doctrinal content. The donor and his family had a traditional right to be placed "cum benedictis." Dürer had no claim to this proleptic beatification. But he was permitted to present himself as the only inhabitant of

a virgin world with the sun just rising above the horizon—the "terra nova" renewed after the Judgment.

We may safely continue to call the Landauer altarpiece *"The Adoration of the Trinity."* But a more precise and exhaustive appellation may be found in the title of the last chapter of St. Augustine's *De Civitate Dei:* "De aeterna felicitate Civitatis Dei Sabbatoque perpetuo" (*"The eternal Bliss of the City of God and the perpetual Sabbath"*).

This shifting of the scene from earth to Heaven created a situation similar to those which Dürer had depicted in the Apocalypse, and unquestionably he harked back to his earlier work in composing the Landauer altarpiece. In the woodcuts *St. John before God and the Elders* (*fig.* 77), and, most particularly, *St. Michael fighting the Dragon* (*fig.* 81), we find a similar combination of a preternatural apparition in the sky and a resplendent landscape seen in bird's-eye view below; and the hanging draperies of the Pope, the Emperor, and the King in the altarpiece, comparable to the fringe of a gigantic curtain, form a pattern not unlike the fringe of monstrous heads and tails in the *Fight with the Dragon.* Needless to say, the woodcuts appear almost two-dimensional in comparison with the painting. As could be observed in the adaptation of the *Martyrdom of the Ten Thousand* of about 1498 for Frederick the Wise's altarpiece of 1508 the realization of both space and volume by far transcends the possibilities of Dürer's earlier period. What had been a planar display of—comparatively speaking—semi-corporeal shapes is now a perspective arrangement of weighty figures emphatically modelled and beautifully posed, yet forming part of a numberless multitude. The figures in the foreground are followed by crowds which seem to emerge from the depths of space, and the gap between the Pope and the Emperor discloses a surging sea of humanity. The very narrowness of this gap creates the sensation of being drawn into a gorge, and this sensation is strengthened by the fact that the most prominent figures are no longer arranged symmetrically as in the preliminary drawing, but face each other on two parallel diagonals: in contrast with the Emperor and his companions, the Pope and the Cardinal turn their back upon the beholder—which also serves to stress their still somewhat closer connection with God.

In spite, or rather just because, of this emphasis on three-dimensionality, the effect of the whole is even more "visionary" than that of the Apocalypse. The very volume and weight of the figures makes the beholder aware of their miraculous suspension, and the very force of the perspective effect compels him to realize his own fantastic situation in relation to the spectacle. The picture has, most fittingly, two perspective "horizons," that of the earthly scenery and that of the heavenly apparition, the former being identical with the natural horizon of the landscape, the latter being determined by the eye level of the Pope and the Emperor. When the spectator tries to adapt his visual processes to these data—as he is forced to do by the irresistible power of the perspective realization, combined with the fact that he is arrested before a stationary altarpiece instead of handling a movable print—he can identify his own level of vision either with the earthly or with the heavenly "horizon." Whichever he does, he will have a visionary experience. If he adopts the earthly "horizon" he will retain,

aesthetically, his normal position on the ground and will experience what may be called a vision by preternatural perception. If he adopts the heavenly "horizon" he will be transported, aesthetically, to the sky where, to quote Wölfflin, "the miraculous seems near and the ordinary far away," and will thus experience what may be called a vision by preternatural locomotion. Since in Dürer's altarpiece the importance of the terrestrial scenery is deliberately suppressed—much more so than in the preparatory drawing—this second possibility will suggest itself more forcefully and will generally be accepted. There is only one work of painting approximately contemporary with the Landauer altarpiece which conveys a similar impression: Raphael's Sistine Madonna.

V · Reorientation in the Graphic Arts; the Culmination of Engraving, 1507/11-1514

FROM the point of view of those Venetian painters who claimed that Dürer "did not know how to handle color" the paintings produced between 1507 and 1511 are retrogressive. While the *Adam and Eve* in the Prado is still vaguely Bellinesque in style, a gradual hardening of form and lessening of coloristic refinement can be observed in the three great altarpieces. The *"Adoration of the Trinity"* is almost metallic in comparison with the *"Feast of the Rose Garlands"* (note, for instance, the treatment of the papal *pluvialia* in these two pictures), and its colors offer the variegated aspect of a bright and cheerful peasant's garden. In the windows of the "Allerheiligenkapelle"—where, it is true, the very medium suggested a planar and linear mode of expression—and in some related workshop drawings (640, 641, 873) we may detect a tendency to revert not only to the spirit but to the style of the Apocalypse.

In the following years—again a "maximum" period—Dürer lost interest in painting altogether. No picture was produced between 1513 and 1516, and the two painted works of 1512 are merely the aftermath of the preceding phase. One of them is a Madonna in half length generally referred to as the *Virgin with the Pear* (Vienna, Gemäldegalerie, 29), where a Virgin Mary reminiscent of the sweet, smiling maidens of Nicolaus Gerhaert von Leyden is combined with an almost Michelangelesque Infant Jesus freely developed from a drawing of 1506 (736). The other is a pair of portraits representing the Emperors Charlemagne and Sigismund (Nuremberg, Germanisches Museum, 51 and 65), the general composition of which had already been established in a "Visierung" of 1510 (1008).

In one of his Venetian letters, we remember, Dürer made fun of Pirckheimer's saltatorial exploits on the occasion of the "Feast of the Imperial Insignia." This merry Feast, called "Heiltumsfest" or simply "Heiltum," was celebrated in Nuremberg about Easter time when the crown jewels of the German Emperors (now happily restored to the "Schatzkammer" in Vienna after their transference to the Germanisches Museum) were exposed to public view. They had been in the custody of the city since 1424 and were normally kept in the "Spitalkirche." During the festivities, however, they were exhibited on the Market Square during the day and locked up in one of the adjacent houses, the "Schopperhaus," at night. Here a special room was set aside for the purpose, and it was as decoration for this room that Dürer was asked to portray the august personages who had figured most prominently in the history of the insignia: Charlemagne, who was supposed to have been their original owner, and Emperor Sigismund, who had entrusted them to the city of Nuremberg.

In the drawing of 1510 (*fig.* 176) both Emperors appear in three-quarter profile, but the superiority of Charlemagne is emphasized by a difference in scale as well as in costume. The

stooping figure of Sigismund—portrayed with the aid of a contemporary likeness preserved to us in mediocre copies—is dwarfed by four shields which occupy much of the available space; he is clad in simple garments and wears a humanist's wreath instead of an Imperial crown. The figure of Charlemagne, erect and with the space above him filled only by the shields of France and Germany, looks considerably taller, and his appearance conforms to a legendary or fairy-tale-like conception of grandeur. He has a long, snowy beard, a huge Gothic crown, a broad collar of ermine, a mantle of heavy brocade and an imposing scepter. However, Dürer was too much of a scholar to be satisfied with this romantic image. He made a careful study, in the same year, of the historic objects preserved in the "Spitalkirche" and rendered them in water color drawings which might well serve as illustrations for an antiquarian treatise (1010-1013). Even the actual length of the Imperial sword, which was too long to be shown in the drawing, was indicated by a piece of string attached to the paper (1011). On the basis of these meticulous studies the figure was revised in a drawing where the legendary Charlemagne is replaced by an "historical" one, beardless and clad in the correct Coronation garb (1009).

The panels themselves (*fig.* 177) were completed early in 1513. Well over life size and executed with the greatest possible accuracy, they delight the beholder, not by pictorial blandishments but by the very profusion of precise and glittering detail. In interpretation, they represent a compromise between popular imagination and archeological correctness. Charlemagne was equipped with the authentic insignia, but in person he appeared again, as simple people liked to think of him: as a kind of secular God the Father with a long white beard and flowing locks. Since he now wore the low octagonal crown and the Imperial sword which were believed to have been worn by him in life, his former attributes, the Gothic crown and the scepter, could be transferred to Sigismund. But while a certain external equality was thus established between the two rulers, the inward superiority of Charlemagne became all the more evident. Tall, erect, and—the most important change from the "Visierung"—rigidly frontalized, he overshadows his humble successor the more the latter's appearance lays claim to imperial dignity.

WHILE DÜRER THE PAINTER thus drifted away from the ideals of "pictorialism" and ultimately abandoned brushwork for a period of more than three years, his evolution as an engraver and woodcut designer, which had been interrupted by his stay in Venice, took a diametrically opposite course. His graphic works became luminaristic and tonal in proportion as his paintings became linear and polychromatic; and his most famed, and indeed most accomplished engravings were made at a time—in 1513 and 1514—when the production of paintings had ceased altogether. It is as though Dürer's activities in a medium which was more properly and exclusively his than brushwork had been stimulated and redirected by the very same impulses which had ceased to be fruitful in the domain of painting.

The post-Venetian woodcuts and engravings differ from the pre-Venetian ones in the same way that ordinary pen and ink drawings differ from drawings on colored paper height-

ened with white: they give what may be called a *clair-obscur* effect. This term is borrowed from those woodcuts which are printed from two blocks in two different tones. The outlines and the deepest shadows are cut upon the "key block" which is inked with black or the darkest tone desired. The lighter shadows are cut upon a "tint block" which supplies the middle tone, and the highlights are cut into both blocks so that, when printed, the white paper will show. The principle of these *clair-obscur* woodcuts is indeed the same as that of drawings on colored paper heightened with white. In both cases the lights and shadows are set out against a neutral middle tone in relation to which they appear as positive and negative values—with the only difference that the woodcuts express this middle tone by printer's ink and suggest the lights by white paper, whereas the drawings suggest the middle tone by colored paper and express the lights by heightenings.

To achieve an analogous effect in ordinary woodcuts and engravings Dürer had to create by linear means a value equivalent to the colored paper in white-heightened drawings, and to the "tint block" in *clair-obscur* prints. He had to stipulate that, as a solidly colored surface of medium darkness is accepted as a middle tone in relation to darker and lighter areas, so a system of parallel hatchings of medium density be accepted as a middle tone in relation to hatchings of greater density—particularly cross-hatchings—and to the blank paper. The introduction of this "*graphic* middle tone" constitutes in fact the main difference between the prints produced before and after Dürer's second trip to Venice. As we remember, an aesthetic transformation of material paper into incorporeal light had already been accomplished in his earlier woodcuts and engravings. But in these the scale of luminary values extended simply from "light" to "dark." In the post-Venetian prints it runs, simultaneously, from "neutral" to "light" on the one hand, and from "neutral" to "dark" on the other. The range of shades, extending, as it does, in two directions, thus seems both wider and more subtly differentiated. What had been an aggregate of contrasting spots or patches became a continuum of modulated "*tones*," as though a polyphonic system had been replaced by an harmonic one.

From a purely technical point of view this brought about two significant changes. First, the hatchings had to be made more uniform in direction and thickness and, more important, they had to achieve a similar independence of the plastic form as had, for instance, the shadows in the Berlin portrait of a Venetian lady. Second, the distribution of luminary values had to be altered. While in the earlier prints comparatively small areas of black seem to be superimposed on a basic surface of white, in the later ones the impression is of comparatively small areas of white reserved from a basic surface of gray.

Let us compare, for instance, the *Ascension and Coronation of the Virgin* (314, *fig.* 178) with any woodcut of the pre-Venetian period such as *St. Michael Fighting the Dragon* (292, *fig.* 81) or, to narrow down the chronological difference as far as possible, the *Presentation of Christ* (308, *fig.* 144). In the print of 1510 we perceive at once a tonal unity entirely absent from the earlier woodcuts. Every luminary value can be appraised in relation to the gray of large, frontal surfaces whose straight, protracted hatchings establish what we have

called the "graphic middle tone." The deep shadows thus strike us as much darker, and the high lights, particularly the quivering haloes cut out of the nocturnal sky, as much lighter than in the earlier prints. The individual figures and objects are modelled by lines more regularly spaced, more protracted, and organized into more extensive areas; and the most startling innovation is the suppression of plastic relief in favor of tonality wherever solid bodies lie in a shadow of medium depth. In such cases straight horizontal hatchings similar to those employed for the shading of architectural backdrops or the nocturnal sky are run across such rounded forms as the right knee of God the Father, the right leg of the Virgin Mary, or the drapery of the Apostle with the open book. As a result, the forms so treated contribute to the compositional pattern as tonal values rather than as plastic volumes.

EXCEPT FOR A DECORATIVE BORDER first used for a book by Pirckheimer which appeared in 1513 (408) and a *St. Jerome in his Cave* of 1512 (333), all the woodcuts here to be considered were executed between 1508/09 and 1511. Setting aside a few broad-sheets and book illustrations (221, 275, 352, 353), they can be classified under three headings. First, the Small Passion, published in 1511. Second, a number of single woodcuts, all of them either "half sheets" or "quarter sheets" except for the large *Trinity* of 1511 (342). Here and in other cases the prints are single compositions in the full sense of the term; but the much-imitated *Martyrdom of St. John the Baptist* (345) has a counterpart in *Salome Bringing the Head of St. John to Herodias* (346); and three subjects, namely *St. Jerome in his Cell* (334), the *Mass of St. Gregory* (343) and *David in Penitence* (339, commonly known as *"Der Büssende,"* the royal penitent bearing Dürer's own features) still seem to reflect the program of the unfinished *"Salus Animae."* The third group includes the woodcuts added to what Dürer calls "Die drei grossen Bücher," that is, the Apocalypse, the Large Passion and the Life of the Virgin. As we remember, Dürer—signing himself as the publisher—brought out these "Three Large Books" in 1511, the Apocalypse in a new Latin edition, the two others —with Chelidonius's versified explanations printed so as to face the corresponding pictures— for the first time. The Apocalypse needed only a Frontispiece to be combined with the beautiful title already extant (280). The Large Passion and the Life of the Virgin were also provided with Frontispieces (224 and 296); but in addition they still lacked several pages, all of which were executed in 1510. To the Large Passion were added: the *Last Supper* (225), the *Betrayal of Christ* (227), the *Harrowing of Hell* (234), and the *Resurrection* (235); to the Life of the Virgin: the *Death of the Virgin* (313), and her *Assumption and Coronation* (314).

It is not possible here to analyze all these woodcuts individually and to show how the *clair-obscur* principle prevails throughout. Suffice it to mention some further good examples of straight horizontal hatchings running across convex forms—for instance, several figures in the *Last Supper*, the Baptist and the companion of Salome in the *Martyrdom of St. John*, the Eve in the *Harrowing of Hell* (*fig.* 87)—and to point out the amazing flexibility of the new style. Now, it serves to sharpen the terror and confusion of the *Betrayal*; now, it lends

color to the weird yet somehow humorous inferno of the *Harrowing of Hell* (*fig.* 179) which delighted such Mannerists as Beccafumi and Bronzino; and then again it enhances the serene dignity of an *Adoration of the Magi* (223, *fig.* 184) where the compositional ideas of the Life of the Virgin appear to be revised according to the standards of the High Renaissance.

One phenomenon, however, deserves some special consideration: a curious revival of the "visionary" within the framework of the new woodcut style.

The *Assumption and Coronation of the Virgin*, added to the Life of the Virgin in 1510 (*fig.* 178), is evidently derived from the Heller altarpiece of 1508/9 (*fig.* 168). Yet the differences are no less important than the similarities. In the first place, the woodcut is less hieratic in character and attempts to impress the beholder by sentiment and concrete associations rather than by solemnity. Christ no longer wears the papal tiara, and His posture is both simpler and more moving than in the painting; He bestows the crown with His left hand so that His arm no longer overlaps His chest, and His head is not quietly turned to full profile but is thrown back with a pathetic expression of suffering. Furthermore the scene is enriched by all those paraphernalia essential to a "real" funeral in the popular mind; there are books, censers, asperges, and processional crosses, and in the foreground is seen a bier which had been present in some of the more archaic representations (for instance in the drawing no. 520), but was significantly absent from the Heller altarpiece.

In the second place, the Apostles are no longer aligned on two diagonals symmetrically divergent from the center, but on two parallel lines, with a canyon of space in between; in this respect the woodcut of 1510 bears the same relation to the painting of 1508/9 as the "*Adoration of the Trinity*" of 1511 (*fig.* 172) to its preparatory drawing, likewise of 1508 (*fig.* 174).

In the third place, the luminary values are reversed so that the relation between the woodcut and the painting may be compared to that between a photographic negative and the positive print. In the panel the Coronation group and the Apostles with the landscape form two comparatively dark areas separated by a bright strip of sky. In the woodcut we have two comparatively bright areas separated by a dark strip of forest. The Coronation group detaches itself as a luminous apparition from a "middle tone" background, and this is bordered by a white band of clouds which offers the strongest possible contrast to the gloom of the terrestrial scenery. The introduction of this contrast is a conscious reversion on Dürer's part to the Nemesis engraving (*fig.* 115) where a similar fringe of bright clouds overhangs a darkening landscape. However, while the Nemesis is silhouetted against the clear sky, the Coronation group stands out from a mass of gray which, like a miraculous curtain, seems to obliterate the physical sky as well as the things on earth. We are not transported to dizzy heights, for the perspective conditions are entirely normal. Instead of the landscape being represented in bird's-eye view, the visual horizon coincides with that of the Apostles. But for this very reason the effect is all the more mysterious. The scene in Heaven, with the band of clouds coming down so as to overlap the visual horizon, is brought so near to the beholder that the celestial

apparition seems to descend upon the earth; it fills him with wonderment, not so much by defying the objective laws of nature as by abolishing the subjective distinction between hallucination and reality.

Similar principles of composition and interpretation can be observed in the last woodcut of the Large Passion, commonly quoted as the *Resurrection of Christ* (235). In reality it fuses the Resurrection with the Ascension just as the Assumption of the Virgin had been fused with the scene of her Coronation; and the miracle is made visible and credible by analogous methods. According to a scheme developed in Italy, but contrary to the Northern tradition to which Dürer adhered in his two other prints (124 and 265), Christ is not represented standing on the ground or on the lid of the sarcophagus, much less in the very act of stepping out of the tomb; He is miraculously suspended above the grave. As in the Coronation woodcut, the figure is set out against a "neutral" background bordered by a band of radiant clouds which cuts into the gloom of a nocturnal scenery. The apparition descends even farther than in the *Coronation*, and again we have the impression that a magic curtain is lowered so as to invade our field of vision and to transfigure rather than overthrow the natural world.

In the *Mass of St. Gregory* of 1511 (343, *fig.* 183), where the Man of Sorrows and the instruments of torture appear to the Saint while he is celebrating Mass, the miraculous event is depicted in an entirely different and perhaps still bolder manner: the natural space is not merely encroached upon or disrupted by a supernatural force, it simply dissolves. The scene is, of course, supposed to take place in the Basilica of St. Peter. But Dürer had the audacity to abolish every indication of an architectural setting. No walls, no piers, no windows or vaults are depicted. They are wiped out by an impenetrable darkness—as though Mass were read by night in the open air—from which emerge white clouds and two adoring angels. Floating in this amorphous darkness, yet endowed with the semblance of full reality, are seen such heavy objects as the hammer, the tongs, the dice, the bust of Judas and his purse. The column, the ladder with the spear and reed, and the cross (on which is perched the cock of St. Peter) stand or lean on the altar as palpably as the candlesticks and the chalice; and the retable is transformed into a stone sarcophagus from which arises the figure of Christ. The visionary effect is achieved, not by a mere interpenetration of the natural world with the supernatural, but by what a spiritualist would call the "dematerialization" of tangible objects coupled with the "materialization" of imaginary ones.

The last step is taken in the Frontispieces of the "Three Large Books," all executed in 1511. Each of them shows a scene of miraculous or mystical character which takes place on terrestrial ground. But the ground itself is lifted into a transcendental environment, thereby presenting a spectacle which the beholder can interpret only as a vision experienced by himself.

The Frontispiece of the Life of the Virgin (296, *fig.* 181) shows a combination of the "Virgin of Humility" (the Virgin Mary sitting on the ground) with the "Apocalyptic Woman" (the Virgin Mary "clothed with the sun, and the moon under her feet"). A fusion of these two images—one realistic and humble, the other visionary and sublime—is not unusual in earlier art and was in fact inherent in the concept of the "Virgin of Humility" as

such—a concept based on that very "coincidence of opposites" which Dante expressed in the Prayer of St. Bernard:

> *"Virgine Madre, figlia del tuo Figlio,*
> *Umile ed alta più che creatura..."*

> (*"Virgin and mother, daughter of thy Son,*
> *Humble and lofty more than any being..."*).

However, if we compare Dürer's woodcut with one of these earlier representations, for instance with a beautiful Flémallesque panel in the Muller Collection at Brussels, we perceive that Dürer reversed the relationship between the natural and supernatural elements. In the Brussels picture the Virgin is seated on a pillow placed on the ground, and the crescent, debased to the rank of a mere attribute, is rendered as a tangible object lying beside her on the lawn. In Dürer's woodcut also the Virgin is depicted on a pillow which rests on a plot of grass. But instead of the crescent lying on the ground the whole group, including the pillow and the piece of ground, is inscribed within the crescent, and the crescent is in turn suspended in a starry sky. A fragment of the earth has been bodily moved into Heaven, and the beholder has to accompany it into a sphere of visionary unreality.

In the Frontispiece of the Apocalypse (280, *fig.* 180) St. John the Evangelist is seen on the island of Patmos. Accompanied by his eagle and seated by a grassy ledge on which he has deposited his inkpot and pen box, he sees and describes the "Apocalyptic Woman" who here appears, not as the "Virgin of Humility" but as a half-length figure radiantly appearing in the sky. But again the whole scene is transposed into a supernatural sphere; St. John the Evangelist, the eagle, and the grassy ledge with inkpot and pen box are miraculously poised in the void, supported only by a band of clouds. St. John on Patmos appears as a vision to the beholder at the very moment when the "Apocalyptic Woman" appears as a vision to St. John on Patmos.

The Frontispiece of the Large Passion, finally, shows what, at first glance, seems to be an incident of the Passion itself (224, *fig.* 182). Christ, crowned with thorns, is seated on a bench of stone, wringing His hands with grief and despair; two scourges lie on the ground, and before Him is kneeling a soldier who offers Him a reed with sneering reverence. The scene thus seems to be identical with the Mocking of Christ as described in *Matthew*, XXVII, 29. But that Dürer did not intend to illustrate any specific event of the life of Christ on earth is demonstrated by the five wounds in His body and by the band of clouds which, as in the Frontispiece of the Apocalypse, removes the scene from the terrestrial realm. It is not a portrayal of the Christ Incarnate mocked by the soldiers of Pilate, but becomes for us a vision of the Eternal Christ Who has completed His Passion on earth and yet continues to be tortured by the sins of mankind. The woodcut makes us "see" the sufferings still inflicted upon Christ by our own wickedness; and the idea of a "Perpetual Passion"—definitely unorthodox,

but widely accepted by popular feeling in Dürer's time—is also brought home to the beholder by the verses with which he is apostrophized by Christ Himself:

> *"These cruel wounds I bear for thee, O man,*
> *And cure thy mortal sickness with my blood.*
> *I take away thy sores with mine, thy death*
> *With mine—a God Who changed to man for thee.*
> *But thou, ingrate, still stabb'st my wounds with sins;*
> *I still take floggings for thy guilty acts.*
> *It should have been enough to suffer once*
> *From hostile Jews; now, friend, let there be peace!"*

Thus interpreted, the Frontispieces of the "Three Large Books" are cognate not only with one another but also with the most monumental woodcut of the period here under discussion, the large *Trinity* of 1511 (342, *fig.* 185). This shows the modern and more emotional version of the "Throne of Mercy"—with God the Father holding the broken body of Christ instead of the Crucifix—which is best represented by a lost but often copied and widely imitated composition by the Master of Flémalle. But Dürer "visionized" the traditional scheme just as he had the St. John on Patmos, the Mocking of Christ, and the "Virgin of Humility." Crowds of Angels approach from either side, carrying the instruments of torture, supporting the arms of the dead Christ and spreading out the papal *pluviale* of God the Father into the likeness of the tent or baldaquin which is frequently seen in earlier representations; and this whole group is mysteriously suspended before a somber sky lit up by milky clouds and by the electric flashes of the halos. In the *"Adoration of the Trinity"* in Vienna God the Father is at least enthroned on a rainbow. Here He floats in the void; and to make the apparition even more incommensurable it is elevated beyond the sphere of the Four Winds, that is, according to pre-Copernican cosmology, beyond the limits of the physical universe. Once more Dürer conjured up a vision to be experienced by a beholder "transported" both in the literal and the figurative sense of the word.

Small wonder that this subjective approach to the most sacred and transcendent concept of Christianity impressed the following generations even more deeply than Dürer's contemporaries. His composition was to live on—to mention only a few of many instances—in Cigoli's *Trinity* in Sta. Croce in Florence, in Tintoretto's mystical *Lamentation* in the Palace of the Doges, and, above all, in Greco's *Throne of Mercy* in the Prado.

THE SMALL PASSION (236-272) can best be considered together with what may be called its more sophisticated counterpart, the Engraved Passion (110-125). Both series were prepared and executed more or less simultaneously (the Small Passion published in 1511, with two woodcuts dated 1509 and two 1510; the Engraved Passion published 1513, with the dates of the individual prints ranging from 1507 to 1512). And both are in part retrospective. In three pages of the Engraved Passion—the *Agony in the Garden* (111), the *Betrayal of Christ*

(112) and *Christ before Pilate* (114)—Dürer reverted to the "Green Passion" (556, 523/566, 525/570). The Small Passion, on the other hand, can be associated with the Life of the Virgin. Three scenes—the Annunciation, the Nativity and the Leave-Taking of Christ —occur in both series, and it has already been mentioned that this duplication may reflect an original program according to which the Life of the Virgin was to be followed by the Passion of Christ. But the relationship is not restricted to the subject alone. The *Annunciation* (239) and the *Leave-Taking of Christ* (241) are variations on the corresponding woodcuts in the Life of the Virgin (303 and 312) rather than new inventions, and in the case of the *Nativity* (240) an even closer connection can be established.

This woodcut (*fig.* 192) differs from the rest of the Small Passion, first, in that the figures are much smaller in scale; second, in that the design is more minute, particularly in such details as draperies and foliage; third, in that the scene is staged on a platform seen *di sotto in sù*, with the additional anomaly that the vanishing point of this platform and the adjoining steps does not coincide with that of the roof. It has rightly been felt that the small-ness of the figures and the tendency toward particularization are reminiscent of the Life of the Virgin, and it has even been proposed to date the woodcut about 1504 rather than about 1509. But this hypothesis does not explain the unusual features of the perspective and is at variance with the technical treatment. What seems more likely is that Dürer reused a drawing originally made at the time of, and probably in connection with, the Life of the Virgin. Since the latter is more than twice as large as the Small Passion, the composition had to be cut down at the margins (witness the truncation of the building as well as of the St. Joseph) and, in addition, to be reduced in scale. Thereby the figures became much smaller than those in the other woodcuts, and the curious, almost Tintorettesque substructure in worm's-eye perspective was added in order to push the figures back into space and thus account for their diminution in size.

With respect to period, then, and in view of their somewhat retrospective tendency, the Small and Engraved Passions can be regarded as parallels. But here the similarity ends. From every other point of view the two series offer a contrast eloquently illustrative of the difference between their respective media.

The very format of the Engraved Passion differs from that of the Small Passion by what may be called an aristocratic slenderness of proportion: it is about 4.5 by 3 inches as against about 5 by 4. No textual interpretation was deemed necessary, for the engraved series was not conceived as an edifying book, but rather as a "collector's item," to be relished by the art-lover instead of read by the devout. In fact there were collectors in the sixteenth century who had the engravings treated so as to suggest the appearance of precious miniatures. In defiance of Erasmus's judicious remark: "If you would spread on pigments you would injure the work," the prints were occasionally illuminated with color, heightened with gold and silver, and even mounted on leaves of vellum the borders of which were decorated with hand-painted flowers and little animals, as was the custom of late fifteenth and early sixteenth century book illuminators.

The engraved series is preceded by a Frontispiece—a *Man of Sorrows* according to St. Bridget—and is concluded by *Sts. Peter and John Healing the Lame*. This piece was appended in 1513, either because Dürer wished to round out the number of prints to a full sixteen which could be printed on a "whole sheet" without waste, or because he planned to follow up the Passion of Christ with the Acts of the Apostles; it is, characteristically, absent from most of the copies bound in the sixteenth century. The Passion proper comprises only fourteen decisive incidents, beginning with the *Agony in the Garden* and ending with the *Resurrection*.

In the woodcut series, the drama of the Passion, paraphrased by Chelidonius in varying classical meters, unfolds in a much wider perspective. Ushered in by a Frontispiece which again brings home the idea of the "Perpetual Passion" (236), the sequence opens with the *Fall of Man* and the *Expulsion from Paradise*. The Passion proper is preceded by the *Annunciation*, the *Nativity* and the *Leave-Taking of Christ*; and the *Resurrection* is followed by four of the "*Appearances*" (Christ appearing to His Mother, to the Magdalen, to the Disciples of Emmaus, and to St. Thomas), the *Ascension*, *Pentecost* and the *Last Judgment*. All in all, there are, including the Title Page, thirty-seven woodcuts as against sixteen engravings, and the scenes of the Passion proper number twenty-four as against fourteen, including as they do the *Entry into Jerusalem*, the *Expulsion of the Money-Lenders*, the *Last Supper*, the *Washing of the Feet*, *Christ before Annas*, the *Mocking of Christ*, *Christ before Herod*, *St. Veronica with the Sudarium*, the *Nailing to the Cross* and the *Descent from the Cross*.

The program of the Engraved Passion is thus less comprehensive than that of the Small. But in spite of its brevity the engraved series has something sumptuous about it. Every scene is carefully worked out with architecture and furnishings, bizarre physiognomies, picturesque costumes and fanciful armor, and emphasis is placed on the refinements of lighting and surface texture. The Engraved Passion stresses spiritual suffering rather than physical torture and never loses sight of the preterhuman dignity of Christ. The shrillest note is struck in the *Agony in the Garden*—a scene of purely mental anguish—while the *Crucifixion* is pervaded by a spirit of resignation and peace. The opposite is true of the Small Passion. It emphasizes the human side of the tragedy, from the magnificent wrath of the *Expulsion of the Money-Lenders* to the quiet sadness of the *Washing of the Feet* and the cruel violence of the *Derision*; and while the narrative as a whole has the redundancy of a popular Mystery Play the individual incidents are told concisely and directly. The treatment is forceful at the expense of delicacy. Picturesqueness and psychological refinements have been suppressed in favor of strong and simple emotions.

The engraved version of *Pilate Washing His Hands* (*fig.* 188), for instance, is so rich in details and so subtle in interpretation that it demands unhurried and sensitive contemplation. The eye of the beholder will delight in the contrast between the threatening darkness of the architecture and the brilliance of a beautiful landscape; his attention is likely to be arrested by the obsequious Jew who still harangues the Governor, and particularly by the negroid servant who, grotesquely arrayed and illumined by the strongest light, is placed

right in the center of the composition. It may take him some time to perceive the figure of
Christ as He is led away by two soldiers, and still more to discover that Pilate does not listen
to his interlocutor. Deaf to what he hears and blind to what he sees, the Governor seems to be
shut within himself, tragic and lonely like the Saul in Rembrandt's late picture in The Hague.
The language of the woodcut (*fig.* 190) is much more direct. The eye is caught at once by the
tall figure of Christ. No picturesque servant detracts from the basic antithesis between Him
Who is dragged to His death and him who is left behind with the burden of his thoughts.
There is a strange void around the figure of Pilate; his loneliness is not expressed obliquely
by his not listening to an interlocutor, but, more directly, by the absence of anyone who
would dare speak to him.

Similar differences can be observed throughout. In the engraved *Lamentation* (*fig.* 186)
the mourners sigh; in the *Lamentation* in woodcut they cry out—not to mention the more
pitiful aspect of the dead Christ—and the Magdalen kisses His feet. The engraved *Deposi-
tion* is a masterpiece of intricate foreshortening, and the felt hat of the wealthy burgher
viewed from the back may have attracted more comment among the experts than anything
else. In the strictly frontalized composition of the woodcut nothing disturbs the atmosphere
of silent grief.

In the engraved *Resurrection* the figure of Christ is not only patterned after the Apollo
Belvedere—this is the rule with Dürer's renderings of this scene, and certainly intentionally
so—but it is also made to stand on the sarcophagus as on a pedestal, exalted and remote like
a beautiful statue. In the woodcut (*fig.* 193) He steps into the midst of the soldiers so that
His foot comes in actual contact with one of theirs; but in the distance is seen the rising sun,
a symbol of the Resurrection so deep and wide that it bridges the gap between the spiritual
and the natural world, and even between Christianity and Paganism. To quote once more
from Chelidonius:

> *"This is the day on which the Lord of Lords*
> *Began to build the world; sacred by ageless*
> *Religion to the King of Heav'n and Phoebus.*
> *This is the day when the all-seeing sun,*
> *Slain on the cross, so as to set in night*
> *And hide in death, splendidly rose again."*

The most significant contrast exists between the two interpretations of the *Bearing of
the Cross*. In the engraving (*fig.* 189) Dürer reverted to a formula prevailing in Byzantine,
Italian and Italianate art, but very rarely retained by Northern artists of the fifteenth
century: instead of breaking down under the weight of the Cross, Christ walks proudly
erect. His figure dominates a pyramidal group comprising, besides Himself, a bestial soldier
on His left and the kneeling Veronica on His right. This group is brought into relief by con-
centrated light; but just the figure of Christ is left in darkness, except for those parts—His

face, the drapery across His shoulder, and His raised right arm—which are the most important, not only in that they mark the apex of the pyramid, but also in that they establish a connection between His figure and that of St. Veronica. The emphasis is not on physical action and physical suffering but on the spiritual relationship between the Saviour and the believer, a relationship all the more subtle as the face of the kneeling Saint remains almost invisible. In the woodcut (*fig.* 191) the interest is divided between this silent dialogue and violent action. Here Dürer retained the more usual type of composition which he had used in the Large Passion (*fig.* 89), repeating even the motif of the callous soldier who stabs the neck of Christ with a stick. But the figure of Christ no longer displays the beautiful pose of the classical Orpheus. He goes to his knees with a terrific impact; His right arm stiffens in an attempt to break His fall; His left hand clutches the lower part of the cross, instead of being raised with an elegant *contrapposto*; His head hangs from His shoulder as from a rack. It is only by excruciating effort that His glance catches the eye of St. Veronica, so that her very piety adds to His suffering.

Some of the scenes represented in the Small Passion but absent from the engraved series, such as the *Mocking of Christ*, the *Nailing to the Cross* or *Christ before Annas*, show a similar emphasis on torture and brutality, and the *Descent from the Cross* verges on the horrible. The broken body of Christ, head downward, lies across the shoulders of a lansquenet like the carcass of a slaughtered animal, its upper part is almost obliterated by a harsh foreshortening, the face is wholly invisible, and the helpless hands and dishevelled hair convey a sense of almost unbearable misery.

In other woodcuts, however, we find a feeling of tenderness and human warmth which is absent from the Engraved Passion and dear to those of whom it has been said that "theirs is the kingdom of heaven." Nothing can be gentler and sadder, yet fuller of promise than the transfigured Christ appearing to the Magdalen, His face in the shadow of the broad-brimmed gardener's hat, the blade of His spade shining before the sky, and—again—the "sun of righteousness" rising behind Him. Nothing can be simpler, yet more solemn than the gesture with which He breaks the bread for the disciples of Emmaus so that "their eyes were opened and they knew Him."

This atmosphere of sympathy and human kindness is felt most intensely in the *Fall of Man* (*fig.* 194). Like the engraving of 1504 (*fig.* 117) this woodcut must be interpreted in the light of the theory according to which the sin of Adam subjected mankind to the domination of the "four humors" and thus dragged it down to the level of animals. This theory, as we remember, existed in two versions. According to the one, man had originally no "temperament" at all, whereas every animal had one of the well-known four. According to the other, man was originally "sanguine," whereas the animals were either "choleric," "phlegmatic," or "melancholy." In the engraving, Dürer had accepted the first of these variants; he had set out the impersonal, or rather pre-personal, perfection of Adam and Eve against the characteristic qualities of four species of animals. In the woodcut he kept to the second version. Only three beasts are depicted, and they symbolize the non-sanguine

temperaments, the lion standing for "choleric" wrath, the bison for "melancholic" gloom and inertia, and the particularly conspicuous badger, notorious for his laziness, for "phlegmatic" sloth. The "sanguine" temperament is represented by Adam and Eve themselves; they illustrate its most characteristic feature, the capacity and inclination for love (see *fig.* 217). While yielding to temptation, they are clasped in an embrace of, as yet, paradisiacal innocence. Their happiness is not to last; but their endearments contribute to the scene a delightful note of affection and tenderness and foreshadow a companionship which, however much changed by the fateful event, will be their and their offspring's heritage for good or worse. In fact it was possible for Dürer to employ the same preparatory drawing (459, *fig.* 195) both for the *Fall of Man* and for the *Expulsion from Paradise* (238).

This almost idyllic interpretation of mankind's tragedy appealed to other Northerners, including the youthful Hans Holbein. Other artists borrowed from other pages of the Small Passion, and still others preferred the engraved series. Here, as always, the character of a given work may be judged by the character of those who were influenced by it.

The Engraved Passion, for instance, appealed to Andrea del Sarto, especially in his earlier period. In his *Sermon of St. John the Baptist* in the Scalzi Cloister at Florence of 1515 he took over, quite literally, the monumentally impassive bystander seen in the foreground of the engraved *"Ecce Homo"*; he was attracted by the strange outfit of the figure as by something "bizarre" or even exotic, but he also understood its simple, almost Masacciesque grandeur and its compositional significance. Like Dürer, he used it as a massive pier or pylon which would consolidate the right-hand corner of the composition and would serve as a "repoussoir" for a group of people farther back; and he retained its diagonal relation to the main figure. But while Dürer's Christ appears not only on a higher level but also in a more distant plane, Sarto's St. John is pushed forward so as to be "in line" with the borrowed onlooker, and the latter's weight is balanced by two figures standing in the left-hand corner of the picture.

The Small Passion, on the other hand, had its deepest effect on artists who were concerned with expression rather than with formal equilibrium. Jacopo da Pontormo's magnificent insanity seized upon and exaggerated Dürer's Gothicism as Sarto's reasonableness appropriated and emphasized his classical tendencies. Pontormo's frescoes in the Certosa di Val d'Ema draw from all the printed series of the Passion; but the emphasis is definitely on the woodcuts. In the *Lamentation* only some details are reminiscent of the engraved version while the composition as a whole appears to be inspired by the woodcut in the Large Passion; in the fresco of Christ before Pilate Pontormo fuses motifs from the Engraved and the Small Passions into an indissolvable unity; and in the *Resurrection* he out-Dürers Dürer in combining the contorted postures of the soldiers in the woodcut from the Small Passion (*fig.* 193) with an ultra-Gothic Christ floating upward like a wisp of smoke.

The greatest posthumous triumph, however, was reserved to the woodcut *Christ driving the Money-Lenders from the Temple* (243). The figure of the irate Lord falling upon the

desecrators with a bunch of heavy ropes was copied by young Rembrandt at a time—1635—
when he strove for drama rather than sentiment. Then Dürer did for him what Pollaiuolo
and Mantegna had done for Dürer.

THE SAME INNOVATIONS in style and technique that could be observed in the woodcut field
distinguish the engravings of 1507-1512 from their pre-Venetian forerunners. They, too,
changed from a "black-on-white" style to a "white-and-black-on-gray," or *clair-obscur*,
style; and apparently this new principle was applied to engravings even before it was
extended to woodcuts. Dürer resumed burin work as early as 1507 whereas the earliest date
on a post-Venetian woodcut is 1509; and it is possible that the very idea of obtaining *clair-
obscur* effects by graphic methods was first suggested by the "Green Passion" which in
several instances furnished models for the engraved series.

However, the style of the one engraving of 1507, the *Lamentation of Christ* (*fig.* 186),
does not yet differ appreciably from that of 1504/05. The full force of a stylistic and
technical reorientation is felt in the engravings of 1508, two of them—the *Agony in the
Garden* (111) and the *Betrayal of Christ* (*fig.* 187)—belonging to the Engraved Passion
while two others—a *Crucifixion* (131, *fig.* 196) and a *Virgin on the Crescent* (138)—are
single prints. With the exception of the *Virgin on the Crescent* all these engravings of 1508
are "nocturnes," which was usual in representations of the Betrayal, but rare in renderings
of the Gethsemane scene and the Crucifixion, and altogether a novelty in prints. This very
fact bears witness to Dürer's wish to put the style of his engravings, too, on a *clair-obscur*
basis. The later pages of the Engraved Passion include three more "nocturnes": the *Cruci-
fixion* (120), the *Resurrection* (124), and, what is almost unprecedented, the *Bearing of
the Cross* (119, *fig.* 189). All the other engravings of the series, except for the *Lamentation*
of 1507, are at least composed in such a way that the figures detach themselves from a
darkish background, whether the scene is laid indoors or in the open air.

The first example of this new style appears to be the *Agony in the Garden* which bears
all the earmarks of a new departure including the tendency toward overstatement. Its tech-
nique is loose, rough, impatient, in parts reminiscent of dry point rather than orthodox burin
work. An explosive radiance emanates from the Angel and the cloud whence he emerges, so
that the figure of Christ is lit up as by the glare of a floodlight; and this violence in treatment
and lighting is matched by an emotional pathos still absent from the composition of 1504
which served as a basis for the engraving (556). The earlier composition already shows Christ
throwing up both His hands in utter despair. But in the engraving the pathos of this gesture
is immeasurably enhanced. The tense figure, lengthened in proportions and enlarged in scale,
forms a sharp contrast with the recumbent form of St. Peter which fills the previously empty
foreground; it is placed much higher and is brought into almost direct contact with the cross
proffered by the Angel. The arms of Christ are no longer encased in tight sleeves but emerge
naked—as with a scream, if one may say so—from ample drapery. And, most important of
all, His figure is no longer foiled by rocks but stands out against the vastness of the dark sky.

The two other "nocturnes" of 1508 are smoother in technique and less *outré* in lighting, but they also glow with a passion more intense and somber than other interpretations of the same subjects. Like the *Agony in the Garden*, the *Betrayal* is developed from a composition which forms part of the "Green Passion" of 1504 (523/566). But several significant changes serve to shift the emphasis from the commotion of the arrest to the tragedy of the betrayal. The number of figures is greatly reduced. Physical violence is limited to the duel between Malchus and St. Peter—who, in addition, is invested with a Mithras-like monumentality. Christ is no longer seized by the arms, pulled by His coat and prodded in the back as in the earlier version; much less is He already bound and dragged away as in the large woodcut of 1510 (227). Unconscious of the noose which threatens His neck, He bends His head and closes His eyes to receive the kiss as though He and Judas were alone in the universe.

The most striking feature of the *Crucifixion* of 1508—the general arrangement of which can be traced back to the painted *Crucifixion* in Dresden (3, *f*)—is the expressive figure of St. John. Turned to full profile, he raises his arms and wrings his hands with a loud cry of anguish, his face a tragic mask of classical Antiquity melted with the heat of Christian passion. The model of this figure is in Mantegna's engraved *Deposition* where a St. John similarly placed, similarly posed, and crying out with similar despair, is seen near the right margin of the composition (*fig.* 198). But Mantegna's pathos is hard and stony compared to Dürer's. Mantegna's St. John clasps his arms against his breast instead of thrusting them out; he stands motionless instead of pressing forward; he holds his head erect instead of tossing it back. Above all, he appears in a Deposition staged in broad daylight and not in a nocturnal Crucifixion. In all these respects Dürer's engraving—significantly different from the restrained *Crucifixion* of 1511 which graces the Engraved Passion—reminds us of that Mathis Gothart Nithart, whom we shall probably continue to know as Matthias Grünewald.

Grünewald was a Christian mystic—no secular representation by him is known—where Dürer, with all his piety, was essentially a humanist. He was a poet in spite of his proficiency in hydraulic engineering, where Dürer was a "scientist" in spite of his fervid imagination. He thought in terms of light and color where Dürer thought, primarily, in terms of line and form. He was, in short, both the consummator of the German Gothic and a prophet of the Baroque where Dürer was the founder of a Northern Renaissance. Thus the same *Crucifixion* which appeared pictorial and vibrant with emotion when compared to Mantegna's *Deposition* seems statuesque and calm when compared to Grünewald's "Small Crucifix" in the Koenigs Collection (*fig.* 197). But for a Dürer engraving of 1508 it is exceptional (also in that the arms of Christ are wrenched upward more cruelly than in any other Crucifixion by Dürer) —just as exceptional as the somber *Betrayal of Christ* and the spasmodically lighted *Agony in the Garden*. We feel that here more than anywhere Dürer approached the precincts of Grünewald's witchery.

Further evidence of this *rapprochement* between Dürer and Grünewald is furnished by an extraordinary charcoal drawing which, with a certain grim humor, portrays a sharp-eyed, hook-nosed man with an enormous double chin not unlike the dewlap of an animal (1043,

fig. 199). That it is by Dürer cannot be questioned in view of a magnificent firmness and sweep of line which brings to mind the charcoal portraits of 1503, and of the perfectly authentic, though somewhat enigmatical inscription "Hye conrat verkell altag." Yet it is understandable that it should have been ascribed to Grünewald. For, while the structural forms are determined by firm and definitely graphic lines, the flesh shows a certain flabbiness—resulting from a profusion of fleeting, blurry shadows and reflected lights—which is peculiar to Grünewald's studies of heads. Moreover, the face is marked by an asymmetrical distortion which is as characteristic of Grünewald as it is normally foreign to Dürer (see *fig.* 200).

Like the *Agony in the Garden*, the *Betrayal* and the single *Crucifixion*, this drawing bears the date 1508; and this year—the year which marks that basic change in Dürer's graphic style —is, curiously enough, one which may have brought him into a new and more momentous contact with Grünewald's art.

The Heller altarpiece, we remember, was a triptych with movable shutters. But for some reason, perhaps in order to screen off the light which came from the rear, it was subsequently provided with fixed wings as well. Each of these wings was composed of two panels *en grisaille*, placed one above the other so as to match the composition of the shutters; and the two panels which have come down to us—a *St. Lawrence* and a *St. Cyriacus*—fully confirm Joachim Sandrart's assertion that the painter commissioned with this addition to Dürer's most sumptuous altarpiece was none other than Grünewald. Grünewald was then residing in Seligenstadt (about fifteen miles east of Frankfort), but he was also active in Mayence (about twenty miles west of Frankfort), as well as in Frankfort itself.

These four panels were probably not executed until 1512 when Grünewald stayed with the Dominicans at Frankfort for a time. We do not know whether Dürer was ever consulted about the matter, nor can we be sure that he himself had come to Frankfort to see Jacob Heller while he was working for him. However, one of his letters to Heller does contain a few passages which may be construed as a reference to such a visit; and if this visit really took place it could have been only in September or October 1508. Thus it is not impossible, though far from demonstrable, that Dürer had another occasion to be impressed by Grünewald's artistic personality precisely at a time when the content of his prints seems to reveal the impact of a strong emotional experience, and when their style suddenly changed toward luminarism and tonality. It is tempting to think that this crisis was precipitated by a new encounter with his antipode.

However that may be, the change in Dürer's graphic style took place in 1508, and the engravings originally led the woodcuts. But in the further course of evolution the "spirit of the burin" proved to be somewhat recalcitrant. As we have seen, the very nature of line engraving calls for analytical precision, curvilinear calligraphy, and emphasis on plastic modelling. As it plows into the revolving copper plate, the graver of necessity produces incisive lines which tend to be marshalled in orderly fashion, which stress the undulation of the contours, and which enclasp, as it were, the plastic forms with circular arcs. This innate character of the medium offers a natural resistance to luminaristic tendencies, and of this

Dürer was fully aware. The *Agony in the Garden*, where he had sacrificed the graphic system at the altar of pictorialism, is an exception, explicable only by the enthusiasm of a new departure. In general, Dürer tried to reconcile his new luminarism with the demands of orthodox line engraving, but he refused a compromise at the expense of intensity. He wanted to achieve, at the same time, a maximum of both pictorial and graphic values, and the result was what a musician would call "over-orchestration." The engravings produced between 1508 and 1512 are marvelously rich but somewhat labored. They are crowded with sharply delineated details—so much so, in fact, that the structure of the whole is at times obscured—and yet an attempt is made at suggesting something like atmosphere. The plastic volumes are heavily and rigidly modelled, so that even human flesh seems to assume a marmoreal or metallic hardness, and yet an equally strong emphasis is placed on the surface texture of different materials. The contrasts between light and dark are stressed to such an extent that the lights begin to flicker or to glare while the shadows tend to turn opaque. The network of lines, strokes and dots appears too dense in some places and too loose in others and at times verges on confusion. Dürer was great enough to force these conflicting elements into a unity exciting just by virtue of its interior tensions. But he was also great enough to see that he could proceed no further in the same direction. He felt that his style of engraving needed what in political life would be called a "purge."

This "purge" took place in 1512 when the conflict between pictorial and graphic principles had reached a climax in such engravings as the *Bearing of the Cross*. In an effort to find an outlet for those tendencies which had proved to be incongruous with the "spirit of the burin," Dürer resorted to a technique which he had strenuously avoided for almost twenty years: he took up dry point.

As will be remembered the dry point artist is free from all the restrictions which are imposed upon the line engraver. Dry point permits, and even demands, improvisation and irregularity where line engraving requires meticulosity and systematization. It is conducive to strong contrasts between slight scratches which, when accumulated, may give an almost impressionistic effect and vigorous slashes which, if the bur is not polished away, will produce deep, soft shadows. In short, it lends itself most willingly to those pictorial tendencies in which the burin can only indulge at the expense of its innate principles and virtues. Thus we can understand why Dürer, after having strained the medium of Schongauer to the very limits of its possibilities, had recourse to the medium of the Housebook Master.

Dürer's dry points are only three in number. Two of them, a *Man of Sorrows* and the *St. Jerome by a Pollard Willow*, are dated 1512. The third, a *Holy Family*, is not quite finished and neither dated nor signed (ultimately Dürer tried to destroy the plate altogether by an angry stroke across the face of the Virgin), but was almost certainly executed in the same year.

The *Man of Sorrows* (128) seems to be the earliest of these three prints. It is simple in composition, small in size—Dürer may have used one of the plates prepared for the Engraved Passion—and somewhat timid in treatment. Dürer still hesitated to apply much pressure to

the tool, and the bur was polished away as in a regular line engraving. The print is delicate and full of tender feeling but, even in good impressions, a little pale.

In the *St. Jerome* (166, *fig.* 202) the possibilities of the new medium are fully exploited. The lighted objects, particularly the lion, the face and arms of the Saint, and the Cardinal's robe spread over his improvised desk, stand out from a rocky landscape, the elements of which are interpreted in terms of tonal values rather than of plastic form. In the earlier proofs Dürer even resorted to a somewhat unorthodox device to strengthen the impression of tonality. After having inked and wiped the plate he put on a thin film of printer's ink wherever he wished to obtain a kind of wash effect ("Plattenton"). But above all he had learned to take advantage of those contrasts between delicacy and vigor which are the royal prerogative of dry point. The face and body of the Saint are modelled with fine little touches, and the volume of his crucifix seems almost to dissolve within the surrounding brightness. But such details as the stubbly branches of the polled willow, the cavities of the rocks, and the shaded parts of the fluffy lion's coat are accentuated by slashing strokes which produce plenty of bur (compare *fig.* 203 with *fig.* 204). In good impressions—which are, of course, extremely rare because of the tendency of the bur to wear off very quickly—the effect of these deep, downy blacks amidst volatile whites and grays heralds what Rembrandt was to do in such pure dry points as the *Clump of Trees with a Vista* of 1652.

The *Holy Family* (150, *fig.* 201) is, perhaps not by accident, somewhat reminiscent of the *"Virgin with the Dragonfly"* (*fig.* 92), which in turn was influenced by Dürer's only forerunner in the use of dry point, the Housebook Master. In both cases the Virgin Mary is seated on a grassy bench while St. Joseph, sitting on the ground behind it, is only half visible. But he is neither playful nor sleepy. Dignified and grave, he looks like a gloomy Prophet instead of playing his more usual pathetic or even slightly ludicrous role. He is indeed interpreted as a seer of tragedy, for he—and not the smiling Virgin—perceives the three mysterious figures which have emerged behind the group of Mother and Child. They are St. John the Evangelist, Nicodemus, and the Magdalen with her ointment jar—the witnesses of the Passion. They fill the whole upper right-hand corner of the composition while the upper left-hand corner is empty except for the unfinished landscape; and this almost Baroque diagonal is echoed and emphasized by a piece of masonry which rises by steps from left to right, its lowest section being taller than the huddled figure of St. Joseph while its tallest section is lower than the tight, columnar group of the "witnesses."

The graphic technique of this print is as bold and free as its design and iconography. Bur and "Plattenton" are used freely, but parts such as the heads of St. John and Nicodemus are so attenuated in volume that they give a truly *plein-air* effect. In the face of St. John not only the plastic modelling but also the outlines are subdued in favor of a gentle play of light and shade, and the face of the Virgin, built up from innumerable tiny flicks and scratches, has practically no contours at all. Here Dürer approaches, for once, the Leonardesque ideal of *sfumato*; his Virgin, in fact, brings to mind Leonardo's St. Ann in the Louvre.

From this brief orgy of luminarism Dürer emerged with what may be called his second "classic" burin style. As the engravings of 1503/04 had achieved perfection by tempering the miniature-like refinement of the *St. Eustace* and the *Nemesis* with the coarser but more ingenuous spirit of his earlier manner, so the engravings of 1513/14 regained perfection by disciplining the conflicting tendencies of the Engraved Passion and its relatives to a purely graphic mode of expression. This does not mean that Dürer renounced the *clair-obscur*, or tonal, principle which he had adopted in 1508. It is, on the contrary, within the limits of this principle that he reinstated that economy, clarity, and uniform density which had distinguished the *Coat-of-Arms with the Skull* or the *Fall of Man*.

This tendency to obviate the dangers of the preceding phase without forfeiting its accomplishments is already evident in an engraving like the *Sudarium* of 1513 (132) which, like the *Coat-of-Arms with the Skull* of 1503, is definitely heraldic in character. Two adolescent Angels, balanced with almost perfect symmetry, yet subtly differentiated in pose and gesture, display the kerchief with the imprint of the Holy Face which—clearly built up from the elements of Dürer's own physiognomy—fastens its eyes on the beholder with hypnotic intensity. The Angels, apparently supported by the billowing folds of their surplices rather than by their half-closed wings, hover in the void, and this void is indicated by horizontal hatchings which spread a veil of gray over the entire background. But this emphatic *clair-obscur* effect no longer seems to endanger the strictly graphic character. Dürer achieved a greater uniformity of the lines in thickness and spacing so that he could exploit their tonal significance without either weakening or overstating their calligraphic effect. Even the deepest shadows remain transparent, and even the highest lights are not too harsh because the accents of light and dark are more subtly graded, more evenly distributed and more carefully balanced against each other than in the engravings of 1508-1512.

The acme of perfection—perfection inasmuch as Dürer succeeded in fusing widely divergent tendencies without a sacrifice of either harmony, as in the preceding years, or concreteness and variety, as in later years—was reached in 1514. Compared with the vivid *Virgin with the Pear* of 1511 (148) on the one hand, and with the stony *Virgin with the Swaddled Infant* of 1520 (145, fig. 251) on the other, the *Virgin by the Wall* (147) represents indeed a perfect coincidence of apparent opposites. Regal and virginal, yet humble and motherly, the Virgin Mary is depicted in an environment in which a sense of sheltered intimacy blends with the freedom of the open spaces. The utmost precision of design is combined with an incomparable softness of texture. The lines and strokes, while fulfilling the difficult and varied tasks of modelling form, of indicating direction (as the converging hatchings of the foreshortened walls and the parallel hatchings of the sloping roof), of suggesting luminary values, and of characterizing surface qualities (as in the woolen stuff and silken lining of the Virgin's mantle), yet maintain what may be called their graphic integrity. The deepest shadows, like the ones above the Virgin's right knee and beneath her neat "Hausfrau's" purse, are so small in compass and so softly embedded amidst other areas of varying darkness that they do not

impair the impression of perfect transparency and homogeneity. The whole engraving, though far from being lusterless, shimmers with the soft, cool tones of mat silver.

IN THE YEARS 1513 and 1514 the production of woodcuts and paintings ceased altogether, but in addition to the four engravings already mentioned (*Sts. John and Peter Healing the Lame*, the *Sudarium*, the *Virgin with the Pear*, and the *Virgin by the Wall*) Dürer produced nine others. Six of these are small in size and unambitious in content: the *Virgin by the Tree*, a *Virgin on the Crescent*, and the *Bag-Piper* (142, 140, and 198, all of them of the same format as the Engraved Passion and probably engraved on plates prepared in this connection); the *Couple of Peasants Dancing* (197); and the first two of a series of Apostles which was never completed, *St. Paul* (157) and *St. Thomas* (155). The three remaining engravings, however, are not only exceptionally large in size—about 7 by 10 inches—and meticulously careful in execution, but also complex and significant in iconography. They are Dürer's most famous engravings and, not unjustly, known as his "Meisterstiche": the *Knight, Death and Devil*, the *St. Jerome in His Study*, and the *Melencolia I*, the former of 1513, the two others of 1514.

These three "Master Engravings," though approximately equal in format, have no appreciable compositional relationship with one another and can thus hardly be considered as "companion pieces" in any technical sense. Yet they form a spiritual unity in that they symbolize three ways of life which correspond, as Friedrich Lippmann pointed out, to the scholastic classification of the virtues as moral, theological and intellectual. The *Knight, Death and Devil* typifies the life of the Christian in the practical world of decision and action; the *St. Jerome* the life of the Saint in the spiritual world of sacred contemplation; and the *Melencolia I* the life of the secular genius in the rational and imaginative worlds of science and art.

Dürer's awareness of the fact that the first of these three prints, the *Knight, Death and Devil* (205, *fig.* 207), was an important enterprise is again manifested by the special form of the signature. The figure 1513 is preceded by an "S.," an abbreviation of the word "Salus" which occurs, identically placed, in the date lines of Dürer's first drafts for an Introduction to his Treatise on Human Proportions, composed in 1512 and 1513.

In the Diary of his journey to the Netherlands Dürer refers to the engraving simply as the "Reuter" ("the Horseman"). But in the same Diary we find a passage which furnishes a clue to its interpretation. Grieved and incensed by the unfounded rumors of Luther's assassination, Dürer jotted down, amidst the records of his daily work and expenses, a magnificent outburst against the Papists which culminates in a passionate appeal to Erasmus of Rotterdam: "O Erasme Roderodame, where wilt thou take thy stand? Look, of what avail is the unjust tyranny of worldly might and the powers of darkness? Hark, thou Knight of Christ [*du Ritter Christi*], ride forth at the side of Christ our Lord, protect the truth, obtain the crown of the Martyrs!" No doubt the phrase "du Ritter Christi" alludes to Erasmus's youthful treatise *Enchiridion militis Christiani* ("Handbook of the Christian Soldier") which had been composed in 1501 and was first published in 1504. But that Dürer promoted the Erasmian

"soldier" (*miles*, not *eques*) to a "knight" riding forth on horseback shows that his mind involuntarily associated him with the hero of his own engraving.

The comparison between the Christian facing a hostile world and the soldier preparing himself for battle can be traced back to St. Paul who speaks of the spiritual weapons of "our warfare" (*II Cor.*, x, 3) and urges the faithful to arm themselves with the "armor of God," the "breastplate of righteousness," the "shield of faith," and the "helmet of salvation" (*Ephes.*, vi, 11-17; see also *I Thess.*, v, 8). It remained popular in medieval writing and also found its way into fifteenth century woodcuts. In these the Christian Soldier is generally depicted singly while the personifications of Death and Devil are found in representations of a closely related theme, that of the Christian Pilgrim. The two ideas intermingled, however, and a complete fusion of Soldier's March and Pilgrim's Progress, with the time-honored simile of the ladder serving as a common denominator, is seen in woodcuts and etchings of the sixteenth century where the *miles Christianus* climbs the ladder which leads to God, hampered but not discouraged by the strings of Death, Luxury, Disease, and Poverty.

In Erasmus's *Enchiridion* these traditional concepts are interpreted in the spirit of humanism. He clothes his thoughts in the garment of beautiful Latin; he takes his examples from Greek and Roman literature as well as from Scripture, "for we must love the classics for the sake of Christ"; and he rejects the "theologians" in favor of the "sources." But above all he humanizes the idea of Christianity as such. He preaches purity and piety, but not monasticism and intolerance; and he spurns sin not only as something forbidden by God but even more as something incompatible with the "dignity of man."

This book could not supply an artist with suggestions for iconographical details. But it could reveal to him the idea of a Christian faith so virile, clear, serene and strong that the dangers and temptations of the world simply cease to be real: "In order that you may not be deterred from the path of virtue because it seems rough and dreary, because you may have to renounce the comforts of the world, and because you must constantly fight three unfair enemies, the flesh, the devil and the world, this third rule shall be proposed to you: All those spooks and phantoms [*terricula et phantasmata*] which come upon you as in the very gorges of Hades must be deemed for nought after the example of Virgil's Aeneas."

This is precisely what Dürer expressed in his engraving: unlike all other representations of similar subjects, the enemies of man do not appear to be real. They are not foes to be conquered but, indeed, "spooks and phantoms" to be ignored. The Rider passes them as though they were not there and quietly pursues his course, "fixing his eyes steadily and intensely on the thing itself," to quote Erasmus again. How did Dürer contrive to create this impression?

It has long been observed that the equestrian figure—almost a symbol of Dürer's art and mentality—is composed of two disparate elements: one German, Late Gothic, and "naturalistic"; the other Italian, High Renaissance, and stylized in accordance with a "classic" canon of pose and proportions. The armored knight was taken over from a costume study of 1498 (1227) which was, however, adapted to the new purpose by minor yet significant changes. The simple sergeant's face of the original model was replaced by a stern mask of concentrated

energy and almost sardonic self-assurance, and the perspective of the helmet was altered in favor of a *di sotto in sù* effect which strengthens the impression of tallness and superiority. The horse, on the other hand, is patterned after one (or more) of Leonardo's studies for the monument of Francesco Sforza. Its proportions are remodelled according to a canon of Dürer's own invention (see the drawings 1674-1676), but its gait retains more of the Italian rhythm than is the case in the *Small Horse* of 1505 (*fig.* 125) or the drawing *Death on Horseback* of the same year (*fig.* 147). In contrast with these earlier instances not only the near foreleg but also the off hind leg are raised and bent, and the movement of the latter was even intensified by a last-minute correction still recognizable in the engraving.

This monumental Horseman—his general appearance somewhat reminiscent of Burgkmair's well-known equestrian portrait of Maximilian I in a woodcut of 1508, which was in turn derived from Dürer's *Small Horse*—is set out against a background of forbidding rocks and bare trees with his ultimate goal, the unconquerable "fortress of Virtue," still far off at the end of a steep, winding road. From the gloom of this "rough and dreary" scenery there emerge the figures of Death and the Devil. As in the drawing of 1505, Death wears a regal crown and is mounted on a meager, listless jade with a cowbell; but he is even ghastlier in that he is not depicted as an actual skeleton but as a decaying corpse with sad eyes, no lips and no nose, his head and neck encircled by snakes. He sidles up to the Rider and tries in vain to frighten him by holding up an hourglass while the swine-snouted Devil sneaks up behind him with a pickaxe. The Rider, on the other hand, is accompanied by a handsome, long-haired retriever whose presence completes the allegory. As the armored man personifies Christian faith, so the eager and quick-scented dog denotes three less fundamental yet no less necessary virtues: untiring zeal, learning and truthful reasoning. In the capacity of "zealous endeavor" he accompanies the Christian Pilgrim on his journey through life; as a symbol of "sacred letters" he occurs in a treatise on hieroglyphs which Dürer illustrated precisely in 1512/13 (see the drawing 970 and our *fig.* 228); and as "Veritas" he helps the huntress "Logica" to catch the hare "Problema."

It has been contended that all these additions were harmful to the aesthetic effect of Dürer's engraving. His original intention, it was argued, was "to represent a horse with a man thereon," and he would have done better to refrain from justifying this intention by an iconographical program: "No one can doubt for a moment that the accompanying figures are merely tacked on, and that the whole is a compromise." But the attempt at reinstating the original beauty of the composition by "blacking out" the whole background defeats its own purpose. It shows that the "many odds and ends" are indispensable, not only from the point of view of subject matter but also from the point of view of form and content. It is quite true that Dürer was anxious to find a subject which would permit him to demonstrate the final results of his studies in the anatomy, movements, and proportions of the horse. But he would not have been a great artist had he conceived of this problem in terms of detachable accessories. Once he had discovered his theme in the idea of the Christian Knight the visual image of the perfect horseman merged with the mental image of the perfect *miles Christianus* into an artistic concept, that is to say, an integral unity. The iconography of the Christian

Knight took shape according to the formal pattern of a carefully balanced equestrian group while, conversely, this formal pattern assumed, as such, an expressive or even symbolic significance.

Based as it is on accumulated research and observation, Dürer's equestrian group bears all the earmarks of a scientific paradigm. The horse is represented in full profile so as to show off its perfect proportions; it is emphatically modelled so as to reveal its perfect anatomy; and it moves with the regulated step of the riding-school so as to give a demonstration of perfect rhythm. With the background obliterated, Dürer's engraving thus looks like a stiff and over-elaborated imitation of an equestrian statue *à la* Pollaiuolo, Verrocchio and Leonardo da Vinci. With the background retained, the compositional structure of the main group is not only enhanced by what may be called a visual counterpoint—note the use of foreshortened forms *versus* full profile, of diagonals *versus* horizontals and verticals—but also endowed with a definite meaning. Contrasted with the twilight and the specters of a Northern forest, the very articulateness and plastic tangibility of this moving monument suggests an existence more solid and real than that of Death and the Devil who appear as little more than shadows of the wilderness. Contrasted with their futile attempts to attract the Rider's attention, the very fact that man, horse, and dog are represented in pure profile convinces us that none of them is even aware of the presence of danger and thus expresses the idea of imperturbability. And contrasted with the jerky obsequiousness of the Devil and the pitiful weakness of Death and his worn-out horse, the measured gait of the powerful charger conveys the idea of unconquerable progress.

Thus it is just by combining a highly formalized equestrian group with a fantastically haunted wilderness that Dürer was able to do justice to the Erasmian ideal of a Christian fortitude which reduces the enemies of mankind to "spooks and phantoms." If his engraving needed a caption this caption could be found in the Biblical motto which Erasmus suggests to the *miles Christianus*: "Non est fas respicere" ("Look not behind thee").

While the Christian Knight goes out into the cold, dark and perilous maze of the world, the Christian Scholar and Thinker, as typified in Dürer's *St. Jerome* (167, *fig.* 208), lives in the warm, bright and peaceful seclusion of a well-ordered study. The room is a real cell, separated from an adjoining one by a partition which cuts right into one of the round-topped, mullioned windows piercing the south wall of a cloister. It is a very simple room, yet thoroughly pleasant, provided not only with the necessities but also with the small comforts of a devout and scholarly life. When Lucas Cranach portrayed the Cardinal Albrecht of Brandenburg in the guise of Dürer's St. Jerome (paintings in Darmstadt and Sarasota) he felt obliged to enrich the milieu by such luxuries as velvet covers, colorful animals and hot-house fruit; but these additions all but destroy the atmosphere of the original setting. This atmosphere can only be described by two untranslatable German words, "gemütlich" and "stimmungsvoll." Such English words as "snug" or "cozy" may express the feeling of intimacy, warmth and protectedness which pervades St. Jerome's sanctum, suffused as it is with a mellow sunlight in which even the skull on the window-sill looks friendly rather than terrifying. But

they do not adequately suggest what may be called its spiritual climate. The threshold of the room is blocked by St. Jerome's lion who, dozing with contented boredom, yet keeps a drowsily suspicious eye on possible intrusions from the outer world. A little dog is fast asleep, one of its feet in friendly contact with the lion's paw. The Saint himself is working at the far end of the room, which in itself gives the impression of remoteness and peace. His little desk is placed on a large table which otherwise holds nothing but an inkpot and a crucifix. Engrossed in his writing, he is blissfully alone with his thoughts, with his animals, and with his God.

It is, however, not only by the magic of light and by the empathic realization of human and animal nature that Dürer transformed the cell of St. Jerome into a place of enchanted beatitude. He also exploited the psychological possibilities of a method which, one would think, is almost inimical to psychological expression, namely, exact geometrical perspective. The construction of the picture space, impeccably correct from a mathematical point of view, is characterized, first, by the extreme shortness of the perspective distance which, if the room were drawn to natural scale, would amount to only about four feet; second, by the lowness of the horizon which is determined by the eye level of the seated Saint; third, by the eccentric position of the vanishing point which is little more than half a centimeter from the right margin. The shortness of the distance, combined with the lowness of the horizon, strengthens the feeling of intimacy. The beholder finds himself placed quite close to the threshold of the study proper on one of the steps which lead up to it. Unnoticed by the busy Saint, and not intruding upon his privacy, we yet share his living space and feel like unseen friendly visitors rather than distant observers. The eccentricity of the vanishing point, on the other hand, prevents the small room from looking cramped and box-like because the north wall is not visible; it gives greater prominence to the play of light on the embrasures of the windows; and it suggests the experience of casually entering a private room rather than of facing an artificially arranged stage.

And yet everything in this informal and unpretentious room is subject to a mathematical principle. The apparently irreducible impression of order and security which is the very signature of Dürer's *St. Jerome* can be accounted for, at least in part, by the fact that the position of the objects freely distributed about the room is no less firmly determined by elementary perspective construction than if they were attached to the walls. They are either placed frontally like the writing table of St. Jerome, the animals, the books, and the skull on the window sill; or orthogonally like the "cartellino" with Dürer's signature; or at an angle of precisely forty-five degrees like the little bench on the Saint's left. Even the slippers beneath the window-seat are arranged so that one is almost parallel and the other exactly at right angles to the picture plane.

This regularity might seem dry or even pedantic were it not softened, or indeed concealed, by the delightful gambol of light and shade. Space and light constitute a perfect balance of stability and oscillation. Yet even the most pictorial effects are obtained by rigorously graphic methods. From a technical point of view the *St. Jerome*—in this respect superior to the *Knight, Death and Devil* in the same sense and to the same degree that the *Virgin by*

the Wall (147) is superior to the *Virgin by the Tree* of 1513 (142)—is a *ne plus ultra* of consistency, clearness and, above all, economy. A maximum of effect is achieved with a minimum of effort and complication, as can be seen, for instance, in the shadows cast upon the window embrasures by the latticed windows (*fig. 205*). The phenomenon is as pictorial and subtle as the treatment is graphic and simple: the "bull's eyes" themselves are rendered by outlines without hatchings, and their shadows by short horizontal hatchings without outlines. That is all.

The *St. Jerome* differs from the *Knight, Death and Devil* in that it opposes the ideal of the "vita contemplativa" to that of the "vita activa." But it differs much more emphatically from the *Melencolia I* (181, *fig.* 209) in that it opposes a life in the service of God to what may be called a life in competition with God—the peaceful bliss of divine wisdom to the tragic unrest of human creation. While the *St. Jerome* and the *Knight, Death and Devil* illustrate two opposite methods of reaching a common objective, the *St. Jerome* and the *Melencolia I* express two antithetical ideals. That Dürer conceived of these two prints as spiritual "counterparts" within the triad of the "Meisterstiche" can be concluded from the fact that he was in the habit of giving them away together and that collectors looked at and discussed them side by side. No less than six copies were disposed of as pairs while only one copy of the *Melencolia I* was given away singly and no impression of the *Knight, Death and Devil* changed hands together with either of the two other prints.

The two compositions offer, indeed, a contrast too perfect to be accidental. While the St. Jerome is comfortably installed at his writing desk, the winged Melancholia sits in a crouching position, not unlike that of the Job in the "Jabach altarpiece" (*fig.* 112), on a low slab of stone by an unfinished building. While he is secluded in his warm, sunlit study she is placed in a chilly and lonely spot not far from the sea, dimly illuminated by the light of the moon—as can be inferred from the cast-shadow of the hourglass on the wall—and by the lurid gleam of a comet which is encircled by a lunar rainbow. While he shares his cell with his contented, well-fed animals, she is accompanied by a morose little *putto* who, perched on a disused grindstone, scribbles something on a slate, and by a half-starved, shivering hound. And while he is serenely absorbed in his theological work, she has lapsed into a state of gloomy inaction. Neglectful of her attire, with dishevelled hair, she rests her head on her hand and with the other mechanically holds a compass, her forearm resting on a closed book. Her eyes are raised in a lowering stare.

The state of mind of this unhappy genius is reflected by her paraphernalia whose bewildering disorder offers, again, an eloquent contrast to the neat and efficient arrangement of St. Jerome's belongings. Attached to the unfinished building are a pair of scales, an hourglass, and a bell under which a so-called magic square is let into the wall; leaning against the masonry is a wooden ladder which seems to emphasize the incompleteness of the edifice. The ground is littered with tools and objects mostly pertaining to the crafts of architecture and carpentry. In addition to the grindstone already mentioned, we find: a plane, a saw, a ruler, a pair of pincers, some crooked nails, a molder's form, a hammer, a small melting pot (per-

haps for melting lead) with a pair of tongs to hold the burning coals, an inkpot with a pen-box; and, half hidden beneath the skirt of the Melancholia, an instrument which can be identified—on the basis of a woodcut by Hans Döring—as the mouth of a pair of bellows. Two objects seem to be not so much tools as symbols or emblems of the scientific principle which underlies the arts of architecture and carpentry: a turned sphere of wood and a trun-cated rhombo-hedron of stone. Like the hourglass, the pair of scales, the magic square, and the compass, these symbols or emblems bear witness to the fact that the terrestrial craftsman, like the "Architect of the Universe," applies in his work the rules of mathematics, that is, in the language of Plato and the *Book of Wisdom*, of "measure, number and weight."

In modern usage, melancholy means, to quote from the Oxford Dictionary, "mental depression, lack of cheerfulness; tendency to low spirits and brooding; depressing influence of a place, etc." However, when Dürer composed his engraving the expression could not yet have been used as of a transient mood, much less of the gloomy emanation of a locality. In order to understand the title "Melencolia I"—inscribed on the wings of a squeaking bat—we must, instead, recall to mind that theory of the "four humors" which has already been touched upon in connection with Dürer's interpretations of the Fall of Man. This theory, fully developed by the end of classical Antiquity, was based on the assumption that both the body and the mind of man were conditioned by four basic fluids which in turn were supposed to be coessen-tial with the four elements, the four winds (or directions of space), the four seasons, the four times of day, and the four phases of life. Choler, or yellow gall, was associated with the element of fire and was believed to share the latter's qualities of heat and dryness. It was thus held to correspond to the hot and dry Eurus, to summer, to midday, and to the age of manly maturity. Phlegm, on the other hand, was supposed to be moist and cold like water and was connected with the wind Auster, with winter, with night, and with old age. The blood, moist and warm, was equated with air and was likened to the pleasant Zephyr, to spring, to morning, and to youth. The melancholy humor, finally—the name deriving from Greek $\mu\acute{\epsilon}\lambda\alpha\iota\nu\alpha$ $\chi\acute{o}\lambda os$, black gall—was supposed to be coessential with earth and to be dry and cold; it was related to the rough Boreas, to autumn, evening, and an age of about sixty. Dürer himself has illustrated this cosmological scheme in one of his woodcuts for Conrad Celtes (350, *fig.* 215) which differs from the original tradition only in that the melancholy humor is identified with winter instead of with autumn, and the phlegmatic with autumn instead of with winter —an understandable concession to the climatic difference between Germany and ancient Greece.

In an ideal or absolutely healthy human being these four humors would be perfectly balanced so that none would predominate over the others. But such a human being would be immortal and free from sin, and we know that both these advantages were irretrievably for-feited by the Fall of Man. In practice, therefore, one of the four humors prevails over the others in every individual, and this determines his or her entire personality. Apart from the fact that each of the humors asserts itself, quite generally, according to the course of the year, the day and the human life—we still speak of "sanguine youth" or "the melancholy of

autumn"—every man, woman and child is constitutionally either a sanguine, or a choleric, or a melancholic, or a phlegmatic. These four types differ from one another in every possible respect. Each of them is marked by a peculiar physical habitus—slender or stout, tender or tough, robust or delicate; by the color of hair, eyes and skin (the word "complexion" derives, in fact, from the Latin word for "humoral mixture" or "temperament"); by a susceptibility to specific diseases; and, above all, by characteristic moral and intellectual qualities. The phlegmatic is inclined to other vices—and, conversely, is capable of other virtues—than the choleric; he behaves differently toward his fellow-men, he is suited to a different set of professions, and he has a different philosophy of life.

As long as the predominance of any one humor keeps within reasonable bounds the mind and body of the individual is merely qualified in this peculiar way. But if his humor gets out of control—either by an excessive increase in quantity which may occur for a variety of reasons, or by a deterioration in quality which may be caused by inflammation, chill or "adustion"—he ceases to be a normal or "natural" phlegmatic, melancholic, etc. He falls sick and may ultimately die; we still speak of "melancholy" and "cholera" as mental or physical diseases.

Obviously the four humors or temperaments could not be considered as equally desirable. The sanguine temperament, associated with air, spring, morning and youth, was, and in some measure still is, regarded as the most auspicious one. Favored with a well-knit body and a ruddy complexion, the sanguine seemed to surpass all other types in natural cheerfulness, sociability, generosity and talents of all description; even his faults, a certain weakness for wine, good food and love, were of the amiable and pardonable kind. Blood is, after all, a nobler and healthier fluid than the two kinds of gall or phlegm. We remember that certain theorists considered the sanguine temperament as the original, or perfectly balanced, condition of man; and even after this ideal equilibrium had been destroyed by the sin of Adam the predominance of the blood was much preferred to any of the other alternatives.

As the sanguine condition was greeted as the most fortunate, so the melancholic was hated and feared as the worst. When excessively augmented, inflamed, or otherwise disturbed, the black gall causes the most dreaded of all diseases, insanity; this disease can befall anybody, but the melancholics by nature are its most likely prey. And even without a downright pathological disturbance the natural or constitutional melancholics—generally considered as *pessime complexionati* ("the most ill-mixtured")—are both unfortunate and disagreeable. Thin and swarthy, the melancholic is "awkward, miserly, spiteful, greedy, malicious, cowardly, faithless, irreverent and drowsy." He is "surly, sad, forgetful, lazy and sluggish"; he shuns the company of his fellow-men and despises the opposite sex; and his only redeeming feature—and even this is frequently omitted from the texts—is a certain inclination for solitary study.

Before Dürer, pictorial representations of melancholy were chiefly found, first, in technical treatises on medicine; second, in popular books or broad-sheets which dealt with the theory of the four humors, especially in manuscript or printed Calendars. In the medical

books melancholy was discussed as a disease, and the main purpose of the illustrations was to show different methods of treatment—how melancholy derangement could be cured by music, or by flogging, or by cauterization (*fig.* 211). In the popular broad-sheets, Calendars and "Complexbüchlein," on the other hand, the Melancholic was depicted not as a pathological case but as a type of human nature. He appeared within a series of four figures or scenes intended to bring out the more or less desirable but, each in its way, perfectly "normal" features of the Four Temperaments.

We have said "four figures or scenes" because the representations of the Four Temperaments fall, roughly speaking, into two classes, one of a purely descriptive, the other of a scenic or dramatic character.

In illustrations of the descriptive type (which ultimately derive from Hellenistic cycles representing the Four Ages of Man) each temperament is typified by one figure only. These four figures—usually on foot, but occasionally on horseback—are differentiated according to age, social status, and profession. In the woodcut illustrated in *fig.* 214, for instance, the sanguine temperament is represented by a youthful, fashionable falconer who walks on a band of clouds and stars which indicates his congeniality with the element of air. The Phlegmatic—always hard to characterize because, as was already observed by Galen, his humor does not make for "characteristic" qualities—appears as a fattish burgher who stands in a pool of water, holding a rosary. The Choleric is a warlike man of about forty briskly walking through fire; to show his irascible temper he brandishes a sword and a stool. The Melancholic, finally, is depicted as an elderly, cheerless miser standing on the solid ground. Leaning against a locked desk the top of which is all but covered with coins, he gloomily rests his head on his right hand while with his left he grasps the purse hanging from his belt.

In illustrations of the scenic or dramatic type the four temperaments are typified by couples. As a rule, there is some indication of the elements, but the figures themselves are not differentiated as to age, social standing and occupation. They reveal their temperament only by their behavior, and it is interesting to note that they do this by reenacting scenes originally used for the characterization of vices. During the high Middle Ages the types of human behavior had been studied and depicted not for their own sake but with reference to the system of moral theology. They were not illustrated in secular monographs but, under the guise of Vices, in the reliefs of such Cathedrals as Chartres, Paris, and Amiens, or in the miniatures of such moral treatises as the *Somme le Roi*. Toward the end of the Middle Ages these moralistic patterns were gradually converted into characterological specimens, the accent on good and evil being lessened and ultimately abolished. Many a trait in Chaucer's "Canterbury Tales" derives from the negative examples adduced in sermons of the twelfth and thirteenth centuries, and many a "Fool" in Sebastian Brant's *Narrenschyff* had originally been—and to the surly author's mind still was—a reprehensible sinner. Thus, when a fifteenth century artist sought models which he might use for a dramatic instead of a merely descriptive representation of the Four Temperaments he had nothing to turn to except the traditional types of the Vices.

In this way the dramatic interpretation of the sanguine temperament, as found in several illuminated manuscripts and printed Calendars, reverts to the high medieval picture of Luxury. As in the *Luxuria* relief at Amiens Cathedral, the Sanguines are depicted as a couple clasped in a fervent embrace (*figs.* 216 and 217). Similarly the choleric temperament is exemplified by a man striking and kicking a woman, which is merely a transformation of what at Amiens Cathedral had been a representation of Discord. Now, as the main characteristic of the melancholy man in popular medieval writing was glumness and drowsiness, his type was modelled upon the pattern of Sloth or "Acedia." This pattern—freely employed, as we remember, in Dürer's *"Dream of the Doctor"* (*fig.* 98)— is based on the idea of the sinful sleep, the pictures showing a farmer asleep by his plow, a burgher asleep by a crucifix to which he ought to pray, a woman asleep by her distaff; the last of these three types (*figs.* 103 and 210) was so popular that Sebastian Brant adopted it for his "Fulheit" (Laziness)—with the kind-hearted amendment that the lazy spinner burns her leg in her sleep.

Consequently the dramatic representations of Melancholy show a woman asleep by her distaff combined with a man asleep at a table or even in bed (*fig.* 212); at times the man has a book over which he has dozed off, and in some later instances the slothful couple is joined by a hermit, a humble representative of study and solitude.

Blasphemous toward Dürer as it may sound—these homespun images must be counted among the ancestry of his famous engraving. Primitive though they are, they supplied its basic compositional formula, as well as the general idea of gloomy inertia. In both cases a woman, prominently placed in the foreground, is accompanied in a diagonal grouping by a less important representative of the opposite sex, and in both cases the essential characteristic of the main figure is her inaction. Needless to say, however, the differences outweigh the similarities. In the miniatures and woodcuts of the fifteenth century the secondary figure is as sleepy and slothful as the principal one, while Dürer's engraving shows a deliberate contrast between the inaction of the Melancholia and the strenuous efforts of the scribbling *putto*. And, more important, the Melancholia is idle and the women in the earlier illustrations have abandoned their distaffs for entirely opposite reasons. These lowly creatures have gone to sleep out of sheer laziness. The Melancholia, on the contrary, is what may be called super-awake; her fixed stare is one of intent though fruitless searching. She is inactive not because she is too lazy to work but because work has become meaningless to her; her energy is paralyzed not by sleep but by thought.

In Dürer's engraving the whole conception of melancholy is thus shifted to a plane wholly beyond the compass of his predecessors. Instead of a sluggish housewife we have a superior being—superior, not only by virtue of her wings but also by virtue of her intelligence and imagination—surrounded by the tools and symbols of creative endeavor and scientific research. And here we perceive a second and more delicate thread of tradition which went into the fabric of Dürer's composition.

From the middle of the twelfth century, with the "Portail Royal" of Chartres as the first known example, we find, in ever increasing numbers, personifications of the Arts. Their circle

was originally limited to the aristocratic Seven Liberal Arts enumerated by Martianus Capella, but it was soon enlarged by a less definite number of "Mechanical Arts" so as to illustrate the Aristotelianizing definition of art as "every productive effort based on a rational principle." The composition of these images followed a constant formula. A female figure, typifying one of the arts—or, on occasion, art in general—and at times accompanied by assistants or subsidiary personifications, is surrounded by the attributes of her activity, holding the most characteristic ones herself. A fourteenth century miniature—one of the rare examples of "Art in General" (*fig.* 218)—fairly bristles with all kinds of scientific and technical implements, and when these implements came to be scattered in three-dimensional space instead of being displayed on a plane surface the general effect began to approach that of Dürer's *Melencolia I*.

In one specific instance a definite iconographic connection can be established. In the 1504 and 1508 editions of Gregor Reisch's *Margarita Philosophica*, one of the most widely read encyclopedic treatises of the period, we find a woodcut entitled "Typus Geometriae" which includes nearly all the devices appearing in Dürer's *Melencolia I* (*fig.* 219). It synthesizes, so to speak, the type of the Liberal Arts with that of the Technical, for it is intended to show that almost all the crafts and many branches of "natural philosophy" depend on geometrical operations.

Geometry, depicted as a richly attired lady, is engaged in measuring a sphere with her compass. She sits at a table on which are drafting instruments, an inkpot and models of stereometrical bodies. An unfinished building, with an ashlar still in the prongs of a crane, is checked over by an assistant while two others work at a drafting board and make a topographical survey. Scattered about the ground are a hammer, a ruler and two molder's forms; and clouds, the moon and stars, announcing the celestial phenomena in Dürer's engraving, are observed by means of quadrants and astrolabes. Not only meteorology and astronomy—a further allusion to the latter, by the way, is the peacock's feather on the hat of Geometry, the peacock's plumage being an ancient symbol of the starry firmament—but also all the technical arts are thus interpreted as applications of geometry; and to this Dürer's conception conforms. His *Underweysung der Messung* is dedicated, "not only to painters but also to goldsmiths, sculptors, stonemasons, carpenters and all those who make use of geometry"; and in a draft probably written just about 1513-15 the "plane and the turning lathe"—the operation of both being based on a geometrical principle—are mentioned together just as the plane and the turned sphere are juxtaposed in the *Melencolia I*. In fact, the whole array of implements in the engraving can be summed up under the heading "Typus Geometriae," the book, the inkpot and the compass standing for pure geometry; the magic square, the hourglass with the bell, and the pair of scales for measurement in space and time ("Geo ponderat," "geometry weighs," to quote from an old mnemonic verse); the technical instruments for applied geometry; and the truncated rhomboid for descriptive geometry, particularly stereography and perspective.

Thus Dürer's engraving represents a fusion of two iconographic formulae hitherto distinct: the "Melancholici" of popular Calendars and "Complexbüchlein," and the "Typus Geometriae" of philosophical treatises and encyclopedic decorations. The result was an intellectualization of melancholy on the one hand, and a humanization of geometry on the other. The former Melancholics had been unfortunate misers and sluggards, despised for their unsociability and general incompetence. The former Geometries had been abstract personifications of a noble science, devoid of human emotions and quite incapable of suffering. Dürer imagined a being endowed with the intellectual power and technical accomplishments of an "Art," yet despairing under the cloud of a "black humor." He depicted a Geometry gone melancholy or, to put it the other way, a Melancholy gifted with all that is implied in the word geometry—in short, a "Melancholia artificialis" or Artist's Melancholy.

Thus almost all the motifs employed in Dürer's engraving can be accounted for by well-established textual and representational traditions pertaining to "melancholy" on the one hand, and to "geometry" on the other. But Dürer, while fully aware of their emblematic significance, also invested them with an expressive, or psychological, meaning.

That the conventional tools and symbols of the "geometrical" professions are arranged, or rather disarranged, so as to convey a feeling of discomfort and stagnation has already been mentioned. The comet and the rainbow, causing the scenery to phosphoresce in an uneasy twilight, not only serve to signify astronomy but also have a weird, ill-boding emanation of their own. Both the bat and the dog were traditionally associated with melancholy, the former (*vespertilio* in Latin) because he emerges at dusk and lives in lonely, dark and decaying places; the latter because he, more than other animals, is subject to spells of dejection and even to madness, and because he looks the more woebegone the more intelligent he is ("the most sagacious dogs are those who carry a melancholy face before themselves," to quote an author of the early sixteenth century who obviously thought of what we call bloodhounds). But in Dürer's engraving the bat and the dog are not merely emblems but, even more, living creatures, one squeaking with evident ill-will, the other shrivelled up with general misery.

What is true of the accessories is no less true of the main figure. Her book and compass belong, of course, to the typical attributes of Geometry; but that she does not make use of either reveals her torpid dejection. That she rests her head on her hand is in keeping with a tradition which can be traced back to ancient Egyptian art. As an expression of brooding thought, fatigue or sorrow this attitude is found in hundreds and thousands of figures and had become a standing attribute of melancholy and "Acedia" (*figs.* 210-214); and even that her hand is clenched to a fist is not as unusual as it may seem. The *pugillum clausum* was a typical symbol of avarice—we still speak of "tight-fistedness," and Dante says that misers will be resurrected "col pugno chiuso"—and it was supposed that if this melancholy vice assumed the proportions of real insanity the patients would never unclench their fingers because they imagined themselves holding a treasure or even the whole world in their fist. But in Dürer's engraving the motif has a totally different meaning. In medieval miniatures

the Melancholic displays his clenched fist as a symptomatic attribute, much as St. Bartholo-mew displays his knife, or the Magdalen her ointment jar (*fig.* 211). Dürer, in making the fist support the head, the center of thought and imagination, transforms a characterological or even medical symptom into an expressive gesture. His Melancholia is neither a miser nor a mental case, but a thinking being in perplexity. She does not hold on to an object which does not exist, but to a problem which cannot be solved.

One of the chief characteristics of the traditional melancholic is his swarthy, "earthlike" complexion which under certain circumstances can deepen to actual blackness. This *facies nigra* was still in Milton's mind when he described his "divinest Melancholy" as one

"Whose saintly visage is too bright
To hit the sense of human sight,
And therefore to our weaker view
O'erlaid with black, staid wisdom's hue."

Dürer, almost as subtle as Milton, substituted a luminary effect for the material discolora-tion of the skin. The face of his Melancholia—like that of Michelangelo's "Pensieroso"—is overcast by a deep shadow. It is not so much a dark as a darkened face, made all the more impressive by its contrast with the startling white of the eyes.

The wreath which she wears on her head is primarily a palliative against the dangers of the *humor melancholicus.* To counteract the bad effects of "dryness" it was recommended to put on one's head "the leaves of plants having a watery nature," and it is precisely of such plants that the wreath is composed; it consists of water-ranunculus—which also occurs in the "Aqua" section of Dürer's cosmological woodcut for Celtes (*fig.* 215)—and watercress. But the very idea of a wreath—normally a symbol of joy or superiority, as in many portraits of humanists or in Dürer's own representations of the Emperor Sigismund (*fig.* 176), a Wise Virgin (645), Hercules (*fig.* 108) and the poet Terence (*fig.* 36)—is here belied by the gloom of the general atmosphere. Again a mere emblem is used as a vehicle of psychological expression.

Perhaps we have no right to assume that practically every detail in the *Melencolia I* has a special "meaning." But the selection of two inconspicuous plants which have nothing in common except their "watery" nature—Copernicus still believed that the seeds of water-cress caused "unhealthy humidity" because the plant grows in humid places—can hardly be an accident. Moreover, we know by Dürer's own testimony that in the context of this engraving even the most conventional and commonplace accessories of a "Hausfrau's" costume are meant to have an emblematical significance. Attached to the belt of the Melan-cholia are a purse and a bunch of keys. Compared with the neat and orderly appearance of these objects in an engraving like the *Virgin by the Wall* (147), they, too, express the dis-traught condition of their owner, for the keys are disarranged and the purse trails on the ground with its leather strips twisted and partly unfastened. But in addition to revealing that

"careless desolation" which still marks the "melancholic" of the Elizabethan stage, they signify two definite concepts. On one of Dürer's sketches for the *Melencolia I* (1201) we find the following note: "Schlüssel betewt gewalt, pewtell betewt reichtum" ("Key denotes power, purse denotes wealth").

The purse is still a common symbol of wealth, particularly in its less enjoyable aspects of parsimony and avarice, and the papal "power of the keys" is still as proverbial in English as the matrimonial "Schlüsselgewalt"—already mentioned in connection with Dürer's *Glorification of the Virgin* (315)—is in German. The purse is therefore a frequent attribute of the miserly Melancholic (*figs.* 213 and 214), and the keys, too, can be connected with the concept of melancholy. As we shall shortly see, the melancholy humor was associated with the planet Saturn who, as the oldest and highest of the planetary divinities, was held to wield as well as to bestow "power," and was in fact occasionally represented with a key or bunch of keys.

However, since Dürer's Melancholia is no ordinary Melancholy, but, as we expressed it, the "Melancholia Artificialis" or Artist's Melancholy, we may well ask whether there might not be a special connection between the qualities of power and wealth and professional artistic activity. This seems indeed to be the case. In his theoretical writings Dürer not only insists that wealth is, or at least should be, the well-deserved reward of the artist (his earliest draft, composed about 1512, emphatically closes with the sentence: "If you were poor, you may achieve great prosperity through such art"), he also uses the German word for power, "Gewalt," as a specific term denoting that consummate mastery which is the final goal of every artist and can be attained only by passionate study and the grace of God: "And the true artists recognize at once whether or not a work is powerful [*gewaltsam*], and a great love will grow in those who understand"; or: "God gives much power [*viel Gewalts*] to ingenious men."

Now this consummate mastery results, according to Dürer—and to all other thinkers of the Renaissance—from a perfect coordination of two accomplishments: theoretical insight, particularly a thorough command of geometry ("Kunst" in the original sense of "knowledge"), and practical skill ("Brauch"). "These two must be together," Dürer says, "for the one without the other is of no avail."

This explains not only the deranged and neglected condition of the Melancholia's keys and purse, which indicates a temporary absence of wealth and power rather than their presence, but also the significant contrast between her torpid inaction and the bustling activity of the *putto*. The mature and learned Melancholia typifies Theoretical Insight which thinks but cannot act. The ignorant infant, making meaningless scrawls on his slate and almost conveying the impression of blindness, typifies Practical Skill which acts but cannot think (whereby it should be noted that Dürer's expression for theoretical insight, "Kunst," is of the feminine gender whereas his term for practical skill, "Brauch," is masculine). Theory and practice are thus not "together," as Dürer demands, but thoroughly disunited; and the result is impotence and gloom.

Three questions remain to be answered. First, with what right could Dürer substitute a spiritual tragedy for what had been the sluggishness and obtuseness of an inferior temperament? Second, on what grounds could he associate, or even identify, the idea of melancholy with that of geometry? Third, what is the meaning of the number "I" which follows the word "Melencolia"?

The answer to the first question lies in the fact that the whole concept of melancholy had been revised, or rather reversed, by Marsilio Ficino, the leading spirit of the Neo-Platonic "Academy" at Florence, and that this new doctrine, developed in Ficino's "Letters" and conclusively formulated in his treatise *De Vita Triplici*, had met with great success in Germany as well as in Italy. The "Letters" had been published by Koberger, and the first two Books of the three "Libri de Vita" had even been translated into German. Of these developments Dürer was certainly aware, for he quotes the "Platonic ideas" as early as 1512.

Marsilio Ficino, himself a man of delicate health and melancholy disposition, tried to alleviate the real and imaginary tribulations of his humor by the time-honored devices of exercise, regular hours, a careful diet and music (Dürer, by the way, also recommends the "cheerful tunes of the lute" in case "a young painter should overwork, from which his melancholy might exceed"). But he found greater consolation in an Aristotelian discourse which, though occasionally quoted by scholastic philosophers, had thus far failed to change the general dislike and fear of melancholy. According to this brilliant analysis of what may be called the psycho-physiology of human greatness (*Problemata*, xxx, 1), the "melancholics by nature"—as opposed to the downright insane—are marked by a peculiar excitability which either over-stimulates or cripples their thoughts and emotions and may, if not controlled, cause raving madness or imbecility; they walk, as it were, on a narrow ridge between two abysses. But they walk, just for this reason, way above the level of ordinary mortals. If they succeed in keeping their equilibrium so that "their very anomaly behaves somehow in a well-balanced and beautiful way," as Aristotle admirably puts it, they may still be subject to depression and overexcitement, but they outrank all other men: "All truly outstanding men, whether distinguished in philosophy, in statecraft, in poetry or in the arts, are melancholics—some of them even to such an extent that they suffer from ailments induced by the black gall."

The Florentine Neo-Platonists were quick to perceive that this Aristotelian doctrine supplied a scientific basis for Plato's theory of "divine frenzy." The action of the melancholy humor, which Aristotle had likened to that of strong wine, seemed to explain, or at least to concur with, those mysterious ecstasies which "petrify and almost kill the body while they enrapture the soul." Thus the expression *furor melancholicus* came to be synonymous with *furor divinus*. What had been a calamity and, in its mildest form, a handicap became a privilege still dangerous but all the more exalted: the privilege of genius. Once this idea—utterly foreign to the Middle Ages where men could become saints but not "divine" philosophers or poets—had been reborn under the joint auspices of Aristotle and Plato, the hitherto disparaged melancholy became surrounded with the halo of the sublime. Outstanding

achievements automatically included the reputation of melancholy—even of Raphael it was said that he was "malinconico come tutti gli huomini di questa eccelenza"—and soon the Aristotelian tenet that all great men were melancholics was twisted into the assertion that all melancholics were great men: "Malencolia significa ingegno" ("Melancholy signifies genius"), to quote from a treatise which tries to demonstrate the excellence of painting by the fact that the better class of painters were just as melancholy as poets or philosophers. Small wonder that persons with social ambitions were as anxious to "learn how to be melancholy," as Ben Jonson's Stephen puts it, as they are today to learn tennis or bridge. A climax of refinement is reached in Shakespeare's Jaques who uses the mask of a melancholic by fashion and snobbery to hide the fact that he is a genuine one.

This humanistic glorification of melancholy entailed, and even implied, another phenomenon: the humanistic ennoblement of the planet Saturn. As physical bodies, the seven planets were held to be determined by the same four combinations of qualities as the terrestrial elements; as sidereal personalities, on the other hand, they had retained the characters and powers of the classical gods after whom they were named. They, too, could thus be correlated with the four temperaments, and a complete system of coordination is already found in Arabic sources of the ninth century. The sanguine temperament was associated with friendly Venus, who was considered as moist and warm like air, or, even more frequently, with the equally well-tempered and benevolent Jupiter; the choleric with the fiery Mars; the phlegmatic with the Moon whom Shakespeare still calls the "watery star"; and the melancholic—as has already been mentioned in passing—with Saturn, the ancient god of the earth. We still use the expression "saturnine" almost as a synonym of "melancholy"—much as we do with the expressions "jovial" and "sanguine"—and in the German woodcut previously mentioned as a specimen of "descriptive" illustrations of the Four Temperaments (*fig.* 214) the unflattering characterization of the Melancholic concludes with the line; "Saturnus und herbst habent die schulde" ("Saturn and autumn are guilty of this").

Once established, this "consonance" between melancholy and Saturn was never questioned. Every human being, mineral, plant or animal supposed to have a melancholy nature—among them, for instance, the dog and the bat—*ipso facto* "belonged" to Saturn, too. The very posture of sadness, with the head resting on the hand, is melancholy as well as Saturnian; and as the black gall was considered the most ignoble of humors, so the "Saturnus impius" was held to be the most unfortunate of celestial influences. As the highest of the planets, as the oldest of the Olympians, and as the former ruler of the Golden Age, he could give power and riches. But as a dry and icy star, and as a cruel father-god dethroned, castrated and imprisoned in the bowels of the earth, he was associated with old age, disablement, sorrow, all kinds of misery, and death. Even under favorable circumstances those born under him could be wealthy and mighty only at the cost of generosity and goodness of heart, and wise only at the cost of happiness. Normally, they were hard-working peasants or laborers in stone and wood—for Saturn had been a god of the earth—privy-cleaners, grave-diggers, cripples, beggars, and criminals (*fig.* 213).

The Florentine Neo-Platonists, however, discovered that Plotinus and his followers had thought as highly of Saturn as Aristotle had thought of melancholy. Since that which is higher is more "exalted" than that which is lower, and since that which begets is closer to the source of all things than that which is begotten, Saturn was thought superior to Jupiter, let alone the rest of the planets. He symbolized the "Mind" of the world where Jupiter merely symbolized its "Soul"; he had thought out what Jupiter had merely learned to govern; he stood, in short, for profound contemplation as opposed to mere practical action. Thus interpreted, the domination of Saturn was willingly accepted by those "whose minds are bent to contemplate and to investigate the highest and most secret things." They hailed him as their celestial patron just as they reconciled themselves to melancholy as their terrestrial condition. The most illustrious members of the Florentine circle—among them, besides Ficino, Pico della Mirandola and Lorenzo the Magnificent—referred to themselves, only half playfully, as "Saturnians," and they discovered to their immense satisfaction that Plato, too, had been born under the sign of Saturn.

This philosophical rehabilitation of Saturn could not weaken the popular belief that he was the most malignant of planets; and Ficino himself, whose horoscope showed "Saturnum in Aquario ascendentem," lived under a permanent cloud of anxiety. He took, and advised his fellow-scholars to take, all possible precautions. He even used and recommended astrological talismans which might counteract the influence of Saturn by invoking the power of Jupiter, and this, by the way, explains the magic square in Dürer's *Melencolia I*. It can be identified as the sixteen-celled *mensula Jovis*; engraved upon a slab of tin, it will "turn evil into good" and "dispel all worries and fear." However, all said and done, Ficino bravely submitted to his Saturnian destiny: "Not only those who take refuge to Jupiter, but also those who wholeheartedly and sincerely concentrate on that divine contemplation which is signified by Saturn, will escape from the latter's pernicious influences and only enjoy his benefits. . . . To the spirits that dwell in the spheres of the sublime Saturn himself is a benevolent father [*juvans pater*, that is, Jupiter]."

It is this new and most humanistic conception of the melancholy and "saturnine" genius that found expression in Dürer's engraving. But what, to turn to the second of our questions, is the specific connection between the ideas of melancholy and Saturn on the one hand, and of geometry and the geometrical arts on the other?

It has been mentioned that Saturn, as god of the earth, was associated with work in stone and wood; in one of the earliest pictorial surveys of what may be called the Saturnian professions, the murals in the "Salone" at Padua, we already encounter the stonemason and the carpenter, here still conceived as lowly manual laborers. But as god of agriculture Saturn had also to supervise the "measurements and quantities of things" and particularly the "partition of land." This is precisely the original meaning of the Greek word Γεωμετρία, and it is not surprising to come upon several manuscripts of the fifteenth century where the rustic attributes of Saturn are supplemented by a compass (*fig.* 220). Jacob de Gheyn was to monumentalize this concept of a Saturn-Geometrician in one of his most impressive engrav-

ings (*fig.* 221). One or two of those fifteenth century manuscripts add the explanation: "Saturn the planet sends us the spirits that teach us geometry"; and in a Calendar published in Nuremberg exactly one year after the *Melencolia I* we read the phrase: "Saturnus . . . bezaichet aus den Künsten die Geometrei" ("Of the arts, Saturn denotes geometry").

In addition to this astrological connection between geometry and Saturn there existed, however, a much subtler psychological connection between geometry and melancholy—a connection brilliantly expounded by the great scholastic philosopher Henry of Ghent who had been greeted as a kindred spirit by Pico della Mirandola, and whose analysis of melancholy was extensively quoted and endorsed in the latter's *Apologia de Descensu Christi ad Inferos*. There exist, to summarize this argument, two kinds of thinkers. On the one hand, there are the philosophical minds which find no difficulty in understanding such purely metaphysical notions as the ideas of an angel or of extramundane nothingness. On the other hand, there are those "in whom the imaginative power predominates over the cognitive one." They "will accept a demonstration only to that extent as their imagination can keep step with it. . . . Their intellect cannot transcend the limits of imagination . . . and can only get hold of space [*magnitudo*] or of that which has a location and position in space. . . . Whatever they think is a quantity, or is located in quantity as is the case with the point. Therefore such men are melancholy, and become excellent mathematicians but very bad metaphysicians, for they cannot extend their thought beyond location and space which are the foundations of mathematics."

Melancholics, then, are gifted for geometry—for, Henry's own definition restricts the field of "mathematics" to a science of *situs et magnitudo*—because they think in terms of concrete mental images and not of abstract philosophical concepts; conversely, people gifted for geometry are bound to be melancholy because the consciousness of a sphere beyond their reach makes them suffer from a feeling of spiritual confinement and insufficiency.

This is precisely what Dürer's Melancholia seems to experience. Winged, yet cowering on the ground—wreathed, yet beclouded by shadows—equipped with the tools of art and science, yet brooding in idleness, she gives the impression of a creative being reduced to despair by an awareness of insurmountable barriers which separate her from a higher realm of thought. Was it perhaps in order to emphasize this idea of a first, or lowest, degree of achievement that Dürer added the number "I" to the inscription? This numeral can hardly refer to the other temperaments, for it is difficult to imagine that Dürer should have planned three more engravings of a similar kind, and no less difficult to find a series of the Four Humors which would begin with Melancholy. The number "I" may thus imply an ideal scale of values, rather than an actual sequence of prints, and this conjecture can be corroborated, if not proved, by what seems to be the most important literary source of Dürer's composition: Cornelius Agrippa of Nettesheim's *De Occulta Philosophia*.

As published in 1531, this famous book appears to be an item from the study of Dr. Faustus, fairly confused in plan and full of cabalistic charms, astrological and geomantic tables and other magical devices. The original version of 1509/10, however, which had been

dedicated to a friend of Pirckheimer's, the Abbot Trithemius of Würzburg, and was circulated among the German humanists in manuscript form, was a much shorter and more "reasonable" book. It is only about one-third as long as the printed version, and the already noticeable emphasis on magic does not yet obscure a clear and, in its way, consistent system of natural philosophy. The author, largely basing himself on Marsilio Ficino, sets forth the Neo-Platonic doctrine of cosmic forces whose flux and reflux unifies and enlivens the universe, and he tries to show how the operation of these forces enables man not only to practice legitimate magic—as opposed to necromancy and commerce with the Devil—but also to achieve his greatest spiritual and intellectual triumphs. Of these man is capable through direct "inspiration" from above (it is worth noting that Dürer, too, refers to "öbere Eingiessungen"); and this inspiration can come to him in three forms—through prophetic dreams, through intense contemplation, and through the *furor melancholicus* induced by Saturn.

In the original version of Agrippa's *De Occulta Philosophia* this theory of melancholy genius—later arbitrarily tucked away in the First Book of the printed edition—is expounded near the end of the last Book and thus marks the climax of his whole work. That it is derived from Ficino's *Libri de Vita Triplici* goes without saying; whole sentences are taken over almost verbatim. But Agrippa differs from Ficino in one important point, and in so doing reveals himself as the intermediary between Ficino and Dürer.

Ficino had little interest in politics and no interest whatever in art. He conceived of geniuses primarily in terms of "studiosi" and "literati," and according to him the creative, Saturnian melancholy is a prerogative of theologians, poets and philosophers. It is only the purely metaphysical and therefore highest of our faculties, the intuitive "mind" (*mens*), which is susceptible to the inspiring influences of Saturn. Discursive "reason" (*ratio*), which controls the sphere of moral and political action, belongs to Jupiter; and "imagination" (*imaginatio*), which guides the hands of artists and craftsmen, to Mars or to Sol. According to Agrippa of Nettesheim, however, the *furor melancholicus*, that is, the Saturnian inspiration, can stimulate each of these three faculties to an extraordinary or even "superhuman" activity.

Agrippa thus distinguishes among three kinds of geniuses, all of whom act under the impulse of Saturn and his *furor melancholicus*. Those in whom "imagination" is stronger than the "mind" or "reason" will turn out to be wonderful artists and craftsmen such as painters or architects; and if they should be blessed with the gift of prophecy their predictions will be restricted to physical phenomena ("elementorum turbationes temporumque vicissitudines") such as "storms, earthquakes or floods, epidemics, famines, and other catastrophes of this kind." He in whom discursive "reason" predominates will become an ingenious scientist, physician or statesman, and his predictions, if any, will refer to political events. Those finally in whom the intuitive "mind" outweighs the other faculties will know the secrets of the realm divine and excel in all that is implied in the word theology; if prophetic, they will foresee religious crises such as the appearance of a new prophet or a new creed.

In the light of this system Dürer's Melancholia, the "Artist's Melancholy," can in fact be classified as "Melencolia I." Moving as she does in the sphere of "imagination"—which is, by definition, the sphere of spatial quantities—she typifies the first, or least exalted, form of human ingenuity. She can invent and build, and she can think, to quote Henry of Ghent, "as long as her imagination keeps step with her thought"; but she has no access to the metaphysical world. Even if she were to venture into the realm of prophecy she would be limited to the domain of physical phenomena; the ominous apparitions in the firmament, in addition to denoting the science of astronomy, may also allude to Agrippa's "elementorum turbationes temporumque vicissitudines," and the fact that some of the trees in the background are surrounded by water may suggest those "floods" which he explicitly mentions among the natural catastrophes foreseen by the "imaginative" melancholic—and which, incidentally, were believed to be caused by Saturn or Saturnian comets. Thus Dürer's Melancholia belongs in fact to those who "cannot extend their thought beyond the limits of space." Hers is the inertia of a being which renounces what it could reach because it cannot reach for what it longs.

The influence of Dürer's *Melencolia I*—the first representation in which the concept of melancholy was transplanted from the plane of scientific and pseudo-scientific folklore to the level of art—extended all over the European continent and lasted for more than three centuries. Its composition was simplified or made even more complicated, and its content was either reconciled with earlier traditions—as is the case with most of the variations produced by Northern artists of the sixteenth century—or reinterpreted according to the taste and mental habits of the day. It was mythologized by Vasari and emblematically transformed by Cesare Ripa; it was emotionalized by such Baroque artists as Guercino, Domenico Feti, Benedetto Castiglione or Nicolas Chaperon who frequently fused it with the then fashionable allegories of Transience and tried to gratify the popular enthusiasm for ruins; it was sentimentalized in English eighteenth century art; it was romanticized by J. E. Steinle and Caspar David Friedrich; and it inspired poetic and literary paraphrases—such as the famous one in James Thomson's *City of Dreadful Night*—as well as paintings, drawings and prints.

In spite of this universal appeal, it has always been felt that Dürer's engraving has an eminently personal connotation. It has been suggested that its somber mood might reflect Dürer's sorrow at the death of his mother who had passed away on May 17, 1514; and it has even been supposed that the numerical elements of this date—17, 5, 15, 14—are in some way referred to in the magic square which consists of 16 cells, and where (therefore) each row of four figures adds up to 34. However, even if the numerological treatment of the date were less arbitrary than it is, even if the *Mensula Jovis*, like all the other "Seals of the Planets," could not be traced back to Arabic sources of the ninth or tenth century, and even if its presence in Dürer's engraving could not be accounted for by good internal reasons; even then this hypothesis would be hard to believe. Dürer respected his "poor and pious mother"; as a dutiful son, he felt sorry for her hard life, and he admired her patience in "many a painful illness, great poverty, derision, contempt, sneering words, anxieties and

other troubles on end." But his real love belonged to his father, and no personal grief would have occasioned an engraving so esoteric and, at the same time, so programmatic in character. Instead of saying that the death of Dürer's mother caused him to create the *Melencolia I*, one might rather contend that only an artist pregnant with the *Melancolia I* could have interpreted the face of an old woman—her squint bringing to mind Shakespeare's Paulina, "one eye declined for the loss of her husband, another elevated that the oracle was fulfilled"—in such a manner as Dürer did when he portrayed his mother two months before her death (1052, *fig.* 222).

In fact the *Melencolia I* reflects the whole of Dürer's personality rather than a single experience, however moving. In a drawing of about 1512/13, apparently made for the purpose of consulting a doctor (1000), Dürer represented himself in the nude, his finger pointing to a mark on the left side of his abdomen. The inscription reads: "Where the yellow spot is, to which I point with my finger, there it hurts"; and the sore spot is obviously the spleen, supposedly the very kernel of melancholy disease. Melanchthon, on the other hand, extols the "melancholia generosissima Dureri" ("Dürer's most noble melancholy"), thus classifying him as a melancholic in the sense of the new doctrine of genius.

Dürer himself, then, was, or at least thought he was, a melancholic in every possible sense of the word. He knew the "inspirations from above," and he knew the feeling of "powerlessness" and dejection. But, more important still, he was also an artist-geometrician, and one who suffered from the very limitations of the discipline he loved. In his younger days, when he prepared the engraving "Adam and Eve," he had hoped to capture absolute beauty by means of a ruler and a compass. Shortly before he composed the *Melencolia I* he was forced to admit: "But what absolute beauty is, I know not. Nobody knows it except God." Some years later, he wrote: "As for geometry, it may prove the truth of some things; but with respect to others we must resign ourselves to the opinion and judgment of men." And: "The lie is in our understanding, and darkness is so firmly entrenched in our mind that even our groping will fail"—a phrase which might well serve as a motto for the *Melencolia I*.

Thus Dürer's most perplexing engraving is, at the same time, the objective statement of a general philosophy and the subjective confession of an individual man. It fuses, and transforms, two great representational and literary traditions, that of Melancholy as one of the four humors and that of Geometry as one of the Seven Liberal Arts. It typifies the artist of the Renaissance who respects practical skill, but longs all the more fervently for mathematical theory—who feels "inspired" by celestial influences and eternal ideas, but suffers all the more deeply from his human frailty and intellectual finiteness. It epitomizes the Neo-Platonic theory of Saturnian genius as revised by Agrippa of Nettesheim. But in doing all this it is in a sense a spiritual self-portrait of Albrecht Dürer.

VI · Dürer's Activity for Maximilian I; the "Decorative Style," 1512/13-1518/19

THE second decade of the sixteenth century represents the most "humanistic" phase of Dürer's life. As he had found himself as a creative artist in the period culminating in the Apocalypse, so he found himself as a scholar, thinker and writer in the period culminating in the *Melencolia I*.

It has already been mentioned that Dürer, during his second stay in Venice, had been drawn into the orbit of those Italians who had built up a theory of art as a scientific and philosophical discipline. Immediately upon his return he began to work along these new lines of his own accord and sketched a program for a comprehensive Treatise on Painting, the more technical sections of which were ultimately to develop into his *Vier Bücher von Menschlicher Proportion* and *Underweysung der Messung mit dem Zirckel un Richtscheyt*. But it was not until 1512/13 that he began to formulate his thoughts in writing. In the synopses and drafts of those years he appears before us, unexpectedly, as a philosopher and scientist. We find him struggling with a linguistic medium never before employed for similar purposes, hampered by the lack of a fixed terminology, but—and perhaps for this very reason—achieving a stupendous force and originality of expression. He reveals, too, an ever-increasing familiarity with the historical, medical, psychological and metaphysical ideas of his time, especially with those Neo-Platonic doctrines which were to find expression in the *Melencolia I*, and which, it seems, are also illustrated in a series of magnificent allegorical drawings executed in 1514 and the two following years (939-941).

In addition to geometrical research and "aesthetic" speculation Dürer engaged in pursuits of a poetic and antiquarian character. In order to "acquire something which he had not learned before," he tried his hand at secular and religious verse, and he began to approach classical subjects in the same scholarly spirit which is apparent in his over-conscientious drawings of the Imperial Insignia (1010-1013). He had, of course, always derived inspiration from the Mythographers or from Philostratus whose *Imagines* had suggested such charming inventions as the industrious *putti* in the *"Sojourn of the Holy Family in Egypt"* (310, *fig.* 142) or the *Family of Centaurs* (904, *fig.* 121). But here the texts had merely touched off the fuse of Dürer's inventive fantasy which had produced spirited paraphrases rather than literal illustrations. The drawings of 1514, such as *Cupid the Honey-Thief* (908), *Arion* (901), or *Hercules Gallicus* (936), carefully executed in pen and water color, attempt to reconstruct their subjects from the descriptions of Lucian and Pseudo-Theocritus much as modern archeologists have tried to reconstruct the murals by Polygnotus from the descriptions of Pausanias.

172

This intellectualization of Dürer's artistic production, which accounts, by the way, for the coolness with which this period of his activity has been received until quite recently, finds its most characteristic expression in the rise of what may be called an "emblematic" spirit. "Emblems" are images which refuse to be accepted as representations of mere things but demand to be interpreted as vehicles of concepts; they are tolerated by most modern critics, as a rule, only if incorporated in a work so rich in "atmosphere" that it can, after all, be "enjoyed" without a detailed explanation (as in the *Melencolia I*).

The most powerful, if not the only, source of this emblematic spirit—amusingly illustrated by a design of two columns in which the contrast between the sanguine and the melancholy temperament is literally reduced to an arrangement of "odds and ends" (1532) —was a treatise on the Egyptian hieroglyphs entitled *Hieroglyphica*. This book was composed in the second or fourth century A.D. by one Horus Apollo whose real name is still unknown to us, and was allegedly translated from the Egyptian into Greek by one Philippus. It is entirely worthless from a scientific point of view, for the true meaning of the hieroglyphs was not disclosed until after the discovery of the Rosetta Stone in 1799. But in 1419, when Horus Apollo's treatise became known in Italy, it struck the humanistic mind with the force of a revelation. Egypt, the home of sacred mysteries, had always held a strange fascination for the erudite and would-be erudite, and the humanists greeted with enthusiasm a new ideographic language which could express a whole sentence by a series of images and was both international and esoteric, "understandable all over the world, but to the initiated only."

This new language, soon enriched by the vocabulary of medieval herbaries, bestiaries and lapidaries, and capable of absorbing any number of further, freely invented characters, was later codified in what is still known as "emblem literature." But long before Andrea Alciati and the host of his followers had published their emblem books, and even before the original text of the *Hieroglyphica* had been printed in 1505, Horus Apollo's concoction had left its mark on Italian medals and funeral monuments, on the woodcuts in Francesco Colonna's *Hypnerotomachia Polyphili*, and on the paintings and drawings by Mantegna, Pinturicchio, Giovanni Bellini and Leonardo da Vinci.

A Latin translation of the *Hieroglyphica* (by Filippo Fasanini) was not printed until 1517. But about five years before Pirckheimer had undertaken a translation of his own, and it fell to Dürer to illustrate it. Only a few pages of the original manuscript have been recovered thus far (966-973); but a complete copy has come down to us (974/75), and even one of the surviving pages (971) suffices to illustrate both the haphazard methods of Horus Apollo and the philological faithfulness of Dürer. A dog draped with a stole, for instance, signifies "a prince or judge"; a man devouring an hourglass denotes "the horoscope"; a man seated stands for "the guardian of a temple"; and a pail of water together with a fire means "ignorance" because it is by fire and water that "everything is cleansed."

It is not by accident that Pirckheimer and Dürer undertook this task in 1512/13, for in 1512 Dürer had been asked to participate in the artistic enterprises of the Emperor Maximilian I, and in these the influence of Horus Apollo looms large, both in letter and spirit.

There was, indeed, nothing better suited to the Emperor's tastes than the hieroglyphs—the latest fashion, yet supposedly derived from hoariest Antiquity; entertaining to look at, yet fraught with meaning; and mysteriously esoteric, yet perfectly rational once you had the key. Still more important, Maximilian loved to think of himself as a direct descendant of Osiris and Hercules Aegyptiacus, whom the imperial genealogists listed between Hector of Troy and Noah.

Maximilian I is known to all as the "Last Knight," but this sobriquet describes only one facet of his complex and charming personality. Affable though enormously proud of his ancestry and personal achievements, courageous though not strong-minded, impulsive, generous and constantly short of money, the Emperor was a great gentleman and a genuinely patriarchal ruler (many great princes have endowed hospitals and homes for the aged, but few would have thought of decreeing, on their death-bed, that every inmate was to receive with his meals a medicinal potion "boiled with honey, juniper-berries and honey-suckle so that it might be pleasing to the taste"); but he was by no means a retrospective medievalist. He was enamored of the pageants, tournaments and chivalrous orders of a feudal past; he dreamed of a new crusade against the infidels; he ordered and collected copies of medieval romances; and he loved to imagine himself in the roles of King Arthur or Sir Galahad. But he was also the founder of the first purely humanistic Faculty; and his most vivid though perhaps no less romantic ambition was to realize the modern ideal of the "Huomo universale." He was a dilettante, not only on a monumental scale but also, paradoxically, with the thoroughness of a perfectionist (so that he achieved real authority in certain fields, particularly in "mechanized warfare"). From statecraft and generalship to veterinary surgery, fishing and cookery; from classical archeology, art criticism, music and poetry to carpentry, ordnance, printing, mining and fashion designing—there was nothing on earth in which he was not actively interested and tried to outdo the professionals. The *Weisskunig*—a somewhat wishful autobiographical novel the punning title of which designates a "white" and a "wise" king—containing about 225 woodcuts by Burgkmair and Leonhard Beck, was to have recorded for public display his deeds and accomplishments; but its original task remained unfulfilled, for the woodcuts were never published in the Emperor's lifetime, and only a posthumous edition was made in 1775.

The *Weisskunig* is typical of Maximilian's undertakings in the field of "official" art. More often than not the works begun at his command failed to materialize or were completed in a makeshift or even incongruous fashion, and almost all of them were products of the printing press.

Whether a prince bent on ensuring his lasting fame (and Maximilian frankly admitted that he wanted to do just this, for "he who does not provide for his memory during his life will have no memory after his death and will be forgotten with the sound of his death-knell") commissions his artists with buildings, statues and murals, or merely with illustrated books and annotated woodcuts is, of course, primarily a question of money. But the fact that most of Maximilian's enterprises existed, if at all, only "on paper" is also characteristic of

the German Renaissance as such. It illustrates the literary rather than visual taste of an intelligentsia which felt more at home in the realm of words and ideas than in the world of forms and colors. It reflects the propagandistic spirit of the Reformation period where pamphlets and illustrated broad-sheets had become almost as important as the press and the radio today. It bears witness, further, to the peculiar predicament of a humanistic movement which could neither rely on the resources of cosmopolitan centers like Rome and Venice, nor on the protection of an aristocracy which produced an unlimited supply of erudite and art-loving princes and Cardinals. German humanism had to invade the very homes of the better classes, nobility and higher bourgeoisie alike, and this is precisely what Maximilian expected from his enterprises in the field of art. They must be understood, not as self-sufficient "things of beauty" but rather as vehicles of a high-class advertising campaign.

The most ambitious of these enterprises, and one of the few which were actually completed according to schedule, was the mammoth woodcut known as the *Triumphal Arch* (358, *figs.* 225, 226, 228). Printed from 192—not 92—separate blocks, it measures, including the beautifully lettered explanations at the bottom, about 11.5 by 9.75 feet, and it required the cooperative effort of four different agencies. Johannes Stabius, the Emperor's astronomer, poet and historiographer, devised the program and wrote the explanations (with the intention of expanding them, later on, into several tomes). Jörg Kölderer, an architect of Innsbruck in the Tyrol, provided the design of the architectural framework. The firm of Hieronymus Andreae, called Formschneyder, took care of the cutting. And Dürer, employing the members of his workshop and assisted by Pirckheimer in iconographical matters, acted as designer-in-chief.

When Dürer applied for payment in a letter of July 15, 1515, he emphasized, quite rightly, that the "ornate work" could not have been brought to a successful end without his strenuous efforts (the cutting, by the way, was not completed until two years later). But his personal contributions are not greatly in evidence. As far as the "stories" (scenic representations) are concerned, he seems merely to have furnished slight sketches and to have supervised their execution in a general way. Only where the work of his collaborators left too much to be desired would he supply an actual working drawing, and such portions as the *Rediscovery of the Holy Coat of Treves* or the *Betrothal of Philip the Fair and Joan of Castille* are easily distinguished from the indifferent work of secondary artists. He designed, however, much of the ornament, and two authentic sketches for details have come down to us (948 and 949). The upper part of the decorative framework of the central portal, the four large columns (excepting the pedestals of the outer, and the standard-bearers in the pedestals of the inner pair, but including the two figures attached to the shafts and the four statues placed in the niches of the crowning tabernacles), the griffons perched on these tabernacles, the drummers above the inner pair of griffons, and the second story of the lateral gables—all these details can be ascribed to Dürer himself. He did not bother to make two separate drawings where motifs had to be repeated symmetrically but furnished only the designs for one half of

the woodcut and left it to assistants to reverse them and to change minor details and, of course, the lighting, accordingly.

Stabius solemnly protests that the *Triumphal Arch* had "the same shape as, of yore, the *Arcus Triumphales* erected to the Roman Emperors in the City of Rome." The structure shows, indeed, three portals or doorways: the "Portal of Fame," the "Portal of Honor and Power"—often "traversed by his Majesty's Imperial mind," to quote Stabius's unintentionally ironical phrase—and the "Portal of Nobility"; and each of these doorways is flanked by heavily projecting columns. But in every other respect the structure differs from a classical Triumphal Arch much as the Castle of Heidelberg differs from the Palace of Diocletian in Spalato. The large columns do not support an epistyle and an *attica*—in fact, no continuous horizontal division occurs in the whole composition—but develop into tabernacles of different size and shape surmounted by griffons. The walls above the side portals outgrow not only the large columns but even the tabernacles; they develop into richly decorated gables culminating in roundels with the insignia of the Golden Fleece. The central doorway is surmounted by a veritable tower crowned by an octagonal cupola; and attached to either side of the structure are narrow cylindrical turrets not unlike those which flank the transepts or west façades of Romanesque churches.

The iconography of this fantastic structure employs all known devices of glorification, from the simple recording of historical events to cryptic emblematical allusions. Military exploits and major political incidents, including dynastic marriages, are represented in the twenty-four panels above the side portals. The more personal accomplishments of the Emperor—his activities as a patron of the arts and crafts, his prowess as a huntsman and linguist, the rediscovery of the Holy Coat of Treves, the foundation, or rather renewal, of the Order of St. George, etc.—are depicted on the cylindrical turrets. The vertical strips of masonry which connect these turrets with the bulk of the structure, the first story of the lateral gables, and the pedestals of the outer columns are filled with portraits in half-length; they show, on the right-hand side, Maximilian's relatives by birth or marriage (with the gable strip reserved to Royalty), and, on the left, the Roman and German-Roman Emperors from Julius Caesar to Rudolf I, with Alphonso of Spain, Richard Coeur de Lion and William I of Holland thrown in for good measure. Attached to the shafts of the outer columns are the statues of St. Arnolf, Bishop of Metz and legendary founder of the Carolingian dynasty, and of St. Leopold, the only Hapsburg ever canonized and foremost patron Saint of Austria; the tabernacles on top of the columns contain the effigies of four Hapsburgs who had attained the rank of King or Emperor of Germany: Rudolf I, Albrecht I, Albrecht II, and Frederick III, Maximilian's father. The front of the central tower is adorned with the Emperor's family tree, flanked by the coats-of-arms of the Austrian branch on the left-hand side, and of the Spanish branch on the right. The tree is rooted in the mythical past, which is personified by the figures of Francia, Sigambria and Troy (because the Merovingian dynasty was believed to descend from Hector), but it actually starts with Clovis, the first Christian King of the Franks. It ends, of course, with Maximilian himself, enthroned and worshipped by twenty-

two Victories; his lamented son Philip the Fair, after a sketch by Dürer (947); and his daughter Margaret of Austria, the future Governor of the Netherlands.

The crowning jewel of the whole is the *aedicula* in front of the cupola wherein is seen the *"Mysterium der aegyptischen Buchstaben"* (*"Mystery of the Egyptian Hieroglyphs"*). The Emperor is depicted sitting on what looks like a sheaf of corn, and he is surrounded by so fantastic an array of animals and other symbols that the meaning of the representation would be wholly incomprehensible had we not Stabius's explanation and several autographic drafts by Willibald Pirckheimer, one of which served as a basis for Dürer's preliminary sketch (a copy of the latter, 946, is illustrated in *fig.* 227). From this evidence it appears that the picture is a carefully worded eulogy actually "written" in hieroglyphs, so that every single phrase in Pirckheimer's Latin and Stabius's German text is directly and unequivocally expressed by a visual symbol. It may be decoded as follows: "Maximilian [the Emperor himself]—a prince [dog draped with stole] of great piety [star on the Emperor's crown], most magnanimous, powerful and courageous [lion], ennobled by imperishable and eternal fame [basilisk on the Emperor's crown], descending from ancient lineage [the sheaf of papyrus on which he is seated], Roman Emperor [eagle or, in the woodcut, eagles embroidered in the cloth of honor], endowed with all the gifts of nature and possessed of art and learning [dew descending from the sky] and master of a great part of the terrestrial globe [snake encircling the scepter]—has with warlike virtue and great discretion [bull] won a shining victory [falcon on the orb] over the mighty king here indicated [cock on a serpent, meaning the King of France], and thereby watchfully protected himself [crane raising its foot] from the stratagems of said enemy, which has been deemed impossible [feet walking through water by themselves] by all mankind."

Had Pirckheimer had his way, the "Mystery of the Egyptian Letters" would have included several other symbols such as the balance of Justice and the club of Hercules; as it is, the only symbols not taken from Horus Apollo's *Hieroglyphica* are the Roman eagle and the cock, the punning emblem of France ("Gallia"). No such restrictions prevail in the architectural ornament, which more than anything else bears the imprint of Dürer's personal genius. Here the symbolism of the "Egyptian" hieroglyphs freely mingles with that of medieval heraldry and classical mythology, and art is fantastically fused with reality: snails the size of a pumpkin round the corners of pedestals, lifelike dogs gracefully balance on cornices, and dragons emerge from the wall to threaten the carved birds in a capital.

Many of these delicious details have been explained by Stabius himself. He tells us, for instance, that the two Archdukes in the pedestals of the central portal—one armored, the other not, and each accompanied by an analogously attired standard-bearer—personify strict discipline and order, on the one hand, and impartial justice, on the other. Sirens hung by their necks (on the columns above the Archdukes) denote "the ordinary adversities of the world which yet have done no damage to this noble Arch of Honor and, God willing, will never be able to do so." The "monstrous, misshapen, pale and miserly" Harpies (on the bases of the inner pair of large columns) are meant to indicate that "his Majesty has not permitted them

to spoil his riches and his generous pleasures." The numerous Cupids, children of Venus to whom the myrtle was sacred, refer to deeds worthy of an "ovation" whereby the victor wore a wreath of myrtle instead of a wreath of laurel. The torches and candelabra serve "to illuminate the honor and fame of his Majesty and to throw light on the truth." The griffons on the inner pair of large columns hold the insignia of the Golden Fleece: the one on the left, the cross of St. Andrew, the patron saint of Burgundy; the one on the right, the flint and steel of which the collar of the Order is composed so as to illustrate the motto "Ante ferit quam micat" ("First strike, then shine!"). The griffon on the outer right-hand column holds a scroll with the motto of the Order of Temperance ("Halt Mass!"), while his companion on the left bears Maximilian's personal device, the pomegranate. A common symbol of fertility and unity, it had been adopted by the Emperor in his youth because it struck him as an image of his own self: "Though the pomegranate lacks a particularly handsome skin and a particularly lovely smell, yet its interior is full of noble munificence and shapely seeds."

"Much could be written about the many other ornaments," Stabius concludes, "but may every beholder explain and interpret them himself." Following this advice, the beholder soon discovers that almost every detail of this luxuriant and seemingly capricious decoration has an emblematic significance. Some of the motifs are "classical," as, for example, the empty thrones surmounted by garlands—a well-known symbol of immortality; the trophies of wars and hunts (the dead herons hung from a hook which are seen on and near the pedestals of the large columns); and the "Aquilifer" and "Draconifer" above the inner pair of griffons. Others are heraldic, for instance: the heralds on the central tower; the insignia of the Order of Temperance—the German successor of the Spanish Order of the Jar ("Orden de la Jarra") —which are suspended on the columns with the Harpies; or Maximilian's pomegranates which are in evidence in several places. Still other motifs belong in the province of ordinary animal and floral symbolism, for instance: the snails which stand for sloth, but also for patience; the fettered monkeys which symbolize the suppression of the baser instincts; the elephants which stand for chastity; the grapes and cornucopias which signify joy and abundance; the fairly ubiquitous lilies-of-the-valley which denote virtuous purity; and the pea blossoms and peasecods beneath the Harpies which suggest luck in love and fertility.

The most unusual features, however, can be traced back to Horus Apollo's *Hieroglyphica*, and it is perhaps not by accident that these are all designed by Dürer himself. That the inscriptions in the second story of the left-hand gable is inscribed on a lion's skin needs no explanation. But that the corresponding inscription, which praises his family connections, is inscribed on a deer's skin can be accounted for by the fact that Horus Apollo adduces the deer as the hieroglyph of "longevity." The goats on either side of these inscriptions signify "a man quick of hearing," and Dürer took particular pains to emphasize this idea by enormous ears. The crane, already known to us as a symbol of watchfulness (because he was believed to hold in his raised foot a little stone which would fall down and wake him should he go to sleep), recurs on the garland of lilies-of-the-valley which is hung across the central portal; and on the tabernacles to which this garland is being fastened by two bearded servants—"the Northern

colleagues of Michelangelo's Slaves in the Sistine Chapel," as Wölfflin calls them—are seen two dogs, also already mentioned as symbols of intelligence and, more specifically, of "sacred letters" (see the drawing 970). The capitals of the inner pair of large columns are made up of lion's heads and ibises, the hieroglyphs of "vigilance" and "wisdom."

Dürer's *Triumphal Arch* has not gained favor with the critics of the nineteenth and early twentieth centuries; it is indeed objectionable both from a classicizing and from an expressionistic point of view. But we should cease to measure the *Triumphal Arch* by the standards of Roman architecture, on the one hand, and of Dürer's Apocalypse, on the other. A typical instance of Northern Mannerism, and therefore, in a sense, an anticipation of modern Surrealism without its Freudian connotations, it may be compared to those intricate specimens of cabinet-making (like the "Pommerscher Kunstschrank" in the Schlossmuseum at Berlin) which are "not beautiful but miraculous," as Vasari would say, manufactured from all sorts of precious materials, redundant with inlays, colonnettes and carved figures, and full of hidden drawers which may guard their secret until a great-great-grandson of the original owner happens to touch the right spring. The *Triumphal Arch* cannot be subjected to the categories of "appreciationists." It demands to be read like a book, to be decoded like a cryptogram, and yet to be enjoyed like a collection of quaint and sparkling jewelry.

The *Triumphal Arch* had, of course, to be supplemented by a *Triumphal Procession*. A detailed program, conceived by the Emperor himself, was worked out in 1512 by his Secretary, Marx Treitz-Saurwein, and some preparatory work was done in the following years. The woodcuts, however, about half of them designed by Burgkmair, the others by Leonard Beck, Altdorfer, Wolf Huber, Schäuffelein, Springinklee and Dürer, were not produced until 1516/18. In 1519 the work was interrupted by Maximilian's death so that the number of woodcuts actually executed falls short of that required by the program; but even so they measure almost sixty yards when arranged in a continuous sequence. What was available was published in 1526 by order and at the expense of the Archduke Ferdinand, the brother and future successor of Charles V.

In this posthumous edition the cortege, announced by a nude "Herald" on a gigantic griffon, unfolds in regal though somewhat incondite splendor. Pipers and drummers, preceded by a horse-borne litter with the "Title Tablet," introduce the representatives of falconry and all other kinds of huntsmanship. Then comes the Court—including the holders of the "Five Courtly Offices," musicians, fools, masqueraders, fencers, and jousters—and after this two endless cavalcades bearing the banners of the Austrian and Burgundian provinces respectively, the latter ushered in by "Burgundian Flute-Players" and appropriately followed by a chariot celebrating the wedding of Maximilian and Mary of Burgundy. Next come the "Wars" in the shape of curious man-driven automobiles, on which are depicted the Emperor's battles, conquests and peace-treaties, followed by a chariot laden with trophies. This precedes a chariot with the marriage of Philip the Fair to Joan of Castille, a number of horse-borne litters with the effigies of Maximilian's great predecessors "in bearings, titles and possessions," a group of prisoners, and an excited crowd of people carrying statues of

Victory. Then we behold a formation of "Imperial Heralds and Trumpeters," but the expectations roused by their fanfares are not fulfilled. They are merely followed by a King and Queen (Philip the Fair and Joan of Castille?) and a Princess (Margaret of Austria?) on horseback, a group of "Worthy Servants," and a charming piece of Renaissance primitivism, *viz.*, a horde of Indians ("Kalekutisch Leut") complete with elephant, parrots, exotic arms and fantastic costumes and headdresses. The whole procession is concluded by the baggage train which still struggles through the woods while all the others have already reached the open country.

We have, then, a Triumphal Procession without a *triumphator*, an anomaly for which Dürer, or rather Pirckheimer, was, in a sense, to blame. The program required, of course, an "Imperial Chariot," to be preceded by the "Imperial Heralds and Trumpeters" and to be followed by the Electors, the Counts, and the lesser Nobility. It was to show "the Emperor in his Imperial garb and majesty and, according to rank, his first Empress, further King Philip and his Queen, and King Philip's children; and Duke Charles shall have a crown on his head." This *pièce de résistance* had naturally been entrusted to Dürer, and he had made a preliminary sketch in pen and ink, exactly corresponding to the above description, as early as 1512/13. But then Pirckheimer took the matter in hand and decided that the "Imperial Chariot" must not be represented in purely descriptive fashion but should be elaborated into a full-dress allegory. This complicated the procedure enormously ("it took much time to arrange all the pertinent Virtues in suitable order," to quote a letter of Pirckheimer to Maximilian), and it was not until March 1518 that a final "Visierung" in color could be submitted and approved. Before it was carried out in woodcut the Emperor died; and since the whole enterprise seemed doomed to failure Dürer retained the drawing for himself. As revised by Pirckheimer, the composition had in fact grown into a self-contained and learned eulogy no longer fitting in with Marx Treitz-Saurwein's operatic pageant. Thus the *Triumphal Chariot of Maximilian I*, known as "*The Great Triumphal Car*," was published in 1522 as an independent work "invented, designed and printed by Albrecht Dürer."

In the drawing of 1512/13 (950, *fig.* 231) the triumphal chariot is rich and costly, "as befits an Imperial conveyance," but light and almost graceful in appearance and comparatively restrained in ornament. It is drawn by four pairs of horses, and allegorical motifs are restricted to eagles, griffons, lions and musical angels supporting the canopy.

All this is changed in the drawing of 1518 (951) and in the woodcut of 1522 (359), the latter differing from the former chiefly by the addition of Pirckheimer's explanations, which accompany the progress of the vehicle like a *basso ostinato*, and by the fact that the somewhat shorter chariot no longer has room for the Emperor's family; after his death it seemed fitting to interpret his "triumph," not as a dynastic manifesto but as a personal apotheosis.

In these two later versions the allegorical spirit runs to an extreme. There are eight pairs of horses instead of four, and the animals are of a heavier breed. Each of them is led by the personification of a statesmanlike or soldierly virtue "so that it might not walk or run in any other manner than is consistent with the quality of this virtue." The first two horses, for in-

stance, are led by Experience and Adroitness ("Sollertia"), and trot along with quiet dignity. The second pair, stimulated by Magnanimity and Audacity, shows spirit and temper; and the fourth pair—one horse rearing, the other trotting—reflects the contrast between Velocity and Firmness. The chariot itself is a weighty monstrosity, not only fraught with emblems of all kinds but also "moralized" in that its very wheels signify "dignity," "glory," "magnificence" and "honor" while the bridles denote "nobility" and "power." Its body and mudguards are adorned with dragons, eagles, lions and the now familiar griffons carrying the flint and steel of the Golden Fleece. Its canopy illustrates the idea of the "Roi Soleil" by the phrase "Quod in celis sol hoc in terra Caesar est" whereby, as Pirckheimer puts it, "a sun has been depicted for the word *sol*, and an eagle for the word *Caesar*." A personification of Reason acts as charioteer, and the lordly figure of Maximilian is not only crowned by a Victory whose pinions are inscribed with the names of conquered nations, but is also surrounded by the four Cardinal Virtues: Justice, Temperance, Prudence and Fortitude. Significantly placed on the four corners (*cardines*) of the car, they hold a chain of wreaths every link of which denotes a derivative virtue; and Gravity, Perseverance, Security and Confidence lend a helping hand in propelling the chariot.

Several other designs intended for the *Triumphal Procession*—six *Riders*, two of them bearing standards and four the trophies of Maximilian's wars (953-962), and, possibly, a group of costume studies (1287-1290)—were never executed at all; the program called, in fact, for "trophies on chariots" and not for trophies carried by horsemen. Thus Dürer's contribution to the woodcut series as published in 1526 is limited to one item: the two-block woodcut representing the Wedding of Maximilian and Mary of Burgundy, commonly quoted as "*The Small Triumphal Car*" or "*The Burgundian Marriage*" (429, *fig.* 232). Rich and magniloquent, yet less confusing and obscure than the *Triumphal Arch* and the "*Great Triumphal Car*," this composition shakes off, to some extent, the shackles of courtly ceremonial and scholastic erudition. It is pervaded by a contagious spirit of youth, vigor and joy, and a perfect harmony has been achieved between the splendor and cheerfulness of the subject and the sweep and flourish of its graphic presentation.

Standing on the canopied platform of a six-wheeled vehicle with wedding-bells attached to its "running-boards" are seen the royal couple, holding a shield with the coat-of-arms of the bride. On a lower platform are three women each joyfully waving—one, a goblet, the second a banner, and the third the gigantic model of a wedding-ring. The canopy is supported by chubby Cupids standing on slender balusters and carrying nuptial torches in their free hands, and the motif of the pomegranate is in evidence throughout; real pomegranates are arranged in a big vase on the main platform, carved pomegranates adorn the frame of the car, and embroidered pomegranates appear on a curtain against which is set out a kind of *tableau vivant* picturing the meeting of the bride with Maximilian's ambassadors. The car is driven by a lovely Victory who with her left hand brandishes a laurel wreath while with her right she bridles four superb horses caparisoned with the emblems of the Golden Fleece, rearing and neighing, their tails magnificently billowing in an imaginary breeze.

However, even the *"Burgundian Marriage"* has not really endeared itself to posterity. Of all Dürer's efforts to please his imperial patron only one has aroused real enthusiasm: his forty-five marginal drawings in the *"Prayer-Book of Maximilian I"* (965, *figs.* 234-238). This Prayer-Book was compiled, arranged and, in certain sections, even worded according to Maximilian's wishes, and was probably intended for the members of the Order of St. George which he had revived in connection with his lifelong dream of a new Crusade. It was printed by Johannes Schönsperger of Augsburg, and we learn from the colophon that the printing, or rather the composition, was finished on December 30, 1513. About three months before, the Emperor had already asked for ten copies on vellum but had been put off with a mere sample page.

Five copies of the Prayer-Book have come down to us; but they do not constitute a real "edition." None of them is entirely identical with any one of the others, and none of them is really complete; the Calendar, which gave rise to controversy among Maximilian's advisers and was not approved by the Pope until after the Emperor's death, was never even set up in type. Some quires were reset and appear in different states, and none of the known copies has a complete set of initials. The copies of 1513 must therefore be regarded as proof-impressions subject to changes and additions before the final publication could be issued.

This is also true of the copy generally referred to as *the* Prayer-Book of Maximilian I— now divided between the Staatsbibliothek in Munich and the Museum at Besançon—where a superficial impression of completeness and unity was subsequently achieved by the insertion of painted initials, some of them covering printed ones while others fill what had been blank spaces. This copy had been given to Dürer to be adorned with marginal drawings. He had about completed the decoration of the first ten quires—except for quire no. 1 which was left without ornaments—in 1515 when he interrupted his work for reasons not altogether clear. The copy was passed on to several other painters who were told to continue, as far as they could, after the pattern set by Dürer; and these masters, including Lucas Cranach, Burgkmair, Hans Baldung Grien, Jörg Breu, and, according to some, Albrecht Altdorfer, decorated the rest of the volume to the best of their abilities. As a whole, the decoration still gives a somewhat fragmentary impression, and even some of Dürer's own pages are evidently unfinished.

Dürer's forty-five drawings—all in the Munich part of the book—are, like those of his followers, pure pen drawings executed with colored ink, Dürer's personal choice being red, olive-green and violet. Unlike certain later drawings by Virgil Solis where hair is indicated by brown lines, flesh by pink lines, foliage by green ones, and so on, these colors served no naturalistic purpose. With Dürer, who never used more than one pigment at a time, their function is a purely decorative one. Beside the Prayer-Book's powerful Gothic letterpress a linear design in black would have looked weak and meager—as every colorless reproduction confirms: the thin black lines tend to be completely overshadowed by the heavy black masses. Colored lines, on the other hand, equally thin and juxtaposed with the same black masses, escape into an aesthetic sphere of their own. They no longer try to compete with the letter-

press—no more than humming-birds try to compete with an elephant; to retain the simile, they skim and flutter around it so that the beholder enjoys a contrast between different qualities instead of witnessing a conflict between unequal forces.

What was the purpose of these marginal decorations? Most recent writers on the subject are inclined to believe that they were meant to remain precisely what they are, that is to say, to adorn one special copy of the Prayer-Book intended for the private use of the Emperor. This view, attractive though it is from a romantic point of view, is however incompatible with the fact that the "Imperial copy" is just as unfinished and incomplete a piece of bookmaking as are the four others. It is improbable that Maximilian would have set aside for his personal use a Prayer-Book unevenly printed, lacking the greater part of its initials and not yet provided with the Calendar which, from a liturgical point of view, was the most important part of the volume. There remains, then, the earlier hypothesis that the alleged "Imperial copy" was in reality a mere working copy, that is to say, that the drawings therein were intended, not to be enjoyed by the Emperor as precious originals, but to serve as a basis for woodcuts.

To this assumption it has been objected, first, that a black-and-white reproduction of the drawings would destroy their decorative charm; second, that the pages of the Munich-Besançon copy are carefully ruled with pinkish lines drawn in with the pen after the printing of the text. This, it was argued, shows that the intention was to imitate a manuscript whose pages were ruled before the scribes began their work (such rulings being obviously useless in a printed book), and this illusion would have been nullified had woodcuts been substituted for the drawings.

At first glance these two objections seem to be well taken; but how—if both the drawings and the rulings were to be reproduced, not in black-and-white but in their original colors, and if, therefore, every copy of the final edition, and not only the "Imperial copy" in Munich and Besançon, had been intended to simulate a hand-written and hand-decorated manuscript?

The type with which the Prayer-Book is printed—apparently designed for the purpose by Vincenz Rocker, one of Maximilian's secretaries—is in itself of a deliberately archaic and therefore imitative character. It imitates the bold *lettre brisée* script of liturgical manuscripts written in the first half of the fifteenth century and anticipates, to some extent, the famous Missals and Graduals later to be issued by Plantin-Moretus in Antwerp. It is, in fact, in Maximilian's times, and particularly in Augsburg, that the interest in calligraphy took an unmistakably retrospective turn. In 1520, for instance, a Canon of St. Ulrich's called Leonhard Wagner—immortalized by the silver point of Hans Holbein the Elder, and regarded by some as the inventor of the *Fraktur* type—collected in one of the earliest "writing books" one hundred different specimens of lettering some of which are quite similar to the type of the Prayer-Book while others are even patterned after imperial deeds of the eleventh and twelfth centuries. The very letterpress of the Prayer-Book, then, was meant to give the impression of handwriting rather than printing—even to the addition of flourishes suggesting

the free play of the pen, some of them printed between the lines, and others attached to the *hastae* of individual letters protruding from the top and bottom lines.

The inventor of these movable flourishes was the Flemish woodcutter Jost de Negker who had come to Augsburg in 1508 or, at the latest, 1510. He is best known for his inventiveness and skill in the field of the *clair-obscur* woodcut, but he was by no means the first to print woodcuts with colored ink. When he appeared in Germany the printers had been experiment- ing with "tint-blocks" for more than twenty-five years, and most of the pioneer work had been done by Erhard Ratdolt of Augsburg whose liturgical books—for instance, the splendid *Missale Aquileiense* of 1494—have illustrations printed in as many as five different colors. The same Ratdolt even solved the problem of printing in gold, and a special copy on vellum of Conrad Peutinger's *Romanae vetustatis fragmenta in Augusta Vindelicorum et eius dioecesi* (Augsburg, 1505), printed in gold, black and red, is supposed to have been intended for Maximilian himself. An Augsburg workshop, then, would have been quite capable of reproducing both the "rulings" and the illustrations of the Prayer-Book in their original colors, and such colored woodcuts would have imitated drawings and pen lines just as successfully as Vincenz Rocker's Gothic type imitates script. That Dürer's cutters, too, were equal to this task is demonstrated by the ornaments beneath the griffons in the *Triumphal Arch* (*fig.* 239) which very faithfully retain the character of such "pen-plays" as frequently appear in the Prayer-Book (*fig.* 238).

Had the final edition ever materialized, the pink rulings would have been printed over the text from one woodblock, and the red, olive-green or violet border-decorations would have been printed on top from another one. The whole would have looked very much like a modern facsimile edition of the originals in Munich and Besançon, and it would indeed have been a facsimile in the full sense of the word. Each copy, printed on vellum, would have simulated a hand-decorated manuscript, written in what would have looked like liturgical Gothic script in black and cinnabar, provided with what would have looked like the rulings required by medieval scribes, and decorated with what would have looked like pen drawings in colored inks. This must have been precisely what Maximilian wanted. A printed book creating the illusion of a hand-written and hand-decorated *Livre d'Heures*, or, to put it the other way, an apparently hand-written and hand-decorated *Livre d'Heures* produced by the printing press, would have symbolized to perfection the tastes and aspirations of a prince engrossed in the past, yet keenly interested in every invention and device of modern technics: of a collector of manuscripts enamored of typography.

The lasting fascination of Dürer's Prayer-Book drawings needs no explanation. They are buoyantly imaginative where the big woodcuts are ponderously allegorical. Their craftsman- ship, enhanced by the very preciousness of the material, is such that the beholder follows the swift and never-failing movement of the artist's pen with a sensation comparable to the almost physical pleasure which we experience when observing a perfect dance, a perfect dive or a perfect jump on horseback. They are full of what the period of their "rediscovery," the early nineteenth century, considered as the most lovable qualities of "primitive" German art,

sincere devoutness, naïveté, and humor; and they unfold before our eyes "the whole world of art, from the figures of the Deity to the artistic flourishes of the writing-master," to quote from a description which, whoever its author, expresses the opinion of Goethe.

Since the text of the Prayer-Book is printed continuously, the illustration had to be confined to the margins. To meet this requirement Dürer synthesized the two main systems of border decoration which were in use by the end of the fifteenth and the beginning of the sixteenth century: one predominating in the Northern countries—the other in Italy; one playfully capricious—the other primly tectonic. In Northern books—not only in manuscripts but also in such printed specimens as the "Ulm Boccaccio" of 1473—the margins are overspread with the unhampered growth of exuberant *rinceaux*, now consisting of stylized hairline sprays, now simulating natural branches and tendrils; now bearing only over-sized fruits and flowers, now interspersed with animals and "drolleries"; now harboring the characters of a Biblical story, now suddenly developing into serpents or grotesque faces (*fig.* 240). The borders of Italian books, drawing from the same classical sources as the ornament of Quattrocento architecture and wall painting, tend to be divided into vertical and horizontal panels; and these are preferably decorated with *grotteschi*, that is to say, free combinations of foliage with artifacts, animals and human forms which are set out against a neutral dark background and which, however fantastic, invariably observe the rule of axial symmetry. The ornaments at the top and bottom of the page are mostly arranged in more or less heraldic fashion, and the lateral margins—not unlike the pilasters in contemporary buildings—are filled with axialized structures, involving, besides vegetal ornament, such objects as vases, masks, candelabra and baskets, and the figures of *putti*, sphinxes or fauns (*fig.* 241; see also Dürer's more literal imitation of this scheme in a slightly earlier Border Decoration for Pirckheimer [408]).

Axialized structures obviously derived from *grotteschi* appear ten or eleven times in Dürer's Prayer-Book drawings. But the very fact that the original *camayeu* effect is replaced by pure line drawing exempts them even from that modicum of static rationality which had been preserved in the Italian and classical specimens. In all but three cases Dürer's constructions do not rest on firm ground but seem to float in space (fols. 16, 24, 35v, 46 [*fig.* 235]) or dangle from the top of the page instead of rising from its bottom (fols. 29v, 48v, 51v, 55v). Even the most "classical" instances (fols. 45 and 56) give an airier and less tectonic impression than their models and ancestors, and in two cases we see the structure not yet finished but in course of erection in that vivacious *putti* set up a complicated column on a pedestal (fol. 19) or plant a little tree in a pot which in turn grows out of a naturalistic bough like an enormous fruit (fol. 36).

Thus even the law of axiality is occasionally loosened (see *fig.* 235), and nowhere do we find an attempt at observing what may be called the principle of existential homogeneity. In the Roman and Italian *grotteschi*, treated as they are *en camayeu*, human or semi-human figures are not interpreted as living beings, but rather as statuettes, while foliage and inanimate objects, though never quite "impossible," are stylized after the fashion of stone or stucco

ornaments instead of appearing as "real" plants or candelabra; the whole is thus reduced to a uniformly artificial, and therefore homogeneous level of existence. Dürer, justly confident of the unifying power of lines, combined the utter realism of living creatures, natural plants and genuine implements with the utter abstractness of purely ornamental flourishes, with all kinds of unexpected mutations between these two poles.

On fol. 53, for instance—one of the three examples where at least the law of gravity has been observed—three lion's claws develop into wings out of which, as an egg from an egg-cup, peers a gigantic mask with foliage for a cap. It serves as support for a fairly "classical" column, on the capital of which is perched a real cock, flapping his wings and crowing at the top of his voice. Tied around the juncture of the mask and the column is a ribbon whose tasseled ends form a symmetrical ornament; but from its knots branch out some of those purely linear flourishes or pen-plays which appear on almost every page of the Prayer-Book, now moving with the freedom of a skimming bird, now developing into rapid sketches of faces, fishes, lions and unicorns, and then again disciplined into extremely complicated, symmetrical arabesques inimitable even by the best of Dürer's followers. On fol. 24 an oval bulb, growing out of a tangle of hanging roots, supports a graceful vase *all'antica* which in turn supports a gimlet-eyed, beaked head quite similar to one of the Dragon's heads in the *Beast with Two Horns like a Lamb* (294) but further embellished by a pair of antlers; on these is perched a heraldically frontalized yet very naturalistic eagle, and the whole is surmounted by a decorative arrangement of branches. On fol. 35v, finally, we have a loose-knit linear arabesque, which develops into two caricatured masks in profile, and from these is suspended the head of a goat or chamois with a ring through its nose from which dangles a fantastic pendant, half watermelon, half artifact, ending in an acanthus-like ornament.

While the Italian *grotteschi* scheme was thus emancipated from the rule of mechanical symmetry and, at the same time, made to assimilate abstract calligraphy as well as unstylized, living reality, the Northern *rinceaux* were subject to a certain amount of discipline. As a rule they do not start at one of the corners so as to cover two adjoining margins or even to creep around the whole page, but respect the "tectonic" principle according to which the four margins are treated as separate "panels." They unfold usually with a certain amount of regularity, and there are cases where it is difficult to tell whether we have a Germanized *grotteschi* ornament or an Italianized *rinceaux* border. On fol. 46, for instance, the lower part of the ensemble consists of a strictly axialized combination of a foliate mask with a classical vase; but the tree which grows in the latter soon defies the principle of axiality and develops into an undulating *rinceau* which harbors a fettered Satyr and a dead bird hung by its neck (*fig.* 235). Fol. 52, on the other hand, shows a naturalistic *rinceaux* ornament of vines and tendrils, but from one of the branches is suspended a perfectly symmetrical mask which definitely belongs in a *grotteschi* system. And whatever "existential disparity" may be felt in these and other fantastic agglutinations is overcome by a pervasive feeling of weightlessness and fluidity, a feeling which takes visible shape, as it were, in the ubiquitous flourishes.

Obliterating as it did the borderline between imagination and reality, this decorative system could easily assimilate the illustrative elements. The trees of a landscape in which are placed the musicians suggested by the text of a Psalm could develop into *rinceaux* and ultimately into calligraphical flourishes (fol. 50, *fig.* 237). The figures and groups required by special invocations could be placed on fantastic flowers or on no less fantastic pedestals and consoles. The locks of Angels' heads could merge with the curves of an arabesque (fol. 16), and the Devil could coil his tail around a branch which forms an integral part of the marginal ornament (fol. 37v). But just this perfect union between the decorative, on the one hand, and the illustrative, on the other, obscures at times the iconographic meaning of Dürer's designs. The animals incorporated in the vegetal ornament or disporting themselves in the *bas-de-pages*, the human and semi-human figures perched on the branches of imaginary trees, the vases, columns, masks and musical instruments derived from the *grotteschi* tradition—all these motifs may or may not have a determinable significance; and even in the case of palpably narrative elements it is not always easy to decide to what extent these elements can be explained by the text or liturgical custom, to what extent they depend on outside sources (such as the *Hieroglyphica*) or were selected in deference to Maximilian's personal wishes, and to what extent they sprang from the imagination of Dürer himself.

An established custom of Prayer-Book illustration is followed in that the beginning of the "Hours of the Virgin" is marked by the Annunciation (fols. 35v, 36, the only double-page composition in the whole volume). In a *Horae B.M.V.* an Annunciation "belonged" to Matins just as a Crucifixion and a Christ in Majesty "belonged" to the Canon in a Missal. Only, Dürer "visionized" the subject after the fashion of the Frontispieces of the "Three Large Books" (*figs.* 180-182) in that not only the Angel but also the Virgin at her *prie-dieu* appears to the beholder in a band of clouds; and it is implemented by the contrast between two *putti* planting and climbing what seems to represent the Tree of Life, and the Devil breaking down under a shower of heavenly fire.

Dürer also conformed to accepted traditions when he accompanied the section from the Gospel of St. John (fol. 17v) and the Psalm *De Profundis* (fol. 16v) by "author's portraits," *viz.*, by a representation of St. John on Patmos and of King David playing his harp before the Lord; and when he illustrated the "Suffrages" by full-length effigies of the Saints to whom they are addressed. These effigies do not offer any particular iconographical problems except for their selection and, in some cases, for the motifs in the *bas-de-pages*. That St. George appears twice—on foot on fol. 9 and on horseback, with a young dragon surprisingly surviving the death of the old one, on fol. 23v—may be accounted for by the probable destination of the Prayer-Book for the Order of St. George. St. Andrew (fol. 25) may have been especially honored because of his connection with Burgundy and the Golden Fleece, and St. Matthias (fol. 24v) because he is the only Apostle buried in Germany, and this in the Cathedral of Treves, so close to the heart of the Emperor.

The most interesting case is that of the Emperor's personal Saint, St. Maximilian, Bishop of Lorch (fol. 25v, *fig.* 234). He is dressed in episcopal garb and holds his conventional

attribute, the sword; but it seems to have escaped notice that he does not wear a Bishop's miter but the bicuspid crown of the Holy Roman Empire as it appears, for instance, in the *Triumphal Arch* and constantly "for crest" in the coat-of-arms of German Emperors. Maximilian and his Saint have, in a sense, merged into one personality; and this may also account for the presence of a bison or bull, the hieroglyphic symbol of "warlike virtue and discretion" ("virilitas cum modestia") which, we remember, prominently figures in the *"Mystery of the Egyptian Letters"* (*fig.* 227). St. Andrew, the patron Saint of the Emperor's Burgundian marriage, so to speak, is accompanied by a stag for the same reason that a stag's skin appears in the *Triumphal Arch*. But it is hard to say why St. Apollonia (fol. 24) should have been associated with a turtle and a heron devouring a fly, unless by way of a facetious contrast between two happily edentate animals and the Saint who "suffered the painful extraction of her teeth"; and why the *bas-de-page* of the St. Matthias page (fol. 24v) should show a hermit tempted by a woman with a cup. The *bas-de-page* of the page with St. Ambrose (fol. 53v), however, may have been suggested by the firm association of the "Te Deum" with Eastertide (it is recited on work days only between Low Sunday and Pentecost) and may specifically reflect the words "Tibi omnes angeli, tibi coeli et universae potestates, tibi cherubin et seraphin incessabili voce proclamant: Sanctus, Sanctus, Sanctus": the drawing shows a paraphrase of the Entry into Jerusalem wherein the Infant Jesus as "Pantocrator"—that is, as King of the Universe, holding the Orb—is substituted for the historical Christ, while those who "spread their garments in the way" are replaced by an Angel.

A closer and more obvious connection between illustration and text exists where pictures were suggested by a direct reference to a Biblical incident, as on fol. 33, where the rubric "Quomodo Judei perterriti ceciderunt in terram" gave rise to a representation of the Betrayal according to *John*, xviii, 3-7, with the *Mater Dolorosa* hovering in clouds above the tragic scene; or where they summarize the basic content of special invocations. Quite appropriately, the prayer "After the Elevation of the Host," evoking the idea of the Mass of St. Gregory, was illustrated by a Man of Sorrows (fol. 10v); the prayer for the souls of the deceased ("et libera eas ab omnibus penis et angustiis et perduc eas ad requiem sempiternam"), by a representation of Purgatory with one of the souls carried to heaven (fol. 16); the "Humble Invocation of the Holy and Indivisible Trinity," by the Throne of Mercy (fol. 21).

Similarly, a request for the intercession of the Virgin Mary called forth the image of the "Virgo electa" in prayer—though it is difficult to see why the *bas-de-page* should show a musical *putto* stepping on a snail (fol. 51); the two *Psalms* "to be recited when one must go to war"—*viz.*, Psalms xci and xxxv—were accompanied by vivid battle scenes, with Angels celebrating Mass in Heaven (fols. 28 and 29v); the page with a prayer "to be remembered in the agony of death" shows Death arresting a knight while a hawk swoops down upon a crane in the nocturnal sky; and the "Plea for Benefactors" is illustrated by a scene of charity—a wealthy burgher giving alms to a beggar—surmounted by a pelican (fol. 15).

Elsewhere, however, Dürer did not "illustrate" in the accepted sense of the term, but

proceeded like a musician extemporizing on a given theme. A sentence, a phrase, or even a mere word would conjure up a visual association which could, in turn, "be fruitful and multiply." Thus the jubilant lines of Psalm xcviii, particularly the verse "With trumpets and sound of cornet make a joyful noise," inspired the marvellous group of a drummer and trumpeters. Five of them are still testing their instruments with gradually increasing success, and the sixth already plays full blast, while the idea of the trumpets and the drums is gaily paraphrased by an elephant's head and a woodpecker in the marginal ornament (fol. 50, *fig.* 237). The beginning of Psalm c ("Make a joyful noise unto the Lord, all ye lands. Serve the Lord with gladness; come before his presence with singing") is illustrated by another trumpeter—this time assisted by a crowing cock—and by a truly "noisy" peasants' dance (fol. 56v). A prayer "in recognition of one's frailty," which contains the line "qui mulierem infirmam curasti" ("Thou Who hast healed the sick woman"), suggested a doctor examining a urinal (fol. 9v). The verse "He has sent from Heaven and saved me," in Psalm lvii, conjured up the vision of God in Heaven as He blesses St. Michael fighting the Devil; and the phrase "donec transeat iniquitas" ("until iniquity has passed by") in the same Psalm was translated into an image which shows a pagan ruler, with an orb surmounted by the heathenish crescent, literally "passing by" on a mock triumphal chariot adorned with harpies and drawn by a goat (fol. 26v). The "fullness of the earth" and "they that dwell therein" of Psalm xxiv are visualized by an American Indian standing on a native, horn-carved ladle the like of which can still be seen in many ethnological collections (fol. 41) and by a be-turbaned Oriental leading a camel (fol. 42v).

In a number of cases the thread of association becomes so thin that it is scarcely visible to the naked eye, and in still others it eludes even the microscope of philological analysis (which, however, may be the fault of the microscope). The "naïve" beholder will perhaps admit that the image of a fox luring a flock of chickens with the tunes of a flute, contrasted with that of a watchful soldier, may have been induced by the phrase "Protect me, so that neither the Devil nor any human enemy may be able to harm me in body or soul" (fol. 34v); that the comprehensive survey of animals contrasted with two musicians and a hermit (fol. 38v) may refer to those verses of Psalm viii in which man is praised as the master of all creatures; or that the appearance of the *Sudarium* on fol. 56 may be accounted for by the word *testimonia* in Psalm xciii, 5 "Testimonia tua credibilia facta sunt nimis" ("Thy testimonies are very sure"). But he will find it hard to believe that a man asleep with his book while a dog jumps at a *putto* (fol. 45) may symbolize the imperturbable calm expressed in Psalm xlvi "Therefore will not we fear, though the earth be removed. . . . Be still and know that I am God"; or that the juxtaposition of a musician and a monkey on fol. 6v may have been suggested by the phrase "Recedant a me omnes immunditiae . . . ut tibi laudes aeternas dicere possim" ("May all uncleanliness recede from me . . . so that I may give Thee eternal praise") because the ape was proverbially known as *immunda simia.* Or again, it may seem hardly credible that the crane and the unicorn in the unfinished border of fol. 17 may be transcriptions of the words *custodia* and *noctem* in the phrase "A custodia matutina usque ad

noctem speret Israel in Domino" ("From the watch of the morning to nightfall let Israel hope in the Lord," Psalm cxxx) because the crane was the hieroglyph of watchfulness while the unicorn—or at least this particular breed of unicorn which reappears in the *Abduction of Proserpine* (179, *fig.* 243)—was associated with the infernal regions, darkness and night.

Five drawings—the noble border decorations of fols. 19, 46 (*fig.* 235) and 53, the Combat Scene on fol. 55v, and the "Hausfrau" returning from the market with a cheese, a basket of eggs and a goose perched on her head while her sturdy feet rest on what is at once a cobblestone pavement and the seeds of a gigantic pomegranate (fol. 51v)— have thus far defied any attempt at interpretation. But the remaining ones, though not connected with the text as such, have a clear moralistic significance. On fol. 37v we find a new, less optimistic version of the "Knight, Death and Devil" theme, the knight in desperate flight as in the illustrations of the Legend of the Three Living and the Three Dead, but the Devil wielding precisely the same pickaxe as in the famous engraving of 1513. The drawing on fol. 48v, contrasting a woman asleep by her distaff with a stern warrior characterized by the familiar symbols of the clever dog and the watchful crane, transforms the old antithesis between Sloth and Labor, as represented in the *Somme le Roi* and Sebastian Brant's "Narrenschiff," into one between Inertia and Vigilance. And fol. 52 opposes divine contemplation, exemplified by an Angel reading a sacred book, to the animal pleasures of a drinking Silenus and a piping Faun, while an eagle perched on a branch—a symbol of all that is sublime in human nature—basks in the rays of a heavenly light.

Two drawings, which have been called "surprising in a Christian Prayer-Book," express the same idea—the victory of spiritual forces over the dangers and temptations of the world —by way of mythological allusion.

One of them shows Hercules killing the Stymphalian Birds (fol. 39v, *fig.* 236); the other, Hercules again, with the dead lion at his feet and significantly contrasted with a drunkard too lazy and self-indulgent to fight off the attack of a spoonbill goose (fol. 47). Hercules, the champion of Virtue and conqueror of evil in all shapes and forms, had long been accepted as a model of the *miles Christianus* or even as a prefiguration of Christ Himself; and for Maximilian, supposedly his direct descendant, he had an eminently personal connotation. The Emperor could as easily identify himself with a classical hero whom he regarded as his ancestor as with the Christian Saint after whom he was named.

THE *Triumphal Arch*, *Triumphal Procession*, and *Prayer-Book* of Maximilian I are significant manifestations of the "decorative" phase in Dürer's stylistic development. Spatial, plastic, textural and luminary values are deliberately suppressed in favor of a pattern designed to fill, to diversify, to enliven, in short to "adorn" a given two-dimensional surface rather than to suggest an autonomous three-dimensional picture space.

This "decorative style" had announced itself in Dürer's pen drawings. Before his second trip to Venice these had been modelled by short, comma-shaped strokes which, irregularly spaced and arbitrarily intersecting both each other and longer "guiding lines," had had no

pattern value of their own; and during the second lustrum of the sixteenth century the pen and ink medium was, to a degree, neglected in favor of those white-heightened brush drawings on colored paper in which the lines, though longer and more systematically arranged, had been subservient to plastic and coloristic tendencies.

From about 1510, however, pen and ink returned to favor under new auspices. The pen drawings of this period differ from the earlier ones by a peculiar transparency. The modelling and shading is effected by long, widely spaced parallels which avoid intersection as far as possible and form a clear and delicate linear pattern. In style and technique these drawings are surprisingly similar to those of Raphael in his Florentine and early Roman periods, and it is perhaps not by accident that some of the most characteristic specimens, for instance, the preliminary sketch for the *Fall of Man* of 1510 (459, *fig.* 195), the *Madonna with the Little St. John* of about 1511 (706) and a *Virgin with Child* of 1514 (670), seem to reveal the influence of Raphael in composition and interpretation as well as in treatment.

The primary purpose of this new technique was, of course, to reconcile the plastic character of Dürer's earlier drawing style with those tonal tendencies which, we remember, asserted themselves in his post-Venetian prints. In such charming drawings as the *Rest on the Flight into Egypt* of 1511 (517, *fig.* 223) or the *Holy Family in a Trellis* (730, *fig.* 224) the effect produced by the widely spaced, protracted parallels is much the same as that of the "graphic middle tone" in woodcuts and engravings; and in a *Holy Kinship*, also of 1511, (733)—particularly in the head of St. Joachim—it is not unlike that of the *Holy Family* in dry point (*fig.* 201). Yet the "transparent" treatment of these drawings had definite "decorative" potentialities. They lent themselves more easily to embellishment by water color, for example: the studies for the Portrait of Charlemagne (1009-1013), the enticing *Siren Chandelier* for Pirckheimer (1563), and the mythological and allegorical drawings of 1514/15 (901, 908, 936, 942). And, more important, their very "linearity" facilitated a shift of emphasis from the function of lines as symbols of volume, space and tonality to their function as elements of an ornamental pattern.

The enterprises of the Emperor could not but liberate these inherent tendencies toward a "decorative" interpretation of line and form. The ornaments and scenic representations of the *Triumphal Arch* had to be conceived in relation to an architecture to which they were attached; the two *Triumphal Chariots* formed part of a procession which moved along an ideal surface, like a painted frieze or a series of tapestries hung on a wall. The Prayer-Book drawings were meant to decorate a given page as well as to express a given content; and in every case Dürer had to coordinate his designs with letterpress, a problem which he had deliberately avoided even posing in the Apocalypse, the Life of the Virgin and the two woodcut Passions, and which he had solved rather cavalierly in the few book illustrations, bookplates and title pages thus far produced. Thus he began to indulge in a magniloquent linearism. In the Prayer-Book the stylization of such motifs as Angels' wings, grotesque physiognomies, clouds or explosions is at times paradoxically reminiscent of the Apocalypse; and the four "stories" which Dürer contributed to the *Triumphal Arch*, as well as the whole

"Great Triumphal Car" have what may be described as an almost textile quality. The modelling tends to be submerged by ornamental patterns, and the spatial relation among the Emperor, the Victory and the Cardinal Virtues seen on the platform of the Imperial Chariot is not immediately clear. The lines have something of the character of those flourishes which are no less ubiquitous in the *"Great Triumphal Car"* than in the Prayer-Book and serve as a common denominator of figures and letterpress. These woodcuts do not aim at plastic relief and spatial depth, but rather at the sharp, unreal sparkle of embroideries in black and silver.

It is not surprising to find this "decorative style" in several other works which were executed at about the same time and presented similar problems; for instance, in a group of drawings for the decoration of a "silvered armor" which Maximilian had ordered from the Augsburg armorer Koloman Colman (1448-1453); in a sketch for the Innsbruck statue of Albrecht of Hapsburg which is in fact also a study in armory (1546); and in five woodcuts for the never published *Freydal*, another autobiographical romance which glorified Maximilian's proficiency in tournaments, jousts, pageants and other forms of chivalrous sport (392, 393, 420-422). It appears again in the *Celestial Maps* of 1515 (365/66) where two drawings of 1503, derived from fifteenth-century miniatures, are subjected to a process of archeological correction and ornamental integration, and in the wonderful *Rhinoceros* of the same year (356). Pictures and descriptions of the animal which had been landed in Lisbon on May 20, 1515, had reached Germany without delay, and both Dürer and Burgkmair were able to present it to the general public a few months after its arrival. But while Burgkmair's woodcut attempts to be realistic in its rendition of thick, yet flexible skin, bushy hair, and even the rope with which the forefeet are tied, Dürer stylized the creature, bizarre in itself, into a combination of scales, laminae and shells suggesting a fantastically shaped and patterned suit of armor.

However, during the period here under discussion the "decorative" style was not limited to subjects which, like all these, demanded or at least invited a "decorative" treatment. A tendency to stress linear calligraphy and two-dimensional display at the expense of volume and perspective can even be felt in such paintings as the curly-bearded *Sts. Philip and James* of 1516 in the Uffizi (40 and 44), whereas the other pictures of this year—the moving Portrait of old Michael Wolgemut in Munich (70), the Portrait of a Clergyman in the Czernin Gallery at Vienna (81), and the *Virgin with the Pink* in Augsburg (30)—partly conform to previous traditions and partly announce the developments of the following phase. The woodcut known as the *Virgin Mary as Queen of the Angels* (321, *fig.* 233, dated 1518) is a glorious tapestry, or stained-glass window, rather than a representation of three-dimensional bodies in a three-dimensional picture space, although the scene is staged on firm, terrestrial ground; and a similar emphasis on sweeping lines arranged so as to form a decorative pattern can be observed in almost all the drawings up to about 1518/19.

This is true not only of those free compositions some examples of which have already been mentioned—a final climax being reached in a superb *Madonna* of 1519 (680)—but also, to some extent, of the large-scale portrait drawings which Dürer executed in the summer of

1518 on the occasion of the Augsburg Diet. Chief among these are the portraits of Maximilian himself, made on June 28, 1518 "high up in the palace in his tiny little cabinet" (1030); of Jacob Fugger the Rich (1023); of Cardinal Albrecht of Brandenburg (1002); and, probably, of Cardinal Lang von Wellenburg of Salzburg (1028).

Three of these drawings, all of them distinguished by a peculiar looseness of texture and mobility of line, matured into more formal works during the next two years. The Fugger drawing served as a basis for the painting in Munich (55, probably 1520). The drawing of Albrecht of Brandenburg was used for the engraving known as *"The Small Cardinal"* which will be discussed in the following chapter. The drawing of Maximilian, finally, was employed, not only for the two paintings in Vienna (61) and Nuremberg (60), but also for a large woodcut (about the size of the Apocalypse) which, like the two paintings, was probably not completed until after the Emperor's death (368, *fig.* 229).

It is largely due to this woodcut portrait by Dürer that the physiognomy of Germany's most beloved Emperor still lives in everybody's memory. The print became so popular that three literal replicas, the third provided with an ornate frame by Hans Weiditz, were published within a year, and in 1520 Lucas van Leyden freely repeated it in one of his best-known prints (*fig.* 230). As a study in human nature, Dürer's woodcut is uncompromising, yet sympathetic in its veracity; it captures Maximilian's noble aloofness and innate benevolence, but also his fatigue and deep disillusionment. As a composition, it still belongs to Dürer's "decorative style." The bust of the Emperor, slightly turned away from the beholder but strictly symmetrized and without hands, is spread out, as it were, before a flat blank background and is cut off sharply by the lateral margins. The forms are reduced to a system of almost countable lines whose undulations conform to the bold sweep of the commemorative scroll and to the play of two strings or ribbons which fulfill a similar function as do the flourishes in the *"Great Triumphal Car."* In the collar of the Golden Fleece the links and the "sparks" form vivid curves suggesting the movement of living creatures, and enormous emphasis is placed on the lozenge pattern of the lapels and on the pomegranate design of the coat.

THE "DECORATIVE STYLE," broad, intentionally planar and somewhat oratorical, was incompatible with the meticulous, plastic and sober spirit of burin work. Between 1514 and 1519 Dürer made only two engravings, the *Virgin on the Crescent* of 1516 (139) and the *Virgin Crowned by Two Angels* of 1518 (146, *fig.* 249), and it was not until he had ceased to work for Maximilian that his production in this field returned to normal. But this gap in the sequence of engravings is filled by six works in a medium which Dürer had not handled before 1515 and which he was to abandon after 1518: etching.

As is suggested by the very word—which is derived from the German "Aetzung," that is: "eating"—an etching is not produced by a mechanical but by a chemical process: the lines are not incised into the metal by a sharp instrument, but "eaten" out of it by an acid. To produce a pattern, the metal is first covered with an insulating ground; where a line is

intended to appear this ground is scraped away by means of a blunt needle, and the whole is then exposed to acid which eats into the metal only where the ground has been removed.

As the burin had originally served to engrave ornaments on goldsmith's work, so the etching process had originally been applied to the decoration of arms and armor, which accounts for the fact that Dürer and the other fathers of etching as a graphic art—the earliest datable instance being a genre piece by Urs Graf of 1513—still used iron instead of copper plates. Quite possibly Dürer became acquainted with the new technique through his collaboration with such armorers as that Koloman Colman of Augsburg whom he supplied with the designs for Maximilian's "silvered armor" (1448-1453). But that he was so eager to adopt it as a vehicle of creative expression is not only due to a taste for experimentation but also to the fact that it was ideally suited to the artistic tendencies of these particular years. Like a burin engraving, an etching is an intaglio print; but unlike a burin engraving, it has the freedom and immediacy of a pen drawing. The plate is not treated piecemeal but as a whole, and it is not rotated in the process. Etched lines are of uniform thickness—whereas the burin line widens and narrows—and slightly fuzzy at the edges because the acid eats a little beneath the insulating ground (see *fig.* 206); they thus give an effect not unlike that of pen lines on somewhat absorbent paper and suggest impulsiveness and unrestraint where burin lines are slow and strictly regulated. The needle glides through the soft etching-ground as effortlessly and speedily as the pen skims over the drawing sheet. Small wonder that Dürer was grateful for a graphic medium which made it possible for him to be as full of decorative *brio* as in the drawings of the Prayer-Book, as passionately dynamic as in the *"Burgundian Marriage,"* and even as visionary as in the Apocalypse—and which, in contrast with woodcut, did not require the intervention of secondary technicians.

What seems to be Dürer's first etching is known, for want of a recognized interpretation, as *"The Desperate Man"* (177, *fig.* 242). Undated and unsigned, it combines a somewhat laborious technique, still reminiscent of burin work, with a crowded and haphazard composition which makes it difficult to discover a consistent representational program. According to some, it is nothing but a medley of figures assembled at random in order to test the possibilities of an unfamiliar medium; according to others, it records a dream; still others believe it to represent Michelangelo surrounded, as it were, by the ideas of his works. The factual evidence is in favor of the first alternative, with the reservation, however, that even a pot-pourri of motifs selected or invented on the spur of the moment and almost automatically may reveal the artist's ideas and preoccupations just as clearly as a carefully devised composition and may therefore be equally susceptible of an "iconographical" interpretation.

Dürer began his work with the profile figure near the left margin for which he used a portrait drawing of 1514 representing his brother Endres (Andrew) at the age of thirty (1018). He added a sparse beard which Endres may or may not have grown in the meantime, but then decided to reduce the volume of the cap and to retrench the contours of the face. It is to this *pentimento*, which reduced the nose to a mere stump, that the features of Endres Dürer owe their resemblance to the famous profile disfigured by the blow of Pietro

Torrigiani; and it is hard to say whether this resemblance is more than an accident. It is certain, however, that the four other figures in the etching—a youngish man tearing his hair, an old, emaciated face staring at the beholder with a fixed and woeful glance, an idiotically smiling, Satyr-like youth with a stein of beer, and a corpulent woman asleep—have no connection with Michelangelo. They emerged from Dürer's imagination; but Dürer's imagination was always preoccupied, and especially so about 1514/15, with the theory of the four humors.

In our discussion of the *Melencolia I* we mentioned that the *humor melancholicus*, dangerous even under the most favorable circumstances, was supposed to cause actual insanity under adverse conditions. In an attempt at differentiating between the types of such insanity, Avicenna had developed an almost unanimously accepted theory according to which they vary with the natural temperament of the persons affected: a sanguine, afflicted with a melancholic derangement, would develop a form of madness which was, so to speak, a caricature of his normal cheerfulness and sociability; a choleric would commit insensate acts of violence and so forth. To quote from Dürer's friend Melanchthon: "If of a sanguine nature, melancholy will produce the foolishness of those who always laugh in a ridiculous fashion . . . ; if it comes from choler, there will be terrible outbursts of raving madness . . . ; if it is phlegmatic, it will cause an extraordinary apathy, and we have known ourselves an imbecile who slept almost permanently, spoke without expression and did not show any emotion whatsoever . . . ; and if the black gall, in addition to being predominant, becomes inflamed [that is to say, if the patient is a "natural" melancholic in addition to being afflicted with melancholic insanity] there will be still deeper depressions and misanthropy. . . ."

It was, it seems, in remembrance of this doctrine that Dürer decided to contrast the figure of a normal, healthy individual with four others each of which represents a characteristic form of humoral, and therefore also "planetary," insanity. The desperate man tearing his hair, from whom the etching received its popular name, is the *melancholicus ex cholera rubra* whose choleric melancholy—associated with Mars—causes him "to inflict injuries on himself as well as on others." The haggard, mask-like face weirdly emerging from the dark background belongs to the Saturnian *melancholicus ex cholera nigra* who may be called the melancholic to the square because he is melancholy both by nature and by disease. The faun-like youth, hilarious with delight over his drink and the sight of a nude, is the *melancholicus ex sanguine*, the gay and amorous, Jovian sanguine degenerated into a grinning, harmlessly lascivious moron. And the sleeping nude herself is the *melancholica ex phlegmate* who, subject to the Moon, "sleeps almost without interruption." That only this fourth form of mental derangement is represented by a woman has a twofold reason: on the one hand, Dürer wished to stress the amorous connotations of the "sanguine" type of dementia (the combination of the two figures bringing to mind the well-known group of Jupiter and Antiope); on the other, he acted upon a theory—unchallenged from the twelfth to the seventeenth century—according to which "all women are by nature cold and moist, that is, phlegmatic," because "the warmest woman is still colder than the coldest man." In fact Luna is the only female among the planets corresponding to the four humors.

The two etchings of 1515—a *Man of Sorrows Seated* (129) and the *Agony in the Garden* (126, *fig.* 244)—exploit more fully the virtues of the medium. They give the impression of rough and impetuous pen drawings rather than of engravings, and the *Agony in the Garden* already takes advantage of the etching technique to blend the *clair-obscur* effects of the preceding phase with the expressive linearism and grand pathos of the Large Passion. The first preparatory drawing (557), ignoring, as it were, the intervening development, recalls the large woodcut of about 1497 (226), except for the fact that the figure of Christ is shifted to one side and that the chalice stands already on a rock instead of being offered by the Angel. In a second drawing (558) and in the etching itself the composition is again approximately centralized, and the figure of Christ is made to dominate the scene, with the huddled heap of Disciples pushed far into the background. But this emphasis on formal equilibrium and statuesque grandeur is outweighed by the emotional quality of the performance as a whole. While the highlights, particularly the clouds and the halo of Christ, have the brilliance of the Engraved Passion or of such woodcuts as the *Resurrection* (235) and the *Throne of Mercy* (*fig.* 185), the lines show an animation accessible neither to the burin nor to the cutting-knife; and the action, restrained though it seems to be in comparison with the engraving of 1508 (111), is all the more dramatic by virtue of suspense. The figure of the Angel, who merely conveys a spiritual message instead of carrying a tangible object, is reduced to a head and a pair of small wings, not unlike the Venetian "angioletti" disporting themselves in the *"Feast of the Rose Garlands"* or the *Virgin with the Siskin*. But his great face is no longer that of a smiling child but resembles the awesome countenance of the Angels in the Apocalypse. It radiates a magic force which bends the bare tree into an almost human gesture of recoil and paralyzes the very hands of Christ so that they are unable to join each other in prayer and stay frozen in a gesture of awe.

This dark and nervous atmosphere is still intensified in the two etchings of 1516 which, though widely disparate in subject, yet share with one another the qualities of eeriness and haunting gloom.

One of these etchings is the *Abduction of Proserpine* (179, *fig.* 243). In remembrance of a late-medieval tradition according to which Pluto, the god of the Underworld, carries off his unwilling bride on horseback, Dürer developed the composition from a drawing in which an anonymous horseman dashes away with a naked woman, leaving behind him a little heap of conquered enemies (898). By eliminating the accessory figures, by arranging the terrain so as to suggest a leap into the void, by suffusing the scenery with a lurid, flickering light, and by transforming the horse into a fabulous unicorn evocative of the ideas of night, death and destruction, Dürer invested a violent, but perfectly natural scene with an infernal character unparalleled in representations of the subject except for Rembrandt's early picture in Berlin.

The other etching of 1516 is a feverish vision, with the pace of the needle accelerated to an *allegro furioso*. It represents a subject which, according to a long tradition repeatedly observed by Dürer himself, normally calls for an hieratic or even heraldic interpretation: the *Sudarium* (133, *fig.* 245). As a rule, Veronica's kerchief is displayed in solemn frontality, but

here it is held aloft by a great Angel and billows like the sail of a ship on a stormy night. Sharply foreshortened and in deep shadow, the imprint of the Holy Face is barely recognizable, while glaring lights are gathered on the draperies of the Angel, on the clouds and on three smaller Angels carrying the implements of torture. Space seems to have dissolved into a darkness pervaded by a long wail of lament, and nothing seems to be left but the accusing symbols of the Passion floating "upon the face of the deep."

The *Sudarium* marks the climax, and the end, of a somber excitement which represents, as it were, the nocturnal aspect of Dürer's "decorative style." The storm subsided as suddenly as it had broken, and with it Dürer's enthusiasm for etching. No etching was produced in 1517, and in the following year there appeared, as a farewell, so to speak, a last specimen of an altogether different character, the *Landscape with the Cannon* (206). This etching, testifying to Dürer's newly acquired interest in ordnance and fortification, is based on the sketch of a peaceful hamlet called Kirch-Ehrenbach through which he had passed on his trip to Bamberg in 1517 (1406), while the imposing "Turk" in the foreground is none other than Dürer himself, dressed up in an oriental costume borrowed, more than twenty years before, from Gentile Bellini (1254). It is a masterpiece of panoramic breadth, perspective coherence and clarity, but for this very reason not an etching in the sense of Dürer's original interpretation of this medium. It announces, to a degree, a new and final phase in his development which, in connection with a general and basic change of style, was to reinstate the predominance of painting and orthodox burin work.

VII · The Crisis of 1519; the Journey to the Netherlands, 1520-1521; the Last Works, 1521-1528

THIS general and basic change of style occurred in the midst of an emotional crisis which had come to a head after the death of Maximilian I. Dürer knew that the twelfth of January 1519 meant more than the disappearance of a glamorous ruler and the "premature loss" of, from his personal point of view, a kindly and generous though not always solvent employer. It meant the end of an era which he himself had helped to shape, and he was deeply disturbed. On a letter from a fellow-humanist which reached Nuremberg about a fortnight after the Emperor's death, the faithful Pirckheimer noted, quite irrelevantly: "Turer male stat" ("Dürer is in bad shape"); and Dürer's own state of mind in the spring and early summer of 1519 seems to bear out his friend's concern. When a hard-working, economical man plans to leave his Nuremberg home for England or Spain and ultimately embarks on a trip to Switzerland, entirely useless from a practical point of view, he betrays a nervous restlessness for which modern doctors might prescribe a "change of scene," and which cannot be accounted for by the mere fear of losing a pension of one hundred florins a year.

We know, in fact, that Dürer's distress was of a spiritual rather than a practical or physical nature. Young Jan van Scorel, who had come to Nuremberg in 1519 to take advantage of Dürer's advice and instruction, found him so preoccupied with the "teachings by which Luther had begun to stir the quiet world" that he preferred to go to other parts of Germany. But soon the master emerged with a new security of mind. The very cause of his malaise had proved to be its remedy: he had heard the rumblings of the earthquake which was to shake the structure of European civilization, and had found shelter in the very center of the seismic disturbance, in the Lutheran doctrine itself. "If God helps me to see Dr. Martinus Luther," he writes in January or February 1520 to Georg Spalatinus, Chaplain and Librarian to Frederick the Wise, "I will diligently make his portrait and engrave it as a lasting memory of the Christian man who has helped me out of great anxieties."

In this adherence to the cause of Protestantism Dürer never faltered; that he continued to go to confession and to work for the Cardinal Albrecht of Brandenburg—as even Cranach did—is by no means a proof to the contrary. His reaction to Luther's rumored abduction and possible assassination in May 1521 has already been mentioned in connection with the *Knight, Death and Devil*; suffice it to quote a few more sentences from this Apocalyptic outcry which so strangely interrupts the sober flow of a traveler's journal: "O God, if Luther is dead, who shall henceforth so clearly expound to us the Holy Gospels? O God, what might he still have written for us in ten or twenty years! O all ye pious Christians, help me to weep over this God-illumined man and beg Him to send us another enlightened one. O Erasme

Roderodame, where wilt thou take thy stand?... Thou art but an old, little man; I have heard that thou givest thyself no more than two years in which to accomplish something. Use these well, for the benefit of the Gospels and the true Christian faith, and let thy voice be heard, and then the Gates of Hell, the Roman See, as Christ has said, will not prevail against thee.... O ye Christians, pray God for help, for His judgment is near and His justice will be revealed. Then we will see bleed the innocent who have been judged and condemned by the Pope, the priests and the monks. Apocalypsis. These are them that were slain, lying under the altar, and they cry for vengeance, whereupon the voice of God answers and says: 'Wait for the full number of the innocently slain; then I will judge.' "

In 1523 Dürer called the cult image known as the "Beautiful Madonna of Ratisbon" a "specter that has risen against Holy Writ and has not been laid because of worldly gain"; in 1524 he referred to himself and his friends as those who "stand in contempt and danger for the sake of Christian faith and are sneered at as heretics"; and that he died a "good Lutheran" is attested by Pirckheimer.

Dürer's art reflects this conversion—for it was a conversion—both in subject matter and in style. The man who had done more than any other to familiarize the Northern world with the true spirit of pagan Antiquity now practically abandoned secular subject matter except for scientific illustrations, traveler's records and portraiture; and the designer-in-chief of the *Triumphal Arch* and the Prayer-Book of Maximilian I turned his back upon the "decorative style."

For his own use, to please a client, or to oblige the authorities of his city, Dürer would still occasionally design an heraldic woodcut (374, 376, 381/434, 383, 433), a mural decoration (1549-1551), a resplendent throne (1560) or a Dance of Monkeys (1334), and it is in these exceptional cases that the joyful calligraphy of the "decorative style" survived. His real interests, however, centered more and more on religious subjects of a strictly evangelical character. The lyrical and visionary element was suppressed in favor of a scriptural virility which ultimately tolerated only the Apostles, the Evangelists and the Passion of Christ. His style changed from scintillating splendor and freedom to a forbidding, yet strangely impassioned austerity; and engraving and painting—the media antipathetic to the tendencies of the "decorative" style and all the better adapted to a non-linear, emphatically three-dimensional mode of expression—returned to favor.

To understand the suddenness and basic nature of this change, let us compare two engravings of approximately the same format, representing almost the same subject and executed no more than a year or a year and a half apart: the *Virgin Crowned by Two Angels* of 1518 and the *Virgin Nursing the Infant* of 1519.

The *Virgin Crowned by Two Angels* (146, *fig.* 249) conveys a feeling of perfect balance and serenity. The Madonna, neither too large nor too small in relation to the frame, is comfortably seated before a picket fence which opens up the view onto a bright landscape under a cloudless sky. Turned to three-quarter profile and gracefully bending forward, she casts a

quiet glance on the beholder, and her drapery enfolds her body with an harmonious flow of curves.

To this Raphaelesque equilibrium of loveliness and solemnity, plastic and pictorial values, the *Virgin Nursing the Infant* (143, *fig.* 250) opposes Michelangelesque monumentality and gloom. Not unlike the *Moses*, the *Jeremiah* on the Sistine Ceiling and the *"Capitani"* in the Medici Chapel, the figure of the Virgin is strictly frontalized and appears colossal within its narrow frame, the droop of her large head contrasting with the rigid pose of her body and evoking the idea of a *Pietà* rather than of a Madonna. The landscape is entirely suppressed, and the sky, darkened by dense hatchings, serves as an almost solid background from which the group detaches itself like a sculpture projecting from a wall. The figure of the Virgin herself is composed of two block-like units which seem hardly connected with one another, the lower one resembling somewhat an enormous cube. The drapery, finally—and this is perhaps the most conspicuous difference from the *Virgin Crowned by Two Angels*—is broken up into folds which as nearly as possible approach the form of such abstract stereometrical solids as prisms or pyramids. In sum, the emphasis is shifted from linear values and dynamic movement to schematized volume. The "decorative" style has given way to what may be called a volumetric or—if we are careful to ignore the modern implications of this term—"cubistic" one.

The same characteristics can be observed in all of Dürer's late engravings. To limit ourselves to those produced in 1519 and 1520: in comparison with the buoyant *Couple of Peasants Dancing* of 1514 (197) the *Couple of Peasants* of 1519 (196) offers a spectacle of statuesque heaviness and immobility. The two Madonnas of 1520, the *Virgin Crowned by One Angel* (144) and the *Virgin with the Swaddled Infant* (145, *fig.* 251) suggest, like that of the preceding year, voluminous sculptures set out against a foil of solid gray; they even surpass it in abstract rigidity, the former by a posture still more stiffly erect and a drapery still more angular than in the *Virgin Crowned by Two Angels*; the latter by a schematization of organic forms which brings to mind the polyhedron in the *Melencolia I*, and by the very fact that the Child is encased in His swaddling clothes not unlike a chrysalis.

The engraved portrait of Albrecht of Brandenburg, known as the *"Small Cardinal"* (209, *fig.* 248), is based on a study from life (1002) made on the same occasion as, and in every respect analogous to, the charcoal drawing which served as a basis of the woodcut portrait of Maximilian I. It is also dated 1519, though apparently executed fairly late in the year because its delivery and favorable reception is mentioned as a recent event in Dürer's letter to Spalatinus which was written in January or February 1520. But while the woodcut portrait of Maximilian stresses the "decorative" quality of sweeping curves, sharply defined contours and embroidered patterns, and in return subdues the plastic values of the figure itself, the engraved portrait of Cardinal Albrecht does exactly the opposite. The bust is not spread out over the sheet and cut off by the margins, but is a fully rounded, space-displacing body. Its volume is made impressive, and becomes almost measurable, because it tightly fills the interval between two planes formed by the dark curtain behind and the parapet-like strip with the

inscription in front; these, having no depth in themselves, delimit a definite amount of space between them. The moire pattern of the mantilla, clearly indicated in the study from life and actually emphasized in the working drawing (1003), is entirely suppressed in favor of a strictly plastic unity of surface, and the drapery breaks in simplified prismatic or conical folds; even the shoulders are marked by an angle instead of by a curve.

It may seem unfair to compare an engraving with a woodcut. But, apart from the fact that the very choice of another technique is indicative of a change in stylistic tendencies, it can be shown that the differences between the *Maximilian* and the *"Small Cardinal"* are not exclusively due to the medium. Lucas van Leyden, we remember, used Dürer's Maximilian woodcut for an engraving—or, to speak more exactly, for a curious crossbreed between engraving and etching—and he, too, made certain changes which, at first glance, seem to parallel Dürer's *"Small Cardinal"*: the frame is enlarged so that the bust is no longer cut off by the margins, a background and a frontal parapet are added, and the pattern of the clothes is suppressed (*fig.* 230). But all these changes were made, not for the sake of a plastic, let alone stereometrical effect, but for the sake of a luminary one. The background is not a plane surface but an architectural setting rich in diversified *valeurs* and suggestive of a space suffused with light; the parapet in front is a real breast-molding, hung with an embroidered tapestry, on which the Emperor rests his forearms—a very significant concession to the Early Flemish type of portrait painting; and the pattern of the coat and its lapels has been omitted, not in order to strengthen the impression of abstract volume, but, on the contrary, in order to bring out the textural difference between dull velvet and shining silk.

In the engravings thus far considered very little prominence is given to the scenery. This applies also to the engravings of the following years, and especially to Dürer's late paintings. As was already the case in the Augsburg *Madonna* of 1516 (30), and, even more particularly, in the Berlin *Virgin in Prayer* of 1518 (35) and the Munich *Lucretia* of the same year (106), they show only single figures or compact groups set out against a neutral dark background. There is a tendency toward strict frontality and over-plastic modelling; and in the paintings of 1519 and 1520, such as the *"Anna Selbdritt"* in the Metropolitan Museum (36), the two *Boys' Heads* in the Bibliothèque Nationale (83) and, above all, the austerely monumental *Head of a Woman* in the same collection (102, *fig.* 253), we find a similar tendency toward stereometrical simplification as could be observed in the engravings of this period, except for the fact that the medium of painting invites a reduction to rounded, or globular, rather than to angular, or prismatic, forms.

The only late engraving in which the scenery plays a major part, and indeed almost dominates the composition, is the *St. Anthony* of 1519 (165, *fig.* 247). But here the scenery itself is a "cubistic" phenomenon. It is not so much a landscape as an agglomeration of buildings, echoing and amplifying the shape of the main figure whose huddled form, represented in full profile, offers the aspect of an almost perfect cone. It is exclusively composed of such clean-cut stereometrical solids as prisms, cubes, pyramids and cylinders which coalesce and interpenetrate so as to bring to mind a cluster of crystals. This "cityscape" was not designed

primarily for the St. Anthony print. It was recorded on Dürer's first journey to Italy and had already been used in the "Pupila Augusta" drawing of about 1495 (938) as well as in the *"Feast of the Rose Garlands"* (*fig.* 149). But in the drawing it had served as a mere backdrop, closing rather than filling the picture space and cut in two by a big tree; and in the painting it had appeared in a still farther distance, radiant and almost diaphanous in the Venetian light. In the St. Anthony engraving, however, it is brought up to the center of the stage—so close, in fact, that Dürer felt the need of introducing a "repoussoir" in the shape of a slender cross-staff—and it has the nearness, sharpness and palpability of an architect's model. One might say that Dürer did not devise an architectural setting for a contemplated St. Anthony, but rather invented a St. Anthony for an architectural setting already on hand—a setting which had been available for almost a quarter of a century but had remained undiscovered as a "cubistic" possibility until the master had developed a "cubistic" mode of vision.

The reader has already been cautioned against interpreting the term "cubistic" according to the usage of today. Yet modern "cubism" and Dürer's have one thing in common: both are not only a matter of aesthetic preference or "taste" but reflect a reasoned theory. There is, however, this difference: that Dürer's theory, unlike the modern one, was intended, not as a justification for breaking away from what is commonly understood by "reality" but, on the contrary, as an aid to clarifying and mastering it.

When Dürer, after the death of Maximilian I, felt free to devote more of his time to theoretical studies he took up his main problem, the rationalization of the human body, from a stereometrical instead of from a planimetrical point of view; and since the irregularly curved surfaces of a living organism are not accessible to elementary mathematical methods he tried to reduce them, as it were, to polyhedral shapes. In a drawing of 1519—the critical year—two human heads are thus broken up into a number of facets like a cut diamond (839, *fig.* 312), and two drawings of about the same time, forming a kind of transition from theory to practice, convey a similar impression of polyhedrality by purely "artistic" means: they show human faces modelled exclusively by a series of straight parallel lines which meet each other at an angle and thus produce, quite automatically, a facet-like effect (1131 and 1653, *fig.* 313).

Now, in a sketch found on the same sheet as the first of these drawings, and in a good many subsequent instances, a somewhat analogous method is also applied to the whole human figure: its parts are inscribed in such stereometrical solids as cubes, obelisks, and truncated pyramids (1653-1656, *fig.* 322). But the purpose of this procedure is not so much the clarification of shape and volume as the rationalization of movement. The various solids are shifted against one another like the parts of a mannequin; in fact one of these "cube-men" is combined with the sketch of an actual mannequin.

The somewhat stiff and mechanical character of the poses thus produced is even more pronounced in another method of making human movement "constructible" which was also evolved in 1519 and further developed in the following years. It employs the technique of parallel projection by means of which the front or rear elevation of the whole figure is directly

transferred into a side elevation and vice versa; it therefore presupposes that every part of the figure moves in a plane either parallel or at right angles to the picture plane. This leads, of course, to an almost Egyptian combination of heads in profile with chests and legs in front view and so on (*fig.* 324).

These studies, too, had their effect on Dürer's artistic activity, and here again a direct transition from theory to practice can be observed in the figure of a nude woman which, sketched on the back of the earliest "cube-man" drawing, definitely shares the latter's marionette-like angularity though it is not "constructed" in the technical sense (1191). As Dürer's idea of dividing human heads into facets can be considered as a theoretical equivalent of his tendency toward a "cubistic" schematization of form, so his interest in "cube-men," parallel projection and mannequins reflects itself in, or at least corresponds to, a rectangular schematization of poses and gestures. Concrete examples of these, however, are not to be found in his engravings and paintings which, in deference to the spirit of their media, had come to be restricted to subjects of a purely existential, stationary character. It was to woodcuts and pen drawings—mostly made in preparation for woodcuts—that the late Dürer reserved the representation of "scenes," that is to say of the figure in action.

Of the woodcuts actually executed after 1519 only five fall within this class of "scenic" compositions: the four illustrations in the "Unterweisung der Messung" which demonstrate the use of perspective apparatuses (361-364, *figs.* 310, 311), and the *Last Supper* of 1523 (273, *fig.* 278). But scenic pen drawings exist in fairly large numbers, and in both groups the poses and gestures tend to be governed by that principle of rectangularity which makes them, now abrupt, now frozen, at times almost contorted, but always—and just by virtue of this inorganic, or rather preterorganic quality—strangely expressive.

Whether we look at the *Draftsman Drawing a Portrait* (*fig.* 310), the *Last Supper* of 1523, or the two *Bearings of the Cross* of 1520 (580 and 579, *fig.* 275), we always find an emphasis on the "basic views"—full face or profile. Often there are such strange combinations of both as, for example, the figure of a bystander who turns his back upon the beholder while his face and one of his legs are shown in profile, or the St. Peter in the *Last Supper* whose head is turned to full profile while his body is seen in full face; the posture of the fifth Apostle from the left in the same woodcut is so cramped, and at the same time so schematized, that his right shoulder has been mistaken for a pillow. A climax is reached in the beautiful *Deposition* of 1521 (612, *fig.* 276) where a Virgin Mary in pure profile is contrasted with a Magdalen in front view; where one of the bearers walks along the picture plane, so to speak, so that his body and right leg appear in profile but his left foot and his face are turned directly toward the beholder; and where a second bearer, stepping backwards, turns both his face and left leg to full profile but so that they point in opposite directions. In one of the few secular drawings of this period (1174, *fig.* 325, dated 1525) even the *Horse-Tamers* of Monte Cavallo are transformed into a paradigm of, if one may say so, expressively mechanized movement which might well have been included in the Fourth Book of Dürer's *Vier Bücher von Menschlicher Proportion*. Where, at the times of the *"Dream of the Doctor,"* the *"Hercules"*

or the *Fall of Man*, a superimposed religious or allegorical meaning had served to make a classical image acceptable, here a classical image serves to exemplify a mathematical theory.

The principle of rectangularity which determines the poses and movements of the individual figures also controls the general scheme of composition and, above all, the structure of space itself. As far as possible the figures are arranged in parallel planes, squeezed in, as it were, between the picture plane and an imaginary relief ground, and the general stream of movement and action tends to flow, not from the foreground into depth but from side to side. Interiors, as in the five woodcuts here under discussion, are shallow, bare and strictly frontalized, and not the smallest object is permitted to budge from a position either parallel or at right angles to the picture plane. Again Dürer's renewed preoccupation with the theory of art, in this case with perspective, is clearly reflected in his creative practice.

In sum: where Dürer's late engravings and paintings show stereometrically definable units, his late woodcuts and pen drawings show stereometrically definable compositions. In both cases the visible phenomena are subjected to what we have called a "cubistic" principle. But in the more plastic media Dürer tended to apply this principle to isolated volumes, in the more linear ones, however, to the picture space as a whole; and this divergent interpretation of the same principle can be observed even in purely technical matters.

For large-sized studies from life, made in preparation for engravings and paintings, Dürer preferred two new techniques—developed, significantly enough, in the years from 1519 to 1521—which have in common an accentuation of pure volume at the expense of linear values. These are: first, broad brush, heightened with white and sometimes reinforced by chalk, on paper washed with gray or black (766, 767, 1049, 1163, 1164 [*fig.* 254], 1204, 1205); and, secondly, and still more frequently, soft stump-like metal point, also heightened with white, on green- or purple-grounded paper (characteristic examples: *figs.* 281-284, 289, 292, 293). His late pen drawings, made in preparation for woodcuts, and his late woodcuts themselves, are, on the contrary, marked by an almost diagrammatic transparency of the linear pattern. "Form-indicative" curves are virtually abandoned in favor of straight lines, spaced at wide and generally equal intervals, parallel wherever the surfaces are frontal, and strictly governed by the rules of perspective convergence where they are foreshortened. Cross-hatchings are reduced to a minimum and practically disappear after 1523 (in the *Horse-Tamer* of 1525 there is not a single one); even curtains and draperies, as in the *Adoration of the Magi* of 1524 (513, *fig.* 274) and in one of the woodcuts in the "Unterweisung der Messung" (*fig.* 310), are often modelled without them.

All this, combined with a certain rock-like quality in the interpretation of organic forms and landscape features, establishes a striking similarity between Dürer's late pen drawings and the graphic works by Andrea Mantegna; in certain cases there are direct reminiscences. The same Dürer who in his youth had greeted Mantegna as a guide to pagan sensuousness and violence now turned to him for rigid, relief-like formality.

Dürer's late style has been called, not inappropriately, "puritanical." But this stiffening and tightening of form strengthens rather than weakens the emotional impact of the content.

As in Beethoven's late fugues, Michelangelo's late drawings or Rembrandt's late pictures, we feel that the outward receptacle had to be made as rigid and impervious as possible in order to withstand the pressure of an inward passion by far exceeding that which, in earlier periods, could be contained within more shapely and pliable vessels. We sense that the "mechanical" quality of poses and gestures, the anxious respect for the frontal plane, and the reduction of space to the barest essentials conceals and thereby betrays, like the "set face" of a man about to kill or to die, an emotion too intense to be conveyed save by repression.

In the works of 1523, such as the *Apostles* in engraving and metal point (*figs.* 290, 291, 293) or a magnificent pen drawing of Christ in Gethsemane (565), this inner tension finds an outlet in what may perhaps be described as a "corrugated" style. Large simplified volumes are contrasted with complicated systems of prominences and indentations so that the whole gives the impression of a compact massif broken up into big tablelands, craggy rocks and deep ravines, though even these show a remarkable tendency toward geometrical schematization (parallel lines, right angles, isosceles triangles, etc.); and near the very end, in 1525/26, a certain softening can be observed in such broadly and fluidly treated figures as the Munich *St. John* (43 and 826, *figs.* 294, 292) and the curiously Schongauerian *Virgin with the Pear* in the Uffizi (31, *fig.* 308). Apart from this development, however, the principles of Dürer's late style were firmly established in 1519/20, and even the most important external event of his later years invigorated and enriched rather than changed the further manifestations of his genius. This event was his journey to the Netherlands.

DÜRER LEFT NUREMBERG ON THURSDAY, July 12, 1520. His primary purpose was, we remember, to obtain the continuation of his pension from Charles V, who was on his way to his coronation in Aix-la-Chapelle. But this was not the only motive of Dürer's journey. He took along his wife and a maid (named Susanna); he stayed in the Netherlands seven months after his request had been granted; and he brought with him an apparently inexhaustible supply of engravings and woodcuts—some by Hans Baldung Grien and Hans Schäuffelein besides his own—as well as several paintings which could be easily transported. His Diary informs us at length how he disposed of his treasures by sales, barter, and as presents. The buyers and recipients of his prints were legion, and as for pictures we learn that the Bishop of Bamberg received, in return for three letters of recommendation and a very useful customs permit, not only a Life of the Virgin, an Apocalypse and one florin's worth of engravings, but also a painted Madonna; that three small paintings on canvas—possibly those in the Bibliothèque Nationale (83 and 102, *fig.* 253)—were sold for four florins and five stuivers; that another "Tüchlein," representing the Virgin Mary, fetched two guilders Rhenish; and that a *Sudarium*, a *Trinity*, a *Dead Christ*, and a *Child's Head* on canvas (a second picture of the same description is not a work of Dürer's, but was given to him by a friend and subsequently passed on to another) were given away as presents. Dürer had even brought along a painted portrait of Maximilian I, most probably the one in the Germanisches Museum; he offered it to the Emperor's daughter, Lady Margaret, Governor of the Netherlands, but had to take it back because she disliked it so, and ultimately traded it for a white English cloth.

It appears, then, that Dürer had planned to expand his pilgrimage to Court into a large-scale sales trip. Yet, he seems to have taken business none too seriously. He would both trade and work on an extremely informal basis. More often than not he dealt with friends and acquaintances whom he obliged either in return for favors received, or in the hope of favors to come; and he had no regrets if he was compensated with delicacies or curios of all kinds instead of with money. He gladly accepted a florin or a ducat for a portrait drawing, but he was also satisfied with a rosary of cedar wood or a hundred oysters. To one Lazarus Ravensburger he gave the *St. Jerome* and the "Three Large Books" just to make friends; and when he received, in return, "a big fin, five snailshells, four silver and five copper medals, two dried fishes, a white coral, four reed-arrows and a red coral," he was so touched that he drew Ravensburger's portrait for nothing and added sixteen engravings, the Engraved Passion, and several woodcuts. He tipped liberally; he enjoyed sightseeing and, occasionally, a little gambling; he spent considerable sums on Italian prints; and he acquired a whole museum of curios such as exotic weapons, buffalo-horns, Calecutian salt-cellars, ivory-carved skulls, precious stones and little monkeys costing four florins in gold.

Small wonder that Dürer summed up the financial result of his journey into the sentence: "In all my work, living expenses, sales and other dealings in the Netherlands I have come out with a deficit." But he writes without bitterness, as though he had never expected anything else. He evidently looked upon the whole venture as a combination of business and pleasure, with the accent rather on the latter. True, the question of the pension had to be settled, and expenses had to be reduced, as far as possible, by working, selling and bartering. But what Dürer really wanted and needed was the rejuvenating excitement of being abroad: the thrill of a new environment made doubly attractive by the impending visit of Charles V with its throng of envoys and spectators from all over the world; the experience of great works of art and craftsmanship; the intercourse with people of all professions, ranks and nationalities; and the recognition more willingly granted to a distinguished guest than to a fellow-citizen, however famous.

Dürer and his party traveled by land to Bamberg, and then, after a cordial reception by the Bishop, by boat to Frankfort where his old patron, Jacob Heller, showed a belated generosity by sending him a present of wine. Hence they proceeded, again by boat, to Mayence and—with the effectiveness of the Bishop's customs permit gradually wearing off—to Cologne, the home of Dürer's cousin Niclas, a goldsmith. After an overland trip of about five days they arrived in Antwerp on August 3.

In Antwerp the family took lodgings with the kindly and honest Jobst Planckfelt (*recte* Joos Blanckvelt). Here the curious agreement by which Dürer, if not invited out, had his meals alone or with his host while the women ate in the "upper kitchen," went into effect on August 20. Dürer used Planckfelt's house as a kind of headquarters whence he made longer or shorter excursions in all directions, leaving his wife in the care of Susanna and Mrs. Planckfelt. As early as August 26 he went to Brussels and Malines, where Lady Margaret had established her residence, and succeeded in making contact with several important personalities, including

the special envoys from Nuremberg who brought the Imperial Insignia for the coronation of Charles V; the Imperial Secretary Jacobus de Banissis to whom the "supplication" for his pension had to be submitted; and Lady Margaret herself. He returned on September 3, stayed about a month and, on October 4, departed for Aix-la-Chapelle where he witnessed the coronation ceremony on October 23. The fate of his petition still being undecided, and the Court repairing to Cologne, Dürer decided to do likewise, especially since the Nuremberg envoys had invited him into their carriage. On November 12 he finally received, "after great labors and exertions," the confirmation of his pension, and was back in Antwerp on November 22, after having passed through Jülich, Zons, Neuss, Duisburg, Wesel, Emmerich, Nymwegen, Hertogenbosch, Hoogstraaten, Baerle and several other places.

The two following excursions were mere sightseeing tours. One was the ill-fated trip to Bergen-op-Zoom and Zeeland, the "country lower than the sea" (December 3 to 14), where Dürer enjoyed the sights of Arnemuyden, Ter Goes, Wolfersdyck, Zierikzee and Middelburg, but missed the whale he had been so anxious to see, had a hairbreadth escape from an accident in Arnemuyden harbor, and suffered the first attack of that "strange disease" which was to haunt him for the rest of his life. The other, undertaken in the company of Jean Prevost (or Provost) of Bruges, was a more pleasurable visit to Bruges and Ghent (April 6 to 11, 1521) where Dürer admired the greatest works of art in the country and was splendidly received by artists and merchants alike; it is touching to read what he felt on the tower of St. John's in Ghent: "On Wednesday morning they led me up St. John's tower, and there I beheld the great wondrous city where I was deemed a great man at once."

According to the same letter of 1524 which mentions the overtures of the Venetians "nineteen years ago," the authorities of Antwerp came forward with an even more generous offer. But again Dürer withstood the temptation for love of his "fatherland," the "honorable City of Nuremberg." As early as March 1521 he started to buy homecoming presents for his friends in Nuremberg, but it was not until June that the preparations for the final departure were completed. A farewell visit was paid to Lady Margaret on the sixth and seventh of the month. The account with Planckfelt was settled in amicable fashion. A big chest was dispatched while some other luggage had already been sent ahead in March and April. A carter was hired after another had proved unsatisfactory; tarpaulins, ropes and a little yellow postboy's horn were bought; and a friendly Vicar about to depart for Nuremberg was entrusted with Dürer's most unwieldy and most cherished possessions, to wit: "The large tortoise-shell, the buckler of fish-skin, the long pipe, the long shield, the shark's fin and the two little vases with citronate and capers." In short, everything was ready when on July 2, King Christian of Denmark, stopping at Antwerp on his way to Brussels, sent for Dürer to execute his portrait in a drawing (1014). The "Nero of the North" was so pleased that he kept Dürer for dinner and asked him to accompany him to Brussels so that the portrait might be carried out in oils. Dürer accepted immediately, packed up his wife, maid and belongings, and departed on the following day. He was present when Charles V came to meet his brother-in-law before the city gates, looked on at a banquet given by the Emperor to King Christian, and was King Christian's

personal guest when the latter reciprocated by a banquet of his own. Thus royally entertained and, for once, well paid—he received thirty florins for the painted portrait—Dürer stayed in Brussels until July 12. On this day he left the Low Countries for good, arriving in Cologne —via Louvain, Tongeren, Maastricht and Jülich—on July 15, precisely one year and three days after his departure from Nuremberg.

There was perhaps never a traveler so sober yet so responsive as Dürer. In his Diary the records of his work, of his impressions and of his feelings are not only interspersed but actually fused with entries pertaining to petty expenses and receipts, purchases, marketing, meals and all the other incidents of daily life. But the very fact that the rays of admiration, just as the lightnings of wrath over Luther's alleged assassination, break through a cloud of trivial details and insignificant figures lends to such utterances the character of candor and irrepressibility. Every page of Dürer's Diary bespeaks his utter naïveté (as when he states that he "had to give" his favorite buffalo-horn and cedar-wood rosary to the hospitable envoys from Nuremberg); his healthy delight in good food and friendly consideration; his helpfulness and readiness to recognize the merits of others; his lack of resentment (as when he writes: "Item, the fellow with the three rings has overreached me by half—I did not know enough about it"); and his unlimited capacity for enthusiasm.

In Antwerp—then the wealthiest and by far the most international city of the northern world, much more important than the older centers of Ypres, Ghent and Bruges—Dürer marveled at the enormous Cathedral, at the "rich Abbey of St. Michael," at the new house of the Mayor van Liere—"the like of which I have never seen in German lands"—and at the magnificent establishment of the Fuggers. He looked with wonder and pleasure at the Town Hall, mansions, fountains and gardens of Brussels, at the fine buildings of Bergen-op-Zoom, Nijmegen, Hertogenbosch and Middelburg, and at the "Münster" of Aix-la-Chapelle with its imported columns of porphyry and sinter from Roman aqueducts (this is the meaning of the enigmatical term "Gossenstein"), all executed "according to the prescripts of Vitruvius." He admired Stephan Lochner's altarpiece in Cologne Cathedral, the paintings of Jan van Eyck in Ghent, Bruges and Malines, the works of Rogier van der Weyden and Hugo van der Goes—"great masters both"—in Bruges and Brussels, and the Bruges *Madonna* by Michelangelo; and he said of Jan Gossart's *Descent from the Cross* in Middelburg almost exactly what the Venetian painters had said of his own work in 1506, namely, that it was "better in design than in painting."

But his interest in the Ghent altarpiece was rivalled by the fascination of the famous lions, one of which he was allowed to portray, and of the huge fish-vat that could be used as a banquet table (or dais?). He was no more impressed by pictures and statues than by the big bed in Brussels which could accommodate fifty persons, by the beautiful steeds in the Fugger stables and at the Whitsuntide horsefair at Antwerp, by the "wondrous things" in Hans Popenreuther's cannon-foundry in Malines, by a colossal fishbone looking "as though it were built up from ashlars," and by the remains of the Giant Brabo who had stood eighteen feet and had ruled over Antwerp in the olden days. The longest and most vivid descriptions

in his Diary, veritable masterpieces of graphic prose, are devoted to the Triumphal Entry of Charles V into Antwerp (Dürer had seen the decorations in the making, was present at the event itself, and bought a printed description afterwards), and to the great procession on Sunday after Assumption which took two hours to watch and more than two pages to describe. And Dürer's enthusiasm reached a peak over the objects recently imported from Mexico: "Further, I have seen the things brought to the King from the new golden land: a sun, wholly of gold, wide a whole fathom, also a moon, wholly of silver and just as big; also two chambers full of their implements, and two others full of their weapons, armor, shooting engines, marvelous shields, strange garments, bedspreads and all sorts of wondrous things for many uses, much more beautiful to behold than miracles. These things are all so costly that they have been estimated at a hundred thousand florins; and in all my life I have seen nothing which has gladdened my heart so much as these things. For I have seen therein wonders of art and have marveled at the subtle *ingenia* of people in far-off lands. And I know not how to express what I have experienced thereby."

Unlike the painters of Venice, the Flemish artists were quick to honor and befriend their German guest. Only three days after his arrival, the Painters' Guild of Antwerp arranged a splendid banquet with ladies, gorgeous plate and "superexcellent" food: "As I was led to the table the crowd stood on both sides as though a great Lord were ushered in . . .; and as I sat there with honors, in came the City-Clerk of Antwerp with two servants and gave me four carafes of wine . . . , and afterwards Master Peter, the City's engineer, and gave me two carafes of wine with his most courteous compliments . . . ; and late at night they saw us home in state with torch-lights." The goldsmiths of Antwerp gave Dürer and his wife a banquet on Shrove Tuesday, and on his excursions alone he was splendidly entertained and honored by the painters, goldsmiths and merchants of Bruges, the painters of Ghent, and the painters and sculptors of Malines. He did not meet, it seems, his greatest fellow-painter in Antwerp, Quentin Massys, for he records only a visit to "Master Quentin's house" and never mentions him again. But he made friends with a host of other artists, painters as well as sculptors, goldsmiths, painters on glass, illuminators and medalists. Suffice it to mention Lady Margaret's Court Sculptor, the great Conrad Meit, "the like of whom I have never seen," as Dürer puts it; Lucas van Leyden, second only to Dürer himself as an engraver and woodcut designer; Bernard van Orley of Brussels; Jean Prevost (already mentioned) of Bruges; Gerard Horenbout, the illuminator, whose eighteen-year-old daughter Susanna practiced her father's art so skilfully that Dürer gave her a florin for a miniature of the *Salvator Mundi* and remarked in his Diary: "It is a great miracle that a mere female should do so well"; the French stone sculptor Jean Mone; and, above all, the "good landscape painter" (probably the first occurrence of this term!) Joachim Patinir of Antwerp with whom Dürer became sufficiently friendly to help him with drawings and to attend his wedding. Special importance must be attached to Dürer's contact with Tommaso Vincidor of Bologna, a pupil of Raphael, who had been sent to Brussels in order to supervise the weaving of Raphael's cartoons for the Vatican

tapestries; he gave Dürer an antique ring and some Italian engravings and undertook to procure him all the prints after Raphael in exchange for a complete set of Dürer's own.

However, Dürer was never inclined to limit his social life to colleagues. He made the acquaintance of musicians, doctors, astronomers, and humanists (such as Erasmus of Rotterdam, Petrus Aegidius, Cornelius Grapheus and Adriaen Herbouts); and his closest friends were, significantly, international men of affairs: Bernhard Stecher, the factor of the Fuggers in Antwerp; Tommaso Bombelli, a rich silk merchant from Genoa and Paymaster General to Lady Margaret, who had two nice brothers and attractive children; and the three economic representatives of Portugal: João Bradão—who may be called the senior factor—, Francisco Pesõa (factor since 1519), and, last but not least, Rodrigo Fernandez d'Almada, Secretary to Bradão up to 1521 and then promoted to factor himself.

The only person of consequence who, for some reason, showed a certain coolness and even hostility to Dürer was Lady Margaret. At first she was quite gracious and even promised to support Dürer's application to her nephew Charles V. Dürer, in turn, did everything in his power to please her; he showered engravings upon her and made her two drawings on vellum so fine and meticulous that he estimated their value at thirty florins as against seven for a complete set of his prints. But his last visit with her—in June 1521—was a sad disappointment. She deigned to show him her library and her collection of paintings where Dürer noticed, among other things, several pictures by his old friend Jacopo de' Barbari (who had died in Lady Margaret's service in 1516); a work by Jan van Eyck (probably the Arnolfini portrait in London which was in her possession up to her death); and about forty small panels, as "good and pure" as he had ever seen, which can be identified as a series of the Life of Christ by Juan de Flandes, now mostly in the Royal Palace in Madrid. But she not only refused, as we remember, to accept Dürer's portrait of her father Maximilian but also turned down his request for Barbari's sketch-book which she had promised, she said, to her own painter. And, to quote Dürer's own words, she "never gave me anything for what I had presented to and made for her."

Except for two or three Coats-of-Arms quickly jotted down on woodblocks (381/434, 433), Dürer's activity in the Netherlands was naturally restricted to paintings and drawings.

Several paintings executed during his sojourn are known to us only from the records in his Diary: one or two *"Herzogangesichter"* (*Duke's Heads*; one cannot be sure whether Dürer refers to two pictures or to the same picture twice) which seem to have been portraits of Frederick II of the Palatinate; two *Sudaria* both of which were given to Dürer's Portuguese friends; and a portrait of his host Jobst Planckfelt which has been incorrectly identified with the beautiful Portrait of a Gentleman in the Prado (85, *fig.* 260).

Four other paintings, however, have come down to us: the Portrait of the elusive Bernhart von Resten (or von Breslen) in Dresden (64, *fig.* 259); the Portrait of Lorenz Sterck, Tax Collector of Brabant in the District of Antwerp, in the Isabella Stewart Gardner Museum in Boston (67); the Portrait of Jobst Planckfelt's wife in Toledo, Ohio (73); and the *St. Jerome in Meditation* presented to Rodrigo Fernandez d'Almada and now preserved in

the National Museum at Lisbon (41, *fig.* 252). All of them were executed during the spring and summer of 1521.

Between 1500 and 1520 Dürer's portraits fell, roughly speaking, in two classes which can be distinguished, to borrow two expressions from the motion picture industry, as "ordinary shots" and "close-ups," with the *"Small Cardinal"* of 1519 (*fig.* 248) forming an intermediary between the two. The "ordinary shot" portraits—already exemplified by the Portrait of Albrecht Dürer the Elder of 1497 (*fig.* 66) and culminating in the two painted Portraits of Maximilian I (60 and 61)—represent the sitter in half length, approximately down to the hips. The figure, with ample space on either side of the shoulders, and the arms lowered at a comfortable angle, rises in pyramidal fashion, and the whole gives the impression of spaciousness and totality, the sitter being interpreted as a complete "personality" rather than as a mere "physiognomy." In the "close-up" portraits—that is, in the overwhelming majority of the portraits executed between 1500 and 1520 on the one hand, and after 1521 on the other—the emphasis is concentrated on the face. The figure is reduced to a tightly framed bust, at times cut down so as not even to include the shoulders, and never complemented by hands.

In the portraits of 1521, however—excepting that of Mrs. Planckfelt which is of a much less formal character than the two others—Dürer reverted to an archaic type which he had completely abandoned from the beginning of the new century because it lacked both the amplitude and completeness of the genuine half-length portrait and the concentration of the bust portrait pure and simple. This was the bust portrait with hands, as typified by the Portrait of Albrecht Dürer the Elder of 1490 (*fig.* 31) and by the Tucher Portraits of 1499 (69, 74, 75). Enhanced by the prestige of Jan van Eyck, the Master of Flémalle, and Rogier van der Weyden, this "kit-cat" portrait was still in favor with the Dutch and Flemish masters when Dürer visited the Netherlands; Lucas van Leyden, we remember, felt obliged to add hands to Dürer's woodcut portrait of Maximilian I (*fig.* 230). Thus the very composition of Dürer's portraits in Dresden and Boston, with the hands brought up before the breast so as to fit into the narrow space of a bust portrait, bears witness to the influence of Netherlandish art. But this influence is also felt in form, light and color; there is a sense of texture (particularly noticeable in the rendering of fur), a tendency to suppress linear details in favor of a broad chiaroscuro effect, and a general feeling for the submergence of solid forms in light-filled space which brings to mind such portraits as Gossart's *Carondelet* in the Louvre or even Lucas van Leyden's Portrait of an Unknown Man in the National Gallery at London. It is not surprising that a portrait actually produced by a Flemish master of about 1520 (88) should have been ascribed to Dürer's "Antwerp phase."

The *St. Jerome* in Lisbon (*fig.* 252)—finished in March 1521 and carefully prepared by five admirable studies, three of them after a man of ninety-three who received three stuivers for his services as a model (817-821)—also reveals the influence of the Flemish environment. But in this case the situation is somewhat more complicated. The Saint is represented in half length, his heavy figure filling almost the entire picture space. He is

seated at a table on which are seen a little reading desk with an open volume on top and three smaller books underneath, an ink-pot, and a skull. A crucifix is attached to a projecting strip of the plain wall which serves as a background. Resting his head on his right hand, the Saint casts a sad, exhorting glance at the beholder and pointingly places his left index finger on the skull which also seems to fix us with its eyeless gaze.

Clearly the picture could have been painted only in Antwerp. The color scheme, the emphasis on chiaroscuro values, the prominence of still-life features, and, above all, the very type of composition—a portrayal in half length with deliberate concentration on the expression of the face and hands—all this is unthinkable without the influence of Quentin Massys whose mission it was to revive the tradition of the "Fathers" of Flemish painting, and yet to fuse it with the attainments of the North Italian Quattrocento, with special emphasis on the physiognomical studies of Leonardo da Vinci.

It is, however, very doubtful whether the Massys scheme of composition, as exemplified, for instance, by the *Banker and his Wife* in the Louvre, had ever been applied to the theme of St. Jerome before Dürer's appearance in Antwerp. None of the Dutch or Flemish representations of St. Jerome in half-length antedate Dürer's picture in Lisbon, and most of them are demonstrably influenced by it. In an engraving of 1521 Lucas van Leyden borrowed the motifs of the skull and the pointing finger conspicuously absent from his engravings of 1513 and 1516. In one of his earliest paintings (Berlin, Deutsches Museum) Marinus van Roymerswaele repeated Dürer's composition fairly faithfully, except for the fact that he revised the pose and costume of the Saint according to Dürer's woodcut of 1511 (334), multiplied the still-life features after the fashion of Massys (which in turn harks back to the tradition of the brothers van Eyck, Petrus Cristus, Colantonio, etc.), and, like most other "Mannerists," preferred to show the skull without its jawbone and to display its honeycombed *os occipitis* rather than its spherical dome; later on he produced about half a dozen further variations the dates of which range from 1528 (?) to 1547, the date inscribed on the Prado version—1521—having been discredited for very good reasons. In the workshop of Joos van Cleve more or less elaborate imitations of Dürer's painting, some of them rather literal except for the accessories, were turned out wholesale, and the continued influence of this tradition, transmitted by such masters as Jan van Hemessen (formerly Vienna, Strache Collection) can still be felt in the seventeenth century.

Thus the painting in Lisbon, while conforming to the Antwerp tradition in treatment and composition, is apparently Dürer's own as far as the "invention" is concerned; and this conclusion is borne out by internal evidence. It has rightly been said that the *St. Jerome* of 1521 reflects the spirit of Luther while the engraving of 1514 (*fig.* 208) conforms to the ideal of Erasmus of Rotterdam: where the engraving shines with the quiet glow of scholastic contentment, the painting is a gloomy *memento mori*; some of its Flemish replicas very appropriately bear the inscription "Homo bulla" ("Man is a bubble"). Yet the skull, however inconspicuously placed on the windowsill, however pleasantly transfigured by the sunshine, and however much ignored by the busy Saint, makes its

first appearance already in Dürer's engraving of 1514; and a further and most important step toward the macabre is taken in a later pen drawing in Berlin which must be considered as a direct forerunner of the picture in Lisbon (816, *fig.* 255). It shows St. Jerome in his cell, still in full length as in the engraving. But he is clad in a hermit's gown—a rare arrangement, repeated, significantly enough, only by the same Joos van Cleve whose workshop specialized in the production of *St. Jeromes* à la Dürer. Furthermore, instead of being engaged in scholarly work, the Saint is lost in meditation over the skull now placed on the table before him, his mood and posture strangely reminiscent of Michelangelo's most famous monuments to universal grief, the *Jeremiah* and the *"Penseroso."*

From the point of view of iconography and content, then, the Lisbon picture—almost a "close-up" of the drawing in Berlin except for the changes in costume, gestures and atti-tude—has its logical place in Dürer's development. Only the author of the *Melencolia I* and the Self-Portrait of about 1491 (*fig.* 25) could have interpreted the peaceful scholar and ardent penitent as a sort of Christian Saturn with all his implications of gloom and tran-sience; when Jan van Eyck's St. Jerome—known to us through its reflections in Petrus Cristus's panel in Detroit, in several miniatures, and even in Ghirlandaio's and Botticelli's frescoes in Ognissanti at Florence—rests his head on his hand this gesture expresses only the concentration of the reader and writer, and not the grief of melancholy.

Thus the history of *St. Jerome* of 1521 parallels in some ways that of the *Christ among the Doctors* of 1506. In both cases Dürer drew inspiration from the ambient air—and it should be noted that the ultimate source of this inspiration was Leonardo da Vinci; but in both cases he did not adopt a given prototype but condensed his impressions into an invention of his own, sufficiently original to startle, yet sufficiently imbued with indigenous tendencies to invite emulation. As the *Christ among the Doctors* was widely imitated in North Italy because it was "Leonardesque" without repeating a composition by Leonardo, so the *St. Jerome in Meditation* appealed to the Flemings because it used the language of Antwerp to deliver a message by Dürer.

Apart from the studies made in connection with this picture, the drawings of the journey to the Netherlands can be divided in two classes: those destined for others and those made for Dürer's own use. The first of these two classes comprises "Visierungen"—or, as in the case of the two drawings on vellum given to Lady Margaret, carefully finished souvenirs for friends and acquaintances—and large-scale portraits, about the size of the Apocalypse if not cut down, in chalk or charcoal (only exceptionally in brush) which were given or sold to the sitters.

Lady Margaret's unappreciated treasures are lost, but we have some other drawings which may give us an approximate idea of their character. These include a few small busts, or rather studies in human physiognomy, on vellum (1132, 1192, 1193, 1238), and a real "collector's item" which shows all sorts of interesting animals and two landscape studies care-fully transferred from sketch-leaves to a great piece of especially prepared paper (1475). A portrait of the excellent lute-player Captain Felix Hungersperg, which Dürer drew in the

latter's album, has at least come down to us in a *propria manu* replica (1026). All the "Visierungen," however, are lost, except for some slight sketches for the Coat-of-Arms of an unknown Englishman (1517). It is only through Dürer's Diary that we know of the "Visierungen" supplied (for unknown purposes) to the painters of Antwerp: of the fillets designed for the Antwerp Goldsmith's Guild; of fancy dresses for Shrove-Tide masquerades; of a seal for the goldsmith Jan van de Perre; of a design for the mural decoration of Tommaso Bombelli's house in Antwerp; of a plan for a house to be built by Lady Margaret's physician; of a St. Nicholas for a chasuble to be donated by the "Meersche Guild" of merchants; and of four St. Christophers on gray-grounded paper for Joachim Patinir.

Of the large-scale portrait drawings, on the other hand, more than a dozen have come down to us; eleven or twelve in charcoal or chalk, one in brush, and one in metal point on purple-grounded paper. They are not preparatory studies but finished works of art—indeed, Dürer used to give them away together with a wooden panel, costing six stuivers, on which they might be mounted. Their composition follows the "bust portrait" formula employed for paintings and prints (1071, *fig.* 261). The head is normally covered with a hat the brim of which achieves what may be called a contrapuntal effect; and the background is blackened, with a narrow strip at the top left blank for the signature, the date and other inscriptions—an arrangement already found, at times, in the chalk and charcoal drawings of 1515-18 (1040 and 1065), but now becoming a usual custom. The only exceptions are the portraits of Agnes Dürer (1050, *fig.* 262) and Erasmus of Rotterdam (1020), the former being the only portrait drawing on colored paper, the other not quite finished. Besides Erasmus, Agnes Dürer and King Christian II of Denmark already mentioned (1014), we can identify Bernard van Orley (1033) and Rodrigo Fernandez d'Almada (1005), the only individual known by name whom Dürer honored by a "big brush drawing in black and white."

An intermediary position between the drawings made for others and those made for Dürer himself is held by three medium-sized portraits in silver point which Dürer probably—though not at all certainly—kept for himself. They represent, with admirable finesse, Lucas van Leyden, the "tiny little man who engraves in copper" (1029); Sebastian Brant—at least probably—whom Dürer had not seen since the days of the "Narrenschiff," but who had come to the Netherlands to do homage to Charles V in the name of the City of Strassburg (1073); and the young negress Catharine who was in the service of João Bradão (1044). Both from a technical and an artistic point of view these more informal portraits form a transition to what is perhaps the most fascinating document of Dürer's stay in the Netherlands: his little oblong sketch-book on pinkish-grounded paper—about 7.5 by 5 inches in size—referred to by himself as "mein Büchlein" (1482-1508, *figs.* 263-270).

In his earlier days Dürer had used silver point primarily for fairly large-sized portraits, secondarily for other studies of a similar nature, and never for landscapes, which he preferred to execute in gouache and water color. Not until about 1515, when landscapes had long ceased to attract him from a coloristic point of view, do we find such silver point drawings as the second version of the *Wire Drawing Mill* (1405, *fig.* 246) and the *View of*

Kirch-Ehrenbach (1406), or an occasional souvenir like the little *Madonna* formerly in Lemberg (676). But even then the instances were few in number; and when Dürer, in 1520, decided to employ silver point for his main sketch-book he may have been influenced, not only by practical considerations—for, silver point was, after all, the only ancient equivalent of the modern plumbago pencil—but also by the very quality of a medium which had been the favorite vehicle of Jan van Eyck and Rogier van der Weyden and was still more popular in the Netherlands than in any other part of the world.

In style, however, the silver point drawings in Dürer's sketch-book are as different from those by Gerard David, Lucas van Leyden or Quentin Massys as they are from his own earlier efforts, and perhaps even more so. With all his sensitiveness for the peculiar delicacy of the medium, Dürer strictly refrained from exploiting its pictorial possibilities at the expense of plastic firmness and graphic precision. He never allowed the lines to merge into indistinct masses; he handled the silver point as though it were at once a pencil and a burin; and it is understandable that, after his return, he should have preferred it to charcoal, chalk and pen for portrait studies from life preparatory to medals (1022) or engravings (1004, 1021).

Where the subject was not suited to the horizontal format of Dürer's "Büchlein"— that is, practically everywhere except for buildings, panoramic views and animals in profile—Dürer economized on paper by using only one-half of the sheet and leaving the rest to be used later. In one instance—the drawing of a mortar-piece presumably made in Popenreuther's cannon-foundry—the right half of the page thus remained empty, and in some others it was filled with sketches unrelated to the main subject except by that undefinable sense of balance which always distinguishes the miscellaneous sketch-leaves of great masters from those of less accomplished artists. But more often than not the subsequent addition of a second figure, of an architectural motif or of a landscape background resulted in the appearance, at least, of a planned composition. Now two utter strangers such as a girl child in Cologne headgear and Agnes Dürer dourly looking in the opposite direction (*fig.* 269), a casual traveling acquaintance named Marx Ulstat and the "beautiful virgin of Antwerp," or a plump matron from Bergen and a delicate young woman from Ter Goes (*fig.* 266) are thrown together into "double portraits" which shed an unexpected light on subtle differences or sharp contrasts in age, sex and character and tantalizingly suggest an imaginary psychological relationship. Now the square face and shoulders of the Imperial Herald Caspar Sturm are monumentally set out against a river landscape (*fig.* 263); now Lazarus Ravensburger contemptuously turns his back upon the tower of the "Hof van Liere." The curiously effeminate countenance of a young man from Antwerp is softly foiled by a city prospect dominated by the tower of St. Michael's; the bust of another gentleman from Antwerp detaches itself from a view of the "Krahnenberg" near Andernach-on-the-Rhine; and two sketches, in different positions, of the head and forepart of a lion suggest a regal pair (*fig.* 268).

Dürer's sketch-book records the ordinary as well as the unusual. He did justice not only to the majesty of the Ghent lions but also to the patient, meditative watchfulness of big dogs and to the quick intelligence of small ones (*fig.* 264). He sketched tiled floors, tables and pewter (*fig.* 270), coffers and andirons. He copied from earlier paintings and sculptures and managed to bestow upon the statuette of a Burgundian princess, executed some fifty or seventy-five years earlier, so much charm and vitality that no one would recognize it as an artifact were the original lost (*fig.* 265). The buildings of Antwerp already mentioned, the Town Hall and "Münster" of Aix-la-Chapelle, the fortified castles of the Rhine valley and the general site of Bergen-op-Zoom were rendered with the glorious pedantry of one who was not only a great artist but also a craftsman, an engineer and a geometrician; and a climax was reached in the magnificent portrayal of the unfinished choir of the "Groote Kerk" at Bergen which courted both Dürer's feeling for texture and his "cubistic" inclinations (*fig.* 267). The masonry is not so much represented as reconstructed, brick by brick; and yet the details are rigorously subordinated to a collective concept which fills the beholder with what Plato calls the "legitimate delight attached to pure geometrical forms." The drawing brings to mind the quality of such architectural etchings as Hercules Seghers's *Ruin* or Meryon's *Eaux-Fortes sur Paris*.

In addition to the sketch-book in silver point, and setting aside a group of projects for a new Passion series, the drawings made for Dürer's own use include, first, a number of small-sized pen drawings which seem to come from another, smaller and simpler sketch-book of vertical format; second, some fairly large-sized single sheets in varying techniques.

With the exception of three figures in full-length—a *Rowing Sailor* (1261), a *Woman in Turkish Dress* (1257, *fig.* 256) and one "Master Arnolt of Seligenstadt" surreptitiously sketched while asleep on board ship (1006)—the pen sketch-book was apparently reserved for studies in human physiognomy, all in half-length. It includes anonymous "characters" such as bearded or otherwise remarkable old men, a beturbaned Oriental, handsome youths in the guise of St. John or St. Sebastian, and women posed as *Matres Dolorosae*; and, in addition, six real portraits such as the likenesses of Dürer's friends, Hans Pfaffrot (1035, with enumeration of the other drawings in this sketch-book), Jobst Planckfelt (1038) and Felix Hungersperg (1025, *fig.* 257) and of a very charming Lady of Brussels (1112, *fig.* 258).

The single drawings include—apart from a *"Corpus Christi" Procession* which may or may not have been made in Antwerp (892)—two studies of feminine fashions in the Netherlands so carefully executed in brush on dark-grounded paper that Dürer specifically mentions them in his Diary (1291 and 1292); a costume study of Irish peasants and soldiers and three others of Livonian women of different ranks, all of them in pen and water color and presumably based on "ethnographical" material which happened to come to Dürer's attention in Antwerp (1293-1296); a wonderful half-length portrait, also in pen and water color, of a walrus which had been captured near the Flemish coast (1365, *fig.* 272) and whose expression of good-natured grumpiness delighted Dürer so much that he thought of including

it, in the role of St. Margaret's Dragon, in what would have been his most ambitious altarpiece (*fig.* 287); and two city prospects in pen.

One of these is a cartographical survey rather than an "artistic" drawing; somewhat like a bird's-eye map or such military illustrations as the *Siege of a Fortress* of 1527 (357), it represents what Dürer himself describes as "the fountains, labyrinth and menagerie behind the King's house in Brussels, lovelier and more delightful to me than anything I have ever seen, not unlike a paradise" (1409). The other, however, marks the climax of Dürer's career as a landscapist (1408, *fig.* 271). It shows the harbor of Antwerp, the quay with its many fishing boats unfolding in a majestic diagonal from lower left to upper right. Here the vista is blocked by buildings picturesque as a group but perfectly crystallomorphic as individual units, the tallest one touching the upper margin with its absurdly high pyramidal roof: on the left is the river, with the low slopes of its opposite bank emerging in the distance.

It has apparently escaped notice that the drawing is, technically speaking, unfinished. While the buildings farther back are detailed in the meticulous manner of the silver point sketch-book, the house next to the right margin—and nearest to the beholder—is merely outlined, and the whole foreground is empty although some hair-thin contours show that Dürer had originally planned to enliven the quay by objects and, possibly, by such diminutive figures as are seen in the background. Yet there is little doubt that he stopped at the drawing, not for want of time—it would not have taken him more than an hour to "complete" it—but because it satisfied him precisely as it is. He felt that further elaboration would impair the effect of vastness and luminosity. Every detail entered into the wall of the foreshortened house on the right, let alone into the foreground, would have introduced an element of nearness, and would have made opaque and commensurable what is now translucent and mysteriously remote.

We have seen how Dürer's first trip to Italy opened his eyes to what may be called a comprehensive interpretation of scenery—how he learned to coordinate isolated details into coherent patterns and finally achieved those panoramic views which we admire in the Apocalypse and in the "*Adoration of the Trinity.*" There had remained, however, a certain discrepancy between the macroscopic style of these panoramas and the still microscopic style of the landscape features incidentally appearing in most other paintings and prints. It was precisely this discrepancy which Dürer tried to overcome in the—no longer colored—landscapes of the second decade of the new century. In the view of Heroldsberg (1402, dated 1510), in the second version of the *Wire Drawing Mill*, in the view of Kirch-Ehrenbach (1405, *fig.* 246, and 1406, both about six or seven years later), and ultimately in the *Landscape with the Cannon* of 1518 (206) he managed to give a particularized account of all and every detail, and yet, to quote Wölfflin, to "divert the eye from the single objects in space to space as a whole." But even here the effect is cumulative rather than integral. Through "cutting" the picture so as to suggest an expanse beyond the margins, and through a skillful use of overlapping forms and "repoussoirs" we are invited and enabled to experience what Wölfflin calls the "Raumganze"; but this

"Raumganze" still comes about by a summation of parts. It was not until 1519/20 and after a second look at the Alps—that is, if we are right in assuming that the exquisite *Landscape on a Lake* (1407) is genuine and was made during Dürer's trip to Switzerland— that he succeeded in presenting sceneries which are to their single elements as a tree is to its trunk, branches and leaves. Though we may say that a tree "consists" of a trunk, branches and leaves, yet we perceive and understand the sum total of trunk, branches and leaves as one phenomenon: tree. In the *Harbor of Antwerp* Dürer achieved such a "total view"; and his very last landscape drawing, the *Fortifications between Rocks and the Sea* of 1526/27 (1411), is perhaps even more grandiose in its fantastic scale which makes a lighthouse look like a fumigating pastil, its utter loneliness and its complete subordination of detail to a leading theme. But it is scientifically sober, though wholly imaginary, where the *Harbor of Antwerp* is real, yet poetic; it is oppressive where the *Harbor* is serenely spacious; and it sacrifices the charm of light on the altar of sheer mass.

THE LIFE OF A CURIOUS AND BUSY VISITOR anxious both to record his experiences and to please his friends left little time for independent, creative activity. Yet several plans for future work were at least partly formulated during Dürer's stay in the Netherlands, though it is difficult to tell to what extent they materialized; for, it is often impossible to decide whether a drawing dated 1521 was made while he was still in Antwerp or only when he was already in Nuremberg. In one case, however, we have the benefit of an explicit entry in Dürer's Diary: "I have made," he writes in May 1521, "three *Bearings of the Cross* and two *Agonies in the Garden* on five half-sheets."

Four of these drawings—three dated 1520 and one 1521—have fortunately come down to us (560, 562, 579, 580), and three others—dated 1521 and representing the Deposition of Christ (611, 612, 613)—are so analogous in style, technique and composition that the whole group must be considered as a coherent series. It would seem, then, that Dürer planned a new Passion, and the style of the drawings suggests that it was to be executed in woodcut. This assumption is confirmed by the fact that a *Last Supper*, based on a drawing of similar size and character (554), was actually carried out in woodcut in 1523 (273). In the fol- lowing year we find another, final version of the Gethsemane scene (563) and further an *Adoration of the Magi* (513) which would have served as a prelude to the whole cycle.

The general characteristics of these late compositions and their curious affinity with the style of Mantegna have already been discussed at the beginning of this chapter. They are all "halbe Bögen," that is to say, they are—if not cut down—more or less identical in size with the Life of the Virgin. But the sheets have been turned through an angle of ninety degrees, and this is in itself a significant novelty. Formerly Dürer had invariably treated the same themes in vertical prints and pictures—except for the *Adoration of the Magi* in the Uffizi, and even here the format is squarish rather than pronouncedly oblong. Now the compositions spread themselves out over a surface much wider than high. The tragic processions of the Bearing of the Cross and the Deposition of Christ move steadily from right to left instead

of emerging from the background and turning after having reached the center of the stage. The approach of the Magi, though not magnified by a retinue, has the slow roll of an ocean wave—and the same could be said of the terrain in the two *Agonies in the Garden*. Even the magnificent and at times slightly artificial pyramids which Dürer had loved to construct in renderings of the Lamentation—one instance as late as 1521 (609)—were ultimately abandoned in favor of an apparently simple, yet intricately organized oblong (615, dated 1522). The dead body of Christ, His legs outstretched and His right palm touching the ground with a strange feeling of final relaxation, lies on a sloping mound of earth, His chest resting on the knees of the cowering Magdalen; the Virgin Mary, bending low, lifts His distorted face to her lips, and St. John the Evangelist and Joseph of Arimathea emerge from behind the mound as half-length figures, their quiet, mournful faces aligned on a horizontal scarcely higher than the head of the Virgin.

The implications of this sudden change from a vertical to a horizontal form of composition are easier to apprehend intuitively than to define in words. An oblong format is more congenial with an epic than with a dramatic or lyrical form of presentation. We do not feel ourselves drawn with a rush into the picture, but tend rather to absorb the spectacle as though watching a stream flowing by, or the waves of the ocean rolling on, or a distant mountain range spread out before us. The oblong format creates, or at least corresponds to, a mood of objectivizing receptivity rather than subjectivizing activity, and it makes for an experience of space wherein depth is not apprehended by breaking through the picture plane but by a quiet, gradual advance on the whole front. It is therefore more suitable for "relief-space" and panoramic space than for a space full of dynamic tensions or dissolving in visionary unreality. It is difficult to imagine Titian's *Crowning with Thorns*, Raphael's *Sistine Madonna* or Dürer's Apocalypse in oblong format, and no less difficult to imagine Poussin's *Rebekah and Eliezer*, Leonardo's *Last Supper* or Rembrandt's landscapes within a vertical frame.

Dürer's previous work had not included a single oblong woodcut except for the Terence illustrations and the *Triumphal Procession of Maximilian*, and only three oblong engravings and etchings (unusual also in other respects), namely, the *Sudarium* of 1513, the *Landscape with the Cannon* of 1518 and the *St. Anthony* of 1519. But he must have felt a certain inward affinity between the horizontal format and what he wanted to express in his late Passion: events of epic majesty, unfolding before the spectator rather than confronting him; staged in a space wide and lucidly organized rather than deep or unfathomably irrational; and inviting grave contemplation rather than lyrical or visionary excitement.

In addition, however, certain external influences can be noted. One of the *Depositions* (612, *fig.* 276) is evidently derived from Mantegna's famous engraving representing the same scene (*fig.* 198), both in general arrangement and in such details as the figure of the carrier walking backwards; and the two *Agonies in the Garden* of 1520 and 1521 (560 and 562) are hardly imaginable without Mantegna's Gethsemane pictures in the National Gallery at London and in S. Zeno in Verona. These three Mantegna compositions are oblong in shape

and Dürer may have sensed the inner correspondence between their format and their style. In the later of the two *Agonies* (*fig.* 273) he even outdid Mantegna in epic horizontalism. In the *predella* panel in S. Zeno one of the Disciples lies prone on the ground. This motif apparently recalled to Dürer's mind an archaic iconography of the scene—based on an unusually literal interpretation of the Gospels of St. Mark and St. Matthew—where Christ Himself is shown face downward before the Angel with the chalice. This type already occurs in a drawing from the workshop of Wolgemut, and Dürer himself had used it, more than ten years before, for a woodcut made for though not included in the Small Passion (274). Normally, however, he had avoided it, and the drawings of 1520 (579) and 1524 (563) show Christ on his knees raising his hands as had been the case in the "Green Passion" (556) and the Engraved Passion (111). It is only in the drawing of 1521 that Dürer reverted to the long-discarded scheme, but he monumentalized the pose of Christ like that of Mantegna's Disciple and yet instilled into it an emotional quality entirely his own. The figure has both the pathos of a human being in agony and the grandeur of a fallen statue, with arms outstretched in the form of the Cross. A series of repeated rocky plinths, also of Mantegnesque cast, leads up to the prostrate figure much as the main theme in the last movement of the Ninth Symphony is incompletely and still inarticulately announced by the orchestra to find fulfillment in the human voice. The clouds in which appears the tiny Angel in the upper left-hand corner fade out into a fog or haze which, rendered by prolonged horizontal lines, echoes the stratification of the ground while enveloping the scene with a haunting atmosphere of mystery and doom.

For the two *Bearings of the Cross*, on the other hand (579 and 580), the oblong format was doubtless suggested by a tradition which, ultimately derived from such Italian models as Andrea da Firenze's fresco in the Cappella degli Spagnuoli in Florence, had been popularized in the North by a widely imitated composition of—generally speaking—Eyckian character. This composition, best transmitted through a painting in Budapest and a drawing in the Albertina in Vienna in which the figure of St. Veronica has been added, shows a many-figured procession unfolding within a wide picture space, with the city of Jerusalem conspicuous in the background; Christ walks erect, firmly grasping the Cross and, if St. Veronica is present, looking back to her over His shoulder. Indirectly, this "Eyckian scheme" had been known to Dürer from early youth through the famous engraving by Schongauer. But this engraving shows a number of significant changes: apart from the fact that the figure of St. Veronica is not included, it reduces the architecture to a minimum, accentuates depth at the expense of frontality, and shows Christ breaking to His knees as was the more usual thing in the Germanic countries.

It is precisely in these respects that Dürer's first drawing of 1520 (*fig.* 275) reverts to the "Eyckian scheme." He enriched the archaic composition by several features which he had used in his earlier renderings of the scene; he modernized and monumentalized not only the figure of Christ but also all the other characters of the drama—the Holy Women, the Thieves and the merciless crowd of soldiers, burghers and sharp-faced "Pharisees"—and he condensed

into a solid yet perfectly articulated phalanx what had been a somewhat rambling caravan. But it cannot be questioned that he, like Massys and Gossart, paid homage to the great tradition of Early Flemish painting.

In the second *Bearing of the Cross* (580) Dürer retained the same general arrangement (the horseman on the right is even more reminiscent of the Albertina drawing than any single figure in the first version). But the relief planes are multiplied; the numerous figures, formerly maintaining a kind of plastic individuality, merge into a mighty stream which gives an impression of infinity; the architecture is used as a mere "back-drop"; and the figure of Christ, magically luminous by virtue of its deliberately wide-spaced modelling, resumes the "Orpheus pose" of the Large Passion (*fig.* 89). It was this second redaction which—with the cortege still further enlarged on the basis of a somewhat later drawing (581)—was finally, though perhaps posthumously, carried out in a "great, artistically painted panel" formerly kept in the Imperial "Kunstkammer" in Vienna (13).

The modern mind, brought up in the worship of Leonardo da Vinci, more or less automatically imagines a *Last Supper* as an oblong, symmetrical composition with the figure of Christ as an axis. Yet Dürer's two earlier representations of the scene (225 and 244), though symmetrical, are not oblong; and his drawing of about 1523 (554, *fig.* 277), though oblong, surprisingly reverts to the ancient Eastern iconography where Christ is placed at the end of the table instead of in the center and is often shown in profile—as in Giotto's fresco in the Cappella dell'Arena—instead of *en face*. How Dürer became familiar with this archaic scheme and why he should have adopted it is difficult to explain. It is almost as though he had tried to assert his originality in the face of Leonardo, whose *Last Supper* was so popular in the Netherlands, and, more particularly, of Raphael, whose revised version of Leonardo's composition, engraved by Marcantonio Raimondi, must have been among the prints acquired by Dürer through Tommaso Vincidor. For, with all its nonconformity Dürer's drawing reveals the influence of those two masters—not only in the format, but also in more specific peculiarities. Although Christ has been shifted to the left, the axis of the composition is still emphasized by a central figure; and while the crossed legs of this central figure and the differentiation of the various physiognomies are reminiscent of Leonardo, the motif of a standing Apostle in profile, bending forward and placing his left hand on the shoulder of a seated one, and the correspondence of two seated figures at either end of the table, agree with the engraving after Raphael.

Needless to say, the differences outweigh the similarities. The classic symmetry is loosened up—the very placement of a cupboard in the farthest corner of the room would have horrified an Italian eye. The standing figure harshly interrupts a continuity which Raphael had been careful to emphasize, and the poses and gestures are both more expressive and more awkward than those in "classic" art. Dürer also retained from his earlier compositions the motif of St. John leaning on the bosom of the Lord, which was no longer compatible with the style of Raphael and Leonardo. In one respect, however, he departed, not only from his Italian prototypes but also from his own previous interpretations: the table (with an interesting *penti-*

mento reducing its surface so as to enhance the monumentality of the figures) has been cleared except for the empty plates and the symbols of the Eucharist, a loaf of bread and a goblet of wine; and Christ has before Him a sacramental chalice, significantly absent from the two earlier woodcuts.

This motif may have been suggested by a representational tradition which had tended to emphasize the sacramental rather than the historical aspects of the scene (Dürer was in Louvain for a few hours and may have seen Dirk Bouts's famous altarpiece in St. Peter's or at least one of its numerous repetitions by Dirk's son Aelbert); but that he adopted it at this moment, and that he omitted the charger with the lamb which had conspicuously figured in his two previous woodcuts, would seem to be more than an art-historical accident. It may be explained by Dürer's convictions in regard to one of the basic issues of the Reformation often referred to as the "Chalice Controversy" ("Kelchstreit"). In his "Sermon on the New Testament, that is, on Holy Mass," of 1520 Luther had supported the old claim to communion *sub utraque forma*, *viz.*, the claim of the layman to receive the chalice as well as the Host; and he had further insisted on the all-importance of the words by which Christ "institutes His Holy Supper." From these he had inferred—heretically according to the Catholic doctrine—that Holy Mass was not a "sacrifice," but a mere "testament and sacrament, wherein, under the seal of a symbol, a promise is made of the redemption of sin." In so conspicuously emphasizing the sacramental chalice while eliminating the sacrificial lamb, Dürer appears to profess his adherence to Luther's point of view. We know that he bought and read whatever Luther wrote in German; and it may have been the basic doctrinal significance of the Last Supper which induced him to develop this one composition into a woodcut for immediate publication while he postponed and ultimately abandoned the execution of his other Passion drawings.

This woodcut (273, *fig.* 278)—published, by a curious coincidence, in the same year as Luther's *Formula Missae*—is still more "Protestant" than the preliminary drawing. The room is without ornament or furniture except for the crude table and the box-like seats. The figure of Christ is restored to its central position, with His head in the exact center of the rear wall, but the perspective vanishing point is not on the same axis; the table is sharply shifted to the left (so sharply that the figure at the end is cut in half by the margin), and an enormous circular window throws its weight to the right. The surface of the table is still further reduced. There is nothing on it save the chalice (while the more material symbols of the Eucharist, the bread basket and the wine jug, have been removed to the floor); and to make the Lutheran connotations even more explicit, an empty charger—not, as has been thought, the basin of the Washing of the Feet—is prominently displayed in the foreground: the Lamb is not merely absent, its absence is almost defiantly proclaimed so as to bring home the doctrine that the Lord's Supper is "*not* a sacrifice."

The most telling innovation, however, is the selection of the moment as such. In his two earlier woodcuts, and even in the preliminary drawing for the present one, Dürer had still

expressed the excitement and suspense which follow the words: "Verily, verily, I say unto you that one of you shall betray me." Now—and, so far as we know for the first and last time in the history of art—the scene is depicted after the crisis has passed. Properly speaking, the woodcut represents, not the Last Supper itself but its aftermath—a scene described exclusively by St. John, the "favorite Evangelist of Luther": "He [Judas] then having received the sop went immediately out: and it was night. Therefore, when he was gone out, Jesus said, Now is the son of man glorified, and God is glorified in him. . . . Little children, yet a little while I am with you. Ye shall seek me: and as I said unto the Jews, Whither I go, ye cannot come; so now I say to you. A new commandment I give unto you, That ye love one another; as I have loved you, that ye also love one another. By this shall all men know that ye are my disciples, if ye have love one to another. Simon Peter said unto him, Lord, whither goest thou? Jesus answered him, Whither I go, thou canst not follow me now; but thou shalt follow me afterwards. Peter said unto him, Lord, why cannot I follow thee now? I will lay down my life for thy sake. Jesus answered him, Wilt thou lay down thy life for my sake? Verily, verily, I say unto thee, The cock shall not crow, till thou hast denied me thrice."

Judas, then, has left the room, and only the faithful Eleven remain, with the sacramental symbol of their union shining from the table. Another tragic announcement is made, but one which does not startle and condemn but exhorts and absolves: the Lord discloses, not the unforgivable sin of the Traitor but the human frailty of him whom He has just appointed His follower. And at the same time a "New Commandment" is given to all: "As I have loved you, that ye also love one another. By this shall all men know that ye are my disciples; that ye also love one another." It is the giving of this "New Commandment" which forms the principal content of Dürer's woodcut and after which it should be named. For a human tragedy and the establishment of a sacred ritual it substitutes the institution of the Evangelical community.

TOGETHER WITH THE "OBLONG PASSION" two other major projects occupied Dürer's mind after his return from Antwerp. One was an altarpiece showing the Madonna surrounded by Saints, the Ancestors and Relatives of Christ and Musical Angels, and thus resembling, in a general way, what the Italians call a "Sacra Conversazione." The other was a large-sized engraving representing a Crucifixion with many figures. Both are grandiose compositions in which impressions from the journey to the Netherlands mingle with reminiscences from Italy. Both were prepared with an unusual thoroughness even for Dürer; and both were never carried out as planned.

The nucleus of the *"Great Crucifixion,"* as we may call it for short, seems to have been a pen drawing of 1521 showing the crucified Christ between the Virgin Mary and St. John (588, *fig.* 279). This very simple composition, without any indication of scenery, evidently harks back to the engraving of 1511 (120) with which it has in common that the nun-like figure of the Virgin, turned toward the Cross and joining her hands in prayer high before her breast, is contrasted with a St. John in front view. The tendencies of Dürer's late style make

themselves felt, however, in the stricter symmetry of the crucified Christ (Who, in the engraving of 1511, had been shown with His right leg bent and with His head inclined towards His mother), in the more sharply defined position of the Virgin Mary, and in the stiffer attitude and psychological restraint of the St. John.

This modest germ developed into one of the most complex of all Dürer's compositions (218 and 216, *fig.* 280). The Virgin and St. John, still dominant but no longer isolated, appear as leaders of two choruses. Between them is seen the Magdalen on her knees embracing the Cross. Little weeping Angels of the round-headed Venetian variety flutter about, and the scenery, rich though not really deep, is enlivened by a fortified castle from the Rhine valley and by the city prospect of Bergen, both faithfully copied from the silver point sketch-book (1508 and 1491).

As a whole this composition is known only through posthumous impressions from two copper plates the earlier of which was apparently engraved by Dürer himself but was abandoned in a sadly unfinished state. Only the contours are incised, and behind St. John, where the Longinus group should be—the upper part of his spear is already drawn in—there appears a blank patch. Dürer seems to have stopped working at this point in a moment of doubt or even despair. It may have dawned upon him that he had become a victim of his virtues, that altogether too much material—and what material—had been crowded into so small a space.

Be that as it may, the engraving was never completed. But this loss is compensated, to some extent, by more than a dozen magnificent studies unlike anything Dürer had ever done in preparation for an engraving. They range in date from 1521 to 1523 and are all executed in chalk or soft metal point on green-or-blue-grounded paper, one of those new techniques which have been mentioned as characteristic of Dürer's later years. Aside from several chubby *Cherubs' and Children's Heads* (539-546), whose bulging modelling brings to mind the paintings on canvas in the Bibliothèque Nationale (83) and the enigmatical *Child with a Long Beard* in the Louvre (84), we have the studies for the Virgin Mary and Two Holy Women (535, *fig.* 284); for the Crucified Christ (534, *fig.* 281); for St. John the Evangelist (538, *fig.* 283); and for the Magdalen (536, *fig.* 282). The Virgin Mary, her body concealed beneath the folds of a long, flowing cloak—the "niederländische Frauenmantel bis auf die Erd"—is a figure of Masacciesque grandeur, no longer bent but regally erect in the majesty of her grief, her eyes turning away from the crucified Christ and staring into the void. Christ Himself is almost terrifying in His somber rigidity. Bolt-upright, His head held high, and His face expressing grim concentration rather than pain or sorrow, He seems suspended between life and death, past suffering and yet incomprehensibly conscious. It has often been noted that His body is fastened to the Cross with four nails instead of with three, and this resumption of a formula almost entirely extinct from the inception of Gothic has justly been explained by Dürer's growing tendency toward hieratic symmetry—noticeable also in the arrangement of the loin-cloth—which could already be observed in the preliminary pen drawing of 1521. But it is not only in form but also in spirit that Dürer's latest Crucifix (the date of the study is 1523) is "Romanesque": it harks back, as it were to the fundamentalism

of those who, even in the thirteenth century, had condemned the three-nail type of Crucifix as a sin against the "faith in the Holy Cross and the traditions of the sainted Fathers."

Contrasted with the frozen grief of the Virgin Mary is the emotion of St. John and the Magdalen. Both seek the Saviour with their eyes; but St. John looks up to Him with the sad determination of one making a vow (it is no accident that his face, with the low forehead, the strong, firm jaw and the high cheekbones, looks like an idealized version of the earlier portraits of Luther)—the Magdalen with the spasmodic tenderness of one entranced. With her mouth half open, unable to tear her eyes away from the crucified Christ, she touches the cross as though it were a living thing, her hands groping upwards in an unconscious effort to reach the unreachable. The idea of placing her behind the cross, so that she has to curl around it, as it were, in order to see the face of Christ, may have been suggested by a composition such as Bernard van Orley's early *Crucifixion* in Berlin. But with this incidental analogy in pose the similarity ends. Dürer's Magdalen is as intriguingly anachronistic as his crucified Christ: where the latter recalls early medieval transcendentalism, the former announces the ecstasies of the Baroque.

At first glance it seems incredible that these large and careful drawings were made merely in preparation for an engraving where they had to be reduced to less than half their size. But the studies for the Holy Women and St. John the Evangelist could not have been made for a painting because the figures would appear on the wrong side of the Cross if not reversed by the printing process, and we shall shortly see that the completed engravings of 1523 were prepared by quite analogous drawings. Only some of the *Children's Heads* may have been made with a double objective in mind. In Dürer's late period the aims of painting and engraving had become so nearly identical—both media being governed by the principle of volumetric schematization—that the same techniques, *viz.*, brush or metal point on dark-grounded paper, could be used for preparatory studies no matter whether they were to serve for the one or the other. There remained, however, one significant difference: the studies for engravings normally represent whole figures, with the heads often less carefully particularized than the rest; whereas the studies for paintings are normally restricted to details such as drapery motifs, faces and hands. It is thus quite conceivable that those of the *Children's Heads* which do not show the expression of grief, were designed for both the *"Great Crucifixion"* and the "Sacra Conversazione" altarpiece which, we remember, was in preparation at precisely the same time and also required a considerable number of incidental little Angels.

The external history of this altarpiece is entirely obscure. We know neither its donor or donors, nor its place of destination. Of its internal history, however, we are better informed than of any other major work of Dürer's. Many careful studies exist for the faces, hands and draperies in the *"Feast of the Rose Garlands,"* the *Christ among the Doctors*, and the Heller altarpiece, but there is not a single drawing which would throw light on the development of these compositions in their entirety. Only an already rationalized "Visierung" and a portrait drawing of the donor can be connected with the *Adoration of the Trinity*, and only one general sketch with the *Martyrdom of the Ten Thousand*. In the case of the *"Sacra Conver-*

sazione," however, we have, in addition to a pen drawing with Musical Angels and more than a dozen admirable studies of heads, hands and draperies (766-780), no less than six drawings of the whole composition which permit us to observe the growth of the invention as an entomologist might observe the development of a butterfly.

When Dürer made the first of these drawings (760, dated 1521) he did not yet have, it seems, a monumental altarpiece in mind but freely elaborated on his *Madonnas* and *Holy Families* of 1518-20 (679, 680, 687, 731). The resulting composition, like the so-called *"Glorification of the Virgin"* (315), combines the theme of the Holy Family worshipped by Saints and Angels with the Mystical Marriage of St. Catharine who kneels before the Infant Jesus as though prepared to receive the ring, with St. James the Great and St. John the Evangelist acting as witnesses. While this group of three occupies the right half of the composition, the left is mainly filled with the bulky forms of a classicizing architecture which all but crush an inconspicuous St. Joseph, and this deliberately "unbalanced" arrangement, coupled with the absence of any baldaquin or cloth of honor, produces a certain informality. Only the oblong format, reminiscent of the *"Feast of the Rose Garlands"* and, at the same time, conforming to the general tendencies of Dürer's late style, and the two Bellinesque Musical Angels, symmetrically placed in either corner of the picture, already introduce an element of ritual solemnity.

In the second drawing—probably only a copy (761, also dated 1521)—this composition is symmetrized and formalized as a monumental altarpiece should be, and its iconography is changed to a "Sacra Conversazione" in the strict sense of the term. St. Catharine has given up her prominent position, and St. Joseph has disappeared; St. John the Evangelist is replaced by St. Sebastian, and two Virgin Martyrs, Sts. Dorothy and Agnes, have been added. These five Saints, with the figure of St. Catharine balanced by Angels, are semicircularly arranged around the Madonna, the figures of Sts. James the Great and Sebastian forming two strong vertical accents. The architecture on the left is reduced to a slender coulisse, and the throne, now placed on a dais so that the Madonna towers over the other figures, is surmounted by what looks like a back of rough stone but may be meant to be a cloth of honor.

However, stately though it is, this drawing is still of a preliminary character. It represents only the introduction to the real story (to which the other, still earlier version formed a kind of preface). The real story unfolds in four magnificent drawings which, though doubtless developed from the preceding ones, are very different from them in several respects. First, two of them include the figure of a donatrix, which seems to show that Dürer now had a definite commission in mind. Second, they all include the Ancestors and Kinsmen of Christ, at least Sts. Joseph and Joachim. Third, they give only contours, spiritedly jotted down without any modelling; they render account, not of the single elements but of the general composition on the surface as well as in space, and, in a measure, of the color scheme which, in two of four cases, is indicated by notes. Yet Dürer's draftsmanship was such that it is possible to recognize in the few lines and circles which make up a human physiognomy the faces carefully portrayed in those wonderful metal point studies on colored paper which were produced along

with the hurried ensemble drawings, and this is of great help in establishing the sequence of these; for, if certain faces portrayed in the elaborate studies are clearly recognizable in one of the ensemble drawings but not yet in another, the latter obviously precedes the former.

This and other purely stylistic considerations make it possible to arrange the four drawings, with some certainty, as follows: first, an oblong composition with fifteen Saints and a Donatrix (762, undated, but datable 1521); second, an oblong composition with ten Saints and a Donatrix (763, undated, and likewise datable 1521); third, a vertical composition with no Donatrix and eight Saints, two of them sitting on the ground (764, dated 1522); fourth, a vertical composition with no Donatrix and eight Saints, all of them standing (765, undated but certainly also done in 1522).

The first project (762, *fig.* 285) is, naturally, closer to what may be called the "second preliminary version" (761) than the three others. In both cases we have an oblong composition with a semicircular group of Saints symmetrically flanking the Virgin and Child; and several motifs such as the architecture on the left, the posture of St. James the Great and the two figures at either margin (Sts. Dorothy and Agnes) are almost identical. But in iconography this version represents a greater departure from the "Sacra Conversazione" pure and simple than any other, the ancestry and kinship of Christ including, besides Sts. Joseph and Joachim, not only Sts. Ann, Elizabeth, and John the Baptist but also Zechariah and King David; and what had been a decorative display, not unlike a rich tapestry, was monumentalized into an architectonic structure. With the number of standing figures increased from four to fourteen, the half-circle around the Madonna could be expanded and solidified so as to give the impression of a colonnaded apse or exedra with human figures as columns. No rival accents detract from the importance of the central group to which the other figures, placed on different levels, lead up in steps. Next to the Virgin, standing on the dais on which her throne is placed, are two symmetrical groups of four (with the exception of St. James, all Kinsmen and Ancestors of Christ), their heads approximately on the level of the Madonna's shoulders; then, standing on the ground, are two symmetrical groups of three (all Virgin Martyrs), their heads approximately on the level of the Madonna's knees. The outline of the whole composition thus somewhat resembles the cross-section through a quinquepartite basilica with the Madonna occupying the place of the nave; and while, in the preliminary versions, two or even four Musical Angels had added their weight to the wings of the group, now one, placed at the feet of the Virgin, accentuates the central axis.

Kneeling in front of the three female Saints on the right is seen the elderly Donatrix, and, facing her, St. Catharine. In the preliminary versions, St. Catharine had been placed on the left of the Virgin and had been shown on her knees. Now she was shifted to the other side and assumes a crouching position, turning round to the Infant Jesus in bold *contrapposto*. This change is not without importance because it calls to mind the contrast between figures standing and figures—mostly youthful females—sitting or squatting on the ground, which exists in so many famous compositions by Memlinc, Hugo van der Goes, Gerard David and Quentin Massys. Dürer's first project, one might say, resulted from a synthesis of Giovanni

Bellini's great Venetian *ancone* and—to quote only the most famous instance—Massys's Brussels altarpiece of 1509; and it is perhaps not by accident that its very iconography fuses the Italian "Sacra Conversazione" with the Northern Holy Kinship.

Some of the faces can be identified with large-scale studies from life: we can recognize the stern thoughtfulness of a young woman, whose forbidding expression contrasts somewhat with the daring lowness of her straight décolleté (768), in the St. Apollonia (second figure from the right); the virginal sweetness of a girl with downcast eyes, a small, bud-like mouth and a long, slender throat (769, *fig*. 289) in the St. Barbara (third figure from the left); and the ecstatic abandon of a slightly androgynous being looking up like one enraptured (774) in the St. Catharine.

In the second project (763, *fig*. 286) the physiognomical characteristics of precisely these three figures are made even more explicit by *pentimenti* obviously made by Dürer with the studies from life before him, and two new individualized faces make their appearance. St. Joseph (fourth figure from the left), originally a thin, morose man with a pointed beard, now shows the clean-shaven, humorous face of the smiling old gentleman portrayed in a drawing in London (772); and the features of the Angel playing the lute (one of the triad in the lower right-hand corner) are clearly identical with those of the handsome youth who sat for a drawing in Bremen (773). The architecture on the left has been retained, and most of the poses and gestures are virtually unaltered. But the total number of Saints has been reduced from fifteen to ten—with Zechariah, St. John the Baptist, St. Elizabeth and two anonymous Virgin Martyrs left out—and two important changes in general arrangement have been made. First, the whole half-circle of standing figures, including the throne of the Madonna, has been removed from the front plane to the middle distance, with the foreground filled by groups of Musical Angels in either corner—as in the "second preliminary version"—and by a little dog and a chained fox—as in the *Virgin with a Multitude of Animals* (*fig*. 135)—in the center; and this more spatial effect is strengthened by the fact that the St. Catharine is placed before instead of in line with the throne of the Virgin, thus forming a sharp diagonal with the kneeling Donatrix who has retained her previous position. Second, the standing figures are no longer divided into four distinct groups mechanically corresponding to one another, but organized into a unified throng. Geometrical symmetry has given way to dynamic symmetry, and while the outline of the first composition could be compared to the cross section through a quinque-partite basilica, that of the second rather evokes the idea of two waves approaching a rock from opposite directions.

However, with all these differences the first and second projects are almost alike as compared to the third and fourth. In these, the oblong format has been given up in favor of a vertical one (about four by three as against about three by four-and-a-half), and several other radical changes have been made. First, the Donatrix has been omitted, which indicates a change in patronage and strongly suggests the possibility that the new donors, no longer included in the main picture, were to be represented, or at least alluded to, in wings. Second, the total number of Saints has been further reduced from ten to eight, with Sts. Ann and

Apollonia omitted, St. Dorothy replaced by St. Margaret, and King David by St. John the Baptist. Third, the architecture on the left, faithfully retained from the very beginning, has disappeared. Fourth, the basic idea of the composition has changed from a half-circle foiling, and surmounted by, the Madonna to a full circle enveloping her. The four figures standing behind the Madonna are placed so high that, in contrast with all the previous redactions, her head is on a level lower than theirs; but this demotion is more than compensated by a majestic throne provided with enormous Baroque volutes for arms and surmounted by a high, round-topped *aedicula*. The female Saints, on the other hand, are no longer in line with the throne, but are arrayed on a curve in front of it. What had been a semicircular "apse" is now a circular enclosure, its inner space enlivened by the same two Musical Angels, now pulled together, who had originally adorned the corners of Dürer's very first preliminary drawing (760).

In the third project (764, *fig.* 287) this ring of figures is very complete; even in front it is closed by St. Margaret's walrus-faced Dragon (see *fig.* 272). But this completeness could be achieved only at the expense of depth and monumentality. The figures of St. Barbara and St. Catharine—the latter now standing and turned inwards, which required a new study from life (775)—had to be reduced in scale more than compatible with sound perspective, and the two other Virgin Martyrs, Sts. Margaret and Agnes, had to be shown squatting in the foreground. The whole thus gives a somewhat archaic impression, with the individual units arranged above rather than behind one another, and it has often been observed that a strong similarity exists between this composition and the *Fountain of Life* by Hans Holbein the Elder in Lisbon, a picture unmistakably derived from Early Flemish sources.

In the fourth and final project (765, *fig.* 288) St. James has changed places with St. John the Baptist, and St. Margaret has yielded her place in the foreground to St. Catharine; otherwise the eight figures are iconographically the same and they still suggest a full circle. But this circle is now opened in front. The two foremost figures are no longer represented sitting on the ground but standing, which *ipso facto* lengthens the interval between them, and the Dragon of St. Margaret has disappeared—quite logically since his mistress had been removed to the second plane. Thus the beholder, formerly overlooking the human *Hortus conclusus* in a kind of bird's-eye view, now feels himself invited to enter it; and this impression of three-dimensionality is enormously strengthened by the character of the two new front figures themselves; monumental in shape and colossal in size, they push their humbler companions into the background and function, so to speak, as pylons guarding the entrance to depth instead of stepping-stones suggesting a rise from below to above. Giovanni Bellini has ultimately prevailed over Gerard David and Quentin Massys.

That Dürer never carried out what would have been the greatest of all his paintings remains an irretrievable loss. And yet his labors were not altogether in vain; for at least the two panels which had been intended to serve as wings for the *"Sacra Conversazione"* were ultimately completed, though in different shape and for a different purpose.

NOT LONG AFTER HIS RETURN FROM THE NETHERLANDS, and simultaneously with the major enterprises thus far discussed, Dürer resumed the production of small-sized engravings. In 1521 he made two *St. Christophers* (158 and 159), the first of them apparently reflecting one of the "four Christophers on gray-grounded paper" which he had designed for Joachim Patinir, for the latter's picture in the Escorial shows a quite similar group in reverse. In 1523 a *St. Bartholomew* (154) and a *St. Simon* (156, *fig.* 290) were added to the series of Apostles begun in 1514. Both these engravings are characteristic specimens of what we have called the "corrugated" style; and, as had lately become Dürer's practice, both were prepared by studies in metal point considerably larger than the prints (537 and 786). It is apparent that one of these was originally intended for the St. John in the *"Great Crucifixion"*; only after it was superseded there by the improved redaction already known to us (*fig.* 283) was it used, with suitable alterations, for the St. Simon engraving.

In the same year another Apostle print, also based on a large-sized study in metal point, was ready for publication: the *St. Philip* (153, *fig.* 291; drawing no. 843, *fig.* 293). Since Dürer was apparently in the habit of releasing the series by pairs, we may assume that he planned to follow it up with a *St. James the Lesser*; "Philippus und Jacobus," whose Feasts fell on the same day, the first of May, were almost twins in the eyes of the people, and there is in fact a somewhat mutilated study for an unnamed Apostle (814) which agrees with the traditional type of St. James the Lesser, and which, when restored to its original proportions, makes a perfect counterpart for the St. Philip drawing. However, this study was never carried out, and the St. Philip engraving itself, though practically finished and already signed and dated in 1523, was not released until three years later, with the date corrected to 1526.

It seems, then, that something prevented the publication of the *St. Philip* at the appointed time, and there is evidence as to the nature of the obstacle. The St. Philip is one of the most monumental figures ever conceived by Dürer. Turned to full profile, motionlessly erect, the horizontal of his arms contrasting with the verticals of his drapery and his cross-staff, clad in a mantle in which the columnar folds of the Mourning Virgin of the *"Great Crucifixion"* are combined with the crests and gorges characteristic of the "corrugated" style, he seems as big and solid as the rock which rises behind him in a bold, diagonal curve. It may have been with some such figure as this in mind that Dürer said to Melanchthon: "When I was young I craved variety and novelty; now, in my old age, I have begun to see the native countenance of nature [*naturae nativam faciem*] and come to understand that this simplicity is the ultimate goal of art"; and that Melanchthon in turn likened Dürer's style to the *genus grande* of rhetoric while comparing Grünewald's to the *genus mediocre* and Cranach's to the *genus humile*. When the engraving was finished Dürer himself must have felt that the inward scale of the figure transcended the limitations of a print three by five inches in size. He decided to use it, instead, for one of the wings of the *"Sacra Conversazione,"* and, when this altarpiece failed to materialize, to carry out the wings as independent panels. They were to become his artistic testament: the *"Four Apostles,"* completed and given to the City of Nuremberg in 1526 (43, *figs.* 294/295).

One of these more than life-sized pictures represents St. John the Evangelist and, in the background, St. Peter; the other St. Paul and, in the background, St. Mark (who was an Evangelist, but not an Apostle, so that the commonly accepted name of the work is, properly speaking, not quite correct). It was as St. Paul that the St. Philip made his reappearance. The bushy head with the short, square beard was made to conform to the traditional type of St. Paul with a bald skull, long flowing beard and aquiline nose, and was slightly turned outward, fixing the beholder with an hypnotic eye. The cross-staff was replaced by a sword, and the position of the hands was changed accordingly. But everything else remained unaltered.

Now, Dürer might have made these changes in a preparatory drawing and then transferred the latter to the panel, much as he had transformed his *Rider* of 1498 (1227) into the *Knight, Death and Devil* of 1513. This, however, is not the case. From traces of dark pigment visible beneath the ochre of the bald forehead, from a curious axial deviation of the sword, and from a series of *pentimenti* in the face, the collar and the hands it becomes perfectly clear that the changes were made on the panel itself; a superimposition of photographs enlarged or reduced to scale reveals the fact that the original contours of the face, still recognizable beneath the *pentimenti*, exactly coincide with those of the St. Philip (*fig.* 298).

It appears, then, that the Munich St. Paul had actually been a St. Philip before he assumed his present identity; and with this fact in mind some further observations can be made. The figure of St. Paul is hard, like flint or bronze, and almost overly detailed; we can even count the layers of leather in the soles of his sandals and can distinguish the stitches by which they are held together. The figure of St. John, however, is more broadly modelled and less particularized, and the heads of Sts. Peter and Mark are almost "pictorial" by comparison. It would be possible, perhaps, to explain the softer and less plastic treatment of the figures in the second plane by Dürer's desire to strengthen the impression of depth. But the stylistic difference between the two front plane figures can be explained only by the assumption of a difference in time. In point of fact the drawing for the St. John (826, *fig.* 292) is dated 1525, which gives a *terminus ante quem non* for this figure, and it has already been mentioned that its smoother, more fluid and more generalizing style is paralleled by the *Virgin with the Pear* in the Uffizi (*fig.* 308) which is dated 1526.

The inference is that, while the St. John—and consequently the St. Mark and the St. Peter—were painted in 1525/26, the St. Paul, or rather a St. Philip subsequently to be transformed into a St. Paul, had already been executed in the same year as the preparatory drawing, that is to say, in 1523. A simple experiment supports this hypothesis. If we bisect both pictures by a vertical the figure of St. Paul—originally St. Philip—is divided into two perfectly balanced halves, with the masses equally distributed on either side of the dividing line. Represented in pure profile, with the left foot about in the center of the base line, it practically fills the whole area of the picture; and if we "black out" the St. Mark, reinstate the original position of St. Philip's hands and restore to him his original cross-staff, it becomes evident that the figure is, aesthetically speaking, self-sufficient. It even gains in impressiveness by the elimination of its rather uncomfortable companion. Of the St. John the opposite is true. He turns inward at an angle of 45 degrees. His feet are placed on a diagonal so that much floor

space is left in the lower right-hand corner, and our bisecting line divides the bulk of the figure in such a way that the left half distinctly outweighs the right. In other words: while the St. Paul, or rather the original St. Philip, was still intended to stand by himself, the St. John was already conceived so as to leave room for, or even demand, another figure in the second plane. The elimination of the St. Peter is in fact as harmful to the effect as that of the St. Mark is advantageous (*fig.* 296).

The genesis of Dürer's *"Four Apostles"* can thus be reconstructed as follows: In 1523, he decided to use the St. Philip—and, presumably, his counterpart, St. James the Lesser—not for engravings but for two panels of more than life size which would show only these two figures in juxtaposition. The publication of the engraved *St. Philip*, already practically finished, was therefore held back, and an engraving of St. James the Lesser was never begun. Instead, the St. Philip was at once carried out on what is now the right-hand panel of the *"Four Apostles."* In 1525—the date of the drawing for the St. John—this plan was radically changed. Dürer decided to fill the panels with four figures instead of with two—remembering, it seems, the equally crowded wings of Giovanni Bellini's altarpiece in the Frari Church at Venice (*fig.* 297)—and to recast their iconography. The contemplated St. James the Lesser was replaced by a St. John the Evangelist and complemented by a St. Peter; the already extant St. Philip was converted into a St. Paul and complemented by a St. Mark. Large studies for the heads were made in 1526 (830, 838, 840), and the two panels were finished in the same year. And now, the painted *St. Philip* having been transformed into a St. Paul, the engraved *St. Philip* could be released, which explains the otherwise inexplicable correction of its date from 1523 to 1526.

What were the reasons for this change of mind? When Dürer, in a letter written shortly before October 6, 1526, offered the *"Four Apostles"* as a "memorial" and "little present" to the authorities of his city, he followed a practice not uncommon with artists who were left with a commission on their hands and for whom such useful institutions as art dealers, art museums and art exhibitions were not as yet available. Dürer himself—not to mention a score of others, among them as widely disparate characters as Titian and Jörg Pencz—had tried to "give" one of his Maximilian portraits to Lady Margaret and had not concealed his disappointment when she failed to respond. The Senate of Nuremberg accepted his present much more graciously; Dürer received, as a "return-present," one hundred guilders Rhenish for himself, twelve for his wife, and two for his servant. But there is little doubt that the two panels were originally intended for a different purpose. Their tall, narrow format characterizes them as wings of a triptych, and the central panel of this triptych would have been, in all probability, the *"Sacra Conversazione."* No other altarpiece was contemplated by Dürer at that time; its format, we remember, had been changed from an oblong rectangle to a vertical one; and the proportions of this vertical rectangle (approximately four by three) correspond exactly to those of the Munich panels which measure 204 cm. by 74 cm. (approximately four by one-and-a-half) each.

The original project—the Virgin with eight Saints in the center, St. Philip on the right

and, presumably, St. James the Lesser on the left—failed to materialize, apparently because of the political and religious conditions in Nuremberg. Under the guidance of liberal theologians, humanists and the overwhelming majority of the patricians, the city moved rapidly toward Lutheranism. The moment was not auspicious for the dedication of a "*Sacra Conversazione*," and it is perhaps not by accident that the idea was given up in the very year—1525—in the spring of which the City of Nuremberg had officially decided to "give leave to the Pope." But the same developments which frustrated Dürer's original plan inspired him with another.

As is always the case with revolutionary movements, the Reformation had produced a series of phenomena which by their radicalism repelled and in some cases alienated its original supporters, and forced its very founder into a "counter-revolutionary" position. Monasteries and convents were broken up by force; the peasants revolted; the poor demanded a "redistribution of wealth"; the teachings of Luther were interpreted as a justification of iconoclasm, communism and polygamy, and Nuremberg was especially troubled by the activities of a theologian and schoolmaster named Johannes Denk (banished in 1524) who wanted to discard the letter of the Bible in favor of its "inner meaning," preached a kind of self-identification with God, considered the life and death of Christ as an example rather than a work of redemption, and advocated anabaptism.

Pirckheimer was so disgusted with all these aberrations that he ultimately turned his back upon Protestantism as a whole. "Things have come to a pass," he wrote in the same letter which contains his well-known accusations against Dürer's wife and also states what had separated him from his best friend in matters of faith, "things have come to a pass that the Popish scoundrels are made to appear virtuous by the Evangelical ones. The old crowd has cheated us with hypocrisy and trickery; the new one proposes to do shameful and criminal things in the open, and they pull wool over people's eyes by saying that they ought not to be judged by their works." And: "We are very good at words and sermons, but 'works' are too strenuous, and most particularly for those who style themselves as the greatest Evangelicals."

Dürer never wavered for a moment in his loyalty to Luther. But—or, as he himself would have said, for this very reason—he, too, was a conservative. He went out of his way to ridicule the revolting peasants in his Treatise on Geometry of 1525 (*fig.* 314), and, he was stanchly opposed to the demagogic dialectics of the Nuremberg radicals. And so it occurred to him to use those mighty figures, which were to have flanked a picture now become meaningless, as messengers of what he believed to be the truth. He not only altered and amplified the iconography of his two panels in the manner already described, but also affixed to each a strip or tablet with a lengthy inscription. These inscriptions begin with a warning to the secular powers "not to accept human seduction for the word of God," and then proceed to quote pertinent passages from the writings of the four holy men portrayed. We hear them inveigh, in the powerful German of Luther's "Septemberbibel," against "false prophets," "damnable heresies," and the "spirit that is not of God" (*II Peter*, II and *I John*, IV);

against the "sinners having a form of godliness but denying the power thereof" (*II Timothy*, III); and against the "scribes who love to go in long clothing and love salutations in the market places" (*Mark*, XII, 38-40). To us, these passages sound anti-sectarian rather than anti-Catholic; but they were meant to castigate radicals and Papists alike. They endorsed the views of Luther while rejecting those of his illegitimate followers, and it is significant that the inscriptions were sawed off—to be restored to their original place only about a dozen years ago—when the pictures were transferred, in 1627, from Protestant Nuremberg to Catholic Munich.

Attention has been called to the fact that one of the earliest and most ardent monastic supporters of Luther, the friar Heinrich von Kettenbach, opens his *Practica practiciert ausz der heylgen Bibel* of 1523 with a similar admonition to accept the Bible as the one and only guide in human affairs, and also calls Sts. Paul and John the Evangelist as witnesses for Luther's cause. But even had Dürer never heard of Kettenbach's treatise it would have been a matter of course for him to substitute these two for Sts. Philip and James the Lesser. St. Philip and St. James the Lesser had never written anything and had no special significance for the Protestant movement. But St. John was, we remember, the "favorite Evangelist" of Luther—no accident that one of Dürer's drawings for the "Great Crucifixion" (*fig.* 283) endows him with the Reformer's own features—and St. Paul was so universally accepted as the spiritual father of Protestantism that Protestants were called "Paulines" by friend and foe alike.

In selecting them as companions for Sts. John and Paul, Dürer did homage to Sts. Mark and Peter also. But it is no accident that they remain in the background—especially with an artist who in a panel of the Heller altarpiece (8, *g*) and in a woodcut of the Small Passion (258) had treated Sts. Peter and Paul as perfect equals, and at a time when the "Primatus Petri" was one of the most important theological issues. There is, then, a subtle discrimination among the "Four Apostles." They are all holy men, and they convey the same message as to the problems of the time. But they are different in character and—from the point of view of a conservative Lutheran who was, at the same time, a natural philosopher—in human and religious merit. This can be confirmed by Dürer's own testimony.

The inscriptions which we have mentioned were written in Dürer's workshop, but not by Dürer himself. They are the work of a professional calligrapher named Johann Neudörffer who, later in life, composed a series of short biographies of Nuremberg artists. In this little book he informs us that the *"Four Apostles"* represented, "properly speaking, a sanguine, a choleric, a phlegmatic, and a melancholic." It is impossible to discard this statement of a man who had worked for Dürer, conversed with Dürer and written the inscriptions of the pictures of which he speaks in Dürer's own workshop. It has been said that a great master would not have used four holy men merely as an excuse for painting the Four Temperaments. But what Dürer did was just the opposite: he used the theory of the four temperaments, whose fundamental importance for him and his age need no longer be stressed, for the characterization of four holy men and, by implication, of four basic forms of religious

experience. The fifteenth century had not scrupled to arrange the representatives of the four humors around the face of God, thereby characterizing them as the four-fold aspect of the image Divine. Dürer succeeded in lending artistic expression to what the poor illuminator had merely intimated by an emblematic symbol.

We know enough about the physical and psychological criteria of the four humors and about their association with the four seasons, the four times of day and the four ages of man to tell which temperament "belongs" to each of our figures. St. John, a young man of about twenty-five, of ruddy complexion, composed and serious, yet gentle and kindly, must be the sanguine. St. Mark—whose symbol is the lion!—is a man of middle age, and not only this, but also his greenish, "gall-colored" skin, his gnashing teeth and rolling eyes characterize him as the choleric. St. Paul, a man between fifty and sixty, domineering, forbiddingly austere (it was he who had introduced the element of asceticism into the Christian religion), and showing the "dusky face" repeatedly mentioned as a symptom of *atra bilis*, must be the melancholic. Finally, St. Peter, by far the oldest of the four, has a pallid, fleshy, tired countenance which, together with his downcast eyes, indicates the phlegmatic.

Now, the theory of the four humors implied, not only a differentiation of physical and psychological qualities but also a hierarchy of values; and it appears that the figures dominant from a compositional point of view are also the representatives of the "noblest" temperaments. As we know, the sanguine disposition of St. John was always considered as the most balanced and desirable one; it represented, according to some, the happy condition of man before the Fall. The melancholy of St. Paul, on the other hand, had been invested by Dürer's period, and by Dürer himself, with the halo of the sublime. As characters, St. Paul and St. John are as opposed to one another as the rigidity and elasticity of their postures, and the cold white and warm red of their cloaks. But both of them exemplify human nature at the height of its powers, and religious faith at the height of its assurance and intensity: perfect youth and dignified virility—gentle, yet unshakable devotion and stern, yet self-possessed strength. Set out against these *maxima*, or *optima*, are attitudes which, by comparison, are deficient either in fervor or in poise: the patient resignation of old St. Peter and the fanaticism of the excited St. Mark. It is highly significant that Dürer, when transforming his St. Philip into a St. Paul, could not but conceive of him as a melancholic. St. Paul was the hero of a new creed just as melancholy was the signature of a new human type which we call genius. Looking more closely at this big, bald-headed, long-bearded face, with the white of his eyes contrasting with the darkness of his skin, we may say that he has the features of the Melancholic in Dürer's early woodcut for Conrad Celtes (*fig.* 215) seen through the medium of the *Melencolia I*. Dürer's St. Paul lives in a realm inaccessible to her, but he shares her gloom and her profundity. To use the system of Agrippa of Nettesheim, he may be said to exemplify the "Melancholia III."

IT HAS ALREADY BEEN MENTIONED that the "decorative" tendencies of the preceding phase survived only where a specific task required a lighter, more ornate and less stereometrical

treatment. They appear, we remember, in heraldic woodcuts, designs for pieces of furniture and such projects for mural decorations as the two sketches for paintings which were to fill the scanty space above and between the tall Gothic windows of the big hall in the Nuremberg "Rathaus" (1549 and 1550), one of them showing the Continence of Scipio, the other combining—with an irony apparently too subtle for the authorities—an airy system of branches and suspended *grotteschi* with roundels wherein are shown the notorious examples of strong or wise men subdued by the power of woman: David and Bathsheba, Samson and Delilah, Aristotle and Campaspe.

There is only one instance in which the "decorative style" was permitted to encroach upon the domain of religious representations, and the resulting fusion of splendor and *brio* with severity may well be called spectacular. This is the *Annunciation* in pen and water color of 1526 (508). Rectangularity still prevails in the construction of the picture space and in the disposition of the objects. But the vaulted room is deeper, higher and more sumptuously appointed than in any other late composition by Dürer. The rear wall, its lower part hung with an ornamental tapestry, is pierced by a circular window still more conspicuous than in the *Last Supper* of 1523, but not admitting any light. Before it dangles a lamp, similarly lightless and cut in two, as it were, by the ray of light divine which breaks into the room in a violent diagonal. On a cornice which, in contrast with the Gothic vault, shows a pure Renaissance style, are seen the symbols of the Virgin—basin, pitcher and candlestick; and her bench, placed against a brocaded cloth of honor and surmounted by an enormous conic canopy, has lions' claws for feet and Baroque volutes for arms as though it belonged on the Triumphal Chariot of Maximilian. The Angel, finally, combines the dignity of Dürer's Virgin Martyrs with the rich flutter of his earlier Victories; and the swift balance of his movement announces, curiously enough, the famous pose of Giovanni da Bologna's *Mercury*.

Whether or not this drawing was intended to suit the personal taste of a prospective owner—its character and medium suggest that it was more than an impromptu—as a late work by Dürer it stands alone; it is at once a new departure and a retrospective glance at a sphere which was no longer his. The other religious representations of the 'twenties—such as a *Bishop Reading Mass* (896, used for the Missal of Cardinal Albrecht of Brandenburg), a *Temptation of St. Anthony* (784), a heavily draped *Apostle* intended but not employed for the unfinished series of engravings (785), and an austere *Virgin Mary Reading* (713) which, like a seated *Judas Thaddaeus* (827), may or may not have been intended for a representation of Pentecost—conform in style, technique and spirit to the drawings connected with the "Oblong Passion," the *"Great Crucifixion"* and the *"Sacra Conversazione."*

In the domain of secular art Dürer's activity was practically restricted to two provinces: the illustration of his scientific books, which will be discussed in the following chapter, and portraiture.

In portraiture, the most significant development was his discovery of the profile portrait. Although the full profile was the most obvious and in fact the earliest scheme of portrait

painting, it had been entirely abandoned in Northern fifteenth century art except for donors' portraits, seals and coins: from about 1420 to the end of the century there is hardly a single exception to the rule that the sitter was turned to three-quarters profile. Northern artists had no wish to eternalize the individual by isolating him from any empirical context and reducing his physiognomy to a diagram as self-contained and unchangeable as a Platonic idea. They tried to show the sitter as a "natural" being, maintaining contact with the world around him, subject to changes in space and time, his appearance diversified by light and shade. In Italy, on the other hand, the profile portrait had held its place throughout the Quattrocento, partly through the influence of classical Antiquity but also because the Italians delighted in that very emphasis on permanence and autonomy which was foreign to the Northern taste. In Germany and Flanders, therefore, the reemergence of the profile portrait, like the approximately simultaneous appearance of the portrait medal, is a Renaissance phenomenon no less characteristic than any other form of Italianism. But before Dürer's return from the Netherlands only Burgkmair, in his woodcut portraits of Jacob Fugger and Pope Julius II, had ventured to transfer the profile principle from medals to prints.

Up to this time Dürer had used the profile only in two exceptional cases: either in copies from Italian paintings, as in the portraits of Caterina Cornaro of 1494/95 (1045) and of an unknown gentleman of 1505 (1061); or in such drawings as were actually made with a medal in mind, as in the two Pirckheimer portraits of 1503 (1036 and 1037, *fig.* 139) and in the Portrait of Count Philipp zu Solms of 1518 (1040). Similar instances occur also in Dürer's latest years, for instance a portrait of Sultan Solyman I of 1526 (1039), which is a copy after a picture in the style of Gentile Bellini, and a beautiful silver point drawing of Frederick II of the Palatinate of 1523 (1022), which was intended to serve, and in fact did serve, as the basis for a commemorative coin. But from 1522 we find autonomous profile portraits along with these heteronomous ones—profile portraits which were neither copied after Italian models nor executed solely for the benefit of medalists.

The earliest instances are two printed portraits: a woodcut of 1522 even larger than the *Maximilian*—representing Ulrich Varnbüler, "Protonotarius" to the Emperor and a good friend of Pirckheimer and Dürer (369, *fig.* 301); and another engraving of Cardinal Albrecht of Brandenburg (210, *fig.* 300), known as the *"Great Cardinal,"* of the following year. The woodcut was based on a study in black and brown charcoal (1042) and exists, in fact, in posthumous two-tone impressions in these two colors; the engraving was based on one of Dürer's most penetrating drawings in silver point (1004).

In general arrangement both these prints conform to the scheme of the large chalk or charcoal drawings in that the figures are set out against a dark background, with a blank strip for inscriptions on top—a scheme abandoned in the following years. But in every other respect they are as different from one another as their media. The Varnbüler portrait—which, being a woodcut, still shows a certain tendency toward the "decorative"—is dramatic in effect, almost theatrical. The figure spreads itself out over the whole surface. The face—its

profile not as yet quite pure—is sharply turned against the breast and is framed all round by a huge cutwork beret which all but obliterates the background, and whose vivid contour encroaches upon the top strip. The remaining space is largely taken up by a piece of vellum with frayed and curling edges which bears a long cryptographic inscription.

The *"Great Cardinal,"* on the other hand, being an engraving, stresses the plastic volume instead of the two-dimensional pattern. There is no divergence between the head and the breast both of which are represented in pure side elevation. As in the *"Small Cardinal,"* the bust rises from behind an inscribed panel. But in contrast with the earlier composition, and in accordance with all the other late portrait engravings, this panel has depth and substance. It is treated as a real tablet, carved and framed after the fashion of those Roman tombstones which were as common in Germany as in Italy and France. A woodcut such as Burgkmair's "Sterbebild" of Conrad Celtes—perhaps the earliest example of a portrait print deliberately patterned after Roman epitaphs—may possibly have served as an intermediary. The dark background is unobstructed except for Dürer's initials and the elegant but unobtrusive coat-of-arms of the Cardinal; and the majestic curves of his biretta—which was substituted for the skullcap seen in the preparatory drawing in order to outbalance the heaviness of his cheeks and chin and to lend dignity to the whole figure—touch but do not invade the top strip.

Yet the two portraits have one thing in common: both represent men of a similar type, thick-set, full-blooded, with bulging eyes, aquiline noses, thick, sensuous mouths and fleshy jowls—men who are apt to look shapeless and stolid in front view or three-quarter profile, and whose more spiritual qualities show to advantage if the massiveness of their features is suppressed in favor of a distinctive outline. This consideration was probably uppermost in Dürer's mind when he decided to use the profile scheme in these particular cases, and it is possible that the idea was suggested to him by a kind of a providential accident: he may have seen Quentin Massys's famous portrait of 1513, now in the Musée Jacquemart-André in Paris (*fig.* 299), which shows a man of very similar type—a cross-breed, as can be demonstrated, between a "caricature" by Leonardo da Vinci and a medal of Cosimo de' Medici—ennobled and, if one may say so, intellectualized by turning his fleshy face to full profile.

However, once adopted for special reasons, the profile scheme gained favor with Dürer, also, in cases where the sitter was not naturally suited for it. It corresponded, as we can easily see, to the mathematical leanings of his latest years which made him prefer the "fundamental views" even in his narrative compositions. He used it for two recently discovered drawings of 1525 (1084 and 1085), for the engraving of Philip Melanchthon of 1526 (212, working drawing 1032) whose type was certainly most different from that of Varnbüler and Albrecht of Brandenburg, and, finally, for his last major work, the masterly drawing of the Nuremberg patrician Ulrich Starck of 1527 (1041, *fig.* 304). This drawing was used for a rather inconspicuous medal, but it is doubtful whether such was its destination from the outset; and even if this should be the case it would have outgrown its practical purpose much as Bach's "Art of the Fugue" outgrew its theoretical one.

In two portrait engravings of 1524 Dürer resumed the bust type in three-quarter profile,

monumentalized by the addition of tablets still heavier and larger than that in the *"Great Cardinal."* One of them shows the fat but somehow tragic face of Frederick the Wise, one year before his death (211, *fig.* 302), and it is most instructive to compare the print with the silver point drawing from life (1021): not only is the movement of the lines intensified to the point of invectiveness—note, for instance, the curls of the beard, the contour of the cheek, the lips which almost look like living animals, and the impassioned sweep of the ear-flaps of the cap—but the engraving also contains infinitely more details than the drawing from life. Dürer's amazing visual memory cooperated with the self-propelling action of the burin to make the elaboration of the record from nature more vital than the record itself. The other engraving of 1524 is a portrait of Pirckheimer (213, *fig.* 303). The magnificent bulldog head of Dürer's best friend is not so much embellished as transfigured. Mass is converted into energy, and the heavy features of the learned, irascible giant appear illumined, as it were, by the enormous eyes which flare from their sockets like powerful searchlights. The Latin inscription "Vivitur ingenio, caetera mortis erunt" ("We live by the spirit, the rest belongs to death"), characterizes the portrait as well as the portrayed.

A portraitist who could do justice to men like Varnbüler, Frederick the Wise, Cardinal Albrecht and Pirckheimer was bound to fail when confronted with the small, quiet, supremely ironical face of Erasmus of Rotterdam. Dürer had drawn him in Brussels in 1520. But a first sketch, which has not been preserved, was apparently so little satisfactory that the attempt had to be repeated; and a second, which has come down to us (1020), remained unfinished because the sitting was interrupted by a visit of "courtly ambassadors" (perhaps the envoys from Nuremberg) and was, characteristically, never resumed. Dürer had lost access to the world of Erasmus, and the very fact that he could imagine him as a martyr of Luther's cause shows a pathetic misunderstanding of the man who was to defend the freedom of the human will against the tyranny of Luther's God. Erasmus, on the other hand, looked upon the "Apelles of Nuremberg" with respect but without personal warmth and, it is to be feared, not without condescension. He belonged, not to Dürer but to Hans Holbein.

In fact Dürer hesitated to rely on memory and on his own drawings when he decided, in 1526, to engrave a portrait of Erasmus after all (214, *fig.* 305). He had recourse to a painting by Massys (transmitted through a copy in the Palazzo Corsini at Rome) which shows the humanist in the quiet comfort of his study. From this composition Dürer took over: the general idea of portraying Erasmus in half-length and thoughtfully writing at his little desk; the asymmetrical arrangement which, in the case of the Massys portrait, had been justified by the fact that it belonged to a diptych the other half of which represented Petrus Aegidius; and the emphasis on genre features which are not quite in keeping with the austere monumentality of the Gargantuan tablet (here placed in the left background). Dürer did his best to "characterize" Erasmus by the paraphernalia of erudition and taste, with a charming bouquet of violets and lilies-of-the-valley testifying to his love of beauty and, at the same time, serving as symbols of modesty and virginal purity. But with all his efforts Dürer produced merely an excellent portrait of a cultured, learned and god-fearing humanist; he failed to capture that elusive blend of charm, serenity, ironic wit, complacency and formidable strength that was

Erasmus of Rotterdam. So curiously impersonal is Dürer's engraving—whose Greek inscription "the better image will his writings show" is truer than it was meant to be—that Carlo Maratta could transform it, about a century and a half later, into an ideal portrait of Correggio merely by changing the face and some of the attributes. Erasmus, characteristically tempering frankness with urbanity, revealed his disappointment by pleading extenuating circumstances for the artist: "That the portrait is not an altogether striking likeness," he wrote to Pirckheimer, "is no wonder. I am no longer the person I was five years ago."

The series of painted portraits—it is impossible here to mention all the portrait drawings of this period, even such masterpieces as the *Henry Parker Lord Morley* of 1523 (1034) or the *Susanna of Bavaria* of 1525 (1057)—is initiated a little later than that of the printed ones. It begins with the Portrait of an Unknown Gentleman in Madrid of 1524 (85, *fig.* 260). Here is represented a man of imperious bearing with a small, firm mouth and piercing eyes which, in contrast with all the other portraits by Dürer, seem to be fixed on a definite object in space. The upward sweep of a broad-brimmed hat strengthens the impression of a domineering personality. This portrait is the only one which, after Dürer's return from the Netherlands, retains the Flemish scheme with both hands included, and also shows some of the delight in textural and luminary values which distinguishes the works produced, three years before, on Flemish soil. But it is harder in substance, more energetic in modelling and, above all, it no longer gives the effect of constraint. It may be said to result from a synthesis of Dürer's Netherlandish experiences with his "stereometrical" style.

Two years later these Flemish reminiscences had again disappeared. In the Berlin portraits of two Nuremberg dignitaries, the reigning Mayor Jacob Muffel (62, *fig.* 307) and the Senator and "Septemvir" Hieronymus Holzschuher (57, *fig.* 306), Dürer reverted to the "bust formula," sharpening the pseudo-sculptural effect by framing the heads almost as tightly as in the engravings of Pirckheimer and Frederick the Wise. The figures no longer emerge from deep, dark space but violently detach themselves from a flat, light-blue surface. The modelling is very particularized, the emphasis is on structure and line rather than on surface and color, and all the contours have a definitely graphic character so that they could easily be traced with a sharp pencil.

The two panels are exactly alike in size and technique and must have been painted for the same, presumably official, purpose. Psychologically, however, they form a strong, deliberate and perhaps slightly humorous contrast. In the pale face of Jacob Muffel everything—the forehead, the mouth and most particularly the nose—is small, thin, tight and narrow, and his eyes, with small, pointed lights giving the impression of sharpness without warmth, stare into vacancy with a detached and disillusioned look. In the florid countenance of Holzschuher, on the other hand, everything is open, broad and full; his dishevelled white hair and contracted eyebrows bespeak a violent temper, and he fixes the beholder with a not too alarming ferocity. One feels that he must have a beautiful baritone voice, and his and Muffel's portrait, hanging side by side on the same wall, almost inevitably bring to mind the contrast between Hans Sachs and Beckmesser.

It is perhaps because of their official character that the portraits of Muffel and Holz-schuher show no sign of that softening and broadening which could be observed in the *"Four Apostles"* in Munich and in the *Virgin with the Pear* in the Uffizi. These qualities are, how-ever, found in a portrait, also of 1526, which is as fascinating, exceptional and, in a way, contradictory as the person whom it depicts (58, *fig.* 309, Vienna, Gemäldegalerie). The painting is one of the most "pictorial" portraits by Dürer, second only to the Berlin Portrait of a Lady of about 1506; yet it imitates a work of sculpture. It is not merely a painting "en buste" but an actual bust simulated by painting. The nude throat is semicircularly cut directly beneath the pit, and projects from a plain roundel, casting a shadow upon it. This roundel is made to appear as a slab of gray marble, but the bust is paradoxically painted in natural colors. The general arrangement might have been suggested by Burgkmair's Portrait of Pope Julius II, already mentioned, or by his series of Roman Emperors, and the effect of plastic projection from a circular frame recalls somewhat the little busts in Ghiberti's "Gates of Paradise." The face of the sitter, however, seems to belong in the period of Romanticism rather than in the Renaissance. The features, framed by soft sideburns and a mass of curly hair, are pure and noble but full of contradictions and melancholy, a high, clear brow and a firmly set, authoritative mouth strangely contrasting with the delicacy of the nose and chin and with the gloom of large, dark, lusterless eyes. The character and career of this personage are as anachronistic and mysterious as his appearance. He was a man who called himself Johann Kleberger although his father had borne the name of Scheuenpflug. This father, a man of humble origin, had left Nuremberg for unknown and possibly discreditable reasons, but the son had come back under another name and with an enormous fortune. He fell in love with Pirckheimer's favorite daughter Felicitas, wore down the furious resistance of her father and finally married her in 1528. Then the inexplicable thing happened: Kleberger left his wife after a few days and went to France. She died one and a half years later—in Pirck-heimer's entirely unfounded opinion from a slow poison administered by his unwelcome son-in-law—and Kleberger spent the rest of his life in Lyons. Like another St. Francis, he gradually gave away his whole fortune, and upon his death the poor erected a wooden statue to "Le bon Allemand," as he was called; a replica of it can still be seen under the name of "L'homme de la roche" ("the man of the rock").

THE ESSENCE OF DÜRER'S LATE PERIOD is epitomized in a drawing of 1522 (635, *Frontis-piece*) which—still more impressively than the painting for which it was used (21)—defies the distinction between portraiture and religious imagery. It represents Dürer himself in the nude, with thinned, dishevelled hair and drooping shoulders, his body ravaged by his lingering disease. But physical pain and decay are interpreted as a supreme symbol of the likeness of man unto God. Dürer carries the scourge and the whip of the Passion. He who had once styled his person into the image of a "Beau Dieu" now likened himself to the Man of Sorrows. He had renounced the "fables of the world," and he sensed that his days were counted.

VIII · Dürer as a Theorist of Art

Like "ars" in Latin and "art" in English, the German word "Kunst" had originally two different meanings the second of which is now all but extinct. On the one hand, it denoted "können," that is, man's ability purposely to produce things or effects as nature produces such objects and creatures as stones, trees and butterflies, or such phenomena as rainbows, earthquakes and thunderstorms. On the other hand, it denoted "kennen," that is, theoretical knowledge or insight as opposed to practice. In the first, or wider, sense the word "Kunst" could be applied to the activities of any producer of things, as the architect, the painter, the carver, the embroiderer or the weaver; but also to the activities of any producer of effects, as the physician or the bee-keeper. In the second, or narrower, sense—which still survives in the expression "Die freien Künste," or "The Liberal Arts"—astronomy could be called "Kunst der Stern" ("art of the stars"); the Biblical phrase "lignum scientiae boni et mali" ("the tree of knowledge of good and evil") could be translated with "Der Baum der Kunst des Guten und Bösen"; and when Dürer wished to express the idea that a good painter needed both theoretical insight and practical skill he could do it, as we remember from our discussion of the *Melencolia I*, by saying that he had to combine "Kunst" and "Brauch."

"Art" in the narrower sense, then, is a prerequisite of art in the wider sense, and this idea is by no means peculiar to the Renaissance. The Middle Ages, which did not yet distinguish between the "Fine Arts" and humbler crafts and skills, emphatically recognized the fact that the practice of painting, sculpture, illumination, metal work, and, most particularly, carpentry and architecture needed some sort of theoretical foundation, a "recta ratio aliquorum faciendorum operum," as Thomas Aquinas puts it; we still possess a number of medieval treatises on art, ranging from the eleventh to the fifteenth century, which supply information as to the handling of all kinds of media, the methods of draftsmanship, iconographical types, the plans and ornaments of buildings, the elements of mechanical engineering, and, above all, geometry. Theophilus's *Schedula diversarum artium*, Villard de Honnecourt's "Album," Jean Le Bégue's "Treatise" on various arts, Martin Roriczer's *Büchlein von der Fialen Gerechtigkeit*, the "Painter's Manual" of Mount Athos—which, though compiled as late as in the sixteenth or seventeenth century, yet contains a considerable amount of genuine medieval workshop lore—and the *Geometria deutsch* of about 1500 are known to all.

However, these and similar treatises are to the writings of Leone Battista Alberti, Piero della Francesca, Francesco di Giorgio Martini and Leonardo da Vinci as the pharmacopoeia is to a work on biochemistry. As the pharmacopoeia tells the druggist how to compound and how to use his drugs, but does not furnish any scientific explanation for their action on the human body, so do the medieval manuals give instructions according to which a man may work, but do not attempt to derive them from general principles or to support them by verifiable

facts. They constitute, in short, a code of rules but not a theory, much less a "science" as envisaged by Leonardo da Vinci.

A medieval treatise on architecture, for instance, whether covering the whole field or concentrating on a special problem, shows only what things can be done and how they should be done; it makes no attempt to explain to the reader why they have to be done in this peculiar way, let alone to supply him with a system of general concepts on the basis of which he may cope with problems not yet foreseen by the writer. The reader is given praiseworthy examples of groundplans, elevations, structural details, ornaments, etc., partly selected from existing monuments and partly invented by the author himself; he is informed about the right way of joining the stones in a compound pier or erecting a scaffold; and he is taught such indispensable methods of geometrical drawing as parallel projection, magnification and reduction, construction of regular polygons, etc.; but he is not given a "theory of architecture."

This was precisely what a writer like Leone Battista Alberti proposed to do. Basing himself on Vitruvius, but varying, expanding and even correcting him in all directions, he derives his prescriptions from general principles such as practical purpose, convenience, order, symmetry and optical appearance. He divides the tasks of the architect in different classes which, taken together, form a coherent and comprehensive system from city-planning to the construction of fireplaces, and he tries to corroborate his statements both by deductive, though naturally not always critical, reasoning and by historical evidence.

When we turn to treatises on the representational arts the difference between the medieval and the modern point of view becomes still more evident. In the Middle Ages paintings and sculptures were not thought of in relation to a natural object which they seek to imitate but rather in relation to the formative process by which they come into being, namely, the projection of an "idea" existing in—though by no means "created" by—the artist's mind into a visible and tangible substance. Master Eckhart's painter paints a rose, as Dante draws the figure of an angel, not "from life" but from the "image in his soul"; and in the exceptional cases in which the procedure of the imitative arts was considered with regard to their relation to a visible model, this model was conceived, not as a natural object but as an "exemplar" or "simile"—that is, as another work of art which served as a pattern. "An artist conceives the form, after which he wishes to work, from some other work of art which he has seen," says Thomas Aquinas, and thereby relieves the individual artist of the necessity of facing nature itself.

The Renaissance, on the contrary, established and unanimously accepted what seems to be the most obvious, and actually is the most problematic dogma of aesthetic theory: the dogma that the work of art is the direct and faithful representation of a natural object. "And thou must know," writes Dürer, "the more accurately one approaches nature by way of imitation, the better and more artistic thy work becomes." Treatises on sculpture and painting, therefore, could no longer be limited to supplying generally accepted patterns and recipes but had to equip the artist for his individual struggle with reality.

This equipment had to be twofold. Since the artist was supposed to "reproduce" the things in nature "as they are" he had to be informed, first, as to how they are; and, second, as to how they can be reproduced. The art theory of the Renaissance, then, was faced with two main problems, one material and the other formal or representational. On the one hand, it had to furnish scientific information about the natural phenomena themselves: about the structure and function of the human body, the expression of human emotions, the characteristics of plants and animals, the action of light and atmosphere on solid bodies, etc. On the other hand, it had to develop a scientific process by which the sum total of these phenomena —that is, three-dimensional space in general and any three-dimensional object in particular —could be correctly represented, or rather reconstructed, on a two-dimensional surface. The first of these pursuits falls clearly within the province of what we now know as the natural sciences; but since these were practically non-existent by the end of the Middle Ages, the theorists of art themselves had to become the first natural scientists. Antonio Pollaiuolo dissected corpses when professional physicians still lectured and were lectured to on the basis of Galen and Avicenna; Leonardo da Vinci laid the foundations of modern anatomy, mechanics, geology and meteorology, and Galileo owes more to him than to all the commentaries on Aristotle's *Physics*. The second pursuit was of a purely mathematical character: it resulted in that discipline which more than anything else deserves the title of a specific Renaissance phenomenon, perspective.

Dürer was the first artist who, brought up in late-medieval workshops of the North, fell under the spell of art theory as it had evolved in Italy. It is in his development as a theorist of art that we can study *in vitro*, as it were, the transition from a convenient code of instructions to a systematic and formulated body of knowledge. And it is in his contributions to this body of knowledge, written and printed, that we can witness the birth of German scientific prose.

The Italians had, since Dante, a language refined and flexible enough to do justice to technical details as well as to poetic and philosophical thought. In Dürer's period, the German language had not yet reached what may be called a scholarly stage. The German of such semi-scientific treatises as Calendars, Herbaries, booklets on health or, for that matter, the *Geometria deutsch*, was of the crudest. The humanists wrote all of their books and pamphlets, and most of their letters, in Latin, and it was only in the field of religious, not scholarly or scientific, prose that the recalcitrant medium of the German language—made pliable, as it were, by the heat of a fervent mystical emotion—had yielded such masterpieces as Suso's or Master Eckhart's German Sermons; but even Master Eckhart wrote his more esoteric treatises in Latin.

Dürer, in his touching modesty, had thought of asking Pirckheimer and other humanistic friends to perfect his language and, more particularly, to write his Prefaces for him. But the result was a dismal failure. Pirckheimer could write a very witty and straightforward German style in his private letters; but as soon as he tried to be "literary" he waxed rhetorical. He tried to duplicate the sonorous phrases of Ciceronian Latin in turgid sentences full of learned

allusions and elaborate metaphors and so complicated in structure as to become, at times, all but unintelligible—not to mention the humanistic habit of praising one's own performance at the expense of forerunners and "envious" competitors.

Thus Dürer, like Luther, had to create a German language of his own. Like Luther, he took a more or less standardized chancery style as a basis and infused life into it, not by a futile attempt at humanistic oratory but, on the contrary, by listening to the man in the street—"one must look people on the mouth," as Luther picturesquely puts it—and by tapping the sources of religious prose. For abstract mathematical concepts he used the graphic expressions which had been handed down from generation to generation of artisans—for instance: "Fischblase" ("fish's bladder") and "der neue Mondschein" ("crescent") for the figures resulting from the intersection of two circles, "Eberzähne" ("boar's teeth") for angles formed by circular arcs, "Ortstrich" ("corner stroke") for diagonal—and coined new terms on similar principles, e.g., "Gabellinie" ("fork line") for hyperbola, "Brennlinie" ("burning line") for parabola, "Schneckenlinie" ("snail line") for spiral, and so on. The "influxus sublimiores" ("influences from above") which play such a prominent part in Neo-Platonic literature were rendered, after the fashion of Suso and Eckhart, as "öbere Eingiessungen"; and Ficino's "thesaurus penetralibus suis absconditus" was transformed, according to Luther's free translation of *Matthew*, XII: 35, into "der heimliche Schatz des Herzens" ("the secret treasure of the heart").

In the end the "poor painter" not only managed to describe complicated geometrical constructions more briefly, more clearly and more exhaustively than any professional mathematician of his time, but also expressed historical facts and philosophical ideas in a prose style no less "classic" than Luther's translation of the Bible. Dürer writes: "Wie alt nun diese Kunst sei, wer sie erstlich erfunden hab, in was Ehren und Wirden sie etwan bei den Kriechen und Römern gewest sei, wie auch ein guter Maler oder Werkmann geschickt soll sein, davon ist jetzt ohn Not zu schreiben. Wer aber das Wissen zu haben begehrt, der lese Plinium und Vitruvium" ("But how old this art may be, who may have invented it, in what honor and esteem it may have been held by the Greeks and Romans, and how a good painter or craftsman should be equipped: of this there is not need to write here; whoever desires to know about that may read Pliny and Vitruvius"). Pirckheimer had proposed the following: "Das Alles die Alten vergangner Jahr nit unfruchtbar vermerkt, bei Kriechen sunderlich, auch Romern mehr dann andern Nationen geachtt. Haben die Werkleut derselbigen hoch gepreist, geliebt und belohnt, unter denen Phidias, Praxitelles, Apelles, Policletus, Parhasius, Lisippus und ander Furtreffende diese Kunst fleissig ersucht, grundlich erfunden und endlich mit ubertreffenden ihren Werken lieblich, wunderlich und zemal künstlich angezeigt und an Tag gebracht, dodurch sie nit allein zu Aufnehmen Lobs, Reichtum, Liebung der Völker bekommen, sunder mehr tapfer Freiungen, unsterblich Gedächtnis der edlen achtbaren Historici und Poeten haben erobert, sind auch Etlich zu der Spitz der zielichen Ehrung, Aufrichtung gebildter Säulen, erhaben" ("All this having been noticed, not unfruitfully, by the Ancients of bygone years, it [*scil.*, the knowledge of proportions] was highly esteemed, especially by the Greeks, but also by the Romans, more than by other nations. They highly praised, loved

and rewarded their craftsmen, among whom Phidias, Praxiteles, Apelles, Polyclitus, Parrha-
sius, Lysippus and other outstanding men industriously investigated, soundly ascertained and
finally, by their excellent works, beautifully, marvelously and altogether artistically ex-
pounded and manifested this art, whereby they not only acquired fame, wealth and the love
of the peoples but also attained to many brave privileges [?] and to the immortal memory of
the noble, praiseworthy *historici* and poets, some of them having been raised to the acme
of temporal honor, the erection of carved monuments").

Dürer says: "Dieweil ich nun in keinen Zweifel setz, ich werde allen Kunstliebhabenden
und denen, so zu lehren Begierd haben, hierin einen Gefallen tun, muss ich dem Neid, so
nichts ungestraft lässt, seinen gewöhnlichen Gang lassen und antworten, dass gar viel leichter
sei ein Ding zu tadeln dann selbs zu erfinden" ("Since I have no doubt that I shall do a favor
to all art lovers and those who are eager to learn I must leave it to envy, which leaves
nothing uncensured, to take its usual course and only answer that it is very much easier to
blame a thing than to invent it"). Pirckheimer had suggested: *"Dazu nit allein mir geborn*
[Lucanus, *Pharsalia*, ii, 383], diesen als bluhende Samen in dorngem unfruchtbarm Erdrich
erstellet von Männiglich ungeachtt beliebe, mittheile ich itzund solch mein viel fleissig erfahrn,
lang, herzlich Mühe und Arbeit allen itz und kummenden Kunstnern, verhoffende, sie mir
(wiewol Unbekannten) in rechter Gunst, Lieb und Freundschaft ewig zu verbinden. Aber
dieweil das durchdringend sterblich Vergift nachredender, gespitter Zungen allzeit bereit ist
auszefliessen, dadurch alle Werk, wie gut, nutzlich die sein, gemeinglichen verunreint und
aufgeblasen werden, bin jedoch solcher Zuversicht, dits mein Büchlein durch das unversehrt
gifttriebig Einhorn der mehren und gerechtern Urtheilern solcher todtlicher Verletzung müge
entfliehen" ("Also, *not having been born for myself alone*, and lest all this, like blossoming
seeds sown in thorny, sterile land, be disregarded by one and all, I now communicate this my
studiously experienced, long and whole-hearted labor and care to all artists present and future,
hoping to tie them to myself eternally—although I am unknown to them—by true good-will,
love and friendship. But while the penetrating, deadly poison of slandering, pointed tongues
is always ready to flow forth, whereby all works, however good and useful they may be, are
commonly polluted and blown up, yet I am confident that this my little book may escape such
deadly injury by the scatheless, poison-chasing unicorn of more and fairer judges").

That "envy" has a place in Dürer's own version at all is his only concession to his erudite
friends; for, in a letter to another humanist—perhaps Hanns Ebner—who had also tried his
hand at a Preface for the *Vier Bücher von Menschlicher Proportion* the thought of envy had
been rejected altogether. Dürer's letter—accompanied by many apologies for his criticism,
and bearing witness both to his good taste and intellectual honesty—reads, in part, as fol-
lows: "Sir, I beseech you kindly to formulate the Preface as indicated below: first, I desire
that no glory nor pride be sensed therein; secondly, that no mention at all be made of envy;
thirdly, that nothing be talked about but that which is contained in these Books; fourthly,
that no use be made of subject matter stolen from other books; fifthly, that I prescribe only

to our German youths; sixthly, that I highly praise the Italians with regard to their nudes and, above all, to perspective."

FOR PERSPECTIVE, in the sense of a scientific theory, Dürer was indeed much indebted to the Italians. During the early and high Middle Ages the reconstruction of three-dimensional space on a two-dimensional plane had not constituted a problem. The "picture" had been conceived as a material surface covered with lines and colors which could be interpreted as tokens or symbols of three-dimensional objects, and a wavy strip of green or brown had been sufficient to indicate the ground on which the figures, trees and houses were placed. In the course of the fourteenth century, however, the forms appearing *on* the surface came to be thought of as something existing *behind* the surface until Leone Battista Alberti could liken the picture to a "transparent window through which we look out into a section of the visible world." Objects of equal size began to diminish as they moved away from the beholder; the walls, floors and ceilings which delimited an interior, or the ground on which were disposed the elements of a landscape, began to "recede" toward the background; and such lines as were at right angles to the picture plane ("orthogonals") developed into perspective "vanishing lines" which tended to converge toward one center.

Around 1340 (in the Northern countries about thirty years later) this center had already assumed the character of a single "vanishing point" in which the "orthogonals" converged with mathematical precision, at least within one unobstructed plane; and as early as about 1420-25 it had been observed that the horizontal lines of a cubiform building set slantwise into space seemed to converge toward two points symmetrically located on one horizontal ("Perspectiva cornuta"). True, the "perspective" image thus developed—and, in part, already constructible by means of a ruler or a tight cord fastened to a pin—was not yet unified, and it was not yet possible to determine the correct sequence of equidistant transversals; Alberti expressly condemns a practice, apparently still in vogue about 1435, by which the intervals between one transversal and the next were mechanically, and of course mistakenly, diminished by one-third each. But even these problems could be solved, and were solved by the Flemish painters of the fifteenth century, on a purely empirical basis. In the 'fifties it was discovered that all orthogonals, and not only those located in one plane, had to converge in one "vanishing point" which thus established the "general horizon" of the picture; and the problem of determining the gradual diminution of equidistant transversals was solved by the simple device of running an oblique line across the converging orthogonals. Such an oblique line, it was reasoned, would cut the converging "orthogonals" so as to form the common diagonal of a continuous row of small, equal squares which would automatically determine the correct sequence of as many transversals (text ill. 2). It was also discovered that this diagonal would intersect the "horizon" at the same point as the diagonals of the adjacent rows of small squares, thus constituting a "lateral vanishing point"; that the foreshortening of the whole system became the sharper the smaller the distance between this "lateral vanishing point" and the "central vanishing point" (that is to say, the

point of convergence of the "orthogonals"); and that, if diagonals were drawn from left to right as well as from right to left, the two "lateral vanishing points" were equidistant from the "central vanishing point."

2. Empirical Perspective Construction of a "Checker-Board Floor"

These draftsmanlike methods were later codified by that Johannes Viator, or Jean Pélerin, who has already been mentioned in connection with Dürer's *Presentation of Christ* (*fig.* 144) and *Martyrdom of the Ten Thousand* (*fig.* 166), and whose *De artificiali perspectiva*, in spite of its late date (1505, second edition 1509), is still a representative of the pattern-and-recipe type of art-theoretical treatise. But they were known already by the last third of the fifteenth century, and they were quite sufficient to ensure perfectly "correct" perspective representations. Dirk Bouts's *Last Supper* of 1464-67 is already as impeccably constructed as any painting by an Italian Quattrocento master, and the same is true, as we remember, of every one of Dürer's works executed after about 1500.

Yet Dürer undertook, in 1506, a special trip to Bologna—well over a hundred miles from Venice—"for the sake of 'art' in secret perspective which some one wants to teach me." After such engravings as "*Weihnachten*" (*fig.* 116) and such woodcuts as the aforementioned *Presentation* Dürer did not need any instruction in perspective as far as its practical application was concerned. What he was after was the theoretical foundation of a process which he had thus far learned only empirically, and this is exactly what he tried to express by saying that he wished to be instructed, not in perspective, but in "*Kunst* in heimlicher Perspectiva"—"Kunst" meaning, as we now know, theoretical knowledge or rational understanding as opposed to mere practice. This knowledge was indeed a "secret" insofar as it had not yet been divulged in any printed book; but it had been accessible to experts for almost exactly three-quarters of a century: it was the method traditionally, and in all probability justly, ascribed to the great architect Filippo Brunelleschi.

The procedure culminating in Dirk Bouts's *Last Supper* and Dürer's pre-Venetian prints had resulted from a more and more successful schematization of such patterns—foreshortened floors and ceilings, receding walls, etc.—as had been handed down by tradition or were perceived by direct observation. It had developed quite independently of that mathematical analysis of the process of vision which was known as Ὀπτική or "Optica" in classical An-

tiquity, and as "Prospectiva" or "Perspectiva" in the Latin Middle Ages. This discipline—
formulated by Euclid, developed by Geminus, Damianus, Heliodorus of Larissa and others,
transmitted to the western Middle Ages by the Arabs, and exhaustively treated by such
scholastic writers as Robert Grosseteste, Roger Bacon, Vitellio and Peckham—attempted to
express in geometrical theorems the exact relation between the real quantities found in objects
and the apparent quantities which constitute our visual image. It was based on the assumption
that objects are perceived by straight visual rays converging in the eye—so that the visual sys-
tem can be described as a cone or pyramid having the object as its base and the eye as its apex
—and that the apparent size of any real magnitude, and thereby the configuration of the en-
tire visual image, depends on the width of the corresponding angle at the apex of said pyramid
or cone ("visual angle").

Classical "Optica" and medieval "Prospectiva," then, were no more concerned with
problems of artistic representation than the representational methods of Jan van Eyck,
Petrus Cristus or Dirk Bouts were based on the doctrines of scholastic writers. A few of these,
to wit Grosseteste and Roger Bacon, could already develop optical instruments—apparently
not unlike our refracting telescopes—by means of which "that which is near and big can be
made to appear very distant and small and vice versa, so that it is possible to read small let-
ters from an incredible distance and to count grains of sand, seeds or other diminutive ob-
jects"; but no one thought of applying the Euclidian theory of vision to the problems of
graphic representation. This was precisely what Brunelleschi proposed to do. He conceived the
truly revolutionary idea of intersecting the Euclidian pyramid by a plane inserted between
the object and the eye, and thereby "projecting" the visual image on this surface just as a
lens projects a picture on the screen or on a photographic film or plate. A pictorial representa-
tion thus came to be defined as "a cross-section through the visual pyramid or cone" ("l'inter-
segazione della piramide visiva," as Leone Battista Alberti puts it, or "a plane, transparent in-
tersection of all those rays which travel from the eye to the object it sees," to translate the
formula adopted by Dürer). To ensure perspective correctness one had only to evolve a
method of constructing this cross-section by means of a compass and a ruler, and this was
the essence of the new "Painter's Perspective" ("Prospectiva pingendi" or "Prospectiva
artificialis") in contradistinction to which the old-time theory of vision came to be called
"Prospectiva naturalis."

In its original and comprehensive form—described, as far as the writings of the
fifteenth century are concerned, only in the admirable *De prospectiva pingendi* by Piero
della Francesca which was composed between 1470 and 1490 but was not printed until
1899—this Brunelleschian construction requires two preparatory drawings, the elevation and
the groundplan of the whole visual system. In each of these, the visual pyramid or cone is
represented by a triangle having its apex in a point standing for the eye while the projection
(or picture) plane is represented by a vertical intersecting this triangle. In the elevation
drawing the object has to be shown in a vertical diagram, and in the groundplan in a hori-
zontal diagram. Either diagram is connected with the point representing the eye, and the

points of intersection between the connecting lines and the vertical will determine the required set of values, namely, the vertical and transversal quantities of the perspective image. The latter can be constructed by simply combining these two sets in a third and final drawing (text ill. 3).

3. Systematic Perspective Construction of a Three-Dimensional Body
("Costruzione legittima")

Since this "costruzione legittima" requires two diagrams of the object, one horizontal and one vertical, it presupposes a familiarity with the method of parallel projection by which any required diagram can be developed from any two others, provided that they are located in planes at right angles to each other. This method had already been practiced by the medieval architects and had been dealt with in their treatises. But it had now to be

applied to the human body in movement instead of being restricted to buildings and archi-
tectural details, and thus developed into a special branch of Renaissance art theory indis-
pensable both for the study of human proportions and for the application of the "costruzione
legittima." It was extensively treated in Piero della Francesca's *De prospectiva pingendi*;
it was practiced by Leonardo and his pupils; and if we can believe Giovanni Paolo Lomazzo,
it was almost a speciality with other Milanese theoreticians such as Vincenzo Foppa and
Bartolommeo Suardi, called Bramantino.

Needless to say, this "costruzione legittima," born in the mind of an architect who thought
in terms of elevations and groundplans, was too unwieldy for actual use. In practice, not even
the most conscientious of painters would ever construct individual objects, let alone figures,
by first developing two diagrams and then projecting these on the picture plane. It was
deemed sufficient to build up a three-dimensional system of coordinates in foreshortening
which enabled the artist to determine the relative magnitude, though not the shape, of
any object he might wish to render. Such a system could easily be developed from a fore-
shortened square correctly divided into a number of smaller squares; and to obtain this
basic square, or rather checkerboard—a problem solved by the Northern artists on purely
empirical grounds, as we have seen—was the purpose of that "abbreviated construction"
which was actually used by the Italian Quattrocento painters. It was described by Leone
Battista Alberti, and, later on, by Piero della Francesca, Pomponius Gauricus and Leonardo
da Vinci, and its practical application can be observed in drawings by Paolo Uccello and
Leonardo himself. This abbreviated method begins with the procedure already followed in
the "pre-Brunelleschian" period: the front line of the future basic square is divided into
an arbitrary number of equal parts, and the dividing points are connected with the central
"vanishing point" P. But now the sequence of the equidistant transversals is determined on
a strictly Euclidian basis, that is to say, by superimposing the now familiar profile elevation
of the visual cone or pyramid upon the system of vanishing lines: we erect a vertical—
representing the picture plane—at one of the front corners of the future basic square and
assume, on the horizontal determined by the vanishing point, a point representing the eye.
When we connect this point with the terminals and dividing points of the front line of the
future basic square, the points of intersection between the connecting lines and the vertical
will indicate, on the latter, the correct sequence of equidistant transversals (text ill. 4).

We do not know the name of Dürer's "teacher" in Bologna. But whoever he was, he must
have been both well-informed and communicative. When Dürer returned from Venice he
was acquainted with the "costruzione legittima" a written description of which could be
found, as we have seen, only in the unpublished treatise by Piero della Francesca; with
Piero's elegant method of transferring any given planimetrical figure from an unfore-
shortened square into a foreshortened one; and, more important, with his fundamental defini-
tion of "perspectiva artificialis" as such: "Perspective is a branch of painting which comprises
five parts: the first is the organ of sight, *viz.*, the eye; the second is the form of the object seen;
the third is the distance between the eye and the object; the fourth are the lines which start

from the surface of the object and go to the eye; the fifth is the plane which is between the eye and the object wherever one intends to place [that is, on which one wishes to project] the objects." In addition, Dürer shows himself informed about such methods and devices as were

4. Systematic, but Abbreviated Perspective Construction of a
"Checker-Board Floor" (called by Dürer "Der nähere Weg")

common to all Italian theoreticians of perspective, but had received, at least in part, the especial attention of the Milanese theoreticians. He knew the "abbreviated construction" first described by Alberti; parallel projection as applied to the human figure; apparatuses enabling the artist to draw directly from nature and yet to achieve "approximate" perspective accuracy; and the geometrical construction of cast-shadows, a speciality of Leonardo da Vinci. His "teacher," then, must have been a man familiar with both Piero della Francesca and the theorists of Milan. This applies to the two most plausible candidates thus far proposed, the mathematician Luca Pacioli and the great architect Donato Bramante; but it may also have been true of many a nameless painter or professor of Bologna University.

Characteristically, most of Dürer's drawings dealing with problems of perspective date from the years between 1510 and 1515—the period of the *Melencolia I* (1700-1706). The final presentation of the subject, however, is found at the end of the Fourth Book of his treatise on Geometry, the *Underweysung der Messung mit dem Zirckel uñ Richtscheyt* of 1525 (revised edition 1538). Here Dürer teaches: first, the "costruzione legittima," illustrated by a cube placed on a square and lighted so as to serve, at the same time, as an example for the construction of cast-shadows; second, the "abbreviated construction" which he happily calls "der nähere Weg" ("the shorter route"); third (in the revised edition only), Piero della Francesca's method of transferring planimetrical figures from the unforeshortened into the foreshortened square; fourth, two (in the revised edition, four) apparatuses to ensure an approximative correctness by mechanical instead of mathematical means.

Two of these apparatuses (361 and 364) were already known to Alberti, Leonardo and Bramantino. The eye of the observer is fixed by a sight, and between it and the object is inserted either a glass plate (*fig.* 310) or a frame divided into small squares by a net

of black thread ("graticola" or grill, as Alberti calls it). In the first case, an approximately correct picture can be obtained by simply copying the contours of the model as they appear on the glass plate and then transferring them to the panel or drawing sheet by means of tracing; in the second case the image perceived by the artist is divided into small units whose content can easily be entered upon a paper divided into a corresponding system of squares. The other two apparatuses—one invented by one Jacob Keser, the other apparently by Dürer himself—are nothing but improvements on the ones already described. Keser's device (363) removes the difficulty that the distance between the eye and the glass plate can never exceed the length of the artist's arm, which entails an undesirably sharp fore-shortening: the human eye is replaced by the eye of a big needle, driven into the wall, to which is fastened a piece of string with a sight at the other end; the operator can then "take aim" at the characteristic points of the object and mark them on the glass plate with the perspective situation determined, not by the position of his eye but by that of the needle. The last apparatus (362) eliminates the human eye altogether: it consists, again, of a needle driven into the wall and a piece of string, but the piece of string has a pin on one end and a weight on the other; between the eye of the needle and the object is placed a wooden frame within which every point can be determined by two movable threads crossing each other at right angles. When the pin is put on a certain point of the object the place where the string passes through the frame determines the location of that point within the future picture. This point is fixed by adjusting the two movable threads and is at once entered upon a piece of paper hinged to the frame; and by a repetition of this process the whole object may be transferred gradually to the drawing sheet (*fig.* 311).

APART FROM THIS TECHNICAL INVENTION Dürer added nothing to the science of perspective as developed by the Italians. Yet the last section of his "Unterweisung der Messung" is memorable in two respects. First, it is the first literary document in which a strictly representational problem received a strictly scientific treatment at the hands of a Northerner; none of Dürer's forerunners and few of his contemporaries had any understanding of the fact that the rules for the construction of a perspective picture are based on the Euclidian concept of the visual pyramid or cone, and it is a remarkable fact that the methods taught in a treatise by one Hieronymus Rodler, published as late as 1531 and even reprinted in 1546, are partly purely empirical and partly downright wrong. Second, it emphasizes, by its very place at the end of a "Course in the Art of Measurement with Compass and Ruler," that perspective is not a technical discipline destined to remain subsidiary to painting or architecture, but an important branch of mathematics, capable of being developed into what is now known as general projective geometry.

The Preface of this "Course in the Art of Measurement," which, like the Treatise on Human Proportions, is dedicated to Pirckheimer, is the first public statement of Dürer's lifelong conviction, to be repeated many a time and alluded to in our discussions at various points: that the German painters were equal to all others in practical skill ("Brauch") and

power of imagination ("Gewalt"), but that they were inferior to the Italians—who had "rediscovered, two hundred years ago, the art revered by the Greeks and Romans and forgotten for a thousand years"—in a rational knowledge ("Kunst") which would prevent them from "errors" and "wrongness" in their work. "And since geometry is the right foundation of all painting," Dürer continues, "I have decided to teach its rudiments and principles to all youngsters eager for art. . . . I hope that this my undertaking will not be criticized by any reasonable man, for . . . it may benefit not only the painters but also goldsmiths, sculptors, stonemasons, carpenters and all those who have to rely on measurement."

The "Unterweisung" is, therefore, still a book for practical use and not a treatise on pure mathematics. Dürer wanted to be understood by artists and artisans. It has already been mentioned that he appropriated their ancient technical language and took it as a model for his own. He liked to explain the practical implications of a given proposition even if he had to interrupt his systematic context, as when he teaches how to use the constructed spiral for capitals or for a foliated crozier. He refrains from learned divagations and gives only one example—the first in German literature—of a strict mathematical proof. But on the other hand his erudite friends kept him informed of those new ideas and problems which—to quote from the excellent Johannes Werner to whom Dürer appears to be indebted in more than one respect—"had wandered from Greece to the Latin geometricians of this age." Besides his first-hand knowledge of Euclid, he had established contact with the thought of Archimedes, Hero, Sporus, Ptolemy and Apollonius; and, more important, he was, himself, a natural-born geometrician. He had a clear idea of the infinite (for instance when he says that a straight line "can be prolonged unendingly or at least can be thought of in this way" or when he distinguished between parallelism and asymptotic convergence); he emphasized the basic difference between a geometrical figure in the abstract and its concrete realization in pen and ink (the mathematical point, he says, is not a "dot," however small, but can be "mentally located so high or so low that we cannot even reach there physically," and what applies to the point applies *a fortiori* to lines); he never confused exact with approximate constructions (the former ones being correct "*demonstrative*," the latter ones merely "*mechanice*"); and he presented his material in perfect methodical order.

The First Book, beginning with the usual definitions, deals with the problems of linear geometry, from the straight line up to those algebraic curves which were to occupy the great mathematicians of the seventeenth century; Dürer even ventures upon the construction of helices, conchoids ("Muschellinie," "shell line") and epicycloids ("Spinnenlinie," "spider line"). One of the most interesting features of the First Book is the first discussion in German of conic sections, the theory of which had just been revived on the basis of classical sources. There can be little doubt that Dürer owes his familiarity with Apollonius's terms and definitions (parabola, hyperbola and ellipse) to the aforesaid Johannes Werner who lived in Nuremberg, and whose valuable *Libellus super viginti duobus elementis conicis* had appeared in 1522, three years before the "Unterweisung der Messung." But Dürer approached the problem in a manner quite different from that of Werner, or, for that matter,

of any professional mathematician. Instead of investigating the mathematical properties of the parabola, hyperbola and ellipse, he tried to construct them just as he had tried to construct his spirals and epicycloids; and this he achieved by the ingenious application of a method familiar to every architect and carpenter but never before applied to the solution of a purely mathematical problem, let alone the ultra-modern problem of the conic sections: the method of parallel projection. He represented the cone, cut as the case may be, in side elevation and groundplan and transferred a sufficient number of points from the former into the latter. Then the normal hyperbola—produced by a section parallel to the axis of the cone—can be directly read off when a front elevation is developed from the two other diagrams, while parabolas and ellipses, produced by oblique sections and therefore appearing in a reduction in any diagram except the side elevation, must be obtained by proportionately expanding their main axes. Crude though it is, this method, which may be called a genetic as opposed to a descriptive one, announces, in a way, the procedure of analytical geometry and did not fail to attract the attention of Kepler who, with a smile, refers to the only mistake in Dürer's analysis. Like any schoolboy, Dürer found it hard to imagine that an ellipse is a perfectly symmetrical figure. He was unable to get away from the idea that it should widen in proportion with the widening of the cone, and he involuntarily twisted the construction until it resulted, not in an orthodox ellipse but in an "Eierlinie" ("egg line"), narrower at the top than at the bottom (text ill. 5). Even with Dürer's primitive methods the error could have been easily avoided. That it was committed, not only illustrates a significant conflict between abstract geometrical thought and visual imagination, but also proves the independence of Dürer's researches. After the publication of his book he invented an ingenious compass which would have saved him from this error (1711): but, needless to say, this instrument solves the problem of the ellipse only *"mechanice,"* not *"demonstrative."*

The Second Book proceeds from one-dimensional to two-dimensional figures, with special emphasis on the "quadratura circuli" and the construction of such regular polygons as cannot be developed from the square and the equilateral triangle, *viz.*, the pentagon, the enneagon, etc. Of these, only the pentagon (which also furnishes the decagon) and the pentecaidecagon, or fifteen-sided figure, had been treated in classical times; the pentagon because it is the basic element of one of the "Platonic" solids, namely, the dodecahedron; and the pentecaidecagon because it was necessary for the construction of an angle of 24 degrees, then generally considered as the correct measurement of the obliquity of the ecliptic. In the Middle Ages, however, the problem had gained a wider and more practical importance. Both Islamic and Gothic decoration—and, after the invention of firearms, fortification—required methods of constructing all kinds of regular polygons. Dürer, in fact, at once proceeds to develop these into tracery patterns and to combine them into "pavements" which anticipate Kepler's "Congruentia figurarum harmonicarum" in the Second Book of his *Harmonices mundi libri V*. The medieval constructions of these polygons were, of course, approximate; but they were, and had to be, simple, preferably not even calling for a change in the opening of the compass (which had no device to recapture an opening once changed); and it was

5. Dürer's Construction of the Ellipse

Dürer rather than Leonardo—who also tried his hand at the construction of the more compli-cated regular polygons—who transmitted these constructions to the future.

The construction of the regular pentagon, for instance, is not described by Dürer accord-ing to Euclid. He gives, instead, the less well known but likewise exact construction of Ptolemy and, in addition, an approximate construction "with the opening of the compass unchanged" which, but for him, would have remained forever buried in the *Geometria*

deutsch; and his approximate construction of the enneagon (the exact construction of which is impossible) is not described in any written source but was taken over directly, as we happen to know, from the tradition of the "ordinary workmen" ("tägliche Arbeiter"). Thus the "Unterweisung der Messung," published in Latin in 1532, 1535 and 1605, served, so to speak, as a revolving door between the temple of mathematics and the market square. While it familiarized the coopers and cabinetmakers with Euclid and Ptolemy, it also familiarized the professional mathematicians with what may be called "workshop geometry." It is largely due to its influence that constructions "with the opening of the compass unchanged" became a kind of obsession with the Italian geometricians of the later sixteenth century, and Dürer's construction of the pentagon was to stimulate the imaginations of men like Cardano, Tartaglia, Benedetti, Galileo, Kepler, and that Pietro Antonio Cataldi who wrote a whole monograph on the "Modo di formare un pentagono . . . descritto da Alberto Durero" (Bologna, 1570).

The Third Book of the "Unterweisung," on the other hand, is of purely practical character. It is intended to illustrate the application of geometry to the concrete tasks of architecture, engineering, decoration and typography. Dürer was an admiring student of Vitruvius —we still possess his German excerpts from several important chapters of the *De architectura* —and recommends him highly in the "Unterweisung," but he was far from being dogmatic about it. His praise of Vitruvius is directly followed by the statement, already referred to in our Introduction, according to which the German mind always demands "new patterns the like of which has never been seen before," and he proceeds to describe two columns not to be found in Vitruvius and submitted to the reader without obligations: "and let anyone cull therefrom what he likes, and do as he pleases." From a most interesting report unfortunately not included in the "Unterweisung" (1685) we learn that Dürer favored the classical roof, with a slope of little more than 20 degrees, against the steep Gothic one; and his ideas about city-planning—laid down in his Treatise on Fortification and possibly connected with one of the earliest "slum-clearing projects" in history, the Augsburg "Fuggerei" of 1519/20— reveal his familiarity with such modern theoreticians as Leone Battista Alberti and Francesco di Giorgio Martini. But his designs for capitals, bases, sun-dials and whole structures such as the tapering tower to be placed in the center of a market place are anything but classical. He also describes, among other things, triumphal monuments to be composed of actual guns, powder barrels, cannonballs and armor, yet accurately proportioned *more geometrico*. When celebrating a victory over rebellious peasants, these monuments are to be composed of rustic implements such as grain chests, milk cans, spades, pitchforks and crates; and a humorous extension of this principle leads—"von Abenteuer wegen" ("for the sake of curiosity")— to an epitaph in honor of a drunkard, consisting of a beer barrel, a checkerboard, a basket with food, etc. It should, however, be noted that these absurd contrivances met with the approval of François Blondel, and that at least one of them—a slender monument crowned by the figure of a wretched conquered peasant (*fig.* 314)—may have been inspired by certain fanciful designs of Leonardo's (*fig.* 315).

6a. Construction of Roman Letters
according to Sigismundus de Fantis,
*Theorica et Pratica . . . de modo scri-
bendi . . .*, Venice (J. Rubeus), 1514

6b. Construction of Roman Letters
according to Dürer's *Underweysung
der Messung* of 1525

At the end of the Third Book, Dürer familiarizes the Northern countries with another
"secret" of the Renaissance, the geometrical construction of Roman letters, "litterae
antiquae," as they were called by Lorenzo Ghiberti, thereby anticipating Geoffroy Tory's
famous *Champ Fleury* by precisely four years. In Italy, this problem had been taken up by
Felice Feliciano, the friend and archeological adviser of Andrea Mantegna, and had sub-
sequently been treated by such authors as Damiano da Moile, or Damianus Moyllus (about
1480); Luca Pacioli (published 1509); Sigismundus de Fantis (published 1514); and—pos-
sibly—by Leonardo da Vinci. Dürer—introducing the subject by instructions on how to deter-
mine the suitable size of inscriptions high above eye level—was not in a position to improve on
the methods of these Italian forerunners. As far as the Roman letters are concerned he had
to limit himself to the role of a middleman (text ills. 6a and 6b). The Gothic letters, how-
ever—or, to use his own expression, the "Textur" type—he constructed on a principle not
to be found in any earlier source. Gismondo Fanti had dealt with them in the same fashion
as with the "antiqua" type, that is to say he had inscribed each letter into a square, had
established its proportions by dividing the sides of the square in a certain way, and had
determined its contours by combining straight lines with circular arcs (text ill. 7a). Dürer,
on the other hand, constructs his Gothic letters according to an entirely different principle.
He dispenses with circular arcs altogether, and instead of inscribing the letter in a large
square, he builds it up from a number of small geometrical units such as squares, triangles or
trapezoids (text ill. 7b). If of anything, this cumulative method is reminiscent of Arabic, and
not of Italian, calligraphy.

After this excursion into the domain of the practical, the Fourth Book resumes the thread
where the Second had left it: it deals with the geometry of three-dimensional bodies or
stereometry, a field entirely disregarded during the Middle Ages. At the beginning, Dürer
discusses the five regular or "Platonic" solids, a problem brought into the limelight by the

7a. Construction of "Gothic" Letters
according to Sigismundus de Fantis

7b. Construction of "Gothic" Letters
according to Dürer

revival of Platonic studies on the one hand and by the interest in perspective on the other. Whether or not Dürer was acquainted with the work of the two Italian specialists in this field, Luca Pacioli and Piero della Francesca, is an open question. Certain it is that, as in the case of the conic sections, he tackled the problem in an entirely independent way. Pacioli discusses, besides the five "Platonic" or regular bodies, only three of the thirteen "Archimedean" or semi-regular ones, and he illustrates them in perspective or stereographic images. Dürer treats seven—in the revised edition of 1538 even nine—of the "Archimedean" semi-regulars, plus several bodies of his own invention (for instance, one composed of eight dodecagons, twenty-four isosceles triangles and eight equilateral triangles), and instead of representing the solids in perspective or stereographic images, he devised the apparently original and, if one may say so, proto-topological method of developing them on the plane surface in such a way that the facets form a coherent "net" which, when cut out of paper and properly folded where two facets adjoin, will form an actual, three-dimensional model of the solid in question (text ill. 8).

This section is followed by the discussion of another problem which had "wandered from Greece to the Latin geometricians of the time," namely, the problem of doubling the cube. This "Delian problem," as it was called, had been treated, almost simultaneously, by a mathematician named Heinrich Schreiber or Grammateus, who gives only one solution, and by the aforesaid Johannes Werner who, in a paraphrase of Eutocius's Commentary on Archimedes, gives no less than eleven. That Dürer, who gives three, made use of Werner's

treatise is all the more probable as it is printed together with the *Libellus super viginti duobus elementis conicis*. Yet it can be shown by the very lettering of Dürer's figures that he also consulted Eutocius himself, with Pirckheimer dictating to him the text in a German translation.

8. Dürer's "Net" of the *Cuboctahedron Truncum*

As the "Delian problem" concerns the cube its discussion formed a welcome transition to the last section of Dürer's *Underweysung der Messung*, the chapter on perspective which, we remember, exemplifies both the "costruzione legittima" and the "shorter route" by the construction of a lighted cube placed on a horizontal plane. To Dürer, as to many of his contemporaries, perspective meant the crown and keystone of the majestic edifice called Geometry.

THIS STRANGE FASCINATION which perspective had for the Renaissance mind cannot be accounted for exclusively by a craving for verisimilitude. There was, of course, an immense satisfaction in a method which could "deceive the eye" like Brunelleschi's vista of the Piazza di S. Giovanni, Alberti's *demonstrationes* (which were certainly actual pictures and not mere models of the geometrical process), or the feigned dining-room and colonnade in the house of a famous mathematician in Vienna. But it is undeniable that, from a physiological or psychological point of view, exact perspective is not always "natural." We do not see with one eye, but with two. Our retina is not a plane surface but a spherical one (as was recognized in classical and medieval optics where the apparent magnitudes depend on the visual angles and not, as in the Brunelleschian construction, on the linear distance); and our mind automatically rectifies the visual diminutions and distortions in favor of a more "objective" relation among the various quantities. The Renaissance theorists, or at least some of them,

knew perfectly well that the results of their perspective construction could vary widely from actual visual experience—just as a modern photograph may distort the appearance of things so as to make buildings seem to tumble down or a protruding foot appear four times as large as a face. But they decided in favor of the construction, or merely advised the artist to avoid "extremities," and none of them thought of denying or even doubting the indispensability and fundamental rightness of perspective as such.

This universal enthusiasm can be accounted for by a variety of reasons. First, there was a curious inward correspondence between perspective and what may be called the general mental attitude of the Renaissance: the process of projecting an object on a plane in such a way that the resulting image is determined by the distance and location of a "point of vision" symbolized, as it were, the *Weltanschauung* of a period which had inserted an historical distance—quite comparable to the perspective one—between itself and the classical past, and had assigned to the mind of man a place "in the center of the universe" just as perspective assigned to his eye a place in the center of its graphic representation. Second, perspective, more than any other method, satisfied the new craving for exactness and predictability (it is chiefly with reference to it that Leonardo defended his assertion that painting, more than sculpture, music or poetry, was a "science"). Third, in a space built up according to the rules of perspective a series of equal magnitudes receding from the picture plane—for instance the sequence of equidistant transversals in the aforementioned "checkerboard floors"—diminishes gradually and regularly; and this diminution, expressible by a mathematical formula, intrinsically agrees with that great principle of classical and Renaissance aesthetics which we shall reencounter toward the close of this chapter: "Beauty is the harmony of the parts in relation to each other and to the whole."

From the point of view of the Renaissance, then, focused perspective was not only a guarantee of correctness but, even more, a guarantee of aesthetic perfection; it was abandoned in periods which shared the Renaissance belief in naturalism while no longer sharing the Renaissance enthusiasm for "beauty." In fact, the harmonious gradation of perspective distances found in Renaissance paintings and drawings expresses the same aesthetic attitude as the equally harmonious gradation from heavy rustication to a less heavy one and finally to ordinary masonry, or from the Doric order to the Ionic and Corinthian, which can be observed in fifteenth century palaces; while the preceding centuries preferred a uniform treatment of the wall surface throughout the three stories. Perspective, one might say, is a mathematical method of organizing space so as to meet the requirements of both "correctness" and "harmony," and is thus fundamentally akin to a discipline which sought to achieve precisely the same thing with respect to the human and animal body: the theory of proportions.

When Jacopo de' Barbari had refused to disclose the secret of the "man and woman which he had constructed by means of measurement," Dürer "set to work on his own and read Vitruvius." The first results of his efforts are already known to us: apart from the isolated case of the *"Large Fortune"* (*fig.* 115), where the Vitruvian data are exemplified by an almost motionless figure pictured in pure profile, they are laid down in the series of

drawings which culminates in the engraving "*Adam and Eve*" (1596-1601, 1627-1639, 458). These figures are posed after classical models which had come to Dürer's knowledge through Italian intermediaries, the men—except for a heavily built *Sol* or *Samson* of about 1500 (1596/97)—in the pose of the Apollo Belvedere, the women—except for a *Reclining Nude* of 1501 (1639)—in that of the Medici Venus. The standing figures are constructed as follows. The total length and general axis of the body is determined by a basic vertical which runs from the heel of the standing leg to the top of the head and goes through the pit of the stomach. The pelvis is inscribed in a trapezoid, and the thorax in a square (or, in the female figures nos. 1627-1634, in a vertical rectangle), and the axes of these, meeting at the pit of the stomach, are slightly shifted against the basic vertical. The knee of the standing leg, and thereby the length of both thighs, is found by bisecting the line which connects the hip-point with the lower terminal of the basic vertical. The head, if turned to full profile, is inscribed in a square, and the contours of the shoulders, hips and loins—in some of the female figures also those of the breasts, the waist, the abdominal muscles and the genitals—are determined by circular arcs (*figs.* 118, 119, 316).

The purpose of this scheme, then, was threefold. First, it established the proportions, and this, as far as the figures in the drawings 458, 1598-1601 and 1635-1639 are concerned, according to the canon of Vitruvius: the length of the head is one-eighth of the total height, that of the face (divided into three equal parts, *viz.*, the brow, the nose and the rest) one-tenth, and the width of the breast from shoulder to shoulder one-quarter. Second, it automatically produced a "classical *contrapposto* pose," that is to say, a differentiation between standing leg and free leg whereby the hip of the free leg and the shoulder above the standing leg are slightly lowered and vice versa. Third, it reduced as many contours as possible to the simplest of geometrical curves.

To determine the historical *locus* of this scheme we have to bear in mind the fundamental difference between the classical and the medieval treatment of the problem involved. The Greek theoreticians, beginning with Polyclitus—whose efforts are known to us only in principle, but not in tangible details—and ending with the anonymous author whose statements are transmitted by Vitruvius, thought of the theory of human proportions as what may be called aesthetic anthropometry. They wished to establish the proportions of the human body regardless of its representation in a work of art. While the Egyptians had devised a method of building up figures from a considerable number of equal squares—so as to facilitate the process of transferring the design to the surface of a block as well as to a wall or panel—Polyclitus and his followers took as a point of departure not a graphic network of equal units but the organic structure of the human body itself: they tried to establish a relationship among the various members, such as leg, head, face, hand, fingers and so forth, toward each other and the whole. They thus elaborated a system of proportions in the stricter sense of the term—that is, a system of relations expressible either in aliquot fractions of the total length, as does Vitruvius, or in a series of individual equations (the hand is to the cubit as one to two, the cubit to the foot as seven to four), as was allegedly

the case with Polyclitus. And since this system of relations expressed the measurements not as they are in any individual person but as they "should be" according to the accumulated experience of the great masters, it constituted what was called a "canon"—no longer a technical device but a formula of beauty. To Vitruvius even an originally cosmological idea assumed the character of an aesthetic principle: it is not "the" body, but the "well-made" body ("homo bene figuratus") which will fill a square when represented with arms out-stretched and feet together, and a circle described around the navel when represented spread-eagled.

As may be expected from what was said at the beginning of this chapter, the medieval writers of manuals on art abandoned these anthropometric and aesthetic aspirations. They did not try to inform the artists as to the "perfect" proportions of the human body, but to supply them with an easy way of drawing figures—a "maniere pour legierement ouvrier," as Villard de Honnecourt defines what he calls "pourtraicture." The artists were told that they could take the length of a face and multiply it by nine to get the whole length of "a figure," by two in order to get its width, and by two and a half to get its width in case the figure were clothed. A human head, including the halo, could be built up from three con-centric and equidistant circles described around the root of the nose—or, in the case of fore-shortened heads, around the pupil or the corner of one eye—the intervals between the circles being determined by the length of the nose; and in the "Album" of Villard de Honnecourt whole human figures, faces, hands and animals are constructed not only out of circles and simple straight lines but also out of triangles, swastikas and pentagrams, this construction determining the measurements as well as, in certain cases, the contours and the poses or movements.

In this respect, Dürer's earliest studies in human proportions are still related to the figures of Villard de Honnecourt—so much so that the expression "studies in human proportions" is, strictly speaking, inaccurate. They, too, are not so much dimensioned on the basis of an anthro-pometric canon as actually constructed by means of geometrical operations which do precisely what they did in Villard's "pourtraicture," that is, determine the measurements as well as the contours and postures; the text belonging to one of these drawings (1627/28) reads, *mutatis mutandis*, like the description of the pentagon construction in the "Unterweisung der Mes-sung."

In another respect, however, the medieval procedure is very different from Dürer's, even before the latter had been rationalized on the basis of the Vitruvius canon. With Villard de Honnecourt the geometrical concept precedes the zoomorphic form, whereas, with Dürer, the zoomorphic form precedes the geometrical concept. A pentagram and a triangle have little or nothing to do with the natural structure of the human body; but it is anatomically under-standable, if not justified, to schematize the thorax and the pelvis into a rectangle and a trapezoid, one movable against the other. Villard's figures come about by entering natural forms into a geometrical scheme; Dürer's geometrical scheme comes about by superimposing a suitable construction on natural forms. In fact, it can be explained as an *ex postfacto*

application of the compass and the ruler to his own studies from life, such as the *Female Nudes* of 1493 (1177, *fig.* 45), 1496 (1180, *fig.* 95) and 1498 (1181 and 911), and to such Italian drawings and engravings as reflected classical statuary (*fig.* 120). Thus Dürer's earliest constructions, perhaps already influenced by Barbari's elusive communications, contain an element of naturalism and classicism utterly absent from their Gothic forerunners, and this classical element was further strengthened by the incorporation of the Vitruvius canon; indeed, after 1500/01 the female figures, including the Eve in the *Fall of Man*, show an unfeminine broadening and shortening of the thorax—suggested by Vitruvius's statement to the effect that the breast of a "well-made" figure had to be as wide as one-quarter of its total length—which had to be corrected in the drawings of 1506 (464-469, *figs.* 161, 162).

Nevertheless, Dürer's original scheme did violence, in some measure, to nature. It denied individual differences and hardened into geometrical curves what should be an organic undulation. At a comparatively early date the number of the circular arcs determining the contours was restricted to three, and we have already seen that they were abandoned altogether in the drawings, just mentioned, for the painted version of the *Fall of Man* (*figs.* 164/165); later on, Dürer was to state explicitly that "the boundary lines of a human figure cannot be drawn with a compass or ruler." However, even these—Venetian—drawings for the *Fall of Man* were still practical "constructions" ready for direct transportation into a panel or engraving, and not yet documents of a theoretical discipline which is to the medieval "pourtraicture" as the "costruzione legittima" is to the perspective practices of Petrus Cristus or Dirk Bouts. In this respect a fundamental change occurred in Dürer's outlook only when he had come into contact with the work of Italian theorists greater than Jacopo de' Barbari, which must have happened shortly before he returned to Nuremberg in 1507.

These great Italian theorists were, to omit a host of less important ones, Leone Battista Alberti and Leonardo da Vinci. They had reinstated the classical idea of "aesthetic anthropometry," that is to say, they were no longer interested in constructing figures but in investigating the proportions of the "homo bene figuratus" pure and simple; and both endeavored to put this undertaking on a new and scientific basis. They actually measured classical statues and, more important, they collected statistical data from living models.

Alberti was especially interested in perfecting the metrical system. He devised a scheme called "Exempeda" whereby the whole length of the body was divided into six "feet" (*pedes*), the "foot" into ten "inches" (*unceolae*, derived, as our word "inch," from Latin *uncia*), and the "inch" into ten "smallest units" (*minuta*). Every part of the body could thus be expressed by three integers (as 1.4.7). Leonardo, on the other hand, was satisfied with the traditional units—Vitruvius's "head" (from the chin to the top of the skull) and "face" (from the chin to the roots of the hair) which are one-eighth and one-tenth of the total length, respectively, and the "face" of a medieval, probably Byzantine, canon where it amounted to one-ninth of the total length. But he went much farther than Alberti in measuring and remeasuring living models; and, more important, he developed a personal method which rendered the metrical system irrelevant. Convinced of the intrinsic unity of the human

organism, he was anxious to discover "correspondences" or, to use the expression of Pomponius Gauricus, "analogies," rather than isolated data: he compared various parts of the body, whether or not they are related to each other from an anatomical point of view, and expressed their relationship, preferably an identity, in statements reading about as follows: "The width of the arm across its junction with the hand corresponds with the length of the thumb; and with the combined width of the three middle fingers; and with the inner length of the small finger; and with the combined width of the four toes excluding the big toe; and with the length of the ear;" etc., etc. Ultimately, these quantities would have to be referred, of course, either to the total length of the body or to such units as "head" or "face"; but from Leonardo's point of view it was much less important to ascertain their numerical value than to establish their relationship.

The drawings illustrating Alberti's and Leonardo's observations are naturally very different from Dürer's early constructions. They were not intended for direct use in works of art but merely served to visualize the measurable proportions of the human body as objectively and completely as possible. The figures are therefore rigidly erect and are represented in three or at least two elevations (frontal, profile and, in some instances, dorsal), aligned on a common standing line. In order that the beholder may "read off" the dimensions with ease, the figures are often plotted against a "uniform grating," its intervals determined by "feet," "heads" or "faces" as the case may be; and the arm of the profile figure is either cut off or forced back as far as humanly possible so as not to obstruct the view of the chest.

Three drawings which correspond to the above description bear witness to the fact that Dürer's encounter with Leonardo marks the turning point in his career as a theorist of human proportions. Two of these are obviously traced from Leonardesque models because they show, in addition to the "uniform grating" and the characteristic motif of the forced-back arm, masculine types of unmistakably Leonardesque cast (1602 and 1603). The third, executed in 1507 and revised in 1509, is an independent study of a woman in profile with her arm cut off, but it retains the "uniform grating" and is accompanied by a long-winded text containing no less than nine Leonardesque "analogies" (1641, *fig.* 317).

A whole group of other drawings executed between 1507 and 1509—all representing female figures in pure profile—show Dürer well launched upon his new course toward strict anthropometry. Technically, he emancipated himself from the influence of Leonardo in a surprisingly short time (1642, 1643). He gradually abandoned the search for "analogies" in favor of directly referring each quantity to the total length, and soon rejected the idea of a "uniform grating," which entailed a somewhat schematic distribution of one large unit over the whole figure. He developed instead a more organic and flexible system according to which the dividing horizontals—whether drawn out as actual lines or replaced by a scale placed at the margin of the diagrams (1605-1613)—are no longer spaced at equal intervals but at intervals determined by the actual divisions of the human body, these intervals then being expressed by aliquot fractions of the total length at times as meticulously calculated as $1/30$, $2/19$ or $1/14 + 1/15$. In principle, however, the contact with Leonardo had the

lasting effect of breaking the spell of the "ideal proportion." Before 1506, the postures, types and shapes of the figures had been based on accepted classical models and their proportions had been determined by the Vitruvius canon, excepting only the above mentioned *Sol* or *Samson* (1596/97) and several feminine figures. After his return from Venice Dürer was forever convinced that there was not one absolute beauty—not even in the Apollos and Venuses of classical Antiquity—but many forms of relative beauty expressing or, to put it the other way, conditioned by the diversity of breeding, vocation and natural disposition. The anthropometrical drawings of 1507-1509 already include specimens of extreme slenderness, extreme stoutness and a "happy medium" normally preferable to but no longer excluding the more exaggerated possibilities. A few years later, Dürer was to discover that even the "mean" type admitted an untold number of subtle variations, and was to state explicitly that it was impossible to capture or to define "the" beautiful; that one and the same figure could appear more or less beautiful in different contexts; that, conversely, a thinner or stouter figure could be equally praiseworthy each in its own way; that the artist had to make his selection from all sorts of types according to his task, except that he had to avoid abnormalities "unless he deliberately wanted them"; and that, therefore, the purpose of the theory of proportions was to provide him, not with one canon but with specimens and methods which would enable him to produce, within the widest limits of human nature and on the basis of sheer measurement, all possible kinds of figures: figures "noble" or "rustic"— leonine, canine or fox-like—choleric, phlegmatic, melancholy or sanguine—wrathful or kindly—timid or cheerful—figures, even, "from whose eyes shine Saturn or Venus."

Working on these entirely original lines—not even Leonardo had thought of developing the theory of proportions into what may be called comparative or differential anthropometry —and, according to his own words, "investigating about two or three hundred living persons," Dürer accumulated and organized his material so rapidly that he could contemplate a printed publication as early as in 1512 and 1513. As we can infer from the numerous drawings dated or datable in these two years, this publication would have been nearly identical with what now constitutes the First Book (brought into final shape in 1523) of Dürer's comprehensive treatise on human proportions, the *Vier Bücher von Menschlicher Proportion* of 1528. As published, this First Book contains five different types of the male and female figure measuring seven, eight, nine and ten "heads" respectively; furthermore—apart from a description of some technical procedures such as parallel projection (1647-1649)—the detailed measurements of the head—both male and female—the hand, the foot, and the baby; all the proportions are given in three dimensions and expressed in aliquot fractions of the total length.

In Dürer's opinion none of these five types deserved to be called deformed or even ugly, though he certainly would have considered the "mittelmässige" ("mean" or rather "moderate") types B and C, descendants of the early Apollos, as closer approximations to the "rechte Hübsche" ("true beauty") than the "grobe bäurische" ("coarse and rustic") type A which, as A. M. Friend has shown, is of Herculean ancestry (1624a, *fig.* 318) or the "lange dünne" ("long and thin") types D and E. It is with the two moderate types that Dürer's

measurements of "the" head, "the" hand and "the" foot agree, and both of them still conform, in general, to the eight-heads canon of Vitruvius. Apart from this concession to a classical authority, all the figures are built up on the basis of empirical data collected by the painstaking investigation of many individuals and coordinated into "types" much as a physicist will condense the results of a thousand experiments into a few charts where minor deviations are smoothed out in favor of coherent curves. There is only one other non-empirical element, likewise suggested by a classical source: the "rule" that the length of the torso (from the pit of the throat to the hip-bone) should be to the thigh (from the hip-bone to the knee) as the thigh is to the shin (from the knee to the ankle). We happen to know that it was through the study of Euclid that Dürer had conceived the idea of applying this magic formula to the human body. He even invented a device—named "Teiler" ("divisor") and described at length in the First Book of the printed treatise—which, given the distance between the pit of the throat and the ankle and the length of the torso, would determine the *locus* of the knee. But it is characteristic that this construction—necessarily erroneous because the problem, as posed, cannot be solved by methods of elementary geometry—is applied to only five figures out of ten, three women and two men.

In 1513 Dürer abandoned the idea of a publication for both external and internal reasons. On the one hand, he had been appointed by Maximilian I for tasks which, in conjunction with his normal activities, left little room for theoretical work. On the other hand, he could not help realizing that, from his own point of view, the content of the First Book had to be supplemented in two directions: by a theory of movement, and by a theory of variation.

As we have seen, Dürer's earlier scheme of construction had taken care of the postures of the figures, as well as of their proportions. When he abandoned this scheme in favor of pure "aesthetic anthropometry" the figures turned into motionless diagrams which, to quote Dürer's own words, "are of no use whatever so stiffly erect as they are," and the problem of movement had to be dealt with separately. In 1512/13 Dürer tried, in a tentative way, to manipulate these diagrams into the familiar poses of the Apollos and Adams of 1500-1504, and this explains what is generally referred to as a "retrospective" group of drawings executed in those two years (1616-1621). But it was not until 1519, after the Emperor's death, that he tackled the problem methodically and worked out what was to constitute the Fourth Book of the *Vier Bücher von Menschlicher Proportion*. As has already been mentioned in our discussion of his latest style, he endeavored to make human movement constructible by means of parallel projection. On the one hand, he devised a series of figures which systematically illustrate all the possibilities of bending, turning and stepping in which every part of the figure, however shifted against the other, remains either parallel or at right angles to the picture plane so that each figure can be conveniently rotated 90 degrees (1656a and *fig.* 324). On the other hand, he tried to facilitate the construction of unrestricted postures by dissecting the whole figure into a number of units which were inscribed into such simple stereometrical bodies as cubes, parallelepipeds and truncated pyramids; by shifting these around in space any number of poses could be produced in what may be called a synthetic fashion (1653-1656 and *fig.* 322).

The shortcomings of both these methods are all too evident. Dürer knew, of course, that human movement is of an organic and not of a mechanical character and that it admits of inexhaustible variety. But in contrast with Leonardo—whose studies in this field he copied whenever he had an opportunity (1663 and 1664)—he had no chance of familiarizing himself with human anatomy; and he could not as yet conceive of movement as a continuous process. Leonardo, basing himself on a more advanced interpretation of infinity or continuity, had envisaged a graphic scheme—to be developed by a late follower—by means of which human movement could be described as a continuous succession of an infinite number of "phases" (*fig.* 323). Dürer could think of it only as an abrupt transformation of crystallized "poses."

Having established the principle, as early as 1512/13, that a geometrical theory of proportions could, and would, do justice to all imaginable variations of human physique and character, Dürer very naturally felt that the five types described in his First Book were not sufficient; he decided to more than double the material by adding eight further types, both male and female, as well as two new male heads. These are described in the Second Book of the *Vier Bücher von Menschlicher Proportion* which differs from the First in two respects. First, the idea of the "rule" has been abandoned, and the influence of Vitruvius no longer manifests itself in actual measurements but merely in the fact that some of the figures are inscribed in a square or circle. Second, the dimensions are no longer expressed in aliquot fractions of the total length but are indexed according to Alberti's "Exempeda" system which must have come to Dürer's attention after 1523, possibly through Francesco Giorgi's *De harmonia mundi totius* of 1525. Dürer translated Alberti's *pedes* by "Masstäbe" ("measures"), *unceolae* by "Zahlen" ("numbers") and *minuta* by "Teile" ("parts"), and even tried to outdo Alberti in accuracy by subdividing this smallest unit into three "Trümlein" ("particles") each of which is equivalent to about one millimeter. Materially, Alberti's method does not differ very much from the one employed in the First Book; formally or rather psychologically, however, it means a final disavowal of a geometrical approach in favor of an arithmetical one. When expressing the parts of a whole in aliquot fractions, we still stress spatial rather than numerical relations because the sequence of those fractions—1/1, 1/2, 1/3, etc.—is wholly different from that of the natural numbers. When expressing them as multiples of a given unit (even if this unit is in turn a fraction of the whole), we do the opposite: the results appear as a tabulation of integers which do not convey the idea of a geometrical division but invite the arithmetical processes of addition and subtraction: Alberti's *pedes*, *unceolae* and *minuta* can be added and subtracted as easily as modern decimal fractions—which indeed they are.

By the addition of the Second Book the number of types placed at the artist's disposal was increased from five to thirteen, or, counting the men and women separately, from ten to twenty-six. But even this did not satisfy Dürer's desire not to restrict the infinite complexity of nature. In the Third Book he submitted various methods which would enable the artist to change the proportions of any basic figure—that is, of any figure described in the First and Second Books—*ad libitum*, yet on the basis of a consistent geometrical principle. These

methods consist of divers kinds of projections by which any given set of quantities can be enlarged or reduced uniformly as well as progressively. They could be applied to any of the three dimensions of the basic figure (for, as Dürer says, "if I have failed it must be either in regard to height, or to width, or to depth"), and to the whole body as well as to the single parts, in which case the resulting relations could become "inexpressible in terms of aliquot fractions" ("unnennbarlich in der Zahl, die man messen will"), that is to say, irrational. They could also be combined with one another, which opened up still further possibilities. The crowning achievement is a device by which the dimensions are projected on a circular curve from which result distortions like those produced by concave or convex mirrors (*fig.* 319).

Dürer was fully aware of the fact that an indiscreet use of all these methods could easily result in unwanted ugliness and, ultimately, in monstrosity. He warns his readers that he had purposely exaggerated the variations in his comparatively small figures, and untiringly admonishes them to use discretion ("Bescheidenheit") lest they might produce "intolerable" distortions. On the other hand, however, he attributed a special educational value to ugliness as such: the beautiful, he thought, resides in the middle between two extremes ("neither a pointed nor a flat head is considered beautiful, but a round one is, because it is the mean between the two others"); therefore the artist had to know these extremes in order to avoid them whenever he wished to achieve a beautiful shape: "Who knows and understands what makes ugly and awkward can infer therefrom that he must keep away from it"; and: "Nobody knows what makes a good shape unless he knows before what makes a bad one."

It is for this twofold purpose—of doing justice to nature's variety and of capturing beauty by way of defining the mean between two opposites—that Dürer devoted a further section of his Third Book to a geometrical analysis of human physiognomies. "Beautiful" faces had already been illustrated by the Apollos, Adams, Eves and classicizing Goddesses of 1500-1504; and the detailed measurements of such ideal, or at least perfectly normal, physiognomies had been established in numerous drawings (e.g. 1645/46) and had ultimately been laid down in the First and Second Books of the *Vier Bücher von Menschlicher Proportion*. In the Third Book, now, Dürer wishes to teach how to vary the features of the face as infinitely, and by similar methods, as he had taught to vary the proportions of the whole body.

Dürer's interest in abnormal physiognomies can be traced back to his first stay in Venice which had given him an opportunity of becoming acquainted with Leonardo's so-called caricatures. This interest, first manifesting itself, we remember, in the *Christ Among the Doctors* of 1506, soon took a direction toward scientific research. Occasionally we find physiognomical series, one of which begins with a normal profile altering itself into a number of more or less monstrous varieties so that the last looks like a cross between a Negro and an ape (1124 [*fig.* 320], 1125, 1129). Soon, however, Dürer began to base his physiognomical studies upon the principle of opposition: they illustrate the contrast between two profiles as widely disparate as possible, for instance one with extremely large eyes, a sharp, drooping, aquiline nose and a protruding, pointed chin, and the other with extremely narrow eyes, a blunt, turned-up pug nose and a flat and fleshy chin (1126, cf. also 1139). Finally—again from 1519 (839)—

these and all other variations were reduced to geometrical principles. Each head is inscribed in a square, and in each case the proportions, the placing of the features and the very contours of the profile are determined by geometrical lines drawn within the square. Lines which in a normal face are parallel will either diverge or converge; straight lines will be replaced either by concave or convex curves; horizontals will either be raised or lowered; verticals will be shifted either to the right or to the left; and the basic contrasts thus created can be diversified *ad infinitum*. To take two pairs from the printed Treatise as an example: in one case, a profile with all lines slanting down is opposed to a profile with all lines slanting up; in the other, features distributed as widely as possible, with the ear pushed upwards and the skull reduced to a minimum, are contrasted with features compressed into a small triangle, with the ear pushed down and the skull prevailing over everything else (*fig.* 321). "And the more of such ugliness is left out," to quote the conclusion of Dürer's physiognomical discussion, "the more remains of the lovely and beautiful."

THE *Underweysung der Messung* was respectfully quoted by Galileo and Kepler; but Pirck-heimer's sister Eufemia—a nun in the convent of Bergen near Neuburg on the Danube—wrote to her brother: "There has just come to hand a book by Dürer, dedicated to your name, about painting and measurement. . . . We had a good time with it, but our paintress says she does not need it because she can paint just as well without it." The *Vier Bücher von Menschlicher Proportion*—translated into Latin by Dürer's friend Joachim Camerarius as early as 1532-34 and then into many modern European languages—laid the foundations of scientific anthropometry; but Michelangelo and a host of other Italian artists and theorists, in part misinterpreting Dürer's intentions but on the whole not without reason, called it a futile enterprise and a mere waste of time.

In point of fact the usefulness of Dürer's two books for the practicing artist is more than questionable. Originally, the problems treated therein should have been dealt with, in a far less exhaustive and theoretical way, in a few chapters of a general Treatise on Painting, or rather on "That which Makes a True Painter, Mastering His Art." But gradually the training camp for painters had developed into the playground of a scientist—a means had become an end in itself.

This general Treatise on Painting, conceived under the impact of Dürer's experiences on his second journey to Venice, would have comprised three principal parts, each part divided into three sections, and each section subdivided into six chapters.

The First Part, or "Preface," would have dealt with the selection and education of the "ideal" young painter and would have ended with a praise of painting on six different counts, such as piety, fame, "richness in joys," glory for God, and worldly prosperity. All this, particularly the emphasis on fame and joyfulness, bears witness to the fact that Dürer wished to join forces with those Italian writers who fought the great battle for the recognition of painting as one of the "liberal" arts; and this tendency—one of the most characteristic Renaissance phenomena—can also be observed in what may be called his educational program.

The young painter should be selected and trained with due regard to his horoscope and humoral disposition (which, to some extent, amounts to the same thing); he should be brought up with love rather than harshness, in quiet, agreeable surroundings, in temperance, chastity and in the fear of God; he should learn Latin in order to understand works of literature; he should not be overworked, and he should be treated with cheerful music "in case his melancholy should superabound because of too much exertion." Injunctions like these are, as such, by no means original. Dürer could, and probably did, appropriate them from such medieval treatises as Conradus's *De disciplina scholarium* which formerly sailed under the flag of Boethius. What is original is their application to a profession which, in the North, was still thought of as a mere handicraft; that Dürer claimed for young painters what had been deemed the privileges of young scholars would have struck his father and old Michael Wolgemut as something revolutionary.

In the Third Part, or "Conclusion," on the other hand, Dürer would have discussed the problems of the mature painter having achieved the highest rank in his profession: where he should practice his art; that he should charge high fees for his work—"for no money is too much therefor, and this is right according to divine and human law"; and that he should praise God for his exceptional gift.

These pedagogic and sociological disquisitions, then, would have formed, as it were, a kind of frame for the *pièce de résistance* of the whole treatise: the Second Part, entitled "Exposition of Painting." This would have set forth the practice and theory of painting itself, rising from a discussion of manual skill ("Freiigkeit," chiefly to be acquired by copying from good masters) to the theory of human and architectural proportions, the theory of color and, finally, perspective.

Dürer soon came to realize the unfeasibility of this over-ambitious program. He planned to isolate the content of the second and third sections of the "Exposition of Painting," that is to say, to confine himself to art theory pure and simple; according to this more modest plan, his "Büchle" (little book) would have covered the following points: first, the proportions of a young child; second, the proportions of a mature man; third, the proportions of a mature woman; fourth, the proportions of a horse; fifth, "something about architecture"; sixth, perspective; seventh, the theory of light and shade; eighth, the theory of color; ninth, composition ("Ordnung der Gemäl"); tenth—a notion shortly to be explained—the production of paintings "out of one's head ("aus der Vernunft") without all other aid."

But even this "restricted program" proved too large for Dürer's conscientiousness. As early as 1512 he decided to cut it up, so to speak, and to develop its parts into separate, specialized treatises. The first of these—covering, or rather more than covering, points one, two and three of the "restricted program"—was that treatise on human proportions which, as we have seen, was ready for publication as early as 1513 but was ultimately incorporated, as the First Book, in the *Vier Bücher von Menschlicher Proportion*. The second (points five, six and seven of the "restricted program") was to deal with architecture, perspective and the theory of light and shade, and gradually developed into the "Unterweisung der Messung."

The third—a book on the proportion of the horse (point four)—never went beyond the stage of practical experiments (witness the drawings culminating in the *Knight, Death and Devil*, 1674-1676). And the fourth—the book on painting proper which Dürer still hoped to write in 1523 (points eight, nine and ten)—did not get beyond a paragraph to the effect that the unity of a given color ought never to be jeopardized by the process of modelling: "Supposing a layman looks at thy picture, which, among other things, contains a red coat, and says: 'Look here, my friend, how nicely red is the coat on one side, and on the other it has a white color or pale spots!'—then thy work is objectionable, and thou hast not satisfied him. Thou must paint a red thing in such a fashion that it is red throughout, and yet appears relieved, and so with all the other colors. The same thou must observe in shading lest one might say a beautiful red is soiled with black. Therefore be careful to shade each color with a color which harmonizes therewith. For instance, take a yellow color: if it is to remain true to its kind thou must shade it with a yellow darker than the principal color; wert thou to set it off with green or blue it would depart from its kind, and would never be called yellow but turn into a changing color as in those shot fabrics of two different colors."

We would give much for knowing what Dürer thought about "composition" or "Ordnung der Gemäl" (point nine of the "restricted program"). But—recent assertions to the contrary notwithstanding—he has not left a single line, written or printed, which would transcend the problem of the individual figure; what he calls "Versammlung" is not the whole of a picture but the ensemble of parts which constitute the human organism, or even a mere unit within the human organism as in the phrase "die ganze Versammlung des Haupts" ("the whole ensemble of the head"). Thus a whole group of categories and problems which play a considerable role in Italian writing, such as "invention," "*decorum*" and the relationship among painting, sculpture, music and poetry, are not even touched upon in Dürer's literary remains.

Dürer's *Underweysung der Messung* and *Vier Bücher von Menschlicher Proportion*, then, are both more and less than they were intended to be. They are less in that they are only a fragment of a much wider program; they are more in that they are richer in content and more scientific in method and presentation than would have been possible within the framework of the original plan. There is, of course, an intrinsic logic in this development. Both by inclination and by conviction, Dürer could not have written on color or atmosphere as he could write on geometry, human proportions, architecture—or, for that matter, fortification. Conversely, if he did write on geometry, human proportions, architecture and fortification the results were bound far to outgrow the purposes of a "Malerbuch."

However, Dürer was not only a geometrical genius and a great technician, he also was a thinker; and, no matter how specialized and at times abstruse his researches became, he never lost sight of those fundamental problems which, later on, were to constitute the domain of what is, not very felicitously, called Aesthetics. He first attempted to discuss these problems in an essay, started afresh and rewritten time and again but never completed, which was to serve as an Introduction into the treatise on human proportions prepared for publication in

1512/13. When he resumed his work in later years—with particular intensity in 1523—he decided to develop these earlier drafts into an exhaustive and self-contained chapter to be appended to the Third Book of the *Vier Bücher von Menschlicher Proportion*, that is to say, at the end of the theory of proportions proper (the Fourth Book, we remember, being devoted to the theory of movement). It is in this "aesthetic excursus," as it is commonly referred to, that we find the final statement of what may be called Dürer's philosophy of art.

MANY POINTS OF DÜRER'S DOCTRINE—which is, of course, not a "system" but an organism of living, interpenetrating and, in part, conflicting thoughts—belong to the basic tenets of the Early and High Renaissance. Like all his Italian contemporaries and predecessors, Dürer demanded verisimilitude and was specific in his repeated exhortations to observe those "strange lines" which delimit "the brow, the cheeks, the nose, eyes, mouth and chin with their indentations, projections and individual shape," to elaborate on the smallest details, and "not to omit the tiniest wrinkles and prominences" ("Ertlein," rendered as "globuli" by Camerarius whose splendid translation is indispensable for the understanding of Dürer's archaic German). Like them, he felt, and never ceased to feel, that the highest aim of art was to capture the beauty of the human body; for he believed that "above all things we love to see a beautiful human figure," and it had been for this very reason that he had decided "first to work on human proportions and to write about other things later if God gives me time." Like them, he was convinced that neither beauty nor even verisimilitude could be attained without that theoretical knowledge or insight which he calls "art" in the narrower sense; for he had realized that practice without "art" was a "deception" or a "prison" (that is, a place both lightless and confined) while, on the other hand, "art" could not "grow" and would "remain hidden" without practice. Like them, finally, he trusted geometry with the power of dispelling "errors" and "wrongness" and of "proving things to be right," though he found himself compelled to admit that this power was limited and that many things "had to be left to human opinion." When Dürer says "But if thou hast no right foundation it is impossible for thee to make something correct and good even though thou mayst have the greatest practice and freedom of hand in the world," he is in complete agreement with Leonardo who wrote: "Those who are enamored of practice without science are like sailors who board a ship without rudder and compass, never having any certainty as to whither they go." When he asserts that the hand of an artist whose "head is full of 'art'" ("scientia plenus," as the Latin translation puts it) will be "obedient" so that "thou wilt not do a stroke or blow in vain . . . and needst not think about it very long," he almost literally repeats a sentence of Leone Battista Alberti: "And the mind, stimulated and warmed up by practice [*exercitatione*], will apply itself quickly and adroitly to the work, and that hand will follow most speedily which is well guided by the unerring insight of the mind [*ragione d'ingegno*]."

In other respects, however, Dürer's ideas were heretical rather than orthodox from the point of view of the rank and file of Italian theorists. With all his longing for beauty, he

did not accept that kind of idealism which requires the artist always to embellish or, as Alberti literally says, to "emend" reality and "not only to give lifelikeness to all the parts but also to add beauty because in painting loveliness is not so much desirable as necessary." He felt, on the contrary, that the crude, the ugly, the fantastic and even the monstrous had their legitimate place in art, and he attributed, as we shall see, a peculiar virtue to those who can display their skill in "coarse and rustic things." Nor did he share Alberti's belief that one objective norm of beauty could be laid down in one canon. He had come to realize that perfect or absolute beauty (in Camerarius's translation of the *Vier Bücher* the expression "rechte Hübsche" is actually rendered by "absoluta pulchritudo") transcends the human mind and is known only to God, the "Master of all beauty," as the *Book of Wisdom* has it; that it does not reside in any individual body and reveals itself to the mortal eye in many shapes according to taste and changing conditions. In this respect he sided with Leonardo da Vinci who demanded, above all other things, variety ("varietà," rendered by "Unterschied" in Dürer's writings); who gave advice as to the representation of beauty, not by way of a decree valid under all circumstances but only "in case thou wantst to make a figure showing gracefulness"; and who contended that there was not one Beauty but as many beauties as there were beautiful faces and competent judges: "Facial beauty can be of equal excellence, yet divers in shape, in different persons; therefore it is of as many varieties as the number [*scil.*, of faces] to which it adheres." And: "As there are different beauties, all of equal grace, in different bodies, different judges of like intelligence will judge them to be of great variety among themselves, each according to his predilection."

However, Dürer did not approach the writings of his Italian predecessors as an eclectic who would pick out whatever utterance seemed plausible to him, now taking sides with Alberti, and now with Leonardo, as the case may be. Being, as it were, an "outsider" and therefore unencumbered by an established tradition which demanded either adherence or opposition, he was free to accept or to reject according to his personal experiences and convictions; and the very freedom of this choice was bound to make him critical where Alberti had been naïvely dogmatic, and Leonardo no less naïvely skeptical. Alberti believed in absolute beauty and thought of it as a prerequisite of artistic value; Leonardo believed in relative beauty and disregarded rather than expressly denied the contention that "in painting loveliness was not so much desirable as necessary." But neither of them was worried by the question whether and to what extent the concept of beauty had a determinable significance in art. Alberti's position precluded such a question by definition, and Leonardo did not even think of posing it: after having proved the relativity of beauty both on objective and subjective grounds, he considered the case as closed. Like Raphael who, in matters of beauty, trusted "a certain idea" which "came into his mind," and of which he "did not know whether it contains any artistic excellence," he did not conceive of reality as a bewildering mass of phenomena which had to be conquered by a philosophical effort, but as a cosmos, ordered by "necessity," which could be penetrated by simple "experience." "Good judgment," he says, "comes from good understanding, and good understanding comes from

a principle derived from good rules, and good rules are the daughters of good experience, the common mother of all sciences and arts."

Dürer, however, thought of reality as something infinitely enigmatical, holding some sort of secret which had to be "pulled out." To his way of thinking truth was "hidden" or, still more significantly, "buried" in nature; and we can easily see that, from this point of view, the realization that beauty was relative could not put an end to the discussion but merely placed it on a new basis.

In the first place, Dürer explicitly stated, in sharp and deliberate contrast with the Albertian doctrine, that there was a fundamental difference between the aesthetic value of the object represented in a work of art, and the aesthetic value of the work of art itself: "Therefore I leave it to anybody," he wrote about 1523, "whether he wishes to make beautiful or ugly things, for every workman must be able to make a noble or rustic figure; he is a great artist who can give evidence of his true power and 'art' in coarse and rustic things." And, in 1528: "It must be noted, however, that a well-instructed and experienced artist may show more power and insight in a coarse, rustic image of small size than another in his great work" ("Etsi peritus exercitatusque artifex in minime subtili ac in exiguo opere quid possit ingenium et ars magis et melius probarit quam alius in grandi et subtili").

In the second place, Dürer, having resigned himself to the fact that mortals will never attain to that Beauty which is known only to God, all the more earnestly sought to determine the criteria of that beauty which can be known to men. After having dwelt on that rich variety ("Unterschied") of human shapes which is the subject of the whole Third Book, Dürer concludes with the statement that some of these varieties are ugly while others are beautiful, and therewith prepares the reader for the decisive question: "When we now ask how to produce a beautiful figure. . . ." In this connection appear the famous sentences: "I believe that there is no man alive who might think out the maximum of beauty in the lowliest living creature, let alone in man who is a special creation of God and master of the other creatures. This I admit that one man may contemplate and produce a figure *more* beautiful than can another, and may demonstrate it with good natural reasons plausible to our understanding; but not to that extent that it could not be *still* more beautiful. For this does not enter the mind of man."

Having thus established that the original question is not answerable, or rather that it was posed under an erroneous assumption—for, instead of asking "how to attain absolute beauty" it should have been asked "how to attain relative beauty"—and having ironically dealt with those who still might claim to know "which the right measure is and none other," Dürer deliberately proceeds to restate the problem. "Now," he says, "since we cannot attain to the *very best*, shall we give up our research altogether? This beastly thought we do not accept. For, men having good and bad before them, it behooves a reasonable human being to concentrate on the *better* ("meliora capessere quamvis optima negata sint," as Camerarius puts it). So, then, let us ask how a *better* figure may be made. . . ."

Even with this qualification, it was not easy for Dürer to define the criteria—or, as he expresses it, the "parts"—of beauty. In the drafts of 1512/13 he had considered three such criteria: utility or, as we would call it in the language of today, "function" ("Nutz"); naïve approval ("Wohlgefallen"); and the rule of the happy medium ("Mittelmass" or "recht Mittel"). Utility means that there is neither a deficiency ("Mangel") such as the absence of a leg, a lame foot or a crippled arm, nor a superabundance ("Ueberfluss") such as the presence of a third eye or hand. Naïve approval means, not the individual sanction of any one man, least of all of the painter who is too easily swayed by a personal predilection similar to a mother's love for her own child, but a kind of *consensus omnium*: "What all the world holds to be beautiful, that we shall think beautiful, too, and shall endeavor to produce it." The rule of the happy medium, finally, means, we remember, that a round head is more beautiful than a flat or a pointed one, that the movements must neither be "sleepy" nor rash ("frech"), etc.: "Between too much and too little there is a right mean; this thou must try to hit upon in all thy works."

The criterion of utility still figures prominently in Dürer's later drafts and in the "aesthetic excursus." Approval, however—even in the sense of a general consensus—was discarded altogether ("But if we ask how to make a beautiful image, some will say: according to the judgment of men; but others will not admit this, and neither will I"); and the rule of the happy medium, though still maintained and eloquently exemplified by the physiognomical contrasts which have been discussed, was qualified by the statement: "This does not prove that every mean between all things is the best; I only propose to apply it to certain things, as if one says 'this is too long or too short a face, or, with regard to parts, this is too long, too short, too bulging or too concave a forehead.' " Dürer had come to realize that, as far as beauty is concerned, the judgment of many men could not be trusted any more than that of one—it is only with respect to errors of fact that he remained willing to accept the verdict of Apelles's cobbler; and he had finally discovered that the rule of the happy medium was only the corollary of a concept which had been barely touched upon in his drafts of 1512/13, but which was ultimately to become the leading principle of his theory of beauty.

This concept—developed by the Stoics, unquestioningly accepted by a host of followers from Vitruvius and Cicero to Lucian and Galen, surviving in medieval Scholasticism and ultimately established as an axiom by Alberti who does not hesitate to term it the "absolute and primary law of nature"—was the principle called συμμετρία or ἁρμονία in Greek, "symmetria," "concinnitas" or "consensus partium" in Latin, "convenienza," "concordanza" or "conformità" in Italian, and "Vergleichung" or, more frequently, "Vergleichlichkeit" in Dürer's German. It meant, to quote Lucian, the "equality and harmony of all parts in relation to the whole," or, to quote Alberti, that which is achieved if "all the members, in size as well as in function, kind, color and other similar things concur toward one beauty."

That this principle of harmony, congruity or "symmetry" (in the original, now obsolescent sense) implies the rule of the happy medium would be evident even if Galen had not expressly said: "We will mentally experience as 'symmetrical' whatever is equally removed

from either extreme." For, since the excessive greatness or smallness of any one part would destroy the harmony of the whole, the harmony of the whole necessarily depends on the "medial" character of the parts and vice versa. It is therefore quite logical for Dürer to affirm, in trying to define what he means by "Vergleichlichkeit": "As everything must be appropriate and right in itself, so the entire ensemble [*die ganze Versammlung*] must harmonize [*sich wohl zusammen vergleichen*]; thus the throat must well rhyme with the head and shall be neither too short nor too long, neither too thick nor too thin."

In one respect, however, the principle of harmony transcends that of the happy medium: it covers not only that which can be expressed in terms of "too much" or "too little" but also that which can be expressed only in terms of "this" or "that"; in other words, not only quantity but also quality. Alberti is careful to define his "convenienza" as a congruity in "size" on the one hand, and in "function, kind [*specie*], color etc." on the other, and he goes on to specify the concept of "kind" by warning the artists not to represent Helena or Iphigenia with elderly and gnarled hands, or Ganymede with a wrinkled forehead and the thighs of a stevedore. Leonardo, basing himself on Alberti, but significantly omitting his classical examples, repeatedly stresses the same idea: "By quality we mean that, in addition to the correspondence of the measurements to the whole, thou must not mix the members of young persons with those of old ones, nor those of fat people with those of lean ones; and, further, that thou must not give feminine members to males or mix graceful members with awkward ones."

This principle of "convenienza," "concordanza," "conformità" or "Vergleichlichkeit," then, covering as it did both the symmetry of proportions and the accordance of qualities, was Dürer's final refuge in his quest for the criteria of beauty. "But in all these things," he sums up his discussion of physiognomics, "I believe the harmonious things [*die vergleichlichen Ding*, rendered by a simple *convenientia* in Camerarius's translation] to be the most beautiful ones; the other, extravagant things [*die andern abgeschiednen Ding—aliena et praerupta*], though causing astonishment, are not all lovely"; and almost a full page of the "aesthetic excursus" is devoted to paraphrases of Alberti's and Leonardo's admonitions not to mix the masculine with the feminine, the fat with the lean, the "smooth, even and full" forms of youth with the "uneven, gnarled, warped and emaciated" forms of old age. As we have seen, Dürer extended the postulate of "Vergleichlichkeit" even to the handling of color: he requested that each color be shaded with a color which harmonizes ("sich vergeleich") therewith, yellow with a darker yellow, red with a darker red, etc., and thereby rejected, for the sake of a theoretical principle, the more progressive method of modelling with complementary colors which had been practiced in the Netherlands for more than a century and was particularly in favor with the Antwerp School at the time of his writing.

One question, however, remained as open as before: the question of *which* proportions were "harmonious" or "symmetrical." That an athletic, youthful body would not fit in with an aged, wrinkled face or that, to quote one of Dürer's more picturesque examples, "a figure must not be made young in front and old behind, and vice versa" is more or less obvious and,

in fact, a common rule of nature rather than a specific requirement of beauty. But whether one-twentieth or one-twenty-first of the total length is the more satisfactory diameter of a knee cannot be verified by objective observation. How, then, can we "arrive at a good proportion and thereby implant, in a measure, beauty in our work?" Dürer, clearly perceiving the difficulty, excluded two possibilities from the outset: the "good proportion" cannot be derived from any individual person ("thou canst not take it from a single human being, for there is nobody alive on earth who has all the beauty about him"; and, later on: "one does not often find a person with all his members well shaped, for every one has some fault"). Nor can it be established *a priori*, for: "Some talk about how human beings ought to be . . . ; but I consider nature as master and human fancy as a fallacy; once for all the Creator has made men as they should be, and I hold that the true shapeliness and beauty is inherent in the mass of all men; to him who can properly extract this [or "can extract the right measure": *der das recht herausziehen kann*] I will give more credence than to him who wants to establish a newly thought-up proportion [*eine neu erdichtte Mass*] in which human beings have had no share."

There remains, then—as indicated by the verb "to extract" ("herausziehen")—a process of selection which does justice to the natural data without tying down the artist to any particular case. At the beginning, Dürer's interpretation of this process was influenced, to some extent, by an immortal anecdote quoted *ad nauseam* in Renaissance writing and then justly ridiculed by men like Bernini and Francis Bacon: Zeuxis, when asked to paint a Venus —or Helen—for the city of Croton, was said to have used the five—or seven—most beautiful virgins in town as models, selecting the most beautiful part of each for the corresponding part of his picture, and thus achieving the "perfect composite": "If thou wantst to make a good figure," Dürer writes in 1512, "thou must take the head from some, the breast, arms, legs, hands and feet from others, thus exploring all kinds throughout all members; for, from many beautiful things one gathers something good in a similar way as the honey is collected from many flowers." Later on, the still somewhat "Zeuxian" idea of combining the measurements of single heads, breasts and arms gave way to the more subtle concept of collecting, comparing, averaging and tabulating the dimensions of many whole bodies, generally believed to be beautiful. The final version of the above sentence (in the "aesthetic excursus") thus reads as follows: "To me, the most effective method seems to take thy measures from many living human beings; but choose people therefor who are regarded as beautiful, and such thou must copy with all possible diligence; for, from many different persons a knowledgeable man may collect something good throughout the parts of their members." It is obvious that the clause "but choose people therefor . . ." opens a back door, so to speak, to the much-maligned *consensus omnium*: the persons from whom the beautiful proportions are to be derived have to be approved by public opinion before being measured just as had been the case with the virgins of Croton before being painted. But Dürer cannot be blamed for having been unable to escape from one of those circles the seeming viciousness of which is in reality the inevitable consequence of what the philosophers call an "organic situation."

Be that as it may, in Dürer's opinion the process of selection was the best method of avoiding both the Scylla of the "newly thought-up proportion in which human beings have had no share" and the Charybdis of the dependence on one individual and necessarily faulty model. Now, had this process always to be carried out by rational and purposeful research? Dürer's answer is: No. He thought it perfectly possible that an experienced master can solve the task of "fusing that, which is scattered, into one," as Aristotle admirably puts it, by an *inward* selection instead of an *outward* one—by an intuitive synthesis in the artist's mind or eye instead of an analytical operation with compasses, rulers and statistical tables: "It is not my opinion that an artist has to measure his figures all the time. If thou hast learned the art of measurement and thus acquired theory and practice together . . . then it is not always necessary to measure everything all the time, for thy acquired 'art' endows thee with a correct eye [*gut Augenmass*]" ("Quin etiam de arte oculi instructi pro regula esse incipiunt"—"thy eyes, instructed by 'art,' will begin to operate as a rule," to quote once more from Camerarius's translation).

Thus reinterpreted as a process of inward and intuitive synthesis, the principle of selection assumed a much wider and indeed fundamental importance in Dürer's philosophy. Not only did it seem to enable the competent artist to arrive at a good—not "newly thought-up"—proportion without actually "measuring everything," and thus to capture beauty as far as humanly possible: it also seemed to enable him to produce all kinds of valid—not "arbitrary" or "purely private"—images without resorting to natural models, and thus to bring forth "new creatures" at will. This is what Dürer means by that "painting out of one's head without all other aid" which he believed to be the ultimate consummation of his art (it was to be treated, as we have seen, in the last chapter of his never written "Büchle" on painting); and this is what he thus describes in the most widely known passages of the "aesthetic excursus": "But life in nature manifests the truth of these things. Therefore observe it diligently, go by it and do not depart from nature arbitrarily, imagining to find the better by thyself, for thou wouldst be misled. For, verily, 'art' [that is, knowledge] is embedded in nature; he who can extract it has it. If thou acquirest it, it will save thee from much error in thy work [*Dann wahrhaftig steckt die Kunst in der Natur, wer sie heraus kann reissen, der hat sie. Überkummst du sie, so wirdet sie dir viel Fehls nehmen in deinem Werk—Prorsus enim in natura demersa est ars, quam si extrahere potueris, iam adeptus errores multos vitaveris in opere tuo*]. . . . Therefore, never put it in thy head that thou couldst or wouldst make something better than God has empowered His created nature to produce. For thy might is powerless against the creation of God. Hence it follows that no man can ever make a beautiful image out of his private [*eigen*] imagination unless he have replenished his mind by much painting from life. That can no longer be called private [*Eigens*] but has become 'art' acquired and gained by study [*überkummen und gelernte Kunst—acquisitum ac comparatum studio artificium*], which germinates, grows and becomes fruitful of its kind. Hence it comes that the stored-up secret treasure of the heart [*versammlet heimlich Schatz des Herzens—reconditus in mente thesaurus*] is manifested by the work and the new creature

which a man creates [*schöpft—concipit*] in his heart in the shape of a thing. This is the reason an experienced artist needs not copy from life for every picture; for, he sufficiently pours forth what he has stored up from the outside for a long time." And: "The mind of artists is full of images which they might be able to produce; therefore, if a man properly using this art and naturally disposed [*genaturt*] therefor, were allowed to live many hundred years he would be capable—thanks to the power given to man by God—of pouring forth and producing every day new shapes of men and other creatures the like of which was never seen before nor thought of by any other man" ("Animus artificum simulacris est refertus, quae omnia incognita prius [!] cum in humanis tum aliarum rerum effictionibus in dies prolaturus sit, si cui forte multorum seculorum vita et ingenium [!] ac studium artis huius ususque divinitus contigerit").

THESE TWO JUSTLY FAMOUS PASSAGES—in which the inward selection or intuitive synthesis ceases to be a mere process of coordination and purification and assumes the character of a "creative" power—grew out of the following sentences penned in 1512: "The art of painting is hard to acquire. Therefore, who does not find himself gifted therefor should not undertake it, for it will come from influences from above [*öbere Eingiessungen*, meaning, according to common usage, the influences of the stars]. . . . This great art of painting has been held in high esteem by the mighty kings many hundred years ago. They made the outstanding artists rich and treated them with distinction because they felt that the great masters had an equality with God, as it is written. For, a good painter is inwardly full of figures [*inwendig voller Figur*], and if it were possible for him to live on forever he would always have to pour forth something new from the inner ideas of which Plato writes."

That this passage is the nucleus of the two later ones cannot be questioned: the phrases "full of figures," "to pour out something new" ("etwas Neus auszugiessen") and "if it were possible for him to live on forever" recur almost word for word in the final versions. Yet there is a remarkable difference which sheds an interesting light on Dürer's development between 1512 and 1528. In the "aesthetic excursus" the artist is no longer likened to God but merely credited with a "power given by God." His special talents are no longer accounted for by "influences from above" but, less astrologically, by a natural disposition ("genaturt"). And, still more important, the mysterious fountainhead of inward images "the like of which was never seen before"—it should be noted that the German verb "schöpfen" means both "to create" and "to draw water from a well"—is no longer thought of as a flow of notions *a priori* but as an accumulation of *a posteriori* experiences—as a "treasure," "stored up from without" instead of "the ideas of which Plato writes." In other words: what appears, in the "aesthetic excursus," as a *theory of selective inward synthesis* had originally been conceived as a *theory of spontaneous inward creation* and had assumed its final form only by way of a compromise after the fact.

This compromise can be accounted for, first, by Dürer's growing awareness of the fact that the doctrine formulated in 1512 had to be moderated in order to remain compatible with

the dogma of rational naturalism; second, by his conversion from a humanistic and therefore more or less anthropocentric point of view to the uncompromisingly theocentric convictions of Luther. To introduce the Platonic ideas led, or at least might lead, to the emancipation of the artist from reality—as actually stated by Plotinus when he wrote: "Phidias has formed his *Zeus*, not after anything visible, but in such a way as Zeus himself would appear were he to show himself to human eyes"; and to compare or even equate the painter with God would have seemed blasphemous from Dürer's later point of view. The medieval scholastics had not infrequently drawn an apparently similar parallel, but not in order to exalt the artist by comparing his production with the creation of God, but to make the creation of God more understandable by comparing it with the production of the artist; Thomas Aquinas had been especially careful to distinguish between the genuine "ideas" in the mind divine and the "quasi-ideas" in the mind of a sculptor or architect. It was only in the proud thought of the Renaissance that this metaphorical comparison was twisted into a glorification of the artist, as when Leonardo writes: "The divine nature of the painter's science transforms the painter's mind into an image of the mind divine, since he [or "it"], with free power, proceeds to the production [*generatione*] of various entities, divers animals, plants, fruits, lands, regions and so forth."

However, with Leonardo the medium of comparison is the painter's "scientia," his "science." He shares with God the insight into the universal principles which underlie the individual things in nature and is thus able to "generate"—not to "create," which expression Leonardo deliberately avoids, as though remembering the distinction laid down by Thomas in *Summa Theologiae* I, 45, 5—as many specimens as he sees fit; there is, at bottom, no contradiction between this statement of Leonardo's and his other, more famous, assertion to the effect that "the mind of the painter must resemble a mirror which permanently transforms itself into the color of its object and fills itself with as many images as there are things placed in front of it." With Dürer, on the other hand, the medium of comparison is not the painter's ability to reproduce all that is, but his ability to call into being something that never was. He shares with God the power to "create"; and the very "ideas of which Plato writes" appear in Dürer's text, not as the unchangeable foundation of knowledge, but as the inexhaustible source of novel inventions, "incognita prius."

The passage of 1512 does not only go farther in its assertion of creative originality than the "aesthetic excursus," it also goes farther than the sources from which it is derived. It is composed, almost verbatim, of two sentences, both Platonizing (though not Platonic) in character, one of which is found in Seneca, and the other in Marsilio Ficino. Seneca writes *"Plenus hic figuris* est, quas *Plato ideas* appellat"* ("he is full of figures which Plato calls ideas"), and Ficino: "Unde *divinis influxibus* oraculisque repletus *nova quaedam inusitataque semper excogitat"* ("thus full of divine influences and oracles he always thinks out what is new and unheard-of"). But Seneca speaks of God Himself, and Ficino of philosophers, poets and prophets. It was for Dürer—encouraged, perhaps, by Agrippa of Nettesheim, who, we remember, was the most important intermediary between Ficino and Germany,

and who had already dared to include architects, painters and other "craftsmen" among those who may become inspired by the Saturnian "furor melancholicus"—to claim for artists what the Florentines had reserved for "seers" ("vates"): the quality of genius.

Marsilio Ficino had not cared for art and—as a true Platonic—could not care for art, and the Italian artists and art theoreticians had originally not cared for Ficino; Leonardo, the "scientist," would have been much surprised, and possibly somewhat offended, had anybody called him a "genius." It was not until the middle of the sixteenth century that a great sculptor and painter, named Michelangelo, could be called "divino," and some more decades had to pass before the philosophers of Mannerism, such as Giovanni Paolo Lomazzo, could transform Ficino's theory of beauty, celestial influences and "creative" ideas into a metaphysics of art. Dürer, however, could fuse the Neo-Platonic theory of genius with the axioms of German mysticism—the acceptance of the irrational, the idea of a direct communion or even fusion with the mind divine, and the respect for the irreducibly individual—into what may be called, with all due reservations, a Proto-Romantic interpretation of art.

If carried a little farther, this interpretation would have jeopardized—and, in fact, did jeopardize, when the time had come—the very *raison d'être* of any general and scientific theory of art, including Dürer's own lifelong researches in the field of geometry and human proportions. For, if the talent for painting was really a gift infused into a chosen few by "influences from above" or by the grace of God; if the truly creative power of an artist resided in the "ideas of which Plato writes"; if his chief virtue was to "pour forth" something "new" the like of which had never been in the mind of any other man: what could be the use of those mathematical disciplines which, to quote Federigo Zuccaro, the champion of "inward design," are not only tedious but also "enslave the mind of the artist to mechanical restrictions and deprive it of judgment, spirit and savor?" Why should it be necessary to bother about "rules" at all since, as Giordano Bruno was to write in 1585, there are as many rules as there are geniuses?

That Dürer himself was not unaware of this danger is evident from his later attempt at softening down the anti-naturalistic and anti-rational accent of what he had written, in 1512, under the fresh impact of Neo-Platonic doctrines and with the *Melencolia I* already germinating in his mind. But even the less radical and, so to speak, de-Platonized versions of his original statement, with the "influences from above," the "ideas" and the name of Plato left out, oppose creativeness to imitation, originality to "demonstrable" rules, the value of the gifted individual to the value of general, teachable principles. Even in the "aesthetic excursus" Dürer maintains the power of the artist—well-instructed, to be sure, but also "naturally disposed therefor"—to create a "new creature in his heart" and to "pour forth something new"; and when discussing the problem of beauty and ugliness he could not resist the temptation to restate the individualistic and—here for once admittedly—mystical aspect of his convictions in a manner which he himself acknowledged to be startling and understandable only to his peers.

He had established, as we have seen, that the aesthetic value of a work of art is not contingent upon the aesthetic value of its object—in other words, that a picture representing a "coarse" or even ugly figure may be better than a picture representing a beautiful one. From the point of view of the layman this statement was—and, to a degree, still is—shocking enough. But Dürer, with a bold *metabasis eis allo genos*, went a considerable step farther. As he had separated the commonly overestimated value of the natural object from the value of the work of art, so he separated, within the artistic sphere itself, the equally overestimated external qualities of the work—size, medium and careful execution—from its internal or, as we would say, "purely artistic" ones. "The right masters," he says, "will understand this speech, that I speak the truth: that a man of minor insight will not achieve in a beautiful work what another will achieve in a plain one; this is the reason one man sketches something with his pen on a paper in one day and is a better artist than another who strenuously labors at his work for a year" (about 1523). And, in the somewhat amplified and even more emphatic version of the "aesthetic excursus," directly following the sentence quoted on p. 275, line 14: "Only the powerful artists will be able to understand this strange speech (*Haec inusitata novaque aliis facile ac soli intelligent potentes intellectu et manu*), that I speak the truth: one man may sketch something with his pen on half a sheet of paper in one day, or may cut it into a tiny piece of wood with his little iron, and it turns out to be better and more artistic than another's big work at which its author labors with the utmost diligence for a whole year. And this gift is miraculous [*wunderlich*]. For, God often gives the ability to learn and the insight to make something good to one man the like of whom nobody is found in his own days, and nobody has lived before him for a long time, and nobody comes after him very soon."

We take it for granted that a pen-and-ink sketch by Rembrandt is worth more than a five by seven yards canvas by Ferdinand Bol. But in Dürer's time, when his own paintings were evaluated, more or less, on the basis of the cost of the materials and the number of working hours, his statement was, indeed, a "strange speech"; and even in Italy the time had not yet come for the drawings of great masters to be looked upon with that mixture of aesthetic admiration and almost sentimental affection with which we are in the habit of approaching them. When Aretino already begged for a scrap of paper hallowed by the pencil of Michelangelo—the first "divino"!—Vasari still collected drawings from a purely historical point of view and put them in an enormous volume which, however much cherished, was little more than a corollary to his biographies. In Dürer's sentences we have a remarkable anticipation of the modern point of view, and this attitude was not only stated in a theoretical way but also governed his practice as an artist and, if one may say so, as a collector. He was the first to sign and date a large percentage of his own studies and sketches even if he had no intention of selling them or giving them away; he inscribed several of them with notes regarding the subject and the circumstances of execution—as in the portrait of Maximilian I (1030), made "high up in the palace in his tiny little cabinet"—and he did the same with the drawings of other, mostly earlier artists which he systematically

acquired and preserved (see, e.g., our nos. 629, 1235, 1277). In one instance he expressly stated that he had written the inscription "in honor of the author" who in this case was Martin Schongauer.

To some extent all this can be accounted for by the specifically Germanic preference for the particular as against the universal, for the curious as against the exemplary, and for the personal as against the objective; and this explains the fact that the signing and dating of drawings did not become the fashion in Italy even after hero-worship had been extended to artists. It is illuminating that no European language has an equivalent for the German words "Handriss" and "Handzeichnung" ("hand-drawing") which stress the fact that the hand of an individual person has rested on this very piece of paper, imparting to it a sentimental value not unlike that of a personal souvenir or even a relic—a hand-written letter, a hand-signed document, a hand-embroidered handkerchief. But in Dürer's case this general German propensity was merely the fertile soil on which could thrive the seeds of the Italian doctrine of genius. This is confirmed by his "seltsame Red" which clearly indicates that he looked upon a drawing as the most distinctive manifestation of that divine, or, as he puts it, "miraculous," gift which raises the "great" artist above all others.

How this reverence for genius could merge in Dürer's mind with what may be called the spirit of relic-worship is illustrated by an almost pathetic incident. In 1515 Raphael had sent him a stately sanguine drawing showing two splendidly posed and modelled nudes. Dürer first noted on it the date of receipt, and after Raphael's death in 1520 he characteristically added the following *in memoriam*: "Raphael of Urbino, who was so highly esteemed by the Pope, has made these nudes and has sent them to Nuremberg, to Albrecht Dürer, in order to show him his hand." Now, modern critics have come to realize that this drawing was never made by Raphael himself. They have rightly ascribed it to a member of his workshop (either Francesco Penni or, more probably, Giulio Romano) and have hence concluded that the inscription was a forgery. This conclusion, however, is erroneous. The inscription is unquestionably written by Dürer. He himself was mistaken, and this mistake shows more than anything the irreconcilability of his point of view with that of his Italian fellow-painter. For Raphael it was a matter of course to present his German colleague with the best available specimen of a *style* for which he felt responsible, no matter whether the manual execution was his or a pupil's. Dürer, on the contrary, took it for granted that an Italian master, whom he respected and loved, could only have wanted to "show him his *hand*"—the hand of an individual chosen by God.

SELECTED BIBLIOGRAPHY

Selected Bibliography*

GENERAL INFORMATION

Bibliographies

1. H. W. Singer, *Versuch einer Dürer Bibliographie* (Studien zur Deutschen Kunstgeschichte, 41), 2nd edition, Strassburg, 1928.

2. G. Pauli, Die Dürer-Literatur der letzten drei Jahre, *Repertorium für Kunstwissenschaft*, XLI, 1919, p. 1-34.

3. H. Tietze, Dürerliteratur und Dürerprobleme im Jubiläumsjahr, *Wiener Jahrbuch für Kunstgeschichte*, VII, 1930/31, p. 232-259.

4. E. Römer, Die neue Dürerliteratur, in: *Albrecht Dürer, Festschrift der internationalen Dürerforschung, herausgegeben vom "Cicerone"* (G. Biermann, ed.), Leipzig and Berlin, 1928, p. 112-132.

Corpuses, Editions and Catalogues of Dürer's Works of Art

WORKS IN ALL KINDS OF MEDIA

5. H. Tietze and E. Tietze-Conrat, *Kritisches Verzeichnis der Werke Albrecht Dürers*; vol. I (*Der junge Dürer*), Augsburg, 1928; vols. II, 1 and 2 (*Der reife Dürer*), Basel and Leipzig, 1937 and 1938, respectively.

6. *The Dürer Society* (C. Dodgson, G. Pauli and S. M. Peartree, eds.), London, 1898-1911.

*7. W. M. Conway, *The Art of Albrecht Dürer (Catalogue of an Exhibition in the Walker Art Gallery)*, Liverpool, 1910.

8. G. Pauli, *Dürer-Ausstellung in der Kunsthalle zu Bremen, October, 1911; Seine Werke in Originalen und Reproduktionen, geordnet nach der Zeitfolge ihrer Entstehung*, Bremen, 1911.

9. *Katalog der Albrecht Dürer-Ausstellung*, Nuremberg, 1928.

PAINTINGS, WOODCUTS AND ENGRAVINGS

10. *Dürer; Des Meisters Gemälde, Kupferstiche und Holzschnitte* (Klassiker der Kunst, IV), 4th edition (F. Winkler, ed.), Stuttgart and Leipzig, 1928 [The previous editions (V. Scherer, ed.) are so full of errors that their usefulness is seriously impaired].

PAINTINGS

11. B. Riehl, *Die Gemälde von Dürer und Wohlgemut in Reproduktionen*, Nuremberg, 1887-1896 [A supplement (T. Schiener and H. Thode, eds.), Nuremberg, 1895/96, contains only a few genuine pieces].

PRINTS IN GENERAL

12. J. Meder, *Dürer-Katalog; Ein Handbuch über Albrecht Dürers Stiche, Radierungen, Holzschnitte, deren Zustände, Ausgaben und Wasserzeichen*, Vienna, 1932.

* This selection from several thousand books and articles concerning the life and works of Albrecht Dürer is necessarily and admittedly subjective and further impaired by the recent disruption of the physical and intellectual communication lines with Europe. It is hoped, however, that the contributions included will enable the reader both to control and to go beyond what has been said in the text. Asterisks indicate, first, contributions which, though published more than a generation ago—that is to say, before 1910—are still indispensable for serious research; second, contributions which, though short or inconspicuous, have struck the writer as fundamentally important. References of a more specialized character may be found in the Handlist.

ENGRAVINGS (INCLUDING DRY POINTS AND ETCHINGS)

13. G. Duplessis, *Oeuvre de Albert Durer, reproduit et publié par Amand-Durand*, Paris, 1877.

14. F. F. Leitschuh, *Albrecht Dürer's Sämtliche Kupferstiche*, Nuremberg, 1892, 1900.

*15. S. R. Koehler, *A Chronological Catalogue of the Engravings, Dry-Points and Etchings of Albrecht Dürer as exhibited at the Grolier Club*, New York, 1897.

16. *Albrecht Dürers sämtliche Kupferstiche in Facsimilenachbildungen* (J. Springer, ed.), Munich, 1914.

17. C. Dodgson, *Albrecht Dürer* (The Masters of Engraving and Etching), London and Boston, 1926 [With illustrations of all engravings, dry points and etchings].

18. H. Heyne, *Albrecht Dürers sämtliche Kupferstiche in der Grösse der Originale*, Leipzig, 1928.

19. *Albrecht Dürers sämtliche Kupferstiche* (Preface by H. Wölfflin), Munich, 1936.

For reproductions of the Engraved Passion see Singer's Bibliography (quoted as no. 1), pp. 22 and 30 ss.

WOODCUTS

*20. C. Dodgson, *Catalogue of Early German and Flemish Woodcuts in the British Museum* (2 vols.), London, 1903, 1911 (*Index* by A. Lauter, Munich, 1925).

21. W. Kurth, *Dürers sämtliche Holzschnitte* (Preface by C. Dodgson). First German edition: Munich, 1927 (reprinted 1935); English edition: London, 1927; an inexpensive, not very satisfactory reprint of the latter: New York, 1946.

22. *Albrecht Dürers sämtliche Holzschnitte* (O. Fischer, ed. and pref.), Munich, 1938.

For reproductions of individual woodcuts and series of woodcuts see Singer's Bibliography (quoted as no. 1), pp. 23 ss. and 30 ss.

DRAWINGS (COMPLETE CORPUSES)

*23. F. Lippmann, *Zeichnungen von Albrecht Dürer in Nachbildungen* (7 vols., vols. VI and VII F. Winkler, ed.), Berlin, 1883-1929.

24. F. Winkler, *Die Zeichnungen Albrecht Dürers* (4 vols.), Berlin, 1936-1939.

DRAWINGS (SELECTIONS)

25. H. W. Singer, *The Drawings of Albrecht Dürer*, London, s.a. (1905).

*26. R. Bruck, *Das Skizzenbuch von Albrecht Dürer in der Königlichen Oeffentlichen Bibliothek zu Dresden*, Strassburg, 1905 [Cf. the reviews by L. Justi, *Repertorium für Kunstwissenschaft*, XXVIII, 1905, p. 365 ss. and by A. Weixlgärtner, *Kunstgeschichtliche Anzeigen*, III, 1906, p. 17 ss.; for the history of the manuscript and its interrelation with others, see I. Schunke, Zur Geschichte der Dresdner Dürerhandschrift, *Zeitschrift des Deutschen Vereins für Kunstwissenschaft*, VIII, 1941, p. 37 ss.].

27. H. Wölfflin, *Albrecht Dürers Handzeichnungen*, Munich, 1914 [Several later editions].

28. A. Reichel, *Die Handzeichnungen der Albertina, II; Albrecht Dürer*, Vienna, 1923.

29. J. Meder, *Dürer-Handzeichnungen* (Albertina Facsimile), Vienna, 1927.

30. C. Dodgson, *Dürer Drawings in Colour, Line and Wash . . . in the Albertina*, London, 1928.

31. A. E. Brinckmann, *Albrecht Dürers Landschaftsaquarelle*, Berlin, 1934 [See also no. 111].

Editions of Dürer's Writings

*32. W. M. Conway, *Literary Remains of Albrecht Dürer . . . with Transcripts from the British Museum Manuscripts*, Cambridge, 1889.

*33. K. Lange and F. Fuhse, *Dürers schriftlicher Nachlass*, Halle a.S., 1893.

34. E. Heidrich, *Albrecht Dürers schriftlicher Nachlass*, Berlin, 1908 [Selection from the preceding publication].

35. *Albrecht Dürer, Records of the Journey to Venice and the Low Countries* (R. Fry, ed.), Boston, 1913.

*35a. E. Reicke, *Willibald Pirckheimers Briefwechsel*, I (Veröffentlichungen der Kommission zur Erforschung der Geschichte der Reformation und Gegenreformation, Humanistenbriefe, IV), Munich, 1940 [With palaeographical transcription of Dürer's letters to Pirckheimer].

For editions of the Diary of 1520-21 see nos. 181, 184, 185 of this Bibliography.

Comprehensive Monographs

BIOGRAPHIES

*36. M. Thausing, *Albrecht Dürer; Geschichte seines Lebens und seiner Kunst*, 2nd edition (2 vols.), Leipzig, 1884. The same (first edition) in English: M. Thausing, *Albert Dürer, His Life and Works* (F. A. Eaton, tr., 2 vols.), London, 1882.

37. A. Springer, *Albrecht Dürer*, Berlin, 1892.

38. L. Cust, *Albrecht Dürer; A Study of His Life and Work*, London, 1897.

39. H. Knackfuss, *Albrecht Dürer* (C. Dodgson, tr.), London, 1899/1900 [Much better than the German original].

40. L. Eckenstein, *Albrecht Dürer*, London and New York, 1902.

41. M. Hamel, *Albert Dürer* (Les Maîtres de l'Art), Paris, s.a. (1903/04).

42. T. Sturge Moore, *Albert Dürer*, London and New York, 1905.

43. F. Nüchter, *Albrecht Dürer; His Life and a Selection of his Works* (L. Williams, tr., with a preface by Sir Martin Conway), London, 1911.

44. E. A. Waldmann, *Albrecht Dürer* (3 vols.), Leipzig, 1916-1918.

45. M. J. Friedländer, *Albrecht Dürer*, Leipzig, 1921.

46. T. D. Barlow, *Albrecht Dürer; His Life and Work, being a Lecture delivered to the Print Collectors' Club on November 15, 1922*, London, 1923.

47. H. Wölfflin, *Die Kunst Albrecht Dürers*, 5th edition, Munich, 1926; 6th edition (K. Gerstenberg, ed.), Munich, 1943.

48. P. du Colombier, *Albert Durer*, Paris, 1927.

49. E. Flechsig, *Albrecht Dürer* . . . (2 vols.), Berlin, 1928, 1931.

50. A. Neumeyer, *Dürer* (L. Loussert, tr.), Paris, 1930.

51. W. Waetzoldt, *Dürer und seine Zeit*, Vienna, 1935; 5th edition, Königsberg, 1944.

COMPREHENSIVE WORKS ON DÜRER'S PRINTS AND DRAWINGS

52. A. M. Hind, *Albrecht Dürer; His Engravings and Woodcuts*, New York, 1911.

53. M. J. Friedländer, *Dürer der Kupferstecher und Holzschnittzeichner*, Berlin, 1919.

*54. C. Ephrussi, *Albert Dürer et ses Dessins*, Paris, 1882.

Biographical Details; Dürer's Family and Friends

*55. P. Kalkoff, Zur Lebensgeschichte Albrecht Dürers, *Repertorium für Kunstwissenschaft*, XX, 1897, p. 443-463; XXVII, 1904, p. 346-362; XXVIII, 1905, p. 474-485.

*56. E. Heidrich, *Dürer und die Reformation*, Leipzig, 1909.

57. E. Hoffmann, Die Ungarische Abstammung Albrecht Dürers, *Mitteilungen der Gesellschaft für Vervielfältigende Kunst* (*Die Graphischen Künste*, supplement), LII, 1929, p. 48/49.

58. H. L. Kehrer, *Dürers Selbstbildnisse und die Dürerbildnisse*, Berlin, 1934.

59. G. Pauli, Die Bildnisse von Dürers Gattin, *Zeitschrift für Bildende Kunst*, Neue Folge, XXVI (L), 1915, p. 69-76.

60. H. Beenken, Beiträge zu Jörg Breu und Hans Dürer, *Jahrbuch der Preussischen Kunstsammlungen*, LVI, 1935, p. 59-73.

61. F. Winkler, Hans Dürer; ein Nachwort, *Jahrbuch der Preussischen Kunstsammlungen*, LVII, 1936, p. 65-74 [See also E. Wiegand, Der Hochaltar von Schalkhausen, *Jahrbuch der Preussischen Kunstsammlungen*, LX, 1939, p. 141-149].

62. E. Reicke, *Willibald Pirckheimer*, Jena, 1930.

*63. E. Reicke, Albrecht Dürers Gedächtnis im Briefwechsel Willibald Pirckheimers, *Mitteilungen des Vereins für Geschichte der Stadt Nürnberg*, XXVIII, 1928, p. 363-406.

64. R. Kautzsch, Des Christoph Scheurl "Libellus de Laudibus Germaniae," *Repertorium für Kunstwissenschaft*, XXI, 1898, p. 286/87.

General Problems

WORKING METHODS; PROBLEMS OF REPRESENTATION AND COMPOSITION

65. L. Justi, Über Dürers künstlerisches Schaffen, *Repertorium für Kunstwissenschaft*, XXVI, 1903, p. 447-475.

66. K. Simon, Das Erlebnis bei Dürer, *Zeitschrift des Deutschen Vereins für Kunstwissenschaft*, III, 1936, p. 14-34.

67. E. Heidrich, *Geschichte des Dürerschen Marienbildes*, Leipzig, 1906.

68. W. Suida, *Die Genredarstellungen Albrecht Dürers* (Studien zur Deutschen Kunstgeschichte, 27), Strassburg, 1903.

69. S. Killermann, *Dürers Pflanzen-und Tierzeichnungen und ihre Bedeutung für die Naturgeschichte* (Studien zur Deutschen Kunstgeschichte, 119), Strassburg, 1910.

69a. K. Gerstenberg, *Dürer, Blumen und Tiere*, 2nd edition, Berlin, 1941 (not seen).

70. E. Waldmann, Albrecht Dürer und die Deutsche Landschaft, *Pantheon*, XIII, 1934, p. 130-136.

71. V. Scherer, *Die Ornamentik bei Albrecht Dürer* (Studien zur Deutschen Kunstgeschichte, 28), Strassburg, 1902.

72. K. Rapke, *Die Perspektive und Architektur auf den Dürerschen Handzeichnungen, Holzschnitten, Kupferstichen und Gemälden* (Studien zur Deutschen Kunstgeschichte, 39), Strassburg, 1902.

73. E. Waldmann, *Lanzen, Stangen und Fahnen als Hilfsmittel der Composition in den graphischen Frühwerken Albrecht Dürers* (Studien zur Deutschen Kunstgeschichte, 68), Strassburg, 1906.

See also nos. 195 and 196 of this Bibliography.

DÜRER AND THE "REBIRTH OF ANTIQUITY"

*74. A. Warburg, Dürer und die Italienische Antike (1905), in: A. Warburg, *Gesammelte Schriften*, Leipzig and Berlin, 1932, vol. II, p. 443-449.

75. G. Pauli, Dürer, Italien und die Antike, *Vorträge der Bibliothek Warburg*, 1921/22, p. 51-68.

76. E. Panofsky, Dürers Stellung zur Antike, *Jahrbuch für Kunstgeschichte*, I, 1921/22, p. 43-92 [Also published singly, Vienna, 1922].

77. E. Panofsky, *Hercules am Scheidewege und andere antike Bildstoffe in der neueren Kunst* (Studien der Bibliothek Warburg, XVIII), Leipzig and Berlin, 1930, pp. 166-173, 181-186.

78. A. Warburg, Heidnisch-Antike Weissagung in Wort und Bild zu Luthers Zeiten (1920), in: A. Warburg, *Gesammelte Schriften*, Leipzig and Berlin, 1932, vol. II, p. 487-558.

79. E. Panofsky and F. Saxl, Classical Mythology in Mediaeval Art, *Metropolitan Museum Studies*, IV, 2, 1933, p. 228-280.

80. G. F. Hartlaub, Dürers "Aberglaube," *Zeitschrift des Deutschen Vereins für Kunstwissenschaft*, VII, 1940, p. 167-196 [See also nos. 155 and 156 of this Bibliography].

CONCERNING DÜRER'S INFLUENCE OUTSIDE HIS LAND AND PERIOD

81. O. Hagen, Das Dürerische in der Italienischen Malerei, *Zeitschrift für Bildende Kunst*, LIII, 1918, p. 225-242.

82. W. Friedländer, Die Entstehung des antiklassischen Stiles in der Italienischen Malerei um 1520, *Repertorium für Kunstwissenschaft*, XLVI, 1925, p. 49-86.

83. A. Weixlgärtner, Alberto Duro, in: *Festschrift für Julius Schlosser zum 60. Geburtstage*, Zurich, Leipzig and Vienna, 1927, p. 162-186.

84. T. Hetzer, *Das Deutsche Element in der Italienischen Malerei des XVI. Jahrhunderts*, Berlin, 1929.

85. W. Paatz, Dürermotive in einem Florentiner Freskenzyklus, *Mitteilungen des Kunsthistorischen Instituts in Florenz*, III, 1932, p. 543-545.

86. F. Baumgart, Biagio Betti und Albrecht Dürer; zur Raumvorstellung . . . in der zweiten Hälfte des 16. Jahrhunderts, *Zeitschrift für Kunstgeschichte*, III, 1934, p. 231-249.

87. H. Tietze, Among the Dürer Plagiarists, *The Journal of the Walters Art Gallery*, 1941, p. 89-95.

88. J. de Vasconcellos, Albrecht Dürer e a sua Influencia na Peninsula, *Renascenza Portuguesa*, fasc. IV, Oporto, 1877.

89. J. Held, *Dürers Wirkung auf die Niederländische Kunst seiner Zeit*, The Hague, 1931.

90. W. Krönig, Zur Frühzeit Jan Gossarts, *Zeitschrift für Kunstgeschichte*, III, 1934, p. 163-177.

90a. J. G. van Gelder, Jan Gossaert in Rome, 1508-1509, *Oud Holland*, LIX, 1942, p. 1-11 (not seen).

90b. W. Wallerand, *Altarkunst des Deutschordensstaates Preussen unter Dürers Einfluss*, Danzig, 1940 (not seen).

90c. St. Eucker, *Das Dürerbewusstsein in der deutschen Romantik*, Berlin, 1939 (not seen).

INFORMATION PERTAINING TO THE CHAPTERS OF THIS VOLUME

To Chapter I: Apprenticeship and Early Years of Travel, 1484-1495

91. C. Glaser, *Die Altdeutsche Malerei*, Munich, 1924.

92. A. Schramm, *Der Bilderschmuck der Deutschen Frühdrucke* (thus far 21 vols.), Leipzig, 1920-1938.

93. M. Geisberg, *Geschichte der Deutschen Graphik vor Dürer* (Forschungen zur Kunstgeschichte, XXXII), Berlin, 1939.

94. M. Lehrs, *Geschichte und Kritischer Katalog des Deutschen, Niederländischen und Französischen Kupferstichs im XV. Jahrhundert* (9 vols.), Vienna, 1908-1934.

*95. W. M. Ivins, Jr., Artistic Aspects of Fifteenth Century Printing, *Papers of the Bibliographical Society of America*, XXVI, 1932, p. 1-51.

96. A. Weinberger, *Nürnberger Malerei an der Wende zur Renaissance und die Anfänge der Dürerschule* (Studien zur Deutschen Kunstgeschichte, 217), Strassburg, 1921.

*97. E. H. Zimmermann, Zur Nürnberger Malerei der II. Hälfte des XV. Jahrhunderts, *Anzeiger des Germanischen Nationalmuseums* (Nuremberg), 1932 and 1933, p. 43-60.

98. C. Koch, Michael Wolgemut, *Zeitschrift für Bildende Kunst*, LXIII, 1929/30, p. 81-92.

99. W. Wenke, Das Bildnis bei Michael Wolgemut, *Anzeiger des Germanischen Nationalmuseums* (Nuremberg), 1932 and 1933, p. 61-73.

100. F. J. Stadler, *Michael Wolgemut und der Nürnberger Holzschnitt im letzten Drittel des 15. Jahrhunderts* (Studien zur Deutschen Kunstgeschichte, 161), Strassburg, 1913.

*101. V. von Loga, Die Städteansichten in Hartman Schedels Weltchronik, *Jahrbuch der Königlich Preussischen Kunstsammlungen*, IX, 1888, pp. 93-107, 184-196.

*102. V. von Loga, Beiträge zum Holzschnittwerk Michel Wolgemuts, *Jahrbuch der Königlich Preussischen Kunstsammlungen*, XVI, 1895, p. 224-240.

103. M. Lehrs, *Martin Schongauer, Nachbildungen seiner Kupferstiche* (Graphische Gesellschaft, V. Ausserordentliche Veröffentlichung), Berlin, 1914 [See also no. 94, vol. V].

104. M. Geisberg, *Martin Schongauer*, New York, 1928.

*105. M. Lehrs, *Der Meister des Amsterdamer Kabinetts* (International Chalcographical Society), Berlin, 1893/94 [See also no. 94, vol. VIII].

106. H. Th. Bossert and W. F. Storck, *Das Mittelalterliche Hausbuch*, Leipzig, 1912.

107. J. Dürkopp, Der Meister des Hausbuches, *Oberrheinische Kunst*, V, 1932, p. 83-160.

108. E. Graf zu Solms-Laubach, Der Hausbuchmeister, *Städeljahrbuch*, IX, 1935/36, p. 13-96.

109. W. M. Conway, Dürer and the Housebook Master, *Burlington Magazine*, XVIII, 1910/11, p. 317-324.

110. J. Meder, Neue Beiträge zur Dürer-Forschung, *Jahrbuch der Kunsthistorischen Sammlungen des Allerhöchsten Kaiserhauses*, XXX, 1911, p. 183-222.

111. E. Waldmann, *Albrecht Dürer; Die Landschaften der Jugend; Zehn Aquarelle* (Maréesgesellschaft), Munich, 1921/22.

112. W. Röttinger, *Dürers Doppelgänger* (Studien zur Deutschen Kunstgeschichte, 235), Strassburg, 1926 [Containing an excellent bibliography up to the date of publication].

113. E. Römer, Dürers ledige Wanderjahre, *Jahrbuch der Preussischen Kunstsammlungen*, XLVII, 1926, p. 118-136; *ibidem*, XLVIII, 1927, pp. 77-119, 156-182.

*114. E. Holzinger, Der Meister des Nürnberger Horologiums, *Mitteilungen der Gesellschaft für Vervielfältigende Kunst* (*Die Graphischen Künste*, supplement), L, 1927, p. 9-19.

*115. E. Holzinger, Hat Dürer den Basler Hieronymus von 1492 selbst geschnitten?, *Same periodical*, LI, 1928, p. 17-20.

116. M. Weinberger, Zu Dürers Lehr-und Wanderjahren, *Münchner Jahrbuch der Bildenden Kunst*, Neue Folge, VI, 1929, p. 124-146.

*117. K. Bauch, Dürers Lehrjahre, *Städeljahrbuch*, VII/VIII, 1932, p. 80-115.

118. O. Schürer, Wohin ging Dürers "ledige Wanderfahrt"?, *Zeitschrift für Kunstgeschichte*, VI, 1937, p. 171-199.

119. F. Winkler, Dürerstudien (I, Dürers Zeichnungen von seiner ersten Italienischen Reise), *Jahrbuch der Preussischen Kunstsammlungen*, L, 1929, p. 123-147.

120. H. E. Pappenheim, Dürer im Etschland, *Zeitschrift des Deutschen Vereins für Kunstwissenschaft*, III, 1936, p. 35-90.

121. A. Rusconi, Per l'identificazione degli Acquerelli Tridentini di Alberto Durero, *Die Graphischen Künste*, Neue Folge, I, 1936, p. 121-137.

122. E. Rupprich, *Willibald Pirckheimer und die Erste Reise Dürers nach Italien*, Vienna, 1930 [See, however, A. Weixlgärtner, *Mitteilungen der Gesellschaft für Vervielfältigende Kunst* (*Die Graphischen Künste*, supplement), LIII, 1930, p. 59; A. Wolf, *Die Graphischen Künste*, Neue Folge, I, 1936, p. 138; and E. Panofsky, *Münchner Jahrbuch der Bildenden Kunst*, Neue Folge, VIII, 1931, p. 2].

For editions of the "Narrenschiff," the "Ritter vom Turn" and the Basel "*Salus Animae*" see Singer's Bibliography (quoted as no. 1), p. 23 and our Handlist, no. 436.

To Chapter II: Five Years of Intense Productivity, 1495-1500

123. F. von Schubert-Soldern, Zur Entwicklung der technischen und künstlerischen Ausdrucksmittel in Dürers Kupferstichen, *Monatshefte für Kunstwissenschaft*, V, 1912, p. 1-14.

124. W. Kurth, Zum graphischen Stil Dürers, *Der Kunstwanderer*, X, 1928, p. 331-335.

*125. W. M. Ivins, Jr., Notes on Three Dürer Woodblocks, *Metropolitan Museum Studies*, II, 1929, p. 102-111.

126. A. Friedrich, *Handlung und Gestalt des Kupferstichs und der Radierung*, Essen, 1931.

*127. F. Kriegbaum, Zu den graphischen Prinzipien in Dürers frühem Holzschnittwerk, in: *Das Siebente Jahrzehnt, Adolph Goldschmidt zu seinem Siebenzigsten Geburtstag dargebracht*, Berlin, 1935, p. 100-108.

128. L. Justi, *Dürers Dresdner Altar*, Leipzig, 1904.

129. F. Buchner, Die Sieben Schmerzen Mariae; Eine Tafel aus der Werkstatt des jungen Dürer, *Münchner Jahrbuch der Bildenden Kunst*, Neue Folge, XI, 1934-36, p. 250-270.

130. C. Schellenberg, *Dürers Apokalypse*, Munich, 1923.

131. M. Dvořák, *Kunstgeschichte als Geistesgeschichte*, Munich, 1924, p. 191-202 [On Dürer's Apocalypse].

132. F. J. Stadler, *Dürers Apokalypse und ihr Umkreis*, Munich, 1929.

133. L. H. Heydenreich, Der Apokalypsen-Zyklus im Athosgebiet und seine Beziehungen zur Deutschen Bibelillustration der Reformation, *Zeitschrift für Kunstgeschichte*, VIII, 1939, p. 1-40.

134. H. F. Schmidt, Dürers Apokalypse und die Strassburger Bibel von 1485, *Zeitschrift des Deutschen Vereins für Kunstwissenschaft*, VI, 1939, p. 261-266.

135. E. Wind, "Hercules" and "Orpheus": Two Mock-Heroic Designs by Dürer, *Journal of the Warburg Institute*, II, 1939, p. 206-218.

136. E. Wind, Dürer's "Männerbad": A Dionysian Mystery, *ibidem*, p. 269-271.

For editions of the Apocalypse and the Large Passion see Singer's Bibliography (quoted as no. 1), pp. 23 ss. and 25, respectively.

To Chapter III: Five Years of Rational Synthesis, 1500-1505

137. L. Justi, Jacopo de' Barbari und Albrecht Dürer, *Repertorium für Kunstwissenschaft*, XXI, 1898, pp. 346-374, 439-458.

138. E. Panofsky, Dürers Darstellungen des Apollo und ihr Verhältnis zu Barbari, *Jahrbuch der Preussischen Kunstsammlungen*, XLI, 1920, p. 359-377.

139. A. de Hevesy, Albrecht Dürer und Jacopo de Barbari, in: *Albrecht Dürer, Festschrift der internationalen Dürerforschung, herausgegeben vom "Cicerone"* (G. Biermann, ed.), Leipzig and Berlin, 1928, p. 32-41.

140. E. Brauer, *Jacopo de' Barbaris graphische Kunst* (Diss. Hamburg, 1931), Hamburg, 1933.

141. H. Weizsäcker, Der sogenannte Jabachsche Altar und die Dichtung des Buches Hiob, in: *Kunstwissenschaftliche Beiträge, August Schmarsow gewidmet*, Leipzig, 1907, p. 153-162.

142. M. L. Brown, The Subject Matter of Dürer's Jabach Altar, *Marsyas (A Publication by the Students of the Institute of Fine Arts, New York University)*, New York, I, 1941, p. 55-68.

143. H. Kauffmann, Albrecht Dürers Dreikönig-Altar, *Wallraf-Richartz Jahrbuch*, X, 1938, p. 166-178.

144. F. Winkler, Dürerstudien (II, Dürer und der Ober St. Veiter Altar), *Jahrbuch der Preussischen Kunstsammlungen*, L, 1929, p. 148-166 [See, however, the following essay].

145. E. Buchner, Der junge Schäufelein als Maler und Zeichner, in: *Festschrift für Max J. Friedländer zum 60. Geburtstage*, Leipzig, 1927, p. 46-76.

146. H. Cürlis, Die Grüne Passion, *Repertorium für Kunstwissenschaft*, XXXVII, 1914, p. 183-197.

147. G. Pauli, Die Grüne Passion Dürers, *Same periodical*, XXXVIII, 1915, p. 97-109.

148. J. Meder, *Dürers "Grüne Passion"* (Albertina Facsimile), Vienna, 1924.

149. J. Meder, *Dürers "Grüne Passion"* (Monographien zur Deutschen Kunstgeschichte, IV), Munich, 1923.

150. H. Beenken, Dürer-Fälschungen? Eine Beweinungsscheibe in Wien und die Grüne Passion, *Repertorium für Kunstwissenschaft*, L, 1929, p. 112-129.

151. E. Rosenthal, Dürers Buchmalereien für Pirckheimers Bibliothek, *Jahrbuch der Preussischen Kunstsammlungen*, XLIX (Beiheft), 1928, p. 1-54 [A supplement by the same author: *ibidem*, LI, 1930, p. 175-178].

152. E. Heidrich, Zur Chronologie des Dürerschen Marienlebens, *Repertorium für Kunstwissenschaft*, XXIX, 1906, p. 227-241.

For Dürer's relation to Barbari see also no. 200a of this Bibliography.

For editions of the Life of the Virgin see Singer's Bibliography (quoted as no. 1), p. 28 s.

For editions of the Nuremberg *"Salus Animae"* and *"Postilla"* see our Handlist, no. 448.

For the engraving *The Fall of Man* (108), the engraving *The Small Horse* (203), and the engraving *"Weihnachten"* (109) see also nos. 198, 203, 204, and 209 of this Bibliography.

To Chapter IV: The Second Trip to Italy and the Culmination of Painting, *1505-1510/11*

153. H. Beenken, Zu Dürers Italienreise im Jahre 1505, *Zeitschrift des Deutschen Vereins für Kunstwissenschaft*, III, 1936, p. 91-126.

154. K. F. Suter, Dürer und Giorgione, *Zeitschrift für Bildende Kunst*, LXIII, 1929/30, p. 182-187.

155. G. F. Hartlaub, *Giorgiones Geheimnis*, Munich, 1925.

156. G. F. Hartlaub, Giorgione und der Mythus der Akademien, *Repertorium für Kunstwissenschaft*, XLVIII, 1927, p. 233-257.

*157. J. Neuwirth, *Albrecht Dürers Rosenkranzfest*, Prague, 1885.

158. A. Gümbel, *Dürers Rosenkranzfest und die Fugger* (Studien zur Deutschen Kunstgeschichte, 234), Strassburg, 1926.

159. O. Benesch, Zu Dürers "Rosenkranzfest," *Belvedere*, IX, 1930, p. 81-84.

160. P. O. Rave, Dürers Rosenkranzbild und die Berliner Museen 1836/37, *Jahrbuch der Preussischen Kunstsammlungen*, LVIII, 1937, p. 267-283.

160a. F. H. A. van der Oudendijk Pieterse, *Dürers "Rosenkranzfest" en de Ikonografie der Duitse Rosenkransgroepen* ..., Antwerp, 1939, and Amsterdam, 1940 [cf. review by D. van Wely, *Historisch Tijdschrift*, XX, 1941, p. 275-283].

161. E. von Rothschild, Tizians "Kirschenmadonna," *Belvedere* XI, 1932, p. 107-116.

162. H. Weizsäcker, *Die Kunstschätze des ehemaligen Dominikanerklosters in Frankfurt a.M.*, Munich, 1923, p. 141-244 [For the Heller altarpiece].

163. E. Ziekursch, *Dürers Landauer Altar*, Munich, 1913.

To Chapter V: Reorientation in the Graphic Arts; The Culmination of Engraving, *1507/11-1514*

*164. P. Weber, *Beiträge zu Dürers Weltanschauung; Eine Studie über die drei Stiche "Ritter, Tod und Teufel," "Melencolia" und "Hieronymus im Gehäus"* (Studien zur Deutschen Kunstgeschichte, 23), Strassburg, 1900.

*165. K. Giehlow, Dürers Stich "Melencolia I" und der Maximilianische Humanistenkreis, *Mitteilungen der Gesellschaft für Vervielfältigende Kunst* (*Die Graphischen Künste*, supplement), XXVI, 1903, p. 29-41; XXVII, 1904, pp. 6-18, 57-78.

166. E. Panofsky and F. Saxl, *Dürers Kupferstich "Melencolia I"; Eine quellen-und typengeschichtliche Untersuchung* (Studien der Bibliothek Warburg, II), Leipzig and Berlin, 1923 [For more recent publications on the engraving *Melencolia I* see the references in Tietze and Tietze-Conrat (quoted as no. 5 in this Bibliography), Dodgson (quoted as no. 17 in this Bibliography), and in our Handlist, no. 181].

To Chapter VI: Dürer's Activity for Maximilian I; The "Decorative Style" *(1512/13-1518/19)*

167. K. Giehlow, Die Hieroglyphenkunde des Humanismus in der Allegorie der Renaissance, besonders der Ehrenpforte Kaisers Maximilian I, *Jahrbuch der Kunsthistorischen Sammlungen des Allerhöchsten Kaiserhauses*, XXXII, 1915, p. 1-229.

168. L. Volkmann, *Bilderschriften der Renaissance; Hieroglyphik und Emblematik in ihren Beziehungen und Fortwirkungen*, Leipzig, 1923.

*169. F. Dörnhöffer, Über Burgkmair und Dürer, in: *Beiträge zur Kunstgeschichte, Franz Wickhoff gewidmet*, Vienna, 1903, p. 111-131.

*170. E. Chmelarz, Die Ehrenpforte des Kaisers Maximilian I, *Jahrbuch der Kunsthistorischen Sammlungen des Allerhöchsten Kaiserhauses*, IV, 1886, p. 289-319.

*171. K. Giehlow, Urkundenexegese zur Ehrenpforte Maximilians I, in: *Kunstgeschichtliche Beiträge, Franz Wickhoff gewidmet*, Vienna, 1903, p. 93-110.

*172. F. Schestag, Kaiser Maximilian I. Triumph, *Jahrbuch der Kunsthistorischen Sammlungen des Allerhöchsten Kaiserhauses*, I, 1883, p. 154-181.

*173. K. Giehlow, Dürers Entwürfe für das Triumphrelief Kaiser Maximilians I. im Louvre, *Jahrbuch der Kunsthistorischen Sammlungen des Allerhöchsten Kaiserhauses*, XXIX, 1910, p. 14-84.

*174. Q. von Leitner, *Freydal. Des Kaisers Maximilian I Turniere und Mummereien*, Vienna, 1880-1882.

*175. E. Weiss, Albrecht Dürers geographische, astronomische und astrologische Tafeln, *Jahrbuch der Kunsthistorischen Sammlungen des Allerhöchsten Kaiserhauses*, VII, 1888, p. 207-220.

*176. K. Giehlow, Beiträge zur Entstehungsgeschichte des Gebetbuches Kaisers Maximilian I, *Jahrbuch der Kunsthistorischen Sammlungen des Allerhöchsten Kaiserhauses*, XX, 1899, p. 30-112.

*177. K. Giehlow, *Kaiser Maximilians I. Gebetbuch*, Vienna, 1907.

178. E. Ehlers, Bemerkungen zu den Tierdarstellungen im Gebetbuche des Kaisers Maximilian, *Jahrbuch der Königlich Preussischen Kunstsammlungen*, XXXVIII, 1917, p. 151-176.

179. G. Leidinger, *Albrecht Dürers und Lukas Cranachs Randzeichnungen zum Gebetbuche Kaiser Maximilians I in der Bayerischen Staatsbibliothek zu München*, Munich, 1922 [Includes only the pages with marginal decorations].

180. L. Baldass, *Der Künstlerkreis Maximilians*, Vienna, 1923.

To Chapter VII: The Crisis of 1519; The Journey to the Netherlands, 1520-21; The Last Works, 1520-1528

181. J. Veth and S. Müller, *Albrecht Dürers Niederländische Reise* (2 vols.), Berlin and Utrecht, 1918.

*182. J. Huizinga, Dürer in de Nederlanden, *De Gids*, LXXXIV, 2, 1920, p. 470-484.

183. E. Schilling, *Albrecht Dürer; Niederländisches Reiseskizzenbuch* (Preface by H. Wölfflin), Frankfort, 1928.

184. *Albrecht Dürer, Tagebuch der Reise in die Niederlande* (Inselbücherei, no. 150, R. Graul ed. and pref.), Leipzig, 1936.

185. J. A. Goris and G. Marlier (eds. and trs.), *Albrecht Dürer, Journal de Voyage dans les Pays-Bas*, Brussels, 1937.

186. E. Panofsky, Zwei Dürerprobleme (II, Die "Vier Apostel"), *Münchner Jahrbuch der Bildenden Kunst*, Neue Folge, VIII, 1931, p. 18-48.

187. H. Swarzenski, Dürers "Barmherzigkeit," *Zeitschrift für Kunstgeschichte*, II, 1933, p. 1-10.

188. Hans Tietze and E. Tietze-Conrat, Neue Beiträge zur Dürer-Forschung (IV, Das Kreuztragungsbild aus Dürers Spätzeit), *Jahrbuch der Kunsthistorischen Sammlungen in Wien*, Neue Folge, VI, 1932, p. 125-127.

For the *"Great Crucifixion"* see no. 3 of this Bibliography.

For Dürer's attitude toward the Reformation see nos. 55 and 56 of this Bibliography.

For Dürer's contact with Netherlandish artists see no. 89 of this Bibliography.

To Chapter VIII: Dürer as a Theorist of Art

189. H. Bohatta, *Versuch einer Bibliographie der kunsttheoretischen Werke Albrecht Dürers*, Vienna, 1928 [Also in *Börsenblatt für den Deutschen Buchhandel*, XCV, 1928, no. 91 (April 19), p. 439-442; no. 110 (May 12), p. 527-531].

190. J. Schlosser, *Die Kunstliteratur*, Vienna, 1924, p. 231-246. Italian translation, with useful bibliographical supplement: J. Schlosser, *La letteratura artistica*, Florence, 1935 (here p. 227-242).

191. L. Olschki, *Geschichte der neusprachlichen wissenschaftlichen Literatur*, vol. I, Heidelberg, 1919, p. 414-end.

192. E. Panofsky, *Dürers Kunsttheorie, vornehmlich in ihrem Verhältnis zu der der Italiener*, Berlin, 1915.

193. E. Panofsky, *Idea; Ein Beitrag zur Begriffsgeschichte der älteren Kunsttheorie* (Studien der Bibliothek Warburg, V), Leipzig and Berlin, 1924, p. 64-end.

194. H. Beenken, Dürers Kunsturteil und die Struktur des Renaissance-Individualismus, in: *Festschrift Heinrich Wölfflin*, Munich, 1924, p. 183-193.

195. H. Kauffmann, *Albrecht Dürers rhythmische Kunst*, Leipzig, 1924.

196. E. Panofsky, Albrecht Dürers rhythmische Kunst, *Jahrbuch für Kunstwissenschaft*, 1926, p. 136-192.

197. E. Panofsky, *The Codex Huygens and Leonardo da Vinci's Art Theory* (Studies of the Warburg Institute, XIII), London, 1940.

*198. L. Justi, *Konstruierte Figuren und Köpfe unter den Werken Albrecht Dürers*, Leipzig, 1902.

199. E. Panofsky, Die Entwicklung der Proportionslehre als Abbild der Stilentwicklung, *Monatshefte für Kunstwissenschaft*, XIV, 1921, p. 188-219.

200. J. Giesen, *Dürers Proportionsstudien im Rahmen der allgemeinen Proportionsentwicklung*, Bonn, 1930.

*200a. A. M. Friend, Jr., Dürer and the Hercules Borghese-Piccolomini, *Art Bulletin*, XXV, 1943, p. 40-49.

201. K. Sudhoff, Dürers anatomische Zeichnungen in Dresden und Leonardo da Vinci, *Archiv für Geschichte der Medizin*, I, 1908, p. 317-321.

*202. F. Dörnhöffer, Albrecht Dürers Fechtbuch, *Jahrbuch der Kunsthistorischen Sammlungen des Allerhöchsten Kaiserhauses*, XXVII, 1907/09, II part, p. i-lxxxi.

*203. G. Pauli, Dürers früheste Proportionsstudie eines Pferdes, *Zeitschrift für Bildende Kunst*, Neue Folge, XXV (XLIX), 1913/14, p. 105-108.

*204. J. Kurthen, Zum Problem der Dürerschen Pferdekonstruktion, *Repertorium für Kunstwissenschaft*, XLIV, 1924, p. 77-106.

205. W. Waetzoldt, *Dürers Befestigungslehre*, Berlin, 1916.

205a. W. Schwemmer, Dürers Befestigungslehre, *Nürnberger Schau*, 1941, p. 104-108 (not seen).

*206. G. Staigmüller, *Dürer als Mathematiker* (Programm des Königlichen Realgymnasiums in Stuttgart), Stuttgart, 1891.

207. W. M. Ivins, Jr., *On the Rationalization of Sight* (Metropolitan Museum, Papers, no. 8), New York, 1938 [With useful bibliography].

208. E. Panofsky, Once more the "Friedsam Annunciation and the Problem of the Ghent Altarpiece," *Art Bulletin*, XX, 1938, p. 419-424 [For pre-scientific perspective].

209. H. Schuritz, *Die Perspektive in der Kunst Dürers*, Frankfort, 1919 [See also no. 72].

210. W. Stechow, Dürers Bologneser Lehrer, *Kunstchronik*, Neue Folge, XXXIII, 1922, p. 251/52.

211. Albrecht Dürer, *Of the Just Shaping of Letters from the Applied Geometry of Albrecht Dürer* (The Grolier Club), New York, 1917.

212. Albrecht Dürer, *The Construction of Roman Letters* (B. Rogers, ed.), Cambridge, 1924.

213. E. Crous, *Dürer und die Schrift* (Berliner Bibliophilenabend, Vereinsgabe), Berlin, 1933.

APPENDIX

Appendix

A. Corrections and Amplifications of the Handlist of Works as Printed in *Albrecht Dürer*, Princeton, Third Edition, 1948, Vol. II, pp. 3-172.

I. NEW ATTRIBUTIONS

1. PAINTING

MAN OF SORROWS, German private collection. Published by K. Steinbart, Albrecht Dürers Schmerzensmann von 1511 als christomorphes Selbstbildnis, *Zeitschrift für Kunstgeschichte*, XIV, 1951, p. 32 ss. In my opinion not by Dürer.

2. WOODCUT

MADONNA CROWNED BY ANGELS. Published by E. Schilling, Ein Holzschnitt aus Dürers Wanderjahren, *Zeitschrift für Kunstwissenschaft*, VI, 1952, p. 57 ss. Probably genuine.

3. DRAWINGS

STUDY FOR THE MANTLE OF THE VIRGIN MARY IN THE HELLER ALTARPIECE (brush on green-grounded paper, heightened with white), Lyons, Musée des Beaux-Arts. Published by E. Schilling, A Drapery Study by Albrecht Dürer, *Burlington Magazine*, XC, 1948, p. 322 s. Unquestionably authentic.

THE VIRGIN MARY AND ST. JOSEPH. Details from a "Nativity" (pen), spuriously signed with Dürer's initials and dated 1515, formerly Lemberg, Lubomirski Museum. Apparently undescribed and certainly not by Dürer.

EUTERPE (pen), London, British Museum. Published by A. E. Popham, A Drawing by Albrecht Dürer, *British Museum Quarterly*, XIX, 1954, p. 36. One of the series Handlist Nos. 976-995, which see.

LION (brush drawing), Detroit, Institute of Arts. Published by P. Wescher, An Unnoticed Dürer Drawing of a Lion in the Detroit Arts Institute, *Art Quarterly*, XIII, 1950, p. 156 ss. The drawing, dated by Wescher towards 1494, does not seem convincing to this writer. The lion bears a suspicious resemblance to the lion of St. Jerome in the engraving B. 61 (168), the only comparable specimen not adduced by Wescher, and may well be a free copy thereof; the alternative hypothesis that the Detroit drawing may have been made in preparation for the engraving is improbable because both lions face in the same direction.

IRIS (water color), Stuttgart, Württembergisches Hauptstaatsarchiv. Published by H. Wentzel, Unbekannte altdeutsche Handzeichnungen aus Württembergischen Archiven und Bibliotheken, *Form und Inhalt: Kunstgeschichtliche Studien Otto Schmitt zum 60. Geburtstag ... dargebracht ...*, Stuttgart, 1950, p. 333 ss., Fig. 7. In my opinion not by Dürer.

TABLE FOUNTAIN (pen), London, Sir John Soane's Museum. Published by A. E. Popham, An Unknown Drawing by Dürer, *Art Quarterly*, XIII, 1950, p. 338. Apparently a genuine drawing of ca. 1500.

II. CHANGES OF OWNERSHIP

1. PAINTINGS

Handlist No. 25: MADONNA IN HALF LENGTH; ON THE BACK, LOT AND HIS DAUGHTERS FLEEING FROM SODOM AND GOMORRAH, formerly Lugano, Thyssen Collection. Now Washington, National Gallery (Kress Collection); see *Paintings and Sculpture from the Kress Collection, Acquired by the Samuel H. Kress Foundation 1945-1951*, Washington, 1951, p. 190 ss., No. 84.

Handlist No. 81: PORTRAIT OF A CLERGYMAN, formerly Vienna, Count Czernin Collection. Now Washington, National Gallery (Kress Collection); see *ibidem*, p. 194 s., No. 85.

2. DRAWINGS*

Handlist No. 619: THE DEAD CHRIST, formerly Lemberg, Lubomirski Museum. Now Cleveland, Cleveland Museum of Art.

* I wish to express my gratitude to Mrs. Elizabeth Drey, who kindly informed me, in so far as she was free to do so, of the present whereabouts of several drawings formerly in the Lubomirski Museum at Lemberg. The fate of the other Lubomirski drawings is as yet undecided. According to the latest reports, not all the Dürer drawings formerly preserved in the Kunsthalle at Bremen but only the water colors (that is to say, Handlist Nos. 1368, 1369, 1375, 1380, 1385, 1392, 1393, 1398, 1430, 1437, 1439) must be added to the war losses.

Handlist No. 622: ASCENSION OF CHRIST, formerly Lemberg, Lubomirski Museum. Now Cleveland, Cleveland Museum of Art.

Handlist No. 697: MADONNA IN A RENAISSANCE HALL, formerly Lemberg, Lubomirski Museum. Now New York, private collection.

Handlist No. 728: HOLY FAMILY, formerly Lemberg, Lubomirski Museum. Now Montreal, L. V. Randall Collection.

Handlist No. 730: HOLY FAMILY IN A TRELLIS, formerly Lemberg, Lubomirski Museum. Now New York, Robert Lehman Collection.

Handlist No. 911: FORTUNA IN A NICHE, formerly Lemberg, Lubomirski Museum. Now New York, Robert Lehman Collection.

Handlist No. 998: SELF-PORTRAIT AND OTHER STUDIES, formerly Lemberg, Lubomirski Museum. Now New York, Robert Lehman Collection.

Handlist No. 1036: WILLIBALD PIRCKHEIMER, formerly Brunswick, Blasius Collection. Now Berlin, Kupferstichkabinett; see N. Powell, Notes on German Art Collections since 1945, Burlington Magazine, XCVI, 1954, p. 343.

Handlist No. 1058: PORTRAIT OF AN OLD MAN ASLEEP, formerly Brunswick, Blasius Collection. Now Berlin, Kupferstichkabinett; see Powell, op. cit.

Handlist No. 1166: HEAD OF A WOMAN, formerly Cambridge (Mass.), Philip Hofer Collection. Now New York, Robert Lehman Collection.

Handlist No. 1216: LEFT HAND, formerly Portland (Oregon) Leroy Backus Collection. Now New York, Robert Lehman Collection.

Handlist No. 1377: THE DOSS' TRENTO (TRINT-PERG), formerly Hanover, Museum für Kunst und Landesgeschichte. Now Basel, R. von Hirsch Collection.

Handlist No. 1349: HEAD OF A ROEBUCK, formerly Lemberg, Lubomirski Museum. Now Kansas City, William Rockhill Nelson Collection.

Handlist No. 1360: STEER, formerly Lemberg, Lubomirski Museum. Now Mr. and Mrs. Richard S. Davis Collection, Wayzata, Minnesota.

Handlist No. 1381: CASTLE IN THE ALPS, formerly Brunswick, Blasius Collection. Now Berlin, Kupferstichkabinett; see Powell, op. cit.

Handlist No. 1382: TREES IN A MOUNTAINOUS LANDSCAPE, formerly Brunswick, Blasius Collection. Now Berlin, Kupferstichkabinett; see Powell, op. cit.

Handlist No. 1427: BUTTERCUP, formerly London, Bale Collection. Now Providence, Rhode Island School of Design; see H. Schwarz, A Water-colour Attributed to Dürer, Burlington Magazine, XCV, 1953, p. 149 s. (an article important for the evaluation of Dürer's botanical studies in general).

Handlist No. 1442: SIX PILLOWS, formerly Lemberg, Lubomirski Museum. Now New York, Robert Lehman Collection.

Handlist No. 1580: CORNER ORNAMENT, formerly Lemberg, Lubomirski Museum. Now New York, private collection.

III. ADDENDA ET CORRIGENDA

1. PAINTINGS

Handlist No. 1 (Supplementary remarks, p. 168, line 9 from beginning of entry): ADAM AND EVE. "Almütz" should read "Olmütz."

Handlist No. 6: "THE JABACH ALTARPIECE." See now V. Denis, Saint Job, Patron des Musiciens, Revue Belge d'Archéologie et d'Histoire de l'Art, XXI, 1952, p. 253 ss. The article, written by a musicologist, contains a useful list of instances but suffers from the author's unfamiliarity with art-historical literature.

Handlist No. 37: HOLY FAMILY. Line 1: "Rotterdam," should read "Vierhouten near Amersfoort." See now Catalogue of the D. G. Van Beuningen Collection, D. Hannema, ed., M. J. Friedländer, pref., Rotterdam, 1949, p. 22, No. 10, Plates 63, 64.

Handlist No. 38 (Supplementary remarks, p. 169, line 9 from the foot of the entry): THE FEAST OF THE ROSE GARLANDS. "1495" should read "1485."

Handlist No. 43: "THE FOUR APOSTLES." Line 3 from the foot of the entry: "Evangelists" should read "Apostles." See now K. Lankheit, Dürers "Vier Apostel," Zeitschrift für Theologie und Kirche, XLIX, 1952, p. 238 ss. The author calls attention to the fact that in Protestant churches painted wings were often attached to the pulpit rather than to a central panel so that the "image," which in a normal retable appears between them, is, as it were, replaced by the "Word."

Handlist No. 50: SELF-PORTRAIT. See now F. Winzinger, Albrecht Dürers Münchener Selbstbildnis, Zeitschrift für Kunstwissenschaft, VIII, 1954, p. 43 ss. The author convincingly shows that, in contrast to previous opinion (including my own), the face was never repainted. The second part of the article tries to establish the system of proportions to which Dürer adapted his own physiognomy and discusses the problem of

Dürer's self-identification with Christ; for this, see the excellent article by Bainton, quoted in the remark to Handlist No. 635.

Handlist No. 58: PORTRAIT OF JOHANNES KLEBERGER. The symbol in the upper left-hand corner represents "Sol in corde Leonis," viz., the moment at which the position of the sun coincides with that of the star Regulus, the "heart" of the Sign of the Lion which, as a whole, constitutes the "mansion" of the sun; a person born at this moment was therefore considered as a "king" within his sphere and exceptionally well favored in every respect. See A. Loehr, Astrologie in der Numismatik, *Numismatische Zeitschrift*, XXXII, 1947, p. 134; K. A. Nowotny, The Construction of Certain Seals and Characters in the Work of Agrippa of Nettesheim, *Journal of the Warburg and Courtauld Institutes*, XII, 1949, p. 56.

Handlist No. 86: PORTRAIT OF A YOUNG MAN AS ST. SEBASTIAN. Professor H. Kauffmann, who recently inspected the picture in the original, kindly informs me *in litteris* that he inclines to consider it as a genuine work of about 1498.

Handlist No. 106: LUCRETIA. See now W. Stechow, "Lucretiae Statua," *Essays in Honor of Georg Swarzenski*, Chicago, 1951, p. 114 ss.

2. ENGRAVINGS

Handlist No. 108: THE FALL OF MAN. See remark to Handlist No. 180.

Handlist No. 119: BEARING OF THE CROSS. For an undescribed first state, see A. C. Hoyt, A. Dürer Proof Discovered, *Bulletin of the Museum of Fine Arts*, Boston, L, 1952, p. 10 s.

Handlist No. 164: ST. EUSTACE. See now E. Panofsky, Dürer's Saint Eustace, *Record of the Art Museum*, Princeton University, IX, 1950, p. 1 ss.

Handlist No. 175: APOLLO AND DIANA. Line 5: "1600" should read "1599."

Handlist No. 179: ABDUCTION OF PROSERPINE. For the iconography, see now R. Bernheimer, *Wild Men in the Middle Ages*, Cambridge (Mass.), 1952, p. 134 ss.

Handlist No. 180: "DER HERCULES." See now E. Tietze-Conrat, A Drawing in Stockholm and Dürer's Engravings B. 73 and B. 1, *Nationalmusei Årsbok*, Stockholm, new ser., XIX-XX, 1949-1950, p. 38 ss. Here a chalk drawing in the Nationalmuseum at Stockholm, wherein a woman (clothed) throws down and attacks another woman (unclothed) while a nude young man, holding a stick in his left hand and a "fruit" (in

my opinion, rather a stone) in his right, stands by, is ascribed to Jacopo de' Barbari and is considered as an intermediary between the *Hercules* (No. 180) of 1500-1501 and the *Fall of Man* (No. 108) of 1504, inspired by the former and exerting a retroactive influence on the latter. The author of the Stockholm drawing is, however, as uncertain as is its date; the fact that it is executed on Italian paper (the watermark being a crown similar to Briquet, Nos. 4705, 4777, 4813, 4816, 4867) is even somewhat unfavorable to its attribution to Barbari, who moved to Germany in 1500. The drawing may as well be the work of an anonymous North Italian, produced about 1510 rather than between *ca.* 1501 and 1504, which reveals the combined influence of Dürer's *Fall of Man* and *Hercules*. Even if its attribution to Barbari were established and if it were exclusively based upon the *Hercules*, it could not be used for the iconographical interpretation of the latter: we could not be sure that Barbari interpreted the meaning of Dürer's engraving correctly and, if he did, intended to duplicate it in his own work.

Handlist No. 181: MELENCOLIA. I. See now T. D. Barlow, *The Medieval World Picture & Albert Dürer's Melancholia*, Cambridge (Roxburghe Club), 1950. R. W. Horst, Dürers "Melencolia I"; Ein Beitrag zum Melancholeia-Problem, *Wandlungen christlicher Kunst im Mittelalter* (Forschungen zur Kunstgeschichte und christl. Archäologie, unter dem Patronat von Georg Opel), II, Baden-Baden, 1953, p. 411 ss. L. Fischer, Zur Deutung des magischen Quadrates in Dürers Melencolia I, *Zeitschrift der Deutschen Morgenländischen Gesellschaft*, new ser., XXVIII, 1953, p. 308 ss.

Space does not permit a discussion of the questions raised by the above contributions, especially that of R. W. Horst.

Handlist No. 184: NEMESIS. See now H. Kauffmann, Dürers "Nemesis," *Tymbos für Wilhelm Ahlmann*, Berlin, 1951, p. 135 ss.

Handlist No. 208: COAT-OF-ARMS OF DEATH. For the iconography, see now Bernheimer (quoted in the remark to Handlist No. 179), p. 183 ss.

Handlist No. 218: CRUCIFIXION WITH MANY FIGURES. F. Ehrenfest, Albrecht Dürer's "Crucifixion in Outline," *Print Collector's Quarterly*, XXX, 1950, p. 48 ss., summarizes the known facts and illustrates a newly discovered impression (the fourth known to be in existence) of the first plate in the City Art Museum at St. Louis.

3. WOODCUTS

Handlist No. 224: THE MAN OF SORROWS MOCKED BY A SOLDIER. Line 12 from the foot of the page: "194" should read "200."

Handlist No. 299: JOACHIM AND ANN MEETING AT THE GOLDEN GATE. The group of two men talking to each other appears to be connected with the analogous group in Grünewald's Munich *Derision of Christ* of 1503. Since the two groups face in different directions, and since Dürer's woodcut is dated 1504, we must either assume that Grünewald had access to a preparatory drawing by Dürer or that Dürer was influenced by Grünewald. I am inclined in favor of the second alternative.

Handlist No. 356 (Supplementary remarks, p. 170): RHINOCEROS. B. Laufer's erroneous assumption that Dürer, stimulated by Martial, attempted to transform his subject, an Indian *rhinoceros unicornis* brought to Lisbon and known to him through a drawing, into an African *rhinoceros bicornis* was revived by F. J. Cole, *Science, Medicine and History, Essays . . . in Honour of Charles Singer*, E. Ashworth Underwood, ed., London, 1954, and brought to the attention of a wider public in *The* [London] *Times Literary Supplement*, May 7, 1954, p. 290.

Handlist No. 358: TRIUMPHAL ARCH OF MAXIMILIAN I. See P. Rossiter, Maximilian's Triumphal Arch; a Woodcut by Dürer, *Bulletin of the Museum of Fine Arts*, Boston, XLIX, 1951, p. 95 ss.

Handlist No. 399: MARTYRDOM OF ST. SEBASTIAN. According to H. Joachim, *Art Bulletin*, XXXV, 1953, p. 66 ss. (review of Winkler's book, quoted under the following number), this woodcut as well as the woodcuts Handlist Nos. 427 (the *Great Calvary*) and 428 (*Lamentation of Christ*) are pastiches after Dürer rather than original designs disfigured by the cutter.

Handlist No. 436: WOODCUTS AND WOOD BLOCKS FOR BOOKS PUBLISHED OR PREPARED DURING DÜRER'S SOJOURN AT BASEL. See now F. Winkler, Dürer's Baseler und Strassburger Holzschnitte; Bemerkungen über den Stand der Forschung, *Zeitschrift für Kunstwissenschaft*, V, 1951, p. 51 ss.; idem, *Dürer und die Illustrationen zum Narrenschiff*, Berlin, 1951. I am glad to note that Winkler's views do not too widely differ from mine, particularly in that he, too, explains the great number of inferior woodcuts in the *Narrenschyff* by the assumption that Dürer left Basel when only about one third of the designs had been completed (cf. my text, p. 29).

Handlist No. 441: CRUCIFIXION WITH THE VIRGIN MARY AND ST. JOHN. The importance of this woodcut is correctly stressed by Winkler, *ibidem*.

Handlist No. 455: WOODCUTS IN DÜRER'S TREATISE ON FORTIFICATION. E. W. Palm, Tenochtitlan y la ciudad ideal de Dürer, *Journal de la Société des Américanistes*, new ser., XL, 1951, p. 59 ss., makes the interesting suggestion, not altogether improbable in view of Dürer's keen interest in the New Continent, that the plan of an ideal city included in his *Treatise on Fortification* of 1527 was influenced, to some extent, by the plan of Tenochtitlan in Mexico which had been published at Nuremberg three years before.

4. DRAWINGS

Handlist No. 496: STUDY FOR THE FEET OF AN APOSTLE IN THE HELLER ALTARPIECE. Line 3: "Rotterdam" should read "Vierhouten near Amersfoort." See *Van Beuningen Catalogue*, p. 154, No. 163, Plate 203.

Handlist No. 523: THE GREEN PASSION. E. Schilling, Werkzeichnungen zur "Grünen Passion," *Berliner Museen*, new ser., IV, 1954, p. 14 ss. expatiates upon the hypothesis (cf. *Albrecht Dürer*, Princeton, third ed., 1948, II, p. 171) that the twelve sheets that constitute the "Green Passion" were intended to be arranged around the *Calvary* W. 371 (591).

Handlist No. 629: THE LORD BLESSING. F. Winzinger, Schongauerstudien, *Zeitschrift für Kunstwissenschaft*, VII, 1953, p. 25 ss., revives the old assumption that the drawing is a *propria manu* copy by Dürer after Schongauer, the word *gemacht* crediting Schongauer with the invention rather than with the manual execution. The linguistic usage of the period in general, and Dürer's own in particular, does not in my opinion justify this interpretation.

Handlist No. 635: MAN OF SORROWS IN HALF LENGTH. See now the excellent essay by R. H. Bainton, Dürer and Luther as the Man of Sorrows, *Art Bulletin*, XXIX, 1947, p. 269.

Handlist No. 928: DEATH OF ORPHEUS. C. Picard, Des Frises du Mausolée aux dessins d' Albert Dürer, *Revue Archéologique*, Series 6, XXXVII, 1951, p. 213, points out the general similarity that exists between Dürer's dying Orpheus and a dying warrior from the Mausoleum but fails to take into account the previous studies on the subject (particularly A. Warburg's epoch-making essay, quoted in the Bibliography, No. 74), where the classical antecedents of Dürer's figure and the

mechanism of their transmission have been explained.

Handlist No. 932: LUCRETIA. See now the article by Stechow, quoted in the remark to Handlist No. 106.

Handlist No. 938: ALLEGORY INSCRIBED "PUPILA AUGUSTA." G. de Tervarent, Dürer's *Pupila Augusta, Burlington Magazine*, XCII, 1950, p. 198, identifies the three women in the foreground with the Horae who, according to *Homeric Hymns*, VI, 7-15, "joyously welcome" Venus as she emerges from the sea to alight on the island of Cyprus. "One of them [is shown] waving to the goddess, the other two predicting, in the manner of soothsayers, the future of the one they were to array, so that she shall be agreeable to the Olympians. Their attitude toward her is the solicitude of chaperons, hence the inscription *Pupila Augusta* (divine ward)." I incline to accept the identification of the three women as welcoming Horae but should like to add that it tends to complement rather than to supplant the hypothesis that the author of Dürer's Italian prototype may have wished to compare, like many poets of the time, the arrival of Venus on Cyprus to the arrival of Caterina Cornaro (officially "The Ward of the Venetian Republic") on that island. That two of the Horae engage in prognostication is a motif entirely foreign to the classical source and more compatible with the advent of a queen equated with a goddess than with that of a goddess *in propria persona*.

Handlist No. 1019: PORTRAIT OF HANNS DÜRER. Line 4: "194" should read "200."

Handlist No. 1020: PORTRAIT OF ERASMUS OF ROTTERDAM. Line 10: "1522" should read "1523."

Handlist No. 1044: THE NEGRESS CATHARINE. First line: "Pen" should read "Silver Point." The error, fortunately absent from the text, p. 214, was pointed out to me by Professor D. R. Robb.

Handlist No. 1081: PORTRAIT OF A BEARDED MAN. The old error that the gentleman portrayed is the Portuguese humanist Damião de Goes is repeated in the legend of the frontispiece preceding the otherwise excellent article by S. A. Dickson, Panacea or Precious Bane; Tobacco in Sixteenth-Century Literature, *Bulletin of the New York Public Library*, LVII, 1953, p. 367.

Handlist No. 1116: PORTRAIT OF A YOUNG WOMAN IN PROFILE. A personal inspection of this drawing and a conversation with Mr. Nils Lindhagen, Curator of Prints and Drawings at the Stockholm Nationalmuseum, have convinced me

that it is perfectly genuine though somewhat rubbed and very slightly retouched. The relation between the figure and the surrounding space, which seems to lack precision in the reproductions, is clearly defined: the figure is placed in the corner of a room illuminated by partially visible windows in both of the walls. The paper, moreover, shows the watermark Briquet 6485, which occurs only in specimens from Ingolstadt, Augsburg and Nuremberg dated between 1471 and 1524. An imitator or forger of about 1600 could hardly have anticipated modern methods of scholarship to the extent of providing himself with a sheet of paper exactly corresponding to the place and date of what he intended to simulate.

Handlist No. 1146: HEAD OF A BEARDED MAN. This drawing was not found among the Lemberg drawings when they were offered for sale in New York.

Handlist No. 1354: SEA CRAB. Line 3: "Rotterdam" should read "Vierhouten near Amersfoort"; see *Van Beuningen Catalogue*, p. 154, No. 162, Plate 202.

Handlist No. 1373: LINDEN-TREE ON A BASTION. Line 3: "Rotterdam" should read "Vierhouten near Amersfoort"; see *Van Beuningen Catalogue*, p. 154, No. 161, Plate 204.

Handlist No. 1374: SKETCH LEAF. The verso of this drawing shows the construction of an octagon.

Handlist No. 1596-1597: CONSTRUCTION OF A NUDE MAN; NUDE MAN WITH LION. Attached to this drawing is another sheet of like material and size which shows a counterproof of the recto (No. 1596). This counterproof, thus far unmentioned, would seem to have been taken by Dürer himself while the ink was still fresh, in order to serve as a model for the fair copy on the verso (No. 1597).

Handlist No. 1656-1657: CONSTRUCTION OF HUMAN FIGURES; MANNEQUIN. F. J. Sánchez-Cantón, Un maniquí del siglo XVI, *Archivo Español de Arte*, XCVIII, 1952, p. 101 ss., adds to the little boxwood mannequins connected with Dürer's studies in human proportion and often traditionally ascribed to himself, a fine specimen in the Prado, stylistically somewhat related to Conrad Meit. The article thus supplements the essay by A. Weixlgärtner, Dürer und die Gliederpuppe, *Beiträge zur Kunstgeschichte, Franz Wickhoff gewidmet*, Vienna, 1903, p. 80 ss., which seems to have escaped the author's attention.

Handlist No. 1711a (Supplementary remarks, p. 167): CELESTIAL MAP. Lines 6 through 3 from

the foot of the page should read as follows: "Though Perseus still carries the original 'Demon's Head' (*Caput Algol*) instead of the classical *Caput Medusae*, the *Equus Volans*. . . ." The second installment of the article by Professor S. G. Barton, quoted at the end of the entry, has appeared in *Sky and Telescope*, VI, 1947, No. 72, p. 12 ss.

5. PLAQUES AND MEDALS

Handlist Nos. 1731-1732: PORTRAIT MEDALS OF A MAN AND A LADY. The original stone models of these two casts are preserved in the Historisk Museum at Stockholm and are of unexpectedly high quality; it would be worthwhile for experts to explore the possibility of an attribution to Adolf Daucher.

B. Additions to the Bibliography as Printed in this volume, pp. 287-296 (excepting titles already quoted in the foregoing notes).

E. Buchner, *Das deutsche Bildnis der Spätgotik und der frühen Dürerzeit*, Berlin, 1953, p. 144 ss., Plates 166-182.

A. M. Cetto, *Watercolours by Albrecht Dürer*, New York and Basel, 1954.

A. von Einem, *Goethe und Dürer; Goethes Kunstphilosophie*, Hamburg, 1947.

H. Jantzen, *Dürer der Maler*, Berne, 1952.

H. Kauffmann, Dürer in der Kunst und im Kunsturteil um 1600, *Anzeiger des Germanischen Nationalmuseums 1940-53*, Nürnberg-Berlin, 1954, p. 18 ss. An excellent contribution to the solution of an unusually fascinating problem.

S. Killermann, *A. Dürers Werk; Eine natur- und kulturgeschichtliche Untersuchung*, Regensburg, 1953. A useful discussion of plants, animals, minerals, costumes, and implements in Dürer's work.

T. Musper, *Albrecht Dürer; Der gegenwärtige Stand der Forschung*, Stuttgart, 1952.

E. Panofsky, "Nebulae in Pariete"; Notes on Erasmus' Eulogy on Dürer, *Journal of the Warburg and Courtauld Institutes*, XIV, 1951, p. 34 ss.

E. Schilling, *Dürer; Drawings and Water Colors*, New York, 1949.

G. Schönberger, *The Drawings of Mathis Gothart Nithart Called Grünewald*, New York, 1948. Important because the author convincingly shows that Dürer's first encounter with Grünewald appears to have taken place as early as 1502-1503, while the latter was busy with an altarpiece for the church of Bindlach in Franconia.

W. Stechow, Justice Holmes' Notes on Albrecht Dürer, *Journal of Aesthetics*, VIII, 1949, p. 119 ss.

M. Steck, *Dürers Gestaltlehre der Mathematik und der bildenden Künste*, Halle, 1948. The author promises the publication of a newly discovered manuscript concerned with mathematical problems (pp. 49, 83, 100). The only sample from this mysterious manuscript, reprinted on p. 49 and adduced as proof of Dürer's intimate knowledge of "workshop mathematics" as practiced by craftsmen and artisans, is, however, a text, describing the construction of the enneagon, which is perfectly identical with a passage in the well-known Merkel manuscript in the Germanisches Nationalmuseum at Nuremberg. This passage was published and analogously interpreted, as early as 1915, in my book on Dürer's art theory (Bibliography, No. 192, p. 93; cf. also this volume, p. 256 s.).

H. Tietze, *Dürer als Zeichner und Aquarellist*, Vienna, 1951.

W. Waetzoldt, *Dürer and His Times* (English translation of the book quoted in the Bibliography, No. 51), London, 1950.

G. Weise, *Dürer und die Ideale der Humanisten* (Tübinger Forschungen zur Kunstgeschichte, VI), Tübingen, 1953.

A. Weixlgärtner, *Dürer und Grünewald*; Ein Versuch, die beiden Künstler zusammen—in ihren Besonderheiten, ihrem Gegenspiel, ihrer Zeitgebundenheit—zu verstehen (*Göteborgs Kungl. Vetenskaps-och Vitterhets-Samhälles Handlingar*, ser. 6, section A, vol. IV, No. 1), 1949.

Index I*

PERSONS

* Page references in italic indicate the most important passages.

Index II*

WORKS BY AND ASCRIBED TO DÜRER, INCLUDING COPIES AND REPLICAS

PAINTINGS

*This index is arranged according to Handlist numbers which are added in parentheses and constitute an iconographical sequence within the categories of Paintings, Engravings, Woodcuts and Drawings; they can be ascertained, if necessary, by consulting the Concordances or the Index of Places in vol. II. Works forming part of a coherent group or series such as the elements of a composite altarpiece, the studies for a major painting or engraving, the woodcuts of the Apocalypse, or the *Tarocchi* copies are individually indexed only if referred to outside the passage dealing with the group or series as a whole. For abbreviations see vol. II, p. xxvi. References in italic indicate the most important passages and illustrations.

ENGRAVINGS, ETCHINGS, AND DRY POINTS

WOODCUTS AND WOODBLOCKS

DRAWINGS

THE ILLUSTRATIONS

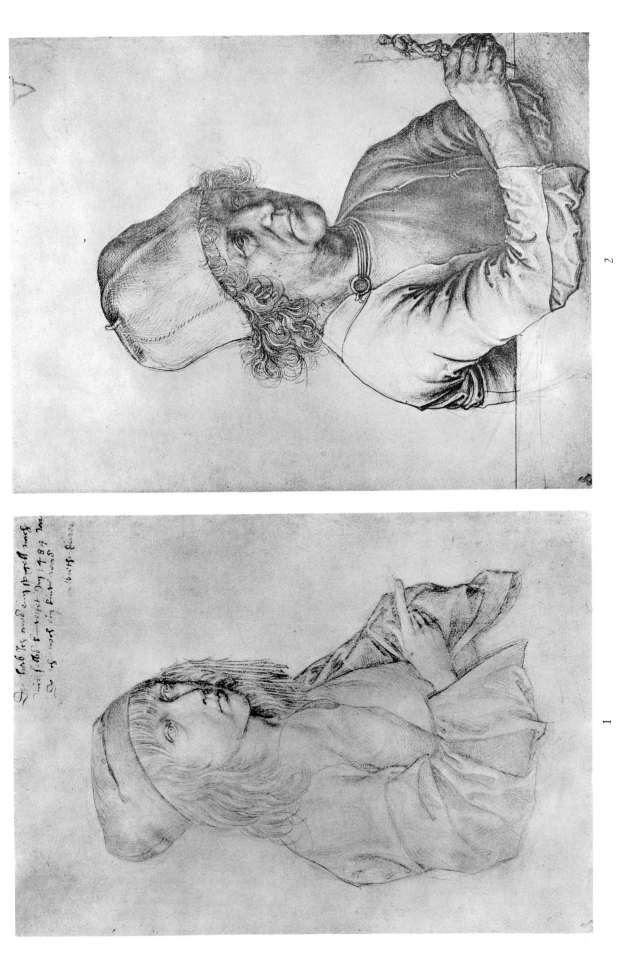

1

2

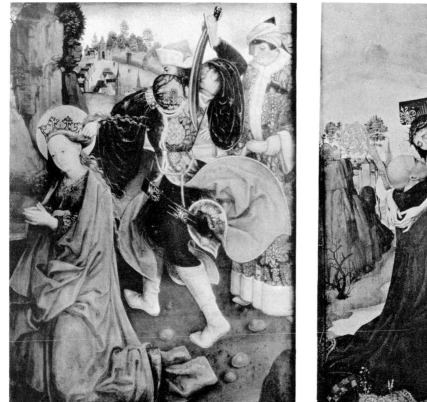

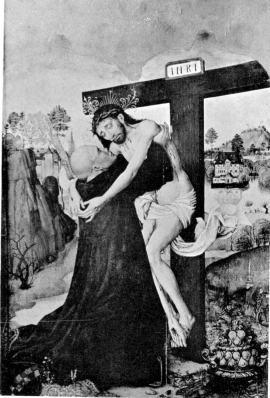

3

4

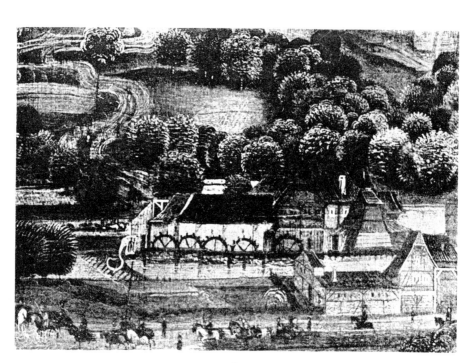

5

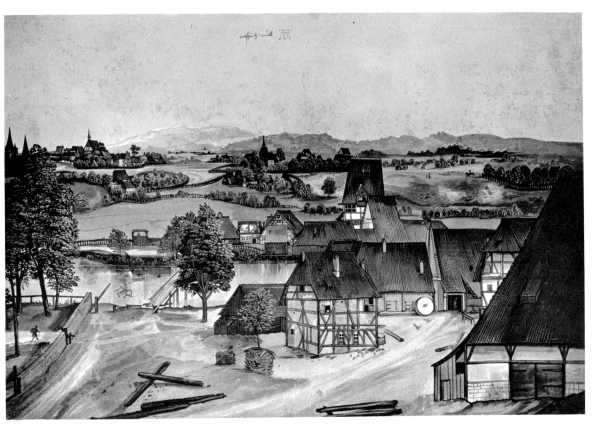

6

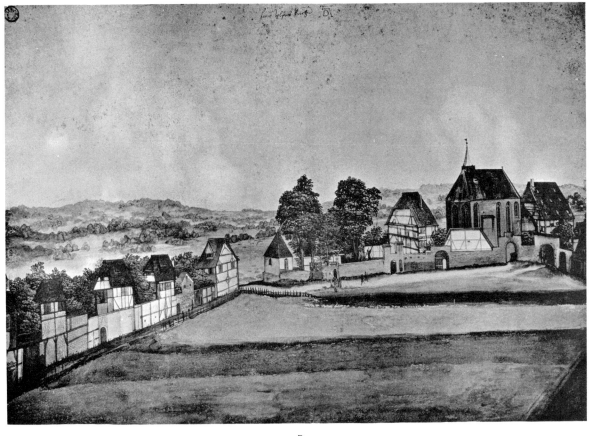

7

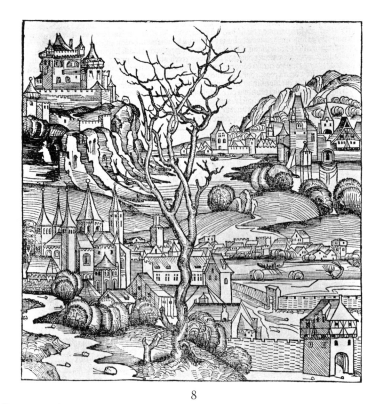

8

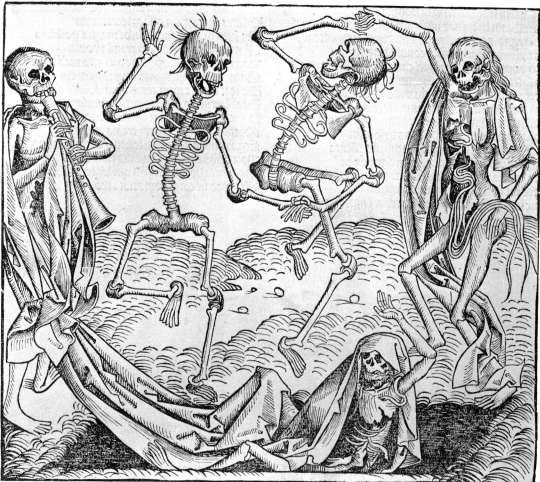

9

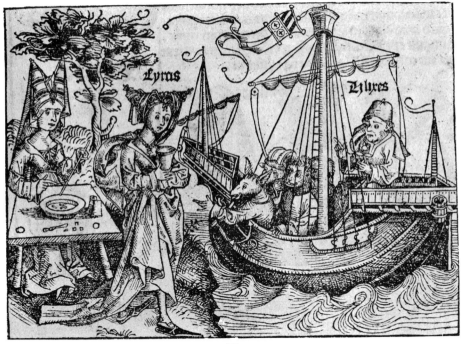

10

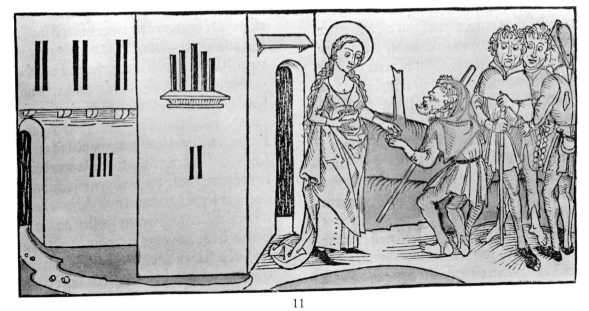

11

12a

12b

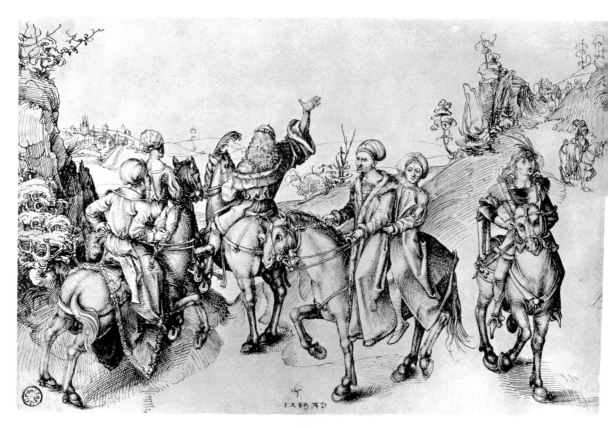

13

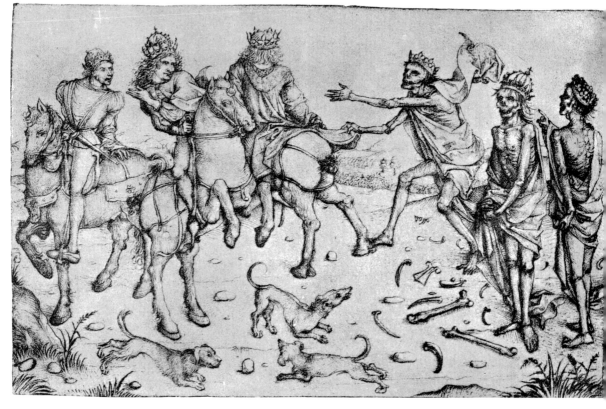

14

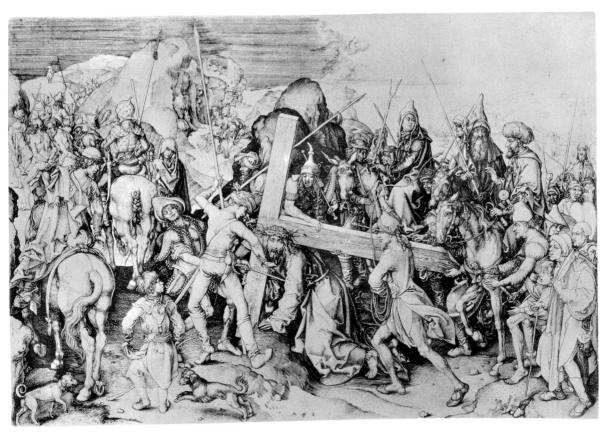

15

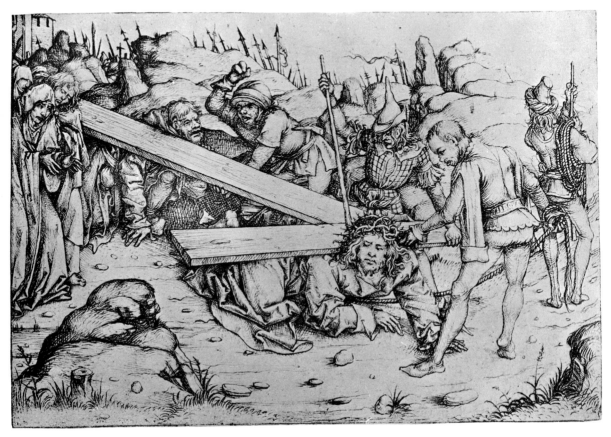

16

18

17

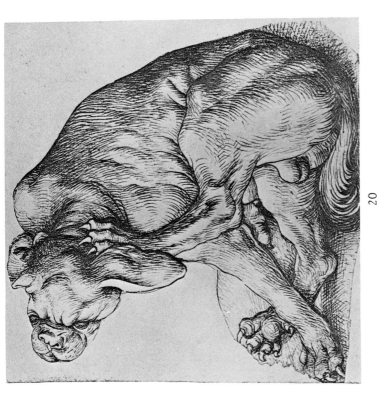

20

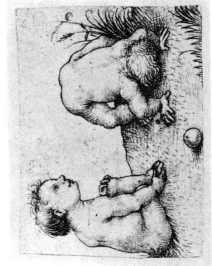

22

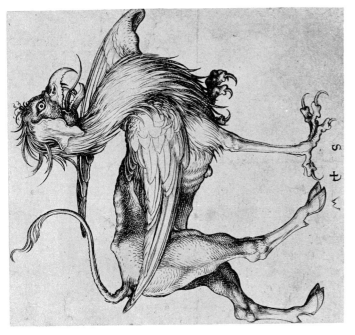

19

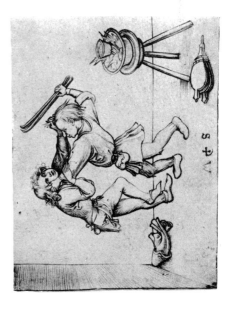

21

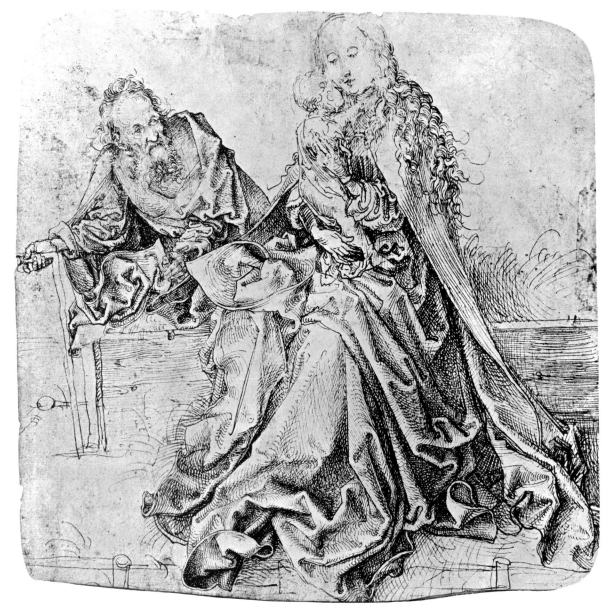

23

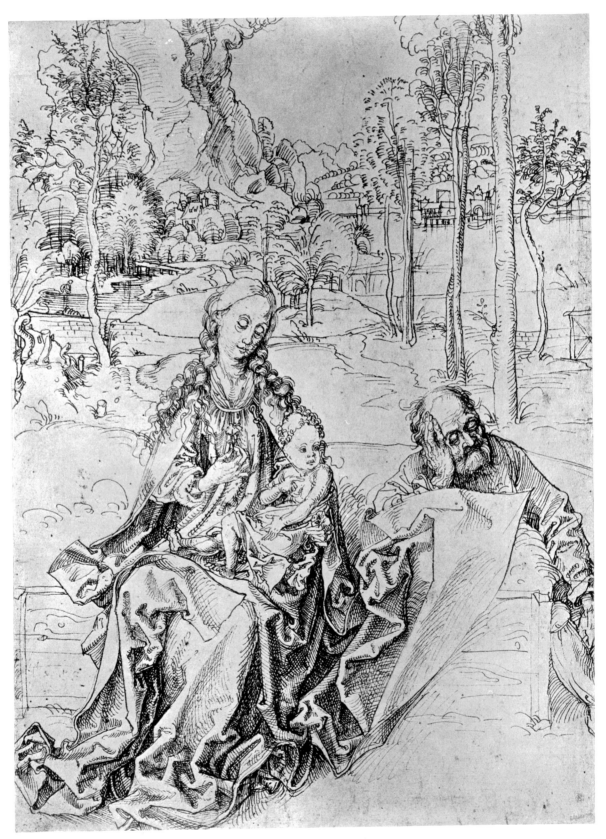

24

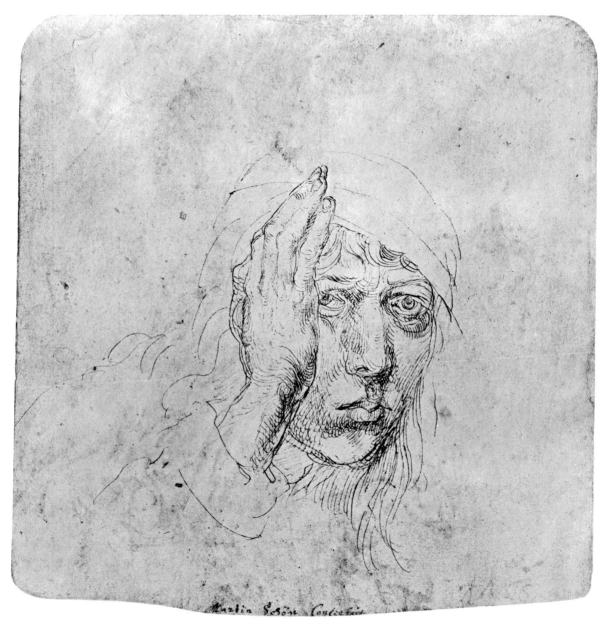

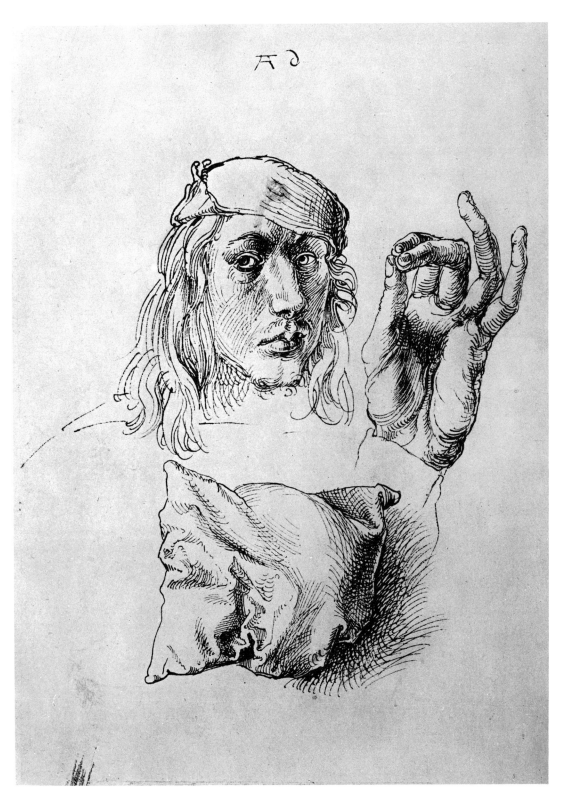

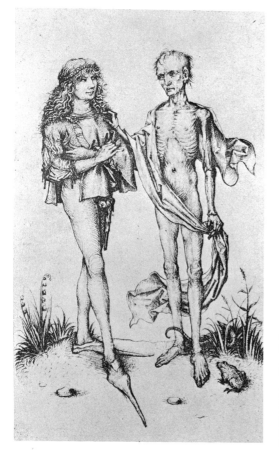

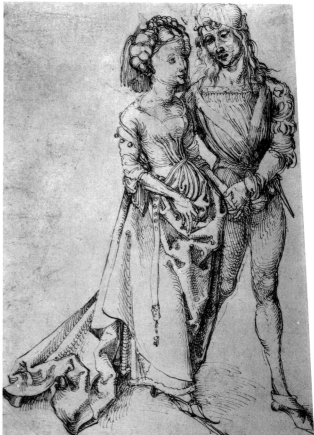

27

28

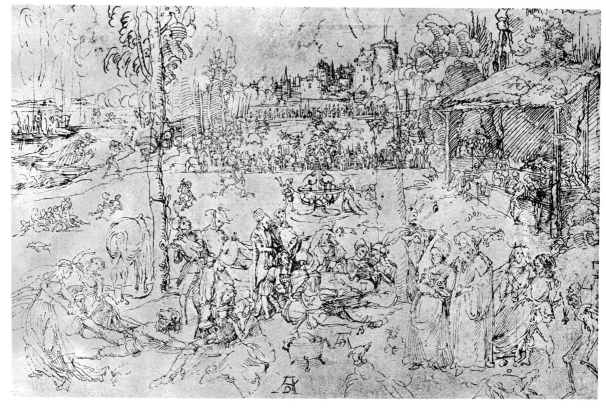

29

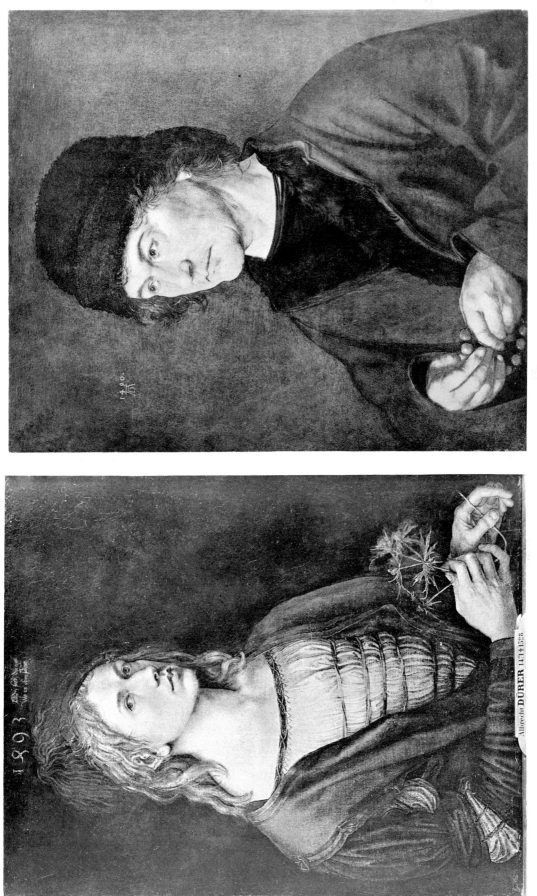

30

Albrecht DÜRER 1471†1528

31

35

34

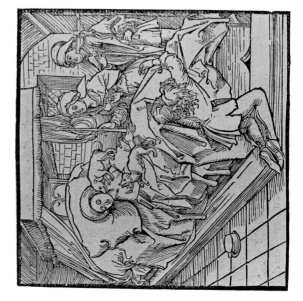

36

37

38

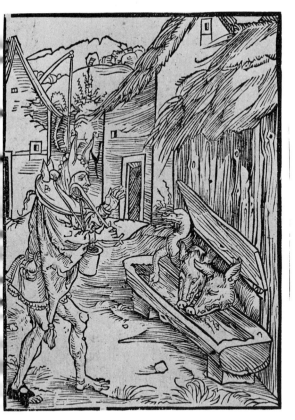

40

41

42

43

44

46

47

48

50

51

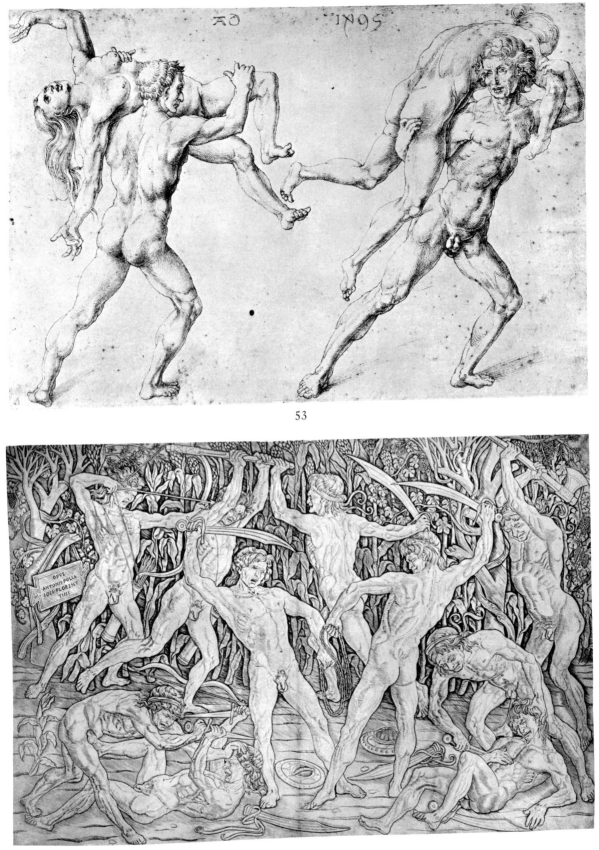

53

54

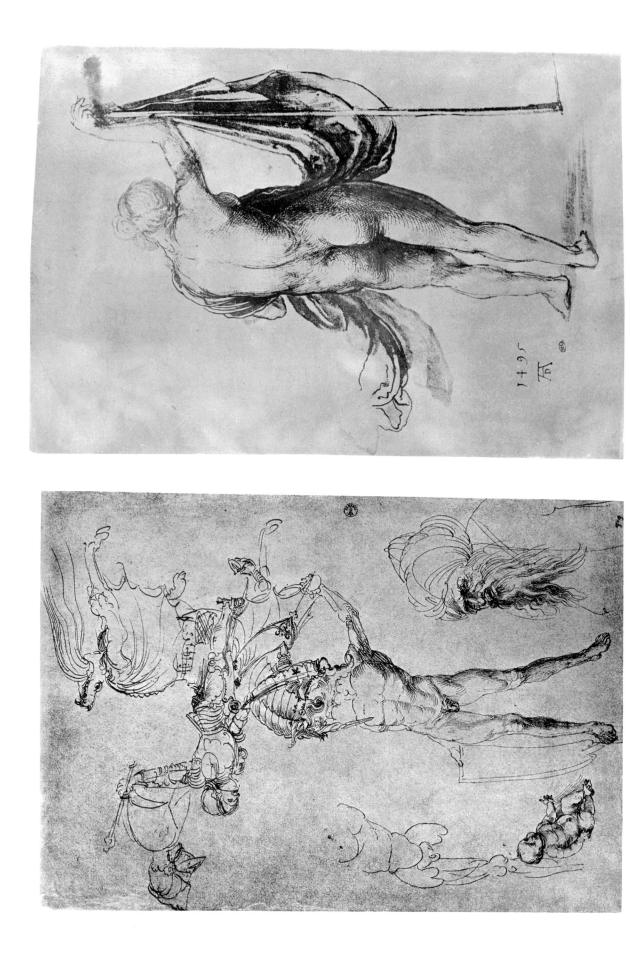

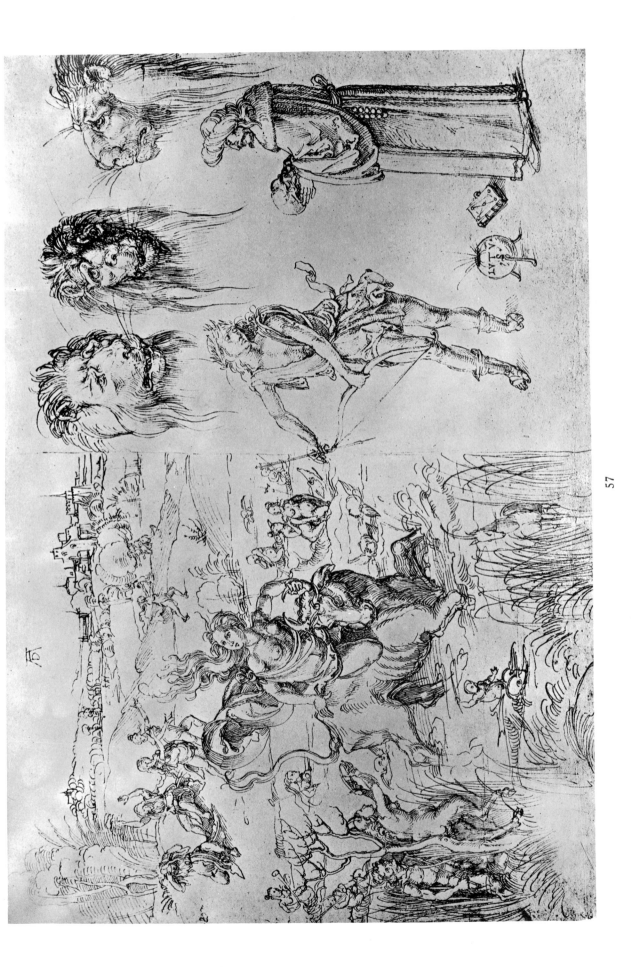

57

59

58

60

61

62

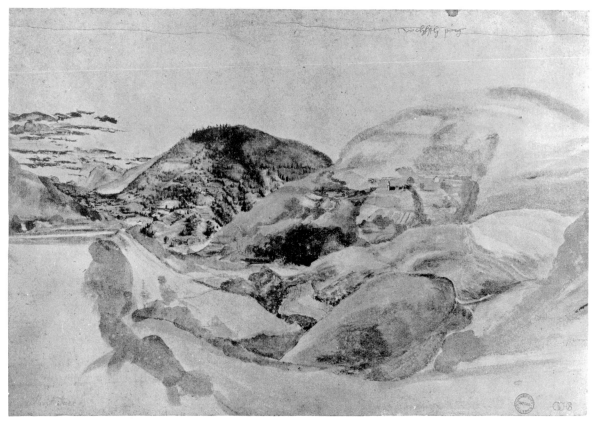

63

65

66

67

68

69

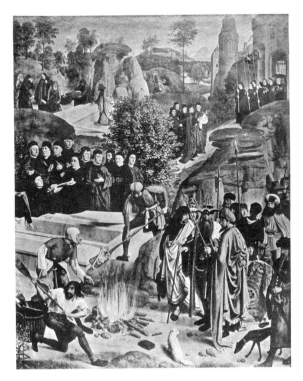

70

73

74

75

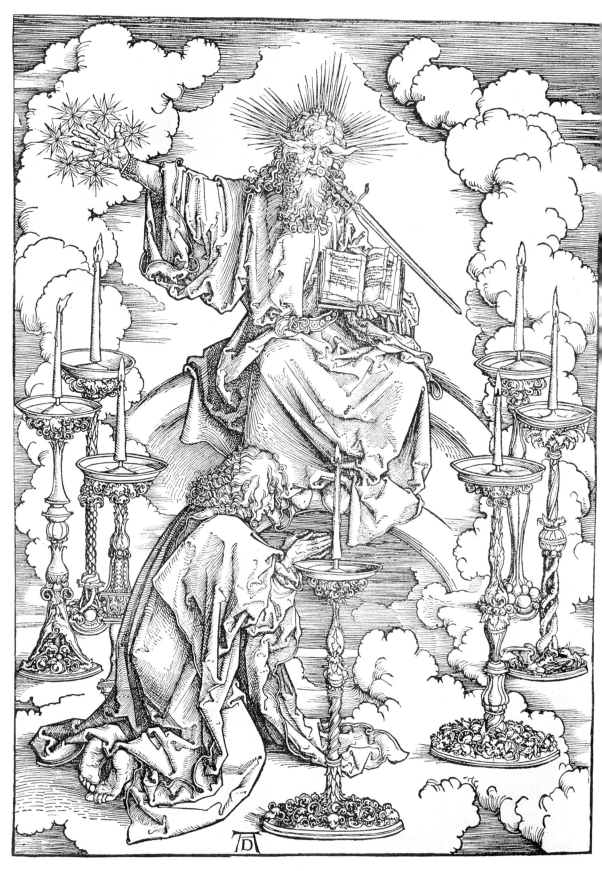

76

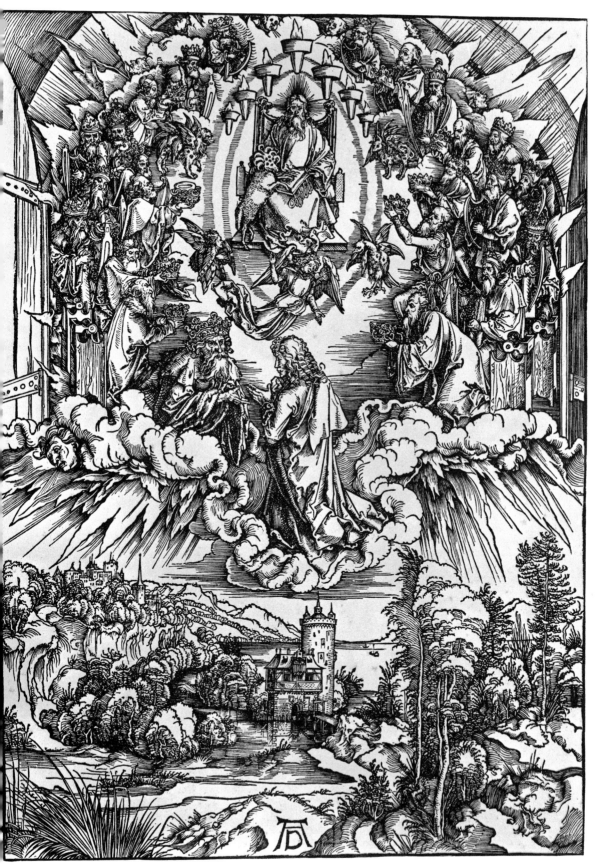

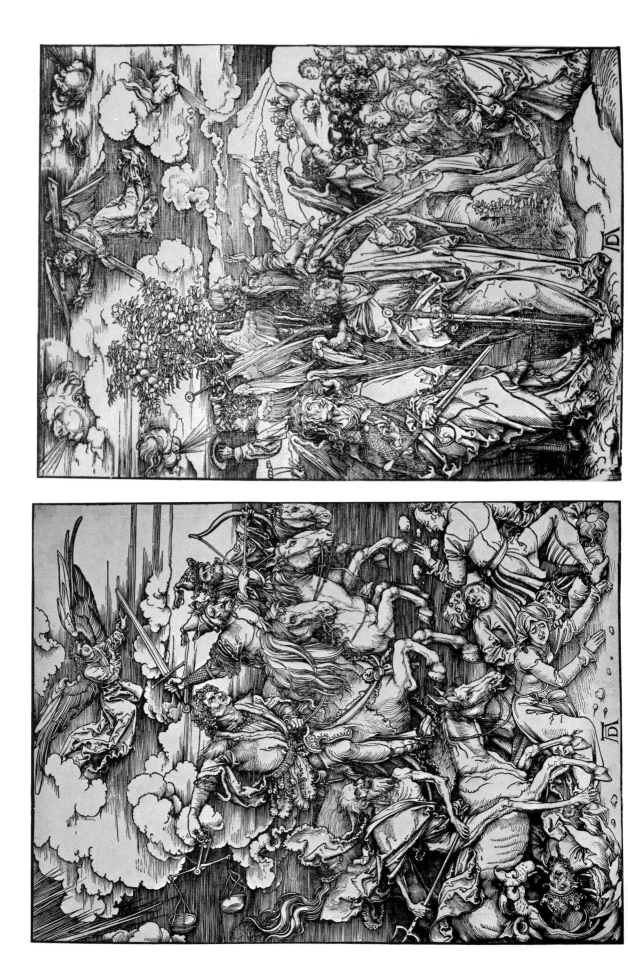

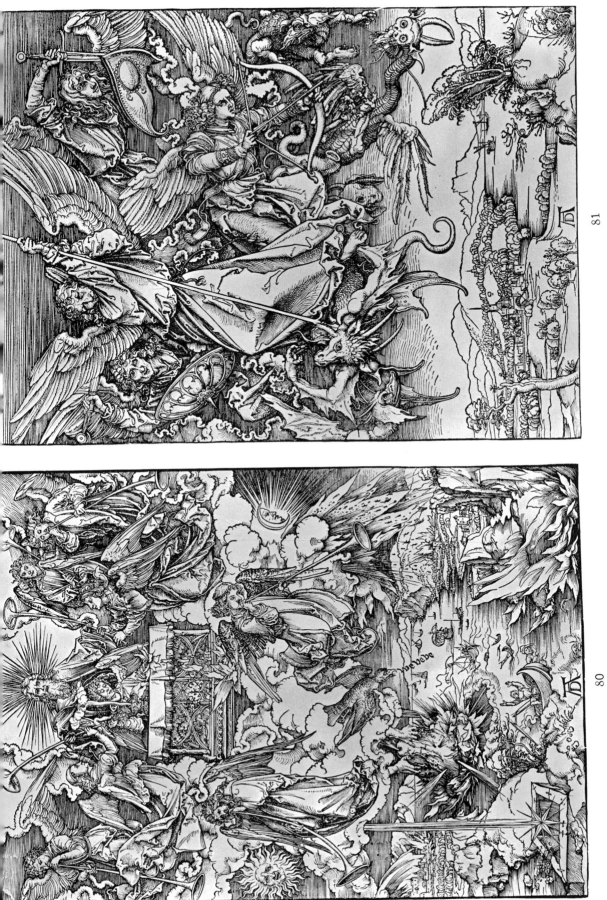

81

80

82

83

84

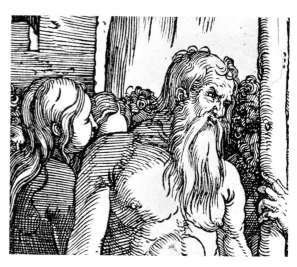

85

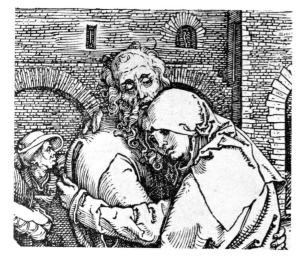

86

87

89

88

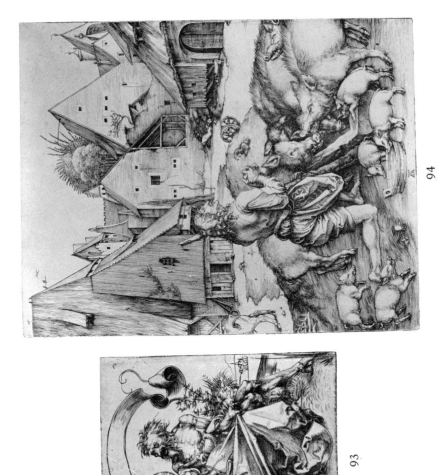

94

93

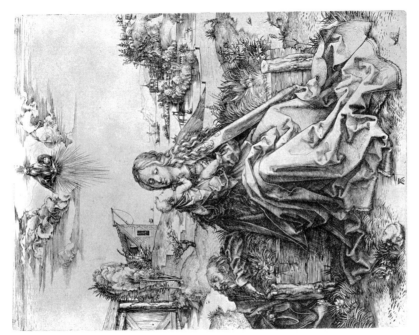

92

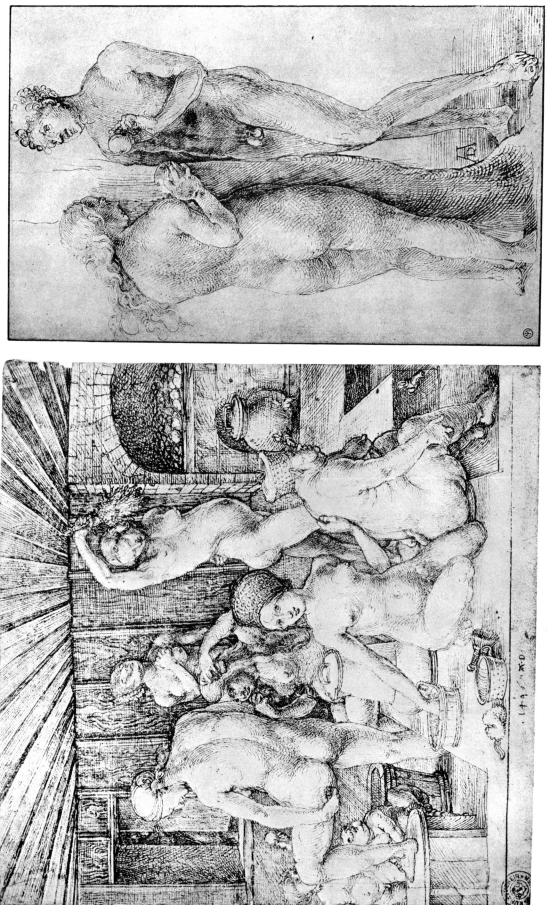

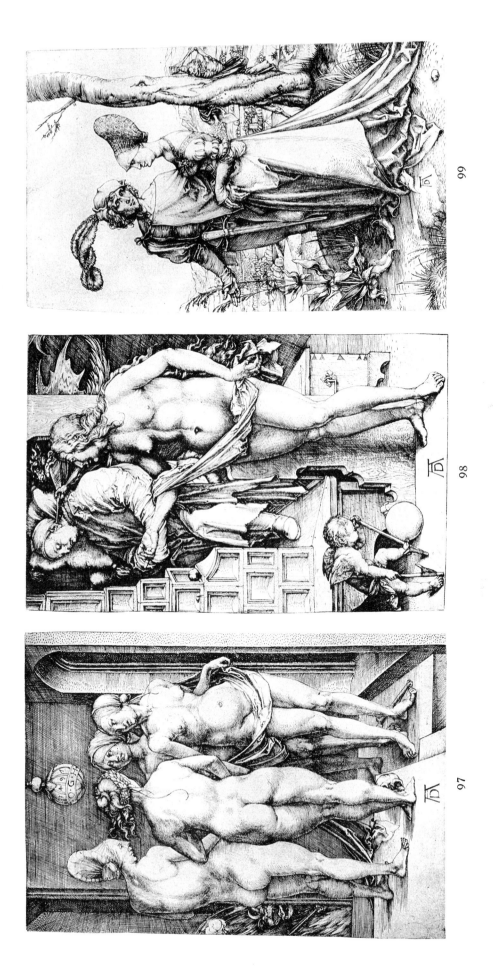

99

98

97

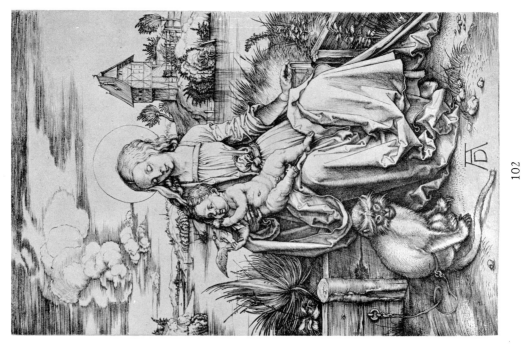

102

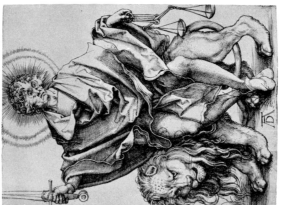

101

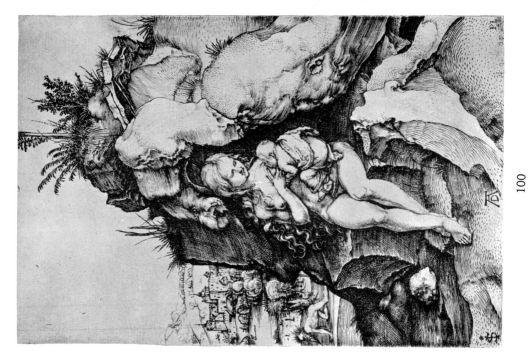

100

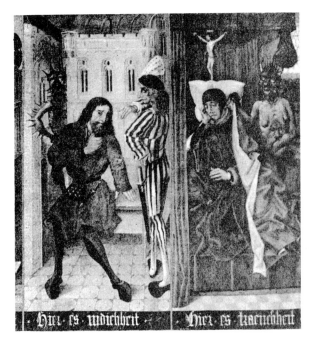

103

104

105

106

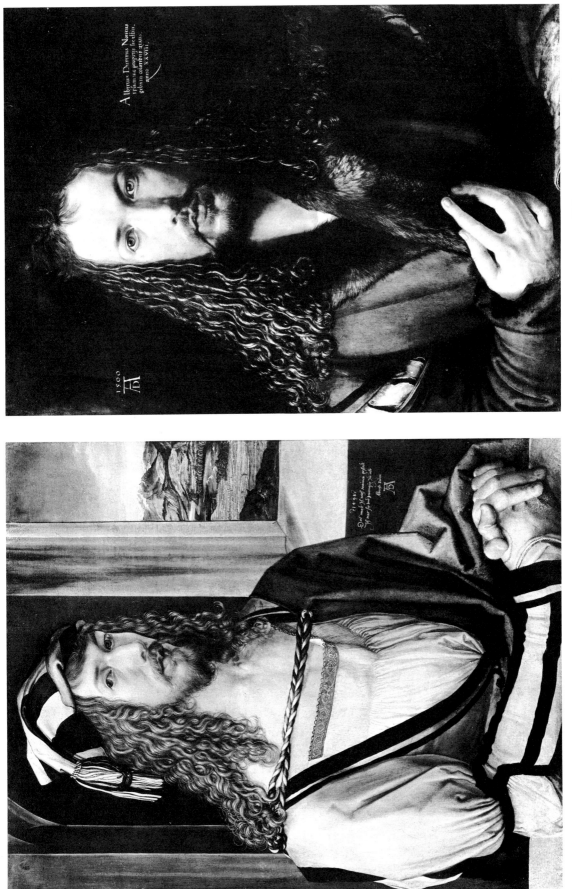

110

109

111

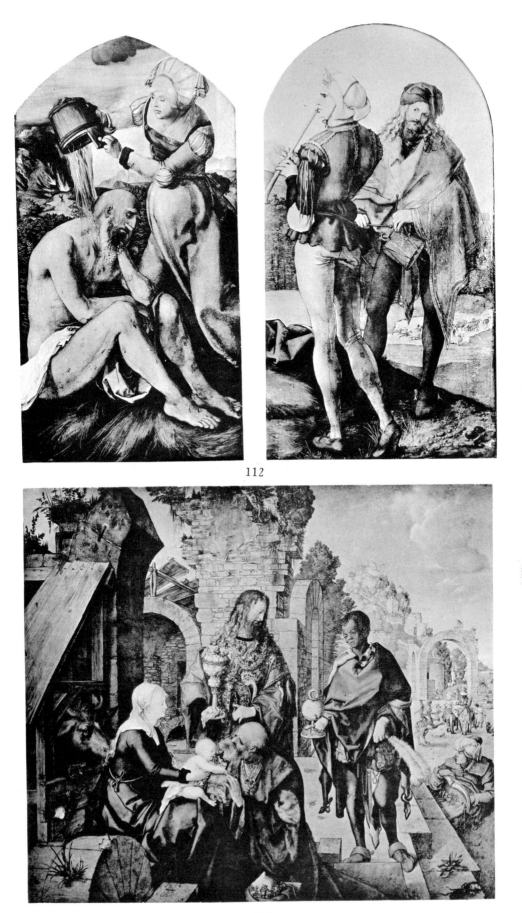

112

113

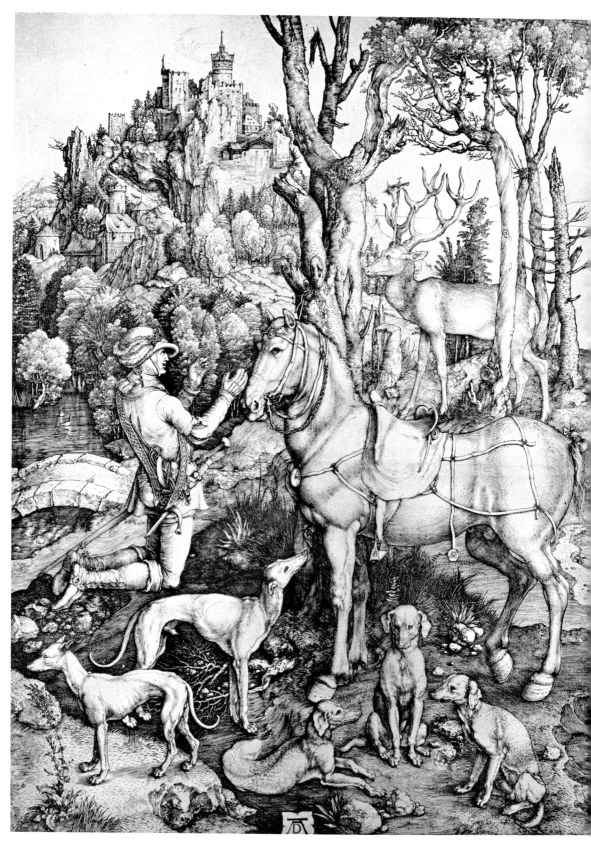

114

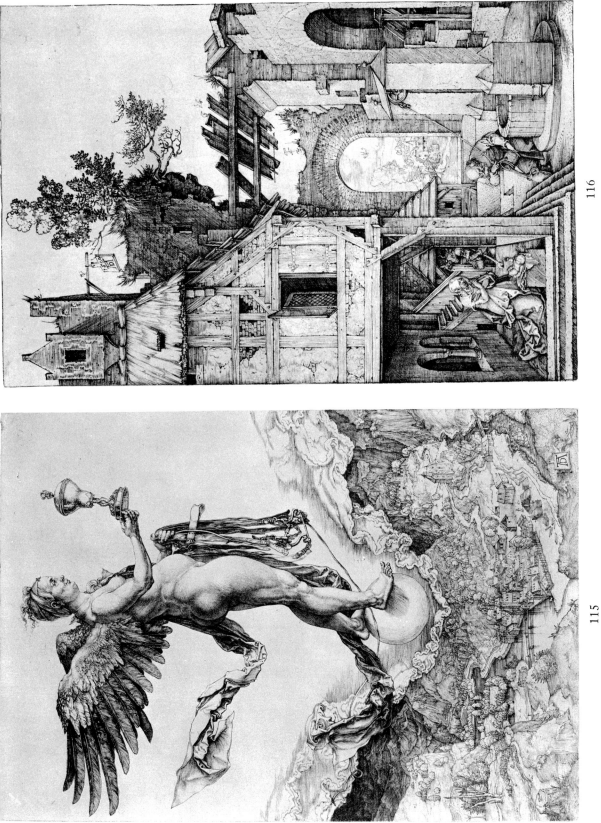

116

115

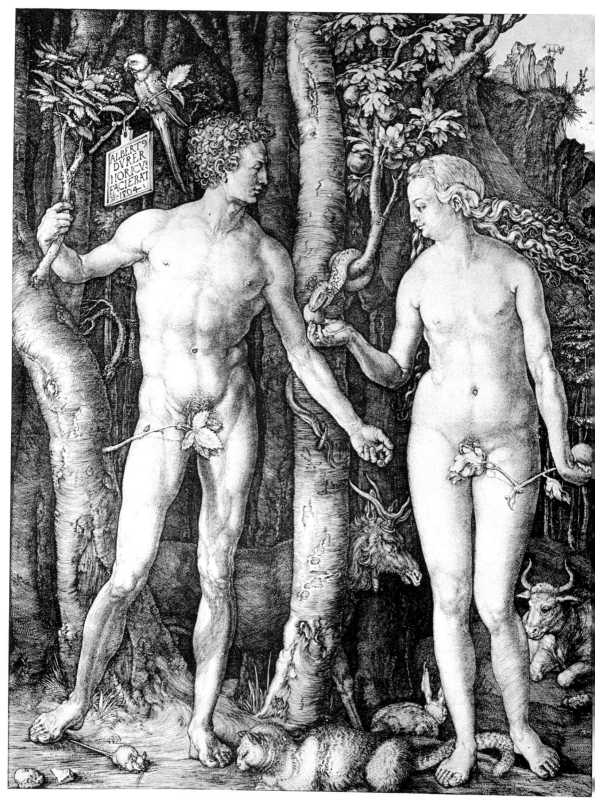

117

120

119

118

121

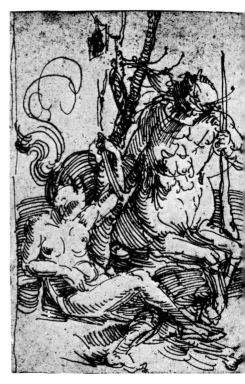

122

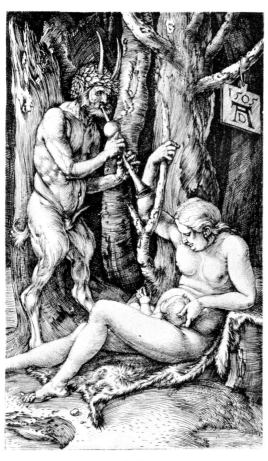

123

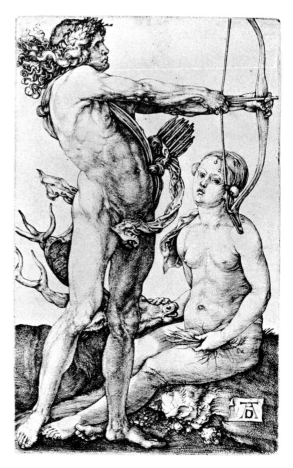

124

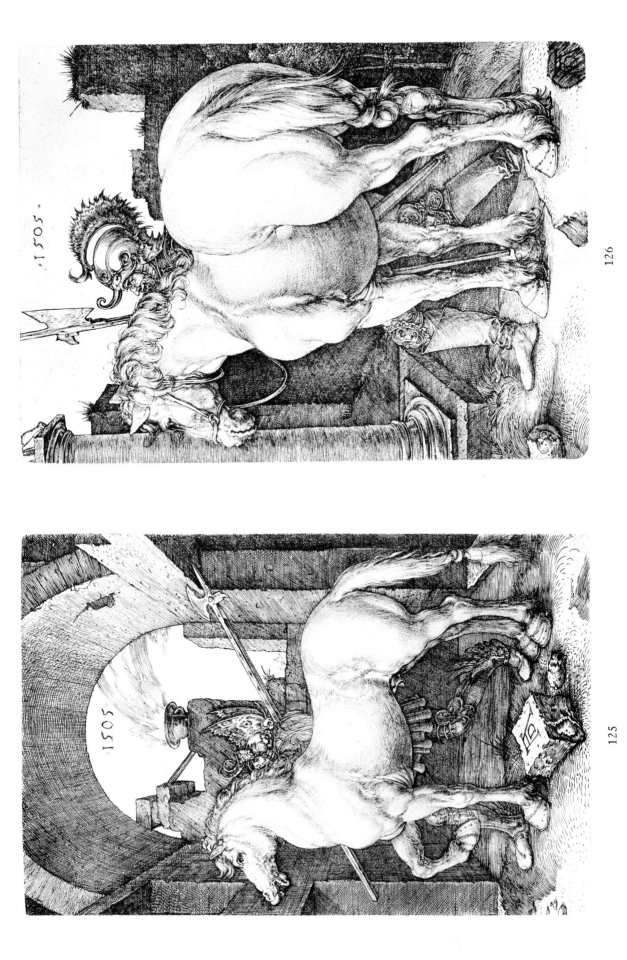

127

128

129

130

131

132

133

134

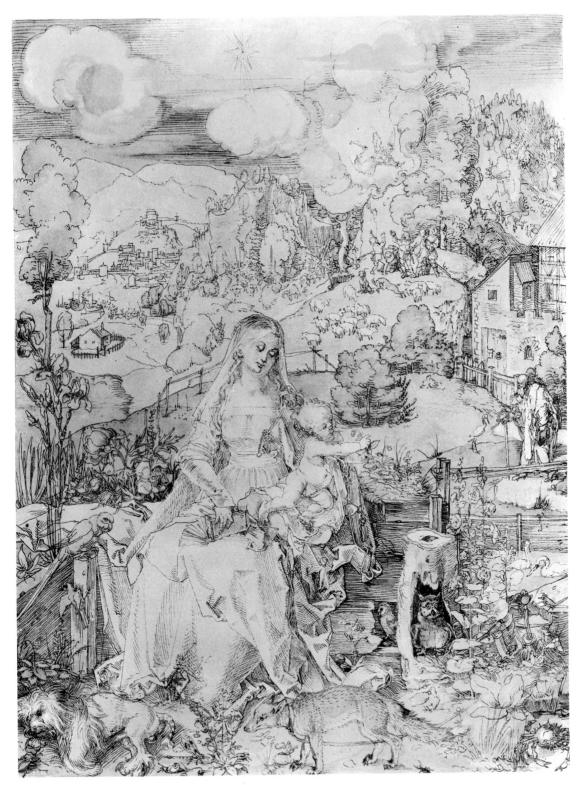

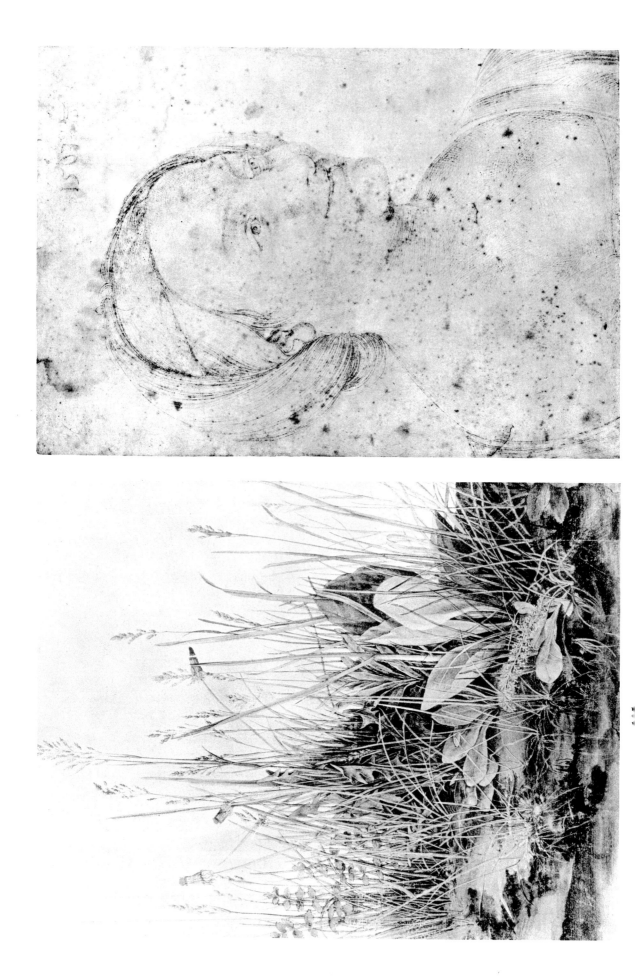

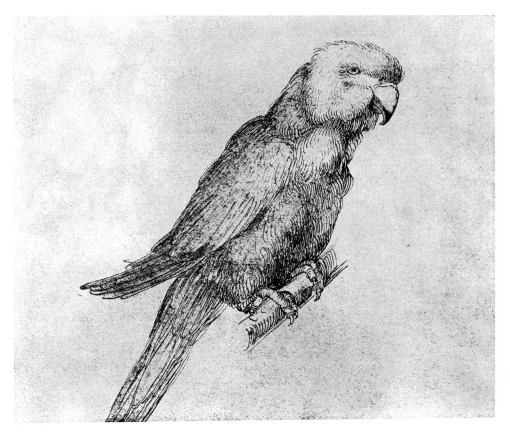

137

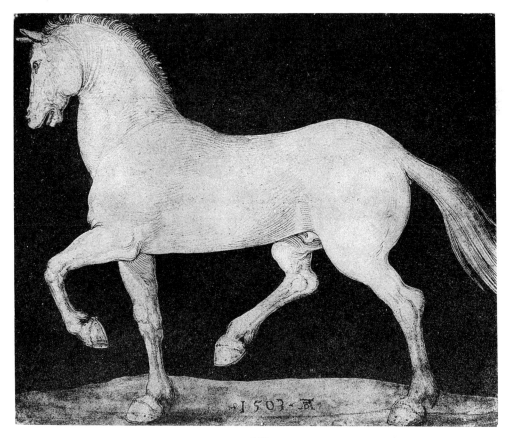

138

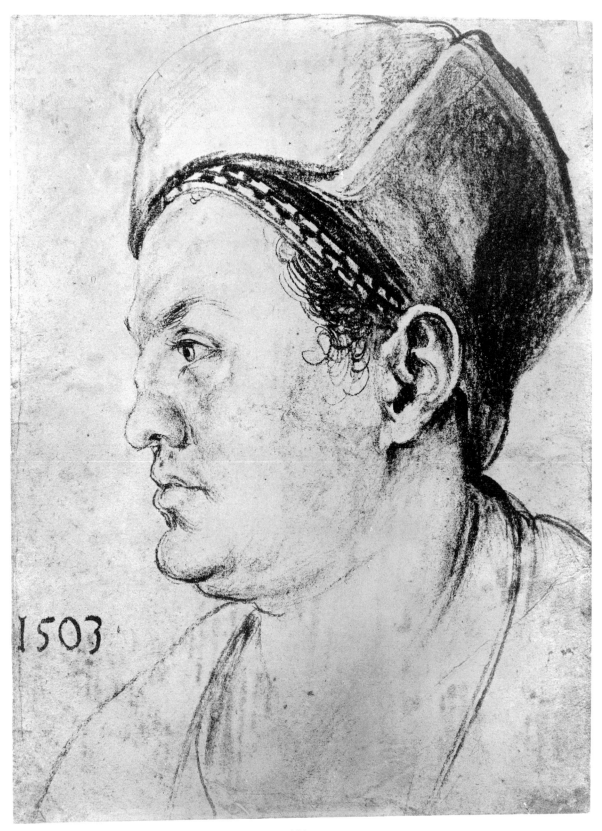

1503

139

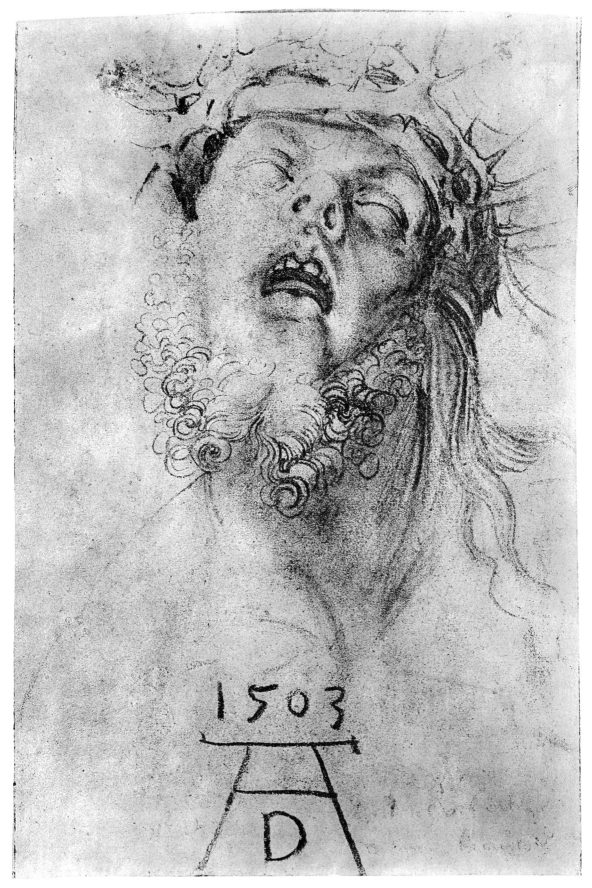

1509

141

142

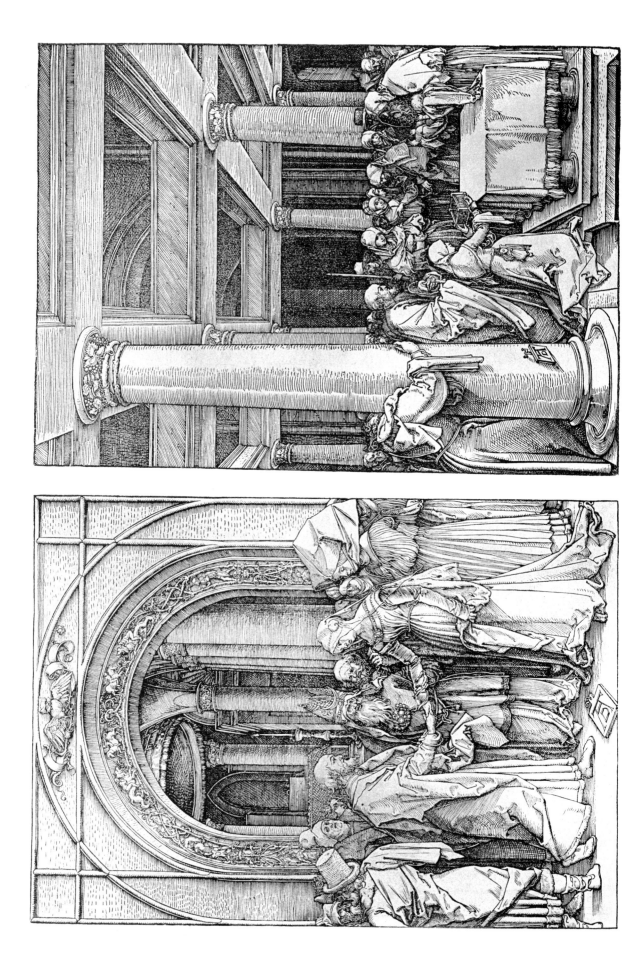

145

146

148

149

150

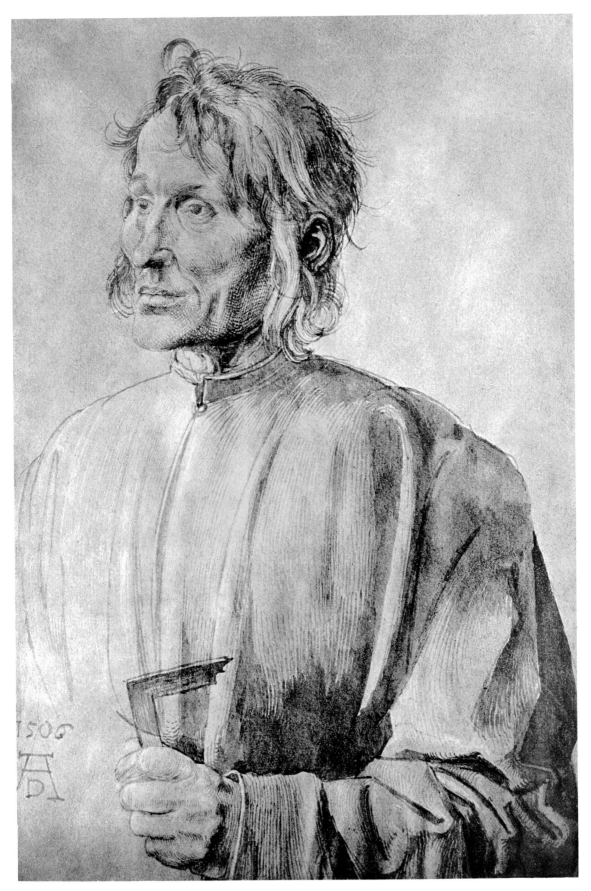

151

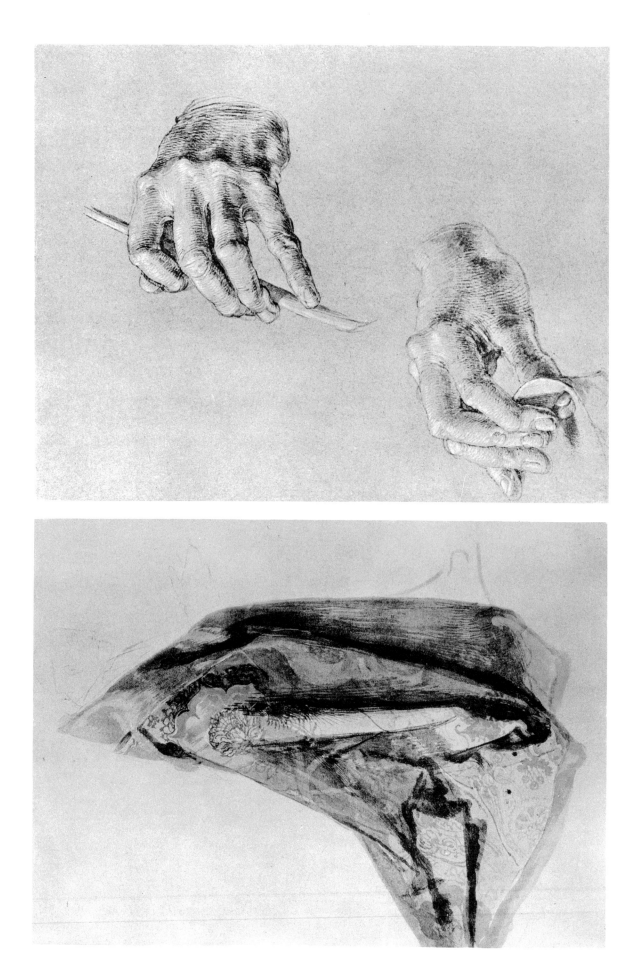

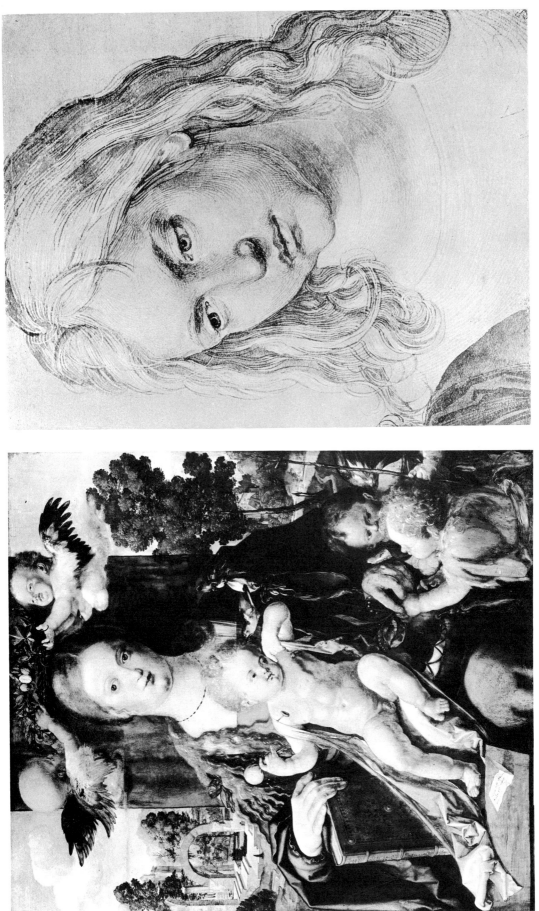

154

155

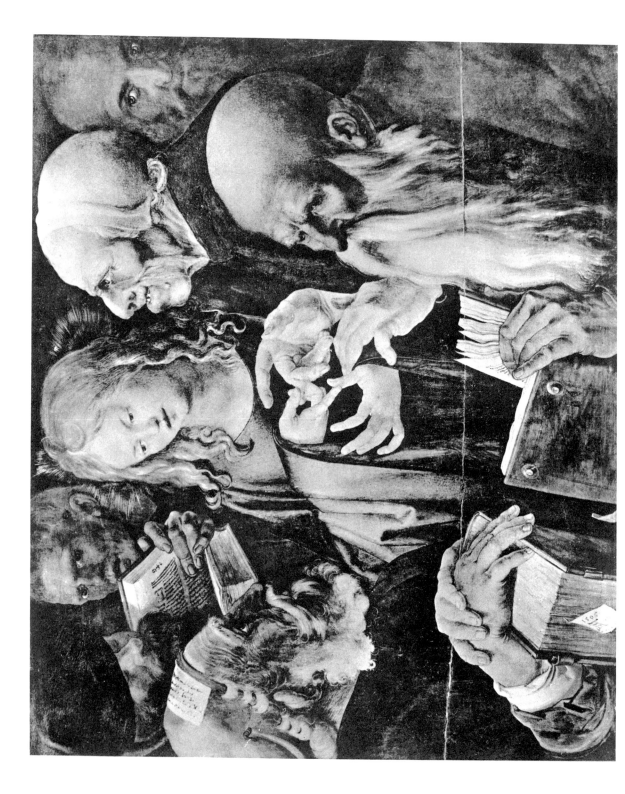

157

158

159

160

163

162

161

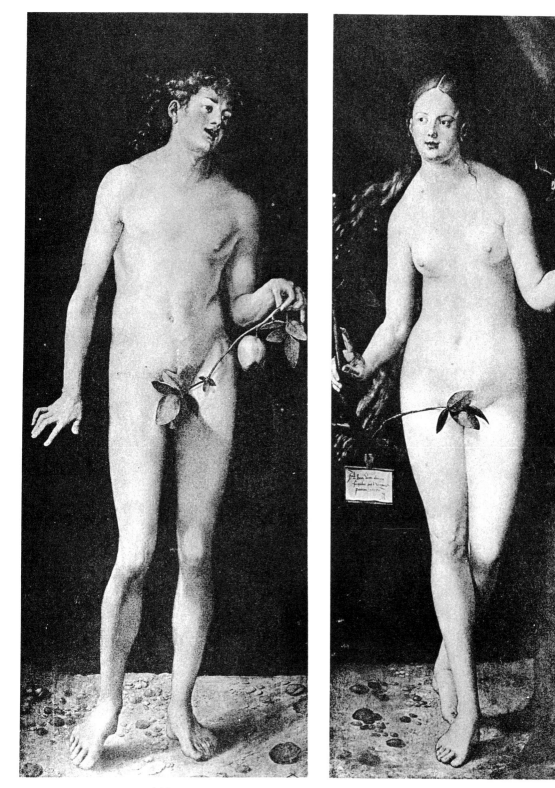

164 165

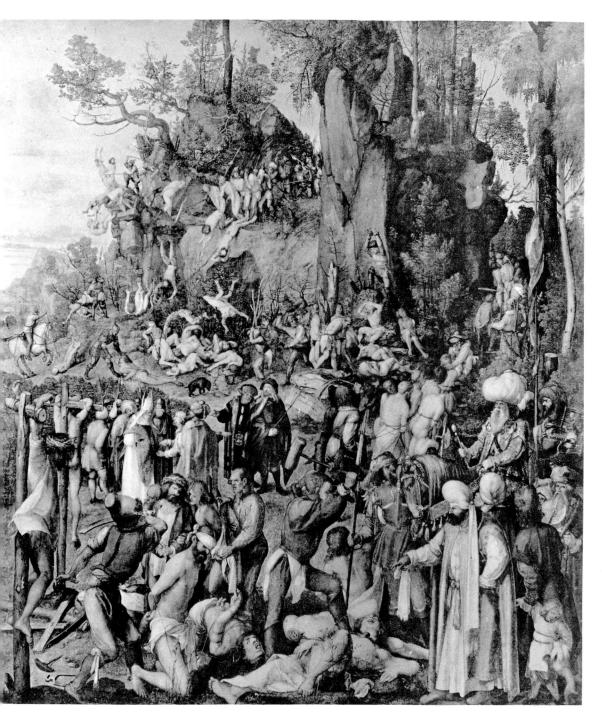

166

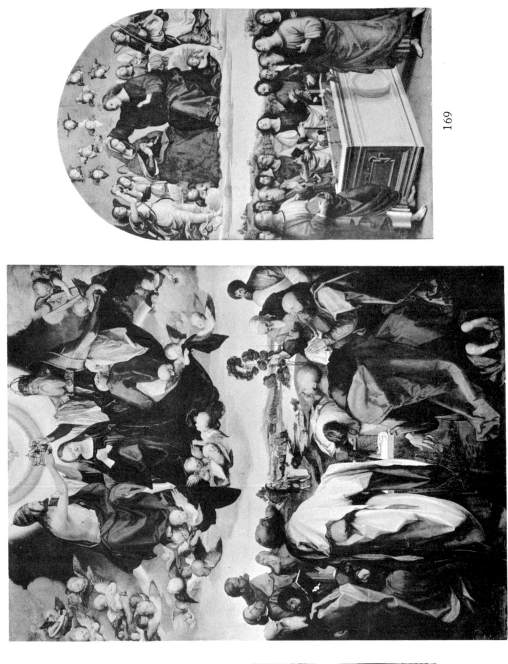

167

168

169

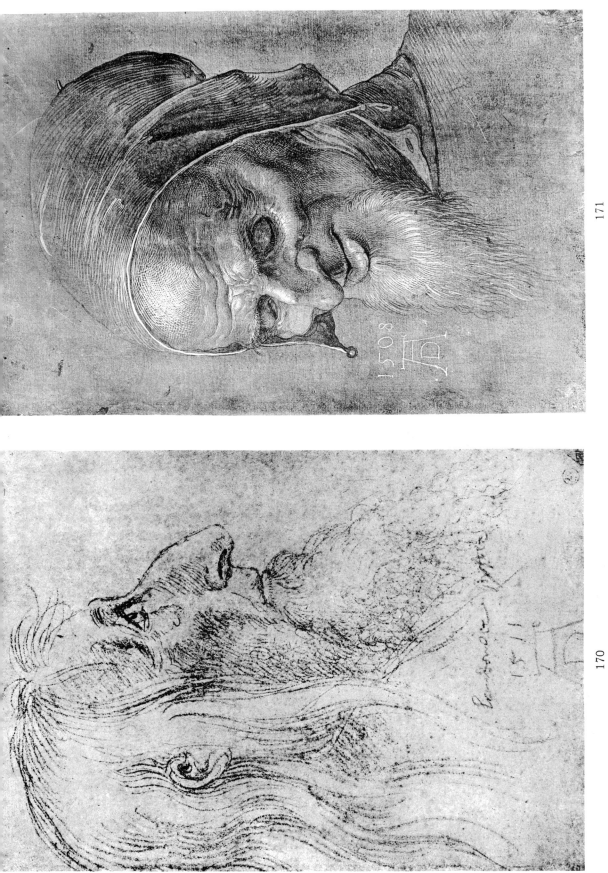

171

170

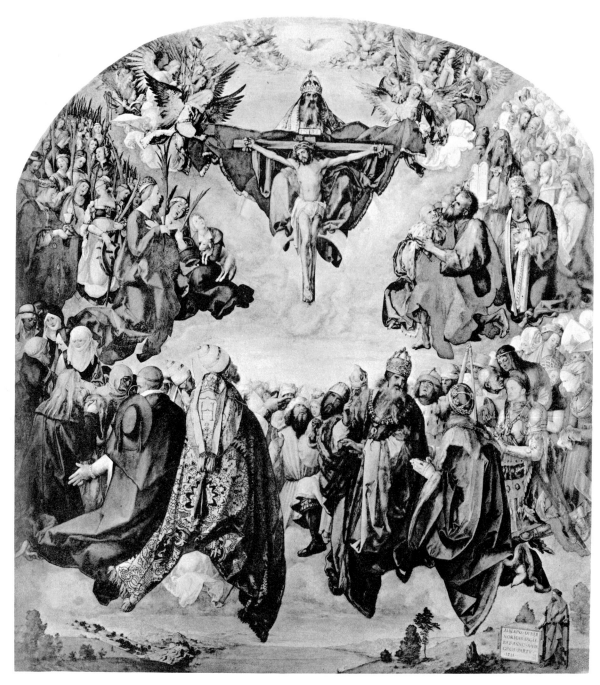

173

174

175

176

177

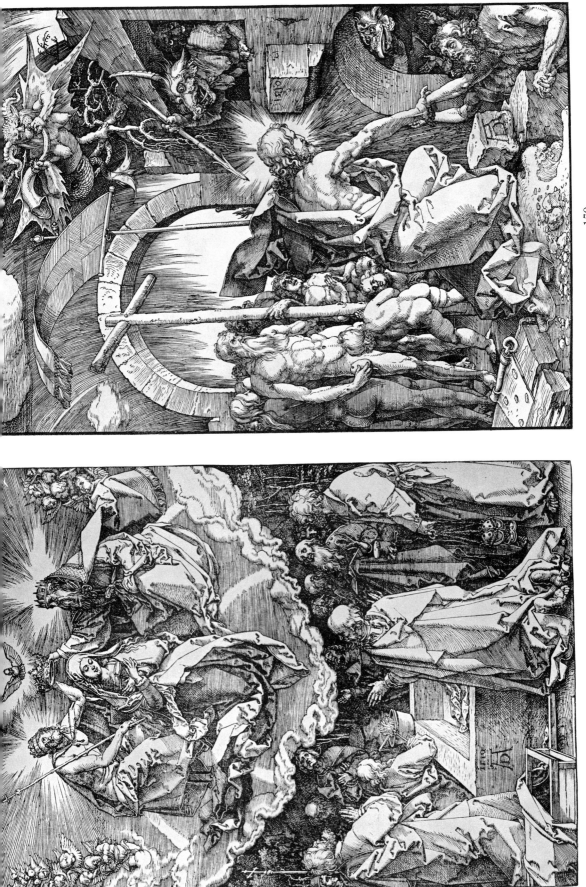

179

178

182

181

1471. *Albert Dürer.* (Mappe.)

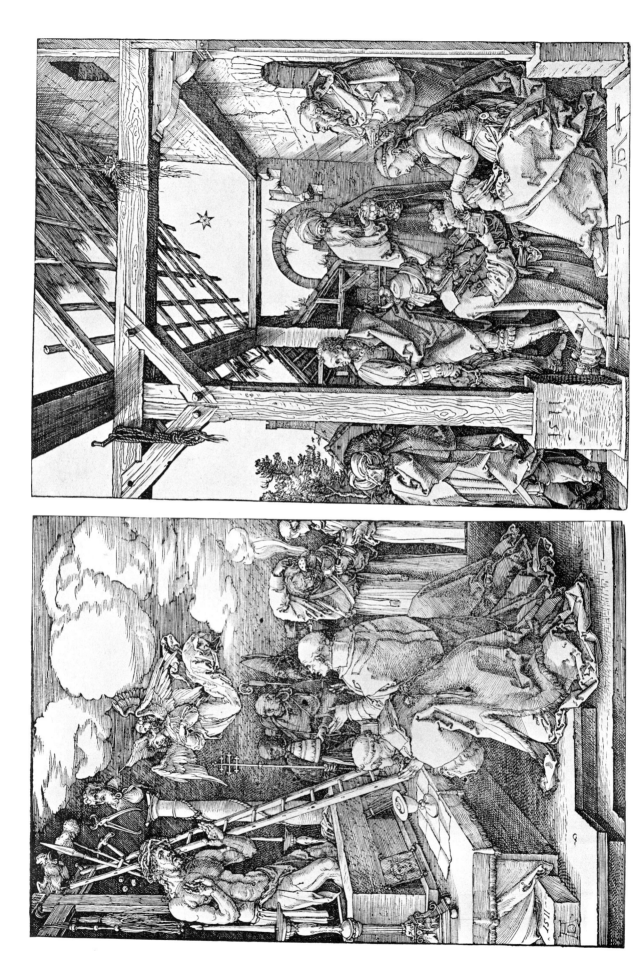

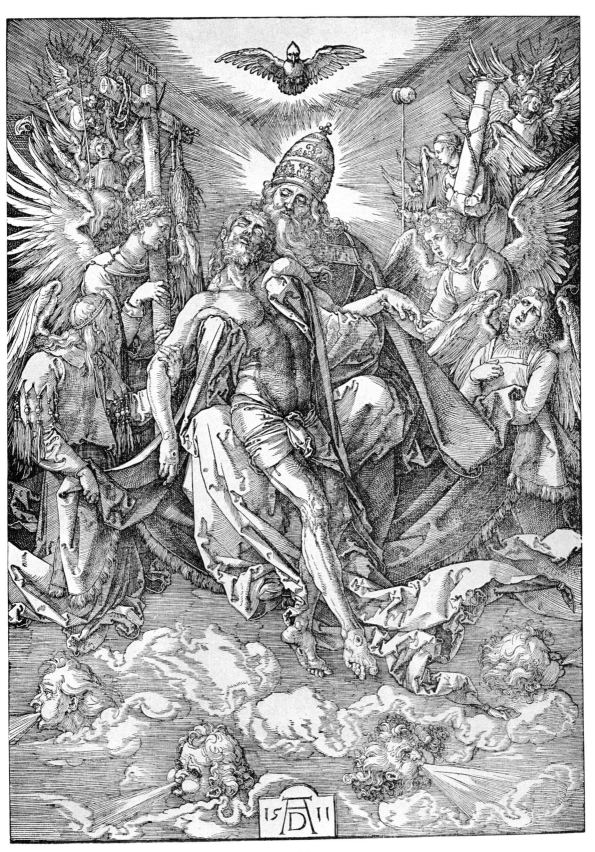

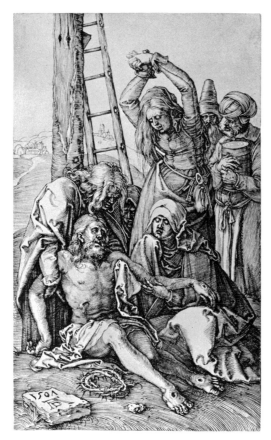

186

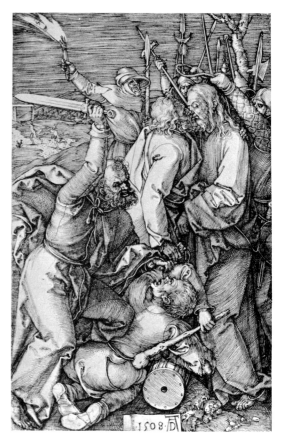

187

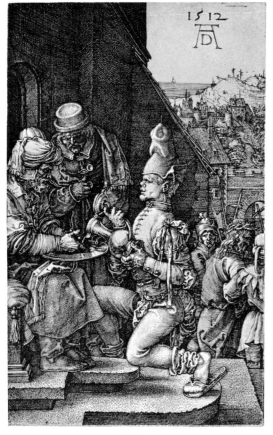

188

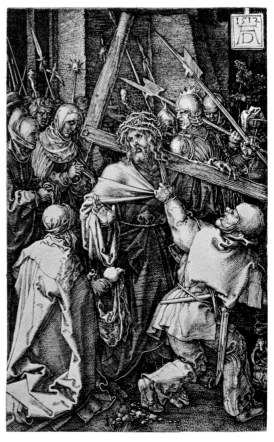

189

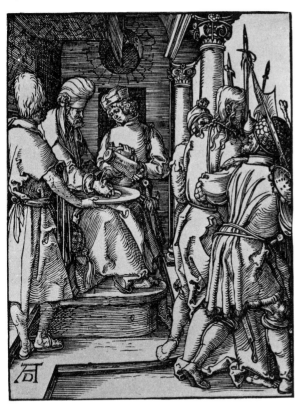

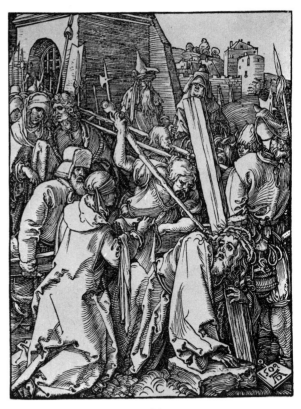

190

191

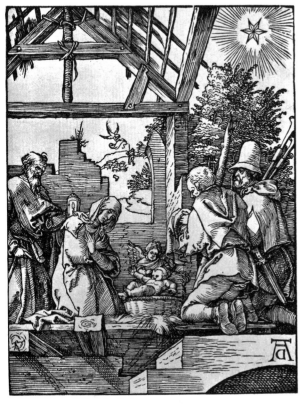

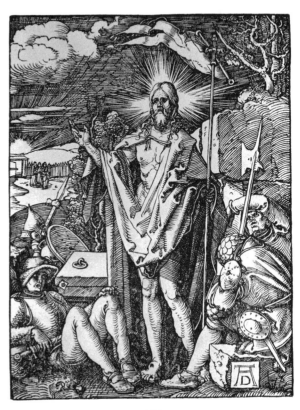

192

193

195

194

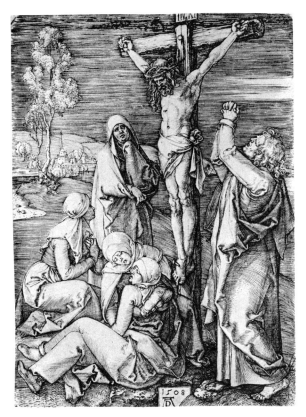

196

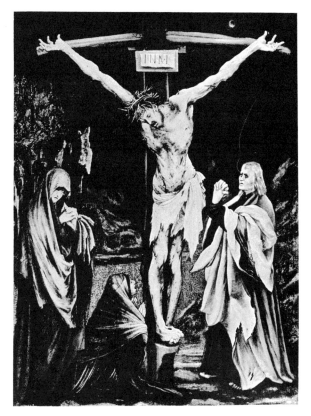

197

198

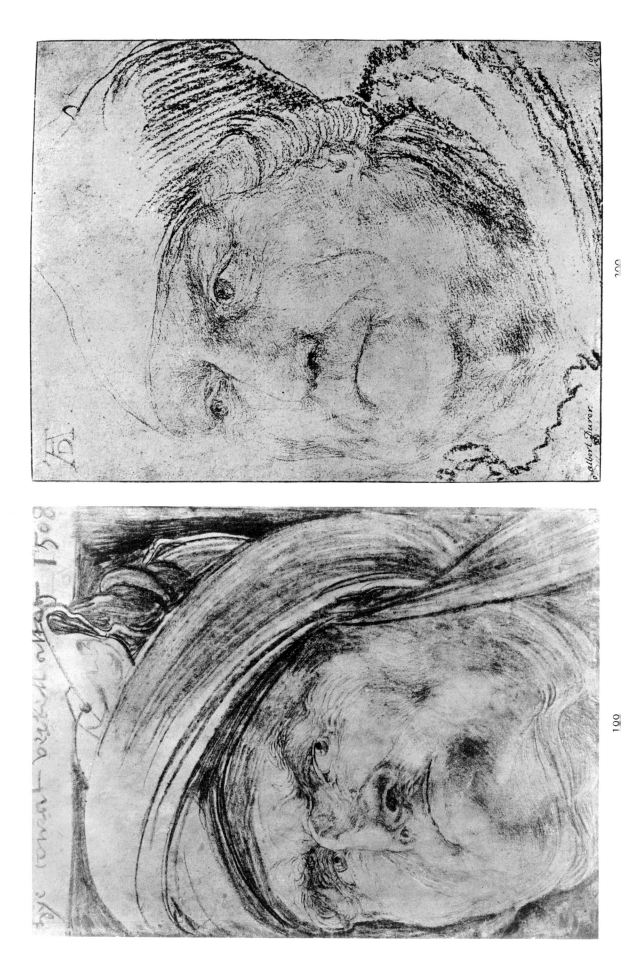

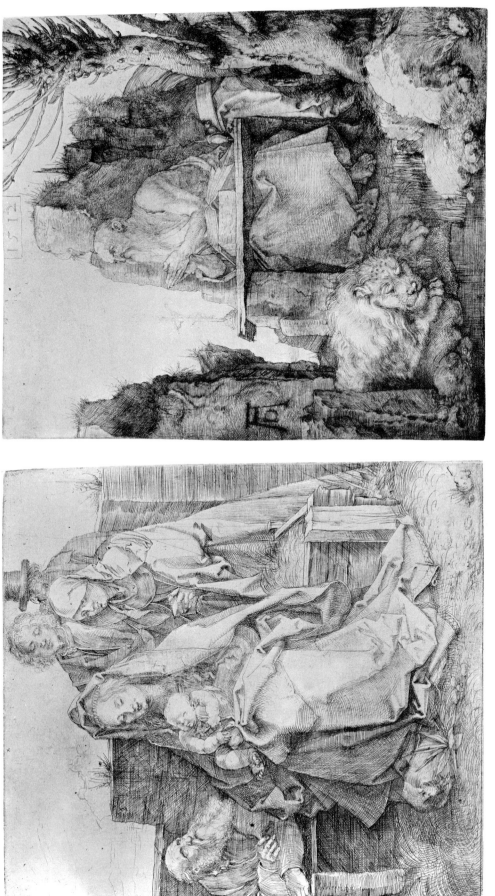

201

202

204

203

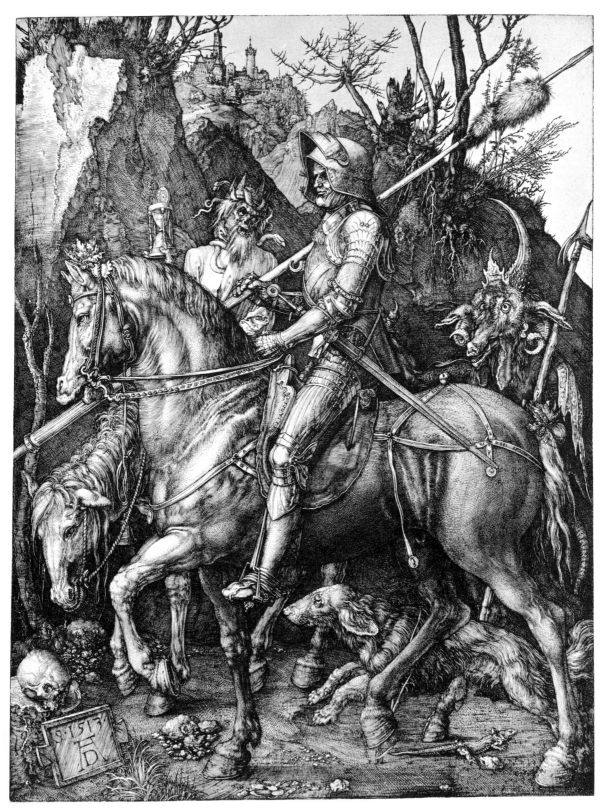

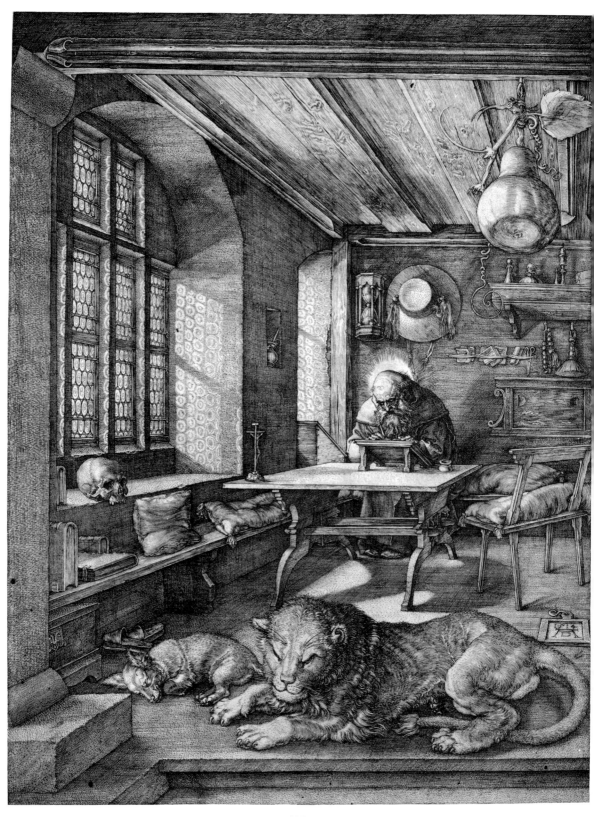

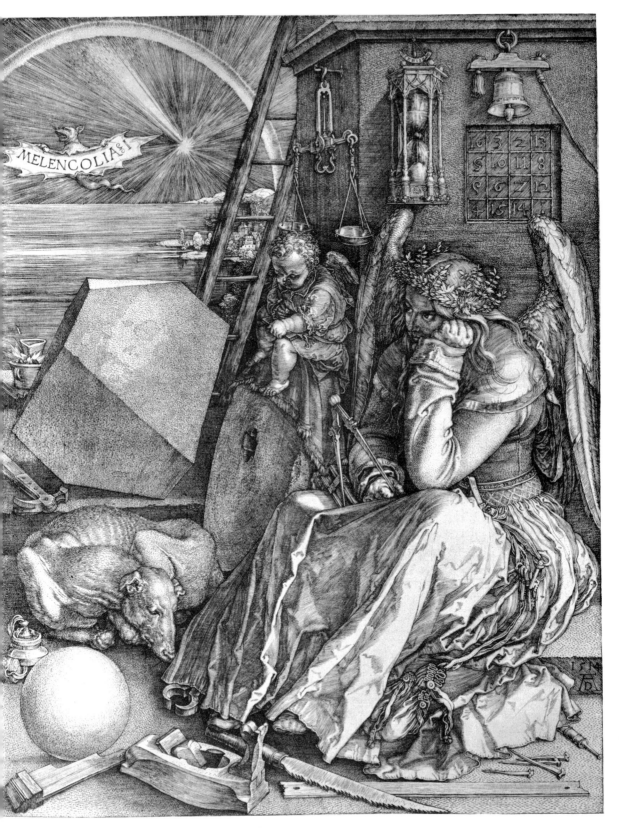

209

212

211

210

216

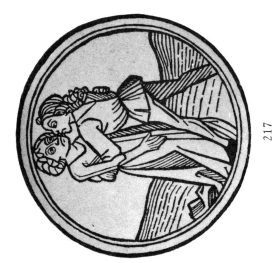

217

218

219

220

221

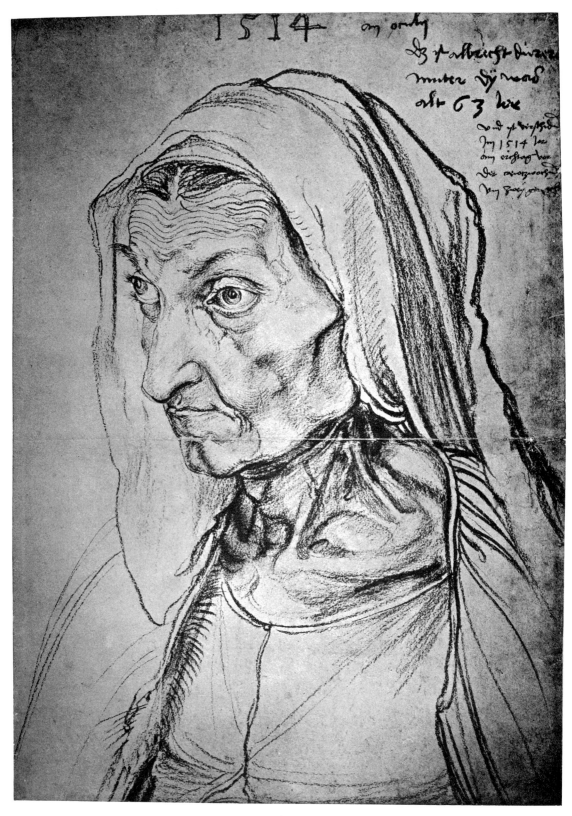

223

224

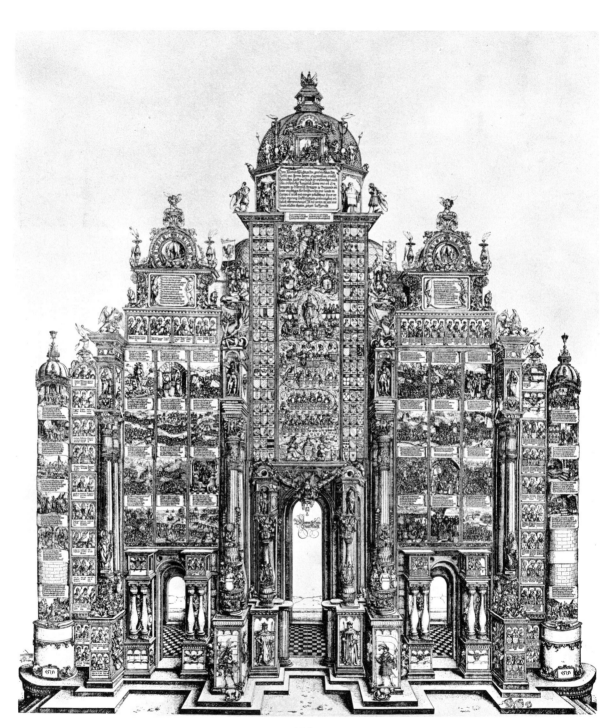

225

228

227

226

231

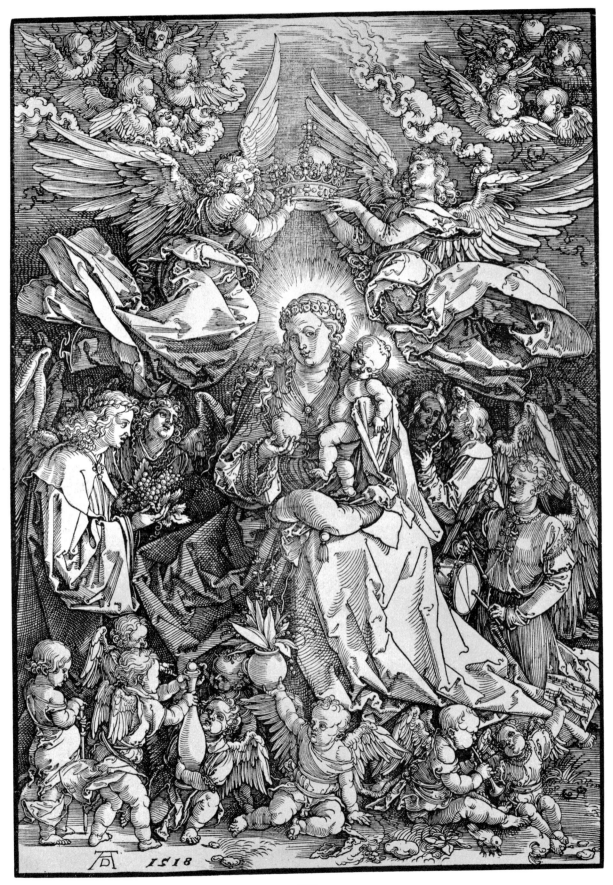

233

exaltabor in terra. O dominus
virtutum nobiscum: suscepit
noster deus iacob. Gloria.
Adiuuabit eam deus vul
tu suo: deus in medio eius non
commouebitur. Antiphona.
Sicut letantium. Psalmus.
Fundamenta eius in mon
tibus sanctis: diligit do
minus portas sion: super om
nia tabernacula iacob. Glori
osa dicta sunt de te: ciuitas dei
Memor ero raab et babilonis
scientium me. Ecce alienigene

Oremus. Maiestatem tuam
domine supplicater exoramus:
vt sicut ecclesie tue beatus An
dreas apostolus extitit predi
cator et rector. Ita apud te sit
ipse pro nobis perpetuus inter
cessor. Per christum dominum
nostrum Amen.
De sancto Maximiliano.
Esto confessor domini
presul reg eterni Maxi
miliane: consors sanctoz: con
ciuis celestium: exaudi preces
tuoru: funde vota supplicati: et

men tuum in universa terra.
Gloria patri. Antiphona. Benedicta tu in mulieribus: et benedictus fructus ventris tui. Psalmus.
Sicut mirra. Psalmus.
Celi enarrant gloriam dei: et opera manuum eius annunciat firmamentum. Dies diei eructat verbum: et nox nocti indicat scientiam. Non sunt loquele neque sermones: quorum non audiantur voces eorum. In omnem terram exivit sonus eorum. et

...ta: da michi virtutem contra hostes tuos. Antiphona. Post partum. Psalmus.
Cantate domino canticum novum: quia mirabilia fecit. Salvavit sibi dextera eius: et brachium sanctum eius. Notum fecit dominus salutare suum: in conspectu gentium revelavit iusticiam suam. Recordatus est misericordie sue: et veritatis sue domui israel. Viderunt omnes termini terre salutare dei nostri. Iubila

238

239

240

241

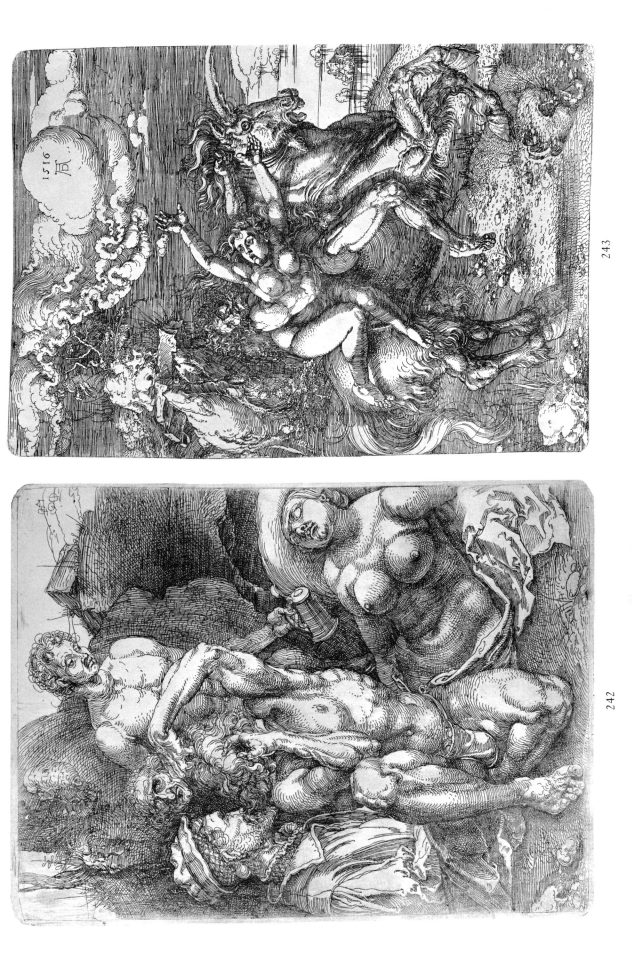

243

242

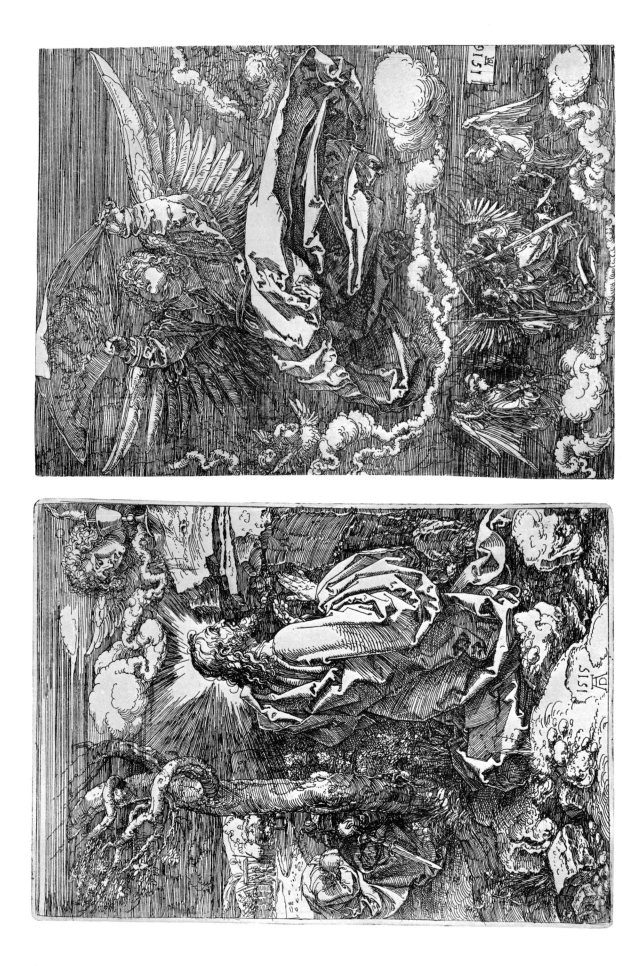

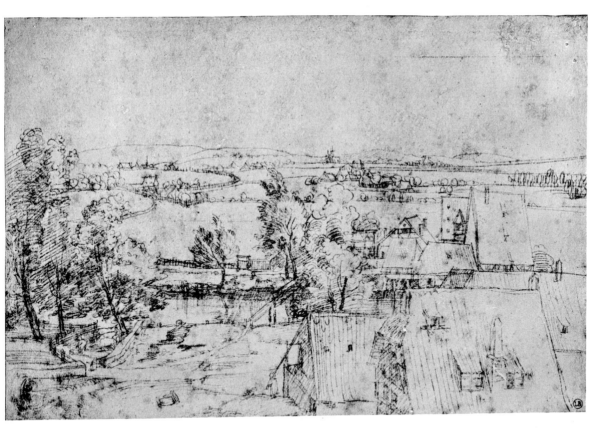

246

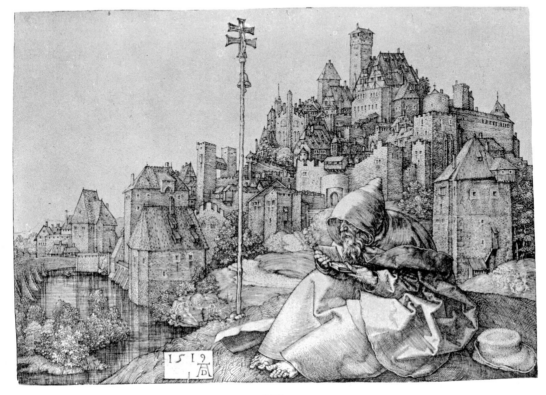

247

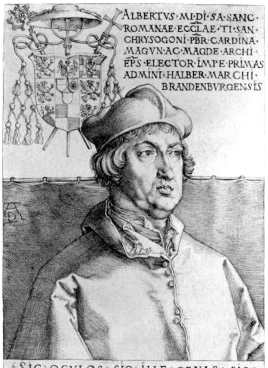

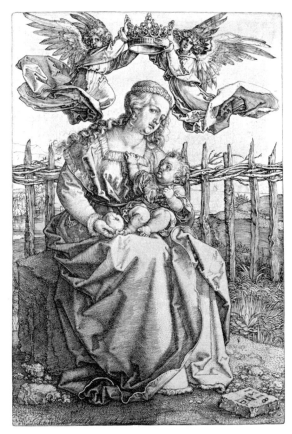

ALBERTVS·MI·DI·SA·SANC·
ROMANAE·ECCLAE·TI·SAN·
CHRYSOGONI·PBR·CARDINA·
MAGVN·AC·MAGDE·ARCHI·
EPS·ELECTOR·IMPE·PRIMAS·
ADMINI·HALBER·MARCHI·
BRANDENBVRGENSIS·

SIC·OCVLOS·SIC·ILLE·GENAS·SIC·
ORA·FEREBAT·
ANNO·ETATIS·SVE·XXIX·
M·D·XIX·

248

249

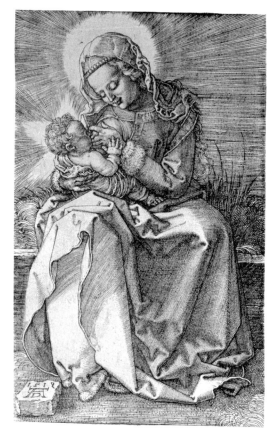

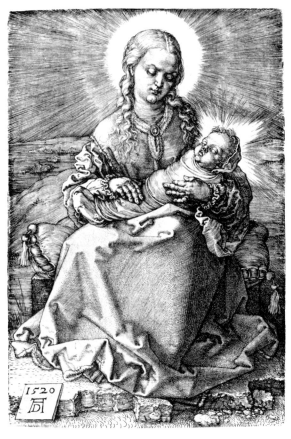

250

251

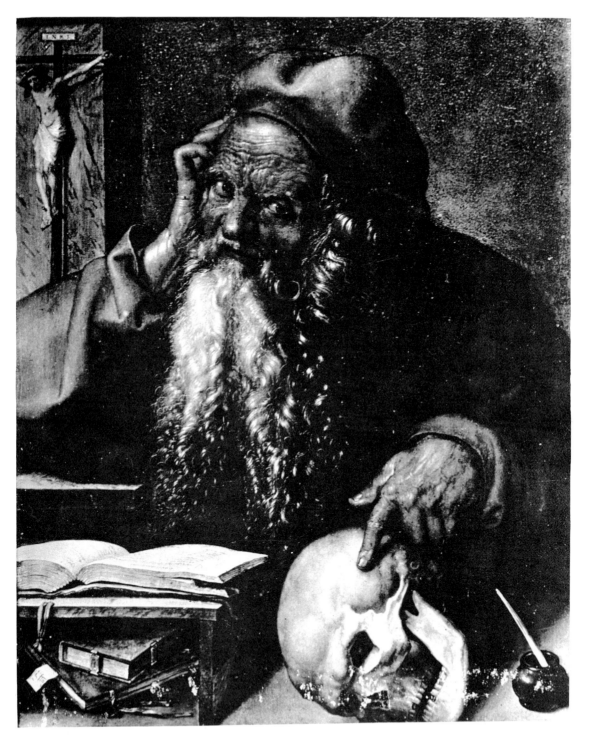

252

253

254

255

256

257

258

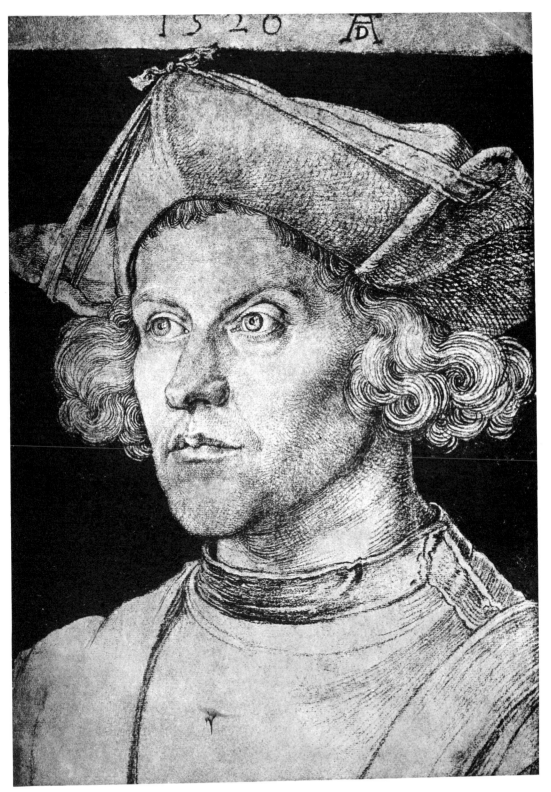

261

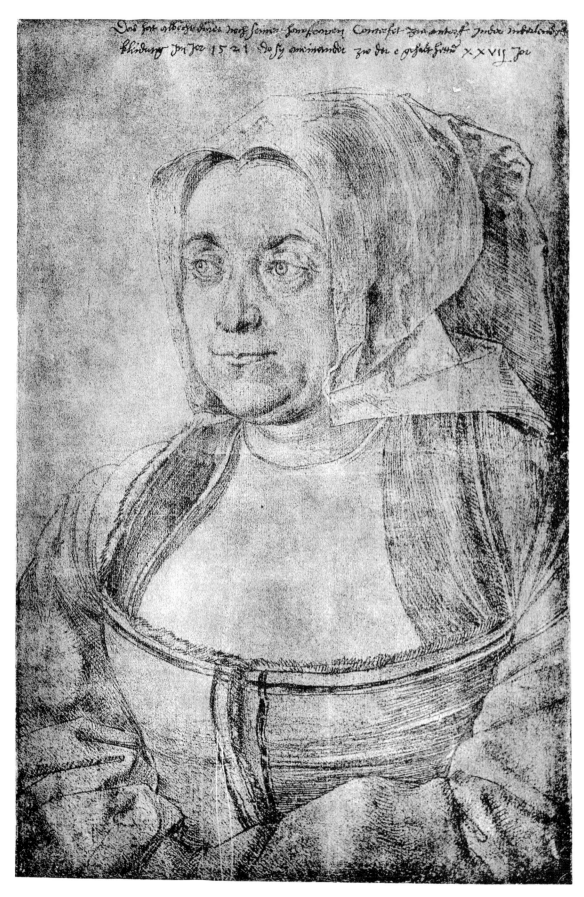

263

264

265

266

267

268

269

270

271

272

274

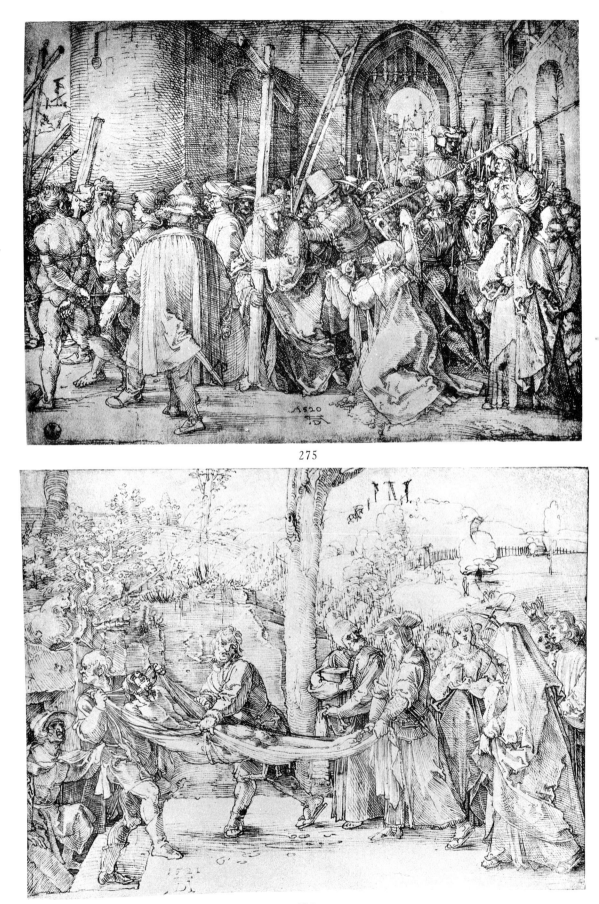

275

276

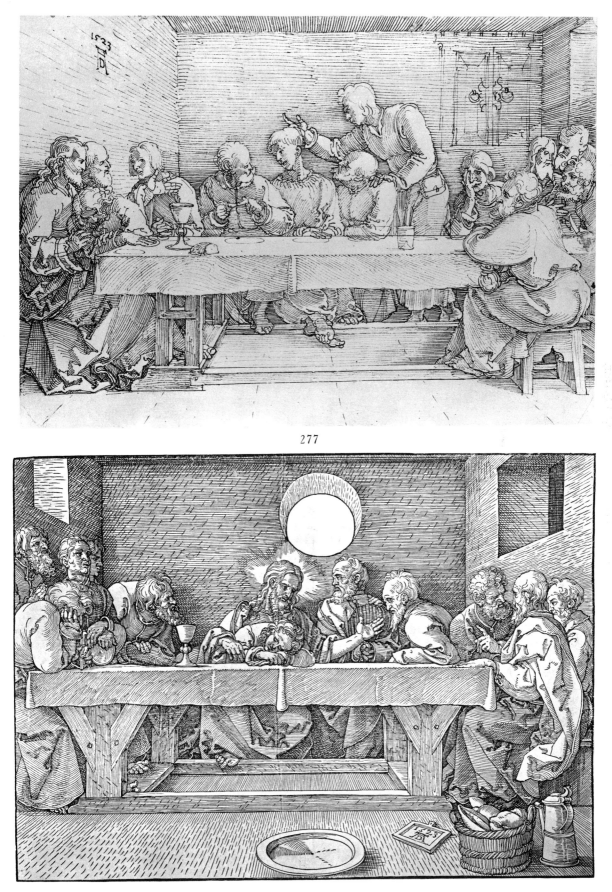

277

278

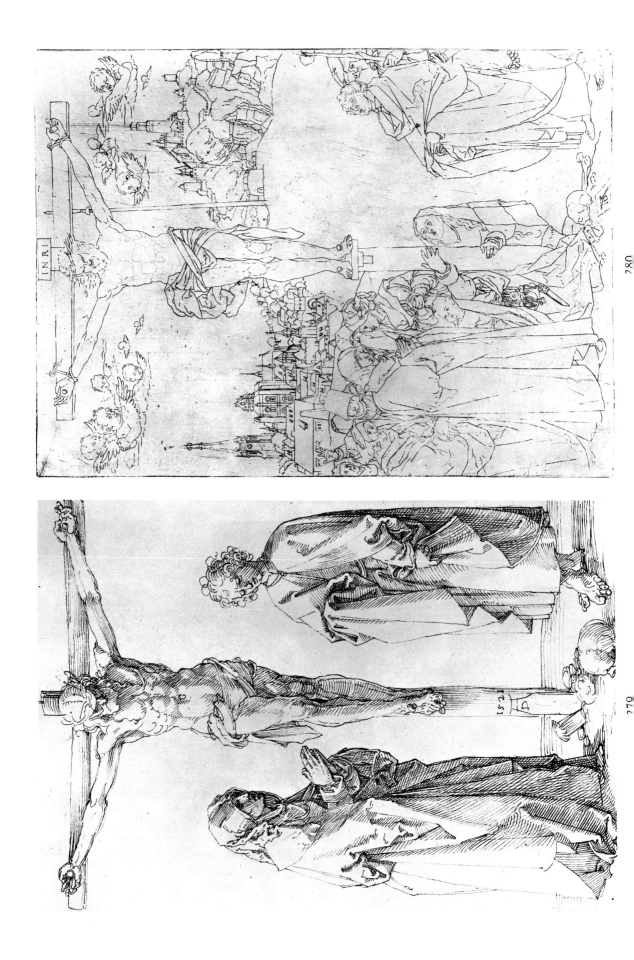

279

280

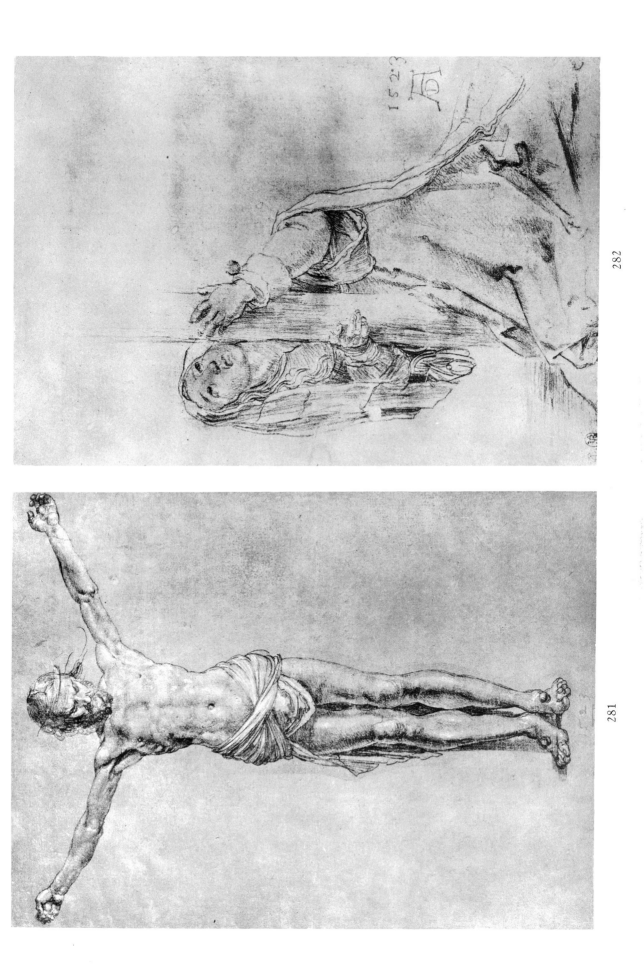

282

281

285

286

288

287

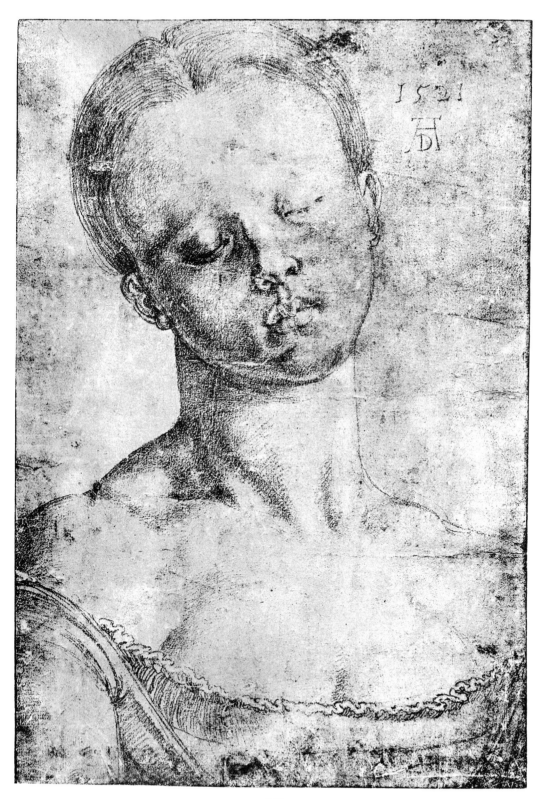

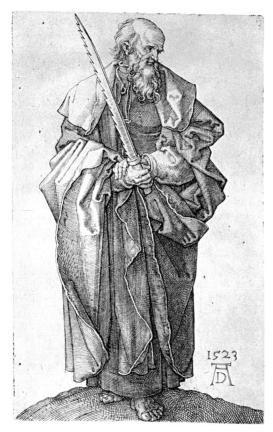

290

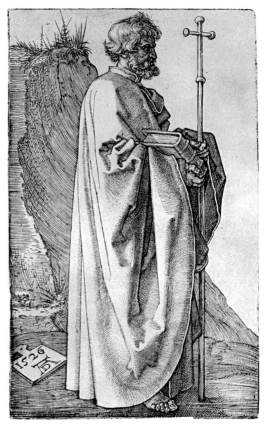

291

292

293

294 295

296

297

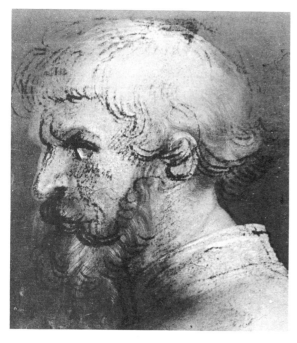

298

299

VLRICHVS VARNBVLER ꝛC.M.D.XXIIᴱ

301

M · D · X X · iii
SIC·OCVLOS·SIC·ILLE·GENAS·SIC·ORA·FEREBAT·
ANNO·ETATIS·SVE·XXXIIII

ALBERTVS·MI·DI·SA·SANC·ROMANAE·ECCLAE·TI·SAN·
CHRYSOGONI·PBR·CARDINA·MAGVN·AC·MAGDE·
ARCHIEPS·ELECTOR·IMPE·PRIMAS·ADMINI·
HALBER·MARCHI·BRANDENBVRGENSIS·

300

· CHRISTO · SACRVM ·

ILLE · DEI · VERBO · MAGNA · PIETATE · FAVEBAT ·
· PERPETVA · DIGNVS · POSTERITATE · COLI ·

· D · FRIDR · DVCI · SAXON · S · R · IMP ·
· ARCHIM · ELECTORI ·

· ALBERTVS · DVRER · NVR · FACIEBAT ·
· B · M · F · V ·

· M · D · XXIIII ·

BILIBALDI · PIRKEYMHERI · EFFIGIES
· AETATIS · SVAE · ANNO · L · iii ·
VIVITVR · INGENIO · CAETERA · MORTIS ·
ERVNT ·

· M · D · XX · IV ·

305

304

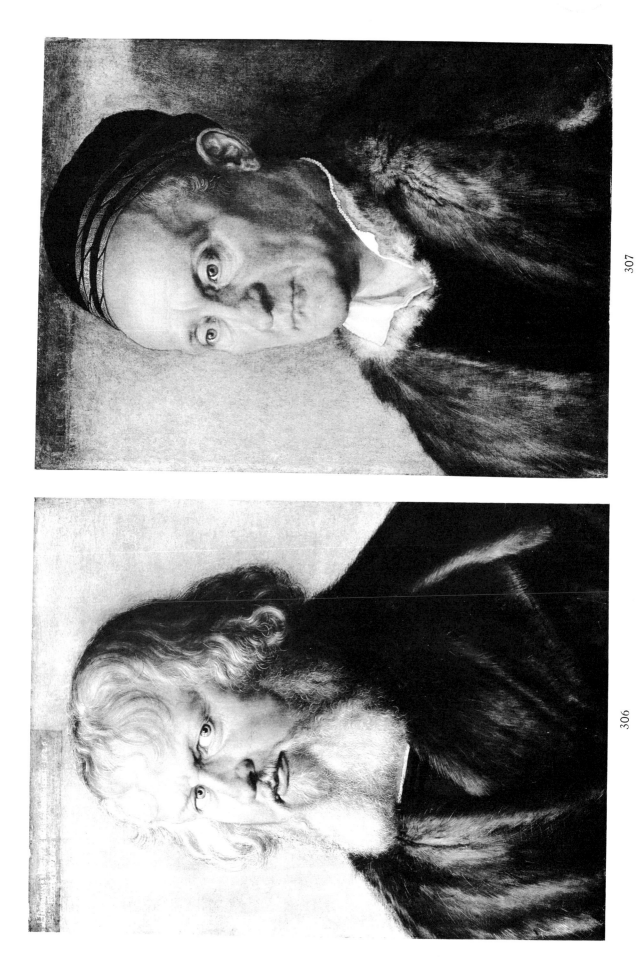

307

306

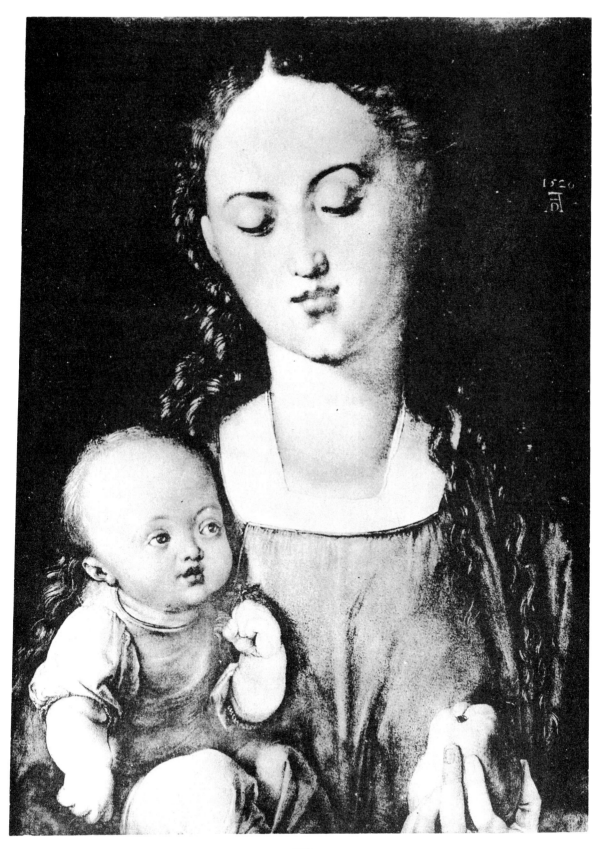

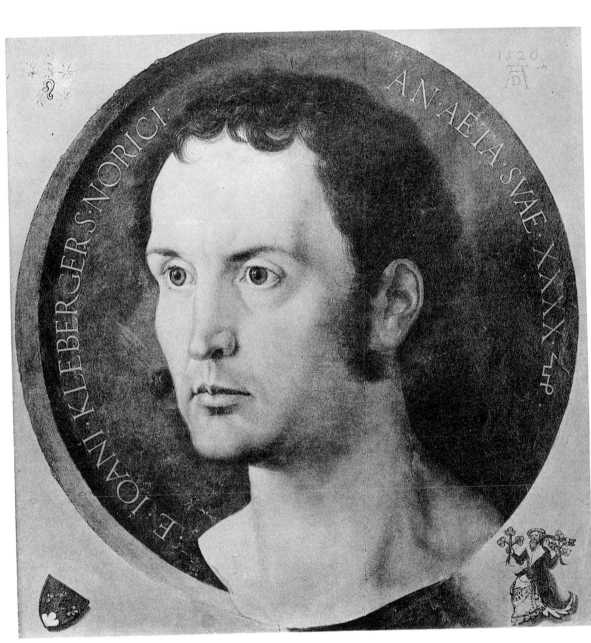

309

310

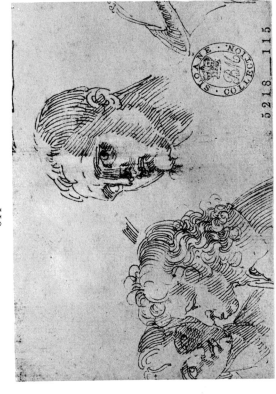

311

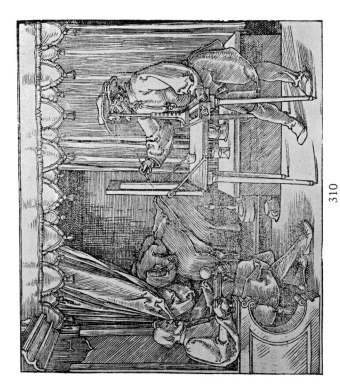

312

313

314

315

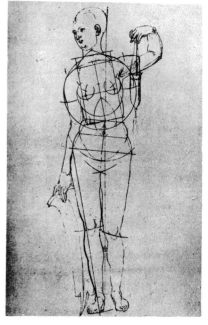

316

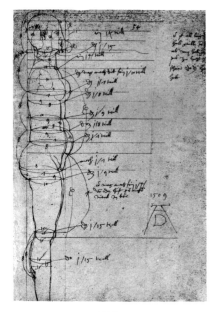

317

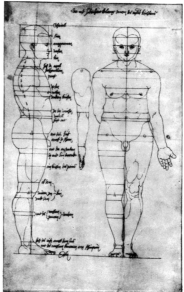

318

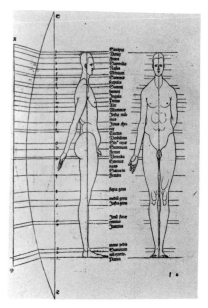

319

320

321

322

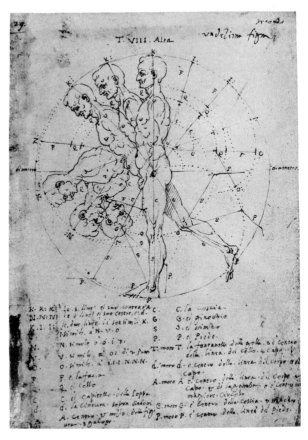

323

325

324